Exhibiting Matters

Camera Austria

International

öS 180,– DM 29,– € 14,75 US$ 22,– **69**

Camera Austria International, 69 (2000), edited by Christine Frisingelli & Manfred Willmann, designed by Jörg Schlick. Photo: Jakob Winkler

Editorial

In the fields of art and architecture we see an expansion of the *exhibitionary complex*: biennales, triennales, and exhibition spaces proliferate, blending with sites of consumption. When art and architecture stand at the core of capitalist reproduction, caught between market-oriented culture and real estate, exhibition strategies are often seen as reinforcing inequalities. However, beyond being a site of both the production and distribution of art and architecture, exhibiting reappears as a site of contestation and, indeed, political confrontation and labour struggle. In *GAM.14* we see exhibiting, as opposed to exhibition, as the deliberate refusal of temporal and spatial closure, thus bringing forth new sites for investigative (dis)play, media manifestations, and crossover collaborations. *GAM.14* is a collection of current positions from the disciplines of art and architecture assembled around the conceptual effort to distinguish the act of exhibiting from exhibition, opening the potential of exhibiting as an exploratory space to address urgent social and political challenges of our time.

Taking a magazine as a site of exhibiting and uninterrupted spatial and temporal exposure intervening in a socio-political context, we start *GAM.14* with reference to the intervention made by *Camera Austria International* 69/2000 (aka The Black Issue) into the political context of the 1999 right turn in Austria to which we see many parallels today, establishing continuity. *GAM.14* defines an exhibition as an act of representation, while exhibiting embraces what is excluded and removed in order for an exhibition to be constituted. The act of constituting exhibition, as a closed temporal and spatial event, becomes a screen obfuscating the production relations, labour, the economic and social situation, and ultimately the conditions of exhibiting as such. In this constellation, we introduce the rupture between exhibiting and exhibition as a way to confront the appropriation and erasure that takes place when the work of art, and the relations that produced it, enter the exhibition. Exhibiting appears on the exhibition as an extra, bringing back the struggle of the erased.

In the first section "Exhibiting – Modernity Rift," *GAM.14* addresses the fatal relationship between modernism and exhibiting. The implications of the relation between modernism and exhibition are at the core of a conversation with Vincent Normand, who proposes understanding the exhibition as "a construction site of the modern aesthetic subject," the privileged site which is at the same time produced by and central to the production of modernity. Ivana Bago argues for the act of titling and an artwork's entry into the public sphere as the exhibiting departure point. While increasing emphasis on the title may be a

In den Bereichen Kunst und Architektur sehen wir eine Erweiterung des *Ausstellungskomplexes*: Biennalen, Triennalen und Ausstellungsräume werden immer mehr und vermischen sich mit Orten des Konsums. Wenn Kunst und Architektur im Zentrum der kapitalistischen Reproduktion stehen, gefangen zwischen marktorientierter Kultur und Immobilienhandel, werden Ausstellungsstrategien oft als Verstärker von Ungleichheiten gesehen. Abgesehen davon verlangt das Ausstellen aber nicht nur einen Ort der Produktion und Verbreitung von Kunst und Architektur sondern auch einen Ort der Auseinandersetzung und sogar der politischen Konfrontation und des Arbeitskampfes. In *GAM.14* sehen wir Ausstellen – im Gegensatz zu Ausstellung – als die bewusste Ablehnung zeitlicher und räumlicher Beschränkung, wodurch neue Orte für investigatives und spielerisches Ausstellen, mediale Manifestationen und Crossover-Kollaborationen entstehen. *GAM.14* versammelt aktuelle Positionen aus den Disziplinen Kunst und Architektur in dem konzeptionellen Bestreben, den Akt des Ausstellens von der Ausstellung zu unterscheiden und das Potenzial des Ausstellens als Forschungsraum für die Bewältigung dringlicher gesellschaftlicher und politischer Herausforderungen unserer Zeit zu öffnen.

Ausgehend von der Tatsache, dass auch eine Zeitschrift zum Ausstellungsort und Ort permanenter räumlicher und zeitlicher Präsentation werden kann, die in einen gesellschaftspolitischen Kontext eingreift, beginnen wir *GAM.14* mit einer Referenz an die Intervention von *Camera Austria International* 69/2000 (aka „Die schwarze Ausgabe") in den politischen Kontext des Rechtsrucks in Österreich im Jahre 1999, zu dem wir gegenwärtig viele Parallelen sehen und Kontinuität herstellen. *GAM.14* definiert die Ausstellung als Akt der Repräsentation, wogegen das Ausstellen das umfasst, was im Zuge der Zusammenstellung einer Ausstellung ausgeschlossen und entfernt wurde. Der Akt der Zusammenstellung einer Ausstellung als geschlossenes zeitliches und räumliches Ereignis wird zu einer Bildfläche, die die Produktionsbeziehungen, die Arbeit, die ökonomische und soziale Situation und letztlich die Ausstellungsbedingungen als solche verschleiert. In diese Konstellation führen wir den Bruch zwischen Ausstellen und Ausstellung als eine Möglichkeit ein, der Aneignung und Auslöschung zu begegnen, die stattfindet, wenn das Kunstwerk und die Beziehungen, die es hervorgebracht haben, in die Ausstellung eintreten. Das Ausstellen erscheint in der Ausstellung als zusätzliche Komponente und bringt den Kampf des Ausgelöschten gegen die Auslöschung zurück.

Im ersten Abschnitt „Exhibiting – Modernity Rift", befasst sich *GAM.14* mit der fatalen Beziehung zwischen Moderne und Ausstellen. Die Implikationen dieses Verhältnisses stehen im Mittelpunkt eines Gesprächs mit Vincent Normand, der vorschlägt, die Ausstellung als „Baustelle des modernen ästhetischen Subjekts" zu begreifen, als privilegierten Ort, der gleichzeitig von der Produktion der Moderne erzeugt wird und von zentraler Bedeutung für sie ist. Ivana Bago argumentiert für den Akt der Betitelung eines Kunstwerks und den Eintritt eines Kunstwerks in den öffentlichen Raum als Ausgangspunkt des Ausstellens. Während die zunehmende Betonung des Titels ein Zeichen für die Reduktion des Kunstwerks auf ein Zahlungsmittel sein kann, ist sie für Bago eine Ausgangsbasis für die Analyse neuer Positionen des Verhältnisses zwischen künstlerischer Arbeit und Kunstwerk. In Anlehnung an Walter Benjamin erläutert anschließend Sami Khatib die vom Begriff „Ausstellen" gebotene seman-

sign of the reduction of an artwork into a currency, for Bago it is a springboard for the analysis of new positions of relation between artistic labour and artistic work. Following Walter Benjamin, Sami Khatib elaborates on the opening exhibiting offers by pointing out that the exhibition of art commodities, even those artworks created to be commodities, also exhibits something extra, beyond the economic function of the circulation of commodities.

For *GAM.14* acknowledging the role of exhibition in the production of the middle class and class consensus makes it possible to use and subvert it as a site where the subjectivity of the excluded produces itself, by its own decision and determination. Exhibiting begins in the moment of emancipation, i.e. the capability to think a problem as public matter. If art is optical machinery to see the contemporary condition (Nicolas Bourriaud), exhibition is the shop floor on which this machinery operates. Ana Dević reminds us that understanding the exhibition as an extension of a revolutionary class war creates a rupture in both representation and the cycle of commodification. Ana María León and Andrew Herscher mobilize exhibiting to fight against the normalization of exclusionary processes in the city carried out in the real space of an exhibition. Here, virtual tools were used to reintroduce class war into the site of "representational triumphalism" and to produce a rift through which the excluded brings reality back into frame and challenges authority.

The second section of *GAM.14* "Returns of the Excluded," shows the importance of addressing exhibiting in the context of art in parallel with architecture. Vincent Normand argues that the origin of exhibition is not in the cabinet of wonders, but in the anatomical theatre, i.e. not in the act of collecting (curiosities) but in the spatial construction of the specific gaze and production of knowledge. Within modernity the modern human is subjectivized through exhibition, and is the object of this process. The alternative process is exhibiting, which opens a site of subjectivization of all actors involved in the constellation of relationships that are framed as exhibition. Understanding the struggle between exhibition as the tool of modernity and exhibiting means considering the struggle to make visible, take voice, and capture political space. How to introduce into exhibition that which has been rejected, temporally and spatially framed out, and blocked as relation? Nicolas Bourriaud reminds us in conversation that art has always had a capacity to bring back what the ruling class rejected, and that the very site of exhibiting becomes one of subjectivization for a different politics. The core proposal is that the limits of exhibition within the modernist subjectivity are not overcome by including, as passive objects, those subjectivities subsumed by modernist primacy, but rather by forging alliances to transform exhibition from a site for the production of objects to one for the production of (political) subjects.

tische Öffnung und weist darauf hin, dass die Ausstellung von Kunstgegenständen auch etwas zeigt, das über die ökonomische Funktion des Warenkreislaufs hinausgeht.

Die Anerkennung der Rolle der Ausstellung in der Produktion der Mittelklasse und des Klassenkonsenses ermöglicht es *GAM.14*, sie als einen Ort zu nutzen und zu untergraben, an dem sich die Subjektivität des Ausgeschlossenen durch eigene Entscheidung und Entschlossenheit selbst produziert. Das Ausstellen beginnt im Moment der Emanzipation, d.h. der Fähigkeit, ein Problem als öffentliche Angelegenheit zu denken. Wenn Kunst eine optische Maschine ist, um den Zustand der Gegenwart zu sehen (Nicolas Bourriaud), dann ist die Ausstellung die Werkstatt, in der diese Maschine arbeitet. Ana Dević erinnert uns daran, dass das Verständnis der Ausstellung als Verlängerung eines revolutionären Klassenkampfes einen Bruch sowohl in der Repräsentation als auch im Kreislauf der Kommodifizierung verursacht. Ana María León und Andrew Herscher mobilisieren den Begriff „Ausstellen", um gegen die Normalisierung von Ausschlussprozessen in der Stadt zu kämpfen, die im realen Ausstellungsraum stattfinden. Hier wurden virtuelle Instrumente eingesetzt, um den Klassenkampf wieder in den Ort des „Triumphalismus der Repräsentation" einzuführen und einen Riss zu erzeugen, durch den das Ausgeschlossene die Realität wieder in den Rahmen rückt und Autorität herausfordert.

Der zweite Teil von *GAM.14*, „Returns of the Excluded", zeigt, wie wichtig es ist, Ausstellen im Kontext der Kunst parallel zur Architektur zu thematisieren. Vincent Normand argumentiert, dass der Ursprung der Ausstellung nicht im Wunderkabinett liegt, sondern im anatomischen Theater, also nicht im Akt des Sammelns (von Kuriositäten), sondern in der räumlichen Konstruktion des spezifischen Blicks und der spezifischen Wissensproduktion. In der Moderne wird der moderne Mensch durch die Ausstellung subjektiviert und ist Objekt dieses Prozesses. Der alternative Prozess ist das Ausstellen, das einen Ort der Subjektivierung aller Akteure eröffnet, die an der Konstellation von als Ausstellung gerahmten Beziehungen beteiligt sind. Den Kampf zwischen Ausstellung als Instrument der Moderne und Ausstellen zu verstehen, bedeutet, den Kampf um Sichtbarmachung, Stimme und politischen Raum ernst zu nehmen. Wie lässt sich das Abgelehnte, das zeitlich und räumlich Ausgerahmte und das als Relation Blockierte in die Ausstellung einbringen? Nicolas Bourriaud erinnert uns im Gespräch daran, dass die Kunst schon immer die Fähigkeit besaß, das zurückzuholen, was die herrschende Klasse abgelehnt hat, und dass der Ort des Ausstellens selbst zu einem Ort der Subjektivierung für eine andere Politik wird. Der Kerngedanke ist, dass die Grenzen der Ausstellung innerhalb der modernistischen Subjektivität nicht dadurch überwunden werden, dass man als passive Objekte jene Subjektivitäten einbezieht, die dem Primat der Moderne untergeordnet sind, sondern dass man Allianzen schmiedet, um die Ausstellung von einem Ort für die Produktion von Objekten zu einem Produktionsort von (politischen) Subjekten zu machen.

Die „Praxis Reports" in *GAM.14* schlagen verschiedene Ansätze vor, mit spekulativen Vorschlägen (Strain), wie der zeitliche und räumliche Rahmen der repräsentativen Ausstellung destabilisiert, unterbrochen und manipuliert werden kann, um so etwas wie Ausstellen zu erreichen. Als philosophisches Problem betrachtet, kann die Ausstellung zum Ort der Untersuchung werden (Springer/Turpin), zum Modell (Kuehn),

The "Praxis Reports" in *GAM.14* suggest various approaches, with speculative proposals (Strain) of how the temporal and spatial frame of representational exhibition can be destabilized, interrupted, and manipulated to achieve exhibiting. Approached as a philosophical problem, exhibition can become a site for investigation (Springer – Turpin), a model (Kuehn), research (Franke), an aesthetic instrument for understanding reality at another level (Latour), exposing (Majača), "displaycing" (Mende), and mirroring (Miljački).

We invited the Museum of American Art in Berlin (MoAA), and artist Armin Linke, in conversation with graphic designer Žiga Testen, to use some of the pages of *GAM.14* as a site of exhibiting. By putting the ideological context in post-war Europe to the fore, MoAA's visual essay reveals how the inclusion or exclusion of artworks in an exhibition played a constitutive role in the articulation of the modernist canon. Linke's photo essay proposes that a new reading is established with each exhibiting constellation, raising the question: Is not the archival methodology used by each individual artist the basis of exhibiting?

Ana Bezić opens the third section of *GAM.14* "Exhibiting – Sites of Departure" by exploring when exhibiting starts and how disciplines such as archaeology use interpretation as a mode of exhibiting. This becomes pertinent when the conceptual apparatus of exhibition is mobilized to problematize rather than pose solutions. Continuing the "Praxis Reports," Barbara Steiner extends an exhibition into exhibiting by publicly analyzing and making visible the correlations that create the very institution she heads. WHW disrupts the authority of the collection, exhibiting works with their public and artistic labour that the collection attempts to cut. Antje Senarclens de Grancy's contribution discusses examples of exhibiting as a site for the construction or disruption of interpretative authority and historical truth, exemplifying how the shift of focus from exhibition to exhibiting enables us to use the very format produced by the modernist impetus of institution building to challenge the modernist institution. Exhibiting creates a rupture in the hypostatic societal relations of the exhibition in which society can find the language and logic different from that prescribed by the institutions. With Bart de Baere's voice we address the institutional impact of this shift by insisting that the constant return to the work of its unruly part, which defies commodification, is the horizon on which the new public exhibiting institution should be conceptualized.

Reconsidering exhibition as an enclosing form means acknowledging exhibiting as a process capable of bursting enclosures by becoming a site of knowledge production and access to the hidden. Our position in favour of exhibiting opens space and time, in which the exhibition has a potential to go beyond "representational triumphalism" into a space of emancipation with the possibility to develop a focus on exhibiting as a self-determining form.

Milica Tomić and Dubravka Sekulić

zur Forschung (Franke), zum ästhetischen Instrument des Verstehens der Realität auf einer anderen Ebene (Latour), zum Exponieren (Majača), zum sogenannten „Displaycing" (Mende) und zur Spiegelung (Miljački).

Wir haben das Museum of American Art in Berlin (MoAA) und den Künstler Armin Linke im Dialog mit dem Grafikdesigner Žiga Testen eingeladen, einige Seiten von *GAM.14* als Plattform für dieses Ausstellen zu nutzen. Indem er den ideologischen Kontext im Nachkriegseuropa in den Vordergrund stellt, zeigt der visuelle Essay des MoAA, wie die Einbeziehung oder der Ausschluss von Kunstwerken in einer Ausstellung eine grundlegende Rolle bei der Ausformung des Kanons der Moderne gespielt hat. Linke schlägt in seinem Fotoessay vor, dass mit jeder Konstellation des Ausstellens eine neue Lesart etabliert wird und wirft folgende Frage auf: Ist nicht auch die von jedem einzelnen Künstler angewandte Archivierungsmethode die Grundlage für die Ausstellung?

Ana Bezić eröffnet den dritten Abschnitt von *GAM.14*, „Exhibiting – Sites of Departure", indem sie erkundet, wann Ausstellen beginnt und wie Disziplinen wie die Archäologie die Interpretation als Form des Ausstellens nutzen. Dies wird relevant, wenn der konzeptuelle Apparat der Ausstellung mobilisiert wird, um Lösungen zu problematisieren anstatt sie zu präsentieren. In Fortführung der „Praxis Reports" erweitert Barbara Steiner eine Ausstellung zum Ausstellen, indem sie öffentlich die Zusammenhänge analysiert und sichtbar macht, die die von ihr geleitete Institution ausmachen. WHW untergräbt die Autorität der Sammlung durch das Ausstellen von Werken zusammen mit deren öffentlicher und künstlerischer Arbeit, die die Sammlung auszublenden versucht. Der Beitrag von Antje Senarclens de Grancy diskutiert Beispiele für das Ausstellen als Ort für die Konstruktion oder den Zusammenbruch von Interpretationshoheit und historischer Wahrheit und veranschaulicht, wie die Verlagerung des Fokus von der Ausstellung zum Ausstellen es uns ermöglicht, genau das Format zu nutzen, das durch den modernistischen Impetus des Institutionenaufbaus erzeugt wurde, um die Institution der Moderne herauszufordern. Das Ausstellen erzeugt einen Bruch in den hypostatischen gesellschaftlichen Verhältnissen der Ausstellung, in denen die Gesellschaft die Sprache und Logik anders finden kann als von den Institutionen vorgeschrieben. Mit Bart de Baeres Stimme sprechen wir die Auswirkungen dieses Wandels auf die Institutionen an, indem wir darauf bestehen, dass die ständige Rückbesinnung auf die Arbeit ihrer widerspenstigen Teile, die sich der Kommodifizierung widersetzt, der Horizont ist, auf dem die neue öffentliche Ausstellungsinstitution konzipiert werden sollte.

Die Ausstellung als umschließende Form zu überdenken, bedeutet, das Ausstellen als einen Prozess anzuerkennen, der in der Lage ist, Grenzen zu sprengen, indem er zum Ort der Wissensproduktion und des Zugangs zum Verborgenen wird. Unsere Position zugunsten des Ausstellens öffnet Raum und Zeit, in der die Ausstellung ein Potenzial hat, über den „Triumphalismus der Repräsentation" hinaus in einen Emanzipationsraum zu gehen, mit der Möglichkeit, einen Fokus auf das Ausstellen als selbstbestimmte Form zu entwickeln.

Milica Tomić und Dubravka Sekulić
Übersetzung: Otmar Lichtenwörther

Exhibiting Matters

Reviews

Faculty News

Exhibiting
—
Modernity Rift

Exhibition.
Exhibiting

What Has Not Yet Been Subsumed:
On the Title of Art (and Its Expositions)
Das noch nicht Subsumierte:
Über die Betitelung von Kunst (und ihrer Ausstellungen)

Ivana Bago

To strike out "Exhibition" and assert instead "Exhibiting" as a practice that grants art and architecture a place in the political struggle for social justice is to argue for a method that embraces a certain position of incompleteness, a deliberate refusal of closure. In the title of this issue, "Exhibiting Matters,"[1] this was achieved already on the level of grammar: a noun was displaced by a gerund, the form that magically fits the place of the noun, while retaining the shape of the verb and its inherent propensity for action. In the logic of Slavic languages, into which I automatically translated this title, things are a bit more complex: the verb "to exhibit" could itself be translated to denote a complete action, *izložiti* (to put on display and be done with it) and an incomplete one, *izlagati* (to be in the process of displaying/ exhibiting).[2] Both these paired verbs, furthermore, have an additional meaning that allows them to be understood not only in

Wenn man „Ausstellung" durchstreicht und stattdessen „Ausstellen" als eine Praxis behauptet, die Kunst und Architektur einen Platz im politischen Kampf um soziale Gerechtigkeit einräumt, so spricht man sich für eine Methode aus, die sich eine bestimmte Position der Unvollständigkeit, eine bewusste Verweigerung der Abgeschlossenheit, zu eigen macht. Im Titel dieser Ausgabe – „Exhibiting Matters"[1] – wurde dies bereits auf grammatikalischer Ebene erreicht: Ein Substantiv wurde durch ein Gerundium ersetzt, die Form, die wie von Zauberhand den Platz des Substantivs einnehmen kann, während die Verbform und die ihr innewohnende Handlungsbereitschaft erhalten bleiben. In der Logik der slawischen Sprachen, in die ich diesen Titel automatisch übersetzt habe, sind die Dinge ein wenig komplexer: Das Zeitwort „ausstellen" ließe sich als Bezeichnung einer vollendeten Handlung übersetzen, mit *izložiti* (ausstellen und damit fertig sein), und einer unvollendeten Handlung, mit *izlagati* (gerade im Begriff sein, etwas zu zeigen/auszustellen).[2] Darüber

1 The final title of *GAM.14* evolved from the working title "Exhibition. Exhibiting," which serves as the starting point of my argument.

2 In most Slavic languages, verbs manifest in pairs of two opposed grammatical aspects, "perfective" and "imperfective." The example listed here is taken from my native language, which I share with the editors of this issue, and whose contested name could itself offer more than enough material for a discussion of the deeply political character of titling.

1 Der finale Titel „Exhibiting Matters" entwickelte sich aus dem Arbeitstitel „Exhibition. Exhibiting", der hier als Ausgangspunkt für mein Argument dient.

2 In den meisten slawischen Sprachen manifestieren Verben paarweise zwei entgegengesetzte grammatische Aspekte: den „vollendeten Aspekt" und den „unvollendeten Aspekt". Das hier aufgeführte Beispiel stammt aus meiner Muttersprache, die ich mit der Redaktion dieser Ausgabe teile und dessen umstrittene Bezeichnung selbst mehr als genug Stoff für eine Diskussion über das zutiefst politische Wesen der Betitelung bieten könnte.

the sense of display or exhibition but also *exposition*, a presentation of one's argument, as in a lecture or courtroom. To the editors' distinction between exhibition and exhibiting I would thus like to add, by means of this "Slavic" intervention, another terminological pair, and juxtapose exhibition and exposition.[3] Although mostly forgotten in English as a name for large-scale, public display, exposition is in fact better suited to address the growing discursification of modern and contemporary art. Over the course of the twentieth century, the intensifying potency of language in the realm formerly known as the visual arts steered art away from exhibition towards exposition, with conceptual art as the culmination of the icon's contamination by logos. The intimacy of what is now known as contemporary art with the traditions of philosophy and critical theory testifies to the longevity of this bond between "art and language," and the purchase it has had in establishing contemporary art as simultaneously a politicized cultural practice and one that is particularly well adapted to the conditions of so-called cognitive capitalism.[4] In what follows, I propose to view the institution of the title as a site on which it is possible to examine this contradictory place of the discursive and the conceptual in contemporary art, and its exhibitions.

"The horror—the honor—of the name, which always threatens to become a title"[5] With the production of art still legitimized as a commerce between individual creation and its social consummation, the title is the key step that takes the artwork from its being-in-process towards its public presentation, i.e. towards its exhibition. It is the moment when the work, with its by then timid and tentative "working title," assumes its final, public, and publicized form. This move, which could be designated as a will-to-exhibition, implies a certain closure, an imposition of a concept onto the messy, and contingent, set of material, ideological, personal and interpersonal, factors that condition the creation of a work of art or an exhibition, and onto the "evident" form it ultimately assumes within the exhibition space. By the same token, the title indicates that the work of art (or a work of curation) is not without provenance, i.e., that it is bound by a signature which authorizes its final release as a form of private property, in a similar way that in legal parlance a "title" proves and defines conditions of ownership.[6] On a structural level, then, the title replicates and extends the privatizing operation of the signature, and thus affirms the link of art with yet another semantic extension of the "title"—that of entitlement, of class and social privilege.

On what might be called a hermeneutical level, the title is the executor of art's will-to-exposition, i.e., of its (again largely authorial) inclination to position itself more or less away from the potential indeterminacy of the artwork and the multiple interpretations that it is able to incite. This (ex)positioning—implicit also in the position of the title as simultaneously integral to the work and outside it—is further complicated in the visual arts by the distinction between the verbal and the visual. Quite contrary to the received wisdom according to which "a picture speaks a thousand words," the historical emergence of the title in the early modern era responded to the need to ensure "recognition" of the (relatively) codified iconographic repertoire of painting and sculpture, as art became increasingly accessible to diverse audiences beyond the narrow circles of its ecclesiastic and aristocratic patrons.[7] Even if the modern history of the title reveals the extent to which artists have played with, or subverted, its supposed clarifying function,[8] such subversion only confirms the title's foundational didacticism, and its capacity to act like a teacher's pointer: while it purports to merely locate its object, by this very gesture it covers it up, and speaks in its name. As will be argued, this representational capacity of the title has assumed an increasingly political character in contemporary art, so that, for example, Cindy Sherman could be accused of "silence" because she "untitled" her works, by the 1980s a sure relic of the legacy of abstract expressionism and its ostensibly depoliticized turn to visuality and rejection of language.[9]

It can be claimed that such ultimately logocentric subordination of image to text on the one hand ignores the un-silencing (discursive, political, didactic, hermeneutic) potentials of the visual in its own right, and that, on the other, it forgets the sensuous, affective, spectacular, codified, and thus equally ambiguous nature of the linguistic sign itself. However, despite the long tradition of various affirmations of the sovereign domain of the painterly, or the pictorial—often accompanied by a

3 An alternative to both could be added as a third term, "exposure," which, understood not as a spectacular unveiling of truth, but as an (inadequate) translation of *izloženost*, would point to an understanding of the exhibition as a deliberate acceptance of vulnerability. See: Ivana Bago and Antonia Majača, *Where Everything Is Yet to Happen: Exposures* (Banja Luka/Zagreb, 2010).

4 Among other theories of "immaterial labor," Yann Moulier Boutang's "cognitive capitalism" names what he argued was a shift from capitalism grounded in "muscle power consumed by machines" to "collective cognitive labour power." Yann Moulier Boutang, *Cognitive Capitalism* (Cambridge, 2011), p. 37.

5 Maurice Blanchot, *The Writing of the Disaster* (Lincoln, 1995), p. 7.

6 On the historical overlaps between legal and literary titles, see Eleanor F. Shevlin, "'To Reconcile Book and Title, and Make 'em Kin to One Another': The Evolution of the Title's Contractual Functions." *Book History* 2 (1999), pp. 42–77.

7 Ruth Bernard Yeazell, *Picture Titles How and Why Western Paintings Acquired Their Names* (Princeton, 2015), pp. 1–24.

8 This history is meticulously traced in John C. Welchman, *Invisible Colors. A Visual History of Titles* (New Haven, 1997), who at the same time takes issue with authors who understand the title as instructional.

9 See Welchman, *Invisible Colors* (see note 8), pp. 339–341.

hinaus hat dieses Zeitwortpaar eine Zusatzbedeutung, die es erlaubt, sie nicht nur im Sinne von Zurschaustellung oder Ausstellung, sondern auch im Sinne einer Exposition oder *Darlegung*, einer Darstellung der eigenen Argumentation, wie in einem Vortrag oder im Gerichtssaal, zu verstehen. Zur Unterscheidung zwischen Ausstellung und Ausstellen möchte ich somit durch die diese „slawische" Intervention ein weiteres Begriffspaar hinzufügen und Ausstellung und Darlegung nebeneinanderstellen.[3] Obwohl dieser Begriff im Englischen – als Bezeichnung für eine groß angelegte, öffentliche Ausstellung – größtenteils in Vergessenheit geraten ist, ist *exposition* [A.d.Ü.: dt. Darlegung] in der Tat besser geeignet, um die zunehmende Wirkmächtigkeit der Sprache im Bereich der ehemals als „bildende Kunst" bezeichneten Kunst zu thematisieren, die im Laufe des zwanzigsten Jahrhunderts die Kunst weg von der reinen Ausstellung hin zur Darlegung führte, wobei die Konzeptkunst den Höhepunkt der Kontamination des Zeichens mit dem Logos darstellte. Die intime Nähe dessen, was heute als zeitgenössische Kunst firmiert, zu den Traditionen der Philosophie und der kritischen Theorie zeugt von der Langlebigkeit dieser Verbindung zwischen Kunst und Sprache und von dem Einfluss, den diese bei der Etablierung der zeitgenössischen Kunst als politisch aufgeladene kulturelle Praxis und gleichzeitig besonders gut an die Bedingungen des sogenannten kognitiven Kapitalismus angepasste Praxis gehabt hat.[4] Im Folgenden schlage ich vor, die Benennung als Bereich zu betrachten, in dem es möglich ist, diesen widersprüchlichen Ort des Diskursiven und Konzeptuellen in der zeitgenössischen Kunst und ihren Ausstellungen zu untersuchen.

„Der Schrecken – die Ehre – des Namens, der immer Gefahr läuft, Bei-name zu werden."[5] Da die Kunstproduktion immer noch als Handel zwischen individueller Schöpfung und deren Vollendung in der Gesellschaft legitimiert ist, ist der Titel eines Kunstwerks der entscheidende Schritt, der es von seinem im-Entstehen-begriffen-Sein zu seiner öffentlichen Präsentation, d.h. zu seiner Ausstellung führt. Das ist der Augenblick, in dem das Werk mit seinem bis dahin zaghaften und vorläufigen „Arbeitstitel" seine endgültige, öffentliche und veröffentlichte Form annimmt. Dieser Schritt, der als Wille zur Ausstellung bezeichnet werden könnte, impliziert einen gewissen Abschluss, die Auferlegung eines Konzepts auf die chaotische Menge zufälliger, materieller, ideologischer, persönlicher und zwischenmenschlicher Faktoren, die die Schaffung eines Kunstwerks oder einer Ausstellung bedingen, und auf die „augenscheinliche" Form, die es letztlich im Ausstellungsraum annimmt. Ebenso deutet der Titel darauf hin, dass das Kunstwerk (oder die Arbeit des Kuratierens) nicht ohne Provenienz ist, d.h. dass es durch eine Signatur gebunden ist, die seine endgültige Freigabe als eine Form von Privateigentum autorisiert, ähnlich wie ein „Titel" im juristischen Sprachgebrauch die Eigentumsbedingungen nachweist und definiert.[6] Auf struktureller Ebene wiederholt und erweitert der Titel folglich die Privatisierungshandlung der Signatur und bekräftigt damit die Verbindung der Kunst mit einer weiteren semantischen Erweiterung des „Titels" – jener des Anspruchs, der Klasse und des gesellschaftlichen Privilegs.

Auf dem, was man eine hermeneutische Ebene nennen könnte, ist der Titel der Vollstrecker des Darlegungswillens der Kunst, d.h. ihrer (wiederum weitgehend auktorialen) Neigung, sich mehr oder weniger weit weg von der potenziellen Unbestimmtheit des Kunstwerks und den vielfältigen Interpretationen zu positionieren, die es anregen kann. Dieses (Dar)legen – implizit auch in der Position des Titels als gleichzeitig wesentlich für das Werk und dessen Außenwelt – wird in der bildenden Kunst durch die Unterscheidung zwischen Wort und Bild noch komplizierter. Ganz im Gegensatz zur überlieferten Weisheit, nach der „ein Bild mehr sagt als tausend Worte", reagierte das historische Aufkommen des Titels in der frühen Neuzeit auf das Bedürfnis, die „Anerkennung" des relativ festgeschriebenen ikonografischen Repertoires von Malerei und Bildhauerei zu gewährleisten, da die Kunst über die engen Kreise ihrer kirchlichen und adeligen Mäzene hinaus zunehmend für ein vielfältiges Publikum zugänglich wurde.[7] Auch wenn die Geschichte des Titels in der Neuzeit verrät, inwieweit Künstler mit seiner vermeintlichen klärenden Funktion gespielt oder diese untergraben haben,[8] so bestätigt eine solche Subversion doch nur die grundlegende Lehrhaftigkeit des Titels und seine Fähigkeit, wie der Zeigestab eines Lehrers zu wirken: Während er vorgibt, sein Objekt lediglich zu verorten, verdeckt er es durch eben diese Geste und spricht in seinem Namen. Wie ich noch näher ausführen werde, hat diese Repräsentationsfähigkeit des Titels in der zeitgenössischen Kunst einen zunehmend politischen Charakter angenommen, so dass z.B. Cindy Sherman des „Schweigens" beschuldigt werden konnte, weil sie ihre Werke explizit „O.T." ließ, was bis in die 1980er Jahre mit Sicherheit ein Relikt des Vermächtnisses des abstrakten Expressionismus und seiner vordergründig entpolitisierten Hinwendung zur Visualität und Ablehnung der Sprache war.[9]

Man kann behaupten, dass eine solche letztlich logozentrische Unterordnung des Bildes unter den Text einerseits die unstillbaren (diskursiven, politischen, didaktischen, hermeneutischen) Potenziale des Visuellen selbst ignoriert und ande-

3 Als Alternative zu diesen beiden Begriffen könnte als dritter Begriff „Aufdeckung" hinzugefügt werden, die aber nicht als spektakuläre Enthüllung einer Wahrheit sondern als (unzulängliche) Übersetzung von *izloženost* auf ein Verständnis der Ausstellung als bewusste Akzeptanz von Verletzlichkeit hinweisen würde. Vgl. Bago, Ivana und Majača, Antonia: *Where Everything Is Yet to Happen: Exposures.* Ausst.-Kat. (Banja Luka/Zagreb: DeLVe/Protok, 2010).

4 Neben anderen Theorien der „immateriellen Arbeit" benennt Yann Moulier Boutangs „kognitiver Kapitalismus" eine Verlagerung vom auf der „Anwendung von Muskelkraft und der Bedienung von Maschinen" beruhenden Kapitalismus zur „kollektiven kognitiven Arbeitskraft". Moulier Boutang, Yann: *Cognitive Capitalism*, Cambridge 2011, 37.

5 Blanchot, Maurice: *Die Schrift des Desasters*, München 2005, 16.

6 Zu den historischen Überschneidungen zwischen juristischen und literarischen Titeln vgl. Shevlin, Eleanor. F.: „To Reconcile Book and Title, and Make 'em Kin to One Another': The Evolution of the Title's Contractual Functions", in: *Book History* 2 (1999), 42–77.

7 Vgl. Yeazell, Ruth Bernard: *Picture Titles: How and Why Western Paintings Acquired Their Names*, Princeton, New Jersey, 2015, 1–24.

8 John C. Welchman vollzieht diese Geschichte in seinem Buch *Invisible Colors* akribisch nach und erhebt gleichzeitig Einwände gegen AutorInnen, die den Titel im belehrenden Sinne verstehen. Vgl. Welchman, John C.: *Invisible Colors. A Visual History of Titles*, New Haven 1997.

9 Vgl. Welchman, *Invisible Colors*, 339–341 (wie Anm. 8).

connoisseurial elitism, or an exoticization of the power of the image—contemporary art seems to cling, more than ever, onto the didactic, promotional, and progressively fetishistic use of language. By now already obligatory, the declaration of the political in art no longer depends on just the title or the exhibition label, but the circulation of exhibition announcements, artistic "statements" and curatorial "concepts," which often do not surpass the function of "recognition," i.e., of making sure that the list of "issues" that the work or exhibition "deals with" or "addresses," together with the list of recycled or proposed theoretical concepts that frame them, be made explicit.[10] Rather than another turn to the visual—or, more recently, the affective, the (newly) materialist, object-oriented, inhuman, microbial, which in any case depend on the evocative "magic" of those very notions—I propose to historicize this insistent claim on language and discourse as political tools in art, and to question whether their proliferation is perhaps proportionate to the equally proliferating integration of contemporary art in the flows of global capitalism, and whether the recurrent language of wishful political thinking appears in art as a solution for its chronic inability to fundamentally challenge the liberal-capitalist (colonial, patriarchal, heterosexual, racist, anthropocen(tr)ic, add-your-own) consensus.

"As to the subject, I leave it to you whether to make it sacred or profane, with men or with women."[11] Despite all the subversions and revolutions *in* art, a fundamental transformation *of* art—would this also imply a transformation of its name/title?—has never really happened. With its gradual secularization and autonomization since the Renaissance, art has been cast as a pursuit of freedom, but the freedom it has won belongs to the individual, free citizen (artist-author), free to create and possess property (artwork), and benefit from placing it on the free (art) market. This freedom of creation, as well as its economic value, have assumed a decidedly intellectual dimension, and it was precisely by claiming art as an intellectual practice, and not simply manual skill, that Renaissance artists advocated for elevating painting and sculpture from the order of mechanical arts into liberal arts. Inherited from antiquity, this division served to delimit the realm of universal knowledge, worthy of the free citizen, from the particular, manual competencies relegated to the slave, and perhaps it is by claiming admittance to the higher order, rather than challenging the overall order, that art sided with the free, and abandoned the slave.

The preoccupation of Renaissance artists with the theories of *disegno*, *idea*, and *concetto* all index the emerging, privileged place that the artist's work assumed as an earthly mirror of divine creation. As Erwin Panofsky has argued, the Renaissance transformed the Platonic notion of *idea* by transposing it from the metaphysical realm into the human mind, as well as by making art, and no longer philosophy, the privileged site of access to *idea*.[12] At the same time, the splitting of the notion of *disegno* (drawing, design), which initially stood for the unity in art of the intellectual and visual, into two types of *disegno*, speculative and practical, paved the way towards the autonomization of the imaginative and intellective aspect of artistic creation.[13] Although this did not yet imply a solidified authorial practice of titling, Paolo Veronese's renaming of his "Last Supper" (1573) into "The Feast in the House of Levi," a cunning response to the Inquisition's charges of heresy, demonstrates the instantaneous, nominalist powers of the title for which Marcel Duchamp would become famous several centuries later.

The key difference between Veronese and Duchamp, however, is that the "Fountain's" (1917) titular subversion is inextricably linked to the framework without which it is illegible, that of public exhibition, which has consolidated itself since the eighteenth century as art's signature domain. Spatially expressing art's increased autonomization from the patronage of the court and the church, the exhibition placed art in the service of the emerging bourgeois public sphere and the art market. The history of the title both mirrored and fostered this development, because, as Ruth Bernard Yeazell has argued, the convention of titling developed in parallel with the democratization of culture since the seventeenth century, marked by the rise of the art market, the expansion of reproductive print, and the growth of public exhibition.[14] From the very beginning, then, the title was the site of contradiction; while as a branding tool it served as an asset in the developing capitalist market and the rising profitability of art, it at the same time affirmed art as a potentially politicized practice able to address and mobilize those with no access to economic, political, and cultural capital.

Seen in this light, the title—which soon became obligatory in the printed catalogues of the Paris Salons, themselves titled "Explanations"—should be regarded as a central element of what Tony Bennett theorized in 1988 as the "exhibitionary complex," or the eighteenth-century emergence of the public exhibition as a simultaneously democratizing and disciplining

10 At least for the initiated, because the elitist obscurity of the discourse of contemporary art is often singled out as the measure of the distance between art and its wider audiences.

11 A letter of a seventeenth-century patron to an artist, cited in Yeazell, *Picture* (see note 7), p. 21.

12 Erwin Panofsky, *Idea: A Concept in Art Theory* (Columbia, SC., 1968), p. 6.

13 See Raymond Quek, "Drawing Adam's Navel: The Problem of Disegno as Creative Tension Between the Visible and Knowledgeable." *Architectural Research Quarterly* 9, no. 3–4 (2005), pp. 255–64.

14 Yeazell, *Picture Titles* (see note 7), p. 20.

rseits das sinnliche, affektive, spektakuläre, festgeschriebene und somit ebenso vieldeutige Wesen des sprachlichen Zeichens selbst vergisst. Doch trotz der langen Tradition verschiedener Formen der Bekräftigung der souveränen Domäne der Malerei, oder jedweder Form der Bildhaftigkeit – oft begleitet von einem kennerhaften elitären Denken oder einer Exotisierung der Macht des Bildes – scheint sich die zeitgenössische Kunst mehr denn je an den didaktischen, werbenden und zunehmend fetischistischen Gebrauch von Sprache zu klammern. Die Ausrufung des Politischen in der Kunst hängt mittlerweile schon bindend nicht mehr nur vom Werktitel oder der Bildunterschrift in der Ausstellung ab, sondern von der Verbreitung von Ausstellungsankündigungen, „Statements" der KünstlerInnen und „Konzepten" der KuratorInnen, die oft nicht über die Funktion der „Bestätigung" hinausgehen, d.h., sicherzustellen, dass die Liste der „Themen", die das Werk oder die Ausstellung „behandelt" oder „anspricht", zusammen mit der Liste der recycelten oder vorgeschlagenen theoretischen Konzepte, die sie umrahmen, verdeutlicht wird.[10] Anstelle einer erneuten Hinwendung zum Visuellen – oder neuerdings Affektiven, zum (neuen) Materialistischen, Objektorientierten, Unmenschlichen, Mikrobiellen, das auf alle Fälle von der viele Assoziationen wachrufenden „Magie" eben dieser Begriffe abhängt, schlage ich vor, diesen beharrlichen Anspruch auf Sprache und Diskurs als politische Werkzeuge in der Kunst zu historisieren und zu hinterfragen, ob ihre Verbreitung vielleicht in einem angemessenen Verhältnis zu der ebenso weitreichenden Integration zeitgenössischer Kunst in die Ströme des globalen Kapitalismus steht, und ob die immer wiederkehrende Sprache des politischen Wunschdenkens in der Kunst als Lösung für ihre chronische Unfähigkeit erscheint, den liberal-kapitalistischen (kolonialen, patriarchalischen, heterosexuellen, rassistischen, anthropozänischen anthropozentrischen usw. – fügen Sie Ihren eigenen hinzu) Konsens grundsätzlich infrage zu stellen.

„Was das Sujet angeht, so überlasse ich es Ihnen, ob Sie es kirchlich oder weltlich machen wollen, mit Männer- oder Frauendarstellungen."[11] Trotz aller Subversionen und Revolutionen *in* der Kunst, ist eine fundamentale Transformation *der Kunst* – würde dies auch eine Transformation ihres Namens/Titels implizieren? – nie wirklich passiert. Mit ihrer allmählichen Säkularisierung und Autonomisierung seit der Renaissance bekam die Kunst die Rolle des Strebens nach Freiheit, aber die Freiheit, die sie gewonnen hat, gehört dem Einzelnen, dem freien Bürger (Künstler-Autor), der frei ist, Eigentum (das Kunstwerk) zu schaffen und zu besitzen und davon zu profitieren, es auf dem freien (Kunst-)Markt zu platzieren. Diese Schaffensfreiheit und ihr wirtschaftlicher Wert haben eine ausgesprochen intellektuelle Dimension angenommen, und gerade durch die Behauptung, Kunst sei eine intellektuelle Praxis und nicht nur handwerkliches Geschick, plädierten Renaissance-Künstler dafür, Malerei und Skulptur aus der Ordnung der praktischen Künste

(lat.: *artes mechanicae*) in die freien Künste (*artes liberales*) zu erheben. Als Erbe der Antike diente diese Teilung dazu, das Reich des universellen Wissens, dessen der freie Bürger würdig war, von den besonderen, manuellen Kompetenzen abzugrenzen, die dem Sklaven zugeschrieben wurden, und vielleicht lag es daran, dass man die Aufnahme in die höhere Ordnung beanspruchte, anstatt die allgemeine Ordnung infrage zu stellen, dass sich die Kunst auf die Seite der Freien stellte und sich vom Sklaven abwandte.

Die Beschäftigung der Renaissancekünstler mit den Theorien des *disegno*, der *idea* und dem *concetto* sind alle ein Nachweis für den aufkommenden privilegierten Platz, den das Werk des Künstlers als irdischer Spiegel der Schöpfung Gottes einnahm. Wie Erwin Panofsky argumentiert hat, hat die Renaissance Platons Begriff der *idea* transformiert, indem sie ihn aus dem Reich der Metaphysik in den menschlichen Geist übertrug und die Kunst, und nicht mehr die Philosophie zum bevorzugten Ort des Zugangs zur *idea* machte.[12] Gleichzeitig ebnete die Aufspaltung des Begriffs *disegno* (Zeichnung, Gestaltung), der zunächst für die Einheit von Geist und Bild in der Kunst stand, in zwei Arten von *disegno*, spekulativ und praktisch, den Weg zur Autonomisierung des auf der Imagination und des auf dem Intellekt beruhenden Aspekts des künstlerischen Schaffens.[13] Obwohl dies noch keine verfestigte auktoriale Praxis der Betitelung impliziert, zeigt Paolo Veroneses Umbenennung seines „Letzten Abendmahls" (1573) in „Das Gastmahl im Hause des Levi", eine raffinierte Antwort auf die Ketzereivorwürfe der Inquisition, die augenblickliche Benennungskraft des Titels, für die Marcel Duchamp einige Jahrhunderte später berühmt werden sollte.

Der Hauptunterschied zwischen Veronese und Duchamp besteht jedoch darin, dass die Subversion in der Betitelung von „Brunnen" (1917) untrennbar mit dem Rahmen verbunden ist, ohne den sie unleserlich ist, nämlich jenem der öffentlichen Ausstellung, die ab dem achtzehnten Jahrhundert ihren festen Platz als unverkennbare Domäne der Kunst eingenommen hat. Als räumlicher Ausdruck der zunehmenden Autonomie der Kunst gegenüber dem Mäzenatentum des Hofes und der Kirche stellte die Ausstellung die Kunst in den Dienst der aufkommenden bürgerlichen Öffentlichkeit und des Kunstmarkts. Die Geschichte des Titels spiegelte und förderte diese Entwicklung, denn, wie Ruth Bernard Yeazell argumentierte, entwickelte sich seit dem siebzehnten Jahrhundert die Konvention der Betitelung parallel zur Demokratisierung der Kultur, die geprägt war vom Aufstieg des Kunstmarktes, der Verbreitung von Druckreproduktionen und von der Zunahme öffentlicher Ausstellungen.[14] Der Titel war also von Anfang an ein Ort des Widerspruchs; als Branding-Instrument diente er zwar als Aktivposten auf dem aufkommenden kapitalistischen Markt und in der wachsenden

10 Zumindest für Eingeweihte, denn die elitäre Obskurität des zeitgenössischen Kunstdiskurses wird oft als Maß für die Distanz zwischen Kunst und ihrem breiteren Publikum herausgestellt.

11 Aus einem Brief eines Mäzens aus dem siebzehnten Jahrhundert an einen Künstler, zitiert in Yeazell: *Picture Titles*, 21 (wie Anm. 7).

12 Vgl. Panofsky, Erwin: *Idea. A Concept in Art Theory*, Columbia, SC, 1968, 6.

13 Vgl. Quek, Raymond: „Drawing Adam's Navel: The Problem of Disegno as Creative Tension Between the Visible and Knowledgeable", in: *Architectural Research Quarterly* 9, 3–4 (2005), 255–264.

14 Vgl. Yeazell: *Picture Titles*, 20 (wie Anm. 7).

mechanism.[15] However, while Bennet placed much emphasis on the latter part of the equation, already in 1929 Walter Benjamin pointed to the oppositional potential of the "exhibition value" of art, which he contrasted to its receding "cult value." The increased circulation of art, a key tenet of its new, exhibition value, carried a political potential, which Benjamin illustrated by the obligatory presence of captions in "picture magazines" and films, which acted as "signposts" for the viewer, thus countering the auratic force of images.[16]

Like others who argued for the capacity of language to demystify the cult-like, distantiating power of images, Benjamin did not consider that the auratic in art could at the same time shift from images into language, a shift heralded by the prophet-painter of the French Revolution, Jacques Louis David, who was allegedly "fascinated by language."[17] In his "Oath of the Horatii" (1785), which art historians cite as a landmark the history of exhibitions and titling, David chose to represent—in fact, reinvent—the Roman legend of the Horatius family not as a narrative of action (murder, battle), but one of speech (oath taking).[18] A decade later, in his tribute to the radical Jacobin journalist Jean-Paul Marat ("Death of Marat," 1793), David marked his painting with a bold and conspicuous inscription: "À Marat. David [To Marat. David]." Themselves a kind of pledge, these words, or rather, these two proper names that invaded the canvas, decidedly augmented the auratic and cult-like character of the painting, and enabled David to not only honor Marat as a martyr "writing for the good of the people," but to embed his own gesture of "writing" within the same heroic trajectory of revolutionary language production. Although not quite a title, David's inscription absorbed the title's didactic function and it did so, moreover, no longer for the purposes of exhibition, but that of exposition: of explicitly stating the political, aesthetic and ideological alliances of the artist. This entirely new, exposition value of the work of art, would come to be the key tenet of art after conceptual art.

"Life, not slogans!"[19] If we follow the standard account of the genesis of conceptual art via American minimalism, the ascendance of language—and by a presumed analogy, of the intellectual and the political—in art was initially motivated by the artists' attempt to seize the critical discourse away from the hegemony of the advocates of abstract expressionism, Clement Greenberg and Michael Fried. What a critic like Fried found unacceptable about minimal art was its "objecthood" (its being neither a painting or sculpture, but an object), as well as its "theatricality" and "literalism," or the fact that it "seeks to declare and occupy a *position*—one that can be *formulated in words* and in fact has been so formulated by some of its leading practitioners."[20] It is, then, precisely art's emergent exposition value that

Fried contrasted to the serene pictorial "presentness" of modernist painting. As John Welchman astutely noted, however, "the [untitled] silence of abstract expressionism could only work under the premise of the loquaciousness of the art critic,"[21] which is exactly what the Art & Language group recognized on the other side of the Atlantic. Their own turn to language, according to Charles Harrison, was initially a hyperbolical response to what they saw as the utter subordination of art to critical discourse, or, in Mel Ramsden's words: "It had seemed necessary, finally, that the 'talk' went up on the wall."[22] The ramifications of this logorrheic contamination of the exhibition wall, as a culmination of the post-1945 neo-avant-garde trends, were truly radical: if the "talk" could be on the wall, then anything could, including nothing—as long as it, of course, included a title and a label, an explicit theme of the Art & Language series Title Equals Text (1967/68). More importantly, the artist now had on her disposal not only the accepted iconographic and allegorical visual devices, but language as presumably the most "literal" and explicit way in which to declare her aesthetic, social and ideological conflicts and alliances.

Robert Rauschenberg's "Erased de Kooning Drawing" (1953) is a condensed history of this shift, a work in which its author negated the "untitled," abstract-expressionist labor by way of his own, decidedly titled intervention. On first sight, the piece resembles a suprematist painting, white on white, with some strange smudges on the surface. However, a small metal plaque, placed aggressively inside the picture frame, and inscribed with Rauschenberg's name, the year of execution, and the title, "Erased de Kooning Drawing," makes sure to eliminate the misreading: this is not an abstract painting, this is a young artist, at the beginning of his career, erasing the work of an abstract-expressionist giant. Although this work involved not only conceptual, but

15 Tony Bennett, "The Exhibitionary Complex." *new formations* 4 (1988), pp. 73–102.

16 Walter Benjamin, "The Work of Art in the Age of Mechanical Reproduction," in *Illuminations*, ed. Hannah Arendt (New York, 1978), pp. 224–226.

17 Dorothy Johnson, paraphrased in Yeazell, *Picture Titles How and Why Western Paintings Acquired Their Names* (see note 7), p.158.

18 See Yeazell, *Picture Titles How and Why Western Paintings Acquired Their Names* (see note 7), pp. 143–165.

19 Željko Jerman, in Zoran Popović's film "Untitled" (1978). Jerman's statement against slogans was, of course, itself a slogan.

20 Michael Fried, "Art and Objecthood" (1967), in *Art and Objecthood: Essays and Reviews* (Chicago, 1998), p. 148. My emphasis.

21 Welchman, *Invisible Colors* (see note 8), p. 45.

22 Charles Harrison, *Essays on Art & Language* (Cambridge, 2001), p. 20. Ramsden cited on pp. 20–21.

Rentabilität der Kunst, aber gleichzeitig bestätigte er die Kunst als eine potenziell politisch aufgeladene Praxis, die in der Lage ist, diejenigen anzusprechen und zu mobilisieren, die keinen Zugang zu wirtschaftlichem, politischem und kulturellem Kapital haben.

Vor diesem Hintergrund ist der Titel – der in den gedruckten Katalogen der Pariser Salons, die selbst den Titel „Explanations" trugen, obligatorisch wurde – als zentrales Element dessen zu betrachten, was Tony Bennett 1988 als „Ausstellungskomplex" oder als das Aufkommen der öffentlichen Ausstellung des achtzehnten Jahrhunderts als gleichzeitig demokratisierender und disziplinierender Mechanismus theoretisch beleuchtete.[15] Während Bennett jedoch den letztgenannten Teil der Gleichung stark betonte, verwies Walter Benjamin bereits 1929 auf das oppositionelle Potenzial des „Ausstellungswertes" der Kunst, den er dem schwindenden „Kultwert" entgegensetzte. Die vermehrte Verbreitung von Kunst, ein Schlüsselbegriff ihres neuen Ausstellungswertes, trug ein politisches Potenzial, das Benjamin durch die obligatorische Präsenz von Bildunterschriften in „Bild-Zeitschriften" und Filmen verdeutlichte, die dem Betrachter als „Wegweiser" dienten und damit der auratischen Kraft der Bilder entgegenwirkten.[16]

Wie andere, die für die Fähigkeit der Sprache plädierten, die kultähnliche, distanzierende Macht der Bilder zu entmystifizieren, vertrat Benjamin nicht die Auffassung, dass die Auratik in der Kunst gleichzeitig von den Bildern in die Sprache verlagert werden könne, eine Verschiebung, die vom Propheten und Maler der Französischen Revolution, Jacques Louis David, angekündigt wurde, der angeblich „von der Sprache fasziniert" war.[17] In seinem Gemälde „Schwur der Horatier" (1785), das unter Kunsthistorikern als Meilenstein der Ausstellungs- und Titelgeschichte zitiert wird, entschied sich David dafür, die römische Legende der Familie der Horatier nicht als Handlungserzählung (Mord, Schlacht), sondern als Spracherzählung (Eidesleistung) darzustellen – und tatsächlich neu zu erfinden.[18] Fast ein Jahrzehnt später, in seiner Hommage an den radikalen Jakobiner und Journalisten Jean-Paul Marat („Der Tod des Marat", 1793), signierte David sein Gemälde mit einer kühnen und markanten Inschrift. „À Marat. David" [An Marat. David]. Selbst eine Art Gelübde haben diese Worte, oder besser gesagt, diese beiden Eigennamen, die in die Leinwand eingedrungen sind, den auratischen und kultischen Charakter des Gemäldes entscheidend verstärkt und David in die Lage versetzt, Marat nicht nur als Märtyrer zu ehren, der „zum Wohle des Volkes schrieb", sondern auch seine eigene Geste des „Schreibens" in die gleiche heroische Bahn revolutionärer Sprachproduktion einzubetten. Die Inschrift Davids, auch wenn sie nicht ganz ein Titel ist, nahm die didaktische Funktion des Titels auf, und zwar nicht mehr zu Ausstellungszwecken, sondern zum Zweck der Darlegung: zur expliziten Nennung der politischen, ästhetischen und ideologischen Allianzen des Künstlers. Dieser völlig neue Darlegungswert des Kunstwerkes würde zum Schlüsselbegriff der Kunst nach der Konzeptkunst werden.

„Das Leben, keine Slogans!"[19] Folgt man der Standardbeschreibung der Genese der Konzeptkunst über die amerikanische Minimal Art, so war der Aufstieg der Sprache – und durch eine vermeintliche Analogie des Intellektuellen und des Politischen – in der Kunst zunächst vom Versuch der Kunstschaffenden motiviert, den kritischen Diskurs der Hegemonie der Verfechter des abstrakten Expressionismus, Clement Greenberg und Michael Fried, zu entreißen. Was ein Kritiker wie Fried an der Minimal Art als inakzeptabel empfand, war ihre „Objekthaftigkeit" (sie ist weder ein Gemälde noch eine Skulptur, sondern ein Objekt), sowie ihre „Theatralität" und ihr „Literalismus", oder die Tatsache, dass sie „danach trachtet, eine *Position* zu erklären und zu besetzen – eine, die *mit Worten formuliert* und in der Tat von einigen ihrer führenden Praktiker so formuliert worden ist."[20] Es ist also gerade der aufkommende Darlegungswert der Kunst, dem Fried die heitere malerische „Gegenwärtigkeit" der modernistischen Malerei entgegensetzte. Wie John Welchman scharfsinnig bemerkte, konnte „das [unbetitelte] Schweigen des abstrakten Expressionismus nur unter der Prämisse der Geschwätzigkeit des Kunstkritikers funktionieren",[21] was genau das ist, was die Künstlergruppe Art & Language auf der anderen Seite des Atlantiks erkannt hat. Ihre eigene Hinwendung zur Sprache, so Charles Harrison, war zunächst eine übertriebene Antwort auf das, was sie als völlige Unterordnung der Kunst unter den kritischen Diskurs sahen, oder, wie Mel Ramsden es ausdrückte: „Schließlich schien es notwendig gewesen zu sein, dass das ‚Gerede' an die Wand kam."[22] Die Auswirkungen dieser Logorrhö-Kontamination der Ausstellungswand als Höhepunkt der neoavantgardistischen Tendenzen nach 1945 waren wirklich radikal: Wenn das „Gerede" an der Wand sein konnte, dann konnte das für alles gelten, auch für nichts – solange es natürlich einen Titel und eine Bildunterschrift enthielt, ein explizites Thema der Art & Language-Reihe *Title Equals Text* (1967/68). Noch wichtiger war, dass Kunstschaffende nun nicht nur über die akzeptierten ikonografischen und allegorischen visuellen Mittel verfügten, sondern auch über die Sprache als die wohl „wörtlichste" und expliziteste Form, ihre ästhetischen, sozialen und ideologischen Konflikte und Allianzen zu deklarieren.

15 Bennett, Tony: „The Exhibitionary Complex", in: *new formations* 4 (1988), 73–102.

16 Vgl. Benjamin, Walter: „Das Kunstwerk im Zeitalter seiner technischen Reproduzierbarkeit", in: ders.: *Illuminationen. Ausgewählte Schriften 1*, Frankfurt/M. 1977, 144–146.

17 Dorothy Johnson in anderen Worten in Yeazell: *Picture Titles*, 158 (wie Anm. 7).

18 Vgl. Yeazell: *Picture Titles*, 143–165 (wie Anm. 7)

19 Željko Jerman in Zoran Popovićs Film „Untitled" (1978). Natürlich war Jermans Statement gegen Slogans selbst ein Slogan.

20 Fried, Michael: „Kunst und Objekthaftigkeit" (1967), in Stemmrich, Gregor (Hg.): *Minimal Art. Eine kritische Retrospektive*, Dresden/Basel 1995, 335. Meine Hervorhebung.

21 Welchman: *Invisible Colors* (wie Anm. 8).

22 Harrison, Charles: *Essays on Art & Language*, Cambridge/MA, 2001, 20. Ramsden zitiert auf den Seiten 20–21.

also practical, aesthetic, and, ironically, hard manual labor,[23] its key component is the expositionary value of the authorial gesture of titling, by which a "new artist" boldly claimed "erasure" as his attitude towards the "old art."

The radical diversification, hybridization, and demystification of artistic themes, procedures and mediums in the twentieth century and, especially, in art after 1945, have gone hand in hand with the diminished status of the "evident" form in which the artwork manifests itself in the exhibition space, and the growing necessitation of additional, mainly discursive "evidence." The pristinely clean and untitled walls of the modernist white cube, dominated by paintings whose sheer presence ostensibly required no further justification, have been replaced by "weak" works, (deliberately) uncertain of their potency in the encounter with the viewer who, in turn, immediately scans the space in search for a title, a wall label, a catalogue entry, anything that would ease the potentially discomforting sense of uncertainty in the face of the inevidently evident: What is it (about)? Who made it, and when? Why? Is it just documentation, an index of the "actual" work of art that took place beyond the constraints of the exhibition space? How long will I have to stand here if I decide to see the whole thing? etc. There is always more than meets the eye, it is insistently suggested, and at times the outright contradiction between what is signaled by the evident (the work) and its evidence (the label) testifies that the artist has not only achieved, but even surpassed the Renaissance ideal of the primacy of intellectual labor and ideational process in the creation of art. Was this victory, which in the modern era elevated art from the lowly order of mechanical arts into a protagonist of universal knowledge, a liberation, one which, moreover, enabled art to be refashioned as the very symbol of freedom, and of nonalienated labor? Was the ultimate autonomization of concept in conceptual art the culminating point of this process of liberation, the pinnacle of struggles against art's instrumentalization, reification, and commodification, or was it instead, as both concurrent and subsequent critiques have argued, merely another form of surrender?[24]

"When Attitudes Become Form" (1969), the legendary exhibition that celebrated the "new art" and at the same time launched the era of the "curator as creator,"[25] centered on Harald Szeemann's claim that the new art was decisively tied to the "inner attitude of the artist," as he explained in the catalogue in reference to the exhibition's title – which, he also noted in passing (in brackets) was "a sentence, not a slogan."[26] Thus bracketing out art from marketing—as if this would also bracket out Phillip Morris's sponsorship of the exhibition—Szeemann identified his own curatorial work as an attitude against commercial and ideological reification.[27] However, even if we let it slide that "When Attitudes Become Form (Works–Concepts–Processes–Situations–Information)" is not really a sentence but a dependent clause, missing the other half of the "when x, then y" syntactical equation, what about the strange injunction, "Live in Your Head," which appears in the catalogue as a sort of chaperone to the title, and which unabashedly embraces the form of a slogan? Is this an attitude in favor of the ultimate dematerialization, a dream of an escape route from the pain, profanity, and drudgery of material existence, a utopia in which our heads would be transformed into the sole (and privatized) place of abode? When attitudes become form, live (and work) in your head! Just like a conceptual artist.

"Artist at Work" (1978), Mladen Stilinović's photographic performance, has become a widely circulated symbol of the refusal of work, an irreverent ode to laziness; however, if it is true that both the form and value of artistic production are now derived from "attitudes," "Artist at Work" might as well be read as a celebration of artistic labor, or else, a critical investigation of so-called immaterial labor.[28] The "lazy" interpretation of this piece depends on the humorous effect of the collision between its title, "Artist at Work," and the (seemingly) contradictory visual component (the artist shown lying in bed and falling asleep). However, what if the artist really is at work, and what if this work, a demonstration of the new stage in the history of artistic labor, is a labor of thinking, the labor of tossing

23 According to Rauschenberg, although reluctantly accepting participation (and the bottle of whiskey that accompanied it), de Kooning deliberately chose an intricate drawing that was not easy to erase. See https://www.sfmoma.org/artwork/98.298/research-materials/document/EDeK_98.298_031/.

24 See Lucy R. Lippard, "Postface," in *Six Years: The Dematerialization of the Art Object From 1966 to 1972* (Berkeley, 1997), pp. 263–264. The "warning" against the objectification of concept in conceptual art was voiced at the same time by one of its main representatives: Daniel Buren, "Beware!" in *Studio International* 179, no. 920 (1970), pp. 100–104. For the key contribution to later critiques, see Benjamin H. D. Buchloh, "Conceptual Art 1962–1969: From the Aesthetic of Administration to the Critique of Institutions," in *October* 55 (1990), pp. 105–43.

25 Bruce Altshuler, *The Avant-Garde in Exhibition: New Art in the 20th Century* (Berkeley, 1998), p. 236.

26 "Von daher ist auch der Titel (ein Satz und kein Schlagwort) der Ausstellung zu verstehen: noch nie wurde die innere Haltung des Künstlers so direkt zum Werk." Harald Szeemann, "Zur Austellung," in *When Attitudes Become Form* (Bern: Kunsthalle Bern, 1969), n.p.

27 Lucy Lippard performed this "desloganization" of the title much more effectively, by filling the entire cover with text, which is in fact to be read as one deliberately protracted title: *Six Years: The dematerialization of the art object from 1966 to 1972: a cross-reference book of information on some esthetic boundaries: consisting of a bibliography into which are inserted a fragmented text, art works, documents, interviews, and symposia, arranged chronologically and focused on so-called conceptual or information or idea art with mentions of such vaguely designated areas as minimal, anti-form, systems, earth, or process art, occurring now in the Americas, Europe, England, Australia, and Asia (with occasional political overtones) edited and annotated by Lucy R. Lippard.* Of course, no one cites this title, and the "dematerialization of art" became a slogan in its own right. See footnote 24.

28 This and the following paragraph contain parts of an existing text, Ivana Bago, "The Artist as an Unemployed Socialist Worker: Performing Work and Negotiating Value in the Yugoslav New Art Practice of the 1970s and 1980s," *Transmissions* 4 (2013), pp. 27–38.

Robert Rauschenbergs „Ausradierte De Kooning-Zeichnung" (1953) ist eine verdichtete Geschichte dieser Verschiebung, ein Werk, in dem der Autor die „unbetitelte", abstrakt-expressionistische Arbeit durch seine eigene, dezidiert betitelte Intervention negiert hat. Auf den ersten Blick ähnelt das Stück einem suprematistischen Gemälde, weiß auf weiß, mit einigen merkwürdigen Flecken auf der Oberfläche. Eine kleine Metallplakette, die aggressiv in den Bilderrahmen eingesetzt und mit dem Namen Rauschenbergs, dem Jahr der Ausführung und dem Titel „Ausradierte De Kooning-Zeichnung" beschriftet ist, sorgt jedoch dafür, dass das Missverständnis beseitigt wird: Dies ist kein abstraktes Gemälde, sondern ein junger Künstler, der zu Beginn seiner Karriere das Werk eines abstrakt-expressionistischen Giganten ausradiert. Obwohl es sich bei dieser Arbeit nicht nur um konzeptuelle, sondern auch um praktische, ästhetische und ironischerweise auch harte körperliche Arbeit[23] handelte, ist ihr zentraler Bestandteil der exponentielle Wert der auktorialen Geste der Betitelung, mit der ein „neuer Künstler" frech „Auslöschung" als seine Haltung gegenüber der „alten Kunst" geltend machte.

Die radikale Diversifikation, Hybridisierung und Entmystifizierung künstlerischer Themen, Verfahren und Medien im zwanzigsten Jahrhundert und vor allem in der Kunst nach 1945 ging einher mit dem verminderten Status der „evidenten" Form, in der sich das Kunstwerk im Ausstellungsraum manifestiert, und der wachsenden Notwendigkeit zusätzlicher, meist diskursiver „Evidenz". Die blütensauberen und unbetitelten Wände des modernistischen White Cube, dominiert von Gemälden, deren bloße Präsenz scheinbar keiner weiteren Rechtfertigung bedurfte, sind durch „schwache" Werke ersetzt worden, die sich (bewusst) ihrer Kraft in der Begegnung mit dem Betrachter unsicher sind, der seinerseits auf der Suche nach einem Titel, einem Saaltext, einem Katalogeintrag sofort den Raum absucht, nach allem, was das potenziell unangenehme Gefühl der Unsicherheit im Angesicht des nicht offensichtlich Offensichtlichen lindern könnte: Was ist das? Worum geht es? Wer hat das gemacht, und wann? Warum? Ist es nur ein Dokument, ein Katalog des „eigentlichen" Kunstwerks, das sich jenseits der Grenzen des Ausstellungsraumes abgespielt hat? Wie lange muss ich hier stehen, wenn ich mich entschließe, das Ganze zu sehen? Und so weiter. Es gibt immer mehr, als man auf den ersten Blick sieht, es wird beharrlich angedeutet, und manchmal zeugt der völlige Widerspruch zwischen dem, was durch das Offensichtliche (das Werk) und seinen Beweis (die Bildunterschrift) signalisiert wird, davon, dass der Künstler das Renaissance-Ideal des Primats der intellektuellen Arbeit und des ideellen Prozesses in der Kunstschöpfung nicht nur erreicht, sondern sogar übertroffen hat. War dieser Sieg, der in der Neuzeit die Kunst von der niederen Ordnung der praktischen Künste zu einem Protagonisten universellen Wissens, zu einer Befreiung erhoben hat, die es im Übrigen ermöglichte, die Kunst als genau das Symbol der Freiheit und der nicht entfremdeten Arbeit umzugestalten?

War die ultimative Autonomisierung des Konzepts in der Konzeptkunst der Gipfel dieses Befreiungsprozesses, der Höhepunkt des Kampfes gegen die Instrumentalisierung, Vergegenständlichung und Kommerzialisierung der Kunst, oder war es stattdessen, wie sowohl die zeitgenössische als auch die spätere Kritik argumentiert hat, lediglich eine andere Form der Kapitulation?[24]

„When Attitudes Become Form" (1969), die legendäre Ausstellung, die die „neue Kunst" feierte und gleichzeitig die Ära des „Kurators als Schöpfer"[25] einleitete, konzentrierte sich auf Harald Szeemanns Behauptung, dass die neue Kunst entscheidend an die „innere Haltung des Künstlers" gebunden sei, wie er im Katalog unter Bezugnahme auf den Titel der Ausstellung erläuterte, der, wie er auch am Rande (in Klammern) feststellte, „ein Satz, kein Slogan" sei.[26] Szeemann klammerte somit die Kunst aus dem Marketing aus – als ob dies auch Phillip Morris' Sponsoring der Ausstellung ausklammern würde – und identifizierte seine eigene Kuratorenarbeit als eine Haltung gegen die kommerzielle und ideologische Vergegenständlichung.[27] Aber selbst wenn wir durchgehen lassen, dass „When Attitudes Become Form (Works – Concepts – Processes – Situations – Information)" nicht wirklich ein Satz ist, sondern ein abhängiger Gliedsatz, dem die andere Hälfte der syntaktischen Gleichung „wenn x, dann y" fehlt, was soll die seltsame Aufforderung „Live in Your Head" (Lebe in deinem Kopf), die im Katalog als eine Art

23 Obwohl er die Einladung (und die dazugehörige Flasche Jack Daniels) widerwillig aber doch annahm, wählte de Kooning ganz bewusst eine sehr vertrackte Zeichnung aus, die sich nicht leicht ausradieren ließ, erzählte Rauschenberg später. Vgl. dazu https://www.sfmoma.org/artwork/98.298/research-materials/document/EDeK_98.298_031/.

24 Vgl. Lippard, Lucy R.: „Postface", in: Six Years: The Dematerialization of the Art Object From 1966 to 1972, Berkeley/CA 1997, 263–264. Die „Warnung" vor der Vergegenständlichung des Konzepts in der Konzeptkunst wurde gleichzeitig von einem ihrer Hauptvertreter ausgesprochen: Buren, Daniel: „Beware!", in: Studio International 179, 920 (1970), 100–104. Für wichtige Beiträge zu späteren Kritiken vgl. Buchloh, Heinz-Dieter: „Conceptual Art 1962–1969: From the Aesthetic of Administration to the Critique of Institutions", in: October 55 (1990), 105–143.

25 Altshuler, Bruce: The Avant-Garde in Exhibition. New Art in the 20th Century, Berkeley/CA 1998, 236.

26 „Von daher ist auch der Titel (ein Satz und kein Schlagwort) der Ausstellung zu verstehen: noch nie wurde die innere Haltung des Künstlers so direkt zum Werk." Szeemann, Harald: „Zur Austellung", in: When Attitudes Become Form, Bern 1969, o. S.

27 Lucy Lippard hat diese „Entsloganisierung" des Titels wesentlich effektiver durchgeführt, indem sie den gesamten Buchdeckel mit Text füllte, der eigentlich als ein bewusst langgezogener Titel zu lesen ist: Six Years: The dematerialization of the art object from 1966 to 1972: a cross-reference book of information on some esthetic boundaries: consisting of a bibliography into which are inserted a fragmented text, art works, documents, interviews, and symposia, arranged chronologically and focused on so-called conceptual or information or idea art with mentions of such vaguely designated areas as minimal, anti-form, systems, earth, or process art, occurring now in the Americas, Europe, England, Australia, and Asia (with occasional political overtones) edited and annotated by Lucy R. Lippard. (dt. in etwa: Sechs Jahre. Die Dematerialisierung des Kunstobjekts von 1966 bis 1972: ein Nachschlagewerk mit Informationen über einige ästhetische Grenzen: bestehend aus einer Bibliografie, in die ein fragmentarischer Text, Kunstwerke, Dokumente, Interviews und Symposien eingefügt sind, chronologisch geordnet und fokussiert auf sogenannte Konzept- oder Informations- oder Ideenkunst mit Erwähnungen solcher vage bezeichneten Bereiche wie Minimal, Anti-Form, System, Earth oder Process Art, die jetzt in Amerika, Europa, England, Australien und Asien (mit gelegentlichen politischen Untertönen) vorkommen, herausgegeben und kommentiert von Lucy R. Lippard.) Selbstverständlich zitiert diesen Titel niemand und die „Dematerialisierung der Kunst" ist zu einer Parole für sich geworden. Vgl. Lippard: Six Years (wie Anm. 24).

and turning, staring at the ceiling, listening to the news that reveal the devastating state of Yugoslav economy and the very disintegration of socialist work? "January 31, 1980. At six o'clock in the morning I'm listening to the radio report on the foreign currency exchange rates of the Zagreb Economic Bank."[29] The artist at work wakes up at 6.00 a.m., like any decent worker, but his factory is located in his head—not least because, with Yugoslavia's rates of unemployment at the time, he has no work to go to, let alone boycott.

The quaint tautology of the artist's work—a carpenter works to produce a table, but an artist works to produce (a) work—is the first reason why art production is always already a lesson on the very conditions of production. By defining her work as an idea, the conceptual artist elevated art in the hierarchy of labor and thus joined the rank presided by priests, who were, according to the author(s) of *The Germany Ideology* the first mental laborers, or the first "ideologists."[30] However, not only is the supposed purity (and joy) of immaterial work (of thinking, or speech) ultimately always material, as the text further warned, but it also leaves a material residue, and it was precisely the rising status and value of what initially seemed like innocuous xeroxed leftovers of the labor of conceptual art, which revealed to its protagonists the extent of the illusion of "dematerialization." A series of photographs and an artist-book that now constitute *Artist at Work*, Stilinović's performance of non-labor, or, alternatively, immaterial labor, present undeniably material evidence that the artist was at work, whose initially insignificant exchange value soared with the post-1989 global commodification of the subversive aura of "Eastern European art."

As Lucy Lippard herself recognized, not only in her "Postface," but already in the long title of her influential book, dematerialization did not equal a disintegration of the art object, but a delineation of new "esthetic boundaries."[31] These new boundaries, I have argued, have been prominently defined by the affirmation of the expositional potential of art, which went hand in hand with the growing aesthetic, political, and commercial significance of the title, and the discursive forms that surround it: the wall label, artistic and curatorial statement, exhibition announcement, exhibition catalogue. The discursive support itself became the work in conceptual art; in Seth Siegelaub's terms, when "secondary information" becomes equivalent to the "primary information," the catalogue can become a work of art or, in his case, an exhibition.[32] As a tool of product placement, the catalogue is also what links art to commerce and reminds of art's historical overlaps with trade fairs and "world exhibitions." It is not surprising, then, that the ostensibly revolutionary transformation of art's discursive support structures into works of art, enabled art historians to link conceptual art

with publicity and the bureaucratic apparatuses of late capitalism.[33] Perhaps even more symptomatically, what all these discursive supports ultimately do is resurrect the Author from her supposed death, and make sure that her singular "attitude" receives an articulation.

"I do not wish to show anything new or original." Goran Trbuljak's "I do not wish to show anything new or original" (1971) can serve as a portrait of art's contradictions, which neither ended nor began with conceptual art, but found in it, so to speak, its most undiluted expression. An example of what Trbuljak called a work-exhibition, *I do not wish to show anything new or original* transformed the art's ultimate support structure, the exhibition, into a work of art. The only object on display at Zagreb's Student Center Gallery was the poster that advertised the exhibition, featuring a close-up photo-portrait of the artist, in addition to the exhibition dates, venue, and title. While this work can certainly be read as an example of the artist's contrarian attitude towards the art system, what it at the same time reveals is precisely the symptomatic conflation of opposition and affirmation, characteristic of conceptual art. Trbuljak's work-exhibition performed a series of formal and ideological conflations: the artist's role was indistinguishable from that of the graphic designer, public relations expert, and curator; the work of art was equated to the exhibition's publicity material; the exhibition was identical to the artwork, and the artwork to the exhibition; the work's content was reduced to a representation of the artist's image and intention, or more precisely, his "wish"; and, finally, the title took the form of an artist statement, whose deliberate tone recalled a commercial or political slogan. On a more abstract level, Trbuljak's work-exhibition can be seen as a signal for a new definition of art as a form of self-perpetuating promise. The viewer encountered the exhibition poster in the street, and so became the recipient of a promise—a promise of a certain content (art)—to be fulfilled only by visiting the gallery.

29 A text-based work that Stilinović exhibited together with *Artist at Work* in 1980. See: Dalibor Matičević, *Mladen Stilinović: Pjevaj!* (Zagreb, 1980), n.p.

30 Karl Marx (With Friedrich Engels), *The German Ideology* (New York, 1998), pp. 50–51. Interestingly, the authorship, i.e. the mental labor behind the manuscript gathered under the contested title "The German Ideology" had itself been a point of contention: was it authored by Karl Marx, Karl Marx and Friedrich Engels, Karl Marx (with Friedrich Engels), did Engels only type what Marx dictated, or was it Marx who in fact merely added a few comments? See T. Carver and Daniel Blank, *A Political History of the Editions of Marx and Engels's "German ideology Manuscripts"* (Basingstoke, UK, 2014).

31 Lippard, *Six Years* (see note 24). See also note 27.

32 Seth Siegelaub, cited in Ursula Meyer, ed., *Conceptual Art* (New York, 1972), p. xiv.

33 See Buchloh, *Conceptual Art* (see note 24); Alexander Alberro, *Conceptual Art and the Politics of Publicity* (Cambridge, MA, 2003); Armin Medosch, *New Tendencies: Art at the Threshold of the Information Revolution (1961–1978)* (Cambridge, MA, 2016).

Chaperon des Titels erscheint und ungeniert die Form eines Slogans annimmt? Ist dies eine Haltung zugunsten der ultimativen Dematerialisierung, ein Traum von einem Fluchtweg aus dem Schmerz, der Profanität und der Plackerei der materiellen Existenz, eine Utopie, in der sich unser Kopf in den einzigen (und privatisierten) Aufenthaltsort verwandeln würde? Wenn Haltungen Form werden, lebe (und arbeite) in deinem Kopf! Genau wie ein Konzeptkünstler.

„Artist at Work" (1978), die fotografische Performance von Mladen Stilinović, ist zu einem weit verbreiteten Symbol der Verweigerung von Arbeit geworden, zu einer respektlosen Ode an die Faulheit. Wenn es aber wahr ist, dass sowohl die Form als auch der Wert der künstlerischen Produktion heute von „Haltungen" abgeleitet sind, dann könnte man „Artist at Work" ebenso gut als eine Feier der künstlerischen Arbeit lesen, oder als eine kritische Auseinandersetzung mit der sogenannten immateriellen Arbeit.[28] Die „faule" Interpretation dieses Werkes steht und fällt mit der humorvollen Wirkung der Kollision zwischen seinem Titel, „Artist at Work", und der (scheinbar) widersprüchlichen visuellen Komponente (der im Bett liegende und einschlafende Künstler). Aber was ist, wenn der Künstler tatsächlich arbeitet, und was, wenn diese Arbeit, eine Demonstration der neuen Etappe in der Geschichte der künstlerischen Arbeit, eine Arbeit des Denkens ist, die Arbeit des Sich-im-Bett-Wälzens, des An-die-Decke-Starrens, des Anhörens der Nachrichten, die den verheerenden Zustand der jugoslawischen Wirtschaft und den Zerfall der sozialistischen Arbeit offenbaren? „31. Januar 1980. Um sechs Uhr morgens höre ich den Radiobericht über die Devisenkurse der Privredna Banka Zagreb."[29] Der Künstler bei der Arbeit wacht um 6 Uhr morgens auf, wie jeder anständige Arbeiter, aber seine Fabrik befindet sich in seinem Kopf – nicht zuletzt deshalb, weil er bei der damaligen Arbeitslosenquote Jugoslawiens keine Arbeit hat, der er nachgehen kann und die er schon gar nicht boykottieren kann.

Die kuriose Tautologie der Arbeit des Künstlers – ein Tischler arbeitet, um einen Tisch zu produzieren, aber ein Künstler arbeitet um (eine) Arbeit zu produzieren – ist der erste Grund, warum Kunstproduktion immer schon eine Lektion über die Produktionsbedingungen selbst ist. Indem er seine Arbeit als Idee definierte, hob der Konzeptkünstler den Status der Kunst in der Hierarchie der Arbeit und trat somit in den Rang der Priester ein, die nach Ansicht der Autoren von *Die deutsche Ideologie* die ersten Geistesarbeiter, oder die ersten „Ideologen" waren.[30] Doch nicht nur ist die vermeintliche Reinheit (und Freude) der immateriellen Arbeit (des Denkens oder der Rede) letztlich immer materiell, wie der Text weiter warnte, sondern sie hinterlässt auch einen materiellen Rückstand, und es war gerade der steigende Status und Wert dessen, was zunächst wie harmlose fotokopierte Überbleibsel der Arbeit der Konzeptkunst wirkte, der ihren Protagonisten das Ausmaß der Illusion der „Dematerialisierung" offenbarte. Als eine Foto-Serie und ein Künstlerbuch, die nun „Artist at Work" bilden, stellt Stilinovićs Performance von Nicht-Arbeit, oder alternativ immaterieller Arbeit, unbestreitbar einen materiellen Beweis dafür dar, dass der Künstler *tatsächlich* am Werk war, ein Künstler, dessen anfänglich unbedeutender Tauschwert mit der globalen Kommerzialisierung der subversiven Aura der „osteuropäischen Kunst" nach 1989 in die Höhe schoss.

Wie Lucy Lippard selbst nicht nur in ihrem „Postface", sondern bereits im langen Titel ihres einflussreichen Buches erkannte, bedeutete Dematerialisierung nicht die Auflösung des Kunstobjekts, sondern das Abstecken neuer „ästhetischer Grenzen".[31] Diese neuen Grenzen, so habe ich argumentiert, wurden maßgeblich definiert durch die Bestätigung des Darlegungspotenzials der Kunst, das mit der wachsenden ästhetischen, politischen und kommerziellen Bedeutung des Titels und der Diskursformen, die ihn umgeben, einherging: Saaltext, Wand-Label, Künstler- und Kuratoren-Statement, Ausstellungsankündigung, Ausstellungskatalog. Die diskursive Unterstützung selbst wurde in der Konzeptkunst zum Werk; wenn, in den Worten von Seth Siegelaub, „Sekundärinformation" mit der „Primärinformation" gleichgesetzt wird, kann der Katalog zu einem Kunstwerk oder, in seinem Fall, zu einer Ausstellung werden.[32] Als Instrument der Produktplatzierung ist der Katalog auch das Bindeglied zwischen Kunst und Kommerz und erinnert an die kunsthistorischen Überschneidungen mit Messen und Weltausstellungen. So ist es nicht verwunderlich, dass die scheinbar revolutionäre Transformation diskursiver Förderstrukturen der Kunst in Kunstwerke es den KunsthistorikerInnen ermöglichte, Konzeptkunst mit Reklame und den bürokratischen Apparaten des Spätkapitalismus zu verknüpfen.[33] Vielleicht noch symptomatischer: Was all diese diskursive Unterstützung letztlich bewirkt, ist, den Autor aus seinem angeblichen Tod wiederauferstehen zu lassen und dafür zu sorgen, dass seiner singulären „Haltung" Ausdruck verliehen wird.

28 In diesem und im folgenden Absatz finden sich Teile eines bestehenden Texts: Bago, Ivana: „The Artist as an Unemployed Socialist Worker: Performing Work and Negotiating Value in the Yugoslav New Art Practice of the 1970s and 1980s", in: *Transmissions* 4 (2013), 27–38.

29 Eine textbasierte Arbeit, die Stilinović 1980 zusammen mit „Artist at Work" ausstellte. Vgl. Matičević, Dalibor/Stilinović, Mladen: „Pjevaj!", Zagreb 1980, o.S.

30 Marx, Karl/Engels, Friedrich: *Die deutsche Ideologie*, 1998, o.S. Interessanterweise war die Autorschaft, d.h. die geistige Arbeit hinter dem unter dem umstrittenen Titel *Die deutsche Ideologie* versammelten Manuskript selbst ein Streitpunkt: Wurde es von Karl Marx verfasst, von Karl Marx und Friedrich Engels, Karl Marx (mit Friedrich Engels), tippte Engels nur das, was Marx diktierte, oder war es eigentlich so, dass Marx nur ein paar Kommentare hinzufügte? Vgl. Carver, Terrell/Blank, Daniel: *A Political History of the Editions of Marx and Engels's „German Ideology Manuscripts"*, London 2014.

31 Lippard: *Six Years* (wie Anm. 27).

32 Vgl. Seth Siegelaub zitiert in Meyer, Ursula (Hg.): *Conceptual Art*, New York 1972, xiv.

33 Vgl. Buchloh (wie Anm. 4); Alberro, Alexander: *Conceptual Art and the Politics of Publicity*, Cambridge/MA 2003; Medosch, Armin: *New Tendencies: Art at the Threshold of the Information Revolution (1961–1978)*, Cambridge, MA 2016.

The gallery visit, however, fulfilled the promise only by repeating it, by showing the viewer the poster that she had already encountered outside. The work's title, with its authorial renouncement of the myth of novelty and originality, was itself a kind of promise, which interpellated the viewer into partaking in the artist's "wish"—ultimately, a desire for a better art, and by extension, a better artist, more ethical, more political.

The form of promise holds a prominent place in contemporary art, as can also be measured by the number of artists, curators, and critics whose work references Jacques Rancière, theorist of the aesthetic regime of art and its promise of political emancipation. However, while Rancière had to read this promise *into* aesthetic practice, in the intense discursification of contemporary art the promise has become literalized, itself assuming an objectified and fetishized form. When promises become form, art turns into a self-perpetuating declaration of its own political power, whose consummation, however, must always be postponed into the future, because the present circumstances regularly seem too gloomy and unyielding. Since it at the same time cannot ignore what had turned out to be the overly-ambitious declarations of its avant-garde past, the declarative promise of contemporary art appears in the more cautious form of a question. Embracing the consolatory mantra that art is not about providing answers but about posing questions—the artworld version of "it is not important to win, but to participate"—countless exhibitions and conferences have asked, but rarely answered, whether we can do or imagine this or that: can we find forms of work that are not complicit with violence and exploitation, can we reactivate the utopias of the past, can we find protocols for imagining the future, etc.? No, we can't, at least not by reveling in wishful thinking or rather, wishful questioning.

Typically arriving in the form of an (e-flux) announcement—itself a form decidedly oriented towards the future—art's wishes reach the entire artworld.[34] A recent symposium titled "International Summit on Curatorial Activism and the Politics of Shock" was thus announced with a series of what-is-to-be-done questions, posed in response to the rise of nationalism and radical conservatism. The announcement, however, promised a decisively what-is-to-be-said solution to those questions, as it stated that "some of the world's leading curators and thinkers about museums and exhibitions will gather in New York for a public reading and discussion of manifestoes and declarative talks written specially on these topics for this extraordinary event."[35] Such romanticized fetishizations of art's declarative power reveal that contemporary art is indeed an heir to the conceptualist "dematerialization," with all the priestly connotations implied, per *The German Ideology*, in the privilege of immaterial labor, and the masking of its own material preconditions. By

the same token, contemporary art can be viewed as a mirror of economic financialization, as its declarative form—the form of either a wish or promise of a better world and a better art—mimics the form of a derivative such as the futures contract, in which the consummation of the expected profit is always postponed, with all the libidinal economy implied in such a transaction.

"Show yourself in the light, wall label. Come out of the shadows of the gallery."[36] Annie McClanahan has made a similar analogy between post-Marxist theories of immaterial labor and the political ideology of economic financialization since 1973, which she finds both to be driven by a type of messianic language of an end-of-history type of futurity, which masks the reality of deindustrialization.[37] The "new economy" is thus ultimately based on the "belief" in financial speculations as "self-fulfilling prophesies," McClanahan argues, citing also a telling 1998 speech by Ronald Reagan, in which he declared that "human invention increasingly makes physical resources obsolete [...] In the beginning was the spirit, and from this spirit the material abundance of creation issued forth."[38] It is not by coincidence, then, that the coupling of "art & spirit," i.e., art & idea/language, also took shape in the 1970s, and that it was vehemently resumed after history ended in 1989.

The "return to painting" in the 1980s was then perhaps less a contemporary of the Reagan-Thatcher era, than its nostalgic anachronism, which attempted to restore what had irreversibly been lost, or at least make an inventory of its remains. In their "Stalin with Hitler's Remains" (1985–86), Vitaly Komar and Alex Melamid thus itemized the entire history of political art from David, suprematism, socialist realism, Rauschenberg, and conceptual art. "Stalin with Hitler's Remains" resurrected "The Death of Marat" for the 1980s, with Hitler and Stalin doubling for the ideological clash between Marat and Charlotte Corday, his murderer. Unlike David, who enveloped his hero in light, Komar & Melamid veil their characters in complete darkness, and it is only the title that supposedly illuminates the scene.

34 The artworld, according to Anton Vidokle, is "not that large"—measured by the e-flux mailing list, is populated by 100,000 people. Cited in Loney Abrams, "Is e-flux the Gatekeeper of the Virtual Art World? Founder Anton Vidokle on His (Benevolent) Plans for the .Art Domain," *artspace.com*, February 25, 2017, accessible online: https://www.artspace.com/magazine/interviews_features/qa/is-e-flux-the-gatekeeper-of-the-virtual-art-world-founder-anton-vidokle-on-his-benevolent-plans-54622.

35 E-flux announcement. "International Summit on Curatorial Activism and the Politics of Shock at School of Visual Arts," email from e-flux's Art & Education mailing list, September 11, 2017.

36 Robert Morris cited in Welchman, *Invisible Colors* (see note 8), p. 331.

37 Annie McClanahan, "Investing in the Future. Late Capitalism's End of History," in *Journal of Cultural Economy* 6, no. 1 (2013), pp. 78–93.

38 Ibid., 79f.

„Ich möchte nichts Neues oder Originales ausstellen." Goran Trbuljaks „Ich möchte nichts Neues oder Originales ausstellen" (1971) kann als Porträt der Widersprüche der Kunst dienen, die mit der Konzeptkunst weder geendet noch begonnen, sondern in ihr sozusagen ihren unverfälschtesten Ausdruck gefunden haben. Als Beispiel dafür, was Trbuljak ein Ausstellungskunstwerk nannte, verwandelte „Ich möchte nichts Neues oder Originales ausstellen" die ultimative Trägerstruktur der Kunst, die Ausstellung, in ein Kunstwerk. Das einzige Objekt, das in der Galerie des Studentenzentrums in Zagreb zu sehen war, war das Plakat, auf dem die Ausstellung beworben wurde, mit einem Porträtfoto des Künstlers in Nahaufnahme sowie den Ausstellungsdaten, dem Ort und dem Titel. Während diese Arbeit durchaus als Beispiel für die nonkonformistische Haltung des Künstlers gegenüber dem Kunstsystem gelesen werden kann, offenbart sie gleichzeitig genau die für die Konzeptkunst charakteristische symptomatische Verschmelzung von Opposition und Affirmation. Trbuljaks Ausstellungskunstwerk führte eine Reihe von formalen und ideologischen Aspekten zusammen: Die Rolle des Künstlers war nicht zu unterscheiden von der des Grafikers, PR-Experten und Kurators; das Kunstwerk wurde mit dem Werbematerial der Ausstellung gleichgesetzt; die Ausstellung war identisch mit dem Kunstwerk und das Kunstwerk mit der Ausstellung; der Inhalt der Arbeit reduzierte sich auf eine Darstellung des Bildes und der Intention des Künstlers, genauer gesagt, seines „Wunsches", und schließlich nahm der Titel die Form eines Künstlerstatements an, dessen wohlüberlegter Ton an einen kommerziellen oder politischen Slogan erinnerte. Auf einer abstrakteren Ebene kann Trbuljaks Ausstellungskunstwerk als Signal für eine neue Definition von Kunst als eine Form der sich selbst erneuernden Verheißung verstanden werden. Der Betrachter begegnete dem Ausstellungsplakat auf der Straße und wurde so zum Adressaten eines Versprechens – eines Versprechens eines bestimmten Inhalts (Kunst) –, das nur durch den Besuch der Galerie erfüllt werden konnte. Der Galeriebesuch erfüllte das Versprechen jedoch nur, indem er es wiederholte, indem er dem Betrachter das Plakat zeigte, dem er bereits draußen begegnet war. Der Titel des Werkes, mit seinem auktorialen Verzicht auf den Mythos von Neuheit und Originalität, war selbst eine Art Versprechen, das den Betrachter aufforderte, am „Wunsch" des Künstlers teilzuhaben – letztendlich dem Wunsch nach einer besseren Kunst, und im weiteren Sinne nach einem besseren Künstler, einem ethischeren, politischeren.

Die Kunstform des Versprechens nimmt in der zeitgenössischen Kunst einen herausragenden Platz ein, was sich auch an der Zahl der KünstlerInnen, KuratorInnen und KritikerInnen ablesen lässt, deren Werk auf Jacques Rancière, den Theoretiker des ästhetischen Regimes der Kunst und dessen Versprechen der politischen Emanzipation, verweist. Doch während Rancière dieses Versprechen in die ästhetische Praxis *hinein* lesen musste, wird es in der intensiven Diskursivierung der zeitgenössischen Kunst zunehmend buchstäblich genommen und nimmt selbst die Form des Objekts oder Fetisches an. Wenn Versprechungen zur Form werden, wird Kunst zu einer sich

selbst erneuernden Deklaration der eigenen politischen Macht, deren Vollzug jedoch immer in die Zukunft verschoben werden muss, weil die gegenwärtigen Verhältnisse regelmäßig zu düster und unnachgiebig erscheinen. Da sie gleichzeitig nicht ignorieren kann, was sich als übertrieben ehrgeizige Erklärungen ihrer avantgardistischen Vergangenheit herausgestellt hat, erscheint das deklarative Versprechen der zeitgenössischen Kunst in der vorsichtigeren Form einer Frage. Das tröstende Mantra aufgreifend, dass es bei der Kunst nicht darum geht, Antworten zu geben, sondern Fragen zu stellen – die Kunstwelt-Version des alten Sprichworts „Dabei sein ist alles" – haben sich zahllose Ausstellungen und Konferenzen gefragt, aber selten beantwortet, ob wir dieses oder jenes tun oder uns vorstellen können: Können wir Formen der Arbeit finden, die keine Mitschuld an Gewalt und Ausbeutung tragen, können wir die Utopien der Vergangenheit reaktivieren, können wir Protokolle für die Vorstellung der Zukunft finden, usw.? Nein, das können wir nicht, zumindest nicht, indem wir in Wunschdenken schwelgen, oder besser gesagt, in sehnsüchtigen Fragen.

Typischerweise in Form einer (*e-flux*)-Ankündigung – selbst eine entschieden zukunftsorientierte Form – erreichen die Wünsche der Kunst die gesamte Kunstwelt.[34] So wurde kürzlich ein Symposium mit dem Titel „International Summit on Curatorial Activism and the Politics of Shock" (A.d.Ü: Internationaler Gipfel über kuratorischen Aktivismus und Schockpolitik) mit einer Reihe von Fragen zu praktischen Maßnahmen angekündigt, die als Antwort auf den Aufstieg des Nationalismus und des radikalen Konservatismus gestellt wurden. Die Ankündigung versprach jedoch eine entschieden in der Theorie und im Diskurs verhaftet bleibende Lösung für diese Fragen, denn es hieß: „Einige der weltweit führenden KuratorInnen von und DenkerInnen über Museen und Ausstellungen werden sich in New York zu einer öffentlichen Lesung und Diskussion von Manifesten und deklarativen Vorträgen versammeln, die speziell zu diesen Themen für dieses außergewöhnliche Ereignis geschrieben wurden."[35] Solche romantisierten Fetischisierungen der deklarativen Macht der Kunst zeigen, dass die zeitgenössische Kunst

34 Laut Anton Vidokle ist die Kunstwelt „nicht so groß" – gemessen an der *e-flux*-Mailingliste, wird sie von 100.000 Menschen bevölkert. Zitiert in Abrams, Loney: „Is e-flux the Gatekeeper of the Virtual Art World? Founder Anton Vidokle on His (Benevolent) Plans for the .Art Domain", in: *artspace.com*, 25. Februar 2017, online unter: https://www.artspace.com/magazine/interviews_features/qa/is-e-flux-the-gatekeeper-of-the-virtual-art-world-founder-anton-vidokle-on-his-benevolent-plans-54622.

35 *E-flux*-Ankündigung. „International Summit on Curatorial Activism and the Politics of Shock at School of Visual Arts", E-Mail aus der *e-flux*-Mailingliste Art & Education, 11. September 2017.

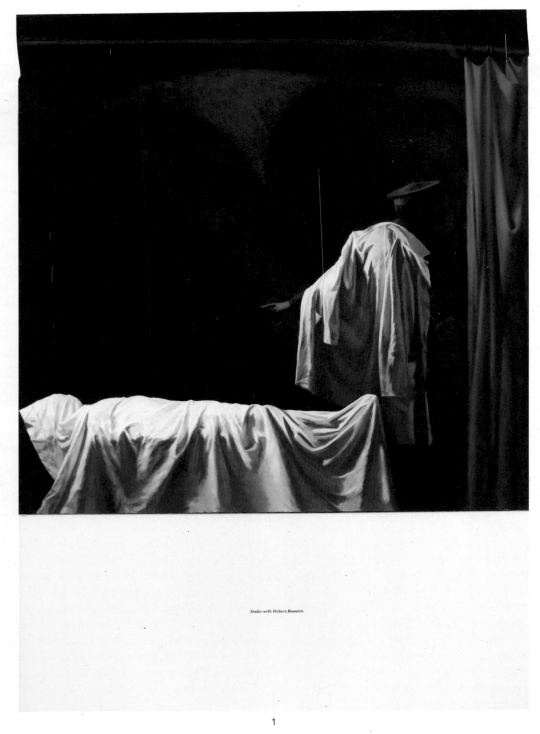

Stalin with Hitler's Remains

Vitaly Komar/Alex Melamid, "Stalin with Hitler's Remains," Oil on canvas, 84 1/4 × 60 1/4 inches | Öl auf Leinwand, 214 × 153 cm,
from the series | aus der Serie "Anarchistic Synthesism," 1985–1986, Collection of the Nasher Museum of Art at Duke University |
Sammlung des Nasher Museum of Art an der Duke University, Durham/NC, Museum purchase | Museumskauf
© Photo: Peter Paul Geoffrion, Courtesy of | Mit freundlicher Genehmigung von Ronald Feldman Fine Arts, New York/NY

"Stalin" is turning away from the viewer towards "someone" unseen behind the red curtain, while his left-hand index finger points towards "Hitler," a dead figure laid out on the table, wrapped in a white sheet, like the Shroud of Turin (fig. 1). This is only the upper part of the painting, however, as right below this scene a perfectly smooth white rectangle competes for the viewer's attention, as if to pit Malevich's "White on White" or Rauschenberg's "White Paintings" against David's revolutionary classicism and Stalin's socialist realism, and to then confront them all with the expositionary power of conceptual art, encapsulated in the text that cuts right through the monochrome: "Stalin with Hitler's Remains." The rectangle and the text are

tatsächlich ein Erbe der konzeptualistischen „Dematerialisierung" ist, mit all den priesterlichen Konnotationen, die laut *Die deutsche Ideologie* im Privileg der immateriellen Arbeit und der Maskierung ihrer eigenen materiellen Voraussetzungen enthalten sind. Umgekehrt kann die zeitgenössische Kunst als Spiegel der ökonomischen Kapitalisierung betrachtet werden, da ihre deklarative Form – die Form eines Wunsches oder Versprechens einer besseren Welt und einer besseren Kunst – die Form eines Derivats wie des Terminkontrakts imitiert, in dem der „Vollzug" [A.d.Ü.: d.h. die Abschöpfung] des erwarteten Gewinns immer aufgeschoben wird, mit all der libidinösen Ökonomie, die in einer solchen Transaktion mitschwingt.

„Zeige dich im Licht, Saaltext. Trete aus dem Schatten der Galerie heraus."[36] Annie McClanahan hat eine ähnliche Analogie zwischen den postmarxistischen Theorien der immateriellen Arbeit und der politischen Ideologie der ökonomischen Kapitalisierung seit 1973 hergestellt, die ihrer Meinung nach beide von einer Art messianischer Sprache einer Zukunft im Sinne eines Ende der Geschichte angetrieben werden, die die Realität der Deindustrialisierung verdeckt.[37] Die „New Economy" gründet sich also letztlich auf den „Glauben" an Finanzspekulationen als „sich selbst erfüllende Prophezeiungen", argumentiert McClanahan und zitiert dabei auch eine aussagekräftige Rede von Ronald Reagan aus dem Jahr 1998, in der er erklärte, dass „die Erfindungen des Menschen die physischen Ressourcen zunehmend obsolet machen. […] Am Anfang war der Geist, und aus diesem Geist ging die materielle Fülle der Schöpfung hervor."[38] Es ist also kein Zufall, dass die Kopplung von „Kunst und Geist", d.h. Kunst und Idee/Sprache, ebenso in den 1970er Jahren Gestalt annahm und nach dem Ende der Geschichte im Jahr 1989 vehement wieder aufgenommen wurde.

Die „Rückkehr zur Malerei" in den 1980er Jahren war damals weniger eine Zeitgenossin der Reagan-Thatcher-Ära, als vielmehr deren nostalgischer Anachronismus, der versuchte, das unwiderruflich Verlorene wiederherzustellen oder zumindest seine Überreste zu inventarisieren. In ihrem Gemälde „Stalin mit Hitlers sterblichen Überresten" (1985–86) haben Vitaly Komar und Alex Melamid so die gesamte Geschichte der politischen Kunst von David, Suprematismus, sozialistischem Realismus, bis hin zu Rauschenberg und Konzeptkunst aufgeschlüsselt. „Stalin mit Hitlers sterblichen Überresten" war eine Wiederbelebung von „Der Tod des Marat" für die 1980er Jahre, wobei Hitler und Stalin den ideologischen Konflikt zwischen Marat und Charlotte Corday, seiner Mörderin, doubelten. Im Gegensatz zu David, der seinen Helden in Licht hüllte, verhüllen Komar & Melamid ihre Figuren in völliger Dunkelheit, und nur der Titel soll die Szene erhellen. „Stalin" wendet sich vom Betrachter ab und wendet sich „jemandem" zu, der sich hinter

dem roten Vorhang verbirgt, während sein linker Zeigefinger auf „Hitler" zeigt, ein Leichnam, der auf dem Tisch liegt, eingewickelt in ein weißes Laken, wie das Grabtuch von Turin (Abb. 1). Dies ist jedoch nur der obere Teil des Bildes, denn direkt unter dieser Szene wetteifert ein vollkommen glattes weißes Rechteck um die Aufmerksamkeit des Betrachters, als ob Malewitschs „Weiß auf Weiß" oder Rauschenbergs „White Paintings" gegen Davids revolutionären Klassizismus und Stalins sozialistischen Realismus kämpfen solle und sie dann alle mit der Darlegungskraft der Konzeptkunst konfrontiert werden sollen, die in diesem das Monochrom durchschneidenden Text enthalten ist: „Stalin mit Hitlers sterblichen Überresten." Das Rechteck und der Text sind ein seitenverkehrtes Spiegelbild von Davids „À Marat. David" als Inschrift auf der vertikalen Holzkiste. Nur in diesem Fall gibt es keinen Slogan, keine Treueerklärung, keine Unterschrift des Künstlers, der es wagt, seine politische Haltung zu verkünden. Stattdessen eine kalte Liste der Bestandteile, „Stalin mit Hitlers sterblichen Überresten", die anscheinend das von ihr gerahmte „Historienbild" aus der Dunkelheit holt und die Geschichte selbst als nichts anderes als eine Summe forensischer Beweise darstellt.

Das betitelte Rechteck ist zugleich ein Crashkurs über den Aufstieg von Text in der Malerei, der erzählt, wie von Davids gemalter Inschrift, Rauschenbergs Einfügung der betitelten Plakette in den Bilderrahmen, den Textbildern von Art & Language und nun, Komar & Melamids eigener Titelmalerei, die diskursive Unterstützung der Kunst soweit aufgeblasen wurde, dass sie droht, die Kunst „selbst" zur verdrängen. Die Galeriewand war nicht mehr bloß Träger des (betitelten) Gemäldes und drang auf dessen Oberfläche ein – weshalb lustigerweise im digitalen Bildarchiv einer Universität das untere Rechteck der Arbeit von Komar & Melamid abgeschnitten wurde.[39] Eine ähnliche Angst vor diesem Eindringen zeigt sich auch in Robert Morris' „Traumjournaleinträgen" der frühen 1990er Jahre, in denen die Bildunterschrift, wie Welchman es ausdrückte, „alptraumhaft überladen erscheint und in denen ihre titelgebende Ergänzung die Stabilität der Objektwelt ‚gefährdet'."[40] Morris verpasst ihr den Kosenamen „vielgestaltiges Sprachmonster" und führt einen heldenhaften Kampf mit der Bildunterschrift und fordert sie heraus, „herauszukommen" und aufzuhören, sich „hinter der institutionellen Bleiernheit ihrer Prosa" zu verstecken.[41]

Man kann sagen, dass die Bildunterschrift – zusammen mit den mit ihr einhergehenden diskursiven sprachlichen Helfern der Kunst – Morris' Herausforderung angenommen

36 Robert Morris zitiert in Welchman: *Invisible Colors*, 331 (wie Anm. 8).

37 McClanahan, Annie: „Investing in the Future. Late Capitalism's End of History", in: *Journal of Cultural Economy* 6, 1 (2013), 78–93.

38 Ebd., 79–80.

39 Vgl. „Stalin with Hitler's Remains" (from Anarchistic Synthesism Series), ULS Digitale Sammlungen, Universität Pittsburgh, online unter: https://digital.library.pitt.edu/islandora/object/pitt%3AEA000041/from_search/491f76eb2a41fb1a47892156e17ad1e.

40 Welchman: *Invisible Colors*, 331 (wie Anm. 8).

41 Morris zitiert in Welchman, *Invisible Colors*, 331 (wie Anm. 8).

an inverted mirror of David's "À Marat. David," inscribed on the vertical wooden crate. Only in this case, there is no slogan, no statement of allegiance, no signature of the artist who dares to proclaim her political stance. Instead, a cold ingredient list, "Stalin with Hitler's Remains," which ostensibly brings from obscurity the "history painting" that it frames, while presenting history itself as nothing but a sum of forensic evidence.

The titled rectangle is at the same time a crash course on the ascendance of text in painting, narrating how, from David's painted inscription, Rauschenberg's insertion of the titled plaque into the picture frame, the text-paintings of Art & Language, and now, Komar & Melamid's own title-painting, the discursive support of art was inflated to such degree that it threatened to supplant art "itself." No longer merely carrying the painting, the (labeled) gallery wall invaded its surface – which is why, funnily enough, in one university's digital image archive the bottom rectangle of Komar & Melamid's work was cut off.[39] A similar anxiety of invasion is revealed in Robert Morris's "dream journal entries" of the early 1990s, in which the exhibition label appears, as Welchman put it, "nightmarishly engorged, and in which its title-bearing supplementarity 'threatens' the stability of the object world."[40] Nicknaming it a "protean linguistic monster," Morris enacts a heroic battle with the label, daring it to "come out" and stop hiding "behind the institutional leadenness of its prose."[41]

It can be said that the label—together with the accompanying discursive supports of art—has accepted Morris's challenge, and took it further. In addition to revisiting conceptual art and recanonizing it as a global phenomenon, art in the 1990s was again proclaimed a politicized practice, and this politicization was followed by a new level of art's discursification. Ronald Jones's objects of the late 1980s and early 1990s stage the tension between the "silence" of the non-figurative form and the politicized use of titling. Jones first "untitles" his minimal-like sculptures, but only to "de-untitle" and politicize them right after, by radically protracting their "Untitled" titles into a sentence- or paragraph-long text placed in brackets. An encounter with the wooden rectangular surface laid out on the gallery floor will thus at first sight evoke Carl Andre's minimalist floor reliefs, but the label will point the viewer in a completely different direction: Ronald Jones, "Untitled Floor Tile (Interrogation room used for the detention of Stephen Biko from September sixth through the eight, 1977 Room 619 of the Sanlam Building, Security Police Headquarters, Strand Street, Port Elizabeth, Cape Province, South Africa)."

The proliferation of the discursive supports as either integral elements, or expositional and authorial agents, of the work of art in the 1990s is perhaps best illustrated by a polemics which, in 2006, centered on the key art-theoretical concept of the 1990s, relational aesthetics. In response to Claire Bishop's critique, Liam Gillick argued that she misread and depoliticized

his work, and that this could have been prevented had she been less "journalistic" in her critique and more dedicated to reading his books: "These books carry precise and clear ideas and structures within them, operate in parallel to other structures in an art context, and are revealed through titles, wall texts, and other forms of information that ought to have rendered Bishop's confusion impossible."[42]

"You say I took the Name in vain; I don't even know the name."[43] Any remaining confusion about the political nature of art in the 1990s was removed by documenta X (1997), which, under the curatorship of Catherine David, refashioned the large-scale exhibition as a discursive format par excellence. With its thematization of global geopolitical issues, its 800-page publication (*The Book*) which remapped the history of post-1945 art as a symbiosis of poetics and politics, its "100 Days–100 Guests" marathon of lectures and discussions, documenta X transformed the exhibition (once again) into a (universal) exposition. If, in the 1960s, minimal art "literalized" the art object, at the end of the twentieth century documenta X "literalized" the exhibition, its negation of tradition inscribed in the promotional materials that thrived on the ambivalence of the symbol "X" (X as both a Roman numeral and a sign for erasure), printed in bright red on top of the lowercase, black "d" (d as documenta, but also the European Exhibition as such). documenta X at the same time augured the new, entitled place that the tradition of critical theory—to a significant extent, at the expense of art theory—would come to assume in contemporary art, including the obligatory and prominent appearance in global art events of the figure of the philosopher, thus turned into the "global theorist."[44]

In this constellation, the "concept," autonomized in conceptual art as a token of art's intellectual power, reemerges again, but no longer as part of art theory, i.e., as an attempt to propose a critique or a redefinition of the practice of art, but as an index of ubiquitous intellectual privatization, by which a curator, artist, or theorist mark their aesthetic and philosophical territory. Such demarcation is nothing new, as the history of complaints of "-isms" can attest to; however, in the context of the twitterization of our attention spans in the face of incessant information overload and the unrelenting hyperproduction on

39 See "Stalin with Hitler's Remains" (from Anarchistic Synthesism Series), ULS Digital Collections, University of Pittsburgh, accessible online: https://digital.library.pitt.edu/islandora/object/pitt%3AEA000041/from_search/491f76eb2a41fb1a47892156e17ad1e.

40 Welchman, *Invisible Colors* (see note 8), p. 331.

41 Morris, cited in Welchman, *Invisible Colors* (see note 8), p. 331.

42 Liam Gillick, "Contingent Factors: A Response to Claire Bishop's 'Antagonism and Relational Aesthetics,'" *October* 115 (2006), p. 103.

43 Leonard Cohen, "Hallelujah," *Various Positions*, 1984.

44 Andrew Stefan Weiner, "Immanence and Infidelity: Fifteen Ways to Leave Badiou," in *ARTMargins* 2, no. 3 (2013), pp. 97–113.

und weitergeführt hat. Neben der Wiederaufnahme der Konzeptkunst und ihrer Rekanonisierung als globales Phänomen wurde die Kunst in den 1990er Jahren erneut zu einer politisch aufgeladenen Praxis proklamiert, und dieser politischen Aufladung folgte ein neues Level der Diskursivierung der Kunst. Ronald Jones' Objekte der späten 1980er und frühen 1990er Jahre inszenieren die Spannung zwischen dem „Schweigen" der nicht gegenständlichen Form und dem politisch aufgeladenen Einsatz der Betitelung. Zunächst belässt er seine minimalistisch anmutenden Skulpturen *explizit* „Ohne Titel", aber nur, um sie gleich danach politisch aufzuladen, indem er ihre „Ohne Titel"-Titel mit einem in Klammern gesetzten Text in Satz- oder Absatzlänge radikal in die Länge zieht. Die Begegnung mit der auf dem Galerieboden angelegten rechteckigen Holzfläche erinnert auf den ersten Blick an die minimalistischen Bodenreliefs von Carl André, aber die Bildunterschrift weist den Betrachter in eine ganz andere Richtung: Ronald Jones, „Untitled Floor Tile (Interrogation room used for the detention of Stephen Biko from September sixth through the eight, 1977 Room 619 of the Sanlam Building, Security Police Headquarters, Strand Street, Port Elizabeth, Cape Province, South Africa)" [A.d.Ü: Fußbodenfliese ohne Titel (Verhörraum bei der Festnahme von Stephen Biko vom 6. September bis zum 8. September 1977, Raum 619 des Sanlam Building, Hauptquartier der Sicherheitspolizei, Strand Street, Port Elizabeth, Kapprovinz, Südafrika)].

Die weite Verbreitung diskursiver Hilfsmittel als entweder wesentliche Komponente oder darlegendes und auktoriales Mittel des Kunstwerks in den 1990er Jahren lässt sich vielleicht am besten an einer Polemik veranschaulichen, die sich 2006 auf das zentrale kunsttheoretische Konzept der 1990er Jahre, die relationale Ästhetik, konzentrierte. In Erwiderung auf die Kritik von Claire Bishop argumentierte Liam Gillick, dass sie sein Werk missverstanden und entpolitisiert habe und dass dies hätte verhindert werden können, wenn sie in ihrer Kritik weniger „journalistisch" gewesen wäre und sich mehr dem Lesen seiner Bücher verschrieben hätte: „Diese Bücher tragen präzise und klare Ideen und Strukturen in sich, operieren parallel zu anderen Strukturen im Kunstkontext und offenbaren sich durch Titel, Wandtexte und andere Informationsformen, die Bishops Missverständnisse hätten unmöglich machen sollen."[42]

„You say I took the Name in vain; I don't even know the name."[43] Jegliche weitere Unklarheit über das politische Wesen der Kunst in den 1990er Jahren wurde durch die documenta X (1997) beseitigt, die unter der Leitung von Catherine David die Großausstellung als Diskursformat par excellence umgestaltete. Mit ihrer Thematisierung globaler geopolitischer Themen, ihrer 800-seitigen Publikation (*Das Buch zur documenta X*), die die Geschichte der Kunst nach 1945 als Symbiose von Poetik und Politik neu aufbereitete, und ihrem Vortrags- und Diskussionsmarathon „100 Tage – 100 Gäste", verwandelte die documenta X das Ausstellungsformat (erneut) in eine (universelle) Expo. Wenn in den 1960er Jahren die Minimal Art das Kunstobjekt

„literalisierte", dann „literalisierte" am Ende des zwanzigsten Jahrhunderts die documenta X die Ausstellung, ihre Negierung der Tradition war eingeschrieben in die Werbematerialien, die durch die Ambivalenz des Zeichens „X" (X als sowohl römische Zahl als auch Zeichen für Auslöschung), das in leuchtendem Rot auf das kleine schwarze „d" (d für die documenta, aber auch die europäische Ausstellung als solche) gedruckt wurde, ihre Wirkung entfalteten. Gleichzeitig versprach die documenta X den neuen Ort, auf den die Tradition der kritischen Theorie – zu einem erheblichen Teil auf Kosten der Kunsttheorie – mit Fug und Recht in der zeitgenössischen Kunst einnehmen würde, einschließlich des obligatorischen und prominenten Auftritts der Figur des Philosophen bei globalen Kunstereignissen, der so zum „Welttheoretiker" wurde.[44]

In dieser Konstellation taucht das „Konzept", das in der Konzeptkunst als Zeichen der intellektuellen Kraft der Kunst autonom wurde, wieder auf, aber nicht mehr als Teil der Kunsttheorie, d.h. als Versuch, eine Kritik oder eine Neudefinition der Kunstpraxis vorzuschlagen, sondern als Indiz der allgegenwärtigen intellektuellen Privatisierung, mit der KuratorInnen, KünstlerInnen oder TheoretikerInnen ihr ästhetisches und philosophisches Territorium markierten. Eine solche Abgrenzung ist nichts Neues, wie die Geschichte der Klagen über all die „-ismen" belegt, aber im Kontext der Twitterisierung unserer Aufmerksamkeitsspanne angesichts der unaufhörlichen Informationsüberflutung und der unerbittlichen Hyperproduktion auf allen Ebenen droht die zunehmend privatisierte, „konzeptuelle" Territorialmarkierung zusehends alles zu sein, was bleibt. Das impliziert eine gewisse hierarchische Beziehung, an deren unterem Ende sozusagen sich die KünstlerInnen über die Einordnung ihrer Arbeiten in die von KuratorInnen verfassten Ausstellungs-„Konzepte" beschweren werden, während KuratorInnen und KünstlerInnen gleichermaßen dazu gedrängt werden, die Grenzen ihrer traditionellen Wissensbasis zu überwinden und zu demonstrieren, dass sie in den begrifflichen Höhen der Theorie schweben können. Im Bereich des theoretischen und akademischen Schreibens zeigen sich die Wirkungen des „Konzept"-Wettbewerbs um die Aufmerksamkeit des hyperaktiven Lesers in den obligatorischen „Abstract-Abstraktionen" dessen, was

42 Gillick, Liam: „Contingent Factors. A Response to Claire Bishop's ‚Antagonism and Relational Aesthetics'", *Oktober* 115 (2006), 95–107, hier 103.

43 (A.d.Ü.: „Du sagst, ich habe Seinen Namen vergeblich angenommen, ich kenne ihn nicht einmal". Cohen, Leonard: „Hallelujah" auf *Various Positions*, 1984.

44 Weiner, Andrew Stefan: „Immanence and Infidelity. Fifteen Ways to Leave Badiou", in: *ARTMargins* 2, 3 (2013), 97–113.

all levels, the increasingly privatized, "conceptual" territory-marking threatens to become all that there is. A certain hierarchical relationship is implicit here, at the bottom of which, so to speak, artists will complain against the subsumption of their work into the exhibition "concepts" authored by curators, while both curators and artists will be similarly pressed to overcome the boundaries of their traditional knowledge-base, and demonstrate that they can float in the conceptual heights of theory. In the realm of theoretical and academic production, the effects of the "conceptual" competition for the attention of the hyperactive reader are evident in the obligatory "abstract-ions" of what must always be claimed as singular "arguments," as well as the anxious prefixing of the author's conceptual contributions by the performative, "what-I-call" territory markers—what I will call *what-I-callism*—as if otherwise no-one would notice that a new concept was presented.

And indeed, in the inflation of what Theodor Adorno, the insistent critic of the conceptual and the identitarian, called "concept fetishism," one is likely not to notice.[45] The title, of course, is the key agent here, as it needs to be able to crystallize at the same time the concept and the argument, and enable the transportability of their singularity in citations, as well as in promotional materials of publishing houses, which, in a telling metonymy, advertise their books as "titles." The same titular logic governs the production of contemporary art, now surrounded by its own discursive arsenal. A single, albeit monumental, "book" produced in the framework of *Documenta X* proliferated into one hundred "notebooks" commissioned by Carolyn Christov-Bakargiev for *Documenta 13*. Titled "100 Notes – 100 Thoughts," the series dematerialized David's "100 Days – 100 Guests," transposing its evocation of the temporal progression of bodies into an agglomerated notation of "thoughts," which accompanied the otherwise "object-oriented" show. The relevance of both the temporal and spatial presence of a "Parliament of Bodies" was reaffirmed at the latest Documenta exhibition, "Learning from Athens" (2017), which was at the same time criticized precisely for its "titular objectification" of both Athens and its national collection of contemporary art.[46]

The title, as the ultimate branding and objectifying tool, is the sign of the honorary privilege of art, its entitlement to the benefits of the dominant (albeit arguably extinguishing) global capitalist order, and its participation in what Herbert Marcuse called affirmative culture. This is its exchange value. In this sense, the title can be used not only to transcend and "aristocratize," but also to banalize, and to explain (away), which, for Adorno is precisely the function opposite to that of art. Explanation reduces the unknown to the familiar, while art, on the contrary, "gravitates to what is not known, what does not yet exist," and "what has not yet been subsumed" into the hegemonic structures and concepts.[47] To what extent does art still

have the power to conspire with the non-existing and the un-absorbed? Perhaps, however, this very fixation on the unabsorbed is yet another fetish, a repetition of the colonial logic of the discovery and conquest of the distant and the dissonant? "What has not *yet* been subsumed" indicates, after all, that it once will be. Still, Adorno's call is not to simply abandon the concept but to always insist in its bond with the nonconceptual, or, in our case, the non-titled, which could be one way to avoid both concept fetishism and the equally seductive fetishism of endless deconstruction.

At the same time, the title—considered in this text as the epitome, or simply an index—of the conceptual tools won in the battle for art's politicization, enables the artist and curator to argue for the persisting capacity of art to fuse the sensuous, the intellectual, the epistemological, and the political and thus create a unique arena from which to engage in what can be acknowledged as contemporary art's attempt to define the "world," and to see beyond the fragmented and the evident. This is the title's use value, its capacity to be employed as a token of Benjamin's exhibition value, which he opposed to cult. However, although Benjamin did not use classical Marxist terminology, exhibition value could perhaps be better understood not as an alternative to cult value, but as what enables art to claim a value beyond the dichotomy of use and exchange, despite the fact that it at the same time remains tied to both. The "dematerialization" of art beyond its traditional, "disciplinary" parameters, has led to its evolution as a form of sanctuary for all cultural and political practices that cannot fit the boundaries of their respective disciplines: for film that is not cinema, for writing that is not literature, for political engagement that is not politics or activism. The persistence of the "exhibitionary complex," despite all its critiques and deconstructions, is precisely what enabled this strange, all-medium condition of contemporary art, because it maintained the frame around art, so as not to allow for everything to "melt into thin air." While this was another form of enclosure, accompanied by new forms of ideological and material containment, it was also a way to embrace this enclosure as a type of (con)temporary autonomous zone, in which art could, as we have seen, perpetually wish itself out of the "merely" (con)temporary and place its bets on the future. And also the past, but this is another story. ∎

45 Theodor W. Adorno, *Negative Dialectics* (New York, 2007), p. 12. Adorno argues for a kind of philosophical reflection that can get rid of concept's "autarky," which implies an engagement with the "nonconceptual in the concept." Jean Baudrillard has argued even more radically, that there is no commodity fetishism that is not primarily the fetishism of the sign. Jean Baudrillard, *For a Critique of the Political Economy of the Sign* (St. Louis, 1981).

46 Stephanie Bailey, "Tough love: documenta 14," August 11, 2017, occula.com, accessible online: https://ocula.com/magazine/reports/tough-love-documenta-14/?notification=subscribed&nonce=022345428534407574.

47 Adorno cited in Andrew Bowie, *Adorno and the Ends of Philosophy* (Cambridge, 2013), p. 145.

immer als singuläre „Argumente" beansprucht werden muss, sowie in der ängstlichen Voranstellung der konzeptuellen Beiträge der jeweiligen AutorInnen durch performative Reviermarker („Ich nenne das") – ich werde das *Ich-nenne-Dasismus* nennen – als ob sonst niemand bemerken würde, dass ein neues Konzept präsentiert worden ist.

Und in der Tat, im inflationären Auftreten dessen, was Theodor Adorno, der nachdrückliche Kritiker des Konzeptuellen und Identitären, „Betriffsfetischismus" genannt hat, wird er leicht übersehen.[45] Der Titel ist hier natürlich der Schlüsselfaktor, denn Konzept und Argument müssen sich gleichzeitig herauskristallisieren und für die Transportierbarkeit ihrer Einzigartigkeit in Zitaten sowie in Werbematerialien von Verlagen, die ihre Bücher in einer vielsagenden Metonymie als „Titel" bewerben, muss gesorgt sein. Dieselbe Titellogik leitet die Produktion zeitgenössischer Kunst, die heute von ihrem eigenen Diskursarsenal umzingelt ist. Ein einziges, wenn auch monumentales, „Buch", das im Rahmen der documenta X produziert wurde, vervielfachte sich in hundert „Notizbücher", die Carolyn Christov-Bakargiev für die documenta 13 in Auftrag gegeben hat. Unter dem Titel *100 Notizen – 100 Gedanken* dematerialisierte diese Reihe Catherine Davids „100 Tage – 100 Gäste" und übertrug ihre Beschwörung der zeitlichen Abfolge von Körpern in eine geballte Notierung von „Gedanken", die die ansonsten „objektorientierte" Schau begleiteten. Die Relevanz sowohl der zeitlichen als auch der räumlichen Präsenz eines „Parlaments der Körper" wurde in der jüngsten documenta-Ausstellung, „Lernen von Athen" (2017), bekräftigt, die zugleich kritisiert wurde, gerade weil sie sowohl Athen als auch sein Nationales Museum für zeitgenössische Kunst (EMST) „im Titel als ‚Objekt' präsentiert" hatte.[46]

Der Titel, als ultimatives Branding- und Objektivierungsinstrument, ist das Zeichen des Ehrenprivilegs der Kunst, ihres Anspruchs auf die Vorteile der dominanten (wenn auch wohl verlöschenden) kapitalistischen Weltordnung und ihrer Beteiligung an dem, was Herbert Marcuse als affirmative Kultur bezeichnete. Das ist sein Tauschwert. In diesem Sinne kann der Titel nicht nur zur Transzendierung und „Nobilitierung", sondern auch zur Banalisierung und (Weg-)erklärung dessen verwendet werden, was für Adorno genau die Funktion ist, die derjenigen der Kunst entgegengesetzt ist. Die Erklärung reduziert das Unbekannte auf das Vertraute, doch „geht die Kunst eher auf Unbekanntes, noch nicht Seiendes," auf jenes von den hegemonialen Strukturen und Konzepten „noch nicht Subsumierte."[47] Inwieweit hat die Kunst noch die Macht, sich mit dem Nicht-Existierenden und dem Nicht-Absorbierten zu verschwören? Vielleicht ist aber gerade diese Fixierung auf das Nicht-Absorbierte ein weiterer Fetisch, eine Wiederholung der kolonialistischen Logik der Entdeckung und Eroberung des Fernen und Dissonanten? „Jenes *noch* nicht Subsumierte" weist im Grunde genommen darauf hin, dass es dies einmal sein wird.

Dennoch besteht Adornos Aufruf nicht nur darin, das Konzept einfach aufzugeben, sondern immer wieder auf seiner Verbundenheit mit dem Nicht-Konzeptuellen, oder in unserem Fall mit dem Unbetitelten, zu bestehen, was ein Weg sein könnte, um sowohl Betriffsfetischismus als auch den ebenso verführerischen Fetischismus der endlosen Dekonstruktion zu vermeiden.

Gleichzeitig ermöglicht es der Titel – in diesem Text als Inbegriff oder einfach als Indiz – der im Kampf um die politische Aufladung der Kunst gewonnenen konzeptuellen Werkzeuge betrachtet –, KünstlerInnen wie KuratorInnen für die anhaltende Fähigkeit der Kunst zu argumentieren, das Sinnliche, das Intellektuelle, das Epistemologische und das Politische zu verschmelzen und so eine einzigartige Arena zu schaffen, von der aus man sich auf das einlassen kann, was als der Versuch der zeitgenössischen Kunst anerkannt werden kann, „die Welt" zu definieren und über das Fragmentarische und Offensichtliche hinauszublicken. Das ist der Nutzwert des Titels, seine Fähigkeit, als Zeichen für Benjamins Ausstellungswert, den er dem Kult entgegensetzte, eingesetzt zu werden. Obwohl Benjamin keine klassische marxistische Terminologie verwendete, könnte der Ausstellungswert vielleicht besser verstanden werden, nicht als Alternative zum Kultwert, sondern als das, was der Kunst ermöglicht, einen Wert jenseits der Dichotomie von Nutzen und Tausch zu beanspruchen, obwohl sie gleichzeitig an beides gebunden bleibt. Die „Dematerialisierung" der Kunst jenseits ihrer traditionellen, „disziplinären" Parameter hat zu ihrer Entwicklung als eine Art Zufluchtsort für alle kulturellen und politischen Praxen geführt, die sich nicht in die auf ihre jeweiligen Disziplinen eingrenzen lassen: für Film, der kein Kino ist, für Schreiben, das keine Literatur ist, für politisches Engagement, das weder Politik noch Aktivismus ist. Die Beständigkeit des „Ausstellungskomplexes", trotz aller Kritik an ihm und seiner Dekonstruktion, ist genau das, was diesen merkwürdigen medienübergreifenden Zustand der zeitgenössischen Kunst erst ermöglicht hat, weil er den Rahmen um die Kunst beibehalten hat, damit ja nicht alles „in dünne Luft zerfließt". Während dies eine andere Form eines umschlossenen Raumes war, begleitet von neuen Formen der ideologischen und materiellen Eindämmung, war es auch ein Weg, diesen umschlossenen Raum als eine Art (kon-)temporäre autonome Zone zu begreifen, in der sich die Kunst, wie wir gesehen haben, immer wieder aus dem „bloß" (Kon-)temporären heraus wünschen und auf die Zukunft setzen kann. Und ebenso auf die Vergangenheit, aber das ist eine andere Geschichte. ∎

Übersetzung: Otmar Lichtenwörther

45 Adorno, Theodor W.: *Negative Dialektik*, Frankfurt 1966, 55. Adorno plädiert für eine Art philosophische Reflexion, die sich von der „Autarkie" des Konzepts befreien kann, was eine Auseinandersetzung mit dem „Nicht-Konzeptuellen im Konzept" impliziert. Jean Baudrillard hat noch radikaler argumentiert, dass es keinen Warenfetischismus gibt, der nicht primär der Fetischismus des Zeichens ist. Vgl. Baudrillard, Jean: *For a Critique of the Political Economy of the Sign*, St. Louis/MO 1981.

46 Bailey, Stephanie: „Tough love: documenta 14", 11. August 2017, online unter: occula.com, https://ocula.com/magazine/reports/tough-love-documenta-14/?notification=subscribed&nonce=022345428534407574

47 Adorno, Theodor W.: *Vorlesungen zur Ästhetik 1967–68*. Zürich 1973, 23.

The Open Secret of Exhibitions

Das offene Geheimnis von Ausstellungen

Vincent Normand (VN)
in Conversation with | im Gespräch mit
Milica Tomić and | und **Dubravka Sekulić (GAM)**

Theater, Garden, Bestiary: A Materialist History of Exhibitions
is a HES-SO/University of Applied Sciences and Arts of
Western Switzerland and ECAL/University of Art and Design
Lausanne research project | ist ein Forschungsprojekt
an der ECAL, der kantonalen Hochschule für Kunst und
Design Lausanne, unterstützt von der HES-SO/
Fachhochschule Westschweiz.

Direction | Leitung: Vincent Normand and Tristan Garcia
Project coordinator | Projektkoordination: Lucile Dupraz
Guest speakers | GastrednerInnen: Mireille Berton, Chris Dercon,
Elie During, Anselm Franke, Dorothea von Hantelmann, Pierre Huyghe,
Jeremy Lecomte, Stéphane Lojkine, Robin Mackay, Celeste Olalquiaga,
Peter Osborne, Filipa Ramos, Juliane Rebentisch, João Ribas,
Ludger Schwarte, Anna-Sophie Springer, Olivier Surel,
Etienne Turpin, Charles Wolfe, Yuk Hui.

theatergardenbestiary.com

1

The perspectival image as planar section of the visual pyramid | Das perspektivische Bild als planares Abbild der Sehpyramide,
in: Brook Taylor, *New Principles of Linear Perspective: Or the Art of Designing on a Plane, the Representations of All Sorts of Objects*, 3rd ed. (London, 1749), p. 80
© Fleuron via Wikimedia Commons

GAM: Together with Tristan Garcia and within the research laboratory "Theater, Garden, Bestiary: A Materialist History of Exhibitions," currently held at the ECAL/University of Art and Design Lausanne you propose to look for a *truly* materialist history of exhibitions, where an epistemology of the exhibition apparatus as a mediating interface of modernity may be produced. What was the trigger to set up this research laboratory?

VN: The first reason to this stems from a quite simple observation, and pertains to the state of hegemony that the exhibition enjoys among the forms of democratic access to art—to such an extent that contemporary art, in its most symptomatic sense, could be reduced to the norms encoded in its privileged mode of presentation, its exhibition—, and to the relative lack of attempts to grasp in complex and dynamic terms the historical stratification of this hegemony. Today the history of exhibitions is clearly having a boom. Many symposia, MA academic courses and journals are dedicated to understanding the practice of exhibition. But they often tend to mobilize its history either as an object of professional hyper-self-reflexivity for curators, or as an institutional narrative based on art-historical markers alone, producing a narration of the history of exhibitions that, more often than not, terminates in exercises of legitimation, leaving its actual hegemony unquestioned. In this framework, the current focalization on the question of the exhibition—its institutions, its architectural spaces, its conceptual and discursive infrastructures—generally ends up providing a perfect platform for contemporary art's "centripetal" obsession with its own identity, or even what we could see as contemporary art's entry into its very own kind of identity politics, which symmetrical correlate may be found in contemporary art's putative "centrifugal" movement towards its many "outsides"—itself too often based on a weak conception of interdisciplinarity.

GAM: Why has the dominant historical approach to contemporary art exhibitions rarely questioned the exhibition as a format or the status of contemporary art as such?

VN: This has a lot to do, I think, with contemporary art's unchecked relation to modernism, and to the abstract logics of modernity at large. It's a long and complex story to which some recent art-philosophical works have been dedicated—a canonical example would be Peter Osborne's[1] work, for instance. But let's just say that the historical category of the "contemporary" increasingly presents itself as a disjunctive—yet apparently ultimately stabilized—unity of different—yet apparently ultimately equal—fragmented present times, which, for most of us, is seen as a rupture

with the abstract temporality of modernity—pictured as linear, unidirectional and authoritative—, while actually the contemporary should be precisely understood as the elaboration of its consequences. As art historian Terry Smith says, the "contemporary" is the advent of the original meaning of "modern", but without its subsequent contract with the future. Modernist teleological scripts haven't simply vanished, they've morphed into different grounds. As such, contemporary art is to some extent blind to the continuity of the historical scripts that continue to be active in its background, that keep on determining our relationship to art practices and to the concept of art itself. They need to be ungrounded. But the way the exhibition is generally mobilized as the forefront of novel experimentations in the arts often becomes an artifact of contemporary art's nominalist, unchecked and unproblematized relation to modernity, which is something we thought ought to be questioned in the framework of an art school, and that's what we tried to do in our research lab by focusing on the exhibition as an object of historical inquiry.

GAM: The "unchecked" relation you identify between modernity and contemporary art in which the exhibition is both an agent and a product is very intriguing. Is the second reason for your materialist approach maybe grounded on exploring this relationship?

VN: Yes, the second reason is directly connected to the first, and pertains to the fact that the exhibition is a very useful and interesting object to understand the historical formation of the "space of art" itself in the conceptual *topos* of modernity: the anthropological, epistemic and political backdrops against which it emerged. In this regard, the core of our inquiry is twofold. First, we want to confront the exhibition genre with its "implicit scripts." These are the positivist and objectivist forms of rationality that historically coded the institutions of exhibition that have emerged throughout scientific modernity (anatomical theaters, natural history collections, zoological gardens …) and that have led up to the consolidation of the museological apparatus and the gallery space, while also considering the modes of relationality, the conditions of mediality, and the semiotic processes these forms of knowledge crystallized. Secondly, we try to reconstruct the ways in which the exhibition of art, throughout modernism and postmodernism, has gradually become a site that has allowed for the space of art to transform its own articulation to these implicit scripts into an object of formal reflection. From this inquiry, our hypothesis is that the exhibition genre consists of a site of *spatialization* of the abstract logics of modernity. A spatialization of its epistemological templates first, by considering

1 See Peter Osborne, *Anywhere or Not at All: Philosophy of Contemporary Art* (London and New York, 2013).

GAM: Gemeinsam mit Tristan Garcia haben Sie sich in dem gegenwärtig an der ECAL, der kantonalen Hochschule für Kunst und Design Lausanne, laufenden Forschungsprojekt „Theater, Garden, Bestiary. A Materialist History of Exhibitions" auf die Suche nach einer *wahrhaft* materialistischen Geschichte der Ausstellung begeben, in deren Rahmen eine Epistemologie des Ausstellungsapparats als vermittelndes Interface der Moderne entstehen könnte. Was gab den Anstoß für die Einrichtung dieses Forschungsprojekts?

VN: Der erste Grund dafür ist schlicht und einfach der zu beobachtende hegemoniale Status, den die Ausstellung unter den demokratischen Kunstzugängen einnimmt – er ist so ausgeprägt, dass sich die zeitgenössische Kunst, in ihrem symptomatischsten Sinn, auf die Normen reduzieren ließe, die dieser privilegierten Präsentationsweise eingeschrieben sind. Dazu kommt der Umstand, dass es relativ wenig Versuche gibt, die historische Schichtung dieser Hegemonie auf komplexe und dynamische Weise zu erfassen. Heute hat Ausstellungsgeschichte zweifellos Konjunktur. Der Praxis des Ausstellens sind unzählige Symposien, MA-Programme und Journale gewidmet. Allerdings mobilisieren sie die Ausstellungsgeschichte meist entweder als Gegenstand einer fachlichen Hyperselbstreflexivität von KuratorInnen oder aber als ein institutionelles Narrativ, das sich ausschließlich auf kunsthistorische Marker stützt, eine Geschichte, die in den allermeisten Fällen auf eine Legitimationsübung hinausläuft und die eigentliche Hegemonie unangetastet lässt. In diesem Rahmen liefert die gegenwärtige Fokussierung auf Ausstellungsfragen – ihre Institutionen, architektonischen Räume, konzeptuellen und diskursiven Infrastrukturen – zumeist eine perfekte Plattform für die „zentripetale" Beschäftigung zeitgenössischer Kunst mit ihrer eigenen Identität, wenn nicht sogar deren Eintritt in eine eigene Form von Identitätspolitik. Als ihr Gegenstück könnte die vermeintlich „zentrifugale" Bewegung der zeitgenössischen Kunst hin zu ihren vielen „Außen" gesehen werden, die ihrerseits allzuhäufig auf einem schwachen Begriff von Interdisziplinarität beruht.

GAM: Warum hat der vorherrschende historische Umgang mit Ausstellungen zeitgenössischer Kunst so selten das Ausstellungsformat oder den Status zeitgenössischer Kunst selbst infrage gestellt?

VN: Das hat, meine ich, viel mit dem ungeprüften Verhältnis der zeitgenössischen Kunst zur Moderne, und zur abstrakten Logik der Moderne im Allgemeinen, zu tun. Es ist eine lange, komplizierte Geschichte, der sich in jüngster Zeit auch einige kunstphilosophische Werke gewidmet haben – ein kanonisches Beispiel wäre etwa das von Peter Osborne.[1] Sagen wir einfach, die historische Kategorie des „Zeitgenössischen" präsentiert sich zunehmend als eine disjunktive – scheinbar aber letztlich stabilisierte – Einheit von unterschiedlichen – scheinbar aber letztlich gleichrangigen – Gegenwartsfragmenten, die die meisten von uns als Bruch mit der als linear, einsinnig und autoritativ dargestellten abstrakten Zeit der Moderne erleben, während das

Zeitgenössische eigentlich als Ausarbeitung ihrer Konsequenzen aufgefasst werden sollte. Der Kunsthistoriker Terry Smith hat das „Zeitgenössische" als Anbrechen des ursprünglichen Sinns von „modern" beschrieben, aber ohne dessen Folgevertrag mit der Zukunft. Die teleologischen Skripte der Moderne sind nicht einfach verschwunden, sie haben sich in verschiedene Hintergründe verwandelt. An sich ist die zeitgenössische Kunst ja zu einem gewissen Grad blind für die historischen Skripte, die in ihrem Hintergrund fortwirken und unser Verhältnis zu künstlerischen Praktiken und zum Begriff der Kunst weiter bestimmen. Sie müssen von ihrem jeweiligen Grund gelöst werden. Aber dadurch, wie die Ausstellung gemeinhin als Vorhut neuer künstlerischer Experimente mobilisiert wird, wird sie oft zu einem Artefakt des nominalistischen, ungeprüften, nicht weiter problematisierten Verhältnisses der zeitgenössischen Kunst zur Moderne, etwas, das unserer Meinung nach im Rahmen einer Kunstakademie hinterfragt werden sollte. Und genau das haben wir in unserem Labor mit der Fokussierung auf die Ausstellung als Gegenstand historischer Forschung versucht.

GAM: Das von Ihnen festgestellte „ungeprüfte" Verhältnis zwischen Moderne und zeitgenössischer Kunst, in der die Ausstellung sowohl Akteur als auch Produkt ist, ist äußerst interessant. Ist die Erforschung dieses Verhältnisses vielleicht der zweite Grund für ihren materialistischen Ansatz?

VN: Ja, der zweite Grund ist direkt mit dem ersten verknüpft und hat mit dem Umstand zu tun, dass die Ausstellung ein Gegenstand ist, an dem sich sehr gut die historische Formation des „Raums der Kunst" im begrifflichen Topos der Moderne erkennen lässt: der anthropologische, erkenntnistheoretische und politische Hintergrund, vor dem er entstand. In diesem Sinn ist unsere Untersuchung von Haus aus zweigeteilt. Einerseits wollen wir das Genre Ausstellung mit seinen „impliziten Skripten" konfrontieren, den positivistischen und objektivistischen Formen von Rationalität, die die in der wissenschaftlichen Moderne entstandenen Ausstellungsinstitutionen (anatomische Theater, naturkundliche Sammlungen, zoologische Gärten …) historisch codiert und zur Konsolidierung des museologischen Apparats und des Ausstellungsraums geführt haben, wobei wir aber auch die Formen von Relationalität, die Bedingungen der Medialität und die semiotischen Prozesse mit einbeziehen, die diese Wissensformen ausgebildet haben. Zweitens versuchen wir zu rekonstruieren, wie die Kunstausstellung im Lauf der Moderne und Postmoderne allmählich zu einem Schauplatz geworden ist, an dem der Raum der Kunst seine eigene Artikulation dieser impliziten Skripte zu einem Gegenstand formaler Reflexion machen

1 Vgl. Osborne, Peter: *Anywhere or Not at All. Philosophy of Contemporary Art*, London/New York 2013.

the museum as the space of registration and administration of the modern cosmography of taxonomy, a space dedicated to the carving of the figure of the humanist subject against the continuum of Nature, a space defined by its specific scenography of the ontological frontiers or "great divides" that modernity imprinted in the world between subjects—or the subjective perception of spectators/eyewitnesses—and objects—the extensive quantity of observed artworks/artifacts. A spatialization of its aesthetic categories also, the exhibition being, from at least Denis Diderot's *Salons*, the central construction site of the aesthetic subject, the space of encounter between the geometrically determined space of representation and the scopic regime inherent of the reception of artworks by the viewer. And finally, a spatialization of the political economy of contemporary exhibition practices, as they seem to be the space of expression of the process of "spatialization of history" described by Fredric Jameson as the main feature of the cultural logic of late capitalism and its post-historical regime.

GAM: In this issue of GAM we approach exhibitions in terms of "exhibiting," as a durational process, which does not depart from a phenomenological experiential subjective approach, but is rather understood as a materialist process through which subjectivity and knowledge are produced. You develop your thesis from the premise that the exhibition is a site of spatialization of the abstract logics of modernity through a materialist reading of this process. However, are you also concerned with the question of how the exhibition becomes a space of subjectivation?

VN: We're interested in describing the historical stratification of these three scales of spatialization. So, when we talk of a "materialist" history, what I have in mind is close to the way Walter Benjamin describes the attitude of the historical materialist investigating the structure of history as a "spectrum analysis." But we could as well talk of our method as a "realist" take on the history of exhibitions. As Tristan Garcia says, realism—in its philosophical sense—is not primarily defined by a content, but rather by an attitude: it is not just a way to recognize reality, but the idea that any object determines its understanding, and not the other way around. We stick to a realistic conception of the anthropological phenomenon of exhibiting artifacts and representations (artworks, images, objects, dead or lively bodies, human or nonhuman animals, etc). We would like to understand historically the logic, the rationality underpinning this phenomenon by which the beholders—their eye, their body, their existence as individuals or as social beings—are always already caught in what they see, and the consequent fabric of subjectivity and objectivity this process entails. So, we don't want to unveil the materiality or the reality of exhibitions as if they were hidden truths beyond or beneath the optical or social illusion of beauty

and knowledge, like a secret tucked away in the dusty corridors of museums or the slick displays of art galleries. There is no secret. Or rather, the open secret of exhibitions is that there is no "given" in the phenomenon of aesthetic consciousness, it is not the result of a sudden recovery of an otherwise inaccessible, ineffable or lost kernel of real. It is the object of a historical construction that, beyond its fascinating specificities, connects the space of art to the broader, generic anthropological matrix of modernity, and it's where we might find, consequently, the possibility of its political potency. That's the reason why we do not proceed by recollecting first subjective conceptions about various exhibitions (in what would be a phenomenological history of art and science exhibitions), but by getting interested in the kind of generic, impersonal subjectivity that is implied by various historical displays and exhibition apparatuses.

GAM: You are critical of the exhibition as a form of art, and when you are articulating your views on the generic dimension of exhibiting, you employ different terminology such as "the exhibition as a genre," "the exhibition genre," and "the genre of exhibition," as a way to maintain a dialectical engagement with the format. Why is it important to make these distinctions?

VN: It is more of a strategic decision. While the interest for the history of exhibitions is becoming a discipline or an aesthetic trope in itself, it is increasingly divided between, on the one hand, art-historical analyses tackling the exhibition as a medium to be deconstructed, and, on the other hand, historicist projects mobilizing it as a reified framework to be staged as such—by reproducing exhibitions excavated from the recent past like facsimiles—or escaped from altogether by negating the exhibition space and moving toward digital platforms or more immediately social spaces. In that context, it seemed important to avoid mobilizing exhibitions as a medium or *form* of art, as is usually the case, but to maintain a dialectical engagement with the exhibition as a *genre*, meaning, as a generic object of modernity. Yet the specific "genus" that is the format of exhibition is not that simple to identify, probably because of the tenuousness and impurity of its ontological ground: decidedly not autonomous, often deemed merely a "frame," neither a stable and collectible object, nor entirely the product of a studio practice, it is always a more or less transparent combination of these elements.

GAM: Why is it important to see the exhibition as a dialectical interplay between form and apparatus?

konnte. Aufgrund dieser Untersuchungen sind wir zur Hypothese gelangt, dass das Genre Ausstellung eine *Verräumlichung* der abstrakten Logik der Moderne darstellt. Erstens eine Verräumlichung seiner epistemologischen Grundmuster, insofern das Museum als Raum der Erfassung und Verwaltung der modernen Kosmografie der Taxonomie gesehen wird, ein Raum, der dem Herausschälen des menschlichen Subjekts aus dem Kontinuum der Natur gewidmet ist und definiert wird durch die besondere Szenografie der ontologischen Grenzen, welche die Moderne der Welt auferlegt hat, der „großen Trennung" zwischen Subjekten – der subjektiven Wahrnehmung des Betrachters/Augenzeugen – und Objekten – der extensiven Menge betrachteter Kunstwerke/Artefakte. Zweitens eine Verräumlichung ihrer ästhetischen Kategorien, insofern die Ausstellung spätestens seit Denis Diderots *Salons* der zentrale Schauplatz für die Herausbildung des ästhetischen Subjekts ist, Begegnungsort zwischen dem geometrisch organisierten Raum der Repräsentation und dem Blickregime, das der Rezeption von Kunstwerken zugrunde liegt. Und nicht zuletzt ist sie auch eine Verräumlichung der politischen Ökonomie zeitgenössischer Ausstellungspraktiken, da es sich dabei um Ausdrucksräume für den Prozess der „Verräumlichung der Geschichte" zu handeln scheint, in der Fredric Jameson das Hauptmerkmal des kulturellen Logik des Spätkapitalismus und seines post-historischen Regimes erblickt hat.

GAM: Es geht uns in dieser Ausgabe von GAM um das „Ausstellen" als durativen Prozess, allerdings nicht unter subjektiven phänomenologisch-erfahrungsmäßigen Gesichtspunkten, sondern verstanden als materielles Geschehen, durch das Subjektivität und Wissen produziert wird. Sie entwickeln Ihre These von der Ausstellung als einer Verräumlichung der abstrakten Logik der Moderne, indem sie dieses Geschehen materialistisch interpretieren. Aber beschäftigen Sie sich auch mit der Frage, wie die Ausstellung zum Raum der Subjektivierung wird?

VN: Wir versuchen, die historische Schichtung der drei genannten Ebenen der Verräumlichung zu beschreiben. Wenn wir also von einer „materialistischen" Geschichte sprechen, so schwebt uns etwas in der Art der „Spektralanalyse" vor, die Walter Benjamin als die Tätigkeit des historischen Materialisten beschrieben hat, der der Struktur der Geschichte nachgeht. Aber man könnte unsere Methode auch als eine „realistische" Herangehensweise an die Ausstellungsgeschichte bezeichnen. Wie Tristan Garcia sagt, ist der Realismus philosophisch gesehen nicht in erster Linie durch einen Inhalt, sondern durch eine Einstellung definiert: Er ist nicht bloß eine Art der Anerkennung von Realität, sondern die Auffassung, dass das Objekt das Verständnis von ihm determiniert und nicht umgekehrt. Insofern halten wir uns an eine realistische Auffassung des anthropologischen Phänomens des Ausstellens von Artefakten und Repräsentationen (Kunstwerken, Bildern, Objekten, toten und lebenden Körpern, menschlichen und nichtmenschlichen Tieren etc.) Wir versuchen historisch zu begreifen, was die Logik, die Ratio hinter diesem Phänomen ist, bei dem die Betrachtenden – ihre Augen, ihre Körper, ihr ganzes Dasein als Individuen und soziale Wesen – immer schon gefangen sind in dem, was sie sehen, und welches Gewebe

an Subjektivität und Objektivität dieser Prozess mit sich bringt. Wir wollen nicht die Materialität oder Realität von Ausstellungen aufdecken, als handelte es sich um versteckte Wahrheiten jenseits oder hinter der optischen und sozialen Illusion von Schönheit und Wissen, ein in den staubigen Korridoren von Museen oder glatten Inszenierungen von Kunstgalerien verborgenes Geheimnis. Es gibt kein Geheimnis. Oder genauer gesagt, es ist das offene Geheimnis von Ausstellungen, dass im ästhetischen Bewusstsein nichts „Gegebenes" existiert, dass es nicht das Resultat der plötzlichen Wiederentdeckung eines sonst unzugänglichen, unbeschreiblichen oder verlorenen realen Kerns, sondern das Objekt einer historischen Konstruktion ist. Das ist es, was den Raum der Kunst jenseits seiner faszinierenden Eigenheiten mit der größeren, generischen anthropologischen Matrix der Moderne verbindet und worin wir darum auch nach der Möglichkeit ihrer politischen Wirkmacht suchen könnten. Deshalb beginnen wir nicht mit einer Sammlung subjektiver Konzeptionen von unterschiedlichen Ausstellungen (einer Art phänomenologischer Geschichte künstlerischer und wissenschaftlicher Ausstellungen), sondern indem wir uns für die gleichsam generische, unpersönliche Subjektivität interessieren, die verschiedenen historischen Ausstellungsapparaten de liegt.

GAM: Sie stehen der Ausstellung als Kunstform kritisch gegenüber, und wenn Sie sich zur generischen Dimension des Ausstellens äußern, bedienen Sie sich anderer Begriffe wie „die Ausstellung als Genre", „das Genre Ausstellung" usw., um die dialektische Auseinandersetzung mit dem Format aufrechtzuerhalten. Warum ist es so wichtig, diese Unterscheidungen zu treffen?

VN: Das hat eher strategische Gründe. Mit der Entwicklung der Ausstellungsgeschichte zu einer eigenständigen Disziplin oder ästhetischen Trope zerfällt diese zunehmend in zwei Teile: einerseits in kunsthistorische Analysen, die die Ausstellung als ein zu dekonstruierendes Medium behandeln, und andererseits in historistische Projekte, die sie als verdinglichten Rahmen ins Spiel bringen, sei es, um ihn als solchen zu inszenieren, etwa durch die faksimileartige Reproduktion von Ausstellungen aus der jüngeren Vergangenheit, oder ihn ganz hinter sich zu lassen, indem man den Ausstellungsraum verwirft und sich digitalen Plattformen oder unmittelbar sozialen Räumen zuwendet. In diesem Kontext schien es uns wichtig, die Ausstellung nicht wie üblich als Medium oder Kunst*form* in Stellung zu bringen, sondern eine dialektische Auseinandersetzung mit ihr als *Genre*, als generisches Objekt der Moderne beizubehalten. Allerdings ist der „Genus" des Ausstellungsformats nicht so einfach zu fassen, vermutlich wegen der Dünnheit und Unreinheit seines ontologischen Grunds: entschieden nichtautonom, oft als bloßer „Rahmen" gesehen, weder stabiles, sammelbares Objekt, noch gänzlich das Produkt einer Atelierpraxis, ist die Ausstellung stets eine mehr oder weniger transparente Mischung dieser Elemente.

GAM: Warum ist es wichtig, die Ausstellung als dialektisches Wechselverhältnis zwischen Form und Apparat zu betrachten?

VN: I'd go so far as to say that the exhibition is actually defined by this "split" identity: it is both a *form* and an *apparatus*. It is quite interesting to detect the ways in which the exhibition became a form in its own right throughout the history of 20th century art. From the introduction by Duchamp of what we could coin as a "curatorial paradigm" (the simultaneous and symmetrical breaking down of the limits of the art object and of those legislating the outermost boundaries of the very concept of art) to the contemporary format of the installation—where the classically modernist delimitation between the space of art and that of non-art is substituted by a delimitation between the private space of the artwork and the public space of the social sphere—, through post-conceptual practices such as institutional critique—foregrounding the exhibition space as the material of the artwork—, the solidarity between the material support of the experience of art (i.e. the gallery space) and the historical transformations in the ontology of the artwork has become a very manifest, palpable reality. But the existence of the exhibition as an apparatus has been an equally important resource of critique in anthropology, sociology, critical studies and art theory. I'm thinking of Carol Duncan, Tony Bennett, Douglas Crimp, or Brian O'Doherty[2] just to name a few well-known authors. In the works tackling the exhibition as an apparatus, Michel Foucault's concept of *dispositif*[3] has become a theoretical model, in that the space of exhibition, from its museological inception, has been connected to a broader network of modern technologies and institutions (natural history, dioramas, panoramas, arcades …) that, together, define modernity as a reformation of vision, just like the institutions described by Foucault have shaped the modern experience of knowledge in general. Historically, the spaces of exhibition have been embedded in a large array of institutions acting as relays of power and knowledge, allowing for the emergence of new disciplines (history, biology, anthropology …) as well as their respective discursive objects (the past, evolution, man …). As such, the institutions of exhibition throughout modernity can be understood as biopolitical spaces where the organization of objects implies an organization of the subjects included in the spectacle of contemplation, where the deracination of exhibited artifacts from their milieus implies the deracination of vision itself and its projection in a fully artifactual space.

The two dimensions of this split identity—form and apparatus—have been caught in a co-productive feedback loop throughout modernism and postmodernism: one is the condition of the power of the other. In that respect, they are, so to speak, the warp and weft of the concept of exhibition we inherited. Hence the necessity to maintain a dialectical engagement with the exhibition neither as a form, nor as an apparatus, but as a generic object of modernity, in order to grasp it in a fully historical way, as an ongoing tactical field for the future of art.

GAM: You argue that the exhibition is increasingly becoming the space of inscription of more or less naïve, or cynical, institutional neo-positivisms. How can neo-positivisms be defined when seen through the lens of the exhibition, and what exactly is your point of critique?

VN: First, I should say that I'm generally a very enthusiastic spectator of contemporary experimentations with the format of exhibition! However, the first teaching offered by a historical inquiry in the apparatuses and forms of exhibition throughout scientific and aesthetic modernity is methodological: it leads to cultivate a certain skepticism in face of the forms of self-congratulatory jubilation underlying the use by art institutions of rubrics such as the decompartmentalization of disciplines, the blurring of boundaries or the overcoming of processes of reification inherent of the very gesture of exhibition. They constitute a good case of representational triumphalism: the positivist addiction of contemporary art institutions to the belief that representing something in the space of art magically implies its full, unaltered translation on the plane of political representation, as if those planes were isotropic. It is precisely because they are not that the exhibition may have a political potency.

We all see press releases calling for the "crosspollination" or the "revitalization" of the symbolic structures of art, and we also see how these same projects keep being deaf to the cultural logic and the political economy of the spaces in which they claim to operate, ending up providing a mere aesthetic translation to the increasing compartmentalization, reproduction and calcification of social relations. In other terms, this type of symbolical pacification, blind to the historical stratification of its objects, tends to organize the continuity of real processes of alienation.

2 See Carol Duncan's *Civilizing Rituals: Inside Public Art Museums* (London and New York, 1995) on the fuction of the art museum as a ritual setting and it's conception as a cultural artifact much more than a neutral shelter for art. See Tony Bennett's "The Exhibitionary Complex," *New Formations* 4 (1988), pp. 73–102, for his introduction of "the exhibitionary complex" as a key term adressing the politics of power inherit in the medium of the exhibition. On the implications of the exhibitionary complex in and on architecture see text of Herscher and Léon in this *GAM* issue, pp. 82–97. See Douglas Crimp's "On the Museum's Ruins," *October* 13 (1980), pp. 41–57, in which he puts forward a Foucauldian critique of the museum as an institution of confinement. In 1976, Brian O'Doherty published "Inside the White Cube The Ideology of the Gallery Space," a series of three articles in *Artforum*, discussing for the first time what the white cube, the highly controlled context of the modernist gallery, does to the art object and the viewing subject. See Brian O'Doherty, *Inside the White Cube: The Ideology of the Gallery Space* (Berkeley, 2000).

3 In the interview published as "The Confession of the Flesh" (1977) Foucault defined "dispositif" (in English also translated as "apparatus") as the system of relations that can be established between elements of society, discourses, laws, architectural forms, scientific statements, philosophical, moral and philanthropic propositions. The interview appeared in *Power/Knowledge: Selected Interviews and Other Writings, 1972–1977* (New York, 1980), pp. 194–228.

VN: Ich würde so weit gehen zu behaupten, dass die Ausstellung eigentlich durch diese „gespaltene" Identität definiert wird: sie ist sowohl *Form* als auch *Apparat*. Es ist überaus interessant zu beobachten, wie die Ausstellung im Lauf der Kunstgeschichte des 20. Jahrhunderts zu einer eigenständigen Form wird. Von Duchamps Einführung dessen, was man als „kuratorisches Paradigma" bezeichnen könnte (dem simultanen, symmetrischen Einreißen der Grenzen des Kunstobjekts und der äußersten Grenzen des Kunstbegriffs selbst), bis zum zeitgenössischen Format der Installation (bei der die klassisch-modernistische Grenze zwischen dem Raum der Kunst und dem Raum der Nichtkunst durch die Grenze zwischen dem privaten Raum des Kunstwerks und dem öffentlichen Raum des Sozialen abgelöst wird) und zu postkonzeptuellen Praktiken wie der Institutionskritik (der Hervorhebung des Ausstellungsraums als Material des Kunstwerks) ist die Solidarität zwischen dem materiellen Träger der Kunsterfahrung (dem Galerieraum) und dem historischen Wandel der Ontologie des Kunstwerks zu einer manifesten, handgreiflichen Realität geworden. Eine gleichermaßen wichtige Quelle der Kritik in Anthropologie, Soziologie, Critical Studies und Kunsttheorie war aber auch die Ausstellung als Apparat. Ich denke hier an AutorInnen wie Carol Duncan, Tony Bennett, Douglas Crimp oder Brian O'Doherty,[2] um nur einige der bekannten zu nennen. In den Arbeiten, die sich mit der Ausstellung als Apparat beschäftigen, ist Michel Foucaults Begriff *Dispositiv*[3] zu einem theoretischen Modell geworden, in dem der Raum der Ausstellung von seinen museologischen Anfängen an in ein größeres Netzwerk moderner Technologien und Institutionen (Naturkunde, Dioramen, Panoramen, Einkaufspassagen …) eingebunden ist, das die Moderne insgesamt zu einer Reformation des Sehens macht, ähnlich wie die von Foucault beschriebenen Institutionen die moderne Erfahrung des Wissens überhaupt geprägt haben. Historisch gesehen sind Ausstellungsräume in ein umfassendes Feld von Institutionen eingebettet, die als Schaltstellen von Wissen und Macht dienen, die Entstehung neuer Disziplinen (Geschichte, Biologie, Anthropologie …) und ihrer jeweiligen diskursiven Objekte (der Vergangenheit, der Evolution, des Menschen …) ermöglichen. Insofern lassen sich die Institutionen der Ausstellung in der gesamten Moderne als biopolitische Räume begreifen, in denen die Organisation der Objekte eine Organisation der Subjekte nach sich zieht, die in das Spektakel der Kontemplation eingebunden sind, wobei die Entwurzelung der aus ihren Milieus herausgerissenen Artefakte mit einer Entwurzelung des Sehens selbst und seiner Projektion in einen vollkommen künstlichen Raum einhergeht.

Die zwei Aspekte dieser gespaltenen Identität – Form und Apparat – waren während der gesamten Moderne und Postmoderne in einer koproduktiven Feedbackschleife gefangen: die eine bedingt die Macht des anderen. In diesem Sinne sind sie gewissermaßen Kett- und Schussfaden des von uns ererbten Ausstellungsbegriffs. Darum die Notwendigkeit, sich mit der Ausstellung dialektisch auseinanderzusetzen, weder als Form noch Apparat, sondern als ein generisches Objekt der Moderne, um sie wahrhaft historisch, als fortbestehendes taktisches Feld für die Zukunft der Kunst erfassen zu können.

GAM: Nach ihrem Befund wird die Ausstellung zunehmend zu einem Ort der Einschreibung mehr oder minder naiver oder zynischer institutioneller Neopositivismen. Wie lassen sich Neopositivismen aus der Sicht der Ausstellung definieren und worin genau besteht Ihre Kritik?

VN: Lassen Sie mich zunächst sagen, dass ich im Allgemeinen ein sehr begeisterter Beobachter zeitgenössischer Experimente mit dem Ausstellungsformat bin! Doch das erste, was uns die historische Untersuchung der Apparate und Formen der Ausstellung in der wissenschaftlichen und künstlerischen Moderne lehrt, ist etwas Methodisches: Sie führt zu einer gewissen Skepsis gegenüber Formen der Selbstgefälligkeit, wie sie aus der Verwendung von Kategorien wie dem Aufbrechen von Disziplinen, dem Verwischen von Grenzen oder der Überwindung der mit der Geste des Ausstellens verbundenen Verdinglichungsprozesse spricht. Sie sind ein gutes Beispiel von *triomphalisme representational*: den positivistischen Hang zeitgenössischer Kunstinstitutionen zu glauben, dass etwas im Kunstraum zu repräsentieren auf magische Weise die volle, unveränderte Übersetzung in die politische Repräsentation miteinbegreift, so als wären die beiden Bereiche isotrop. Wenn die Ausstellung irgendeine politische Wirkmacht besitzt, so genau deshalb, weil sie es nicht sind.

Wir alle kennen die Presseaussendungen, die nach „Fremdbestäubung" oder „Revitalisierung" der symbolischen Strukturen der Kunst rufen, aber wir sehen auch die Blindheit gerade solcher Projekte für die kulturelle Logik und die politische Ökonomie der Räume, in denen sie zu operieren behaupten, so dass sie letztendlich bei einer rein ästhetischen Übersetzung der zunehmenden Aufsplitterung, Reproduktion und Verknöcherung der sozialen Verhältnisse landen. Mit anderen Worten, diese Art symbolischer Befriedung, die blind ist für die historische Schichtung ihrer Objekte, neigt dazu, die Kontinuität der realen Entfremdungsprozesse zu organisieren. In diesem Kontext ist wichtig, auf

2 Vgl. Duncan, Carol: *Civilizing Rituals. Inside Public Art Museums*, London/New York 1995, zur Funktion des Kunstmuseums als rituelles Setting und seine Konzeption als kulturelles Artefakt und nicht als neutraler Kunsthangar. Vgl. Bennett, Tony: „The Exhibitionary Complex", in: *New Formations* 4 (1988), 73–102, insbesondere seine Einführung des „exhibitionary complex" als Schlüsselbegriff für die Auseinandersetzung mit der dem Medium Museum eingeschriebenen Machtpolitik. Zu den Auswirkungen des „exhibitionary complex" in der Architektur und auf die Architektur vgl. den Text von Herscher/Léon in der vorliegenden Ausgabe von *GAM*, auf den Seiten 82–97. Vgl. Crimp, Douglas: „On the Museum's Ruins", in: *October* 13 (1980), 41–57 (deutsch in überarbeiteter Form in Crimps gleichnamiger Essaysammlung *Über die Ruinen des Museums*, Übers. Rolf Braumeis, Dresden/Basel 1996) mit seiner Foucault'schen Kritik des Museums als Verwahranstalt. 1976 veröffentlichte Brian O'Doherty „Inside the White Cube The Ideology of the Gallery Space", eine dreiteilige Artikelserie im *Artforum*, in der erstmals erörtert wurde, was der White Cube, der hochkontrollierte Kontext des modernen Galerie mit dem Kunstobjekt und dem betrachtenden Subjekt anstellt. Vgl. O'Doherty, Brian: *In der weißen Zelle/Inside the White Cube*, Übers. Wolfgang Kemp, Berlin 1996.

3 In dem Gespräch mit Angehörigen der Département de Psychanalyse der Universität Paris VIII in Vincennes definierte Foucault das „Dispositiv" (im Englischen auch als Apparat übersetzt) als das System von Beziehungen, das sich zwischen Elementen der Gesellschaft, „Diskurse[n], Institutionen, architekturale[n] Einrichtungen, Gesetze[n], administrative[n] Maßnahmen, wissenschaftliche[n] Aussagen, philosophische[n], moralische[n] und philanthropische[n] Lehrsätze[n]" herstellen lässt. Das Gespräch erschien unter dem Titel „Ein Spiel um die Psychoanalyse", in: Foucault, Michel: *Dispositive der Macht. Über Sexualität, Wissen und Wahrheit*, Berlin 1978, 118–175, hier 119f.

Yet, in this context it's important to insist on the most basic operation of any exhibition. Historically, the exhibition has been entirely determined by, on the one hand, negative processes of reification and, on the other hand, their materialist critique within the forms of art. As curator Anselm Franke wrote in the catalogue of the exhibition *Animism*, the exhibition is, in its most generic sense, defined by the dialectical inversion it inscribes in the "life" of objects: it "de-animates" previously "animated" entities by uprooting them from their milieus, and it "re-animates" "dead" objects by projecting them in a highly-scripted field of attention. This is probably the source of the spell the exhibition has had on the modern psyche. The history of this dialectical reversal has been an important resource of critique for art theory, and its economy has been through many transformations. But the negativity inherent of the gesture of exhibition remains, I think, a major theoretical, aesthetic and political issue that a real project of transgression and emancipation cannot only evacuate in naïve border-breaking scenarios: it is a historical battlefield which, contrary to the way in which the cultural logic of late capitalism increasingly naturalizes the contemporary as the terminus of history, is still entirely open, dynamic, unequal, discontinuous, and prone to all types of capture and production of symbolic and social capital.

> **GAM**: In addition to approaching the exhibition as a generic genre you also conceive of the exhibition as an optic device. Why is it important to reclaim this knowledge of history of exhibition through the scopic regimes it once established?

VN: Our aim is to build an epistemology of the exhibition as a mediating interface of modernity, in order to read art in its dynamic and continuous tension with an enlarged epistemological and political horizon, in which images, figures, and formal expressions can be considered in light of their historical continuity and complex articulation with the normative and systemic conditions of modernity. But since the exhibition is neither entirely a medium (the business of art history), nor entirely a media (which could be read through the lens of media archaeology alone), nor entirely an apparatus—which could be described by critical studies, anthropology or sociology—, this leads us to navigate the disciplinary "fault line" articulating these fields, in which the history of optical devices and technologies of the gaze that emerged throughout scientific modernity has indeed an important role.

The modern institutions of exhibition of nature, specifically in the context of the advent of natural sciences in the 17th century, have been important sites of invention of hermeneutic conditions allowing for the production of scientific facts. The example of the dissections enacted in early anatomical theatres, and their expansion as a model reproduced by other natural sciences in the 17th and 18th centuries, in quite telling. We can see the anatomical theatre as a spatial experiment in which the performativity of the human actors is folded into the theatrical machinery, where the theatricality of observation performs a rational universe in which certain perceptual contingencies are transferred onto the object, here, the dissected body. This economy of observation requires perception to be "purified" so that the perceived can be disputed: the visual economy of the anatomical theatre is the product of an architectonic operation whereby the situatedness of the gaze of the witnesses, the perspective through which they observe, is transposed to the object as a mode of presentation. This hermeneutic dimension, dramatized by the scopic regime of the anatomical theatre, is chiefly rooted in Cartesian perspectivalism, the canonically modern, geometrically isotropic, rectilinear, abstract and uniform concept of space originated by the invention of perspective, that forms so to speak the spatial backdrop of the modern psyche. The fundamental feature of this double process of mathematization of space and rationalization of vision is the notion of virtual pyramids anchoring the viewer as a fictional apex of the visible.

As Martin Jay has shown, this scopic regime is typical of the modern dualism of subject and object, visually founded in the placement of a detached observer, a subject, at the apex of a perspectival cone whose sides lead to an infinity of objects against which the subject measures itself. In ordering visual space according to an abstract uniform system of linear coordinates, the scopic regime inherent of the modern institutions of scientific exhibition such as the anatomical theatre binds subjective perception and objective spatial extension through mathematical convertibility. And the importance of this optical consistency has been paramount for the development of modern scientific culture: common to linear perspective, scientific mapping, and technical drawings, it permitted the description of physical spaces and objects in a systematic geometric fashion that facilitated the circulation of these representations and allowed for the possibility of going from one type of visual trace to another.

> **GAM**: You propose that this scopic regime also defines the relationship and the space between the "macro" scale of the ontological designation, legislating the outermost limits of the space of art (and its institutional complex: the museum, the gallery), and the "micro" scale of the ontology of the individual artwork (and the aesthetic consciousness it produces when exhibited). Could you elaborate on this relation?

der grundlegendsten Operation jeder Ausstellung zu beharren. Historisch gesehen, ist die Ausstellung total determiniert durch negative Prozesse der Vergegenständlichung auf der einen Seite und ihre materialistische Kritik innerhalb der Formen der Kunst auf der anderen. Die Ausstellung im allgemeinsten Sinn ist – wie der Kurator Anselm Franke im Katalog zur Ausstellung *Animismus* feststellt – durch die dialektische Inversion bestimmt, die sie dem „Leben" der Objekte einschreibt: sie „de-animiert" vormals „belebte" Gegenstände, indem sie sie aus ihren Milieus herausreißt, und sie „re-animiert" vormals „tote" Objekte, indem sie sie in ein hochgradig geskriptetes Aufmerksamkeitsfeld einfügt. Das ist wahrscheinlich der Grund für den Bann, in den die Ausstellung die moderne Seele geschlagen hat. Die Geschichte dieser dialektischen Umkehrung war eine wichtige Quelle der Kritik in der Kunsttheorie, und ihre Ökonomie hat viele Transformationen durchlaufen. Gleichwohl bleibt die der Geste des Ausstellens innewohnende Negativität ein vorrangiges theoretisches, ästhetisches und politisches Problem, das ein wirkliches Projekt der Transgression und Emanzipation nicht einfach in naive Grenzüberschreitungsszenarien auslagern kann: es ist ein historisches Schlachtfeld, das – im Gegensatz zur von der Logik des Spätkapitalismus betriebenen Naturalisierung des Zeitgenössischen zu einem Endpunkt der Geschichte – immer noch völlig offen, dynamisch, ungleich, diskontinuierlich und anfällig für alle Formen der Aneignung und Produktion symbolischen und sozialen Kapitals ist.

GAM: Neben Ihrer Untersuchung der Ausstellung als generischem Genre betrachten Sie sie auch als Sehapparat. Warum ist es wichtig, dieses Wissen von der Ausstellungsgeschichte durch die einst von ihr etablierten Blickregimes zurückzugewinnen?

VN: Unser Ziel ist die Schaffung einer Epistemologie der Ausstellung als vermittelndes Interface der Moderne, die es uns erlaubt, Kunst in ihrem ständigen und dynamischen Spannungsverhältnis zum umfassenderen epistemologischen und politischen Horizont zu erfassen, in dem sich Bilder, Figuren und formale Ausdrucksformen im Licht ihrer historischen Kontinuität und komplexen Verschränkung mit den normativen und systemischen Bedingungen der Moderne betrachten lassen. Da aber die Ausstellung weder ausschließlich Medium (Angelegenheit der Kunstgeschichte) noch ausschließlich medial (allein aus der Perspektive der Medienarchäologie lesbar) noch ausschließlich Apparat ist (der von Critical Studies, Anthropologie oder Soziologie beschrieben werden könnte), müssen wir uns an die disziplinäre Verwerfungslinie halten, die diese Felder zusammenhält, wobei die Geschichte der im Lauf der wissenschaftlichen Moderne entstandenen optischen Geräte und Techniken des Sehens eine wichtige Rolle spielt.

Die modernen Institutionen der Naturausstellung waren – vor allem im Zusammenhang mit dem Aufstieg der Naturwissenschaften im 17. Jahrhundert – bedeutende Stätten für die Erfindung der hermeneutischen Bedingungen, die die Schaffung wissenschaftlicher Tatsachen gestatteten. Sehr bezeichnend ist das

Beispiel der in den frühen anatomischen Theatern durchgeführten Sektionen und deren Erweiterung zu einem im 17. und 18. Jahrhundert von anderen Naturwissenschaften reproduzierten Modell. Das anatomische Theater lässt sich als ein Raumexperiment sehen, bei dem die Performativität der menschlichen Akteure in eine Theatermaschinerie eingebunden ist und der theatrale Akt des Beobachtens ein rationales Universum darstellt, in dem bestimmte perzeptive Kontingenzen auf ein Objekt, in diesem Fall den sezierten Körper, übertragen werden. Diese Ökonomie der Beobachtung erfordert eine „Läuterung" der Wahrnehmung, damit über das Wahrgenommene gestritten werden kann: Die visuelle Ökonomie des anatomischen Theaters ist das Ergebnis einer architektonischen Maßnahme, durch die die Situiertheit des Blicks der Zeugen, die Perspektive, aus der sie beobachten, als Präsentationsmodus auf das Objekt übertragen wird. Diese im Blickregime des anatomischen Theaters dramatisierte hermeneutische Dimension hat ihre Wurzeln vor allem im cartesianischen Perspektivismus, der kanonisch-modernen, geometrisch isotropen, geradlinigen, abstrakten und einheitlichen Auffassung des Raums, der mit der Erfindung der Perspektive entstand und gewissermaßen die räumliche Kulisse der moderne Seele bildet. Grundmerkmal dieses Doppelprozesses der Mathematisierung des Raums und der Rationalisierung des Sehens ist die Vorstellung von einer virtuellen Pyramide, die den Betrachtenden an die fiktive Spitze des Sichtbaren setzt.

Wie Martin Jay gezeigt hat, ist dieses Blickregime typisch für den modernen Subjekt-Objekt-Dualismus, der visuell auf der Platzierung eines distanzierten Beobachters, eines Subjekts an der Spitze einer Sehpyramide fußt, deren Grundlinien eine unendliche Menge an Objekten einschließen, an denen das Subjekt sich misst. Indem es den sichtbaren Raum in ein abstraktes einförmiges System linearer Koordinaten ordnet, verbindet das Blickregime, das modernen wissenschaftlichen Ausstellungsinstitutionen wie dem anatomischen Theater eingeschrieben ist, subjektive Wahrnehmung und objektive Raumausdehnung durch mathematische Konvertibiltität. Und diese optische Konsistenz war von überragender Bedeutung für die Entwicklung der modernen wissenschaftlichen Kultur: Als Grundlage der Linearperspektive, der wissenschaftlichen Kartografie und des technischen Zeichnens gestattete sie die Beschreibung physischer Räume und Objekte in einer systematischen geometrischen Form, die die Verbreitung und Weitergabe dieser Repräsentationen erleichterte und die Möglichkeit schuf, von einer visuellen Spur zur anderen zu wechseln.

GAM: Sie vertreten die These, dieses Blickregime definiere auch das Verhältnis und den Raum zwischen der „Makro"-Ebene der ontologischen Bestimmung, die die äußersten Grenzen des Raums der Kunst (mitsamt ihres institutionellen Komplexes, Museum und Galerie) regeln, und der „Mikro"-Ebene der Ontologie des einzelnen Kunstwerks (und des durch sein Ausstellen erzeugten ästhetischen Bewusstseins). Könnten Sie dieses Verhältnis näher beschreiben?

VN: Sehr schematisch ausgedrückt besagt unsere Hypothese, dass dieses Blickregime, insofern es die moderne Wissenserfahrung insgesamt determiniert, im Museum seinen endgültigen

VN: To put it in extremely schematic terms, our hypothesis is that if this scopic regime determined the modern experience of knowledge at large, it also found its terminal, institutional form in the museum, hence constituting the foundation for the role the art exhibition played in the fabric of the aesthetic subject. The history of modern forms of art can be seen as a constant revaluation of the conditions of phenomenological transactions between viewer and artwork, a ceaseless experiment on the way the artwork can destabilize in interesting ways the hermeneutic access of the subject to the object. Modern aesthetic experiences can be described as the measurement and the internalisation by the aesthetic subject of the space of its separation from the object, on the stage provided by the secular ritual of exhibitions. As such, the history of modern art can be described as the history of the gradual advent of a contract binding the "micro" scale of the artwork and the "macro" scale of the site acting as the material surrogate for the very concept of art: the exhibition space. In a way we could say that, even if unknowingly, the history of modern art has always been the history of its exhibition.

> **GAM:** At the end of your text "The Eclipse of the Witness"[4] you propose using Bertolt Brecht's approach on the political dimension of theatre and the sustained consciousness of its separation from society to highlight and claim the political potentiality of the exhibition genre. Being aware of this continuous and unavoidable separation, and deliberately making this split explicit with all its consequences, how can we conceptualize exhibiting?

VN: It's a complex question that points to something that is still very much in construction in my research. If we agree on the fact that historically, the exhibition has allowed the modern subject to internalise and formally reflect on the rationalization of experience inherent of capitalist modernity, we should be able to operate a distinction between its emancipatory promises, i.e. the possibility for the modern individual to picture itself as a historical subject, and the ways in which this project has been more or less faithfully achieved in practice. Brecht's conception of the relationship between the arts and revolution intervened in the context of the long-standing tension between the artwork and the commodity form, which today has receded in the background. The kind of separation Brecht—and the historical avant-garde in general—was interested in had to do with the broader intervention of art forms in the capitalist economy of production of objects. In classical Marxian terms, commodity fetishism is the object of a mystification: capitalism organizes a process of ascension of labor into capital—or the transformation of use value into exchange value—, a process that it also constantly pushes into a zone of forgetting, a blind spot that in turn becomes the central

source of commodity fetishism. The intervention of the avant-garde can be seen as a critical modelization at the scale of the inner structure of the artwork of the terms of commodity fetishism: it decomposed and recomposed it by replacing its structural terms ("labor" and "capital") by semiotic and formal ones (like "content" and "form", the central axes of the modernist reflection on the ontology of the artwork), critically performing commodity fetishism in the production of what might be called an "exhibition value." In that context, the beauty and political relevance of Brecht's gesture consisted in intensifying the autonomy of the theatrical form for instance—by transforming its separation from society into a formal resource—which precisely allowed for the comprehension of this separation as a *social fact*, i.e. as a divide not only running between spectators and stage, but within society, like a "fourth wall" diffracted in the social sphere.

> **GAM:** Yet, merely repeating Brecht's gesture is not possible, as the current capitalist condition has much more developed the capacity to subsume such gestures than in Brecht's time.

VN: Of course, our contemporary conditions are very different, and reclaiming today this kind of modernist gesture as a static frame to be copied on the present would be politically inconsistent. The political economy of the contemporary space of art seems to be still very much coded by the "expanded field" of postmodern art. Following the modernist project of critical reduction of the specificity of the mediums of art, the expanded field has radically changed the terms of the potential critique art can address to the social sphere. Crucially, I think it transformed the structure of historical time against which modernism conceived its critique, by turning it into an underdetermined, apparently boundless conception of space. It is a complex historical process in which the advent of the exhibition as a form in its own right has been a crucial vector, and that I can't entirely unfold here, but let's just say that by replacing the conception of modernist historical temporality—as a project gradually *purified* by artworks—by a conception of postmodern space as a generic instance—constantly *reformulated* by artworks—, the expanded field has introduced art to an ever-reformable space that, consequently, knows of no "outside." Whatever fringe or frontier an artwork formalizes in the expanded field, it immediately counts as a new region of positive space for the expansion of the concept of art. The paradox of the contemporary space of art is thus

4 Vincent Normand, "The Eclipse of the Witness: Natural Anatomy and the Scopic Regime of Modern Exhibition-Machines," in *L'Internationale* (2016), http://www.internationaleonline.org/research/politics_of_life_and_death/ 77_the_eclipse_of_the_witness_natural_anatomy_and_the_scopic_ regime_of_modern_exhibition_machines (accessed November 8, 2017).

institutionellen Ausdruck fand und damit die Grundlage für die Rolle bildet, die die Kunstausstellung im Gefüge des ästhetischen Subjekts einnimmt. Die Geschichte der Formen moderner Kunst kann als eine ständige Neubewertung der Bedingungen der phänomenologischen Transaktionen zwischen BetrachterIn und Kunstwerk gesehen werden, ein endloses Experiment über die Möglichkeiten des Kunstwerks, den hermeneutischen Zugang des Subjekts zum Objekt auf interessante Weise zu destabilisieren. Moderne Formen ästhetischer Erfahrung könnten als Vermessung und Internalisierung der Trennung des ästhetischen Subjekts von seinem Gegenstand beschrieben werden, vollzogen auf der Bühne, die ihm das säkulare Ritual der Ausstellung bietet. So gesehen könnte man die Geschichte der modernen Kunst als das allmähliche Entstehen eines Vertrags auffassen, der die „Mikro"-Ebene des Kunstwerks mit der „Makro"-Ebene des Schauplatzes verbindet, der als materielles Surrogat für den Kunstbegriff selbst dient: den Ausstellungsraum. In gewisser Weise könnte man sagen, dass die Geschichte der modernen Kunst immer schon die Geschichte ihrer Ausstellung war, auch wenn sie es nicht wusste.

GAM: Am Ende Ihres Textes „The Eclipse of the Witness"[4] schlagen Sie Bertolt Brechts Auffassung von der politischen Dimension des Theaters und des anhaltenden Bewusstseins seiner Trennung von der Gesellschaft als eine Möglichkeit vor, das politische Potenzial des Genres Ausstellung aufzuzeigen und zu behaupten. Wie können wir uns angesichts dieser ständigen, unvermeidlichen Trennung und mit der bewussten Sichtbarmachung dieser Spaltung in all ihrer Konsequenz den Akt des Ausstellens vorstellen?

VN: Das ist eine sehr komplexe Frage, die auf etwas verweist, das in meiner Forschung erst noch im Entstehen ist. Wenn es stimmt, dass die Ausstellung historisch gesehen dem modernen Subjekt ermöglicht hat, die Rationalisierung der Erfahrung, die mit der kapitalistischen Moderne einhergeht, zu internalisieren und formal zu reflektieren, sollten wir in der Lage sein, eine Unterscheidung zu treffen zwischen ihren emanzipatorischen Verheißungen, d.h. der Möglichkeit des modernen Individuums, sich als historisches Subjekt zu entwerfen, und der Art und Weise, wie dieses Projekt mehr oder weniger getreu in der Praxis umgesetzt wurde. Brechts Vorstellung von der Beziehung von Kunst und Revolution griff in das althergebrachte Spannungsverhältnis zwischen Kunstwerk und Warenform ein, das heute in den Hintergrund getreten ist. Die Art der Trennung, für die sich Brecht und die historische Avantgarde im Allgemeinen interessierte, hatte mit der umfassenderen Intervention von Kunstformen in die kapitalistische Ökonomie der Objektproduktion zu tun. Im klassisch-marxistischen Sinn ist der Warenfetischismus das Resultat einer Mystifikation: Der Kapitalismus organisiert den Prozess der Verwandlung von Arbeit in Kapital – oder von Gebrauchs- in Tauschwert –, und relegiert diesen Prozess zugleich dauernd in eine Zone des Vergessens, die dann zur entscheidenden Quelle des Warenfetischismus wird. Die Intervention der Avantgarde lässt sich als eine kritische Modellierung der Bedingungen des Warenfetischismus in der inneren Struktur des Kunstwerks sehen: sie

zerlegt ihn und setzt ihn neu zusammen, indem sie seine strukturellen Komponenten („Arbeit" und „Kapital") durch semiotische und formale (wie „Inhalt" und „Form", die zentralen Koordinaten der modernen Reflexion über die Ontologie des Kunstwerks) ersetzt und den Warenfetischismus kritisch in der Produktion dessen nachvollzog, was man als „Ausstellungswert" bezeichnen könnte. Die Schönheit und politische Relevanz von Brechts Geste bestand in diesem Zusammenhang darin, dass er die Autonomie der theatralischen Form verstärkte, deren Trennung von der Gesellschaft in eine formale Ressource verwandelte. Das ermöglichte es, diese Trennung als gesellschaftliche Tatsache zu sehen, eine Kluft, die nicht nur zwischen Publikum und Bühne verläuft, sondern die gesamte Gesellschaft durchzieht, wie eine in den sozialen Raum umgelenkte „vierte Wand".

GAM: Aber eine bloße Wiederholung von Brechts Geste ist nicht möglich, da der Kapitalismus in seiner gegenwärtigen Form die Fähigkeit zur Vereinnahmung solcher Gesten wesentlich weiterentwickelt hat.

VN: Natürlich sind unsere gegenwärtigen Bedingungen ganz andere, und diese Geste der Moderne als eine Art starren Rahmen auf die Gegenwart zu übertragen, wäre politisch nicht ganz stimmig. Die politische Ökonomie des zeitgenössischen Kunstraums scheint mir immer noch sehr durch das „erweiterte Feld" der postmodernen Kunst codiert zu sein. Nach dem Projekt der Moderne, dem es um die kritische Reduktion auf die Besonderheit des jeweiligen künstlerischen Mediums ging, hat das erweiterte Feld die Bedingungen der möglichen Kritik der Kunst an der Gesellschaft grundlegend verändert. Insbesondere hat es, glaube ich, die Struktur der historischen Zeit verändert, gegen die die Moderne ihre Kritik entwickelte, indem es diese historische Zeit in einen unterdeterminierten, scheinbar grenzenlosen Raum verwandelte. Es handelt sich um einen komplexen historischen Prozess, bei dem die Entstehung der Ausstellung als eigenständige Form ein entscheidender Vektor war, und den ich hier nicht zur Gänze darlegen kann. Aber sagen wir einfach, das erweiterte Feld hat die Kunst mit der Ersetzung der historischen Zeitvorstellung der Moderne – als ein Projekt, das von Kunstwerken mehr und mehr *geläutert* wird – durch die Vorstellung eines postmodernen Raums – als generischer Fall, der von Kunstwerken ständig *reformuliert* wird – in einen immer weiter reformierbaren Raum überführt, der kein „Außen" kennt. Jeder Rand und jede Grenze, die ein Kunstwerk im erweiterten Feld formalisiert, gilt sofort als ein neues Stück positiven Raums für die Erweiterung des Kunstbegriffs. Das ist das Paradoxon des Raums der zeitgenössischen Kunst: Die Überschreitung seiner Grenzen führt zur Erweiterung des durch sie begrenzten Gebiets.

4 Normand, Vincent: „The Eclipse of the Witness. Natural Anatomy and the Scopic Regime of Modern Exhibition-Machines," in: *L'Internationale* (2016), online unter: http://www.internationaleonline.org/research/politics_of_life_and_death/77_the_eclipse_of_the_witness_natural_anatomy_and_the_scopic_regime_of_modern_exhibition_machines (Stand: 8. November 2017).

the following: the transgression of its limits terminates in the expansion of the domain they demarcate.

GAM: You propose that those who engage in exhibition-making, curators and (materialist) historians alike, should reconceive their position towards a "boundary making practice," thus starting to resist the tendency of continuously expanding borders which make an "outside" disappear.

VN: I'd rather call this outside a "negativity." Negativity (i.e. that which is not, or not *yet*) is not located "outside" one's though experiments and political actions, it is their very engine (or at least it should be). And this is specifically what the contemporary artworld desperately lacks, exactly because it mistakes the labor of negation with the panic-struck appropriation of whatever "outside" lays within range. The situation of ever-expansion of the space of art, deprived of a negative from which it could perceive its historical depth, needs to be put in dialogue with the way Mark Fisher defined contemporary capitalism as a fundamentally "spatial" phenomenon. What Fisher calls "capitalist realism"[5] is capitalism's principle of tautological identity, its transparent occupation of the horizons of the thinkable, in ways that cause historical time to shrink to the status of mere pre-history of the capitalist present. Both achieving and flattening all the previous states of history, the planetary history of capitalist realism reveals itself as a dehistoricised commodified world, as if it had reached a point of post-historical equilibrium. As Sami Khatib recently pointed out in *Former West*,[6] capitalist realism is a mode of spatialized teleology in which the very concept of history becomes ahistorical: it turns into a historicist category, a quantity always available but disconnected from the present. Here, we can start perceiving that planetary capitalism in its post-historical age hasn't abolished the idea of teleological progress, it has simply shifted in terrain of operation: progress is not projected onto historical time but is mapped onto space. So, if I were to give a critical concept of the expanded field of art, I would tend to define it as the aesthetic counterpart of the spatialized teleology inherent of the post-historical stasis of planetary capitalism. It is the aesthetic image of the process of spatialization of historical time inherent of the cultural logic of contemporary capitalism. It is very interesting to act like a speculative detective and look for the ways in which this is expressed in art: from what Jeff Wall called the "second appearance" of the historically determined modern forms of art (dance, theatre, cinema) in the generic space of the white cube to the phenomenon of re-exhibitions that I mentioned earlier, contemporary art seems to be animated by the desire to put its own history at the service of the expansion of its space. Of course, contemporary art largely pictures itself as a mode of resistance to the dynamics of planetary capitalism, and a successful contemporary artwork often is! But, in its most symptomatic state as a "global signifier," contemporary art does so by picturing itself as a bastion of immediacy, a space of production of affects intractable to rational thought, to the extent that it tends to recede into the ineffable, blind and deaf to the ways in which this immediacy, as well as the spontaneity of experience it claims to produce, are coded by the modern regimes of production of truth and value, and as such entirely mediated by capital. Far from having fully acknowledged the bankruptcy of the conceptual framework of modernism, contemporary art merely spatializes it, by projecting it into a transnational utopia of free market fluidity. As such, the contemporary expanded field of art often merely performs, semantically and materially, the neoliberal crisis: it is obsessed with escape, but knows of no outside; it insists on its agency in the world, but disavows any direct causal, logic, or pragmatic impact on it.

GAM: You insist that the expanded field of art often performs the neoliberal crisis, and that the exhibition is the main site of this performance. Yet you see a capacity in the genre to reclaim its critical edge and propose new approaches for achieving emancipatory ends of the exhibition.

VN: Of course, this is what the exhibition is too often reduced to. But it's not necessarily what it ought to be. In place of this immediacy, a critical discourse embracing the states of mediality afforded by the exhibition genre can be initiated by maintaining a realism of relations in place of the eclipse of mediations that codes the implicit, neo-positivist representational triumphalism of contemporary art. Hence, the great attention a materialist history of exhibitions (one aiming at contrasting the spaces of art exhibition with the regime of rationality in which they emerged, one aiming at reclaiming history as a medium of emancipation) should pay to the ontological, epistemic, semiotic, hermeneutic and aesthetic dimensions of the exhibition as the theatre of production of our sociability. So, to get back your question about Brecht, this doesn't mean we should simply reproduce like a facsimile a Brechtian gesture today—this is precisely the business of the most symptomatic forms of contemporary art—, but rather take stock of its negativity in order to mobilize it as a dynamic vector of historical description.

GAM: Thank you for the interview.

VN: You are more than welcome. ∎

5 For more on the concept of "capitalist realism" see Mark Fisher, *Capitalist Realism: Is There No Alternative?* (Winchester, 2009).

6 See Khatib, Sami: "No Future: The Space of Capital and the Time of Dying," in *Former West: Art and the Contemporary after 1989*, ed. Maria Hlavajova and Simon Sheikh (Cambridge, 2017), pp. 639–652.

GAM: Sie sind der Meinung, dass jene, die sich mit dem Machen von Ausstellungen beschäftigen, KuratorInnen wie (materialistische) HistorikerInnen, ihre Haltung zur „Praxis der Grenzziehung" überdenken sollten, anfangen sollten, sich der Tendenz zur ständigen Ausweitung von Grenzen zu widersetzen, die das „Außen" zum Verschwinden bringt.

VN: Ich würde dieses Außen lieber als „Negativität" bezeichnen. Negativität (d.h. das, was nicht – oder *noch* nicht – ist) liegt nicht „außerhalb" der eigenen Gedankenexperimente und politischen Handlungen, sie ist ihr Motor (oder sollte es zumindest sein). Und das ist genau das, was der zeitgenössischen Kunstwelt so sehr fehlt. Und zwar genau deshalb, weil sie die Arbeit der Negation mit der panischen Aneignung eines jeden in Reichweite liegenden „Außen" verwechselt. Die Situation der ständigen Expansion des Raums der Kunst, ohne ein Negativ, von dem aus dieser seine historische Tiefendimension erkennen könnte, muss mit dem fundamental „räumlichen" Phänomen in Verbindung gebracht werden, als das Mark Fischer den zeitgenössischen Kapitalismus definiert hat. Was Fisher als „kapitalistischen Realismus"[5] bezeichnet, ist nichts anderes als das tautologische Identitätsprinzip des Kapitalismus, seine transparente Besetzung der Horizonte des Denkbaren in einer Weise, die die historische Zeit auf den Rang einer bloßen Vorgeschichte der kapitalistischen Gegenwart schrumpfen lässt. Mit ihrer gleichzeitigen Einholung und Verflachung aller früheren Stadien der Geschichte erweist sich die planetare Geschichte des kapitalistischen Realismus als eine enthistorisierte warenförmige Welt, die einen posthistorischen Gleichgewichtszustand erreicht zu haben scheint. Der kapitalistische Realismus ist – wie Sami Khatib in seinem Beitrag zu *Former West*[6] festgestellt hat – eine Form verräumlichter Teleologie, in der der Geschichtsbegriff selbst ahistorisch wird: Er wird zu etwas Historistischem, einer ständig verfügbaren, aber von der Gegenwart getrennten Menge. Damit wird auch erkennbar, dass der planetare Kapitalismus im posthistorischen Zeitalter die Idee des teleologischen Fortschritts nicht abgeschafft, sondern lediglich das Operationsgebiet verändert hat: Fortschritt wird nicht mehr auf die historische Zeit, sondern auf den Raum projiziert. Müsste ich also eine kritische Bewertung des erweiterten Kunstfelds abgeben, würde ich es als ästhetisches Pendant zur verräumlichten Teleologie beschreiben, die dem posthistorischen Stillstand des planetaren Kapitalismus zugrunde liegt. Es ist das ästhetische Abbild der Verräumlichung der historischen Zeit, die die kulturelle Logik des zeitgenössischen Kapitalismus mit sich bringt. Interessant ist, sich als spekulativer Detektiv zu betätigen und Anhaltspunkte dafür in der Kunst zu suchen: Von dem, was Jeff Wall als das „zweite Erscheinen" historisch determinierter moderner Kunstformen (Tanz, Theater, Kino) im generischen Raum des White Cube bezeichnete, bis hin zum früher erwähnten Phänomen der Reinszenierung von Ausstellungen scheint die zeitgenössische Kunst von dem Wunsch beseelt zu sein, die eigene Geschichte in den Dienst der Erweiterung ihres Raums zu stellen. Natürlich stellt sich die zeitgenössische Kunst dabei hauptsächlich als eine Form des Widerstands gegen die Dynamik des planetaren Kapitalismus dar, und auf ein gelungenes Werk zeitgenössischer Kunst trifft das meist auch zu! Nur tut sie das – in ihrer symptomatischsten Form als „globaler Signifikant" –, indem sie sich als Bastion der Unmittelbarkeit ausgibt, als einen Raum der Gefühlsproduktion, der dem rationalen Denken unzugänglich ist, und zwar so sehr, dass er zum Rückzug ins Unsagbare neigt, blind und taub gegenüber der Umstand, dass die Unmittelbarkeit und die Spontaneität des Erlebens, das sie verspricht, durch die modernen Regimes der Wahrheits- und Wertproduktion codiert und also vollständig durch das Kapital vermittelt ist. Weit davon entfernt, den Bankrott des begrifflichen Rahmens der Moderne ganz erkannt zu haben, verräumlicht die zeitgenössische Kunst diesen bloß, indem sie ihn auf die transnationale Utopie eines fluiden freien Marktes projiziert. Insofern vollzieht das zeitgenössische erweiterte Feld häufig nur semantisch und materiell die neoliberale Krise nach: es ist besessen von Flucht, kennt aber kein Außen; es besteht auf seiner Handlungsmacht in der Welt, leugnet aber jede direkte kausale, logische oder pragmatische Auswirkung auf sie.

GAM: Sie behaupten, das erweiterte Feld der Kunst sei häufig nur Nachvollzug der neoliberalen Krise und die Ausstellung der Hauptschauplatz dafür. Aber Sie sehen auch ein gewisses Potenzial des Genres, sein kritisches Vermögen wiederzuerlangen, und schlagen neue Wege zur Erreichung seiner emanzipatorischen Ziele vor.

VN: Natürlich wird die Ausstellung allzuoft darauf reduziert. Aber das muss nicht so sein. Statt dieser Unmittelbarkeit kann ein kritischer Diskurs in Gang gesetzt werden, der sich die vom Genre Ausstellung gebotenen Medialitätszustände zu eigen macht und einen Realismus der Relationen beibehält, statt die Vermittlungen auszublenden – wie es der impliziten neopositivistischen Repräsentationstriumphalismus der zeitgenössischen Kunst tut. Deshalb sollte eine materialistische Ausstellungsgeschichte (eine, die die Räume der Kunstausstellung dem Rationalitätsregime gegenüberstellen möchte, in dem sie entstand, und die Geschichte als Medium der Emanzipation zurückzugewinnen versucht) auch starken Fokus auf die ontologischen, epistemischen, semiotischen, hermeneutischen und ästhetischen Dimensionen der Ausstellung legen – als Theater für die Produktion unseres Zusammenlebens. Das heißt nicht – und damit komme ich auf Ihre Brecht-Frage zurück –, dass wir die Brecht'sche Geste heute einfach als Faksimile reproduzieren sollten – das ist genau das Geschäft, das die zeitgenössische Kunst in ihrer symptomatischsten Form betreibt. Stattdessen sollten wir uns ihrer Negativität besinnen und sie als dynamischen Vektor historischer Beschreibung einsetzen.

GAM: Danke für das Gespräch.

VN: Gern geschehen. ∎

Übersetzung: Wilfried Prantner

5 Zum Begriff des „kapitalistischen Realismus" vgl. ausführlicher Fisher, Mark: *Capitalist Realism. Is There No Alternative?*, Winchester 2009.

6 Vgl. Khatib, Sami: „No Future: The Space of Capital and the Time of Dying", in: Hlavajova, Maria/Sheikh, Simon (Hg.): *Former West. Art and the Contemporary After 1989*, Cambridge 2017, 639–652.

LA COLLEZIONE

PEGGY

GUGGENHEIM

Exhibitions of Post-war Modernism

///

From the Archive of the Museum of American Art-Berlin

///

"Exhibition is a spectacle, both physical and symbolic, that could define
a theoretical platform in a way no written text could do."[1]

Walter Benjamin

///

During the 1930s in Europe there were, in essence, two competing visions of the future dominating the public sphere: one based on traditionalism and nationalism, and the other, based on modernism and internationalism. The first option, having been overwhelmingly embraced, inevitably led to war and destruction previously unknown to humanity.

By that time, modern art in Europe was already marginalized through a series of exhibitions. It was branded as "degenerate" in Germany, because of its internationalism, and as "bourgeois" and "formalist" in the Soviet Union. At the same time, European modern art was preserved and reinterpreted in the Museum of Modern Art in New York and, after the war, brought back to Europe when it became clear that modernism was the only promising option remaining. Following the exhibitions in those years, it is interesting to observe how this process took different paths in each European country. While in the west these different paths soon converged into some kind of abstract art, in most of the Soviet controlled countries, that were also embracing internationalism, modernism in art was still considered "bourgeois" and didn't (re)appear at all. This was well illustrated in the 1950s at major exhibitions like documenta (Kassel) and Deutsche Kunstausstellung (Dresden).

The early post-war international exhibitions were organized first in France of artists living there, while in other countries, like in Germany, modernism was still confined within the national boundaries. Although the first exhibitions, which brought back the pre-war modernists, took place in Berlin and Dresden very early on (1945/46), those were exclusively national selections. It was the documenta 1955 that introduced to post-war Germany and Europe a major exhibition based on internationalism, modernism, and individualism, i.e. the opposite of the Venice Biennial that was still being organized by national pavilions. But the first exhibition that brought together pre-war European modernism, the Russian/Soviet avant-garde, and Abstract Expressionism was the Peggy Guggenheim Collection at the Venice Biennale 1948, thus introducing what would become the post-war modern canon.

Unlike in Western Europe, where the history of modern art keeps "continuity" with pre-war modernism, in the East, that kind of narrative didn't exist for many decades, and today it remains an open question as to what kind of 20th century art history—or histories—will be told in those countries and how it will relate to the modern canon. Whether to somehow adopt it or to establish another narrative?

However, it seems that the more fundamental question today is not if the modern canon should be adopted, but what will become of it. We must consider not only the possibility that it might have exhausted its internal potential, but also that it may have become marginalized by the changes in contemporary society, including growing migrations to Europe from the cultures foreign not only to modernism but to the entirety of modernity. It is becoming clear that internationalism is not a one way, but rather a two way street.

In order to adjust to this development, art institutions like galleries, museums, and the disciple of art history will have to be transformed in a way that will accommodate and incorporate other cultures, while not forgetting modernity. In other words, a new canon will have to include, in some way, achievements from the other parts of the world, while both remembering its own past (modernity) and, at the same time, not being modern itself anymore.

*) *The texts in this contribution are based on various recent lectures and articles by the associates of the Museum of American Art: Gertrude Stein, Alfred Barr, Walter Benjamin, Dorothy Miller, and Porter McCray.*

/// 1 Walter Benjamin, *Recent Writings* (Vancouver, 2014).

A few years after the October Revolution, some art theoreticians and museologists began thinking what art museums should be and how best to exhibit works of art in the new socialistic society. They came to the conclusion that, if socialism is the most advanced form of society, than the art in that society should be superior to the art of all previous epochs. Thus in 1931, art theoretician and museologist Fedorov-Davidov organized the Experimental Complex Marxist Exhibition in the Tretyakov Gallery, displaying art of all epochs with distinct labels ("etiquettage"), including, among others, paintings by Kandinsky, Malevich, and Rodchenko together with large labels reading "formalism" and "self-denial" next to the Black Square. On the top of the wall exhibiting abstract art was a long banner with the text "The Dead-End of Bourgeois Art."

It seems this was thought to be the way to display modern/abstract art but as something that was product of capitalism, and thus undesirable. Visitors could still see it, but not admire it, and socialist-realism would become the only true art of the new society. However, even this idea was abandoned, and eventually all modern/abstract works by Malevich, Tatlin, Rodchenko, Lissitzky, etc. were labeled as formalist, removed from the museum walls and placed in the depot. They stayed there for many decades, hidden from the public eye, and, during that time, the term "formalism" remained the key word for dismissing any kind of modern/abstract art.

"Entartete 'Kunst'" and
**"Grosse Deutsche
Kunstausstellung,"**
Munich, 1937

After the Third Reich was firmly in place, a decision was made that all modern art should be removed from museums throughout Germany. But, in 1937, before being disposed one way or another, modern art was shown throughout the country in a mocking and disparaging way—branded as Bolshevik, Jewish, or simply insane—in a traveling exhibition titled "Entartete 'Kunst'"("Degenerate 'Art'") so that everybody in Germany could see this so called "art" before it was removed from the public eye. Many of the works for this exhibition were selected by Adolf Hitler personally. So were the works for the "Grosse Deutsche Kunstausstellung" held the same year in the newly built Haus der Deutschen Kunst in Munich. The exhibition, which would become an annual event until 1944, was intended to promote a form of nationalist-realism as the only true art. It is only after the defeat of Nazi-Germany that modern art was gradually brought back to the museums and recognized again as art, while the "true art" was removed from public display, mostly confined to the historical museums.

"Cubism and Abstract Art,"
MoMA, New York, 1936

In 1936, at the time when modern art in Europe was being officially disparaged and disappearing from the public sphere, Alfred Barr, the young director of the Museum of Modern Art in New York, organized an exhibition entitled "Cubism and Abstract Art" intended to historicize 20th century modern art. Until that point both art history and museum displays were organized according to nationality and national schools, following the concept introduced in the early 1800s with the emergence of the first museums like the Louvre. Instead of basing the exhibition on the idea of the national schools, Alfred Barr opted for introducing modern art through international movements. While the concept of international movements was articulated earlier in Europe, it was Barr who first introduced it within the context of a museum as the key notion to tell the history of modern art.

In this way Barr also changed the meaning of these phenomena (Fauvism, Cubism, Futurism, etc.), since they all originally appeared within the art scene defined by the national schools. By removing this concept, he gave them another meaning, interpreting them now within the story based on the international movements. Instead of internationalism as a conglomerate of distinct nationalities (as in the Venice Biennale), here we have an internationalism of individuals identified with a particular art movement or style. Instead of internationalism as a set of nationalisms as pre-determined identities, we have an internationalism of individually chosen identities based on affiliations.

The diagram Barr proposed is structured chronologically and covers a time interval of 45 years, from 1890 to 1935. It begins with the Post-Impressionists (Cezanne) and branches in two directions. One goes to Matisse and Fauves, and ends with the Non-Geometrical Abstraction. The other line goes to Picasso and Cubism, and from there to Suprematism, Constructivism, Bauhaus, and ends with the Geometrical Abstraction.

When it appeared, this diagram didn't look strange to the visitors since many American collections of European modern art were avant-garde oriented. Another interesting thing about Barr's diagram—there were no Americans in this story. However, it was American artists who first had a chance to see this new paradigm and build upon it.

After the war, which was the result of nationalistic ideologies, Europeans were looking for another option and embraced this internationalist concept coming from New York. Thus, the modern European art, forgotten at home, but preserved and reinterpreted at MoMA, was brought back after the war and reintroduced to Europeans, but dressed in these "new (international) clothes."

47

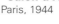

"Salon d'Automne,"
Paris, 1944

At the first "Salon d'Automne," after the liberation, Pablo Picasso was awarded with a one-man show where he exhibited his latest works. The exhibition had many visitors, including a number of American soldiers. Even General Lee came to see the show. But, not too long after the opening, images of gendarmes inside the Picasso exhibition started to appear in the Paris press. Strangely enough, they were placed in the gallery to protect Picasso's paintings from Parisians who, in fact, on several occasions had attacked Picasso's paintings. Even the beaux-arts students staged demonstrations in front of Picasso's studio, demanding to burn his paintings. This must have been very confusing, especially to Americans like Alfred Barr or Sidny Janis, who had a hard time explaining how it was that in Paris, the capital of modern art, Parisians were attacking the works of Pablo Picasso, then considered to be the most important modern artist. If this was happening to Picasso in Paris, how was it in the rest of Europe? This incident shows the degree to which the public in post-war Europe was disconnected from modern art, especially in relation to the story that was being shaped and promoted at MoMA.

"Maler der Gegenwart,"
Augsburg, 1945

The exhibition of modernist works "Maler der Gegenwart" held in Augsburg in December 1945, organized in collaboration between the American authorities and local representatives, provoked such violent outbursts among the visitors that some paintings were even attacked and damaged. The most negative reaction, like in Paris a year earlier, came from young people. In some cases they demanded that abstract art in particular should be "stuck in the concentration camps" or simply "gunned down." The negative attitude toward modern art was perceived as an indicator of the continuing strength of the traditionalism in art supported by the defeated national-socialist ideology, especially among young people, and as a rejection of democratic culture and the failure of re-education up to that point.

Both of these two incidents, especially the one in Paris, illustrate the degree to which modern art in Europe was not simply forgotten, but also made the object of hostility and derision when shown in public. It is only thanks to the Museum of Modern Art in New York that memories on European modernism were preserved, reinterpreted, and gradually (re) introduced to the European public in the years after the war, primarily through the series of exhibitions.

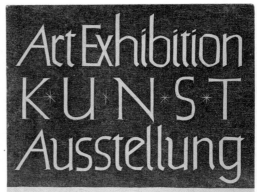

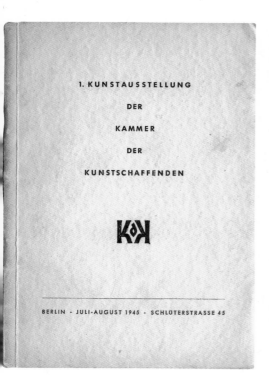

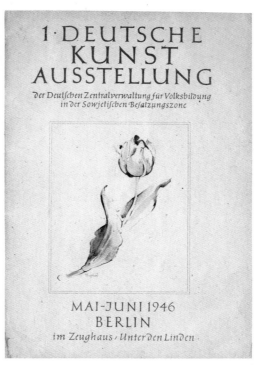

For some readers it might come as a surprise to learn that the first exhibition that re-introduced modernism in post-war Germany was not documenta in Kassel 1955. In fact, as early as 1945, immediately after the end of the war, several exhibitions were organized in Berlin, Dresden, and Augsburg that brought back some of the names that had last time appeared in the 1937 "Entartete 'Kunst'" exhibition. It seems that the first such exhibition took place in Berlin, from July through August 1945, under the title: "1. Kunstausstellung der Kammer der Kunstschaffenden." Among 52 artists and 184 works, it included Max Beckman, Erich Heckel, Ludwig Kirchner, Otto Mueller, Ernst Wilhelm Nay, Max Pechstein, Christian Rohlfs, and Karl Schmidt-Ruttluf. The chief organizer was Adolf Behne, a well known critic, art historian, and theoretician of the avant-garde during the Weimar Republic, who also wrote the introductory text in the catalog.

By the end of 1945, two more exhibitions had opened in Berlin, "Winter-Ausstellung 1945" and "Ausstellung Bildender Künstler," while a major national exhibition was organized in spring 1946: "1. Deutsche Kunstausstellung" in the Soviet Occupied Zone, with 593 works by 194 artists. In spite of the large number of participants, there were just a few known names: Ernst Barlach and Kate Kollwitz exhibited posthumously, while Max Pechstein was the only one from the previous show, and even included Georg Kolbe who was regularly exhibiting at the "Grosse Deutsche Kunstausstellung" in Munich from 1937–1944.

"Befreite Kunst," Dresden, 1945 and **"Allgemeine Deutsche Kunstausstellung,"** Dresden, 1946

Another exhibition took place in 1945 in Dresden, titled "Befreite Kunst" and was organized by Der Ruf, a group of artists who were looking for a fresh start in a city devastated by the war. Among those earliest art exhibitions in post-war Germany, perhaps the best known is the "Allgemeine Deutsche Kunstausstellung," which took place in Dresden 1946.

It is interesting to notice that all of the exhibitions organized in those years in Germany were either local, or national, and not very modernistic. However, the first signs of internationalism could be noticed in the early 1950s, like the "Neue Gruppe mit Französische Gesten" in 1952 and, finally, the first major post-war international exhibition of modern art: documenta in Kassel.

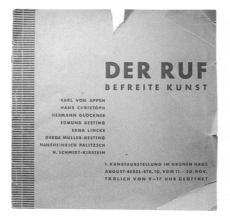

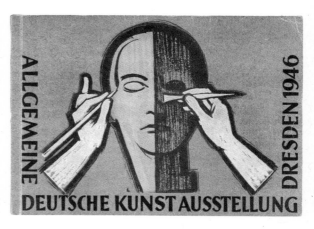

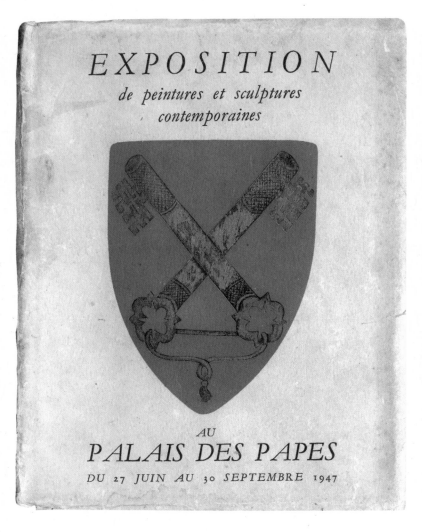

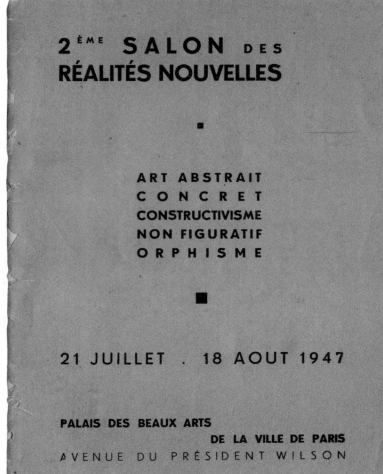

"Exposition de peintures et sculptures contemporaines," Avignon, 1947 and
"2ème Salon des Realités Nouvelles," Paris, 1947

Although Paris, with its international art scene, was considered to be the center of modern art, its Musee d'Art Moderne did not reflect this. The 1947 museum catalog was lacking works by Hans Arp, Marcel Duchamp, Wassily Kandinsky, Kurt Schwitters, Laslo Moholy-Nagy, Max Ernst, Rene Magritte, Man Ray, Bocioni, Van Doesburg, Paul Klee, Miro, Malevich, Tatlin, or Rodchenko. Piet Mondrian, who had spent most of his life in Paris where he had painted the most important neo-plastic paintings, was also not featured in the museum's collection. In fact, the first painting by Mondrian was acquired by the museum in Paris only in 1978, when the Beaubourg opened.

It seems that modern art was forgotten in Paris not only during war-time, but in fact it had never truly been embraced at all, especially abstract art and the avant-garde movements. This is why it is important to mention here two comprehensive international exhibition of modern art that in 1947 took place in France: one in the Palais des Papes in Avignon and the other in Paris in the Palais des Beaux Arts. The exhibition in Avignon took place in the huge cathedral-like Papal Palace, and was organized by art enthusiasts led by Yvonne Zervos. Titled "Exposition de peintures et sculptures contemporaneis," it included works by classical modernists, Matisse, Picasso, Braque, Leger, but also Arp, Calder, Max Ernst, Kandinsky, even one Mondrian neo-plastic painting from Arp's collection. It seems that most of the works came from collectors, friends, and artists themselves. This important international exhibition intended to bring back memories on pre-war modern art included only works by the artists who, at least at some point, lived and worked in France.

While this exhibition took place far away from Paris, another international exhibition titled "2ème Salon des Realites Nouvelles" was organized in the capital of modernity. It was in essence an international contemporary exhibition of various forms of abstract art divided in five categories: abstract art, concrete art, constructivism, non-figurative, and orphism. It included works by Europeans: Arp, Kupka, Gleizes, Sonia Delaunay, Barbara Hepworth, Hans Hartung, Auguste Herbin, Mathieu, Bruno Munari, Cesar Domela, Jean Gorin, and among numerous Americans, Ilya Boltowsky and Moholy-Nagy, while Baziotes and Motherwell were brought by Paris' Galerie Maeght. Although international, this was only a contemporary exhibition, without historical perspective, addressing the issues of the day: geometric or non-geometric, realism and abstraction, and, if abstraction, then what kind?

"Advancing American Art,"
New York, 1946, Prague, 1947

After the war, in 1946, some people in the State Department realized that the cultural image of America in Europe was not so great. Americans were known for chewing gum and Camel cigarettes but not for high culture and art. The State Department, with a budget of about $50,000 and the help of LeRoy Davidson, "visual-arts specialist for the newly formed OIC," acquired the works of mainstream American Modernism from the previous three decades. Before sending it to Europe, they proudly presented the collection at the Metropolitan Museum. However, immediately after the exhibition at the Metropolitan Museum opened, an article appeared in the *New York Journal* (Hearst press) on October 4, 1946, with the heading: "State Department backs Red Art Show." The report detailed how "The State Department, which is officially refusing to compromise with international communism, was sponsoring an art exhibition featuring the work of left-wing Red Fascist painters." More ridiculously, the article stated that these artists "served on communist fronts set up by Moscow." Then *Look* magazine, a major photography and illustration-based magazine, published an article and a two-page spread with reproductions of the paintings, under the title "Your Money Bought These Paintings." The entire collection was perceived to be a misrepresentation of America. Finally, after the congressional hearings about the exhibition, the State Department realized their mistake to use the taxpayers' money for buying art. By the time of the exhibition's greatly successful opening in Prague, the State Department decided to bring the show back to the United States and sell the entire collection as government surplus for $5,000. This was the context in which Alfred Barr felt compelled to write a scathing article in a 1952 issue of the *New York Times Magazine* titled "Is Modern Art Communistic?."

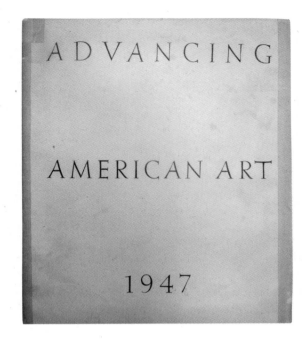

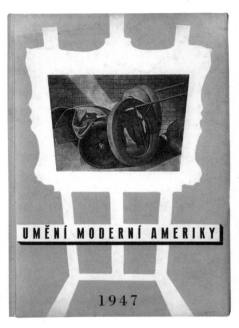

"Amerikanische Malerei,"
Berlin, 1951 and
"American Painting and Sculpture," Moscow, 1959

In spite of this failure, another exhibition of American art to travel to Europe was the 1951 exhibition "Amerikanische Malerei" held in Berlin and organized by the American Federation of Arts. It included work from thirty museums, galleries, and private collections. The majority were from the 20th century, very similar to Advancing American Art, but this time including Abstract Expressionists Motherwell from the Whitney Museum and Kootz Gallery, and Pollock and Rothko, both from the Betty Parsons Gallery. This was perhaps the first time that works by this group of artist were shown in Germany, and an almost identical exhibition titled "Amerika Shildert" was organized in 1950 in the Stedelijk Museum in Amsterdam.

Eight years after the Berlin show, as a part of the American National Exhibition, a very similar collection of American Modern Art was brought to Moscow. It was selected by a committee of art professionals appointed by President Eisenhower and installed in Moscow by Edith Halpert from Downtown Galleries in New York.

While the expression of artistic freedom in MoMA exhibitions was modernism and abstract art, in these government exhibitions it was the "variety of styles."

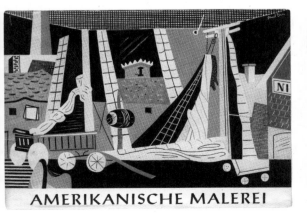

"Peggy Guggenheim Collection" at the Venice Biennale, 1948 and "Biennnale di Venezia," Venice, 1948

When the first post-WW2 Venice Biennale was organized in 1948, Peggy Guggenheim brought her collection of modern art to Europe. The organizers decided to give Peggy the Greek pavilion to show her collection, since Greece could not participate because of the civil war. It was the first time that Europeans had a chance to see the works of the most important modern artists exhibited together, including those that had almost been forgotten in Europe (e.g. Picasso, Miró, Ernst, Mondrian), representatives of the Russian avant-garde (Malevich and Lissitzky), and American abstract expressionists (e.g. Pollock, Motherwell, Gorky).

Both in the catalog and on display, artists were presented as individuals regardless of their country of origin. When the first major post-war exhibition of modern art organized by Europeans (documenta 1, Kassel 1955) it was strictly Western European, it included neither the Russian avant-garde nor the Americans. The exhibition of Peggy Guggenheim collection in Venice 1948 anticipated what would some ten years later become the modern canon.

In the next few years the collection was exhibited in several Italian cities (Milano and Florence 1949) and subsequently in Amsterdam, Zurich, and Brussels (1951). Because Willem Sandberg, the director of the Stedelijk Museum in Amsterdam, helped Peggy bring her collection to Europe, she decided to give the Stedelijk five paintings by Jackson Pollock. These were the first Pollock paintings that entered a European museum collection.

It is interesting to note that this international exhibition, based on individualism, modernism, and internationalism, was presented within another kind of international exhibition, the Venice Biennale, which is structured by nationalities and national pavilions and as such does not represent the modern canon, as each national pavilion could have its own interpretation of art.

"International Exhibition of Arts," Berlin, 1951

Three years later, in 1951, a major exhibition titled "Internationale Kunstausstellung" was organized in Berlin that included artists from 38 countries, from Denmark and Columbia to Vietnam and Nigeria. However, the most notable characteristic of this global exhibition, held in the Soviet zone, was its anti-modernism. Most of the works were primarily on social themes or explicitly socialist-realistic. This was another kind of international exhibition that could be seen in those early years after the Second World War. It represented an opposite understanding of art from the one shown at the Peggy Guggenheim exhibition in Venice and later at documenta.

"XX Century Masterpieces,"
Paris and London, 1952, and
**"Berliner Neue Gruppe mit
französischen Gästen,"** Berlin, 1952

When in 1952 the Congress for Cultural Freedom organized the art festival "Masterpieces of the 20th Century" it included an art exhibition with the same title. James Johnson Sweeney, the established former curator of MoMA newly appointed director of the Guggenheim Museum in New York, curated the exhibition. The exhibition was intended to assemble the iconic works of modern art and show them in Paris and London. Although the curator was an American, the exhibition included only European modern art. Some of the most important works, such as Kandinsky, Klee, Duchamp, Leger, and Mondrian, came from American museums and collections, including four Suprematist paintings by Malevich from the MoMA collection. It is worth noticing that, at a time in post-war Europe when memories of modern art were gradually beginning to emerge, some of the most avant-garde works, not yet seen in Europe, were brought from US collections by the Congress for Cultural Freedom, including those by Malevich, whose work could not be seen in his home country.

The same year that this American-organized exhibition of European modern art traveled to Paris and London, another exhibition of modern art entitled "Berliner Neue Gruppe mit Französischen Gästen" was organized in Berlin and included works of primarily post-war German and French artists such as Jean Bazaine, Maurice Esteve, Pierre Soulage, Raoul Ubac, Max Pechstein, Karl-Schmid Rottluff, Karl Hartung, and Werner Heldt. This was another example of a contemporary international exhibition organized by artists in Germany in lead up to the first documenta in 1955, a major European international survey of 20th century modern art, but without the Russian/Soviet avant-garde and Abstract Expressionism.

"documenta 1,"
Kassel 1955

"Modern Art in the USA,"
Belgrade, 1956 and
"The New American Painting,"
New York, 1958

From 1955 to 1956, MoMA sent a comprehensive exhibition of its collection to several European cities. Starting in Paris, it travelled to London, Frankfurt, Barcelona, and other cities. This exhibition, titled "Modern Art in the USA," included major modern American artists of the 20th century, with half of the exhibition consisting of Abstract Expressionism. Realizing that the last scheduled stop, Vienna, is close to Belgrade, the United State Information Service (USIS) in Belgrade had the idea to suggest to the Yugoslav authorities to bring the exhibition to Belgrade. The first response was negative with the comment that "this will be some kind of American Tutti-Frutti." However, after receiving an official letter describing the entire exhibition in detail, Marko Risti, president of the Yugoslavian Committee for Cultural Relations, replied: "I am absolutely for it!" Clearly, the importance of bringing this exhibition to Belgrade was understood. Bringing the exhibition to Belgrade turned out to be of equal importance to MoMA, which issued not one, but two press releases for the occasion. The exhibition, which opened July 7 and lasted until August 6, included works by Man Ray, Hopper, Wyeth, Gorky, de Kooning, Motherwell, Pollock, Tomlin, and Kline, among others. The second press release issued by MoMA announcing the opening of the exhibition pointed out that the exhibition was brought to Belgrade "at the invitation of the Yugoslavian Committee." In those years, this was the only MoMA exhibition of American art shown in a socialist country. The press, not only in Belgrade but also throughout the country, covered the exhibition. The American Cultural Center in Zagreb even had a window display exhibiting photographs of the works being shown in Belgrade. However, not long after it closed, the exhibition was completely forgotten, as at the time American art was perceived to be provincial and of little importance. The Belgrade exhibition also happened to be the last exhibition Pollock appeared in as a living artist.

Being the first successful presentation of American modern art to European audiences, this travelling MoMA exhibition opened the door for another MoMA exhibition two years later, this time consisting only of works by Abstract Expressionists, titled "The New American Painting." After traveling through eight European cities it was proudly presented back home at MoMA. While it is largely understood as the turning point of the post-WW2 art scene, marking the end of the dominance of European modern art and the emergence of the Americans, it seems that it was the previous exhibition, the "Modern Art in the USA," that was, in fact, that turning point.

"50 Ans d'Art Moderne,"
Brussels, 1958, and
"documenta II," Kassel, 1959

When the first post-war Expo opened in Brussels in 1958, inviting nations from all over the world to forget the past and imagine a future based on modernism, technology, and progress, a giant model of an atom, named "Atomium," was chosen as the symbol of the Expo and a monument to this vision of the future. As part of the Expo an art exhibition titled "50 Ans d'Art Moderne" was organized. Though not exactly entirely modern, as each nation, like at the Venice Biennale, had the autonomy to bring any kind of works it believed representative of the best its vision of art, the exhibition was nevertheless predominantly modernistic and included some important works of the pre-war European modern art. While Americans also brought a selection of modern art, including "White Forms" by Kline and "NY" by Ellsworth Kelly, only the socialist realism, such as "Lenin in Smolny" by Brodsky and "Defense of Petrograd" by Deineka came from Soviet museums. Interestingly,

the only two paintings by Malevich at the exhibition were brought to Brussels from the Stedelijk Museum in Amsterdam.

The following year, the second documenta was held in Kassel. Though titled "Art Since 1945," the exhibition nevertheless included some important works of pre-war modernism. Unlike the first documenta, which only included modern art of Western Europe, this time a selection of modern American art, predominantly Abstract Expressionist, though also some younger artists like Robert Raushenberg and Jasper Johns, were brought in through MoMA's International program. And at this exhibition too, Stedelijk Museum brought one painting by Malevich, the "*Eight Red Rectangles*." Eleven years after the Peggy Guggenheim show in Venice, Europeans finally managed to bring together all three major components of the 20th century modernism.

What Does Art Exhibit? Remarks on "Exhibition Value"

Was stellt Kunst aus? Anmerkungen zum „Ausstellungswert"

Sami Khatib

In his reflections on installation art and the contemporary role of the curator, Boris Groys raised an obvious question. If "art functions in the context of the art market" and if "every work of art is a commodity," to whom is art exhibited?[1] Indeed, "art is also made and exhibited for those who do not want to be art collectors, and it is in fact these people who constitute the majority of the art public."[2] While the art market is inherently in need of exhibiting its products as commodities, the act of exhibiting itself is not limited to its economic function. Paradoxically, the anonymous public, the majority of those who visit today's large-scale exhibitions, also relate to art commodities in a non-commodified way: art exhibitions produce an extra-economic surplus, which, in turn, is conveyed by the very economic mediations and conditions of the art market. This extra-economic surplus, inextricably linked to the economic function of art commodities (yet not reducible to it), informed Walter Benjamin's famous essay on "The Work of Art in the Age of its

In seinen Betrachtungen zur Installationskunst und der zeitgenössischen Rolle des Kurators stellte Boris Groys eine offensichtliche Frage. Wenn „Kunst im Kontext des Kunstmarktes funktioniert" und wenn „jedes Kunstwerk eine Ware ist", für wen wird Kunst ausgestellt?[1] Tatsächlich „wird Kunst auch für diejenigen gemacht und ausgestellt, die nicht Kunstsammler sein wollen, und es sind in der Tat diese Menschen, die die Mehrheit des Kunstpublikums ausmachen."[2] Während der Kunstmarkt aufgrund seiner Eigenlogik seine Produkte als Waren ausstellen muss, ist der Akt des Ausstellens nicht nur auf seine ökonomische Funktion beschränkt. Paradoxerweise bezieht sich das anonyme Publikum, die Mehrheit der Besucher heutiger Großausstellungen, auf die Waren der Kunst auch auf eine nicht-kommodifizierte Art und Weise: Kunstausstellungen erzeugen einen extraökonomischen Mehrwert, der wiederum durch die ökonomischen Mittlertätigkeiten und Bedingungen des Kunstmarktes vermittelt wird. Dieser extraökonomische Mehrwert, der untrennbar mit der ökonomischen Funktion von Kunstgütern verbunden ist (ohne darauf reduzierbar zu sein), fand Eingang in Walter Benjamins berühmten Aufsatz über „Das

1 Boris Groys, "Politics of Installation," *e-flux*, no. 2 (2009): http://www.e-flux.com/journal/02/68504/politics-of-installation/ (accessed October 10, 2017).

2 Ibid.

1 Groys, Boris: „Politics of Installation", *e-flux*, 2 (2009), online unter: http://www.e-flux.com/journal/02/68504/politics-of-installation/ (Stand: 10. Oktober 2017).

2 Ebd.

Technological Reproducibility" (1935/36) and provided the material basis for introducing the concept of "exhibition value."[3] According to Benjamin, the work of art has always been split between two polar extremes: "exhibition value" and "cult value."[4] Conceptually, this dialectical pair combines the social and artistic function as well as the productive and receptive modes of a work of art. Following Benjamin's argument, with the historical introduction of technologically reproducible art, the exhibition value prevails over the work of art's cult value, which retrospectively appears as the distinctive feature of premodern magically or religiously embedded artifacts. "The scope for exhibiting the work of art has increased so enormously with the various methods of technologically reproducing it that, as happened in prehistoric times, a quantitative shift between the two poles of the artwork has led to a qualitative transformation in its nature. Just as the work of art in prehistoric times, through the exclusive emphasis placed on its cult value, became first and foremost an instrument of magic which only later came to be recognized as a work of art, so today, through the exclusive emphasis placed on its exhibition value, the work of art becomes a construct [*Gebilde*] with quite new functions."[5] These new functions are of political nature and related to modern capitalist mass societies and their inherent technological possibilities. The mass exhibition of technologically reproduced art (Benjamin mentions film and photography — today we can add the digital reproducibility of all artistic media) affects artworks in a fundamental way, changing their character as unique and original, endowed with what Benjamin called "aura."[6] The auratic way of seeing always maintains a certain contemplative distance towards its object; it is directed to objects that exist uniquely in one place and ideally last long — its

paradigmatic case might be ancient statues made of stone. Technological reproducibility, in contrast, does not aim at spatial singularity and temporal persistence but allows for proximity, mobility, disposability; its material features are not intended to persist in time as unique objects but allow for circulation and exchange as well as mass exhibition and collective reception. Reproducibility is thus not limited to a merely technological feature or development but also designates, as Benjamin's editor Michael Jennings rightly argues, "a political capacity of the work of art; its very reproducibility shatters its aura and enables a reception of a very different kind in a very different spectatorial space: it is precisely the shattering of the aura that enables the construction, in the cinema, of a political body through 'simultaneous collective reception' of its object."[7] Without going into the intricacies of Benjamin's argument, we should remind ourselves that Benjamin's understanding of technological reproducibility still assumes the discriminability of copy and original. Today, we realize that every copy can again be turned into an original, situated in a specific spatio-temporal setting able to artificially produce an aura — "the unique apparition of a distance, however near it may be."[8] Contrary to Benjamin's politico-aesthetic prognosis, aura ("the here and now of the work of

3 Walter Benjamin, "The Work of Art in the Age of Its Technological Reproducibility," 2nd version, in *The Work of Art in the Age of Its Technological Reproducibility, and Other Writings on Media*, ed. Michael W. Jennings, Brigid Doherty, and Thomas Y. Levin, (Cambridge, MA, 2008), pp. 19–55. I follow the editors' view that the (less known) second version comes closest to Benjamin's original intention while writing and rewriting his essay between 1935 and 1939. Including the French version, which was published during Benjamin's lifetime in 1936, there are five versions of his essay, see Walter Benjamin, *Das Kunstwerk im Zeitalter seiner technischen Reproduzierbarkeit*, ed. Burkhardt Lindner. Vol. 16, *Werke und Nachlaß. Kritische Gesamtausgabe* (Berlin, 2012).

4 Benjamin, "The Work of Art," pp. 25–27 (see note 3). We cannot miss Benjamin's implicit reference here to Marx and his theory of the dual character of the commodity, split between "use-value" and "exchange-value," see Karl Marx, *Capital: A Critique of Political Economy*, Vol. 1, trans. Ben Fowkes (London, 1990), pp. 125–137.

5 Benjamin, "The Work of Art," p. 25 (see note 3).

6 Ibid., p. 23.

7 Michael W. Jennings, "Editor's Introduction" to Benjamin, "The Work of Art," p. 15 (see note 3); quoted in Benjamin, "The Work of Art," p. 36 (see note 3).

8 Benjamin, "The Work of Art," p. 23 (see note 3).

Kunstwerk im Zeitalter seiner technischen Reproduzierbarkeit" (1935/36) und lieferte ihm die materielle Grundlage für die Einführung des Begriffs des „Ausstellungswerts".[3] Laut Benjamin war das Kunstwerk schon immer zwischen zwei Polen gespalten: „Ausstellungswert" und „Kultwert".[4] Konzeptionell verbindet dieses dialektische Paar die soziale und künstlerische Funktion sowie die Modi der Produktion und Rezeption eines Kunstwerks. Benjamin zufolge überwiege mit der historischen Einführung von technisch reproduzierbarer Kunst der Ausstellungswert gegenüber dem Kultwert des Kunstwerks; letzterer erscheint im Nachhinein als das spezifische Merkmal vormoderner magischer oder religiös verankerter Kunstgegenstände. „Mit den verschiedenen Methoden technischer Reproduktion des Kunstwerks ist dessen Ausstellbarkeit in so gewaltigem Maß gewachsen, daß die quantitative Verschiebung zwischen seinen beiden Polen ähnlich wie in der Urzeit in eine qualitative Veränderung seiner Natur umschlägt. Wie nämlich in der Urzeit das Kunstwerk durch das absolute Gewicht, das auf seinem Kultwert lag, in erster Linie zu einem Instrument der Magie wurde, das man als Kunstwerk gewissermaßen erst später erkannte, so wird heute das Kunstwerk durch das absolute Gewicht, das auf seinem Ausstellungswert liegt, zu einem Gebilde mit ganz neuen Funktionen [...]."[5] Diese neuen Funktionen sind ihrem Wesen nach politisch und beziehen sich auf die modernen kapitalistischen Massengesellschaften und die ihnen innewohnenden technologischen Möglichkeiten. Die Massenausstellung von technisch reproduzierter Kunst (Benjamin erwähnt Film und Fotografie – heute können wir die digitale Reproduzierbarkeit aller künstlerischen Medien hinzufügen) beeinflusst Kunstwerke auf fundamentale Weise und verändert ihr Wesen als Unikat und Original, ausgestattet mit dem, was Benjamin „Aura" nannte.[6] Die auratische Betrachtungsweise hält immer eine gewisse kontemplative Distanz zu ihrem Objekt aufrecht; sie ist auf Objekte ausgerichtet, die ausschließlich an einem einzigen

Ort existieren und im Idealfall lange Zeit überdauern – ihr paradigmatischer Fall die antiken Statuen aus Stein. Technische Reproduzierbarkeit hingegen zielt nicht auf räumliche Singularität und Langlebigkeit ab, sondern ermöglicht Nähe, Mobilität, Verfügbarkeit; ihre materiellen Eigenschaften sind nicht dazu bestimmt, als Unikate in der Zeit zu verharren, sondern erlauben Verbreitung und Austausch sowie Massenausstellung und kollektive Rezeption. Die Reproduzierbarkeit beschränkt sich also nicht nur auf eine technische Funktion oder Entwicklung, sondern bezeichnet, wie Benjamins amerikanischer Herausgeber Michael Jennings zu Recht argumentiert, auch „ein politisches Potenzial des Kunstwerks; gerade seine Reproduzierbarkeit zertrümmert seine Aura und ermöglicht eine Rezeption ganz anderer Art in einem ganz anderen Zuschauerraum: es ist die Zertrümmerung der Aura, die es ermöglicht, im Kino einen politischen Körper durch ‚gleichzeitige kollektive Rezeption' ihres Objekts zu konstruieren."[7] Ohne auf die Komplexität von Benjamins Argumentation einzugehen, sollten wir uns daran erinnern, dass Benjamins Verständnis der technischen Reproduzierbarkeit immer noch die Unterscheidbarkeit von Kopie und Original voraussetzt. Heute erkennen wir, dass jede Kopie wieder in ein Original verwandelt werden kann, das sich in einer bestimmten räumlich-zeitlichen Umgebung befindet und in der

3 Benjamin, Walter: „Das Kunstwerk im Zeitalter seiner technischen Reproduzierbarkeit (Zweite Fassung)", in Tiedemann, Rolf/Schweppenhäuser, Hermann (Hg.): Gesammelte Schriften, Bd. VII.1, Frankfurt/M 1989, 357. Ich folge der Einschätzung der Herausgeber, dass die weniger bekannte zweite Fassung (1935/36) am nächsten an Benjamins ursprünglicher Intention liegt („Urtext"). Insgesamt existieren nach heutigem Forschungsstand fünf verschiedene Versionen des Essays, die Benjamin zwischen 1935 und 1939 schrieb, mehrfach überarbeitete und mitübersetzte. Die französische Version von 1936 ist die einzige, die zu Lebzeiten Benjamins veröffentlicht wurde, siehe Benjamin, Walter: Das Kunstwerk im Zeitalter seiner technischen Reproduzierbarkeit, Berlin 2012 in Lindner, Burkhardt (Hg.): Werke und Nachlaß. Kritische Gesamtausgabe, Bd. 16, Berlin, ab 2008. (A.d.Ü.: Die historisch-kritische Ausgabe von 2012 listet die 1989 noch als „zweite Fassung" betitelte Version des Essays als „dritte Fassung". Originalzitate in meiner Übersetzung folgen der Ausgabe von 1989, die auch Vorlage der englischen Übersetzung ist, siehe Benjamin, Walter: „The Work of Art in the Age of Its Technological Reproducibility", in: Jennings, Michael W./Doherty, Brigid/Levin, Thomas Y. (Hg.): The Work of Art in the Age of Its Technological Reproducibility, and Other Writings on Media, Cambridge, MA 2008, 19–55. Die zweite bzw. nach heutiger Zählung dritte Fassung weicht signifikant von der letzten Fassung von 1939 ab, die als die meistverbreitete Fassung in der Edition Suhrkamp, Frankfurt am Main 1963, und in Benjamin, Walter: Illuminationen. Ausgewählte Schriften 1, Frankfurt am Main 1977, 136–169, publiziert wurde.

4 Benjamin: „Das Kunstwerk", 357–358 (wie Anm. 3). Benjamins impliziter Bezug auf Marx und seine Theorie des Doppelcharakters der Ware als „Gebrauchswert" und „Tauschwert" lässt sich nicht übersehen, siehe Marx, Karl: Das Kapital. Kritik der politischen Ökonomie, Bd. 1, Institut für Marxismus-Leninismus beim ZK der SED (Hg.), Marx-Engels-Werke, Bd. 23, Berlin 1962, 49–61.

5 Benjamin: „Das Kunstwerk", 358 (wie Anm. 3).

6 Ebd., 353–355.

7 Michael W. Jennings: „Editor's Introduction", in: Michael W. Jennings/ Brigid Doherty/Thomas Y. Levin (Hg.): The Work of Art, 15 (wie Anm. 3). Übers. O.L.

art—its unique existence in a particular place"⁹) can be transposed to the spatio-temporal singularity of any artistic object, text or situation, independently of its assumed material or physical properties.¹⁰

In today's exhibitions of art commodities the medial sphere of technological reproducibility (in the Benjaminian sense) is bracketed and gradually substituted by what Fredric Jameson recently called a neoliberal "aesthetics of singularity," rendering each work of art as an original of itself—a singularity of its own temporal and spatial uniqueness. Of course, Jameson's prime example is installation art, the exhibition of "phenomena equally spatial, equally ephemeral."¹¹ Indeed, as Groys put it, installation art "operates by means of a symbolic privatization of the public space of an exhibition."¹² Quite ironically, today "what the installation offers to the fluid, circulating multitudes is an aura of the here and now. The installation is, above all, a mass-cultural version of individual flânerie, as described by Benjamin, and therefore a place for the emergence of aura, for 'profane illumination.' In general, the installation operates as a reversal of reproduction. The installation takes a copy out of an unmarked, open space of anonymous circulation and places it—if only temporarily—within a fixed, stable, closed context of the topologically well-defined 'here and now.'"¹³ What Jameson discussed in the context of an aesthetics of singularity, Groys reads as the capitalist reproducibility of artistic aura in the age of installation art.

This reading, contra Benjamin, provides us with a different clue to thematize the exhibition practice of art commodities. Whereas Benjamin still insisted on the dialectical character of the work of art, caught between the polar extremes of the work of art's technologically reproducible exhibition value and unique cult value, today we witness the capitalist reproducibility of an aesthetic mode, which Benjamin saw as outdated,

in decline. The contemporary practice of installation art is more than ever bound to the exhibition of artistic aura, short-circuiting dialectical extremes: spatial uniqueness (cult value) and temporal transitoriness (exhibition value). Consequently, formerly utopian potentialities of the mass exhibition and collective reception of technologically reproduced artworks turn out to be commodified: the mobility and transitoriness of installation art do not lead to a functional transformation of the entire domain of art, increasing its political impact and emancipation of the masses, but appear as contradictory attributes of an exhibition practice that thrives on an artificially produced and reproducible aura.

Our initial question, however, remains: what does art exhibit? If we leave the case of installation art aside and concentrate on classic exhibition sites of museums, documentas, biennales and manifestas, we cannot miss the fact of a mass audience that relates to the exhibition space in a manner not fully reducible to the capitalist exchange value of art. The exhibition of art commodities also exhibits something that exceeds the economic function of the circulation of commodities. Here, an earlier text by Benjamin could provide us with an insight to rethink the practice of exhibiting, *ausstellen*—literally "setting out."

In a review from 1930, Benjamin discussed the exhibition technique of a show dedicated to the goal of "Volksaufklärung," the education of people on a mass scale. The theme of the reviewed show at a Berlin "Gesundheitshaus" (Health Education Center) was not artistic in the narrow sense (it dealt with the medical issue of "healthy" or "sound" nerves); however, its mode of presentation touched upon the challenge of exhibiting objects to a mass audience in the age of technological reproducibility—an age marked by a deep change of aesthetic modes of perception, induced yet not reducible to advanced capitalist means of production. In a dense passage, Benjamin

9 Ibid. p. 21.

10 A close reading of Benjamin's essay reveals that he never based his argument about the technologically induced decline of the aura of the work of art on the latter's material or physical properties. I have argued elsewhere that his argument is based on a historical change of social modes of (mass) perception, see Sami Khatib, "This is the Reproducibility of Singular Time," in *This is the Time. This is the Record of the Time*, ed. Angela Harutyunyan and Nat Muller, (Beirut, 2016), pp. 40–49.

11 Fredric Jameson, "The Aesthetics of Singularity," *New Left Review* 92 (2015), p. 110.

12 Groys, "Politics of Installation," p. 3 (see note 1).

13 Ibid., p. 5 (see note 1).

Lage ist, künstlich eine Aura zu erzeugen – die „einmalige Erscheinung einer Ferne, so nah sie sein mag.“[8] Im Gegensatz zu Benjamins politisch-ästhetischer Prognose lässt sich die Aura („das Hier und Jetzt des Kunstwerks – sein einmaliges Dasein an dem Orte, an dem es sich befindet“[9]) unabhängig von den angenommenen materiellen oder physikalischen Eigenschaften in die raum-zeitliche Singularität eines künstlerischen Objekts, Texts oder einer Situation transponieren.[10]

In den heutigen Ausstellungen von Kunstwaren wird die mediale Sphäre der technischen Reproduzierbarkeit (im Sinne Walter Benjamins) ausgeklammert und allmählich durch das ersetzt, was Fredric Jameson kürzlich eine neoliberale „Ästhetik der Singularität“ nannte, die jedes Kunstwerk zu einem Original seiner selbst mache – eine Singularität seiner eigenen zeitlichen und räumlichen Einzigartigkeit. Jamesons Paradebeispiel ist natürlich die Installationskunst, die Ausstellung von „Phänomenen, die gleichermaßen räumlich wie vergänglich sind“.[11] Tatsächlich „arbeitet [Installationskunst] mit einer symbolischen Privatisierung des öffentlichen Raums einer Ausstellung“, wie Groys es formuliert hat.[12] Ironischerweise ist heute „das, was die Installation den fluiden, zirkulierenden Massen bietet, eine Aura des Hier und Jetzt. Die Installation ist vor allem eine massenkulturelle Version der individuellen Flânerie, wie sie von Benjamin beschrieben wurde, und damit ein Ort für die Entstehung der Aura, für ‚profane Erleuchtung‘. Generell arbeitet die Installation wie eine Umkehrung der Reproduktion. Die Installation nimmt eine Kopie aus einem unmarkierten, offenen Raum anonymer Zirkulation heraus und stellt sie – wenn auch nur vorübergehend – in einen festen, stabilen, geschlossenen Kontext des topologisch wohldefinierten ‚Hier und Jetzt‘.“[13] Was Jameson im Kontext einer Ästhetik der Singularität diskutiert hat, liest Groys als die kapitalistische Reproduzierbarkeit künstlerischer Aura im Zeitalter der Installationskunst.

Diese Lesart, contra Benjamin, eröffnet einen anderen Zugang zur Thematisierung der Ausstellungspraxis von Kunstgegenständen. Während Benjamin noch auf dem dialektischen Charakter des Kunstwerkes beharrte, der zwischen den Polen des technisch reproduzierbaren Ausstellungswerts des Kunstwerks und dessen einzigartigen Kultwerts eingefasst war,

erleben wir heute die kapitalistische Reproduzierbarkeit einer ästhetischen Form, die Benjamin als veraltet, im Verfall begriffen sah. Die zeitgenössische Praxis der Installationskunst ist mehr denn je an die Ausstellung von künstlerischer Aura im Kurzschluss dialektischer Extreme angewiesen: räumliche Einzigartigkeit (Kultwert) und zeitliche Vergänglichkeit (Ausstellungswert). Die vormals utopischen Potenziale der Massenausstellung und der kollektiven Rezeption technisch reproduzierter Kunstwerke entpuppen sich folglich als Kommodifizierung: Die Mobilität und Vergänglichkeit der Installationskunst führen zu keiner funktionalen Verwandlung des gesamten Kunstfelds, erhöhen dessen politische Wirkung und die Emanzipation der Massen nicht, sondern erscheinen als widersprüchliche Attribute einer Ausstellungspraxis, die von einer künstlich produzierten und reproduzierbaren Aura lebt.

Unsere eingangs gestellte Frage bleibt jedoch: Was stellt Kunst aus? Wenn wir den Fall der Installationskunst beiseite lassen und uns auf klassische Ausstellungsorte wie Museen, Documentas, Biennalen und Manifestas konzentrieren, sollten wir die Tatsache eines Massenpublikums nicht außer Acht lassen, das sich auf den Ausstellungsraum in einer Weise bezieht, die nicht vollständig auf den kapitalistischen Tauschwert der Kunst reduziert werden kann. Die Ausstellung von Kunstgegenständen zeigt auch etwas, das über die ökonomische Funktion des Warenkreislaufs hinausgeht. Einen Hinweis in diese Richtung lässt sich einem früheren Text Benjamins entnehmen, der uns die Praxis des Ausstellens überdenken lässt.

In einer Rezension aus dem Jahr 1930 erörterte Benjamin die Ausstellungstechnik einer Schau, die sich „Volksaufklärung“ zum Ziel gesetzt hatte, die Bildung von Massen. Das Thema der von ihm rezensierten Ausstellung in einem Berliner

8 Benjamin, „Das Kunstwerk“, 355 (wie Anm. 3).

9 Ebd., 139.

10 Eine eingehende Lektüre von Benjamins Essay zeigt, dass Benjamins Auseinandersetzung mit dem technisch bedingten Verfall der Aura des Kunstwerks niemals auf dessen materiellen oder physikalischen Eigenschaften beruht. Ich habe andernorts argumentiert, dass sein Argument auf einem historischen Wandel der gesellschaftlichen Formen der (Massen-)Wahrnehmung beruht, siehe Khatib, Sami: „This is the Reproducibility of Singular Time“ in: Harutyunyan, Angela/Muller, Nat: (Hg.): *This is the Record of the Time*, Beirut, 2016, 40–49.

11 Jameson, Frederic: „The Aesthetics of Singularity“ in *New Left Review* 92 (2015), 110.

12 Groys: „Politics of Installation“, 3. (wie Anm. 1).

13 Ebd., 5.

reflects on the problem of presenting scientific objects and their relations to a mass audience of non-experts. "The new education for the masses […] proceeds from the fact that visitors attend in masses. The slogan now is to turn quantity into quality, a reversal that for them is identical to the conversion of theory into practice. The visitors, as stated, should remain laymen. They should leave the exhibition not more learned but more savvy. The task of real, effective presentation [*Darstellung*] is just this: to liberate knowledge from the bounds of the compartmentalized discipline [*Fach*] and make it practical. But what is 'real presentation'? In other words, what is exhibition technique? […] It means that real presentation [*Darstellung*] banishes contemplation. In order to incorporate the visitor into the show's montage, as occurs here, the optical must be carefully controlled. Any viewing [*Anschauung*] that lacks the element of surprise would result in a dumbing—down of the visitor. What there is to see must never be the same as, or even approximate, what the inscription says it is. It must bring with it something new, a twist of the obvious which fundamentally can not be achieved with words."[14] This comprehensive take on the relation of exhibition technique and modes of effective presentation is not limited to conventional pedagogical ends: it espouses the stakes of mass exhibitions and takes into account the extra-economic surplus generated by the practice of exhibiting objects, texts and situations to a mass audience. This surplus—playful smartness or savvy—is produced in a precise and controlled manner, yet its effects on a mass scale exceed controllable prescription and instruction. Effective purposiveness and uncontrollable effect maintain a dialectical tension. The mass audience of the show is intended by the show, yet not addressed in an instrumental manner—it is neither treated as a pedagogical subject to be instructed nor as an economic agent

to be motivated to become a buyer or collector. Rather, the exhibition technique succeeds in mediating a certain surprise, an excitement without having the ideal recipient in mind or prescribing the aesthetic modes of reading, seeing, learning.

What Benjamin calls "real presentation" leaves the confines of distant contemplation and embeds the audience in its very purposiveness without conveying a defined purpose. The visitor does not leave the exhibition as an expert, a knowledgeable scholar but as a surprised subject open to new insights. These new insights rely on a syn-aesthetic, visual and tactile relation between visitor and object generated in the exhibition space. In this sense, the very term "visitor" might be too narrow since the trans-disciplinary exhibition space Benjamin is talking about exceeds the visual field—it is not limited to an optical relation (which allows for distance, contemplation) but opens up a space where words can turn into situations, situations into words, texts into images, images into texts and, most importantly, theoretical knowledge into a surprising montage of synaesthetic practice. Following these reversible relations, exhibition as a practice is thus practice exhibited, whether scientific, cultural, or artistic. An exhibited practice does not rely on a symmetric transmission between the practical encounter *with* objects and textual knowledge *about* objects but introduces an asymmetry, a cut, a surprising happenstance, which opens up a space in between contemplative theory and closely engaged practice.

Practice and technique, exhibition and presentation are dialectical concepts that cannot be compartmentalized according to distinct and well defined disciplines. In line with Benjamin's insight we might state: art can only exhibit its own practice of exhibition when it is free of the confines of prescribed exhibition techniques. Only when left to its own devices, art exhibits its own mediacy, capacity, and purposiveness. If the exhibition value of art is forcibly increased (by means of curatorial trends of presentation or externally applied exhibition techniques), artistic objects, texts or situations exhibit only themselves—a commodity, that is, a material or immaterial bearer of economic surplus value devoid of its extra-economic surplus. ∎

14 Walter Benjamin, "Garlanded Entrance," in Walter Benjamin, *The Work of Art in the Age of Its Technological Reproducibility, and Other Writings on Media*, ed. Michael W. Jennings, Brigid Doherty, and Thomas Y. Levin, (Cambridge, MA, 2008), pp. 61–63 (trans. modified, S.K.).

„Gesundheitshaus" war nicht künstlerisch im engeren Sinne (es ging um die medizinische Frage der „gesunden" oder „intakten" Nerven); ihre Form der Präsentation berührte jedoch die Herausforderung, Objekte einem Massenpublikum im Zeitalter der technischen Reproduzierbarkeit vorzustellen – einem Zeitalter, das von einem tiefgreifenden Wandel der ästhetischen Wahrnehmungsweisen geprägt ist, der von fortgeschrittenen kapitalistischen Produktionsmitteln herbeigeführt, aber nicht auf diese reduzierbar ist. In einer dichten Passage reflektiert Benjamin über das Problem der Präsentation wissenschaftlicher Objekte und ihre Beziehung zu einem Massenpublikum von Nichtfachleuten. „[D]ie neue Volksbildung [geht] von der Tatsache des Massenbesuchs aus. Quantität in Qualität verwandeln ist die Parole, ein Umschlag, der für sie identisch mit dem vom Theoretischen zur Praxis ist. Die Besucher sollen, wie gesagt, Laien bleiben. Nicht gelehrter sollen sie die Ausstellung verlassen, sondern gewitzter. Die Aufgabe der echten, wirksamen Darstellung ist geradezu, das Wissen aus den Schranken des Faches zu lösen und praktisch zu machen. Aber was ist ‚echte Darstellung'? Mit andern Worten: was ist Ausstellungstechnik? […] Das heißt: echte Darstellung drängt die Kontemplation zurück. Um den Besucher, wie es hier geschehen ist, in die Schau hineinzumontieren, muß das Optische sich in Schranken halten. Verdummend würde jede Anschauung wirken, der das Moment der Überraschung fehlt. Was zu sehen ist, darf nie dasselbe, oder einfach mehr oder weniger sein, als eine Beschriftung zu sagen hätte. Es muß ein Neues, einen Trick der Evidenz mit sich führen, der mit Worten grundsätzlich nicht erzielt wird."[14] Diese umfassende Sichtweise des Verhältnisses von Ausstellungmethode und wirkungsvollen Präsentationsformen beschränkt sich nicht auf gängige pädagogische Ziele: Sie unterstützt die Interessen von Massenausstellungen und berücksichtigt den außerökonomischen Mehrwert, der durch die Praxis der Ausstellung von Objekten, Texten und Situationen für ein Massenpublikum entsteht. Dieser Mehrwert – spielerische Intelligenz oder Gewitztheit – wird präzise und kontrolliert erzeugt, seine Auswirkungen auf die Masse übersteigen jedoch kontrollierbare Vorschriften und Unterweisungen. Wirksame Intentionalität und unkontrollierbarer Effekt halten eine dialektische Spannung aufrecht. Das Massenpublikum der Ausstellung wird angesprochen, nicht aber als Mittel zum Zweck adressiert – es wird weder als pädagogisches Subjekt, das unterwiesen werden muss, noch als *ökonomischer Akteur*, der motiviert werden soll, Käufer oder Sammler zu werden, behandelt. Vielmehr gelingt es der Ausstellungsmethode, eine gewisse Überraschung, eine Spannung zu vermitteln, ohne einen idealen Rezipienten im Auge zu haben oder die ästhetischen Formen des Lesens, Sehens, Lernens vorzuschreiben.

Was Benjamin „echte Darstellung" nennt, verlässt die Grenzen der distanzierten Betrachtung und bezieht das Publikum in ihre eigene Zweckbestimmung mit ein, ohne einen bestimmten Zweck zu vermitteln. Der Besucher verlässt die Ausstellung nicht als Experte, als kenntnisreicher Gelehrter, sondern als überrachtes Subjekt, das für neue Einsichten offen ist. Diese neuen Einsichten beruhen auf einer synästhetischen, visuellen *und* taktilen Beziehung zwischen Besucher und Objekt, die im Ausstellungsraum erzeugt wird. Der Begriff „Besucher" mag in diesem Sinne zu eng gefasst sein, da der transdisziplinäre Ausstellungsraum, von dem Benjamin spricht, das Feld des Visuellen überschreitet – er beschränkt sich nicht auf eine optische Beziehung (die Distanz, Betrachtung zulässt), sondern öffnet einen Raum, in dem Worte zu Situationen, Situationen zu Worten, Texte zu Bildern, Bilder zu Texten und vor allem theoretisches Wissen zu einer überraschenden Montage synästhetischer Praxis werden können. Folgt man diesen reversiblen Bezügen, ist die Ausstellung als Praxis somit ausgestellte Praxis, sei sie nun wissenschaftlich, kulturell oder künstlerisch. Eine ausgestellte Praxis beruht nicht auf einer symmetrischen Übertragung zwischen der praktischen Begegnung mit Objekten und dem Textwissen über Objekte, sondern führt eine Asymmetrie, einen Schnitt, einen überraschenden Zufall ein, der einen Raum zwischen kontemplativer Theorie und eingreifender Praxis eröffnet.

Praxis und Methode, Ausstellung und Darstellung sind dialektische Konzepte, die sich nicht nach eindeutigen und klar definierten Disziplinen unterteilen lassen. Im Einklang mit Benjamins Erkenntnis könnte man sagen: Kunst kann ihre eigene Ausstellungspraxis nur dann zeigen, wenn sie frei von den Grenzen vorgeschriebener Ausstellungstechniken ist. Erst wenn sie sich selbst überlassen bleibt, zeigt die Kunst ihre eigene Medialität, Funktion und Intentionalität. Wenn der Ausstellungswert von Kunst erzwungen wird (durch kuratorische Präsentationstrends oder extern angewandte Ausstellungstechniken), zeigen künstlerische Objekte, Texte oder Situationen nichts als sich selbst – eine Ware, d. h. einen materiellen oder immateriellen Träger ökonomischen Mehrwerts ohne seinen außerökonomischen Mehrwert. ∎

Übersetzung: Otmar Lichtenwörther

14 Benjamin, Walter: „Bekränzter Eingang" in: Rexroth, Tillman (Hg.): *Gesammelte Schriften*, Bd. IV.1, Frankfurt/M 1989, 359–360.

Hidden in Plain Sight: "Illegal Artistic Exhibition"

Auf dem Präsentierteller versteckt: Die „Illegale Kunstausstellung"

Ana Dević

"Once the exhibition was closed, the comrades picked up their rifles to continue the struggle on the frontline."[1]
—Marin Studin

The clandestine counter exhibition "Illegal Artistic Exhibition," organized in 1943 in the occupied city of Split (Croatia) by a number of cultural workers and under the auspices of the National Liberation Committee Split and the Local Committee of the Communist Party, is sparsely known outside of the post-Yugoslav territory. This article not only contextualizes the "Illegal Artistic Exhibition" within the cultural production of the Yugoslav People's Liberation Struggle (henceforth, NOB),[2] its subsequent reception, and its status within the collective memory, but furthermore touches upon the modalities of exhibiting in impossible conditions, in this case, within the extreme and sociopathic climate of the Second World War. Positioning the "Illegal Artistic Exhibition" within the historical context of cultural production of the NOB and anti-fascist resistance during the Second World War in Yugoslavia, I reflect on the exhibition as an active component of the resistance to fascism.

Focusing on the "Illegal Artistic Exhibition" as a case study, this article also discusses potential interventionist aspects of the exhibition format that can stimulate the broadening of our understanding of the exhibition as a medium. Although I am primarily addressing some aspects of historical anti-fascist artistic production in Split, it is important to note that the exhibition was an integral part of the liberation struggle against the Nazifascist occupying forces, and thus forms a part of the greater multidimensional political, historical, military and cultural formation that, in the words of Gal Kirn, "should be read as a complex encounter of social forces that waged anti-fascist struggles and wars of national liberation, and also started the socialist revolution."[3]

"Illegal Artistic Exhibition" in the Context of Antifascist Resistance in Split. During the Second World War, Split played a prominent role in the resistance to Nazi-fascism. From the very beginning of the war, an active group of artists was directly working with the Communist Party[4] as a part of the Action Committee of Intellectuals based in Split. This circle of artists, comprised of visual artists and cultural workers, included such figures as Mirko Ostoja, Marin Studin, Pero Ružić, Ivo Lozica, Franka and Duško Stanojević, Ante Kostović, Raul Goldoni, Nikola Ignjatović, Ante Zuppa, Vjekoslav and Dalibor Parać, Živko Kljaković, Ljubo Nakić, Rudlof Sablić, Petar Zrinski, Rudolf Bunk, Branko Kovaičević, and Ivo Lovrenčić. Many of them took part in the "Illegal Artistic Exhibition" either as artists or organizers. As the resistance grew in the city, the artists became increasingly organized around the Action Committees. Illegal print offices were set up in special bunkers in the neighborhood of Gripe. A group of young artists, including Mirko Ostoja[5], Ante Šitić, and Raul Goldoni, were engaged in cutting templates for posters and slogans that were then sent to the "woods" to the fellow partisan fighters on the front line.[6] The "Illegal Artistic Exhibition" was inaugurated by the closed circle of artists and conspirators on April 7, 1943, thus marking the first anniversary of the constitution of the City People's Committee that had been established in Split exactly one year earlier. The City People's Committee Split was the first instance of a new people's anti-fascist authority, and it soon became the political engine around which all progressive artists were gathering. Its main aims were to claim the continuity of free cultural activities in occupied Split and to raise funds to support both the armed resistance struggle and the artists in the city who refused to collaborate with the fascist authority.[7]

The "Illegal Artistic Exhibition" had first been initiated during a meeting between the artists Antun Zuppa and Marin Studin, composer Ivo Tijardović, conductor Maks Ungar, writer Razija Handić, and actor Slavko Štetić. This group drafted a proposal that was later was accepted by and received the support of the Local Committee of the Communist Party and the National Liberation Committee of the City of Split. Studin was chosen to be a main coordinator of the exhibition.

It is important to stress at this point that the artists who took part in and organized the "Illegal Artistic Exhibition" had all refused to exhibit their works within the official fascist exhibition "Mostra d'Arte," which had been an organized attempt by the *Istituto nazionale di cultura fascista*[8] to co-opt the

1 Marin Studin, "Ilegalna izložba slika i kipova u Splitu," *Naprijed*, June 2, 1945, p. 8. (Trans. A.D.)

2 This abbreviation, widely used in domestic and international scholarship, is derived from the local name for the People's Liberation Stuggle: "*Narodnooslobodilačka borba.*"

3 Gal Kirn, "On the Specific (In)existence of the Partisan Film in Yugoslavia's People's Liberation Struggle," in *Yugoslavia: Literature, Film and Visual Culture*, ed. Miranda Jakiša and Nikica Gilić (Bielefeld, 2015), pp. 197–227, esp. p. 200.

4 The Communist Party of Yugoslavia (KPJ) had been founded in 1919 and was banned by the Kingdom of Yugoslavia's government in 1920. In the beginning, the KPJ was a "cadre party and a section of the Comintern, obliged to international discipline as a member of the World Communist Movement but without much influence on the bodies of the Communist Party, finding itself at the margins of its policy. The inner renovation of the KPJ started, in the period from 1932 to 1934, even without the influence of the Central Committee of the Comintern." Branko Petranović, "Narodni front i komunisti", *Istorija Jugoslavije: 1918–1988* (Beograd, 1988), pp. 212–213 (Trans. A.D.).

5 Marko Ostoja was the commissioner of Agitprop of the People's Liberation Committee for Dalmatia.

6 See Studin, "Ilegalna izložba" (see note 1).

7 Ibid.

8 National Institute of Fascist Culture.

„Als die Ausstellung beendet war, nahmen die Kameraden wieder ihre Gewehre in die Hand, um den Kampf an der Front fortzusetzen."[1] (Marin Studin)

Von der im Geheimen organisierten Gegenausstellung „Illegale Kunstausstellung", die 1943 in der besetzten Stadt Split (Kroatien) von einer Reihe von Kulturschaffenden unter der Schirmherrschaft des Nationalen Befreiungskomitees Split und des Lokalkomitees der Kommunistischen Partei organisiert wurde, ist außerhalb des post-jugoslawischen Territoriums kaum etwas bekannt. Dieser Artikel kontextualisiert die „Illegale Kunstausstellung" nicht nur innerhalb des Kulturschaffens des jugoslawischen Volksbefreiungskampfes (NOB),[2] seiner späteren Rezeption und seines Status im kollektiven Gedächtnis, sondern berührt auch die Modalitäten des Ausstellens unter unmöglichen Bedingungen, in diesem Fall im extremen und soziopathischen Klima des Zweiten Weltkriegs. Indem ich die „Illegale Kunstausstellung" im historischen Kontext der Kulturproduktion des NOB und des antifaschistischen Widerstands während des Zweiten Weltkriegs in Jugoslawien verorte, verstehe ich die Ausstellung als aktiven Bestandteil des Widerstandes gegen den Faschismus.

Mit Hauptaugenmerk auf der „Illegalen Kunstausstellung" als Fallstudie werden in diesem Artikel auch mögliche interventionistische Aspekte des Ausstellungsformats diskutiert, die die Erweiterung unseres Verständnisses der Ausstellung als Medium anregen können. Obwohl ich mich in erster Linie mit einigen Aspekten der historischen antifaschistischen Kunstproduktion in Split befasse, ist es wichtig, darauf hinzuweisen, dass die Ausstellung ein wesentlicher Bestandteil des Befreiungskampfes gegen die nationalsozialistischen Besatzungsmächte war und somit Teil der größeren multidimensionalen politischen, historischen, militärischen und kulturellen Formation ist, die, in Gal Kirns Worten, „als komplexes Zusammentreffen sozialer Kräfte zu lesen ist, die antifaschistische Kämpfe und nationale Befreiungskriege führten, und auch die sozialistische Revolution auslösten."[3]

Die „Illegale Kunstausstellung" im Kontext des antifaschistischen Widerstands in Split. Während des Zweiten Weltkriegs spielte Split eine herausragende Rolle im Widerstand gegen den Nazi-Faschismus. Von Beginn des Krieges an arbeitete eine aktive Gruppe von Künstlern direkt mit der Kommunistischen Partei[4] als Teil des Aktionskomitees der Intellektuellen mit Sitz in Split zusammen. Dieser Künstlerkreis, bestehend aus bildenden KünsterInnen und KulturarbeiterInnen, umfasste Persönlichkeiten wie Mirko Ostoja, Marin Studin, Pero Ružić, Ivo Lozica, Franka and Duško Stanojević, Ante Kostović, Raul Goldoni, Nikola Ignjatović, Ante Zuppa, Vjekoslav und Dalibor Parać, Živko Kljaković, Ljubo Nakić, Rudlof Sablić, Petar Zrinski, Rudolf Bunk, Branko Kovačević und Ivo Lovrenčić. Viele von ihnen nahmen entweder als Kunstschaffende oder Organisatoren an der „Illegalen Kunstausstellung" teil. Als der Widerstand in der Stadt zunahm, organisierten sich die Künstler zunehmend um das Aktionskomitees herum. In der Umgebung von Gripe wurden in speziellen Bunkern illegale Druckereien eingerichtet. Eine Gruppe junger Künstler, darunter Mirko Ostoja,[5] Ante Šitić und Raul Goldoni, beschäftigte sich mit dem Zuschnitt von Schablonen für Plakate und Slogans, die dann in die „Wälder" zu den Partisanen-Kollegen an der Front geschickt wurden.[6] Die „Illegale Kunstausstellung" wurde am 7. April 1943 durch diesen geschlossenen Zirkel von Kunstschaffenden und Verschwörern eröffnet und markiert damit den ersten Jahrestag der Konstituierung des Städtischen Volkskomitees, das genau ein Jahr zuvor in Split gegründet worden war. Das Städtische Volkskomitee Split war das erste Beispiel für eine neue antifaschistische Volksvertretung und es wurde bald zum politischen Motor, um welchen sich alle progressiven Kunstschaffenden versammelten. Seine Hauptziele waren, die Kontinuität der freien Kulturaktivitäten im besetzten Split zu beanspruchen und Gelder zu sammeln, um sowohl den bewaffneten Widerstandskampf als auch die Kunstschaffenden in der Stadt zu unterstützen, die sich weigerten, mit den faschistischen Behörden zusammenzuarbeiten.[7]

Die „Illegale Kunstausstellung" wurde während eines Treffens zwischen den Künstlern Antun Zuppa und Marin Studin, dem Komponisten Ivo Tijardović, dem Dirigenten Maks Ungar, dem Schriftsteller Razija Handić und dem Schauspieler Slavko Štetić erstmals initiiert. Diese Gruppe erarbeitete einen Vorschlag, der später vom Lokalkomitee der Kommunistischen Partei und dem Nationalen Befreiungskomitee der Stadt Split angenommen und unterstützt wurde. Studin wurde als Hauptkoordinator der Ausstellung ausgewählt.

An dieser Stelle ist es wichtig zu betonen, dass die Künstler, die an der „Illegalen Kunstausstellung" teilgenommen und diese organisiert haben, sich alle geweigert haben, ihre Werke im Rahmen der offiziellen faschistischen Ausstellung „Mostra d'Arte" auszustellen, die ein organisierter Versuch des *Istituto nazionale di cultura fascista*[8] war, die lokale Kulturszene

1 Studin, Marin: „Ilegalna izložba slika i kipova u Splitu", in: *Naprijed*, 2. Juni 1945, 8. (A.d.Ü.: Übersetzung auf Basis der Übersetzung der Autorin ins Englische)

2 In diesem Text fortan NOB genannt. Diese in der nationalen und internationalen Forschung weit verbreitete Abkürzung leitet sich von der lokalen Bezeichnung für den Volksbefreiungskampf ab: *„Narodnooslobodilačka borba".*

3 Kirn, Gal: „On the Specific (In)existence of the Partisan Film in Yugoslavia's People's Liberation Struggle", in: Jakiša, Miranda/Gilić, Nikica (Hg.): *Yugoslavia: Literature, Film and Visual Culture*, Bielefeld 2015, 197–227, hier 200.

4 Die Kommunistische Partei Jugoslawiens (KPJ) wurde 1919 gegründet und 1920 von der Regierung des Königreichs Jugoslawien verboten. Am Anfang war die KPJ eine „Kaderpartei und eine Sektion der Komintern, die als Mitglied der kommunistischen Weltbewegung der internationalen Disziplin verpflichtet war, aber ohne großen Einfluss auf die Organe der Kommunistischen Partei, und an den Rändern ihrer Politik angesiedelt. Die innere Erneuerung der KPJ begann zwischen 1932 und 1934 sogar ohne Einflussnahme seitens des Zentralkomitees der Komintern." Petranović, Branko: „Narodni front i komunisti", in: *Istorija Jugoslavije: 1918–1988*, Belgrad 1988, 212–213 (A.d.Ü.: Übersetzung auf Basis der Übersetzung der Autorin ins Englische).

5 Marko Ostoja war Agitprop-Kommissar des Volksbefreiungskomitees für Dalmatien.

6 Vgl. Studin, „ilegalna izložba" (wie Anm. 1).

7 Ebd.

8 Istituto Nazionale di Cultura Fascista

local cultural scene of Split under the fascist occupation. Before that, in 1941, the Italian prefect also called for artists to make decorative figures for the palace of the fascist prefecture, and many of the artists refused cooperation and consolidated their positions. In Split, people boycotted the fascist cultural manifestations.[9] The fascist nomenklatura applied pressure to co-opt the artists to take part in "Mostra d'Arte," offering commissions of the works and other privileges.[10] "The Italian prefect was persistent, he was promising the artists numerous benefits, life in Rome, Venice, Florence … But the answer was a collective silence. It is fascinating that not a single artist in Split accepted this invitation."[11]

As the "Mostra d'Arte" exhibition was collectively boycotted, ultimately no local artists were included. Instead, the fascist attempt to co-opt local artists sparked a counter exhibition: the "Illegal Artistic Exhibition." This somewhat tautological name stands in opposition to "Mostra d'Arte," appropriating its title and adding the adjective "illegal" as an acknowledgment of its clandestine status and as a reference to communist "Ilegala."

The exhibition was set up in a flat where Marin Studin lived with his family, situated at a highly frequented location in the city center at the Corso di Italia 15,[12] in the same building where a dentist office popular among fascists was located.[13] During the exhibition Studin's family was closely involved with the organization; Studin and his wife Bira[14] served as the "exhibition guard," creating a changing system of passwords that ensured a safe entrance to the apartment, whereas their 15-year-old daughter Sunčana was the courier communicating the password to the audience.[15]

The exhibition lasted for six months and encompassed around 80 artworks by eight local artists as members and sympathizers of NOB and the Communist Party: Nikola Ignjatović, Ivo Lozica, Ljubomir Nakić, Rudolf Sablić, Marin Studin, Vjekoslav Parać, Ivo Tijardović, and Antun Zuppa. From April until September 1943, the exhibition was continuously open to an audience that supported the anti-fascist movement, with an estimated 2,000 visitors.[16] The exhibition was kept undercover through the solidarity of the inhabitants of the city, not only among supporters of the partisan movement, but among ordinary citizens as well. The exhibition encompassed a selection of figurative paintings, sculptures, and drawings presenting mostly social themes, such as suffering, struggle, class relations, as evidenced by the titles of the works, such as "Poor People in Front of the Soup Kitchen" and "Fisherman's Lunch" by Antun Zuppa or "Executed Partisans" by Vjekoslav Parać.

The artworks, primarily paintings and drawings, as well as several bronze and wooden sculptures and reliefs (Studin's "Pioneer," "Proletarian," and "Avenger"[17] among them) were placed in three rooms; paintings hung on the walls, while the

2
Venue for the "Illegal Artistic Exhibition" | Veranstaltungsort der „Illegalen Kunstausstellung", Split, 1943 © Archive of The Split City Museum | Archiv des Stadtmuseums Split

sculptures were leaning against the furniture or were placed on pedestals. During the exhibition, and as an integral part of it, material aid for the partisan struggle was surreptitiously collected, an activity that needed to be camouflaged. The spatial arrangement of the art objects and the furniture in the flat resembled a

9 See Studin, "Ilegalna izložba" (see note 1).

10 Similar exhibitions took place in Zagreb, such as traveling Nazi exhibitions, but also exhibitions of local producers organized by the fascist authorities were held as well. For example, the "2nd Exhibition of Croatian Artists in NDH" (Independent State of Croatia), Umjetnički paviljon (22. 11.–13. 12. 1942), organized in Zagreb.

11 Studin, "Ilegalna izložba" (see note 1).

12 The frequent change of the street's name mirrors the political shifts; before the Second World War the street was named after Ivo Tartaglia, the mayor of Split. During socialism, it was renamed to "Ulica Prvoboraca" (Street of Partisan Fighters). And, since the early 1990s, the street bears the name of Croatian King Zvonimir.

13 Studin, "Ilegalna izložba" (see note 1). The fact that the exhibition was placed in a well-attended location was beneficial, as the mass of people that visited the exhibition were less suspicious to the fascist authorities.

14 Studin's wife Bira was the sister of eminent Croatian sculptor Ivan Meštrović.

15 See Studin, "Ilegalna izložba" (see note 1).

16 Ibid.

17 Studin's "Avenger" was chosen by Split's City People's Committee as a gift to be given to Josip Broz Tito, the general secretary of the Communist Party of Yugoslavia and the leader of the partisan People's Liberation Movement, during his visit to Split.

von Split unter der faschistischen Besatzung einzubinden. Zuvor, 1941, forderte der italienische Präfekt auch Künstler auf, dekorative Figuren für den Palast der faschistischen Präfektur herzustellen, und viele der KünstlerInnen lehnten die Zusammenarbeit ab und festigten ihre Positionen. In Split boykottierten die Menschen die faschistischen Kulturäußerungen.[9] Die faschistische Nomenklatura übte Druck auf die Künstler aus, sich an der „Mostra d'Arte" zu beteiligen und bot Auftragswerke und andere Privilegien an.[10] „Der italienische Präfekt war hartnäckig, er versprach den Kunstschaffenden zahlreiche Vergünstigungen, ein Leben in Rom, Venedig, Florenz [...]. Doch kollektives Schweigen war die Antwort. Es ist faszinierend, dass kein einziger Künstler in Split diese Einladung angenommen hat."[11]

Die Ausstellung „Mostra d'Arte" wurde kollektiv boykottiert und letztendlich nahm kein einziger einheimischer Künstler daran teil. Stattdessen war der faschistische Versuch, lokale Künstler gleichzuschalten, der Auslöser für eine Gegenausstellung: die „Illegale Kunstausstellung". Dieser etwas tautologische Name steht im Gegensatz zur „Mostra d'Arte" (dt.: „Kunstausstellung"), indem er sich deren Titel aneignet und das Adjektiv „illegal" als Bekenntnis zu ihrem heimlichen Status und als Verweis auf die „Illegalität" der Kommunisten hinzufügt.

Die Ausstellung wurde in einer Wohnung eingerichtet, in der Marin Studin mit seiner Familie wohnte, an einem stark frequentierten Ort im Stadtzentrum am Corso di Italia 15,[12] im selben Gebäude, in dem sich auch eine bei den Faschisten beliebte Zahnarztpraxis befand.[13] Während der Ausstellung war die Familie Studin eng mit der Organisation verbunden; Studin und seine Frau Bira[14] fungierten als „Ausstellungswächter" und schufen ein System von wechselnden Losungsworten, die einen sicheren Zutritt zur Wohnung sicherstellten, während ihre 15-jährige Tochter Sunčana die Kurierin war, die dem Publikum das Losungswort mitteilte.[15]

Die Ausstellung dauerte sechs Monate und umfasste rund 80 Kunstwerke von acht lokalen Künstlern als Mitglieder und Sympathisanten des NOB und der Kommunistischen Partei: Nikola Ignjatović, Ivo Lozica, Ljubomir Nakić, Rudolf Sablić, Marin Studin, Vjekoslav Parać, Ivo Tijardović, und Antun Zuppa. Von April bis September 1943 war die Ausstellung durchgehend für ein Publikum geöffnet, das die antifaschistische Bewegung unterstützte. Sie hatte schätzungsweise 2.000 Besucher.[16] Die Ausstellung wurde durch die Solidarität der Stadtbevölkerung verdeckt gehalten, nicht nur unter den Anhängern der Partisanenbewegung, sondern unter der ganzen Bevölkerung. Die Ausstellung umfasste eine Auswahl von figürlichen Gemälden, Skulpturen und Zeichnungen, die vor allem soziale Themen wie Leiden, Kampf, Klassenverhältnisse, wie die Titel der Werke belegen, wie z.B. „Arme Leute vor der Suppenküche" und „Fischermittagessen" von Antun Zuppa oder „Hingerichtete Partisanen" von Vjekoslav Parać.

Die Kunstwerke, vornehmlich Gemälde und Zeichnungen, sowie mehrere Bronze- und Holzskulpturen und Reliefs (darunter Studins „Pionier", „Proletarier" und „Rächer"[17]) wurden in drei Räumen platziert; Gemälde hingen an den Wänden,

während die Skulpturen an den Möbeln lehnten oder auf Sockeln standen. Während der Ausstellung und als wesentlicher Bestandteil der Ausstellung wurde heimlich materielle Hilfe für den Partisanenkampf gesammelt, eine Tätigkeit, die getarnt werden musste. Die räumliche Anordnung der Kunstobjekte und der Möbel in der Wohnung glich einer typischen bürgerlichen Wohnsituation. Ausgehend von den wenigen Originalfotografien, die die Ausstellung dokumentieren, lässt sich schwer sagen, ob das, was der Betrachter betrachtete, tatsächlich eine Ausstellung war und nicht nur das Interieur einer ganz gewöhnlichen Wohnung.

Es wurden jedoch alle wesentlichen Elemente des Ausstellungsgenres einbezogen: Abgesehen von einer feierlichen Eröffnung wurden die Werke vor der Ausstellung ordentlich gerahmt,[18] die Ausstellung gepflegt und einige performative Aspekte entwickelt; die Skulptur „Mutter" nahm in der Ausstellung einen prominenten Platz ein und wurde als Trauergeste für den kurz vor der Ausstellungseröffnung hingerichteten Bildhauer Ivo Lozica in schwarzes Tuch gehüllt. Für den Fall, dass Faschisten die Wohnung betreten sollten, umfasste die Auswahl auch „neutrale" Werke wie klassische Landschaftsgemälde oder Stillleben, die als Täuschungswerkzeuge fungierten. In der Ausstellung konnte man speziellen Codes folgen, die nur den Teilnehmern bekannt waren, wie z.B. die Auswahl der Sehenswürdigkeiten von Split, die das „rote" Viertel von Vela Varoš darstellten, aus dem viele Teilnehmer am Partisanenkampf stammten. Eines der ausgestellten Gemälde, Nikola Ignjatovićs „1. Mai 1942", schilderte das bemerkenswerte Protestereignis, das sich unter faschistischer Besatzung in Split am 1. Mai 1942 ereignete, als

9 Vgl. Studin, „Ilegalna izložba" (wie Anm. 1).

10 Ähnliche Ausstellungen fanden in Zagreb statt, wie z.B. nationalsozialistische Wanderausstellungen, aber auch Ausstellungen lokaler Kunstschaffender, die von den faschistischen Behörden organisiert wurden. Zum Beispiel in der vom 22.11. bis 13.12.1942 im Umjetnički paviljon in Zagreb gezeigten „II. Ausstellung kroatischer Künstler im NDH" (Unabhängiger Staat Kroatien).

11 Studin, „Ilegalna izložba" (wie Anm. 1).

12 Die häufige Änderung des Straßennamens spiegelt die politischen Veränderungen wider; vor dem Zweiten Weltkrieg wurde die Straße nach Ivo Tartaglia, dem Bürgermeister von Split, benannt, während des Sozialismus wurde sie in „Ulica Prvoboraca" (Straße der Partisanenkämpfer) umbenannt. Seit den frühen 1990er Jahren trägt sie den Namen des kroatischen Königs Zvonimir.

13 Studin, „Ilegalna izložba" (wie Anm. 1). Die Tatsache, dass die Ausstellung an einem gut besuchten Ort stattfand, war von Vorteil, da die Masse der Besucher der Ausstellung für die faschistischen Behörden weniger verdächtig war.

14 Studins Frau Bira war eine Schwester des bedeutenden kroatischen Bildhauers Ivan Meštrović.

15 Vgl. Studin, „Ilegalna izložba" (siehe Fußnote 1).

16 Ebd.

17 Studins „Rächer" wurde vom Volkskomitee der Stadt Split als Geschenk an Josip Broz Tito, den Generalsekretär der Kommunistischen Partei Jugoslawiens und Führer der Partisanenbewegung der Volksbefreiung, während seines Besuchs in Split ausgewählt.

18 Ivan Galić, ein Galerist und Initiator eines Kunstsalons, rahmte alle Kunstwerke. Unter dem Namen „Salon Galić" ist diese Galerie noch immer in Split aktiv. Vgl. Božanić-Bezić, Nevenka: „Ilegalna likovna izložba–jednstveni događaj u probljenoj Evropi", in: *Poruka borca*, Zbornik 3, Split 1973, 723–728.

typical middle class living situation. Judging from the few original photographs documenting the exhibition, it would be hard to tell that what the observer was looking at was actually an exhibition, rather than just the interior of an ordinary flat.

However, all integral elements of the exhibition genre were included: apart from having an inauguration opening, the works were properly framed before being exhibited,[18] the exhibition was maintained and some performative aspects were developed; the sculpture "Mother" occupied a prominent position in the exhibition and was wrapped in black cloth as a gesture of mourning for the sculptor, Ivo Lozica, who had been executed shortly before the exhibition opening. In preparation for the event that fascists would enter the apartment, the selection also encompassed "neutral" works, such as classical landscape or still life paintings, functioning as tools of deception. In the exhibition one could follow special codes only known among participants, for example, the choice of the sights of Split depicted a "red" neighborhood of "Vela Varoš" from which many members of the partisan struggle originated. One of the exhibited paintings, Nikola Ignjatović's "May 1, 1942," depicted the remarkable protest event that happened under fascist occupation in Split on May 1, 1942 when a seven meter long red flag had been installed onto the tower of the Cathedral of St. Duje.[19] Using the gesture of protest in public space as a motive of the painting is indicative for the versatile and often "spectacular" forms of resistance protests organized in occupied cities.[20]

Equally important is the fact that the exhibition entailed a crowd-funding process to support the partisan struggle through the selling of art works to visitors. As soon as one of the works was sold, another was put on display. As new art works were continuously added to the exhibition, the presentation was continuously changing, diversifying in its overall content. The exhibition raised 100,000 lira, of which 10% was donated to support the partisan armed struggle and was sent to the frontline, 60% was allocated to participating artists, and 30% was donated to other artists in the city who were supporting resistance.[21]

The exhibition also played a cohesive role in the spreading of the movement, serving as a meeting place for members of the City People's Committee.[22] Initiated as a gesture of resistance, the continuous collective effort and self-organization played a crucial role in the way the exhibition was conceived, organized, maintained, and supported by the audience. What makes the event of the "Illegal Artistic Exhibition" exceptional is not only the courage of its protagonists and audience in the wider context of the Second World War. The exhibition was also an unprecedented cultural event that, in extreme circumstances, succeeded in producing a counter-public within the reconfigured locus of an exhibition conceived as a continuous, political, and convivial pursuit that formed a support structure enabling the expression of dissent and solidarity. Over the duration of many months, the exhibition served as a convivial gathering place where clothing, food, and books were collected for frontline fighters, as well as toys for children living in the liberated territories.[23]

One of the reasons for such a strong people's response was the prominent role of Split within the workers' movement between the two wars. At the end of the 1930s, many protests arose in Split in response to the police killing of shipyard worker and Communist Party member Vicko Buljanović. On December 18, 1939 the people of Split organized a funeral for Buljanović, which quickly turned into mass rallies involving 25,000 people from Split. The funeral was preceded by a general strike involving 12,000 people.[24] This massive protest happened in the very same street where the "Illegal Artistic Exhibition" was later held, so it seems that the choice of the venue certainly resonated in the collective memory as a place of protest and opposition. The planned extension of the exhibition was interrupted by the capitulation of Italy. Among others artists, Mirko Ostoja and Rudolf Bunk had also been preparing to participate, but the exhibition was closed upon the liberation of the city of

18 Ivan Galić, a gallerist and initiator of an art salon, framed all the art works for the exhibition. This gallery is still active in Split under the name "Salon Galić." See Nevenka Božanić-Bezić, "Ilegalna likovna izložba–jednistveni događaj u probljenoj Evropi," in Poruka borca, Zbornik 3, (Split, 1973), pp. 723–728.

19 This action was realized by two young activists, Mirko Dvornik and Franka Gospodnetić-Sojka by using the dynamite that activated the flag at high noon. The idea for that action came from the party cell under the leadership of Jugana Kezić-Senjanović. In 1961, the feature film Stairs of Courage by Oto Denš depicted this legendary event that exhilarated people and confused the fascist forces. See also Marin Kuzmić, Antifašistički Split Ratna kronika 1941–1945. Udruga antifašističkih boraca i antifašista Grada Splita (Split, 2011), p. 241.

20 For similar protest actions imbued with bold performative gestures of protest in Slovenia, see Miklavž Komelj's description of May 1st protest in Ljubljana, where the actions involved painting slogans on the facades of buildings and the sound of explosions ringing throughout the whole city. See Miklavž Komelj, Kako misliti partizansko umetnost? (Ljubljana, 2009), pp. 16–17.

21 Stipe Delić, "Splitska epopeja," interview by Jakov Jalinov, Vjesnik, December 1, 1986, p. 14. (Trans. A.D.)

22 Such an exhibition had become possible, not only due to skillful planning and well-developed organizational strategies but also due to the fact that the resistance in Split and in the wider region of Dalmatia was exceptionally strong and versatile. It is estimated that out of the pre-war Split population of around 40,000 people, 12,500 joined the partisan struggle on the frontline, while the majority of the citizens supported NOB. In the summer of 1944, the number of NOB activists in Split reached 15,000, meaning that every other resident of Split was involved in it. Damir Pilić, "Split: Cijeli grad otišao u partizane," BUKA, October 26, 2016, http://www.6yka.com/novost/115954/split-cijeli-grad-otisao-u-partizane.

23 See Delić, "Splitska epopeja" (see note 21).

24 Goran Kotur, "Split prkosi okupatoru," in Antifašistički Split Ratna kronika 1941–1945. Udruga antifašističkih boraca i antifašista Grada Splita, ed. Marin Kuzmić, (Split, 2011), pp. 16–19.

eine sieben Meter lange rote Fahne auf dem Turm der Kathedrale von St. Duje installiert wurde.[19] Die Verwendung der Geste des Protestes im öffentlichen Raum als Motiv des Gemäldes ist bezeichnend für die vielfältigen und oft „spektakulären" Formen von in besetzten Städten organisierten Widerstandsprotesten.[20]

Ebenso wichtig ist die Tatsache, dass die Ausstellung einen Crowdfunding-Prozess mit sich brachte, um den Partisanenkampf durch den Verkauf von Kunstwerken an die Besucher zu unterstützen. Sobald eines der Kunstwerke einen Käufer gefunden hatte, wurde ein weiteres ausgestellt. Da die Ausstellung ständig um neue Kunstwerke erweitert wurde, änderte sich die Präsentation ständig und diversifizierte sich in ihrer Gesamtheit. Die Ausstellung brachte 100.000 Lire ein, von denen 10% zur Unterstützung des bewaffneten Partisanenkampfes gespendet und an die Front geschickt wurden, 60% an die teilnehmenden Kunstschaffenden gingen und 30% an andere Kunstschaffende in der Stadt, die den Widerstand unterstützten.[21]

Die Ausstellung spielte auch eine Rolle als Bindeglied bei der Verbreitung der Bewegung und diente als Treffpunkt für die Mitglieder des Städtischen Volkskomitees.[22] Initiiert als Geste des Widerstandes, spielten kontinuierliche kollektive Anstrengung und Selbstorganisation eine entscheidende Rolle bei der Konzeption, Organisation und Pflege der Ausstellung, und der Art und Weise, wie sie vom Publikum unterstützt wurde. Das Besondere an der Veranstaltung der „Illegalen Kunstausstellung" ist nicht nur der Mut der Protagonisten und des Publikums im weiteren Kontext des Zweiten Weltkriegs. Die Ausstellung war auch ein beispielloses Kulturereignis, das es unter extremen Umständen schaffte, eine Gegenöffentlichkeit innerhalb des rekonfigurierten Ortes einer Ausstellung zu schaffen, die als kontinuierliches, politisches und geselliges Unterfangen konzipiert war und einen Unterstützungsrahmen bildete, der den Ausdruck von

Dissens und Solidarität ermöglichte. Über viele Monate hinweg diente die Ausstellung als geselliger Treffpunkt, an dem Kleidung, Lebensmittel und Bücher für Frontkämpfer sowie Spielzeug für Kinder in den befreiten Gebieten gesammelt wurden.[23]

Einer der Gründe für die so starke Reaktion der Bevölkerung war die bedeutende Rolle von Split innerhalb der Arbeiterbewegung in der Zwischenkriegszeit. Ende der 1930er Jahre kam es in Split zu zahlreichen Protesten als Reaktion auf die Ermordung des Werftarbeiters und KP-Mitglieds Vicko Buljanović durch die Polizei. Am 18. Dezember 1939 organisierten die Spliter ein Begräbnis für Buljanović, das sich schnell in eine Massenkundgebung mit 25.000 Menschen aus Split verwandelte. Der Beerdigung ging ein Generalstreik voraus, an dem

19 Diese Aktion wurde von zwei jungen Aktivisten, Mirko Dvornik und Franka Gospodnetić-Sojka, mit Dynamit realisiert, das die Fahne zu Mittag aktiviert hat. Die Idee zu dieser Aktion kam von der Parteizelle unter der Führung von Jugana Kezić-Senjanović. Der Spielfilm Stairs of Courage (Treppen des Mutes) von Oto Denš schilderte 1961 dieses legendäre Ereignis, das die Menschen erheiterte und die faschistischen Kräfte verwirrte. Siehe auch Kuzmić, Marin: Antifašistički Split Ratna kronika 1941–1945. Udruga antifašističkih boraca i antifašista Grada Splita, Split 2011, 241.

20 Für ähnliche Protestaktionen, die von kühnen performativen Gesten des Protests in Slowenien durchdrungen sind, siehe Miklavž Komeljs Beschreibung der Aktion vom 1. Mai in Ljubljana, als mit Parolen an den Fassaden und Explosionen in der ganzen Stadt protestiert wurde. Siehe Komelj, Miklavž: Kako misliti partizansko umetnost? Ljubljana 2009, 16–17.

21 Delić, Stipe: „Splitska epopeja", ein Gespräch mit Jakov Jalinov, Vjesnik, 1. Dezember 1986, 14. (A.d.Ü.: Übersetzung auf Basis der Übersetzung der Autorin ins Englische)

22 Eine derartige Ausstellung war nicht nur durch geschickte Planung und gut entwickelte Organisationsstrategien möglich geworden, sondern auch dadurch, dass der Widerstand in Split und in der Region Dalmatien außerordentlich stark und vielseitig war. Es wird geschätzt, dass von den rund 40.000 Einwohnern der Vorkriegszeit, die in Split lebten, 12.500 sich dem Partisanenkampf an der Front anschlossen und der Großteil der Bevölkerung den NOB unterstützte. Im Sommer 1944 erreichte die Zahl der NOB-Aktivisten in Split 15.000, was bedeutet, dass jeder zweite Bewohner von Split daran beteiligt war. Pilić, Damir: „Split: Cijeli grad otišao u partizane", in: BUKA, 26. Oktober 2016, online unter: http://www.6yka.com/novost/ 115954/split-cijeli-grad-otisao-u-partizane.

23 Siehe Delić, „Splitska epopeja" (wie Anm. 21).

Split in September 1943. At the time Split was the only free city of its size in occupied Europe.[25] The struggle of the artists and organizers who had taken part in the "Illegal Artistic Exhibition" subsequently continued on the front.

What is Partisan in the Artistic Production of NOB?

On the territory of Yugoslavia the Second World War formally started on April 6, 1941 when the Axis powers attacked the Kingdom of Yugoslavia, which capitulated on April 17, 1941. The fragmentation of Yugoslav territory was followed by a system of occupation in which local quislings collaborated with the Nazi-fascist forces. Beginning with various acts of resistance, including local uprisings and acts of sabotage, the Yugoslav People's Liberation War started in the summer of 1941 as the resistance activities spread through all parts of the country and, in few months time, led to a mass folk uprising.[26] The Communist Party of Yugoslavia led the NOB and the Partisan Army from 1941 to 1945. In all parts of Yugoslavia, the NOB was directly organized by the Communist Party, except in Slovenia, where partisan activities were organized by the Liberation Front, "an organization that united a variety of anti-fascist groups, with cultural workers among its founding groups."[27] "By the end of the war there were more than 800,000 partisans organized in four Yugoslav armies, which made it the largest resistance movement and army in Europe."[28]

The NOB was characterized by a massive response of cultural workers resulting in artistic production that radically mixed high and low culture. These cultural workers not only instrumentalized artistic production as a weapon of agitation and propaganda, but were also democratizing it by using artistic creativity as a form of educational empowerment. This enabled experimentation in various popular, often collective, formats such as poetry, choirs, people's agit-theatre, propaganda prints, posters, caricatures, wall papers, drawings, graphics, popular songs, film, and photography, as well as some hybrid formats such as the famed "oral newspapers" (usmene novine). These diverse cultural practices played various important roles, ranging from being activist tools for mobilizing masses, to taking part in constructing the identity of the nascent state, to serving the propagandistic, educational, memorial, convivial and intimate purposes in documenting traumatic events of the war.

The response from Croatian artists was massive; about 106 artists joined the partisan struggle and produced a wide range of artworks.[29] As with many other agitprop departments during the NOB, their activities were mostly concerned with translating the revolutionary enthusiasm of the anti-fascist uprising to a graphic and visual language in the formats of posters, paroles, agitation printouts and linocuts clandestinely produced in illegal print shops – the so-called "techniques." The artistic production of the NOB, seen as a whole, is dominated by the work of artist-partisans who, whether in the battlefields or in liberated territories, acted in direct connection with political struggle under the auspices of the Communist Party of Yugoslavia and the auxiliary bodies of the party's Committee. One prominent example would be the agitprop units whose task was to organize agitational propaganda, newspapers, magazines, and posters for the purpose of political mobilization. Artistic production was especially active in liberated territories often organized around the so-called "partisan ateliers."[30]

On the territory of Croatia, the largest group of fine artists worked in the ZAVNOH Cultural Art Department[31] led by Ivo Vejvoda. In the Croatian context, Smiljka Mateljan distinguishes three generations of artists: the left oriented artistic association "Zemlja" (Earth),[32] whose many members joined the partisan struggle; the middle-generation artists; and the youngest generation, often autodidacts who only acquired formal education in the late 1940s and early 1950s.[33] Apart from being commissioned, artistic production was also spontaneous and resulted in numerous works on paper, drawings and sketches, graphics that documented partisan life or reflected the effects of the war.

25 Srđan Vrcan, "Split i Nacifašizam," in Antifašistički (see note 24), pp. xxx.

26 See Dušan Bilandžić, Historija socijalističke federativne Republike Jugoslavije, Glavni procesi 1918–1985, (Zagreb, 1985), pp. 43–61.

27 See Miklavž Komelj, Art of Partisan Resistance (Madrid, 2014), p. 236. Published in conjunction with the exhibition "Really Useful Knowledge" at the Museo Nacional Centro de Arte Reina Sofia.

28 Kirn, "On the Specific (In)existence" (see note 3), pp. 197–227.

29 Smiljka Mateljan et. al., Jugoslavenska umetnost u narodnooslobodilačkom ratu, 1941–1945 (Beograd, 1975), pp. 29–38. Published in conjunction with the exhibition of the same name shown at the Muzej savremene umetnosti, Beograd.

30 Miloš Miletić and Mirjana Radovanović, Lekcije o odbrani: Prilozi za analizu kulturne delatnosti NOP-a, (Beograd, 2016), pp. 76–79.

31 ZAVNOH stands for Zemaljsko antifašističko vijeće narodnog oslobođenja Hrvatske (The National Anti-Fascist Council of National Liberation of Croatia), which was the highest body of new people's authority in Croatia during the NOB. The first session of the Council was held in 1943 in Otočac and at the Plitvice Lakes.

32 The group exhibited collectively in Zagreb, Paris and Belgrade, being active from 1929 until 1935, the year when their work was banned. "Zemlja" was a left-wing artistic association which, in addition to educated professional artists included also peasants and workers in order to take a collective front to reflect and oppose the effects of the economic crisis of 1928 and the growing threat of fascism. Imbued with ongoing discussions and fervent polemics about leftist artistic positioning and dilemmas, their manifesto, published on the occasion of their first collective exhibition in 1929 in Zagreb, they called for urgency of collectivity and the fusion of life and art. Many members of the "Zemlja" were members of the Communist Party. One of the new interpretations of "Zemlja" by curatorial collective BLOK from Zagreb explores the ties between the association and Communist Party. See also http://www.blok.hr/hr/vijesti/problem-umjetnosti-kolektiva-slucaj-zemlja.

33 Mateljan, Jugoslavenska umetnost (see note 29), pp. 30–31. Published in conjunction with the exhibition of the same name shown at the Muzej savremene umetnosti in Beograd.

12.000 Menschen teilnahmen.[24] Dieser massive Protest ereignete sich in der gleichen Straße, in der später die „Illegale Kunstausstellung" stattfand, so dass die Wahl des Veranstaltungsortes im kollektiven Gedächtnis als Ort des Protestes und der Opposition sicherlich bereits verankert war. Die geplante Ausstellungserweiterung wurde durch die Kapitulation Italiens unterbrochen. Unter anderem hatten sich auch Mirko Ostoja und Rudolf Bunk auf die Teilnahme vorbereitet, aber die Ausstellung wurde mit der Befreiung der Stadt Split im September 1943 beendet. Zu diesem Zeitpunkt war Split die einzige freie Stadt ihrer Größe im besetzten Europa.[25] Der Kampf der Künstler und Organisatoren, die an der „Illegalen Kunstausstellung" teilgenommen hatten, setzte sich an der Front fort.

Was ist an Partisanenkunst partisanenhaft? Auf jugoslawischem Territorium begann der Zweite Weltkrieg offiziell am 6. April 1941, als die Achsenmächte das Königreich Jugoslawien angriffen, das am 17. April 1941 kapitulierte. Auf die Zersplitterung des jugoslawischen Territoriums folgte ein Besatzungssystem, in dem einheimische Kollaborateure mit den nationalsozialistisch-faschistischen Kräften zusammenarbeiteten. Mit anfangs einigen wenigen Akten des Widerstands wie lokalen Aufständen und Sabotageakten nahm der Jugoslawische Volksbefreiungskrieg im Sommer 1941 sein volles Ausmaß an, als die Widerstandsaktivitäten auf das ganze Land ausgeweitet wurden und innerhalb weniger Monate zu einem Massenvolksaufstand führten.[26] Die Kommunistische Partei Jugoslawiens führte den NOB und die Partisanenarmee von 1941 bis 1945. In allen Teilen Jugoslawiens wurde der NOB direkt von der Kommunistischen Partei organisiert, außer in Slowenien, wo die Aktivitäten der Partisanen von der Befreiungsfront geleitet wurden, „einer Organisation, die eine Vielzahl antifaschistischer Gruppen mit Kulturarbeitern unter ihren Gründungsgruppen vereinte."[27] „Am Ende des Krieges waren mehr als 800.000 Partisanen in vier jugoslawischen Armeen organisiert, was sie zur größten Widerstandsbewegung und Armee in Europa machte."[28]

Der NOB war geprägt von einer massiven Reaktion der Kulturschaffenden, die zu einer Kunstproduktion führte, in der Hochkultur und Popularkultur radikal gemischt wurden. Diese Kulturschaffenden instrumentalisierten nicht nur die Kunstproduktion als Waffe der Agitation und Propaganda, sondern demokratisierten sie auch, indem sie die künstlerische Kreativität als eine Form der pädagogischen Ermächtigung nutzten. Dies ermöglichte Experimente in verschiedenen populären, oft kollektiven Formaten wie Lyrik, Chöre, Agit-Theater, Propagandadrucken, Plakaten, Karikaturen, Tapeten, Zeichnungen, Grafiken, Volksliedern, Filmen und Fotografien sowie in einigen hybriden Formate wie den berühmten „mündlichen Zeitungen" (usmene novine). Diese vielfältigen kulturellen Praxen spielten verschiedene wichtige Rollen, angefangen von aktivistischen Werkzeugen für die Mobilisierung der Massen, über die Teilnahme an der Konstruktion der Identität des entstehenden Staates, bis hin zu Zwecken der Propaganda, der Erziehung und Geselligkeit, sowie ganz persönlichen Zwecken bei der Dokumentation traumatischer Kriegsereignisse.

Die Resonanz unter den kroatischen Kunstschaffenden war enorm; etwa 106 Künstler schlossen sich dem Partisanenkampf an und produzierten eine breite Palette von Kunstwerken.[29] Wie bei vielen anderen Agitprop-Abteilungen während des NOB ging es vor allem darum, den revolutionären Enthusiasmus des antifaschistischen Aufstands in eine grafische und visuelle Sprache zu übersetzen, in Form von Plakaten, Parolen, Agitationsdrucken und Linolschnitten, die heimlich in illegalen Druckereien hergestellt wurden – um die sogenannten „Techniken". Das Kunstschaffen des NOB wird in seiner Gesamtheit vom Werk der Künstlerpartisanen dominiert, die, ob auf den Schlachtfeldern oder in befreiten Gebieten, in direktem Zusammenhang mit dem politischen Kampf unter der Schirmherrschaft der Kommunistischen Partei Jugoslawiens und der Hilfsorgane des Parteikomitees agierten. Ein prominentes Beispiel sind die Agitprop-Einheiten, deren Aufgabe es war, Agitationspropaganda, Zeitungen, Zeitschriften und Plakate zum Zwecke der politischen Mobilisierung zu organisieren. Besonders rege war das Kunstschaffen in den befreiten Gebieten, wo es häufig um die so genannten „Partisanenateliers" organisiert war.[30]

Auf dem Territorium Kroatiens arbeitete die größte Gruppe bildender Künstler in der ZAVNOH-Abteilung für Kultur und Kunst[31] unter der Leitung von Ivo Vejvoda. Im kroatischen Kontext unterscheidet Smiljka Mateljan drei Künstlergenerationen: die linksgerichtete Künstlergruppe „Zemlja" (Erde),[32]

24 Kotur, Goran: „Split prkosi okupatoru", in: Kuzmić, Marin (Hg.): *Antifašistički Split Ratna kronika 1941–1945*. Udruga antifašističkih boraca i antifašista Grada Splita, Split 2011, 16–19.

25 Vrcan, Srđan: „Split i Nacifašizam", in: Kuzmić, Marin (Hg.): *Antifašistički Split Ratna kronika 1941–1945*. Udruga antifašističkih boraca i antifašista Grada Splita, Split 2011, xxx.

26 Siehe Bilandžić, Dušan: *Historija socijalističke federativne Republike Jugoslavije, Glavni procesi 1918–1985*, Zagreb 1985, 43–61.

27 Siehe Komelj, Miklavž: *Art of Partisan Resistance*, Madrid 2014, 236. Erschienen im Zusammenhang mit der Ausstellung „Really Useful Knowledge" im Museo Nacional Centro de Arte Reina Sofia.

28 Kirn, „On the Specific (In)existence", 197–227 (wie Anm. 3).

29 Vgl. Mateljan, Smiljka et al.: *Jugoslavenska umetnost u narodnooslobodilačkom ratu, 1941–1945*, Belgrad 1975, 29–38. Erschienen im Zusammenhang mit der gleichnamigen Ausstellung im Muzej savremene umetnosti.

30 Miletić, Miloš/Radovanović, Mirjana: *Lekcije o odbrani: Prilozi za analizu kulturne delatnosti NOP-a*, Belgrad 2016, 76–79.

31 ZAVNOH steht für *Zemaljsko antifašističko vijeće narodnog oslobođenja Hrvatske* (Antifaschistischer Landesrat der Volksbefreiung Kroatiens), der während des NOB das höchste Gremium der neuen Volksvertretung in Kroatien war. Die erste Ratssitzung wurde 1943 in Otočac und an den Plitvicer Seen abgehalten.

32 Die Gruppe stellte gemeinsam in Zagreb, Paris und Belgrad aus und war von 1929 bis 1935 aktiv, dem Jahr, in dem ihre Arbeit verboten wurde. „Zemlja" war ein linker Kunstverein, der neben ausgebildeten Künstlern auch Bauern und Arbeiter einbezog, um eine kollektive Front zu bilden, um die Auswirkungen der Wirtschaftskrise von 1928 und die wachsende Bedrohung durch den Faschismus zu reflektieren und zu bekämpfen. Erfüllt von anhaltenden Debatten und heftiger Polemik über linke künstlerische Positionen und Dilemmata mahnte „Zemlja" in seinem Manifest, das anlässlich der ersten gemeinsamen Ausstellung 1929 in Zagreb veröffentlicht wurde, die Dringlichkeit der Kollektivität und die Verschmelzung von Leben und Kunst ein. Viele Mitglieder von „Zemlja" waren Mitglieder der Kommunistischen Partei. Eine der Neuinterpretationen von „Zemlja", vom Kuratorenkollektiv BLOK aus Zagreb, erforschte die Verbindungen zwischen dem Verein und der Kommunistischen Partei. Vgl. dazu http://www.blok.hr/hr/vijesti/problem-umjetnosti-kolektiva-slucaj-zemlja.

In the wider theoretical discussion on the project of socialist Yugoslavia in relation to the NOB, numerous theorists, philosophers, historians, and cultural workers have researched and analyzed its various aspects.[34] For this article, especially valuable are recent texts on "partisan art" by the Slovenian authors Rastko Močnik, Miklavž Komelj and Gal Kirn. The term "partisan art" is used not merely to indicate that this cultural production was the work of artists who were partisans,[35] but rather to indicate the prominent role of art in a revolutionary process "that was radical because it transformed not only the inner structure of culture but also the very position of cultural sphere within the social structure."[36]

These authors do not offer a unified definition of partisan art. Rather, they engage in an ongoing debate on various aspects of this expression of political and cultural production. Močnik emphasizes its "liminal and radical character,"[37] while Komelj, in focusing on its contradictions and the continuous process of becoming, considers how a revolutionary subjectivity steps out of bourgeois culture into a realm of experimentation where spheres of life and art merge. Gal Kirn notes that it would be too simplistic to define it as mere propaganda or socialist realism, instead stressing that its characteristics are the result of a specific "revolutionary encounter of politics and art."[38]

Thus, the artistic corpus of NOB is not formalized by a fixed repertoire of expression. Rather, in the abundant creativity of partisan production, one can trace the participation of different classes, collectivism, and self-reliance that favored the creation of hybrid forms. The convergence of life and art, crucial for interpreting a broad field of heterogeneous artistic practices related to revolt, resistance, protests, and revolutions, is also indicative of a wider understanding of the role of cultural production realized in the resistance to fascism in The Second World War.[39]

Partisan Exhibitions and Exhibitions of Partisanship. Rapidly catalysed by the war, the instances of art, life, and political engagement in the "Illegal Artistic Exhibition" were drastically merged. In contrast to the official exhibition, "Mostra d'Arte," which was supposed to serve as a tool of co-optation, the "Illegal Artistic Exhibition" was created, inter alia, as an expression of maintaining the continuity of cultural life under occupation and as a counter practice to the Nazi-fascist use of propagandist exhibitions as a tool of co-optation and dominance. During The Second World War, many of the traveling exhibitions based on the cultural policy that promoted *Nazi-Kunst* were also shown in Croatia, with accompanying catalogs. One such example was the exhibition "Deutsche Plastik der Gegenwart" ("German Sculpture of the Present") held at the Croatian Academy of Sciences and Arts in Zagreb in April and May of 1942.

Like propaganda posters and cinema, exhibitions played a crucial role in self-representation of the ideology of fascism through art and culture.

Studin's description of how the visual appearance of the "Illegal Artistic Exhibition" mimicked "an atmosphere of a warm home, where people live well and content, calmly and without worry, outside the events themselves"[40] testifies that the use of the bourgeois setting of a private interior for the exhibition was a tactical means that, through the joint involvement of the cultural workers, political movement, and audience, turned the private space into the space of a counter-public. Acting as a support structure, the exhibition resonates with Diego Rivera's justification that while doing revolutionary art one "must not refuse to use the best technical devices of bourgeois art, just as [the proletariat] uses bourgeois technical equipment in the form of cannon, machine guns, and steam turbines."[41]

The "Illegal Artistic Exhibition" should be viewed as a radical reappropriation of an oppressive cultural tool and as a first step towards instituting an infrastructure that found in the medium of the exhibition an authentic expression of what Komelj identifies as "revolutionary subjectivity."[42] Komelj positions it in the locus of the impossible, between "nothing and everything."[43] This revolutionary subjectivity has not only produced outstanding artistic production, but has also radically reconfigured the boundaries of both art's place in society and art's continuous self-reflection. It is in this self-reflection that art challenges its own limits and "that also re-examines its own boundaries—and that sometimes finds itself outside these limits."[44]

34 Darko Suvin, Rastko Močnik, Miklavž Komelj, Gal Kirn, Boris Buden, Lev Centrih, Branimir Stojanović to name a few.

35 The term "partisan" originates from Latin and via mid 16th century French it designates a supporter of a party or a cause, a member of an armed guerilla group formed to fight against occupying force, in particular in Yugoslavia and Italy in the Second World War. As an adjective, partisan means of this particular struggle or indicates a devotion, even a bias to the cause. This term in Yugoslav context is imbued with resonances of revolutionary modalities such as opening up new social ground.

36 Rastko Močnik, "The Partisan Symbolic Politics," in *SLAVICA TERGESTINA – European Slavic Studies Journal*, ed. Jernej Habjan and Gal Kirn, special issue, The Yugoslav Partisan Art 17 (2016), pp. 19–38. esp. p. 25.

37 Ibid., p. 19.

38 For a more nuanced discussion on the status and various aspects of partisan art see: Jernej Habjan and Gal Kirn, eds. *SLAVICA TERGESTINA* (see note 36), pp. 10–15.

39 Smiljka Mateljan, Miklavž Komelj and Gal Kirn addressed this aspect in the context of NOB.

40 Marin Studin, "Ilegalna izložba" (see note 1).

41 Diego Rivera, "The Revolutionary Spirit in Modern Art," *The Modern Quarterly* 6, no.3 (1932), pp. 51-57, esp. p. 51.

42 Miklavž Komelj, "Partisan Art Obliquely," in *Art As Resistance to Fascism*, Museum of Yugoslav History (Belgrade, 2015), p. 34–35.

43 Ibid.

44 Ibid.

deren zahlreiche Mitglieder sich dem Partisanenkampf anschlossen; die Künstler der mittleren Generation; und die jüngste Generation, oft Autodidakten, die erst in den späten 1940er und frühen 1950er Jahren eine Ausbildung erhielten.[33] Neben Auftragswerken war das Kunstschaffen auch spontan und führte zu zahlreichen Arbeiten auf Papier, Zeichnungen und Skizzen, Grafiken, die das Partisanenleben dokumentierten oder die Folgen des Krieges reflektierten.

In der breiteren theoretischen Diskussion über das Projekt des sozialistischen Jugoslawiens in Bezug auf den NOB haben zahlreiche Theoretiker, Philosophen, Historiker und Kulturschaffende dessen unterschiedlichste Aspekte erforscht und analysiert.[34] Von ganz besonderem Wert für diesen Artikel sind aktuelle Texte über „Partisanenkunst" von den slowenischen Autoren Rastko Močnik, Miklavž Komelj und Gal Kirn. Der Begriff „Partisanenkunst" wird nicht nur verwendet, um anzudeuten, dass diese Kulturproduktion das Werk von Künstlern war, die Partisanen waren,[35] sondern vielmehr, um die herausragende Rolle der Kunst in einem revolutionären Prozess zu verdeutlichen, „der radikal war, weil er nicht nur die innere Struktur der Kultur, sondern auch die Position der kulturellen Sphäre innerhalb der sozialen Struktur veränderte".[36]

Diese Autoren bieten jedoch keine einheitliche Definition von Partisanenkunst an. Vielmehr führen sie eine laufende Debatte über verschiedene Aspekte dieses Ausdrucks politischer und kultureller Produktion. Močnik betont ihren „liminalen und radikalen Charakter"[37], während Komelj, indem er sich auf ihre Widersprüche und den kontinuierlichen Prozess des Werdens konzentriert, darüber nachdenkt, wie eine revolutionäre Subjektivität aus der bürgerlichen Kultur in ein Experimentierfeld tritt, in dem Lebens- und Kunstbereiche verschmelzen. Gal Kirn stellt fest, dass es zu simpel wäre, sie als bloße Propaganda oder als sozialistischen Realismus zu definieren, und betont stattdessen, dass ihre Eigenschaften das Ergebnis einer spezifischen „revolutionären Begegnung von Politik und Kunst" sind.[38]

So wird der künstlerische Korpus des NOB nicht durch ein festes Repertoire an Ausdrucksmöglichkeiten formalisiert. Vielmehr kann man in der reichlich vorhandenen Kreativität der Partisanenproduktion die Teilnahme verschiedener Klassen, Kollektivismus und Selbstvertrauen nachvollziehen, die die Schaffung hybrider Formen begünstigten. Die Zusammenführung von Leben und Kunst, die für die Interpretation eines weiten Feldes heterogener künstlerischer Praxen im Zusammenhang mit Revolte, Widerstand, Protesten und Revolution ausschlaggebend ist, ist auch ein Indiz für ein breiteres Verständnis der Rolle kultureller Produktion, die im Widerstand gegen den Faschismus im Zweiten Weltkrieg realisiert wurde.[39]

Partisanenaustellungen und Ausstellungen über Partisanentum. Immens beschleunigt durch den Krieg wurden die Beispiele für Kunst, Leben und politischem Engagement in der „Illegalen Kunstausstellung" drastisch verschmolzen. Im Gegensatz zur offiziellen Ausstellung „Mostra d'Arte", die als Instrument der Gleichschaltung dienen sollte, wurde die „Illegale Kunstausstellung" u.a. als Ausdruck der Aufrechterhaltung der Kontinuität des kulturellen Lebens unter Besatzung und als Gegenpraxis zur nationalsozialistisch-faschistischen Nutzung propagandistischer Ausstellungen als Gleichschaltungs- und Herrschaftsinstrument ins Leben gerufen. Während des Zweiten Weltkrieges wurden viele der Wanderausstellungen, die auf einer kulturpolitischen Förderung von Nazi-Kunst beruhten, auch in Kroatien gezeigt, samt begleitenden Katalogen. Ein Beispiel dafür war die Ausstellung „Deutsche Plastik der Gegenwart", die im April und Mai 1942 in der Kroatischen Akademie der Wissenschaften und Künste in Zagreb stattfand. Wie Propagandaplakate und Kino spielten Ausstellungen eine entscheidende Rolle bei der Selbstdarstellung der Ideologie des Faschismus durch Kunst und Kultur.

Studins Beschreibung, wie das visuelle Erscheinungsbild der „Illegalen Kunstausstellung" „eine Atmosphäre eines warmen Zuhauses nachahmte, in dem die Menschen gut und zufrieden, ruhig und unbesorgt, außerhalb der Ereignisse selbst leben"[40], zeugt davon, dass die Nutzung des bürgerlichen Rahmens eines privaten Interieurs für die Ausstellung ein taktisches Mittel war, das durch die gemeinsame Beteiligung der Kulturschaffenden, der politischen Bewegung und des Publikums den Privatraum in den Raum einer Gegenöffentlichkeit verwandelte. Als Trägerstruktur ist die Ausstellung im Einklang mit Diego Riveras Rechtfertigung, dass man sich bei der Ausübung der revolutionären Kunst „nicht weigern darf, die besten technischen

33 Mateljan: *Jugoslavenska umetnost*, 30–31 (wie Anm. 29).

34 Darko Suvin, Rastko Močnik, Miklavž Komelj, Gal Kirn, Boris Buden, Lev Centrih, Branimir Stojanović, um nur einige wenige zu erwähnen.

35 Der Begriff „Partisan" stammt aus dem Lateinischen und bezeichnet über das Französische der Mitte des 16. Jahrhunderts einen Anhänger einer Partei oder einer Sache, oder ein Mitglied einer bewaffneten Guerillagruppe, die zur Bekämpfung der Besatzungsmacht gebildet wurde, insbesondere in Jugoslawien und Italien im Zweiten Weltkrieg. Als [A.d.Ü engl. oder frz.] Adjektiv bezeichnet dieses Wort die Eigenschaft der Teilnahme an einem bestimmten Kampf oder deutet auf Hingabe oder sogar Voreingenommenheit hin. Im Kontext Jugoslawiens ist dieser Begriff durchdrungen von Nachklängen revolutionärer Modalitäten, wie z.B. der Erschließung neuer gesellschaftlicher Räume.

36 Močnik, Rastko: „The Partisan Symbolic Politics", in: Habjan, Jernej/Kirn, Gal (Hg.) *SLAVICA TERGESTINA* – European Slavic Studies Journal, The Yugoslav Partisan Art 17 (2016), 19–38, hier 25.

37 Ebd., 19.

38 Für eine differenziertere Diskussion über den Status und die verschiedenen Aspekte der Partisanenkunst siehe: Habjan/Kirn (Hg.): *SLAVICA TERGESTINA*, 10–15 (wie Anm. 36).

39 Smiljka Mateljan, Miklavž Komelj und Gal Kirn beschäftigten sich mit diesem Aspekt im Zusammenhang mit dem NOB.

40 Studin, Marin: „Ilegalna izložba" (wie Anm. 1).

Within the previously mentioned inherent heterogeneity of partisan art, Komelj detects a fundamental dichotomy that can be roughly divided into two spheres or "sequences" in his own words: "In the beginning, Partisan art has often positioned itself in an explicit opposition to bourgeois art institutions; on the other hand, the Partisan Movement has re-established institutions. The latter contradiction is also associated with contradiction between two time sequences of the national liberation struggle: the sequence 1941–1943 in which Partisanship is constituted as a breakthrough through the impossible; and the sequence 1943–1945, in which the partisan movement places itself in the service of building a new state implying establishment of new institutions. The self-reflection of Partisan art in that period increasingly focuses on the issue of building a system that will be true to the break which is itself anti-systemic."[45]

Following that distinction, the "Illegal Artistic Exhibition," by its specific profile, manifests at full capacity a "revolutionary break through the impossible, … symbolically articulating impossibility into possibility,"[46] not only in regard to the shortage of material resources but also through the mixing of artistic and political impulses and a collectivist approach that produced a new form of sociability through the exhibition format.

Within the cultural production created in the resistance to fascism, one can observe numerous exhibitions that were integral to the NOB, mostly on the liberated territories. There were a number of cultural events that included exhibitions in liberated territory during the "Užice Republic"[47] of 1941 and around the first and second meeting of The Anti-Fascist Council for the National Liberation of Yugoslavia. An exhibition realized by artists Pivo Karamatijević and Bora Baruh as part of a celebration of the October Revolution had been installed first in Užice in 1941 after which it traveled through the liberated territories (Požega, Čačak, Gornji Milanovac, Arilje, Ivanjica, and Bajina Bašta).[48] Among the exhibitions presenting graphics, posters, and paintings, there were also two photography exhibitions. The first was held in Livno in 1943, organized alongside the second meeting of the Anti-fascist Council of National Liberation Struggle of Yugoslavia, and a second one was held in Gornji Grad, Slovenia.

In this context, the exhibitions organized in liberated territory in the Bela Krajina region of Slovenia should also be mentioned as pertinent examples of partisan exhibitions that were an integral part of the exceptionally diverse artistic life organized in the liberated territories. Among the several exhibitions presented in the area of Bela Krajina, the exhibition of partisan art in Črnomelj in 1945 was the most ambitious and particularly interesting for our purposes insofar as it approached the medium of the exhibition as a tactical tool. To some extent, this exhibition reveals a line of thinking about the instrumentality of the exhibition akin to that of the "Illegal Artistic Exhibition." On the occasion of the exhibition in Črnomelj, partisan cultural workers spent days carefully planning the exhibition that also entailed an exhibition structure in front of the venue and the production of several sculptures. The opening was planned for April, 27th 1945, but the exhibition was actually a decoy intended to mislead the intelligence services of the Allies forces. Instead of opening the exhibition, the partisans abruptly left Bela Krajina to participate in the liberation of Trieste.[49]

45 Ibid, p. 34.

46 Miklavž Komelj, *Kako misliti partizansko umetnost?* (Ljubljana, 2009), p. 3. (Trans. A.D.)

47 The Republic of Užice was a short-lived state established by the partisans in autumn of 1941 as the first liberated territory in Europe during the Second World War, with the city of Užice (Serbia) as its administrative center.

48 Miloš Miletić and Mirjana Radovanović from the Belgrade-based collective KURS and Mirjana Dragosavljević analyzed the role of culture in the National Liberation Movement, with a special focus on the events on the cultural events on the liberated territory of the "Užice Republic" in 1941 in Serbia and around the First and Second Meetings of The Anti-Fascist Council for the National Liberation of Yugoslavia (AVNOJ). See also Miloš Miletić and Mirjana Radovanović, *Lekcije o odbrani: Prilozi za analizu kulturne delatnosti NOP-a*, (Beograd, 2016), pp. 76–77.

49 This particular exhibition was described in greater detail by partisan artist Alenka Gerlovič. See Alenka Gerlovič, "Okruški mojega življenja," *Forma* 7 (2006), pp. 176–177. See also Miklavž Komelj, *Kako misliti partizansko umetnost?* (Ljubljana, 2009), pp. 16–17. It was included as reference in the exhibition *20th Century. Continuities and Ruptures* that presents the collection of Museum of Modern Art in Ljubljana.

4

Exhibition of partisan arts | Ausstellung der Partisanenkunst, Črnomelj, April 25, 1945 © Photo: Stane Viršek, TN724/11, Archive of the National Museum of Contemporary History | Archiv des Nationalmuseums für Zeitgeschichte, Ljubljana

Mittel der bürgerlichen Kunst zu benutzen, so wie [das Proletariat] bürgerliche technische Geräte in Form von Kanonen, Maschinengewehren und Dampfturbinen einsetzte".[41]

Die „Illegale Kunstausstellung" ist als radikale Wiederaneignung eines repressiven Kulturinstruments und als erster Schritt zur Schaffung einer Infrastruktur zu sehen, die im Medium der Ausstellung einen authentischen Ausdruck dessen gefunden hat, was Komelj als „revolutionäre Subjektivität"[42] bezeichnet. Komelj positioniert sie im Ort des Unmöglichen, zwischen „nichts und allem".[43] Diese revolutionäre Subjektivität hat nicht nur herausragendes Kunstschaffen hervorgebracht, sondern auch die Grenzen des Platzes der Kunst in der Gesellschaft und der ständigen Selbstreflexion der Kunst radikal neu definiert. Genau in dieser Selbstreflexion stellt die Kunst ihre eigenen Grenzen in Frage und „hinterfragt auch ihre eigenen Grenzen – und findet sich manchmal außerhalb dieser Grenzen".[44]

In der bereits erwähnten inhärenten Heterogenität der Partisanenkunst findet Komelj eine fundamentale Dichotomie, die sich in seinen eigenen Worten grob in zwei Sphären oder „Sequenzen" aufteilen lässt: „Am Anfang hat sich die Partisanenkunst oft in einer expliziten Opposition zu bürgerlichen Kunstinstitutionen positioniert; andererseits hat die Partisanenbewegung Institutionen wiederhergestellt. Der letztgenannte Widerspruch wird auch mit dem Widerspruch zwischen zwei Sequenzen des nationalen Befreiungskampfes in Verbindung gebracht: die Sequenz 1941–1943, in der sich die Partisanenbewegung als Durchbruch durch das Unmögliche konstituiert; und die Sequenz 1943–1945, in der sich die Partisanenbewegung in den Dienst des Aufbaus eines neuen Staates stellt, der die Errichtung neuer Institutionen impliziert. Die Selbstreflexion der Partisanenkunst in dieser Zeit konzentriert sich zunehmend auf die Frage des Aufbaus eines Systems, das dem Bruch treu bleibt, der selbst anti-systemisch ist."[45]

Dieser Unterscheidung folgend manifestiert die „Illegale Ausstellung" mit ihrem spezifischen Profil in vollem Umfang „einen revolutionären Durchbruch durch das Unmögliche [...], indem sie symbolisch die Unmöglichkeit als Möglichkeit artikuliert",[46] nicht nur im Hinblick auf die Verknappung materieller Ressourcen, sondern auch durch die Vermischung von künstlerischen und politischen Impulsen und einem kollektivistischen Ansatz, der durch das Ausstellungsformat eine neue Form der Sozialität hervorbrachte.

Innerhalb des Kulturschaffens, das im Widerstand gegen den Faschismus entstanden ist, kann man zahlreiche Ausstellungen beobachten, die ein wesentlicher Bestandteil des NOB waren, vor allem in den befreiten Gebieten. Es gab eine Reihe von kulturellen Veranstaltungen, darunter Ausstellungen in befreiten Gebieten während der „Republik Užice"[47] von 1941 und um die erste und zweite Sitzung des Antifaschistischen Rates für die nationale Befreiung Jugoslawiens herum. Eine Ausstellung, die von den Künstlern Pivo Karamatijević und Bora Baruh im Rahmen der Feier der Oktoberrevolution realisiert wurde, wurde erstmals 1941 in Užice installiert und reiste anschließend durch die befreiten Gebiete (Požega, Čačak, Gornji Milanovac, Arilje, Ivanjica und Bajina Bašta).[48] Neben den Ausstellungen mit Grafiken, Plakaten und Gemälden gab es auch zwei Fotoausstellungen. Erstere fand 1943 in Livno statt und wurde parallel zum zweiten Treffen des Antifaschistischen Rates des Nationalen Befreiungskampfes von Jugoslawien organisiert, zweitere wurde in Gornji Grad, Slowenien, gezeigt.

In diesem Zusammenhang sind auch die in befreiten Gebieten in der slowenischen Region Bela Krajina organisierten Ausstellungen als einschlägige Beispiele für Partisanenausstellungen zu nennen, die ein wesentlicher Bestandteil des außerordentlich vielfältigen künstlerischen Lebens in den befreiten Gebieten waren. Unter den zahlreichen Ausstellungen, die im Gebiet von Bela Krajina gezeigt wurden, war die Ausstellung der Partisanenkunst in Črnomelj im Jahre 1945 die ehrgeizigste und für unsere Zwecke besonders interessante, da sie sich dem Medium der Ausstellung als taktisches Werkzeug näherte. In gewisser Weise offenbart diese Ausstellung eine Denkweise über die Zweckdienlichkeit von Ausstellungen, die derjenigen der „Illegalen Kunstausstellung" ähnelt. Anlässlich der Ausstellung in Črnomelj verbrachten die Kulturschaffenden der Partisanen Tage damit, die Ausstellung sorgfältig zu planen, was auch eine Ausstellungsstruktur vor dem Veranstaltungsort und die Produktion mehrerer Skulpturen mit sich brachte. Die Eröffnung war für den 27. April 1945 geplant, aber die Ausstellung war eigentlich ein Köder, der die Geheimdienste der alliierten Streitkräfte irreführen sollte. Anstatt die Ausstellung zu eröffnen, verließen die Partisanen die Bela Krajina abrupt, um an der Befreiung von Triest teilzunehmen.[49]

41 Rivera, Diego: „The Revolutionary Spirit in Modern Art", in: *The Modern Quarterly* 6, 3 (1932), 51–57, hier 51.

42 Komelj, Miklavž: „Partisan Art Obliquely", in: *Art As Resistance to Fascism*, Belgrad 2015, 19–42, hier 26.

43 Ebd.

44 Ebd.

45 Ebd., 34.

46 Komelj, Miklavž: *Kako misliti partizansko umetnost?* Ljubljana 2009, 3. (A.d.Ü.: Übersetzung auf Basis der Übersetzung der Autorin ins Englische)

47 Das erste befreite Gebiet in Europa im Zweiten Weltkrieg, die Republik Užice in Serbien, wurde vom NOB geschaffen. Dieses befreite Gebiet bestand als Ministaat im Herbst 1941, mit Užice als Verwaltungssitz.

48 Miloš Miletić und Mirjana Radovanović vom Belgrader Kollektiv KURS und Mirjana Dragosavljević analysierten die Rolle der Kultur in der Nationalen Befreiungsbewegung, mit besonderem Schwerpunkt auf die Ereignisse rund um Kulturveranstaltungen in den befreiten Gebieten während der „Republik Užice" 1941 in Serbien und um das erste und zweite Treffen des Antifaschistischen Rates für die Nationale Befreiung Jugoslawiens (AVNOJ). Vgl. dazu Miletić, Miloš/Radovanović, Mirjana: *Lekcije o odbrani: Prilozi za analizu kulturne delatnosti NOP-a*, Belgrad 2016, 76–77.

49 Diese spezifische Ausstellung wurde von der Partisanen-Künstlerin Alenka Gerlovič näher beschrieben. Vgl. Gerlovič, Alenka: „Okruški mojega življenja", in: *Forma* 7 (2006), 176–177. Vgl. dazu auch Komelj, Miklavž: *Kako misliti partizansko umetnost?*, Ljubljana 2009, 16–17. Sie fand Eingang in die Ausstellung *20. Jahrhundert. Kontinuitäten und Brüche*, in der die Sammlung des Muzej sodobne umetnosti Metelkova (Museum für moderne Kunst), Ljubljana, gezeigt wird.

There is not yet a comprehensive chronology and analysis of all exhibitions that were part of NOB and its post-war representation. In 1955, Zdenko Grum made an initial chronology of partisan exhibitions in Croatia, in which the "Illegal Artistic Exhibition" occupies a significant position in its history.[50] Many of those exhibitions were organized by agitprop departments of the Central Committee of the Communist Party. Some of them were travelling exhibitions, such as the 1943 exhibition organized in Otočac, where, for the first time, Croatian partisan artists exhibited their work in the liberated territories. After that, the exhibition was also shown in Senj, Kraljevica, and Crikvenica. In Split, a major partisan exhibition was held in 1944, and Marko Ostoja produced the announcement poster. There were also some other exhibitions outside of Yugoslavia; in Alexandria and in the Croatian refugee camp in El Shatt in Egypt.[51] Often, partisan exhibitions accompanied conferences of cultural workers, such as the 1943 "Conference of Cultural Workers of Dalmatia" in Hvar or the "Conference of Cultural Workers of Istria" in 1944, or the largest of such cultural events, "The First Congress of Cultural Workers of Croatia" in Topusko in 1944.

Though the overall chronology of partisan exhibitions remains to be completed and systematized with other partisan exhibitions during the Second World War on the territory of Yugoslavia, it is evident from the frequency, geographic spread, and post-war veneration that the genre of partisan exhibitions had an important and prominent place in the revolutionary struggle, as well as in the formation of the identity of the new society and its dominant ideology. It is important to stress that partisan exhibitions produced within the NOB do not form a unified genre. Rather, they are imbued with a similar heterogeneity and greater variety of creative impulses than the rest of this artistic corpus. However, in post-war representation, a specific genre was presented and perpetually venerated. To a certain extent, partisan post-war exhibitions were fulfilling the role of remembering and served as the "sites of *memory*"[52] that, with time and the proliferation of the genre, gradually dulled the initial cutting edge. According to Kirn, these exhibitions "introduced an increasingly dominant view of the partisan art as something belonging to a history that had been long gone, an object of ritualistic reproduction by the state."[53] Lilijana Stepančič, writing about the partisan art exhibitions, notes that the last of the major exhibitions of this kind took place back in 1981, over a decade before the dissolution of Socialist Federal Republic of Yugoslavia,[54] thus indicating the exhaustion of that genre.

The post-war reception of the "Illegal Artistic Exhibition" included numerous articles and conversations with its participants. The first exhibition that documented the "Illegal Artistic Exhibition" was organized at the Headquarters of the Yugoslav Navy in Split in 1957, when the works were commissioned by the Museum of the Revolution in Split. The prominent place held by the exhibition in the collective memory of Socialist Yugoslavia is evident from the fact that celebrated filmmaker Stipe Delić, who had received international acclaim for his epic partisan film "The Battle of Sutjeska" (1973),[55] was commissioned to direct the documentary about the "Illegal Artistic Exhibition" in 1986.

In the 1990s, along with the breakup of Yugoslavia, the reception of the exhibition experienced a significant breakdown amidst the changing social systems, sinking into oblivion under the rising tide of "anti-anti-fascism" and anti-communism. It was only in 2015 that the exhibition was reactualized within the exhibition "Art Password, the Illegal Art Exhibition of Split Artists in Occupied Split in 1943," held at the Mala Galerija of the Museum of City of Split, organized and curated by Tonći Šitin. Along with the documentary archival work, this reactualization also included several preserved art works from the original exhibition. Given the contemporary context of Split, which like the rest of Croatia is marked by a sustained resurgence of neo-fascist and neo-Nazi elements permeating the public sphere, the reactualization of the exhibition serves as an important intervention in the public discourse.

Exhibitions produced as an integral part of political struggles and protests form a separate, and still insufficiently systematized, chapter in the history of exhibitions. However, more often than not, these exhibitions are confined to the margins of global narratives of this history. Yet it is precisely such

50 Zdenko Grum, *Crteži grafike NOB*. Published in conjunction with the exhibition of the same name, shown at Umjetnički paviljon, Zagreb, *Institut za likovne umjetnosti Jugoslavenske znanosti i umjetnosti* (Zagreb, 1955), pp. 8–10.

51 Organized by the Allies and the National Committee for the Liberation of Yugoslavia, from February 1944 to March 1946, more than 30,000 refugees from Dalmatian islands were evacuated to camps in the Sinai desert in Egypt. See the exhibition catalogue *El Shatt, zbijeg iz Hrvatske u pustinji Sinaja (1944–1946)* (Zagreb, 2007).

52 The term "site of memory" is a concept developed by Pierre Nora in his four-volume book *Les Lieux de Mémoire*.

53 Gal Kirn, "The Yugoslav Partisan Art: Introductory Note," in *SLAVICA TERGESTINA* (see note 36), pp. 10–15, esp. p. 10.

54 Ibid.

55 "The Battle of Sutjeska" (1973), in which Tito was played by Hollywood star Richard Burton, was one of the most spectacular feature films of this genre.

Eine umfassende Chronologie und Analyse aller Ausstellungen, die Teil des NOB und dessen Darstellung in der Nachkriegszeit waren, gibt es noch nicht. Zdenko Grum hat 1955 eine erste Chronologie der Partisanenausstellungen in Kroatien erstellt, in der die „Illegale Kunstausstellung" einen bedeutenden Platz in ihrer Geschichte einnimmt.[50] Viele dieser Ausstellungen wurden von Agitprop-Abteilungen des Zentralkomitees der kommunistischen Partei organisiert. Einige von ihnen waren Wanderausstellungen, wie die 1943 in Otočac organisierte Ausstellung, wo zum ersten Mal kroatische Partisanenkünstler ihre Werke in den befreiten Gebieten ausstellten. Danach wurde die Ausstellung auch in Senj, Kraljevica und Crikvenica gezeigt. In Split fand 1944 eine große Partisanenausstellung statt, und Marko Ostoja produzierte das Ankündigungsplakat. Außerhalb Jugoslawiens gab es noch weitere Ausstellungen in Alexandria und im kroatischen Flüchtlingslager El Shatt in Ägypten.[51] Oft begleiteten Partisanenausstellungen Konferenzen von Kulturschaffenden, wie die „Konferenz der Kulturschaffenden Dalmatiens" 1943 in Hvar oder die „Konferenz der Kulturschaffenden Istriens" 1944, oder die größte dieser Kulturveranstaltungen, den „Ersten Kongress der Kulturschaffenden Kroatiens" 1944 in Topusko.

Obwohl die Gesamtchronologie der Partisanenausstellungen noch zu vervollständigen und mit anderen Partisanenausstellungen während des Zweiten Weltkrieges auf dem Territorium Jugoslawiens zu systematisieren ist, zeigt sich an der Häufigkeit, der geografischen Verbreitung und der Verehrung in der Nachkriegszeit, dass das Genre der Partisanenausstellungen einen wichtigen und prominenten Platz im revolutionären Kampf sowie in der Herausbildung der Identität der neuen Gesellschaft und ihrer vorherrschenden Ideologie einnimmt. Es ist wichtig zu betonen, dass die im Rahmen des NOB produzierten Partisanenausstellungen kein einheitliches Genre bilden. Vielmehr sind sie von einer ähnlichen Heterogenität und einer größeren Vielfalt an kreativen Impulsen durchdrungen als der Rest dieses künstlerischen Korpus. In der Nachkriegsdarstellung wurde jedoch ein bestimmtes Genre präsentiert und immer wieder verehrt. Die Partisanenausstellungen der Nachkriegszeit erfüllten gewissermaßen die Rolle des Erinnerns und dienten als „Erinnerungsorte"[52], denen mit der Zeit und der Verbreitung des Genres jedoch allmählich die anfängliche Schärfe abhanden kam. Kirn zufolge führten diese Ausstellungen „eine zunehmend dominante Sichtweise der Partisanenkunst als Teil einer längst vergangenen Geschichte ein, als Objekt ritualisierter Reproduktion durch den Staat".[53] Über die Partisanen-Kunstausstellungen

schreibend, stellt Lilijana Stepančič fest, dass die letzte der großen Ausstellungen dieser Art 1981 stattfand, mehr als ein Jahrzehnt vor der Auflösung der Sozialistischen Föderativen Republik Jugoslawien,[54] was auf die Erschöpfung dieses Genres hinweist.

Die Nachkriegsrezeption der „Illegalen Kunstausstellung" umfasste zahlreiche Artikel und Gespräche mit deren TeilnehmerInnen. Die erste Ausstellung, in der die „Illegale Kunstausstellung" dokumentiert wurde, wurde 1957 im Hauptquartier der jugoslawischen Marine in Split organisiert, als die Arbeiten vom Museum der Revolution in Split in Auftrag gegeben wurden. Die herausragende Stellung der Ausstellung im kollektiven Gedächtnis des sozialistischen Jugoslawien zeigt sich daran, dass der gefeierte Filmemacher Stipe Delić, der für seinen epischen Partisanenfilm „Die Schlacht an der Sutjeska" (1973)[55] internationale Anerkennung erlangt hatte, 1986 mit der Regie der Dokumentation über die „Illegale Kunstausstellung" beauftragt wurde.

In den 1990er Jahren erlebte die Rezeption der Ausstellung, zusammen mit dem Zerfall Jugoslawiens, einen signifikanten Zusammenbruch inmitten der sich wandelnden Gesellschaftssysteme und geriet durch die Strömungen von „Anti-Anti-Faschismus" und Antikommunismus in Vergessenheit. Erst im Jahr 2015 wurde die Ausstellung im Rahmen der Ausstellung „Kunst-Losungswort, die illegale Ausstellung von Spliter Künstlern im besetzten Split 1943" in der Mala Galerija des Stadtmuseums von Split, organisiert und kuratiert von Tonči Šitin, reaktualisiert. Neben der dokumentarischen Archivarbeit umfasste diese Reaktualisierung auch mehrere erhaltene Kunstwerke aus der ursprünglichen Ausstellung. In Anbetracht des zeitgenössischen Kontexts von Split, das wie das übrige Kroatien von einem anhaltenden Wiederaufleben neofaschistischer und neonazistischer Elemente geprägt ist, die die Öffentlichkeit durchdringen, stellt die Reaktualisierung der Ausstellung einen wichtigen Eingriff in den öffentlichen Diskurs dar.

50 Grum, Zdenko: *Crteži grafike NOB*, Zagreb 1955, 8–10. Erschienen im Zusammenhang mit der gleichnamigen Ausstellung im Umjetnički paviljon, Zagreb, *Institut za likovne umjetnosti Jugoslavenske znanosti i umjetnosti*, Zagreb.

51 Organisiert von den Alliierten und dem Nationalen Komitee für die Befreiung Jugoslawiens wurden von Februar 1944 bis März 1946 mehr als 30.000 Flüchtlinge von den dalmatinischen Inseln in Lager in der Wüste Sinai in Ägypten evakuiert. Vgl. dazu den Ausstellungskatalog *El Shatt, zbijeg iz Hrvatske u pustinji Sinaja. 1944–1946*, Zagreb 2007.

52 Der Begriff „Erinnerungsort" ist ein von Pierre Nora in seinem vierbändigen Werk *Les lieux de mémoire* entwickeltes Konzept.

53 Kirn, Gal: „The Yugoslav Partisan Art: Introductory Note", in: *SLAVICA TERGESTINA*, 10–15, hier 10 (wie Anm. 36).

54 Ebd.

55 „Die Schlacht an der Sutjeska" war einer der spektakulärsten Spielfilme dieses Genres, mit Hollywood-Star Richard Burton als Tito.

experiences, combining social struggles, protests, and revolutionary movements, that stand well positioned to forge historical connections and inform wider discussions about the past and future political aspects of the exhibition format. Given that the format of the exhibition as a political medium is increasingly being rethought today, the question of how the "Illegal Artistic Exhibition" can become an incentive for rethinking the exhibition in contemporary contexts resonates with many possible perspectives. For example, we can interpret the exhibition as an early example of "Apt-art"[56] (i.e. exhibitions in private flats) or as a specific forerunner to ongoing exhibitions in which the boundaries between art and life are blurred.

Certainly, revisiting and re-politicizing this exhibition in the post-Yugoslav context also helps to broaden the current position against revisionist politics that use the field of culture to depoliticize anti-fascism and discredit revolutionary methods of the past and present. In a time when we are rapidly losing the achievements of the partisan struggle, such as public and social infrastructure, partisan art and its exhibitional situation can be one of the possible answers to the current dispersal of political imaginaries. Studying its local reception can be instructive for understanding the devastating side-effects of aggravated far-right revisionism, which rapidly crumbles the institutional infrastructure and wider manifolds of secular solidarity inherited from the socialist era. Furthermore, the "Illegal Artistic Exhibition" brings to the fore the inherent capacity of the exhibition to involve its protagonists in immersive social processes that are capable of creating educational, convivial, and communal spaces of solidarity.

It is particularly relevant for the contemporary context that the "Illegal Artistic Exhibition" not only appropriated existing modes of bourgeois culture but also, by partaking in a social and political transformation, changed the very framework of exhibition making.

The "Illegal Artistic Exhibition" insisted that an exhibition is a collective practice by putting into focus the material conditions of artistic and cultural production as an integral part of exhibition making. These issues can be related to the increasingly precarious conditions that today determine the production of those exhibitions resisting the growing trend toward monetization or subjugation to "objective indicators" such as mechanically counting visitors to be classified as precisely as possible into box-like compartments. The "Illegal Artistic Exhibition"

testifies that the exhibition form is one that is potentially open-ended insofar as the exhibition format can be redefined from its foundation and the effects it creates are not straightforwardly measurable. It also reminds us of the fact that the illegal and the legitimate are not mutually exclusive. This is a particularly valuable reminder in light of the ever-increasing pressures of censorship and self-censorships in exhibition practices today. It also poetically demonstrates how exhibitions calibrate varying degrees of visibility; they often relate their exhibitional efforts toward bringing more light into spheres lacking visibility. Yet, in doing so, the temporary illumination that exhibitions are capable of producing inevitably delves into a shadow or semi-visibility. Paradoxically, it is often rescued from that terrain by yet another exhibition, resurfacing and reinforcing the initial contents.

After all, the "Illegal Artistic Exhibition" informs us about the possibility that an exhibition can be a medium of revolution and not just a site for its remembering. The artists and organizers of the "Illegal Artistic Exhibition" closed the exhibition to join the struggle on the frontline. This dynamic is instructive for discerning resistance and revolution, as differentiated by Tatjana Jukić: "The revolution is an ultimate point of resistance and at the same time, a site of its dismissal as resistance: it is the scene of its deconstruction."[57]

Today, in the time of yet another social collapse, the "Illegal Artistic Exhibition" serves as an invitation to continue creating the conditions of opening and urgency through the practice and medium of exhibitions. If we acknowledge the inherent power of the exhibition, the interpretation of representational, symbolic, and performative elements, and the capacity to connect to emancipatory potentials, then we should understand the exhibition not only as a medium but also as a positioning and intervention. It is a positioning towards a particular social, political, and cultural framework, and an intervention into the imposed—rather than imagined or lost—social and cultural landscapes. ∎

56 Coined by the merging of the two words "apartment" and "art," the term "apt-art" originates from Moscow 1980s non-official scene. It is related to the practice of self-organizing the exhibitions in private apartments.

57 Tatjana Jukić, "Revolution Between Biopolitics and Psychoanalysis," in *Otpor: Subverzivne prakse u hrvatskom jeziku, književnosti i kulturi*, eds. Tatjana Pišković and Tvrtko Vuković (Zagreb, 2014), pp. 21–34, esp. p. 22. (Trans. A.D.)

Fazit. Ausstellungen, die als wesentlicher Bestandteil politischer Kämpfe und Proteste produziert werden, bilden ein eigenständiges, noch unzureichend systematisiertes Kapitel der Ausstellungsgeschichte. Meistens beschränken sich diese Ausstellungen jedoch auf die Randbereiche globaler Erzählungen dieser Geschichte. Doch gerade solche Erfahrungen, die soziale Kämpfe, Proteste und revolutionäre Bewegungen miteinander verbinden, sind gut positioniert, um historische Verbindungen zu knüpfen und breitere Diskussionen über vergangene und zukünftige politische Aspekte des Ausstellungsformats zu führen. Angesichts der Tatsache, dass das Format der Ausstellung als politisches Medium heute zunehmend neu überdacht wird, ist die Frage, wie die „Illegale Kunstausstellung" zu einem Anreiz für ein Umdenken in zeitgenössischen Kontexten werden kann, mit vielen möglichen Perspektiven verbunden. So kann die Ausstellung beispielsweise als frühes Beispiel für „Apt-Art"[56] (d.h. Ausstellungen in Privatwohnungen) oder als spezifischer Vorläufer für aktuelle Ausstellungen interpretiert werden, in denen die Grenzen zwischen Kunst und Leben verschwimmen.

Sicherlich trägt das Wiederaufgreifen und ihre Re-Politisierung im post-jugoslawischen Kontext auch dazu bei, die gegenwärtige Position gegen revisionistische Politiken zu erweitern, die das Feld der Kultur nutzen, um den Antifaschismus zu entpolitisieren und revolutionäre Methoden der Vergangenheit und Gegenwart zu diskreditieren. In einer Zeit, in der wir die Errungenschaften des Partisanenkampfes wie öffentliche und soziale Infrastrukturen rapide verlieren, können die Partisanenkunst und ihre Ausstellungssituationen eine der möglichen Antworten auf die gegenwärtige Auflösung des politischen Imaginären sein. Die Untersuchung der lokalen Rezeption kann lehrreich sein, um die verheerenden Nebeneffekte des verschärften Rechtsextremismus zu verstehen, der die institutionelle Infrastruktur und die breiteren Formen der säkularen Solidarität, die aus der sozialistischen Ära geerbt wurden, rasch zerbröckeln lässt. Die „Illegale Kunstausstellung" hebt zudem die der Ausstellung innewohnende Fähigkeit hervor, ihre Protagonisten in immersive soziale Prozesse einzubinden, die in der Lage sind, erzieherische, gesellige und gemeinschaftliche Solidaritätsräume zu schaffen.

Für den zeitgenössischen Kontext ist es besonders relevant, dass sich die „Illegale Kunstausstellung" nicht nur bestehende Formen der bürgerlichen Kultur aneignet, sondern durch die Teilnahme an einem sozialen und politischen Wandel auch den Rahmen des Ausstellungsmachens selbst verändert hat. Die „Illegale Kunstausstellung" bestand darauf, dass eine Ausstellung eine kollektive Praxis ist, indem sie die materiellen Bedingungen der Kunst-und Kulturproduktion als wesentlichen Bestandteil des Ausstellungsmachens in den Mittelpunkt

stellt. Diese Fragen lassen sich mit den zunehmend prekären Bedingungen in Verbindung bringen, die heute die Produktion derjenigen Ausstellungen bestimmen, die sich dem zunehmenden Trend zur Monetarisierung oder Unterwerfung unter objektive Indikatoren widersetzen, wie z.B. die mechanische Zählung der Besucher, um sie möglichst präzise in Schubladen einzuordnen. Die „Illegale Kunstausstellung" bezeugt, dass die Ausstellungsform eine potenziell offene Form ist, insofern als das Ausstellungsformat von Grund auf neu definiert werden kann und die Wirkungen, die es erzeugt, nicht ohne weiteres messbar sind. Sie erinnert uns auch daran, dass sich Illegalität und Legitimität nicht gegenseitig ausschließen. Dies ist eine besonders wertvolle Erinnerung angesichts des ständig wachsenden Drucks der Zensur und Selbstzensur in der Ausstellungspraxis von heute. Es zeigt auch poetisch, wie Ausstellungen unterschiedliche Sichtbarkeitsgrade kalibrieren; oft beziehen sie sich auf ihre Ausstellungsbemühungen, um mehr Licht in undurchsichtige Sphären zu bringen. Dabei taucht die temporäre Beleuchtung, zu der Ausstellungen in der Lage sind, zwangsläufig in einen Schatten oder eine Halbsicht ein. Paradoxerweise wird sie oft durch eine weitere Ausstellung aus diesem Terrain gerettet, die wieder auftaucht und die ursprünglichen Inhalte neu vermittelt.

Schließlich informiert uns die „Illegale Kunstausstellung" über die Möglichkeit, dass eine Ausstellung ein Medium der Revolution und nicht nur ein Ort der Erinnerung an ebendiese sein kann. Die Künstler und Organisatoren der „Illegalen Kunstausstellung" beendeten die Ausstellung, um sich dem Kampf an der Front anzuschließen. Diese Dynamik ist lehrreich für anspruchsvollen Widerstand und Revolution, wie Tatjana Jukić differenziert: „Die Revolution ist ein ultimativer Punkt des Widerstandes und zugleich Ort ihrer Verwerfung als Widerstand: sie ist Schauplatz ihrer Dekonstruktion."[57]

Heute, in der Zeit eines erneuten gesellschaftlichen Zusammenbruchs, ist die „Illegale Kunstausstellung" eine Einladung, die Bedingungen der Öffnung und Dringlichkeit durch die Praxis und das Medium der Ausstellungen weiter zu schaffen. Wenn wir die der Ausstellung innewohnende Kraft, die Interpretation von gegenständlichen, symbolischen und performativen Elementen und die Fähigkeit, sich mit emanzipatorischen Potenzialen zu verbinden, anerkennen, dann sollten wir die Ausstellung nicht nur als Medium, sondern auch als Positionierung und Intervention verstehen. Es ist eine Positionierung auf einen bestimmten sozialen, politischen und kulturellen Rahmen und eine Intervention in die eher oktroyierten – als imaginären oder verlorenen – sozialen und kulturellen Landschaften. ∎

Übersetzung: Otmar Lichtenwörther

56 Der Begriff „Apt-Art", geprägt durch die Verschmelzung der beiden Wörter „Apartment" und „Art", stammt aus der Moskauer Off-Szene der 1980er Jahre. Er bezieht sich auf die Praxis von selbstorganisierten Ausstellungen in Privatwohnungen.

57 Jukić, Tatjana: „Revolution zwischen Biopolitik und Psychoanalyse", in: Pišković, Tatjana/Vuković, Tvrtko (Hg.): *Otpor. Subverzivne prakse u hrvatskom jeziku, književnosti i kulturi*, Zagreb 2014, 21–34, hier 22. (A.d.Ü.: Übersetzung auf Basis der Übersetzung der Autorin ins Englische)

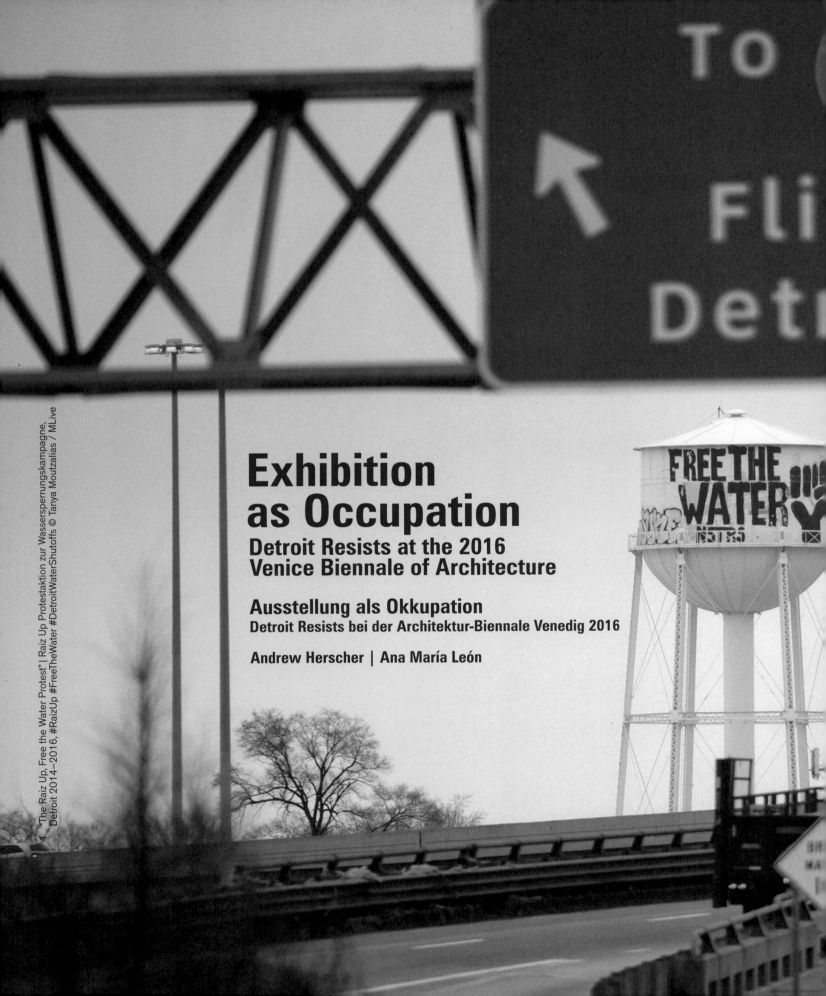

Exhibition as Occupation
Detroit Resists at the 2016
Venice Biennale of Architecture

Ausstellung als Okkupation
Detroit Resists bei der Architektur-Biennale Venedig 2016

Andrew Herscher | Ana María León

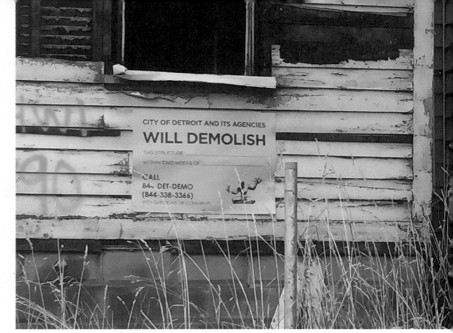

Blight removal campaign |
Abrisskampagne sanierungsbedürftiger Häuser,
Detroit, 2016 © Ana María León

In the summer of 2015, "The Architectural Imagination" was announced as the program for the U.S. Pavilion in the 2016 Venice Biennale of Architecture. Two curators won the bi-annual competition for this program overseen by the U.S. Department of State: Mónica Ponce de León, at the time the outgoing Dean of the Taubman College of Architecture and Urban Planning at the University of Michigan in Ann Arbor, Michigan, and Cynthia Davidson, editor of the New York-based architecture journal *Log*.

In "The Architectural Imagination," Ponce de León and Davidson proposed to commission "speculative architectural proposals" for four sites in Detroit. "Like many postindustrial cities," the program description reads, "Detroit is coping with a changed urban core that for decades has generated much thinking in urban planning. As advocates of the power of architecture to construct culture and catalyze cities, curators Cynthia Davidson and Mónica Ponce de León will commission twelve visionary American architectural practices to produce new work that demonstrates the creativity and resourcefulness of architecture to address the social and environmental issues of the 21st century."[1]

"The Architectural Imagination" was itself imagined during a period of radical urban redevelopment in Detroit; the project placed "speculative architecture" and the academic institutions in which this architecture is produced, discussed, and evaluated in relation to this redevelopment. This period of redevelopment was initiated by the 2013 declaration of a state of financial emergency in Detroit by Michigan's governor and the governor's replacement of Detroit's democratically-elected mayor and city council by an emergency manager—in other words, by the suspension of democracy in a democracy that constituted a state of exception.[2] In this state of exception, the emergency manager forced Detroit into bankruptcy, and, in a moment that is still ongoing, downtown Detroit is undergoing a renewal primarily driven by two billionaire investor-developers while radical post-bankruptcy austerity policies are yielding large-scale displacements of working-class and disadvantaged communities of color.

These austerity policies include a campaign to demolish over 40,000 so-called "blighted" houses, the largest

blight removal campaign in U.S. history, undertaken while the need for affordable housing in Detroit remains acute; the largest mass tax foreclosure in U.S. history, a campaign that had led to the mass eviction of tens of thousands of mostly working-class black families from their houses in order that these houses can be auctioned off (fig. 2); and the imposition of a policy to shut off water to tens of thousands of houses where mostly working-class black families are late on their payment of unaffordable water bills, the largest mass water shut-off campaign in U.S. history that is displacing thousands of families and destroying the neighborhoods these families built and live in.

These policies are fissuring the city into a phenomenon termed "Two Detroits:" a downtown redeveloped through public subsidy in league with corporate capitalism and neighborhoods undeveloped through radical urban austerity.[3] The program of the U.S. Pavilion did not critique this situation; instead, this program enmeshed speculative architecture within it. The four sites chosen by the curators for speculative architectural exploration were each places of current or incipient redevelopment by and for a mostly white creative class, the corporate interests that profit from this class, and the political forces in league with those interests.

1 "The Architectural Imagination," http://www.thearchitecturalimagination. org/ (accessed October 6, 2017).

2 On emergency management as a state of exception, see "Detroit Under Emergency Management," in *Mapping the Water Crisis: The Dismantling of African-American Neighborhoods in Detroit*, ed. We the People of Detroit Community Research Collective (Detroit, 2016) and "The System Is Bankrupt," in Scott Kurashige, *The Fifty-Year Rebellion: How the U.S. Political Crisis Began in Detroit* (Berkeley, 2017).

3 See Laura A. Reese, Jeanette Eckert, Gary Sands, and Igor Vojnovic, "'It's Safe to Come, We've Got Lattes': Development Disparities in Detroit," *Cities* 60 (2017), pp. 367–377; on the state's denial of "Two Detroits," see Lee DeVito, "Duggan Calls 'Two Detroits' Narrative 'Fiction' on Heels of Big Primary Win, *Metro Times*, August 9, 2017.

Im Sommer 2015 wurde „The Architectural Imagination" als Programm für den US-Pavillon der Architektur-Biennale Venedig 2016 angekündigt. Zwei Kuratorinnen gewannen den alle zwei Jahre stattfindenden Wettbewerb für dieses Programm, das vom US-Außenministerium betreut wird: Mónica Ponce de León, damals aus dem Amt scheidende Dekanin des Taubman College of Architecture and Urban Planning an der University of Michigan in Ann Arbor, Michigan, und Cynthia Davidson, Herausgeberin der New Yorker Architekturzeitschrift Log.

In „The Architectural Imagination" schlugen Ponce de León und Davidson vor, „spekulative Architekturvorschläge" für vier Standorte in Detroit in Auftrag zu geben. „Wie viele postindustrielle Städte", heißt es in der Programmbeschreibung, „kämpft Detroit mit einem veränderten Stadtkern, der der Stadtplanung seit Jahrzehnten großes Kopfzerbrechen bereitet. Als Verfechterinnen der Kraft der Architektur, Kultur zu bauen und Städte zu beleben, werden die Kuratorinnen Cynthia Davidson und Mónica Ponce de León zwölf visionäre amerikanische Architekturbüros damit beauftragen, neue Arbeiten zu produzieren, die die Kreativität und den Einfallsreichtum der Architektur im Hinblick auf die Bewältigung der sozialen und ökologischen Probleme des 21. Jahrhunderts demonstrieren."[1]

„The Architectural Imagination" selbst wurde während einer Zeit der radikalen Stadtsanierung in Detroit konzipiert; das Projekt stellte „spekulative Architektur" und die akademischen Institutionen, in denen diese Architektur produziert, diskutiert und evaluiert wird, in Beziehung zu dieser Sanierung. Diese Sanierungsphase wurde eingeleitet, als der Gouverneur von Michigan 2013 für Detroit den Finanznotstand erklärte und den demokratisch gewählten Bürgermeister von Detroit samt Stadträten durch einen Notfallmanager ablöste – in anderen Worten: durch die Aufhebung der Demokratie in einer Demokratie, die einen Ausnahmezustand darstellte.[2] In diesem Ausnahmezustand zwang der Notfallmanager Detroit in den Konkurs, und seit damals bis zum heutigen Tage wird das Zentrum von Detroit einer Stadtsanierung unterzogen, die in erster Linie von zwei milliardenschweren Investoren und Bauträgern vorangetrieben wird, während die Arbeiterschaft und sozial benachteiligte afroamerikanische und Latino-Communitys nach dem Konkurs durch radikale politische Maßnahmen im großen Maßstab verdrängt wurden.

Diese Sparpolitik umfasste eine Kampagne zum Abriss von mehr als 40.000 so genannten „sanierungsbedürftigen/

verfallenen" Häusern, die größte Abrisskampagne, die in der Geschichte der Vereinigten Staaten jemals durchgeführt worden ist, obwohl in Detroit weiterhin dringender Bedarf an leistbarem Wohnraum herrscht (Abb. 2); die massivste Massensteuer-Verfallserklärung in der Geschichte der Vereinigten Staaten, eine Kampagne, die zur Delogierung von zehntausenden zumeist afroamerikanischen Arbeiterfamilien aus ihren Häusern geführt hat, damit diese Häuser versteigert werden können; und die Auferlegung einer Politik der Sperrung der Wasserversorgung von zehntausenden Häusern, wo zumeist afroamerikanische Arbeiterfamilien mit der Begleichung der unerschwinglichen Wasserrechnung in Verzug sind; die umfangreichste Wassersperrungskampagne in der Geschichte der Vereinigten Staaten, die aktuell zur Vertreibung von tausenden Familien und zur Zerstörung der Viertel geführt haben, die diese Familien gebaut haben und bewohnen.

Diese politischen Maßnahmen spalten die Stadt in ein Phänomen, das als „Two Detroits" (zwei Detroits) bezeichnet wird: eine durch öffentliche Mittel im Bunde mit dem Konzernkapitalismus sanierte Innenstadt und Viertel, die durch die radikalen Sparmaßnahmen der Stadt dem Verfall preisgegeben sind.[3] Das Programm des US-Pavillons kritisierte diese Situation nicht, sondern flocht spekulative Architektur darin ein. Die von den Kuratorinnen für die spekulative architektonische Erkundung ausgewählten Standorte, waren jeweils Orte der aktuellen oder beginnenden Sanierung durch und für hauptsächlich weiße Kreativberufler, die von ihnen profitierenden Unternehmensinteressen und die mit diesen Interessen im Bunde stehenden politischen Kräfte.

Detroit Resists. Im Herbst 2015 gründete eine kleine Gruppe von Künstlern, Architekten, Akademikern und Aktivisten „Detroit Resists" als eine Plattform zur Anfechtung ebendieser „Architectural Imagination"; diese Anfechtung richtete sich gegen die Aneignung von Detroit seitens der Ausstellung für die Entwicklung von institutionellen und fachlichen Zukunftsperspektiven für die Architektur und die damit einhergehende Ratifizierung anhaltender urbaner Gewalt in der Stadt. Ein entscheidender Bestandteil dieser Auseinandersetzung war

1 „The Architectural Imagination", online unter: http://www.thearchitecturalimagination.org/ (Stand: 6. Oktober 2017).

2 Zum Notfallmanagement als Ausnahmezustand siehe „Detroit Under Emergency Management", in: Mapping the Water Crisis: We the People of Detroit Community Research Collective (Hg.): The Dismantling of African-American Neighborhoods in Detroit, Detroit 2016 und „The System Is Bankrupt", in: Kurashige, Scott: The Fifty-Year Rebellion. How the U.S. Political Crisis Began in Detroit, Berkeley 2017.

3 Siehe Reese, Laura A.; Eckert, Jeanette; Sands, Gary and Vojnovic, Igor in: „It's Safe to Come, We've Got Lattes': Development Disparities in Detroit", in: Cities 60 (2017), 367–377; zur Leugnung der „zwei Detroit" seitens des Bundesstaates Michigan siehe DeVito, Lee: „Duggan Calls ‚Two Detroits' Narrative ‚Fiction' on Heels of Big Primary Win", in: Metro Times, 9. August 2017.

Detroit Resists. In the fall of 2015, a small group of artists, architects, academics, and activists formed "Detroit Resists" as a platform to contest "The Architectural Imagination;" this contestation was directed against the exhibition's appropriation of Detroit for the development of architecture's institutional and professional futures and accompanying ratification of ongoing urban violence in the city. A crucial component of this contestation was identifying and mobilizing digital spaces for the presentation of images, texts, and political claims that were inadmissible in physical spaces, especially prominent spaces like those at the Venice Biennale, access to which depends on wealth, power, privilege, and many other entitlements besides. Another component of this contestation was to pose "The Architectural Imagination" as a phenomenon not contained by the U.S. Pavilion, but rather dispersed among a disaggregated series of digital and physical sites, any and all of which were potential sites of resistance.

Historicizing the curators' advocacy of "the power of architecture," we wrote an "Open Statement" in which we argued that:

> What the project description refers to as "the power of architecture" might serve as simply another name for architecture's political indifference—the capacity of architecture to be of service to political regimes, no matter their ideological orientation. This architectural power has been manifestly apparent in architecture's recruitments against indigenous, impoverished, marginalized, and precarious communities across the globe, usually in the name of "development" or "modernization" in the second half of the 20th century. Now, as the project description aptly points out, it is being increasingly mobilized in the name of "the social and environmental issues of the 21st century."[4]

We suggested that "the power of architecture is being demonstrated in Detroit even more emphatically today, in the wake of the city's emergency financial management, forced bankruptcy, and current austerity urbanism."[5] And we concluded that, "if the mass dispossession of Detroit's predominantly African-American residents by the mobilization of their homes in austerity urbanism does not exemplify the power of architecture, then we do not know what does."[6]

We made our "Open Statement" public on a website, Facebook, and Twitter, and we continued to use these digital platforms to circulate our responses to the curators' efforts to advertise and publicize "The Architectural Imagination."[7] Some of the forms of our contestation duplicated the forms by means of which the U.S. Pavilion exhibition was publicized and framed.

For example, the Princeton University School of Architecture, where Ponce de León became dean in January 2016, announced a lecture series entitled "Detroit 101" which presented a creative-class narrative of urban change in the guise of telling the untold "real story of Detroit."[8] In response, we produced a reading series entitled "Detroit 102," publicized on a poster that mimicked the poster for Detroit 101 (fig. 3). Detroit 102 critiqued

4 "Statement on the U.S. Pavilion at the 2016 Venice Architecture Biennale," Detroit Resists, https://detroitresists.org/2016/02/20/statement-on-the-u-s-pavilion-at-the-2016-venice-architecture-biennale/ (accessed October 6, 2017).

5 Ibid.

6 Ibid.

7 See https://detroitresists.org; https://twitter.com/detroitresists; https://www.facebook.com/detroitresists.

8 "Detroit 101," http://arts.princeton.edu/events/detroit-101/.

DETROIT 102

"The story of Detroit is well known ... yet the real story of Detroit goes quietly untold. The Detroit 101 lecture series at Princeton University's School of Architecture will focus on the underlying causes that perpetuated Detroit's decline, and use this as a lens to supplant the usual disciplinary rhetoric and explore new territories across multiple fields of study. With increased attention on Detroit and urgent calls for social justice in America, many disciplines are retelling the city's history while others are projecting its future. We must ask ourselves: is the contemporary narrative of Detroit based on a fact or fiction?"

"Detroit 101," Princeton University School of Architecture

The Detroit 101 lecture series will provide students at Princeton University's School of Architecture with a focused introduction to the urban restructuring of Detroit by and for the creative class, albeit in the guise of uncovering "the real story" of the city. As such, Detroit 101 also serves as product placement for the U.S. Pavilion at the 2016 Venice Biennale, dedicated to the theme of Detroit's "Architectural Imagination." The curriculum of Detroit 102 will extend Detroit 101 by providing students with tools to critically unpack the neoliberal politics of contemporary urbanism in Detroit, as well as to locate the race- and class-based exclusions that are invisible or disavowed in creative class narratives of urban change.

Topic 1 — **Art, Creative Labor & Neoliberalism**
Stefano Harney, "Unfinished Business: Labour, Management and the Creative Industries," Cultural Studies 24:3 (2010).

Rosalind Gill and Andy C. Pratt, "In the Social Factory? Immaterial Labour, Precariousness, and Cultural Work," Theory, Culture, and Society 25:7-8 (2008).

Topic 2 — **Austerity Urbanism & Design**
Jamie Peck, "Austerity Urbanism: American Cities Under Extreme Economy," City 16:6 (2012).

Jason Hackworth, "Right-sizing as Spatial Austerity in the American Rust Belt," Environment and Planning A 47:4 (2015).

L. Owen Kirkpatrick, "Urban Triage, City Systems, and the Remnants of Community: Some 'Sticky' Complications in the Greening of Detroit," Journal of Urban History 41:2 (2015).

Topic 3 — **The Arts of Urban Gentrification**
Martha Rosler, "Culture Class Part I: Art and Urbanism," in Culture Class. Berlin: Sternberg Press, 2013.

Grant Kester, "Eminent Domain: Art and Urban Space," in The One and The Many: Contemporary Collaborative Art in a Global Context. Durham: Duke University Press, 2011.

Topic 4 — **Philanthrocapitalism & Private Policy**
Andrea Smith, "Introduction: The Revolution Will Not be Funded," in The Revolution Will Not be Funded: Beyond the Non-Profit Industrial Complex, ed. INCITE! Women of Color Against Violence. Boston: South End Press, 2009.

Vincanne Adams, "Charity, Philantrocapitalism, and the Affect Economy," in Markets of Sorrow, Labors of Faith: New Orleans in the Wake of Katrina. Durham: Duke University Press, 2013.

Topic 5 — **Race, Real Estate & "Regeneration"**
Peter J. Hammer, "Race, Regionalism, and Reconciliation: Detroit Planning Fails the Three Rs," Progressive Planning 205 (2015).

Daniel Clement and Miguel Kanai, "The Detroit Future City: How Pervasive Neoliberal Urbanism Exacerbates Racialized Spatial Injustice," American Behavioral Scientist 59:3 (2015).

Andrew Herscher, "Blight,' Spatial Racism, and the Demolition of the Housing Question in Detroit," in Housing After the Neoliberal Turn, ed. Stefan Aue, Jesko Fezer, Martin Hager, Christian Hiller, Nikolaus Hirsch, Anne Kockelkorn, and Reinhold Martin. Leipzig: Spector Books, 2015.

For more information, please visit **DETROIT RESISTS** at www.detroitresists.org and follow us on twitter @detroitresist. You can reach us at detroitresists@gmail.com.

Detroit 102 was made possible with generous support of **DETROIT RESISTS**: a coalition of activists, artists, architects, and community members working on behalf of an inclusive, equitable, and democratic city.

3

Detroit 101," lecture series | Vorlesungsreihe,
Princeton University School of Architecture,
Detroit 102," reading list | Leseliste,
Venice Architecture Biennale | Architekturbiennale Venedig,
2016 © Detroit Resists

die Identifizierung und Mobilisierung digitaler Räume für die Präsentation von Bildern, Texten und politischen Ansprüchen, die in physischen Räumen unzulässig sind, insbesondere in so einem prominenten Rahmen wie dem der Architektur-Biennale Venedig, zu dem der Zutritt überdies von Reichtum, Macht, Privileg und vielen anderen Anrechten abhängt. Ein weiterer Bestandteil dieser Anfechtung war es, „The Architectural Imagination" als ein Phänomen darzustellen, das nicht vom US-Pavillon eingeschlossen ist, sondern auf eine Reihe von digitalen und physikalischen Standorten verteilt ist, die allesamt potenzielle Orte des Widerstands waren.

Wir stellten die Befürwortung der „Macht der Architektur" seitens der Kuratorinnen in einen historischen Zusammenhang und verfassten eine „Offene Erklärung", in der wir folgende Argumente anführten:

„Was in der Projektbeschreibung als ‚die Macht der Architektur' bezeichnet wird, könnte einfach eine andere Bezeichnung für die politische Gleichgültigkeit der Architektur sein – die Fähigkeit der Architektur, politischen Regimes, unabhängig von deren ideologischer Orientierung, zu dienen. Diese Macht der Architektur zeigte sich ganz offenkundig in der Rekrutierung der Architektur gegen indigene, verarmte, marginalisierte und prekäre Communitys auf der ganzen Welt, meist im Namen der ‚Entwicklung' oder ‚Modernisierung', in der zweiten Hälfte des 20. Jahrhunderts. Nun wird sie, wie die Projektbeschreibung treffend hervorhebt, zunehmend im Namen der ‚sozialen und ökologischen Fragen des 21. Jahrhunderts' mobilisiert."[4]

Wir schlugen vor, dass „die Macht der Architektur heute in Detroit noch eindringlicher demonstriert wird, im Kielwasser des Notfallmanagements der Stadt, des erzwungenen Bankrotts und der aktuellen städtebaulichen Austerität."[5] Und wir kamen zu dem Schluss, dass „wenn die Massenenteignung der vorwiegend afroamerikanischen Bevölkerung von Detroit durch die Mobilisierung ihrer Häuser in Zeiten städtebaulicher Austerität als Beispiel für die Macht der Architektur dient, dann wissen wir nicht was sonst."[6]

Wir haben unsere „Offene Erklärung" auf einer Website, auf Facebook und auf Twitter veröffentlicht und nutzen diese digitalen Plattformen weiterhin, um unsere Antworten auf die Bemühungen der Kuratorinnen, „The Architectural Imagination" zu bewerben und zu publizieren, zu verbreiten.[7] Mit einigen Formen unserer Anfechtung kopierten wir die Formen, mit denen die Ausstellung des U. S. Pavillons publik gemacht und gestaltet wurde. Zum Beispiel kündigte die Princeton University School of Architecture, an der Ponce de León im Januar 2016 Dekan wurde, eine Vorlesungsreihe mit dem Titel „Detroit 101" an, in der eine Geschichte des städtischen Wandels für die kreative Klasse in der Gestalt einer noch nie erzählten „wahren Geschichte Detroits" präsentiert wurde.[8] Als Reaktion darauf produzierten wir eine Vortragsreihe mit dem Titel „Detroit 102", die auf einem das Plakat für Detroit 101 imitierenden Plakat publik gemacht wurde. (Abb. 3). Detroit 102 kritisierte Detroit 101 als Produktplatzierung für den US-Pavillon, bot

4 Detroit Resists: „Statement on the U.S. Pavilion at the 2016 Venice Architecture Biennale", online unter: https://detroitresists.org/2016/02/20/statement-on-the-u-s-pavilion-at-the-2016-venice-architecture-biennale/ (Stand: 6. Oktober 2017).

5 Ebd.

6 Ebd.

7 Siehe https://detroitresists.org; https://twitter.com/detroitresists; https://www.facebook.com/detroitresists.

8 „Detroit 101", http://arts.princeton.edu/events/detroit-101/.

Detroit 101 as a product placement for the U.S. Pavilion, offered readings to unpack the neoliberal politics of contemporary urbanism in the city, and located the race- and class-based exclusions that are invisible or disavowed in creative class narratives of urban change.[9]

We undertook a similar action in reaction to a series of panel discussions organized by the curators at the U.S. Pavilion under the title "Architecture and Change." We annotated the announcement of this event, incorporating its poster into another poster on which we pointed out some of the problems that have become symptomatic to many such events in architecture discourse at large. We pointed out that "change," as a depoliticized, value-free, and generic term, was here used to displace political understanding of historical transformation. We argued that repeated references to "the social" and "the political" in the description of the event functioned as a ruse: they were brought up as frames for discussion in order to elide their absence in the curatorial process itself. And we pointed out that many of the sources of funding for the U.S. Pavilion were corporations that would benefit from the displacement of Detroit's mostly African American working class communities.[10]

We circulated our annotated poster as a PDF, encouraged our allies to print and post the poster in their schools, and highlighted this physical dissemination back into our social media network.[11] By broadcasting our message in this way, we hoped to spark conversations within schools of architecture on the circular logic that is often employed in architectural discourse—one in which the very communities' architecture pretends to aid are simultaneously invoked and erased.

Architecture's Exhibitionary Complex. In effect, the statements made by the curators of "The Architectural Imagination" about a city poised to be re-imagined by speculative architecture and the human catastrophe taking place in that same city seem to belong to different worlds. However, if we disentangle the power relationships produced by this state-sponsored architectural exhibition, we discover that the exhibition and catastrophe are intimately connected: "The Architectural Imagination" is an example of how exhibitions can produce both narratives for the nation-state and its municipal components and willing and complicit audiences for those narratives. The actions of Detroit Resists revealed and contested these operations.

In the last few years, the figure of the curator and the format of the architectural exhibition have received increasing attention in architectural discourse. Conferences have been dedicated to these topics, masters programs have been created around them, and architectural biennials and triennials have popped up everywhere from Shenzhen to Chicago. Certainly these events have provided new and needed spaces for disciplinary conversations. However, while some exhibitions have productively used these spaces to critically engage the status of the discipline, others have pushed forward agendas linked to larger interests and, in so doing, they have joined the long history of exhibitions as ideological agents of power and capital.

The sociologist Tony Bennett has theorized this phenomenon as "the exhibitionary complex."[12] In his analysis of the museum, Bennett expands on Antonio Gramsci's analysis of the modern state's education of its citizens and Michel Foucault's insights on the prison and school as architectural forms embodying relations between knowledge and power. Bennett examines the museum and international exhibitions as spaces in which the public is instructed on how and what to look at. By virtue of this instruction, Bennett argues, the public sees itself in the place of power, and through this experience the public comes to constitute itself as a self-regulating citizenry. Via Bennett, we understand national and international exhibitions like the Venice Biennale as producing two interrelated identities: that of the power represented by the exhibition, that is, the nation-state, and that of a willing, complicit audience. In doing so, they constitute instances of architecture's own exhibitionary complex.

What Bennett fails to note is that displays of power and capital embodied in the exhibitionary complex have, on occasion, been resisted, at times by using the same exhibitionary tactics in order to offer a counter-narrative to that offered by the state and its surrogates. For instance, the imperial reach of the Paris Colonial Exposition of 1931 was resisted by *La Vérité sur les colonies* (The Truth about the Colonies), a counter-

9 "Detroit 102," https://detroitresists.org/2016/02/27/detroit-102/. One of the allies of Detroit Resists then posted pdfs of the readings on the Detroit 102 reading list on an online library that facilitates the free sharing of intellectual labor.

10 "Architecture and Change," https://detroitresists.org/2016/09/26/architecture-and-change-the-politics-of-change-in-the-u-s-pavilion-at-the-2016-venice-biennale/.

11 See for instance https://www.instagram.com/p/BK9F8h4j-Cc/, www.instagram.com/p/BK9U0y0Dzd4, www.instagram.com/p/BLCf5TDDbXS/, and www.instagram.com/p/BLR8JHpj9u6/.

12 Tony Bennett, "The Exhibitionary Complex" *New Formations* 4 (1988), pp. 73–102.

Lesungen zur Aufdeckung der neoliberalen Politik des zeitgenössischen Urbanismus in der Stadt an und verortete die rassen- und klassenbasierte Exklusion, die in den Narrativen vom urbanen Wandel, die sich die kreative Klasse erzählt, unsichtbar ist oder verleugnet wird.[9]

Wir führten eine ähnliche Aktion als Reaktion auf eine Reihe von Podiumsdiskussionen durch, die von den Kuratoren des US-Pavillons unter dem Titel „Architecture and Change" (Architektur und Veränderung) organisiert worden waren. Wir haben die Ankündigung dieser Veranstaltung mit Kommentaren versehen und das Plakat dazu in ein weiteres Plakat integriert, auf dem wir einige der Probleme, die für viele solche Veranstaltungen im Architekturdiskurs symptomatisch geworden sind, herausgestellt haben. Wir wiesen darauf hin, dass „Veränderung" als entpolitisierter, wertfreier und allgemeiner Begriff hier benutzt wurde, um das politische Verständnis von historischem Wandel zu verlagern. Wir argumentierten, dass wiederholte Verweise auf „das Soziale" und „das Politische" in der Veranstaltungsbeschreibung als List dienten: Sie wurden als Diskussionsrahmen aufgezogen, um ihre Abwesenheit im kuratorischen Prozess selbst auszusparen. Und wir betonten, dass viele der Geldgeber für den US-Pavillon Unternehmen waren, die von der Verdrängung der großteils afroamerikanischen Arbeiter-Communitys in Detroit profitieren würden.[10]

Wir verbreiteten unser mit Kommentaren versehenes Plakat als PDF-Datei, ermutigten unsere Verbündeten, das Plakat in ihren Schulen auszudrucken und auszuhängen, und warfen in unserem Social Media-Netzwerk wiederum ein Schlaglicht auf dessen physische Verbreitung.[11] Indem wir unsere Botschaft auf diese Weise sendeten, hofften wir, den Dialog innerhalb der Architekturschulen auf den Zirkelschluss zu lenken, der im architektonischen Diskurs häufig zur Anwendung kommt – einen, in dem genau die Communitys, denen die Architektur zu helfen vorgibt, ins Felde geführt und gleichzeitig ausgelöscht werden.

Der Ausstellungskomplex der Architektur. In der Tat sind die Aussagen der Kuratorinnen von „The Architectural Imagination" über eine Stadt, die im Begriff ist, von spekulativer Architektur neu gedacht zu werden, und die menschliche Tragödie, die sich in derselben Stadt gerade abspielt, anscheinend in verschiedenen Welten angesiedelt. Wenn wir jedoch die von dieser staatlich geförderten Architekturausstellung produzierten Machtverhältnisse entwirren, entdecken wir, dass Ausstellung und Katastrophe eng miteinander verbunden sind: „The Architectural Imagination" ist ein Beispiel dafür, wie Ausstellungen sowohl Narrative für den Nationalstaat und dessen kommunale Komponenten als auch ein williges und komplizenhaftes

Publikum für diese Narrative produzieren können. Die Aktionen von Detroit Resists haben diese Operationen aufgedeckt und angefochten.

Die Figur des Kurators und das Format der Architekturausstellung haben in den letzten Jahren im Architekturdiskurs zunehmend an Bedeutung gewonnen. Konferenzen sind diesen Themen gewidmet, um sie herum wurden Master-Programme ins Leben gerufen und Architektur-Biennalen und Triennalen sind von Shenzhen bis Chicago überall auf der Welt ins Leben gerufen worden. Sicherlich haben diese Ereignisse neue und notwendige Räume für Gespräche innerhalb des Faches geschaffen. Doch während einige Ausstellungen diese Räume produktiv genutzt haben, um den Status des Faches kritisch zu hinterfragen, haben andere mit größeren Interessen verbundene Agenden vorangetrieben und sich damit der langen Geschichte von Ausstellungen als ideologische Erfüllungsgehilfen der Macht und des Kapitals angeschlossen.

Der Soziologe Tony Bennett stellte für dieses Phänomen die Theorie des „Ausstellungskomplexes" auf.[12] In seiner Analyse des Museums vertieft Bennett Antonio Gramscis Analyse der Erziehung seiner Bürger durch den modernen Staat und Michel Foucaults Einsichten über das Gefängnis und die Schule als architektonische Formen, die Beziehungen zwischen Wissen und Macht verkörpern. Bennett untersucht das Museum und internationale Ausstellungen als Räume, in denen das Publikum über das Wie und Was des Betrachtens belehrt wird. Aufgrund dieser Belehrung, so Bennett, sehe sich das Publikum an der Stelle der Macht, und durch diese Erfahrung könne sich das Publikum als selbstregulierende Bürgerschaft konstituieren. Über Bennett verstehen wir nationale und internationale Ausstellungen wie die Biennale von Venedig als Produzenten zweier miteinander verbundener Identitäten: der der von der Ausstellung repräsentierten Macht, also der des Nationalstaats, und der eines willigen und komplizenhaften Publikums. Sie sind damit Beispiele für den eigenen Ausstellungskomplex der Architektur.

Was Bennett nicht bemerkt, ist, dass den im Ausstellungskomplex verkörperten Zurschaustellungen von Macht und Kapital gelegentlich widerstanden wurde, bisweilen mit der gleichen Ausstellungstaktik, um der vom Staat und seinen Stellvertretern angebotenen Erzählung eine eigene Gegenerzählung entgegenzusetzen. So widersetzte sich beispielsweise *La Vérité*

9 „Detroit 102", https://detroitresists.org/2016/02/27/detroit-102/. Einer der Verbündeten von Detroit Resists postete dann PDF-Dateien der Lektüre auf der Leseliste von Detroit 102 in einer Online-Bibliothek, die das kostenlose Teilen von geistiger Arbeit ermöglicht.

10 „Architecture and Change", online unter: https://detroitresists.org/2016/09/26/architecture-and-change-the-politics-of-change-in-the-u-s-pavilion-at-the-2016-venice-biennale/.

11 Siehe zum Beispiel https://www.instagram.com/p/BK9F8h4j-Cc/, www.instagram.com/p/BK9U0y0Dzd4, www.instagram.com/p/BLCf5TDDbXS/, and www.instagram.com/p/BLR8JHpj9u6/.

12 Bennett, Tony: „The Exhibitionary Complex", in: *New Formations* 4 (1988), 73–102.

exhibition produced by the French Communist Party and a group of Surrealists.[13] In the 1937 International Exhibition, also in Paris, the Pavilion of the Spanish Republic called attention to the ongoing resistance to the forces of Franco, documenting the conflict through photographs, sculptures, and among other art works, Picasso's *Guernica*.[14] A few years later in Brazil, Lina Bo Bardi and Martim Gonçalves designed and curated an exhibition of the forgotten region of Bahia to confront the developmentalism espoused by the São Paulo 1959 Bienal.[15]

One of the few moments in the history of the Venice Biennale of this resistance was during the boycotts and demonstrations of the 1968 Biennale.[16] In the context of revolutionary activities across the world, artists acted in solidarity with the student movements and attacked the Biennale and the Italian art establishment. The Biennale was accused of advancing a colonial politics through the hosting of national pavilions tied to the official politics of the countries that were represented, as well as placing art in an unbreakable alliance with capital. In response to these protests, the statute of the Biennial, composed in Fascist Italy in the 1930s, was re-written.[17]

All these counter-exhibitions called attention to hegemonic narratives by introducing forgotten populations into sites of privilege and power. In so doing, they revealed the workings of the exhibitionary complex, transforming the space of exhibition into a space of dissensus and contestation. They called out the powers represented by these exhibitions and disrupted the reading made by their audiences.

Some of the power relations represented by "The Architectural Imagination" are openly acknowledged — the exhibition was financed and promoted by the U.S. Department of State, along with a number of institutional and corporate sponsors. The State Department's involvement in the U.S. Pavilion began during the Cold War, when the U.S. government expanded its recruitment and deployment of culture in its struggle with the Soviet Union for global dominance.[18] The exhibitions that the State Department chooses for the U.S. Pavilion are to celebrate "the excellence, vitality, and diversity of American arts" — a celebration that intersects with the imperative, on the part of the arts, to maintain themselves as culturally-relevant and institutionally-prominent.[19] Beyond the interests of the U.S. Department of State, additional sponsors have their own interests in the financial processes on which exhibitions in the pavilion are based and sometimes advance.[20]

These relationships are also foregrounded when we elucidate who might be the intended audience for this exhibition. We might argue that the audience of "The Architectural Imagination" is primarily that of architects, who, in a twist of Bennett's argument, see themselves represented and thus empowered and emboldened by the power of the state (the United States here functioning as a metonym for "the state" more generally), and more importantly, authorized and encouraged to collaborate with the processes represented specifically in this exhibition. In other words: if the exhibition suggests that the power of architecture can rescue the city, it also suggests the figure of the architect as the heroic protagonist in this narrative. The exhibition seductively suggests that the architecture profession at large can occupy the role of savior in the narrative of Detroit's redevelopment, and, under this guise, invites architects to become complicit, if unself-conscious agents in the institutional racism, forced displacement, and gentrification perpetrated by the state.[21]

13 Louis Aragon, Paul Éluard, and Yves Tanguy. Images of the counter-exhibition were later featured in *Le Surréalisme au service de la révolution*, n° 4, December 1931.

14 See Catherine Blanton Freedberg, *The Spanish Pavilion at the Paris World's Fair*. Outstanding Dissertations in the Fine Arts (New York, 1986).

15 For information on the exhibition, see Zeuler Lima, *Lina Bo Bardi* (New Haven, 2013). The specific argument of Bo Bardi and Gonçalves' work as counter-exhibition is developed in Ana María León, "Lina in Bahia, *Bahia no Ibirapuera*," (paper presented at the annual meeting of the Society of Architectural Historians, Pasadena, California, April 6–10, 2016).

16 Grace Glueck, "Venice Student Protests Are Disrupting Biennale," *New York Times*, June 21, 1968; Lisa Ponti, "68 in Venice," *Domus* 917 (2008), pp. 41–47.

17 The Venice Biennale began to develop into an international exhibition in the 1930s in Fascist Italy. For a history of the Biennale, see www.labiennale.org/en/history.

18 See Robert Haddow, *Pavilions of Plenty: Exhibiting America in the Cold War* (Washington, 1997), and Michael Krenn, *Fallout Shelters for the Human Spirit: American Art and the Cold War* (Chapel Hill, 2005).

19 See U.S. Department of State, "Venice Architectural Biennale" https://exchanges.state.gov/us/program/venice-architectural-biennale (accessed September 11, 2017).

20 For an analysis of the entanglements of the biennial complex in the broader art world, see Elena Filipovic, Marieke Van Hal, and Solveig Ovstebo, *The Biennial Reader: The Bergen Biennial Conference* (Ostfildern, 2010), and Caroline A. Jones, *The Global Work of Art World's Fairs, Biennials, and the Aesthetics of Experience* (Chicago, 2017).

21 The exhibition was exhibited in Detroit in the Winter 2017 at the Museum of Contemporary Art. However, we would argue many audiences at MOCAD, as is the institution itself, are also implicated in Detroit's gentrification; on MOCAD and gentrification, see M. H. Miller, "Don't Call it a Comeback: Detroit's Post-Bankruptcy Crisis," *ArtNews*, September 15, 2016, http://www.artnews.com/2016/09/15/dont-call-it-a-comeback-detroits-post-bankruptcy-crisis/.

sur les colonies (Die Wahrheit über die Kolonien), eine von der Kommunistischen Partei Frankreichs und einer Gruppe von Surrealisten produzierte Gegenausstellung, dem imperialen Einflussbereich der Pariser Kolonialausstellung von 1931.[13] Bei der Expo 1937, auch in Paris, machte der Pavillon der Spanischen Republik auf den anhaltenden Widerstand gegen die Truppen Francos aufmerksam und dokumentierte den Konflikt mit Fotografien, Skulpturen und anderen Kunstwerken, u. a. mit Picassos „Guernica".[14] Wenige Jahre später und in Brasilien entwarfen und kuratierten Lina Bo Bardi und Martim Gonçalves eine Ausstellung über die vergessene Region Bahia, um der von der Biennale von São Paulo 1959 propagierten Entwicklungs-Mentalität entgegenzutreten.[15]

Einer der wenigen Augenblicke dieses Widerstands in der Geschichte der Biennale von Venedig war anlässlich der Boykotte und Demonstrationen bei der Biennale 1968.[16] Im Zusammenhang mit revolutionären Aktivitäten weltweit agierten Künstler solidarisch mit den Studentenbewegungen und griffen die Biennale und das italienische Kunst-Establishment an. Der Biennale wurde vorgeworfen, durch die Bereitstellung von nationalen Pavillons, die an die offizielle Politik der vertretenen Länder gebunden waren, eine koloniale Politik voranzutreiben und die Kunst in einer unumstößlichen Allianz mit dem Kapital zu verorten. Als Reaktion auf diese Proteste wurde das Statut der Biennale, das in den 1930er Jahren im faschistischen Italien verfasst wurde, neu geschrieben.[17]

Alle diese Gegenausstellungen machten auf hegemoniale Erzählungen aufmerksam, indem sie vergessene Bevölkerungsteile an privilegierte Orte der Macht brachten. Dabei enthüllten sie die Funktionsweise des Ausstellungskomplexes und verwandelten den Ausstellungsraum in einen Raum des Dissens und der Auseinandersetzungen. Sie forderten die von diesen Ausstellungen repräsentierten Machthaber heraus und durchkreuzten deren Lesart seitens des Publikums.

Einige der Machtverhältnisse, die durch „The Architectural Imagination" repräsentiert werden, werden offen eingeräumt – die Ausstellung wurde vom US-Außenministerium finanziert und beworben, zusammen mit einer Reihe von institutionellen Sponsoren und Sponsoren aus der Privatwirtschaft. Die Beteiligung des Außenministeriums am US-Pavillon begann während des Kalten Krieges, als die US-Regierung die Rekrutierung und den Einsatz von Kultur in ihrem Kampf mit der Sowjetunion um die globale Vorherrschaft ausdehnte.[18] Die vom amerikanischen Außenministerium für den US-Pavillon ausgewählten Ausstellungen sollen „die Vortrefflichkeit, Vitalität und Vielfalt amerikanischer Kunst" feiern – eine Feier, die sich mit der Notwendigkeit auf Seiten der Kunst überschneidet, selbst kulturell relevant und institutionell bedeutsam zu bleiben.[19] Über die Interessen des US-Außenministeriums hinaus haben weitere Sponsoren ihre eigenen Interessen an den finanziellen Abläufen, auf denen die Ausstellungen im Pavillon beruhen und bisweilen weiterentwickelt werden.[20]

Diese Zusammenhänge stehen auch im Vordergrund, wenn wir verdeutlichen, wer das Zielpublikum für diese Ausstellung sein könnte. Man könnte argumentieren, dass das Publikum von „The Architectural Imagination" in erster Linie ein Architektenpublikum ist, das sich in einer Wendung von Bennetts Argumentation durch die Macht des Staates (die Vereinigten Staaten hier als Metonymie für „den Staat" im Allgemeinen) repräsentiert, gestärkt und ermutigt sieht, und was noch wichtiger ist, autorisiert und ermutigt, mit den Prozessen, die speziell in dieser Ausstellung dargestellt werden, zu kollaborieren. Mit anderen Worten: Wenn die Ausstellung den Eindruck erweckt, dass die Macht der Architektur die Stadt retten kann, dann suggeriert sie auch die Figur des Architekten als heroischen Protagonisten in dieser Erzählung. Die Ausstellung suggeriert auf verführerische Art und Weise, dass der Berufsstand des Architekten insgesamt die Rolle des Erlösers in der Erzählung von der Sanierung Detroits einnehmen kann, und lädt unter diesem Deckmantel Architekten dazu ein, komplizenhafte wenn auch unreflektierte Akteure beim vom Staat verübten institutionellen Rassismus, Zwangsumsiedlungen und Gentrifizierung zu werden.[21]

13 Louis Aragon, Paul Éluard und Yves Tanguy. Bilder der Gegenausstellung erschienen später in *Le Surréalisme au service de la révolution*, Nr. 4, Dezember 1931.

14 Siehe Freedberg, Catherine Blanton: *The Spanish Pavilion at the Paris World's Fair*, in: *Outstanding Dissertations in the Fine Arts*, New York 1986.

15 Informationen zu dieser Ausstellung finden Sie in Lima, Zeuler: *Lina Bo Bardi*, New Haven 2013. Die konkrete Argumentation der Arbeit von Bo Bardi und Gonçalves als Gegenausstellung ist herausgearbeitet in León, Ana María: „Lina in Bahia, *Bahia no Ibirapuera*" (Aufsatz, vorgestellt anlässlich der Jahrestagung der Society of Architectural Historians, Pasadena, Kalifornien, 6.–10. April 2016).

16 Glueck, Grace: „Venice Student Protests Are Disrupting Biennale", in: *New York Times*, 21. Juni 1968; Ponti, Lisa: „68 in Venice", in: *Domus* 917 (2008), 41–47.

17 Die Biennale von Venedig begann sich in den 1930er Jahren im faschistischen Italien zu einer internationalen Ausstellung zu entwickeln. Für einen historischen Überblick über die Biennale (in englischer Sprache), siehe www.labiennale.org/en/history.

18 Siehe Haddow, Robert: *Pavilions of Plenty: Exhibiting America in the Cold War*, Washington 1997, und Krenn, Michael: *Fallout Shelters for the Human Spirit: American Art and the Cold War*, Chapel Hill 2005.

19 Siehe Außenministerium der Vereinigten Staaten: „Venice Architectural Biennale", online unter: https://exchanges.state.gov/us/program/venice-architectural-biennale (Stand: 11. September 2017).

20 Eine Analyse der Verflechtungen des Biennalekomplexes in der Kunstwelt im weiteren Sinne finden Sie in Filipovic, Elena/Van Hal, Marieke/Ovstebo, Solveig (Hg.): *The Biennial Reader: The Bergen Biennial Conference*, Ostfildern 2010, und Jones, Caroline A.: *The Global Work of Art World's Fairs, Biennials, and the Aesthetics of Experience*, Chicago 2017.

21 Die Ausstellung wurde im Winter 2017 im Museum of Contemporary Art (MOCAD) in Detroit gezeigt. Wir würden jedoch argumentieren, dass ein Großteil des Publikums im MOCAD, wie die Institution selbst, ebenso in Gentrifizierung von Detroit verwickelt ist; Informationen zum MOCAD und Gentrifizierung finden Sie in Miller, M.H.: „Don't Call it a Comeback: Detroit's Post-Bankruptcy Crisis", in: *ArtNews*, 15. September 2016, online unter: http://www.artnews.com/2016/09/15/dont-call-it-a-comeback-detroits-post-bankruptcy-crisis/.

Kant in Detroit: Architecture, Imagination, Autonomy. Might architects be so eager to believe this narrative that in some cases they are willing to ignore their own articulated political positions in order to do so, or to happily embrace the free pass given by positions of autonomy? Entitled "The Architectural Imagination," the curators implicitly reference Kantian aesthetics. In the exhibition catalog, co-curator Cynthia Davidson wrote that her use of the term "imagination" aligns with Arjun Appadurai's *Modernity at Large: Cultural Dimensions of Globalization*.[22] For us, Appadurai's use of the term fits into the Kantian genealogy—as Appadurai himself implicitly suggests in *Modernity at Large* when he writes that "it is important to stress here that I am speaking of the imagination now as a property of collectives, and not merely as a faculty of the gifted individual (its tacit sense since the flowering of European Romanticism)."[23]

This genealogy is made explicit in the contribution of architectural theorist K. Michael Hays to the U.S. Pavilion catalogue.[24] In his piece, Hays maps Kant's theory of perception onto architecture, and his reading is worth a close examination. Per Kant, our imagination operates as an intermediary stage between our senses—apprehending from the external world of things—and our understanding—the moment of critical thought.[25] The imagination is, according to Kant, a faculty of intuition, whereas the understanding is a faculty of concepts. The interplay between the two produces judgement:

> For that apprehension of forms in the Imagination can never take place without the reflective Judgement, though undesignedly, at least comparing them with its faculty of referring intuitions to concepts. If now in this comparison the Imagination (as the faculty of *a priori* intuitions) is placed by means of a given representation undesignedly in agreement with the Understanding, as the faculty of concepts, and thus a feeling of pleasure is aroused, the object must then be regarded as purposive for the reflective Judgement.[26]

The imagination is a very rich moment of conception in which the stimuli received from the outside world is "imagined"—structured or assembled by our imagination—and delivered for rational thought. Hays maps this process onto architecture, isolating "the architectural imagination" as the schema or diagram, a generative and productive stage which he views as a model for architectural interpretation. By focusing on the generative and productive qualities of the imagination,

however, Hays shifts the weight of Kant's schema: the understanding, in this reading, becomes a passive receptor of the work done by the active imagination. *This shift is problematic because the imagination is the active and temporal stage of the Kantian diagram, conveniently distant from material, economic, and political circumstances.*

Within Kant's theory of perception, the "imagination" mediates between the senses—which mine the outside world for stimuli—and the understanding—which compares the information delivered by the senses to that provided by our sensus communis—an assumption of universal agreement.[27] In other words, while the senses and the understanding both require, in one way or another, data from the outside world, the imagination is the most isolated, private stage in this scheme. Hays is probably more concerned with pushing forward an agenda of architectural autonomy independent from the aims or designs of the U.S. Pavilion. But his mapping of the architectural imagination via Kant is easily appropriated by architecture's exhibitionary complex as this complex allows architects to deploy this most internalized moment and transform it into a gift—not only is the architect the heroic savior of the city, but the instrument of this salvation is the gift of the architectural imagination. The architect can have their autonomous cake and also eat this cake by imagining themselves as saviors in the recuperation of a suffering city.

"It's A Revolution:" Augmented Reality and Exhibition Politics.

> "HoloLens is going to bridge that gap between the two-dimensional and the three-dimensional and physical space … It's a revolution."[28]—Greg Lynn

22 Cynthia Davidson, "The Architectural Imagination," *cataLog* 37 (Summer 2016), pp. 23–31, esp. p. 24.

23 Arjun Appadurai, *Modernity at Large: Cultural Dimensions of Globalization* (Minneapolis, 1996), p. 8. See also Detroit Resists, "Detroit Resists fires back at Venice Biennale's U.S. pavilion curators over community engagement," in *The Architect's Newspaper*, September 1, 2016), https://archpaper.com/2016/09/detroit-resists-venice-biennale-us-pavilion/.

24 See K. Michael Hays, "Architecture's Appearance and The Practices of Imagination," *cataLog* 37 (2016), pp. 205–213.

25 See Immanuel Kant, *Kant's Critique of Judgement*, trans. J. H. Bernard (London, 1914).

26 Immanuel Kant, "§7: Of the Aesthetical Representation of the Purposiveness of Nature," in *Kant's Critique of Judgement*, (note 25), p. 32.

27 Immanuel Kant, "§40: Of Taste as a kind of sensus communis," *Kant's Critique of Judgement*, (note 25), pp. 169–173.

28 Greg Lynn quoted in Jason Sayer, "Greg Lynn uses Microsoft HoloLens to visualize architecture at this year's Venice Biennale," *The Architecture Newspaper*, June 2, 2016, https://archpaper.com/2016/06/microsoft-hololens-greg-lynn-venice-biennale/ (accessed August 22, 2017).

Kant in Detroit: Architektur, Imagination, Autonomie. Könnten Architekten diesem Narrativ so eifrig Glauben schenken, dass sie in einigen Fällen bereit sind, ihre eigenen artikulierten politischen Positionen zu ignorieren, um dies zu tun, oder den Freifahrtschein, den sie von Positionen der Autonomie erhalten, freudig anzunehmen? Mit dem Titel „The Architectural Imagination" beziehen sich die Kuratorinnen implizit auf die Ästhetik von Immanuel Kant. Im Ausstellungskatalog schrieb die Co-Kuratorin Cynthia Davidson, ihre Verwendung des Begriffs „Imagination" sei an Arjun Appadurai's *Modernity at Large: Cultural Dimensions of Globalization* angepasst.[22] Appadurais Verwendung des Begriffs passt für uns in die kantianische Genealogie – wie Appadurai selbst in *Modernity at Large* implizit andeutet, wenn er schreibt: „Es ist wichtig, hier zu betonen, dass ich von der Imagination jetzt als eine Eigenschaft von Kollektiven spreche, und nicht nur als ein Vermögen des begabten Individuums (in ihrem stillschweigenden Sinne seit der Blüte der europäischen Romantik)."[23]

Diese Genealogie wird im Beitrag des Architekturtheoretikers K. Michael Hays im Katalog des US-Pavillons explizit dargestellt.[24] In seinem Text bildet Hays Kants Wahrnehmungstheorie auf die Architektur ab, und seine Interpretation ist eine eingehende Betrachtung wert. Nach Kant fungiert unsere Vorstellungskraft als Zwischenstufe zwischen unseren Sinnen – die äußere Welt der Dinge erfassend – und unserem Verstehen – dem Moment des kritischen Denkens.[25] Die Vorstellungskraft ist nach Kant ein Vermögen der Intuition, während das Verstehen ein Vermögen der Begriffe ist. Das Zusammenspiel dieser beiden erzeugt die Urteilskraft:

> Denn jene Auffassung der Formen in die Einbildungskraft kann niemals geschehen, ohne daß die reflektierende Urteilskraft, auch unabsichtlich, sie wenigstens mit ihrem Vermögen, Anschauungen auf Begriffe zu beziehen, vergliche. Wenn nun in dieser Vergleichung die Einbildungskraft (als Vermögen der Anschauungen *a priori*) zum Verstande (als Vermögen der Begriffe) durch eine gegebene Vorstellung unabsichtlich in Einstimmung versetzt und dadurch ein Gefühl der Lust erweckt wird, so muß der Gegenstand alsdann als zweckmäßig für die reflektierende Urteilskraft angesehen werden.[26]

Die Imagination ist ein äußerst reichhaltiger Moment des Erfassens, in dem die von der Außenwelt empfangenen Reize – strukturiert oder von unserer Vorstellungskraft zusammengebaut – „imaginiert" und an das rationale Denken ausgeliefert werden. Hays bildet diesen Prozess auf die Architektur ab, indem er die „architektonische Vorstellungskraft" als Schema oder Diagramm isoliert, eine generative und produktive Bühne, die er als Vorbild für architektonische Interpretation betrachtet.

Indem er sich auf die generativen und produktiven Qualitäten der Imagination konzentriert, verlagert Hays jedoch das Gewicht von Kants Schema: Das Verstehen wird in dieser Lesart zum passiven Rezeptor der von der aktiven Vorstellungskraft geleisteten Arbeit. *Diese Verschiebung ist problematisch, weil die Vorstellungskraft die aktive und zeitliche Bühne im kantianischen Diagramm ist, in vorteilhafter Distanz zu den materiellen, ökonomischen und politischen Umständen.*

In Kants Wahrnehmungstheorie vermittelt die „Vorstellungskraft" zwischen den Sinnen – die die Außenwelt nach Reizen durchforsten – und dem Verstehen, – das von den Sinnen gelieferte Informationen mit denen unseres *sensus communis* (Gemeinsinn) vergleicht – dem die Annahme einer universellen Rücksichtnahme zugrunde liegt.[27] Mit anderen Worten: Während die Sinne und das Verstehen beide auf die eine oder andere Weise Daten von der Außenwelt benötigen, ist die Vorstellungskraft die abgeschottetste, private Bühne in diesem Schema. Hays geht es wohl eher darum, eine Agenda der Architekturautonomie voranzutreiben, die unabhängig von den Zielen oder Entwürfen des US-Pavillons ist. Doch der Ausstellungskomplex der Architektur eignet sich seine Kartierung der architektonischen Vorstellungskraft über Kant mit Leichtigkeit an, da dieser Komplex es den Architekten erlaubt, diesen höchst verinnerlichten Moment zu nutzen und in ein Geschenk zu verwandeln – nicht nur ist der Architekt der heldenhafte Retter der Stadt, sondern das Instrument dieses Heils ist das Geschenk der architektonischen Vorstellungskraft. Indem der Architekt sich einbildet, er sei der Heilsbringer für eine leidgeprüfte Stadt, pickt er sich dabei die Rosinen heraus.

22 Davidson, Cynthia: „The Architectural Imagination", *cataLog* 37 (2016), 23–31, hier 24.

23 Appadurai, Arjun: *Modernity at Large: Cultural Dimensions of Globalisation*, Minneapolis 1996, 8. Vgl. Detroit Resists: „Detroit Resists fires back at Venice Biennale's U.S. Pavilion curators over community engagement", in *The Architect's Newspaper*, 1. September 2016, https://archpaper.com/2016/09detroit-resists-venice-biennale-us-pavilion/.

24 Siehe Hays, K. Michael: „Architecture's Appearance and The Practices of Imagination", in *cataLog* 37 (2016), 205–213.

25 Siehe Kant, Immanuel: *Kritik der Urteilskraft*, Berlin 1790.

26 Kant: „§7: Von der ästhetischen Vorstellung der Zweckmäßigkeit der Natur", in Kant, Immanuel: *Kritik der Urteilskraft*, Stuttgart 1863, online unter: http://gutenberg.spiegel.de/buch/kritik-der-urteilskraft-3507/5.

27 Die Idee eines *gemeinschaftlichen* Sinnes lässt sich mit Kant als die „eines Beurteilungsvermögens verstehen, welches in seiner Reflexion auf die Vorstellungsart jedes andern in Gedanken (a priori) Rücksicht nimmt, um *gleichsam* an die gesamte Menschenvernunft sein Urteil zu halten". Kant, Immanuel: *Kritik der Urteilskraft*, Stuttgart 1863, „§40: Vom Geschmacke als einer Art von sensus communis", online unter: http://gutenberg.spiegel.de/buch/kritik-der-urteilskraft-3507/50.

Architecture has reacted to the promises of augmented and virtual reality, as well as social media platforms and instant messaging tools, by framing them as "revolutionary" representational tools.[29] For example, the preceding quote by Greg Lynn symptomatically posed the visual innovation promised by HoloLens, a virtual reality tool produced by Microsoft (which partially sponsored Lynn's project in the U.S. Pavilion) as "a revolution." But these tools have other, political potentials beyond mere representation. They can be used for political repression, as Turkish president Erdogan used FaceTime in the summer of 2016 when he urged his followers to take to the streets to defend an authoritarian state that had momentarily lost its footing. And they can be used for political resistance by introducing images, ideas and politics into the spaces where precisely those images, ideas, and politics have been denied. For instance, also in the summer of 2016, Black Lives Matter activist Deray McKesson was arrested while broadcasting a protest via Periscope—and the widespread audience he gathered through this media prompted his release the next day.

In the summer of 2016, the technology of augmented reality became very familiar to audiences across the globe through Pokémon Go. Detroit Resists engaged augmented reality a few months before Pokémon Go was released, and we understood it to offer much more than not only Pokémon Go but also Greg Lynn and other architects invested in augmented and virtual reality tools—we saw it as offering a new possibility to advance a right to the city. We availed ourselves of this possibility by using augmented reality to digitally occupy the U.S. Pavilion in Venice, at once intervening in and contesting the exhibitionary complex. Layar, the free app we used to provide access to our

occupation, anticipates its use in fluid capitalism for advertising and product placement. The augmented reality platform is, literally, only a set of geomarkers on a map and a collection of digital shapes and media stored in a database. But this platform allowed us to virtually exhibit examples of ways in which the communities we are part of and in solidarity with are architecting their own survival and their own emancipation in Detroit.

At the 2016 Venice Biennale, then, visitors to the U.S. Pavilion had two possibilities. They could enter the Pavilion, read the introduction to the exhibition, and explore the speculative projects authored by visionary American architects that demonstrate the power of architecture in Detroit. However, they could also scan a QR code that they found on catalogues and postcards that two members of Detroit Resists had brought to Venice, download Layar, and use that app to view our digital occupation of the U.S. Pavilion (figs. 4–5).

Our occupation featured three projects (fig. 6). One project was a fence built by Detroit Eviction Defense and community members to protect a woman threatened with eviction from her house and to transform the surrounding neighborhood into a foreclosure-free zone (fig. 4).[30] A digital image of this fence ran through the U.S. Pavilion. A second project was a protest carried out by the activist group, Detroit Light Brigade, against

29 Consider, for instance, the use of Twitter and Instagram by architect Bjarke Ingels to represent himself and his work to larger publics. See twitter.com/BjarkeIngels and www.instagram.com/bjarkeingels/.

30 Lela Whitfield, Feedom Freedom (https://feedomfreedom.wordpress.com), Detroit Eviction Defense (http://detroitevictiondefense.org) and community members, *Eviction Defense Fence.* For more information about this project, see Bill Laitner, "Activists, neighbors hope to block Detroiter's eviction," *Detroit Free Press,* August 15, 2015), http://www.freep.com/story/news/local/michigan/detroit/2015/08/15/foreclosure-reverse-mortgage-detroit-fannie-mae-eviction-hud-katrina/31798169/

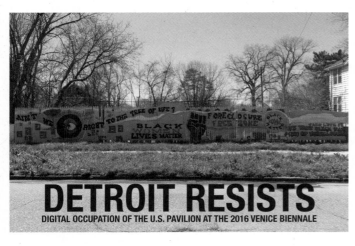

INSTRUCTIONS

1. Install the LAYAR app on your phone

2. Scan this QR code in LAYAR

3. Explore Detroit Resists' digital occupation of the U.S. Pavilion through LAYAR

detroitresists.org

Image: Fence next to Lela Whitfield's house built by Lela Whitfield, Feedom Freedom, Detroit Eviction Defense, and community members as community-mobilizing barricade to her eviction. Detroit, August 2015.

4

Postcard with QR code and instructions for the use of the Layar app, distributed in Venice |
Postkarte mit QR Code und Anleitung zur Nutzung der Layar-App, 2016 © Detroit Resists

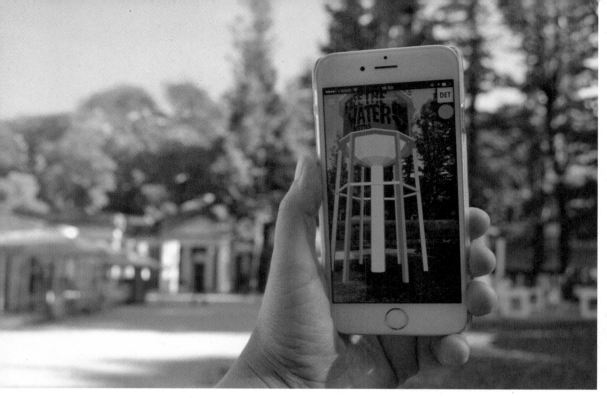

5

"Free the Water Protest," featured in Digital Occupation of the U.S. Pavilion at the Venice Architecture Biennale by Detroit Resists | Digitale Okkupation des U.S. Pavillons auf der Architekturbiennale, Venice, Italy | Venedig, Italien, 2016 © Detroit Resists

„Das ist eine Revolution": Augmented Reality und Ausstellungspolitik.

> „HoloLens wird diese Lücke zwischen dem zweidimensionalen und dem dreidimensionalen und physikalischen Raum überbrücken […] Das ist eine Revolution."[28] (Greg Lynn)

Die Architektur hat auf die Versprechen von Augmented Reality und Virtual Reality sowie Social Media-Plattformen und Instant Messaging Tools reagiert, indem sie diese als „revolutionäre" Darstellungswerkzeuge gestaltet hat.[29] Beispielsweise stellte das vorangestellte Zitat von Greg Lynn symptomatisch die visuelle Innovation dar, die HoloLens, ein Virtual-Reality-Tool von Microsoft (welches das Projekt von Lynn im US-Pavillon teilweise gesponsert hat), als „Revolution" versprochen hat. Aber diese Instrumente haben über die bloße Repräsentation hinaus auch andere, politische Potenziale. Sie können für politische Repression genutzt werden, wie es der türkische Präsident Erdogan im Sommer 2016 mit FaceTime tat, als er seine Anhänger aufforderte, auf die Straße zu gehen, um einen autoritären Staat zu verteidigen, der kurzzeitig den Boden unter den Füßen verloren hatte. Und sie können für politischen Widerstand genutzt werden, indem sie Bilder, Ideen und Politik in die Räume einbringen, in denen genau diese Bilder, Ideen und Politik verleugnet wurden. Zum Beispiel wurde, ebenfalls im Sommer 2016, der Black Lives Matter-Aktivist Deray McKesson verhaftet, während er via Periscope eine Demo sendete – und das breite Zielpublikum, das er über dieses Medium versammelte, verhalf ihm am nächsten Tag zur Freilassung.

Im Sommer 2016 wurde die Technologie der Augmented Reality durch Pokémon Go weltweit bekannt. Detroit Resists nutzte Augmented Reality einige Monate, bevor Pokémon Go auf den Markt kam und wir verstanden nicht nur, dass sie viel mehr zu bieten hatte als bloß Pokémon Go, sondern auch Greg Lynn und andere Architekten investierten in Augmented und Virtual Reality Tools – wir sahen darin eine neue Möglichkeit, ein Recht auf die Stadt zu erlangen. Wir machten von dieser Möglichkeit Gebrauch, indem wir Augmented Reality dazu nutzten, den US-Pavillon in Venedig digital zu okkupieren, indem wir in den Ausstellungskomplex gleichzeitig eingriffen und ihn anfochten. Layar, die kostenlose App, die der Schlüssel für unsere Okkupation war, antizipiert ihre Verwendung als Werbe- und Produktplatzierungs-Tool im fluiden Kapitalismus. Diese Augmented-Reality-Plattform ist buchstäblich nur ein Satz Geomarker auf einer Karte und eine Sammlung von in einer Datenbank gespeicherten digitalen Formen und Medien. Doch diese Plattform erlaubte es uns, Beispiele dafür auszustellen, wie die Communitys, denen wir angehören und mit denen wir solidarisch sind, ihr eigenes Überleben und ihre eigene Emanzipation in Detroit organisieren.

Auf der Biennale von Venedig 2016 hatten die Besucher des US-Pavillons dann zwei Möglichkeiten. Sie konnten den Pavillon betreten, die Einleitung zur Ausstellung lesen und die spekulativen Projekte der visionären amerikanischen Architekten, die die Kraft der Architektur in Detroit demonstrieren, erforschen. Sie konnten aber auch einen QR-Code scannen, den

28 Greg Lynn zitiert nach Sayer, Jason: „Greg Lynn uses Microsoft HoloLens to visualize architecture at this year's Venice Biennale", in: *The Architecture Newspaper* (2. Juni 2016), online unter: https://archpaper.com/2016/06/microsoft-hololens-greg-lynn-venice-biennale/ (Stand: 22. August 2017).

29 Betrachten wir zum Beispiel den Einsatz von Twitter und Instagram des Architekten Bjarke Ingels, um sich selbst und sein Werk einer breiteren Öffentlichkeit zu präsentieren. Siehe twitter.com/BjarkeIngels and www.instagram.com/bjarkeingels/.

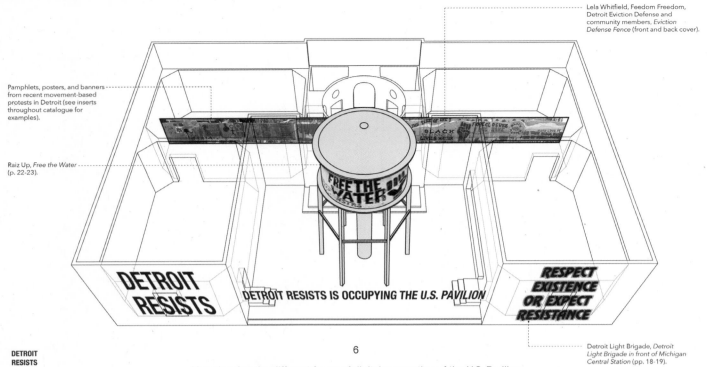

Pamphlets, posters, and banners from recent movement-based protests in Detroit (see inserts throughout catalogue for examples).

Raiz Up, *Free the Water* (p. 22-23).

DETROIT RESISTS

DETROIT RESISTS IS OCCUPYING *THE U.S. PAVILION*

FREE THE WATER

RESPECT EXISTENCE OR EXPECT RESISTANCE

6

DETROIT RESISTS

Map showing the different forms of digital occupation of the U.S. Pavilion at the Venice Architecture Biennale | Übersicht über die Formen digitaler Okkupation des U.S. Pavillons, Architekturbiennale, Venice | Venedig, 2016 © Detroit Resists

mass water shut-offs (fig. 7); we placed a digital image of a sign from this protest in a gallery in the U.S. Pavilion.[31] A third project was a water tower painted by the Raiz Up Collective to protest water shut-offs in Detroit (fig. 1); a life-size digital model of this water tower stood in the courtyard of the U.S. Pavilion (fig. 5).[32]

Each of these projects emerged from an act of collective self-architecting—an act by means of which a community or its activist representatives asserted a right to the city through architecture. By virtually inserting these real(ized) projects in Venice, we juxtaposed them to the imaginary projects represented through mostly material objects—models, artifacts, and drawings in the exhibition. We also left a number of digital tags throughout the U.S. Pavilion to reveal that the Pavilion's space was in fact a contested space, just like the space of Detroit itself.

Occupying Architecture's Exhibitionary Complex.
While the U.S. Pavilion appropriated Detroit as a blank canvas on which the discipline of architecture could advance its future, we appropriated the U.S. Pavilion as a platform to uplift the architecture of Detroit's indigenous communities and movement-based activism. By occupying architecture's exhibitionary complex, we are also addressing architecture students whose education is at once part of and targeted by that complex.

But our occupation, we believe, points to still-larger disciplinary stakes. By contesting the hegemony of the exhibitionary complex, architecture can undertake an exploration of its status not as the (most often unwanted) savior of the margin-

alized, but as a practice undertaken by the marginalized themselves: a position of resistance to the complicity between architecture and capital, architecture's aestheticization of spatial violence, and architecture's role in necropolitical urbanism.

In so doing, architecture can move beyond its sanctioned ignorance of what bell hooks calls "the cultural genealogy of resistance"—a genealogy that, as she writes, resists the erasure and destruction of "those subjugated knowledges that can only erupt, disrupt, and serve as acts of resistance if they are visible, remembered."[33] Attempting to both register and advance that genealogy, our occupation turned to the very different sort of imagination that hooks envisions:

> Subversive historiography connects oppositional practices from the past with forms of resistance in the present, thus creating spaces of possibility where the future can be imagined differently-imagined in such a way that we can witness ourselves dreaming, moving forward and beyond the limits and confines of fixed locations.[34] ■

31 Detroit Light Brigade, *Protest in Front of Michigan Central Station* #DetroitLightBrigade #FightWithLight #OLB. For more information on the Detroit Light Brigade, see https://www.facebook.com/DetroitLightBrigade/.

32 Raiz Up, *Free The Water* #RaizUp #FreeTheWater #DetroitWaterShutoffs. For more information on this project see the ongoing documentation provided here http://www.detroitmindsdying.org.

33 bell hooks, "Black Vernacular: Architecture as Cultural Resistance," in *Art on My Mind: Visual Politics* (New York, 1995), pp. 145–151, esp. p.151.

34 Ibid.

sie auf Katalogen und Postkarten fanden, die zwei Mitglieder von Detroit Resists nach Venedig gebracht hatten, Layar herunterladen und diese App nutzen, um sich unsere digitale Okkupation des US-Pavillons anzusehen (Abb. 4–5).

Unsere Okkupation umfasste drei Projekte (Abb. 6). Ein Projekt war ein von der Detroit Eviction Defense und Community-Mitgliedern gebauter Zaun, der eine mit der Delogierung aus ihrem Haus bedrohte Frau schützen und die unmittelbare Umgebung in eine Zone frei von Zwangsvollstreckungen verwandeln sollte (Abb. 4).[30] Ein digitales Bild dieses Zauns verlief durch den US-Pavillon. Ein zweites Projekt war ein Protest der Aktivistengruppe Detroit Light Brigade gegen die massenweise Sperrung der Wasserversorgung (Abb. 7); wir platzierten ein digitales Bild eines Schildes von diesem Protest in einer Galerie im US-Pavillon.[31] Ein drittes Projekt war ein vom Raiz Up Collective gemalter Wasserturm als Protest gegen die Sperrung der Wasserversorgung in Detroit (Abb. 1); ein lebensgroßes digitales Modell dieses Wasserturms stand im Innenhof des US-Pavillons (Abb. 5).[32]

Jedes dieser Projekte ging aus einem Akt kollektiver Do-it-yourself-Architektur hervor – einem Akt, mit dem eine Community oder deren aktivistische Vertreter durch Architektur ein Recht auf die Stadt geltend machten. Indem wir diese real(isiert)en Projekte in Venedig virtuell einfügten, stellten wir sie den imaginären Projekten gegenüber, die in der Ausstellung meist durch materielle Objekte – Modelle, Kunstwerke und Zeichnungen – repräsentiert werden. Wir hinterließen auch eine Reihe von digitalen Tags im gesamten US-Pavillon, um aufzuzeigen, dass der Raum des Pavillons in der Tat ein umkämpfter Raum war, genau wie der Raum von Detroit selbst.

Den Ausstellungskomplex der Architektur okkupieren. Während sich der US-Pavillon Detroit in Form einer leeren Leinwand zu eigen machte, auf der das Fach der Architektur seine Zukunft vorantreiben konnte, eigneten wir uns den US-Pavillon als eine Plattform zur moralischen Unterstützung der Architektur der in Detroit beheimateten Communities und eines sich auf sozialen Bewegungen gründenden Aktivismus an. Durch die Okkupation des Ausstellungskomplexes der Architektur richten wir uns auch an Architekturstudierende, deren Ausbildung gleichzeitig Teil des Komplexes ist und auf die dieser abzielt.

Aber wir glauben unsere Okkupation deutet auf noch höhere Einsätze innerhalb unseres Faches hin. *Indem sie die Hegemonie des Ausstellungskomplexes infrage stellt, kann die Architektur ihren Status nicht als (meist ungewollter) Retter der Marginalisierten, sondern als Praxis der Marginalisierten selbst erforschen*: eine Position des Widerstands gegen die Komplizenschaft zwischen Architektur und Kapital, die Ästhetisierung räumlicher Gewalt durch die Architektur und die Rolle der Architektur in der nekro-politischen Urbanistik.

Dabei kann die Architektur über ihre sanktionierte Unkenntnis dessen hinausgehen, was bell hooks als „die kultu-

relle Genealogie des Widerstands" bezeichnet – eine Genealogie, die, wie sie schreibt, der Auslöschung und Zerstörung „jener unterjochten Erkenntnisse [trotzt], die nur dann ausbrechen, stören und als Akte des Widerstands dienen können, wenn sie sichtbar sind und man sich an sie erinnert."[33] In seinem Versuch, diese Genealogie sowohl zu erfassen als auch voranzubringen, wendete sich unser Beruf der ganz anderen Art von Vorstellungskraft zu, die hooks sich ausmalt:

> Subversive Geschichtsschreibung verbindet oppositionelle Praxen der Vergangenheit mit Formen des Widerstands in der Gegenwart und schafft so einen Raum der Möglichkeiten, in dem die Zukunft anders vorstellbar ist, so dass wir selbst miterleben können, wie wir träumen, uns vorwärtsbewegen und über die Grenzen und Einschränkungen von festen Orten hinausgehen.[34] ∎

Übersetzung: Otmar Lichtenwörther

30 Whitfield, Lela: Feedom Freedom (https://feedomfreedom.wordpress.com), Detroit Eviction Defense (http://detroitevictiondefense.org) und Mitglieder der Community, *Eviction Defense Fence*. Weitere Informationen zu diesem Projekt finden Sie in Laitner, Bill: „Activists, neighbors hope to block Detroiter's eviction", in: *Detroit Free Press* (15. August 2015), online unter: http://www.freep.com/story/news/local/michigan/detroit/2015/08/15/foreclosure-reverse-mortgage-detroit-fannie-mae-eviction-hud-katrina/31798169/.

31 Detroit Light Brigade, *Protest in Front of Michigan Central Station* #DetroitLightBrigade #FightWithLight #OLB. Weitere Informationen zur Detroit Light Brigade finden Sie auf Facebook unter https://www.facebook.com/DetroitLightBrigade/.

32 Raiz Up, *Free The Water* #RaizUp #FreeTheWater #DetroitWaterShutoffs. Weitere Informationen zu diesem Projekt finden Sie in der laufenden Dokumentation unter http://www.detroitmindsdying.org.

33 hooks, bell: „Black Vernacular: Architecture as Cultural Resistance", in: *Art on My Mind. Visual Politics*, New York 1995, 145–151, hier 151.

34 Ebd.

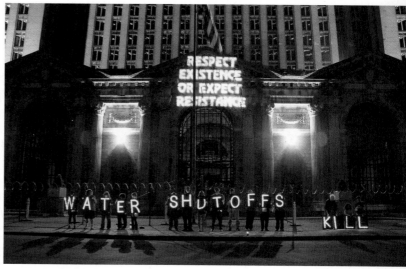

7

Detroit Light Brigade, Protest Against Water Shutoffs | Protestaktion zur Wassersperrungskampagne, Michigan Central Station, Detroit, 2016, #DetroitLightBrigade #FightWithLight #OLB © Shanna Merola

Returns of the Excluded

"Aesthetics Is a Tool to Understand Reality at Another Level, in a State of Suspension"

„Ästhetik ist ein Mittel, mit dem wir die Realität auf einer anderen Ebene verstehen, in einem Schwebezustand."

Nicolas Bourriaud (NB)
in Conversation with | im Gespräch mit
Milica Tomić and | und **Dubravka Sekulić (GAM)**

VETRO GLASS

Museo Espacio
Av. Manuel Gómez
Morin s/n
Antiguos Talleres del
Ferrocarril
Aguascalientes,
México
20259

4/15

ALTO
TOP

FRAGILE

PROTECT FROM

ALL ELEMENTS

Leading theorist, curator, and director of the art center La Panacée in Montpellier, Nicolas Bourriaud, in his latest book, *The Exform* (2016, first published as *La Exforma*, 2015), introduces art as a tool to understand the world in which we are living. For him, art is an "optical machinery" having the ability to capture the neuralgic moments and diagnose the contemporary condition by revealing the ideological mechanisms of exclusion from the public sphere and distinguishing the productive and the product from the unproductive and the waste. Going back to Courbet, Bourriaud outlines the process of rehabilitating the despised as one of the corner stones of modernism and, consequently, of modern art. Grounded on Louis Althusser's concept of "aleatory materialism"—the encounter with chance and contingency, and the non-chronological progress of concepts and ideas—the book looks through art into the realms of ideology and psychoanalysis to see how exclusion becomes normalized through diverse cultural, racial, and economic practices. In the following conversation with *GAM*, he sheds light on the "exform," the mechanisms behind it, and its potential to provide a new territory from which a renewed reading of the contemporary can emerge.

GAM: In *The Exform* you claim that "contemporary art proceeds with a similar anti-idealism [as Althusser], which finds expression in its will to concretize economic abstractions, represent immaterial fluxes, produce chance artificially, and lend form to the invisible (or to certain spiritual forces)." How does this understanding of art as an "optical machinery," a tool to understand the world we live in, influence your work as a curator, and as a theorist?

NB: In a previous book, *Postproduction*[1], I describe how today's artists use artworks for diverse purposes, insisting on the interest of "using" art as a tool. Use value and aesthetic value are actually close: art generates knowledge and critical grids, it produces ideas, and it materializes a specific relationship to the world. It is a vehicle, and we use vehicles to move, to evolve into reality. But as an optical machinery, it is located at the gaze level: The way we look at something changes throughout history. "Looking at" implies a position, an ideology, technical devices, the knowledge of the way our predecessors framed their own gaze.

GAM: In the introduction of your book you write that the exform "designates a point of contact, a 'socket' or 'plug' in the process of exclusion and inclusion." Yet, the most important message is that "the point where the exform "emerges, constitute[s] an authentically organic link between the aesthetic and the political." Can you elaborate more on how this connection works?

NB: This border station, this passageway between the authorized and the forbidden, the official and the excluded, has been the central point for modern art since the 19th century, and constitutive of its aesthetic discourse. And this double movement, centrifugal and centripetal, was a part of its energy. The "Salon des refusés" in 1863 was also the name of a statement, as modernity organized itself by opening up and enlarging this political breach, allowing the artist to explore the outdoors, the realm of "what people don't want to see" or "what is not allowed to see." What I call an "exform" is an object (material or not) seized by this process of exclusion/re-inclusion, which has to pass through this "gate" separating, more or less officially, the accepted and the rejected. The book tries to explore this process as crucial for the constitution of meaning in contemporary art. Today, in a totally overground society, the mechanisms of exclusion start to operate in different ways: when everything is accessible in a few clicks, when physical walls divide people, the symbolical center ceases to exist as well as peripheries. We have to face a very different mental geography, and artists try to decode this new regime. If some images or discourses are not necessarily forbidden anymore, they can become either inaccessible or remote, pornographically overexposed, or their rarity is organized. New types of exforms are emerging.

GAM: You also often cite Liam Gillick who compares the activity of the artist to a dog bringing the thrown object back to the "master." It is an act, as you say, of a centripetal, and centrifugal force that builds a relation between the product and the waste. How does this relation influence the arrangement of exhibits or the spaces of exhibiting as such? And is this an act of building a space that actually is a limbo?

NB: The exform exists within limbos, or grey areas. And an exhibition also is an in-between, but in a different way. It creates a time of suspension, a space where aesthetics becomes more

1 Nicolas Bourriaud, *Postproduction* (Berlin, 2007).

In seinem letzten Buch *The Exform*, (2016, zuerst veröffentlicht als *La Exforma*, 2015) präsentiert Nicolas Bourriaud, der bedeutende Theoretiker, Kurator und Direktor des Kunstzentrums La Panacée in Montpellier, die Kunst als Verständniswerkzeug für die Welt, in der wir leben. Für ihn ist Kunst eine „optische Maschine", die die Fähigkeit besitzt, neuralgische Punkte zu erkennen und die zeitgenössische Lage zu diagnostizieren, indem sie die ideologischen Mechanismen der Exklusion aus dem öffentlichen Raum aufzeigt und das Produktive vom Unproduktiven, das Produkt vom Abfall scheidet. Ausgehend von Gustave Courbet skizziert Bourriaud die Rehabilitierung des Verworfenen als einen Eckpfeiler der Moderne und damit auch der modernen Kunst. Mit Louis Althussers Begriff des „aleatorischen Materialismus" – der Begegnung mit Zufall und Kontingenz und dem nichtchronologischen Voranschreiten von Begriffen und Ideen – analysiert er – über die Kunst – die Bereiche Ideologie und Psychoanalyse, um die Normalisierung der Exklusion durch verschiedene kulturelle, rassistische und ökonomische Praktiken zu verstehen. Im folgenden Gespräch mit *GAM* beleuchtet Bourriaud die „Exform", die dahinterstehenden Mechanismen und ihr Potenzial als ein Territorium, von dem aus eine neue Lesart des Zeitgenössischen möglich wird.

> **GAM**: In *The Exform* schreiben Sie: „Die zeitgenössische Kunst operiert mit einem ähnlichen Anti-Idealismus [wie Althusser], was sich in ihrem Willen ausdrückt, ökonomische Abstraktionen zu konkretisieren, immaterielle Ströme zu repräsentieren, künstlich Zufall zu generieren und dem Unsichtbaren (oder gewissen spirituellen Kräften) Form zu verleihen." Inwieweit beeinflusst Ihre Auffassung von der Kunst als „optischer Maschine", als Verständniswerkzeug für die uns umgebende Welt Ihre Arbeit als Kurator und Theoretiker?

NB: In meinem früheren Buch *Postproduction*,[1] habe ich beschrieben, wie heutige KünstlerInnen Kunstwerke für verschiedene Zwecke gebrauchen und somit darauf beharren, die Kunst als Werkzeug einzusetzen. Gebrauchswert und ästhetischer Wert liegen im Grunde nicht weit auseinander: Die Kunst schafft Wissen und kritische Raster, generiert Ideen und verleiht einer bestimmten Beziehung zur Welt materielle Gestalt. Sie ist ein Vehikel, und wir verwenden Vehikel gewöhnlich, um uns in die Realität hineinzubewegen. Als optische Maschine ist sie allerdings auf der Ebene des Blicks angesiedelt: Die Art, wie wir etwas betrachten, ändert sich im Lauf der Geschichte. „Betrachten" impliziert einen Standpunkt, eine Ideologie, technische Geräte, das Wissen darüber, wie unsere Vorfahren ihren Blick gestaltet haben.

> **GAM**: In der Einleitung zu Ihrem Buch schreiben Sie, die Exform verweise auf einen „Kontakt, eine ‚Steckdose' oder einen ‚Stecker' im Prozess der Exklusion und Inklusion." Am wichtigsten aber ist, dass „die Stelle, an dem die Exform erscheint, eine authentisch organische Verbindung zwischen dem Ästhetischen und dem Politischen bilde[t]." Können Sie mehr darüber sagen, wie diese Verbindung funktioniert?

NB: Diese Grenzstation, dieser Übergang zwischen dem Autorisierten und dem Verbotenen, dem Offiziellen und dem Ausgeschlossenen, ist seit dem 19. Jahrhundert das zentrale Moment der modernen Kunst und konstitutiv für ihren ästhetischen Diskurs. Und diese zentrifugale und zentripetale Doppelbewegung war zu einem Gutteil für ihre Energie verantwortlich. Der „Salon des refusés" von 1863 war zugleich ein Statement, da die Moderne sich durch das Schlagen und Erweitern dieser politischen Bresche organisierte: sie ermöglichte es den Künstlern im Freien zu arbeiten, den Bereich dessen zu erkunden, was „man nicht sehen will" oder „sehen darf". Was ich die „Exform" nenne, ist ein (materielles oder auch immaterielles) Objekt, das von diesem Prozess der Exklusion/Re-Inklusion erfasst wird, das durch dieses „Tor" hindurchmuss, welches das Akzeptierte und Abgelehnte mehr oder weniger offiziell trennt. Das Buch versucht, diesen Prozess als wesentlich für die Bedeutungskonstituierung der zeitgenössischen Kunst zu untersuchen. Heute in unserer durch und durch oberirdischen Welt operieren die Mechanismen des Ausschlusses anders: Wenn alles durch wenige Klicks zugänglich wird, wenn physische Wände die Menschen trennen, hören symbolisches Zentrum und Peripherie gleichermaßen zu existieren auf. Wir haben es mit einer ganz anderen geistigen Geografie zu tun, und KünstlerInnen versuchen dieses neue Regime zu entschlüsseln. Wenn einige Bilder oder Diskurse nicht mehr unbedingt verboten sind, werden sie entweder unzugänglich oder rücken in die Ferne, werden pornografisch überbelichtet oder ihre Seltenheit wird organisiert. Neue Arten der Exform entstehen.

> **GAM**: Sie zitieren häufig Liam Gillick, der die Aktivität des Künstlers/der Künstlerin mit einem Hund vergleicht, der/die seinem/ihrem „Herrn" das weggeworfene Objekt zurückbringt. Nach Ihrer Analyse ist dabei eine zentripetale und zentrifugale Kraft am Werk, die eine Relation zwischen Produkt und Abfall herstellt. Inwiefern beeinflusst diese Relation das Arrangement von Ausstellungsstücken oder gar den Ausstellungsraum selbst? Handelt es sich dabei um die Erzeugung eines Raums, der eigentlich eine Art Zwischenreich ist?

1 Bourriaud, Nicolas: *Postproduction*, Berlin 2007.

important than moral values: it does not mean that it annihilates the political meaning of an object, on the opposite. Because aesthetics is not about "beautiful things," it is a tool to understand reality at another level, in a state of suspension which allows us to overcome our aversion towards the waste, the unbearable, the unacceptable. More generally, I think that the exhibition is delivering a kind of symbolic visa. In an exhibition, anything is allowed to be seen. Any object (material or immaterial) has to be confronted by the visitor, because it is automatically given this status, this visibility. Hence, the distinction between the product and the waste is disintegrated, or suspended.

> **GAM**: If the exform exists, or rather "insists" in the limbo, is it exhibitable at all? What happens with the relation between exclusion and inclusion? Do we stop this process/relation (centripetal, and centrifugal) when we exhibit? What does become of the exform as soon as we expose it? What kind of spatial approach or act does it require?

NB: This centrifugal movement is never erased in the act of exhibiting. We can take the example of Duchamp's "Fountain": it is highly interesting, because the circumstances of its recognition as an artwork, and later its inscription in history of art, has been controversial all the way. Not mentioning Courbet's "The Origin of the World," whose life as an artwork was even more complicated. But we can also mention more contemporary works whose subjects, or references, makes them complicated to handle: think about Dana Schutz's painting which was attacked at the Whitney recently, because she was denied the right to represent a tragic episode of American racism, as a white female artist. There is still policing of memories, but it is not anymore located within the center of power: it is disseminated, in a way that Foucault had predicted … Today's symbolic borders do not stand between the power and the forces that resist it: they are everywhere. The binary streams contested by Courbet or Duchamp in their times, are nowadays multiple, and they go in all directions. Walter Benjamin has taught us that history was always written by the winners, but it is not that simple anymore.

> **GAM**: In the 10th LEEUM Anniversary lecture you referred to the concept of four forms developed by the French philosopher Roger Caillois, all of which you see present in contemporary art, yet insufficient to capture all emancipatory properties of art. In what way is this related to your conception of the exform?

NB: Caillois said something very simple: wherever you look at, you will only see four types of forms. They are either born by growth, by a mold, by accident or by will. Not only in contemporary art, but literally all existing forms. One of the true originalities of 20th century art was to include all four as artworks, whereas ancient art was mainly generated by human will. Duchamp introduced the mold. This was already very controversial, as the dominant ideology considered art as a specific skill and the artist as someone who had to "create" something with his/her own hands.

> **GAM**: Each of your previous books is deeply rooted in the moment of its writing, and can be seen as the attempt to think through the state of relations between art – artist – society. Relational Aesthetics is capturing and articulating what is at stake at the moment in which artists are trying to forge a new social contract between different communities by instigating certain relations thus making them visible. *The Exform* also proposes that only contemporary art has the capacity to read present-day relations and to understand these sets of relations, yet it is much less based on the contemporary art of the moment and uses the key moment in the history of modern art, when referring to art to develop a concept. Why so?

NB: Because sometimes it is useful to look back. First, *The Exform* is the first book I ever wrote using other books as a base, and not exhibitions and artists' studios. I am not a philosopher: I am only a curator who writes and attempts to describe in a theoretical way the artistic landscape he lives in. Nevertheless, this link between art and the leading social stakes has always been crucial to me. It is the red line that brings all my books together. I also embraced the last two centuries in 1999 with *Formes de vie: L'Art moderne et l'invention de soi,*[2] a longer essay which has not been translated into English. Here again, as I wanted to show that the dynamics I describe had actually been exhausted and haven taken on new shapes, I had to get back to the source. The modern dialectics of rejection had ended: in order to understand the phenomenon that is currently replacing it, I had to write the full story, and display the respective roles of Courbet, Marx, and Freud as by-products, or effects, of these dialectics. Yes, Courbet. We are used to see the two others associated, but placing them at the same level than a painter clearly indicates the particularity that you mention: according to me, art allows us to understand the world we live in, as much as philosophy.

2 Nicolas Bourriaud, *Formes de vie: L'Art moderne et l'invention de soi* (Paris, 1999).

NB: Die Exform existiert in Zwischenreichen oder Grauzonen. Auch eine Ausstellung ist ein Zwischenreich, aber anders. Sie schafft eine Zeit der Aufhebung, einen Raum, in dem Ästhetik wichtiger wird als Moral: Das heißt nicht, dass sie die politische Bedeutung eines Objekts außer Kraft setzt. Ganz im Gegenteil, zumal es bei Ästhetik nicht um das „Schöne" geht. Sie ist ein Mittel, mit dem wir die Realität auf einer anderen Ebene verstehen, in einem Schwebezustand, der es uns ermöglicht, unsere Aversion gegen den Abfall, das Unerträgliche, das Inakzeptable zu überwinden. Allgemeiner gesprochen, würde ich sagen, dass die Ausstellung eine Art symbolisches Visum ausstellt. In einer Ausstellung darf alles betrachtet werden. In ihr muss sich der Besucher oder die Besucherin mit jedem (materiellen oder immateriellen) Objekt auseinandersetzen, weil es automatisch diesen Status, diese Sichtbarkeit erhält. Mithin wird die Unterscheidung zwischen Produkt und Abfall außer Kraft gesetzt, aufgehoben.

> **GAM**: Wenn die Exform im Zwischenreich existiert oder besser „insistiert", ist sie dann überhaupt ausstellbar? Was passiert dabei mit dem Verhältnis von Exklusion und Inklusion? Gebieten wir diesem (zentripetalen und zentrifugalen) Prozess/diesem Verhältnis durch das Ausstellen Einhalt? Was wird aus der Exform, wenn wir sie ausstellen? Was für einen räumlichen Ansatz oder Akt erfordert sie?

NB: Diese zentrifugale Bewegung wird im Akt des Ausstellens niemals beendet. Nehmen wir das Beispiel von Duchamps „Brunnen" Es ist höchst interessant, weil die Umstände seiner Anerkennung als Kunstwerk und seiner späteren Einschreibung in die Kunstgeschichte die ganze Zeit über strittig war. Ganz zu schweigen von Courbets „Der Ursprung der Welt", dessen Leben als Kunstwerk sogar noch komplizierter war. Aber man könnte auch zeitgenössischere Werke nennen, bei denen Themen oder Bezüge den Umgang mit ihnen komplizieren: Denken Sie an das Gemälde von Dana Schutz, das neulich am Whitney Museum unter Beschuss kam, weil man ihr als weißer Künstlerin das Recht absprach, ein tragisches Ereignis aus der Geschichte des amerikanischen Rassismus darzustellen. Die Kontrolle von Erinnerungen findet immer noch statt, aber nicht mehr aus dem Zentrum der Macht heraus. Sie ist, so wie es Foucault vorhergesagt hat, verteilt … Die heutigen symbolischen Grenzen verlaufen nicht mehr zwischen der Macht und den Kräften des Widerstands, sie sind überall. Die seinerzeit von Courbet oder Duchamp attackierten binären Ströme sind heute vielfältig und fließen in alle Richtungen. Walter Benjamin hat uns gelehrt, dass die Geschichte immer von Siegern geschrieben wurde, aber das ist nicht mehr so einfach.

> **GAM**: In der LEEUM 10th Anniversary Lecture rekurrierten Sie auf die vom französischen Philosophen Roger Caillois entwickelte These von den vier Formen, die Ihrer Meinung nach alle in der zeitgenössischen Kunst zu finden sind, aber nicht ausreichen, um alle ihre emanzipatorischen Eigenschaften zu erfassen. Wie ist das mit Ihrer Idee der Exform verbunden?

NB: Caillois sagte etwas sehr Einfaches: Wohin man auch schaut, man findet überall nur vier Arten von Formen. Sie entstehen entweder durch Wachstum, Abguss, Zufall oder Willen. Das gilt nicht nur für die Formen der zeitgenössischen Kunst, sondern praktisch alle existierenden Formen. Eine der wirklich originären Neuerungen der Kunst des 20. Jahrhunderts war, alle vier Formen einzubeziehen, wogegen die antike Kunst vor allem durch den menschlichen Willen entstand. Duchamp führte den Abguss ein. Schon das war sehr umstritten, da Kunst nach der damals herrschenden Ideologie eine besondere Fähigkeit war und der Künstler oder die Künstlerin jemand, der/die etwas mit eigenen Händen „schafft".

> **GAM**: Alle Ihre früheren Bücher sind tief in der Zeit ihrer Entstehung verwurzelt und können als Versuch gesehen werden, den Stand der Beziehung zwischen Kunst, KünstlerIn und Gesellschaft zu durchdenken. *Relational Aesthetics* beschreibt und artikuliert etwa, was im Moment auf dem Spiel steht, wenn Künstler versuchen, einen neuen Gesellschaftsvertrag zwischen verschiedenen Gruppen zu stiften, indem sie gewisse Verhältnisse oder Relationen anregen und damit sichtbar machen. *The Exform* postuliert darüber hinaus, dass nur die zeitgenössische Kunst in der Lage sei, gegenwärtige Verhältnisse zu lesen und diese Ensembles von Relationen zu verstehen. Gleichzeitig beziehen Sie sich aber weit weniger auf die zeitgenössische Kunst von heute, sondern auf einen Schlüsselmoment in der Geschichte der modernen Kunst, um den Begriff herauszuarbeiten. Warum?

NB: Weil es manchmal sinnvoll ist zurückzuschauen. Erstens ist *The Exform* das erste meiner Bücher, das auf andere Bücher und nicht auf Ausstellungen und das Geschehen im Künstleratelier aufbaut. Ich bin kein Philosoph, ich bin nur ein schreibender Kurator, der versucht, die künstlerische Landschaft, in der er lebt, theoretisch zu erfassen. Dennoch war diese Verbindung zwischen Kunst und dem, was gesellschaftlich auf dem Spiel steht, immer wesentlich für mich. Es ist der rote Faden, der alle meine Bücher zusammenhält. Die letzten zwei Jahrhunderte hatte ich übrigens auch in *Formes de vie: L'Art moderne et l'invention de soi*,[2] einem 1999 erschienenen, nicht ins Englische übersetzten längeren Essay behandelt. Da ich zeigen wollte, dass sich die von mir beschriebene Dynamik erschöpft und neue Formen angenommen hat, musste ich wieder zu den Ursprüngen zurück. Die moderne Dialektik der Exklusion ist an ihr Ende gekommen: Um das Phänomen zu verstehen, das gegenwärtig an ihre Stelle tritt, musste ich die ganze Geschichte schreiben und die Rolle von Courbet, Marx und Freud als Nebenprodukte oder Effekte dieser Dialektik aufzeigen. Ja, Courbet. Wir sind

2 Bourriaud, Nicolas: *Formes de vie: L'Art moderne et l'invention de soi*, Paris 1999.

GAM: In *The Exform* you return to Althusser and his concepts of materialism, especially the concept of "aleatory materialism" that he developed at the end of his life. Why did you choose Althusser's approach and not, for example, approaches like historical materialism or new materialism that have recently been gaining traction?

NB: I try not to follow any trend. I explain in the book why Althusser is important to me now, and why one has to read him only to understand, for example, the birth of cultural studies and what they meant originally. Lots of "new materialist" thinkers should also read him, as "aleatory Marxism"[3] is on some issues way further than they are. One of the reasons why it goes further is that Althusser includes ideology amongst the material forces that drive the world.

GAM: The third important concept in your book relates to the unconscious and to psychoanalysis. How much are these approaches contingent to your understanding of art's capacity to make visible what is excluded?

NB: In *The Exform*, psychoanalysis stands as a model for understanding the dialectical movement of exclusion and reappropriation that function at every level of society. Our unconscious hides us certain images, ideas, or facts, and the analytic process consists in trying to "recuperate" them. Doing so, the patient is led to rewrite the scenario of his/her life, or reconstruct invisible parts of it. In a way, the artist works the same way. Art is very close to social psychoanalysis when it shows us the uncanniest aspects of life, when it re-writes the political screenplays we are supposed to play. Societies have a grammar, and the artist articulates it. Doing so, he/she exposes the unthought of societies.

GAM: Both books, *The Exform* as well as *Relational Aesthetics* follow the materialist tradition in philosophy. More specifically, both rely on the concept of "aleatory materialism" which Althusser puts forward in one of his last texts, *The Philosophy of Encounter*. While Althusser is barely mentioned in *Relational Aesthetics*, in *The Exform*, he returns as pivotal for the book and is considered as a whole person and not only through his concepts. Can this return be read as the "act of a dog bringing back the excluded" in relation to your first book *Relational Aesthetics*?

NB: You are right; Althusser's thought accompanies me since *Relational Aesthetics*.[4] And there is already a whole chapter of *The Radicant*[5] examining aleatory materialism, which is titled: "Under the cultural rain: Althusser, Duchamp and the use of artistic forms." But the perspective here is completely different, as much as the references to his writings in *Relational Aesthetics*. So, Althusser has not "come back" to my work, he has always been there, like a few other philosophers whose concepts are diffracted, present under different forms and seen from diverse angles. But you could say the same for artists …

GAM: Is the book *The Exform*, which establishes relations with the excluded, with Althusser as the excluded philosopher, also an attempt to resist the ideological framework of exclusion and rejection within art history and theory, which tries to hold onto Althusser as a writer and philosopher, but excludes him as a psychotic, murderer and Stalinist? Because of that attempt, and the way it is written, is it possible to conceive of *The Exform* as an artwork in itself? In other words: Can we see your act bringing Althusser into the focus of your book as an exform?

NB: First, Althusser provided a theory of ideology which presented it as a social unconscious, activated by a network of institutional interpellations. Secondly, he wrote many texts about psychoanalysis, from the point of view of the "worker," meaning the patient who is "at work" on the sofa. As his mental illness excluded him in many ways, he was at the right place to understand and accurately describe rejection as a mass phenomenon. Of course, a philosopher who also was mentally ill and became a murderer was the right protagonist for a book about exclusion … That's why I reconstituted as precisely as possible some episodes of his life, for example his entry by effraction at Lacan's congress in 1980. There are narrative parts in the book, but I wouldn't consider it as an artwork.

GAM: Is the exform, i.e., the "realism" with Althusser at the forefront an attempt to introduce the critique of ideology as the resistance to the political discourse that normalizes politics and practices of exclusion? Is "realism" just another word for the critique of ideology as the integral part of art or an artwork?

3 For more on Althusser's concept of "aleatory Marxism," in: Louis Althusser, *Philosophy of the Encounter* (London and New York, 2006).

4 Nicolas Bourriaud, *Relational Aesthetics* (Dijon, 1998).

5 Nicolas Bourriaud, *The Radicant* (Berlin, 2009).

es gewohnt, die beiden anderen miteinander zu verknüpfen, aber sie mit einem Maler auf dieselbe Ebene zu stellen, geht klar in Richtung der von Ihnen erwähnten Besonderheit: Was mich betrifft, ermöglicht uns die Kunst genauso wie die Philosophie, die Welt zu verstehen, in der wir leben.

GAM: In *The Exform* kehren Sie zu Althusser und seinen Materialismusauffassungen zurück, vor allem zum Begriff des „aleatorischen Materialismus", den er gegen Ende seines Lebens entwickelte. Warum haben Sie sich für Althussers Ansatz entschieden und nicht für andere materialistische Ansätze wie den historischen Materialismus oder neue Formen des Materialismus, die in letzter Zeit aufgekommen sind?

NB: Ich versuche, keinem Trend zu folgen. Ich erkläre im Buch, warum Althusser für mich jetzt wichtig ist und warum man ihn lesen sollte, sei es auch nur um die Entstehung der Cultural Studies zu verstehen und was sie ursprünglich bedeuteten. Viele der „neuen Materialisten" sollten ihn ebenfalls lesen, denn der „aleatorische Marxismus[3] ist in manchen Fragen wesentlich weiter als sie. Einer der Gründe, warum das so ist, ist der, dass Althusser die Ideologie mit zu den materiellen Kräften zählt, die die Welt bewegen.

GAM: Der dritte wichtige Gedanke in Ihrem Buch betrifft das Unbewusste und die Psychoanalyse. Inwieweit hängt das mit Ihrer Auffassung zusammen, dass die Kunst fähig ist, das Ausgeschlossene sichtbar zu machen?

NB: In *The Exform* dient die Psychoanalyse als Modell für ein Verständnis der dialektischen Bewegung von Ausschluss und Wiederaneignung, die auf allen Ebenen der Gesellschaft am Werk ist. Das Unbewusste verbirgt gewisse Bilder, Ideen und Fakten vor uns, und der analytische Prozess besteht darin, sie wieder „ans Licht zu holen". Dabei wird der Analysand oder die Analysandin dazu angehalten, das Szenario seines/ihres Lebens umzuschreiben oder seine unsichtbaren Teile zu rekonstruieren. In gewisser Weise arbeiten KünstlerInnen ähnlich. Die Kunst ist fast so etwas wie eine Psychoanalyse der Gesellschaft, wenn sie uns die unheimlichsten Aspekte des Lebens zeigt, die politischen Drehbücher umschreibt, nach denen wir agieren sollen. Gesellschaften besitzen eine Grammatik, und der Künstler oder die Künstlerin artikuliert sie. Dabei entblößt er/sie das Ungedachte einer Gesellschaft.

GAM: Sowohl *The Exform* als auch *Relational Aesthetics* stehen in der philosophischen Tradition des Materialismus. Beide stützen sich auf die Vorstellung eines „aleatorischen Materialismus". Wird aber Althusser in *Relational Aesthetics* kaum erwähnt, kehrt in

The Exform als Angelpunkt des gesamten Buch wieder, und zwar in der vollen Person und nicht nur mit seinen Ideen. Könnte man diese Wiederkehr im Verhältnis zu *Relational Aesthetics* ebenfalls als „ein Apportieren des Verworfenen" interpretieren?

NB: Sie haben recht; Althussers Denken begleitet mich seit *Relational Aesthetics*.[4] Und es gibt schon in *Radikant*[5] ein ganzes Kapitel, das sich mit dem aleatorischen Materialismus auseinandersetzt, nämlich das Kapitel „Im kulturellen Regen (Louis Althusser, Marcel Duchamp und der Gebrauch künstlerischer Formen)". Doch ist die Perspektive dabei eine ganz andere, ebenso wie der Bezug auf seine Schriften in *Relational Aesthetics*. Insofern ist Althusser in meiner Arbeit nicht „wiedergekehrt", er war immer da, so wie auch einige andere Philosophen, deren Begriffe abgewandelt, in verschiedenen Gestalten und aus unterschiedlichen Blickwinkeln, darin präsent sind. Aber dasselbe könnte man von KünstlerInnen sagen.

GAM: Ist das Buch *The Exform*, das Beziehungen zum Ausgeschlossenen knüpft, zu Althusser als ausgeschlossenem Philosophen, auch ein Versuch, dem ideologischen System von Exklusion und Verwerfung in Kunstgeschichte und Theorie zu widerstehen, die an Althusser als Autor und Philosoph festhält, ihn aber als Psychotiker, Mörder und Stalinist ablehnt? Und könnte man das Buch *The Exform* wegen dieses Versuchs, und der Art, wie es geschrieben ist, selbst als Kunstwerk sehen? Anders gefragt: Ist Ihr Akt, Althusser in das Zentrum Ihres Buches zu stellen, selbst als etwas Exformes zu sehen?

NB: Erstens vertrat Althusser eine Theorie der Ideologie, die letztere als soziales Unbewusstes darstellte, das durch ein Netz institutioneller Anrufungen aktiviert wird. Zweitens schrieb er zahlreiche Texte über Psychoanalyse aus der Sicht des „Arbeiters", d.h. aus der Sicht des Analysanden, der auf der Couch „am Werk" ist. Da ihn seine psychische Erkrankung in vieler Hinsicht ausschloss, befand er sich an der richtigen Position, um die Ablehnung als Massenphänomen verstehen und präzise beschreiben zu können. Ein geisteskranker Philosoph, der zum Mörder wurde, war der richtige Protagonist für ein Buch über Ausschließung … Darum habe ich einige Episoden seines Lebens so genau wie möglich rekonstruiert, zum Beispiel wie er sich 1980 gewaltsam Zugang zur Abschiedsversammlung von Lacan verschafft hat. Es gibt in dem Buch narrative Elemente, aber ich betrachte es nicht als Kunstwerk.

3 Ausführlicheres zu Althussers Begriff des „aleatorischen Marxismus" findet sich in Althusser, Louis: *Materialismus der Begegnung*, Übers. Franziska Schottmann, Zürich und Berlin 2011.

4 Bourriaud, Nicolas: *Relational Aesthetics*, Dijon 1998.

5 Bourriaud, Nicolas: *Radikant*, Übers. Katharina Grän und Ronald Voullié, Berlin 2009.

NB: Yes, partly, but realism cannot be reduced to a critique. Having a critical position generally excludes you from the scene you describe, because you adopt an overlooking position. Althusser, using his knowledge about psychoanalysis, developed the idea that you can be "within" a situation and criticize or transform it from this "within."

> **GAM:** You have never really mentioned the exhibition as a format in the book; yet, it can be read as pertinent to your definition of art, which points to a triangular relationship between the artist, the object, and the beholder. What role does the exhibition, the public moment, play in relation to the exform?

NB: You are right, I don't mention exhibitions in this book, because for once, as I told you, it was not elaborated from artworks. But those triangular relations are always present in my essays. Here it is the relation between power, the artist and the beholder. Three is the main cipher of art, in a way. I always think in triangles. Maybe because binary situations are the least interesting ones.

> **GAM:** In a lecture you once said: "Art is transformed into a pure commodity if it is not seen by human consciousness." Should we read the exform as an attempt to take a distance from commodity culture/the commodified object? Or, can we think of exhibiting as a resistance to commodification? Is the mere act of being included in the exhibition for you enough to resist commodification, or is it related to a more durational and different form of exhibiting?

NB: The dissolution of the subject/object relationship will be the pattern of my next book, which is almost finished. Human consciousness being the center of this pattern, I try to reconsider it within the context of the anthropocene, whose first feature is the dissolution of the division between nature and culture. But art would not exist without a human gaze, it is not an essence, it only is a specific regime of our relationship to the world. So yes, exhibiting art is a complex and totally unnatural process, but it can provide tools against reification. All my essays are attempts to describe and criticize the diverse facets of reification: I prefer this term to commodification, as commodity is not the only aspect of it. Nevertheless, exhibiting can also become a process of commodification, if it values objects more than the forces that built them, if the processes are erased or negated, if there is no self-reflexivity.

> **GAM:** All of the books you have written, *Relational Aesthetics*, *Postproduction*, *Radicant*, *The Exform*, follow the parallel trajectory to the exhibitions you were curating in the last 20 years. Can you tell us a little bit about the exhibitions that lead to *The Exform*?

NB: Your remark is totally true. I generally intertwine exhibitions and books, except for my two more "historical" ones, Formes de vie and *The Exform*. My research about the anthropocene led to curating of "The Great Acceleration" for the Taipei Biennial in 2014, which lead me to the next one, "Crash Test," which opened in February 2018 at La Panacée in Montpellier, and which is much more focused, trying to point out a "molecular turn" in contemporary art. This cycle of two exhibitions will generate a book that will be published this year.

> **GAM:** In an interview you once said that when you have questions, i.e., when you develop an idea, you curate an exhibition, and when you have answers, you write a book. Do you also use the format of the exhibition as a research, investigation tool and, if so, how does that manifest spatially?

NB: These two activities generate different types of thoughts and mobilize different ways of working. The collective exhibition can be a way to verify the different aspects of my theoretical work, but it also is a generator, as the coexistence of artworks within the same space triggers theory, produces new associations. Even if I curate an exhibition with a very precise idea, it is always transformed afterwards. Artworks always escape, from one point or more, to the box you want to include them in.

> **GAM:** At the end of the introduction to *The Exform* you write: "This book seeks to participate in this new beginning – even as it refuses to return to anything at all." What does this new beginning mean for the culture of exhibiting? And in what ways does it change the spaces where exhibiting takes place?

NB: I am describing and documenting a dead end, or the dissolution of a movement—like global warming dissolves the Gulf Stream into the Atlantic. But I cannot be more precise, at this moment, about the shape of things to come. Let's see more artworks, for a start.

> **GAM:** Thank you for the interview. ∎

GAM: Ist die Exform, d.h. der „Realismus" bei Althusser in erster Linie ein Versuch, die Ideologiekritik als Widerstand gegen einen politischen Diskurs zu mobilisieren, der Politik und die Praxis der Exklusion normalisiert? Ist „Realismus" lediglich ein anderes Wort für Ideologiekritik als integraler Bestandteil der Kunst oder des Kunstwerks?

NB: Ja, teilweise. Aber Realismus lässt sich nicht auf Kritik reduzieren. Das Beziehen einer kritischen Position schließt einen gewöhnlich von der beschriebenen Szene aus, weil man dabei einen übergeordneten Standpunkt einnimmt. Althusser entwickelte mithilfe seines psychoanalytischen Wissens die Idee, dass man eine Situation von „innen" heraus transformieren und kritisieren könnte.

GAM: Sie erwähnen in Ihrem Buch eigentlich nirgends die Ausstellung als Format; dabei kann man sie als durchaus relevant für Ihre Kunstdefinition betrachten, die ein Dreiecksverhältnis zwischen KünstlerIn, Objekt und BetrachterIn beinhaltet. Welche Rolle spielt die Ausstellung, der öffentliche Moment in Verbindung mit der Exform?

NB: Sie haben Recht, ich erwähne in diesem Buch keine Ausstellungen, einfach weil es, wie gesagt, nicht von Kunstwerken ausgehend konzipiert war. Aber diese Dreiecksverhältnisse sind in meinen Essays immer präsent. In diesem Fall geht es um das Verhältnis von Macht, Künstler und Betrachter. Die Drei ist gewissermaßen die Hauptziffer der Kunst. Ich denke stets in Triaden. Vielleicht deshalb, weil binäre Situationen so gänzlich uninteressant sind.

GAM: In einem Vortrag haben Sie einmal gesagt: „Kunst wird zur reinen Ware, wenn sie nicht durch ein menschliches Bewusstsein gesehen wird." Ist die Exform als ein Versuch zu verstehen, sich von der Kultur der Ware/dem warenförmigen Objekt zu lösen? Oder sollen wir das Ausstellen als Widerstand gegen die Kommodifizierung lesen? Reicht die Einbeziehung in die Ausstellung für Sie bereits aus, um der Kommodifizierung zu widerstehen, oder ist sie an eine dauerhaftere, andere Form des Ausstellens gebunden?

NB: Die Auflösung der Subjekt/Objekt-Beziehung wird das Muster meines fast fertigen nächsten Buches sein. Da das menschliche Bewusstsein im Zentrum dieses Musters steht, versuche ich, es im Rahmen des Anthropozäns, dessen Merkmal die Auflösung der Trennung von Kunst und Natur ist, neu zu denken. Aber ohne den menschlichen Blick würde die Kunst nicht existieren, sie ist kein Wesen, nur ein bestimmtes Regime unserer Beziehung zur Welt. Demnach: Ja, das Ausstellen von Kunst ist ein komplexer und vollkommen unnatürlicher Prozess, aber er kann Werkzeuge gegen die Verdinglichung bereitstellen. Alle meine Essays sind Versuche, unterschiedliche Facetten der Verdinglichung zu beschreiben und zu kritisieren: Ich ziehe diesen Begriff dem der Kommodifizierung vor, da die Warenförmigkeit nicht der einzige Aspekt davon ist. Gleichwohl kann das Ausstellen auch zu einem Prozess der Kommodifizierung werden, wenn es Objekte über die sie erzeugenden Kräfte stellt, wenn Prozesse gelöscht oder negiert werden, wenn es keine Selbstreflexion gibt.

GAM: Alle ihre Bücher – *Relational Aesthetics*, *Postproduction*, *Radikant*, *The Exform* – bilden eine Parallele zu den Ausstellungen, die sie in den letzten zwanzig Jahren kuratiert haben. Können Sie uns etwas über die Ausstellungen sagen, die zu *The Exform* geführt haben?

NB: Ihre Beobachtung ist absolut richtig. Im Allgemeinen verflechte ich Bücher und Ausstellungen miteinander. Nur nicht bei meinen zwei „historischeren" Büchern *Formes de vie* und *The Exform*. Meine Forschungen zum Anthropozän führten zum Kuratieren der Ausstellung „The Great Acceleration" für die Taipei Biennale 2014, die mich dann weiter zur nächsten – „Crash Test" – führte, die im Februar im La Panacée in Montpellier eröffnet wurde und wesentlich fokussierter ist, versucht, einen „molecular turn" in der zeitgenössischen Kunst herauszuarbeiten. Der Zyklus dieser zwei Ausstellungen wird in ein Buch münden, das im nächsten Jahr erscheinen soll.

GAM: In einem Interview haben Sie einmal gesagt, wenn Sie Fragen hätten, d.h. einen Gedanken entwickelten, kuratierten Sie eine Ausstellung, und wenn Sie Antworten hätten, schrieben sie ein Buch. Verwenden Sie das Format der Ausstellung auch als Forschungs- und Rechercheinstrument, und wenn ja, wie äußerst sich das räumlich?

NB: Die beiden Aktivitäten zeitigen unterschiedliche Denkformen und mobilisieren unterschiedliche Arbeitsweisen. Die Gruppenausstellung kann eine Möglichkeit sein, Aspekte meiner theoretischen Arbeit zu verifizieren, aber sie ist auch ein Generator, da das Nebeneinander von Kunstwerken im gleichen Raum Theorie generiert, neue Assoziationen hervorruft. Selbst wenn ich eine Ausstellung mit einer sehr klaren Idee kuratiere, verändert sie sich nachher jedes Mal. Kunstwerke entkommen der Schachtel, in die man sie einzupferchen versucht, auf die eine oder andere Weise immer.

GAM: Am Ende Ihrer Einleitung zu *The Exform* schreiben Sie: „Dieses Buch versucht, an diesem neuen Anfang teilzuhaben – auch wenn es sich weigert, zu irgendwas zurückzukehren." Was bedeutet dieser neue Anfang für die Kultur des Ausstellens? Und inwiefern verändert er die Räume, in denen Ausstellen stattfindet?

NB: Ich beschreibe und dokumentiere eine Sackgasse, oder die Auflösung einer Bewegung – so wie die globale Erwärmung den sich in den Atlantik ergießenden Golfstrom auflöst. Genaueres zu dem, was kommen wird, kann ich im Augenblick nicht sagen. Betrachten wir für den Anfang mehr Kunstwerke.

GAM: Danke für das Interview. ∎

Übersetzung: Wilfried Prantner

Exhibiting Models
Modelle Ausstellen | Ausstellungsmodelle

Wilfried Kuehn

1 Kuehn Malvezzi, "Inside Out" contribution for the "Vertical City" section at the Chicago Architecture Biennial 2017 | Beitrag zur „Vertical City" Sektion auf der Architekturbiennale Chicago 2017 © Kuehn Malvezzi

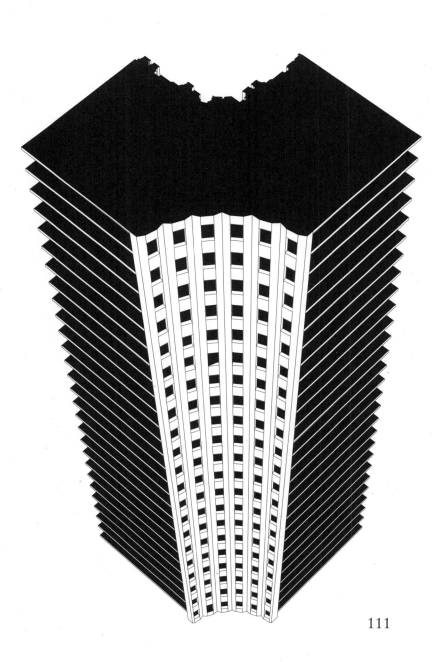

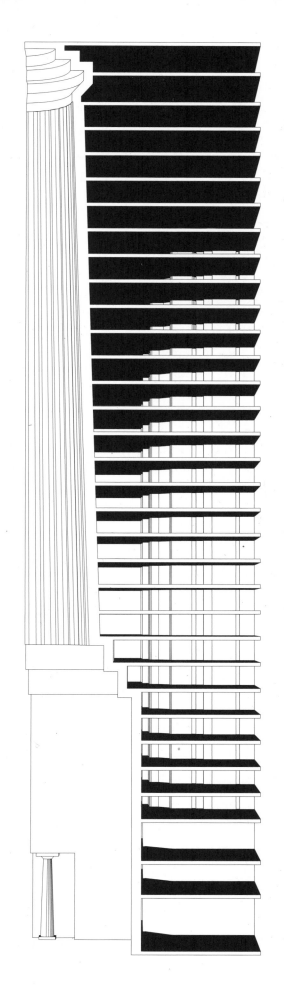

111

Participating in a curated group exhibition triggers conflicting thoughts. Biennial-format exhibitions are at once relational and competitive, as, together with the displayed works, they expose the workings of our professional contexts. They reveal the politics of production. The curatorial principle of contemporary biennials is being challenged by the often fair-like character of their spatial manifestation, which in light of historical precursors like the Salon de Paris and the "World's Fair" comes as no surprise; before having been curated, biennials came of age as trade fairs. Art Biennials and Architecture Biennials are not the same; as an architect, participating in a themed group show bears a resemblance to participating in a building competition. There is a commissioner, there is a brief, there is a presentation of a project, and there is a public review. Above all, there is a confrontation between different positions articulated as projects rather than buildings: a contrasting juxtaposition of architectural models. Taking part in architectural competitions largely shapes the way we conceive and design spaces, and it definitely informs the way architects exhibit within a group show: we present representations rather than the thing itself; we show a model rather than a built reality. It appears to be a truism that architectural exhibiting bears a deficiency in comparison to the way artists exhibit within group shows. Where they are able to present the original work of art, exhibited architecture, rather than being an exhibit in and of itself, commonly appears to be a display of an absent building. Still, we may invert our perspective and look at this difference not as a deficiency, but as a potential strength. Transcending the inherent tendency of an art exhibition to fetishize objecthood, the distant perspective of architectural representation allows for understanding of exhibiting as an event that eschews the cult of the object. While we take into account the fundamental importance of the architectural competition for our exhibiting practice, we also understand architectural competitions for what they are beyond being an instrument of acquisition: competitions are exhibitions proper.

Calling 16 architects to reconsider the 1922 brief for the design of a tower to house the *Chicago Tribune* as one of several sections of their 2017 biennial, curators Sharon Johnston and Mark Lee drew a straight line from one of the very first international architecture competitions of the 20th century to the second edition of the "Chicago Architecture Biennial": "The collusion of print media, exhibition, and architecture, in this instance, effectively sealed the imagery of individual towers shown as a collection; and the influence and reach of this particular project drove many responses and copies … The 2017 Chicago Architecture Biennial eschews drawings for the exhibition format. Each tower design is represented as a scaled model, 16 feet high. Collected together, these enormous, slender forms appear as a Hypostyle Hall stage set. The designs are at once a tower and a column."[1] Asked to design one of the 16 scaled models, we started revisiting the historical "Chicago Tribune Tower." Although being the phenotype of the unoriginal second-rate artist, the architect Raymond Hood won the international competition. In her controversial novel *The Fountainhead*, Ayn Rand modeled the character of architect Peter Keating after Hood, pitching him against Frank Lloyd Wright's alter ego Howard Roark. It is the Hood of the Chicago Tribune Tower against the Wright of Usonia. In Rand's novel, American modernism equals heroism of forceful individuals. Hood, in contrast, is not a hero but a pragmatist whose winning design in the 1922 competition reveals how modernization splits from modernism. If *The Fountainhead* ideologically links modernism and capitalism, the actual corporate architecture went the other way. Pragmatic and corporate, Raymond Hood's winning entry for the 1922 Chicago Tribune Tower competition epitomizes the tall office building beyond modernist ideology. While it provided a building block for the American downtown that made Wright's questioning of the city and its relation to society appear academic, it took Rem Koolhaas's *Delirious New York* for Hood to get a literary rematch. In contrast to the 1920s heroism, we are provided with a narrative of metropolitan hedonism that intellectually transcends rigorous modernism. Skyscrapers appear, like exhibits, on pedestals, the city, being a regular grid, allows for individual vanity to flourish on private parcels. The capitalist city turned real by way of becoming a triumphant display. The only European contribution to the 1922 competition which embraced American realism was Adolf Loos's design. Featuring a column-shaped shaft on a square pediment, Loos proposes an architectural display that oscillates between capitalist exhibitionism and a radical transfer of Durchamp's readymade to the architectural sphere.

2017–1980. The curatorial concept of Sharon Johnston and Mark Lee makes reference to Paolo Portoghesi's first "Biennale di Architettura" in 1980. More precisely, the "Hypostyle Hall" purposefully re-enacts Portoghesi's "Strada Novissima" by shifting the city analogy from the European street to the American downtown grid. If the 2017 exhibition calls for a spatial typology of 16 skyscraper models forming a grid, the typological model in 1980 was the street. But Strada Novissima wasn't actually a street. Built by the Italian dream factory "Cinecittà" in Rome, the exhibition space of the very first architecture biennial resembled a film set. As such, it was meant to be perceived by a spectator

1 Sharon Johnston and Mark Lee, "Vertical City," in *Make New History: 2017 Chicago Architecture Biennial*, ed. Sharon Johnston, Sarah Hearne and Letizia Garzoli, Exhibition Catalog (Zurich/Chicago, 2017), pp. 219–223, esp. p. 219.

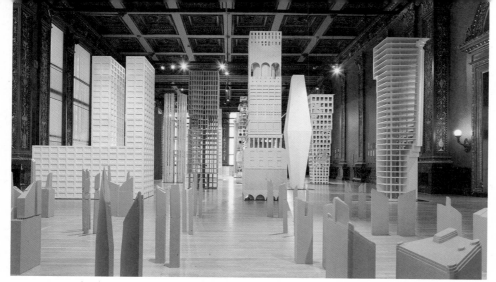

2

Installation view of "Vertical City" at Sidney R. Yates Hall, Chicago Architecture Biennial 2017 | Ausstellungsansicht der „Vertical City" in der Sidney Yates Halle, Architekturbiennale Chicago 2017 © Photo: Steve Hall, Hall Merrick Photographers, Courtesy of Chicago Architecture Biennial | Mit freundlicher Genemigung der Architekturbiennale Chicago

Die Einladung zu kuratierten Gruppenausstellungen löst widersprüchliche Gedanken aus. Biennalen sind zugleich beziehungsreich und kompetitiv, indem sie zusammen mit den ausgestellten Arbeiten auch die Funktionsweisen unseres Berufsfelds offenbaren. Sie zeigen Produktionspolitik. Das kuratorische Prinzip zeitgenössischer Biennalen wird durch ihre oft messeartige Erscheinung infrage gestellt, was angesichts ihrer historischen Vorläufer wie dem „Salon de Paris" und der „World's Fair" nicht überrascht, denn die Biennalen waren in ihren Anfängen, bevor sie kuratiert wurden, echte Verkaufsmessen. Kunst-Biennalen und Architektur-Biennalen sind nicht dasselbe; Teil einer thematischen Gruppenausstellung zu sein, gleicht für einen Architekten einer Wettbewerbsteilnahme. Es gibt einen Auftraggeber und eine Aufgabe, es wird ein Projekt präsentiert und es gibt schließlich eine öffentliche Vorstellung, Würdigung und Kritik. Vor allem aber gibt es in der Ausstellung wie im Wettbewerb eine Auseinandersetzung zwischen verschiedenen Positionen in Form von Entwürfen statt realer Bauten: eine Gegenüberstellung architektonischer Modelle. Architekturwettbewerbe bestimmen stark, wie wir Räume denken und entwerfen, und sie sind die Blaupause für Ausstellungsbeiträge in Gruppenausstellungen: wir zeigen Architekturdarstellungen statt realer Architektur, ein Modell statt gebauter Wirklichkeit. Es scheint ein Gemeinplatz zu sein, dass das Ausstellen von Architektur gegenüber dem Ausstellen von Kunst einen Mangel aufweist; wo Künstler das originale Werk ausstellen, zeigen Architekten statt eines konkreten Werks nur das Display eines abwesenden Bauwerks. Umgekehrt kann dieser Unterschied aber auch alles andere als ein Defizit sein und ist ganz im Gegenteil eine Stärke. Der distanzierte Blick architektonischer Darstellung vermag die Tendenz zum fetischisierten Objekt, die der Kunstausstellung inhärent ist, zu überwinden und ein Verständnis des Ausstellens als Ereignis jenseits des Objektkults zu schaffen. Während wir uns der grundlegenden Bedeutung des Architekturwettbewerbs für unsere Ausstellungspraxis bewusst sind, verstehen wir umgekehrt auch, was Wettbewerbe außer einem Akquisitionsinstrument vor allem sind: Sie sind echte Architekturausstellungen.

Mit ihrer Anfrage an 16 Architekten, die Wettbewerbsausschreibung von 1922 für ein Turmgebäude der *Chicago Tribune* erneut zu betrachten, ziehen die Kuratoren Sharon Johnston und Mark Lee eine direkte Linie von einem der allerersten internationalen Wettbewerbe des 20. Jahrhunderts zur zweiten Edition der Chicago Architecture Biennial: „Das Zusammenwirken von Printmedien, Ausstellung und Architektur hat in diesem Fall die Bildsprache einer aus individuellen Türmen bestehenden Sammlung geschaffen; Einfluss und Reichweite dieses speziellen Projektes waren der Antrieb für zahlreiche Reaktionen und Kopien … Die Chicago Architecture Biennial 2017 vermeidet Zeichnungen in diesem Ausstellungsformat. Alle Turm-Entwürfe werden als Maßstabsmodelle mit einer Höhe von 16 Fuß dargestellt. Gemeinsam wirken diese großen schlanken Formen wie das Bühnenbild einer Säulenhalle. Die Entwürfe sind Turm und Säule zugleich."[1] Die Einladung, eines der 16 Maßstabsmodelle zu entwerfen, führte uns zurück zum historischen Chicago Tribune Tower und dessen Architekten. Raymond Hood gewann den internationalen Wettbewerb, obgleich er der Phänotyp des zweitklassigen, nicht-originellen Künstlers war. In ihrem Bestseller *The Fountainhead*, nimmt Ayn Rand Raymond Hood als Vorbild für die Figur des Architekten Peter Keating, der im Roman gegen Howard Roark alias Frank Lloyd Wright in Stellung gebracht wird: der Hood des Chicago Tribune Tower gegen den Wright von Usonia. In Rands Erzählung ist die amerikanische Moderne synonym mit dem Heroismus starker Einzelgänger. Hood hingegen ist kein Held, sondern ein Pragmatiker, dessen siegreicher Wettbewerbsentwurf 1922 entlarvt, wie Modernisierung sich von der Moderne entzweit. So sehr *The Fountainhead* den Versuch antritt, Moderne und Kapitalismus ideologisch gleichzusetzen, zeigt der Wettbewerb, dass die Unternehmensarchitektur einen anderen Weg nimmt. Raymond Hoods siegreicher Entwurf im internationalen Architekturwettbewerb für den *Chicago Tribune* Turm 1922 verkörpert das Bürohochhaus jenseits der Moderne: es ist pragmatisch und *corporate*. Für die amerikanische *Downtown* liefert es zwar den prototypischen Baustein, der Wrights grundsätzliche Infragestellung der dichten Stadt und ihres Verhältnisses zur Gesellschaft akademisch erscheinen lässt. Doch es bedurfte Rem Koolhaas' *Delirious New York*, um Hood eine literarische Revanche zu verschaffen. Im Gegensatz zum Heroismus der

1 Johnston, Sharon/Lee, Mark: „Vertical City", in: Johnston, Sharon/Hearne, Sarah/Garzoli, Letizia (Hg.): *Make New History. 2017 Chicago Architecture Biennial*, Ausst.-Kat., Zürich/Chicago 2017, 219–223, hier 219.

rather than a visitor, an observer rather than a user. If an exhibition is distinct from a stage, just as a site is distinct from a set, for the very fact that it is being experienced by a physically active beholder engaged in moving about, "Strada Novissima" reveals itself to be a hybrid of sorts, neither entirely rooted in exhibition nor theater. The purpose of "Strada Novissima" was foremost ideological: to establish a discourse concerning the architecture of the city in relation to history as the basic assumption of making an architecture exhibition. By calling a limited number of contemporary colleagues to deliver a facade design in order to generate a street-scenography, Portoghesi invoked the concept of architecture as typologically driven and rooted in the city, while cross-breeding the intention of a concrete and palpable piece of architecture with the aspiration for theatrical illusion: "After a dutiful tribute to Schinkel, and near the Alexanderplatz, between the echo of the late Behrens and the outlines of the Stalinallee, we discovered a marvelous enclosed amusement park with a small piazza surrounded by small stands that imitated facades of houses in temporary materials, the ground floor in true scale and the others in a scale of 1:2: a paradoxical answer to one of the needs of the city, a need for closed and inviting space at the center of one of the cross-roads of modern architecture."[2] Portoghesi's account of the moment in which he, accompanied by amongst others Aldo Rossi, conceived the "Strada Novissima" on a winter day in 1979, paradoxically shows the exhibition model for a concrete architectural experience in Venice to be an amusement park in the socialist East Berlin.

 Portoghesi's 1980 exhibition was conceived as an analogous urban space. Vice-versa, in the years leading up to the Biennale, the city has been read as an exhibition. While Aldo Rossi's Città Analoga, O.M.Ungers's Green Archipelago, Colin Rowe's and Fred Koetter's *Collage City* and Rem Koolhaas's *Delirious New York* all re-conceptualize the city as an exhibition of life-size scale, the "Berlin International Building Exhibition" (IBA) in the same years sets out to build a life-size exhibition of contemporary architecture by mostly the same architects who realized the "Strada Novissima." If the 1970s, especially in Europe, were a decade of fervent architectural debate rather than building, the 1980 "Biennale" resolves the main dispute between mostly Marxist European "Rationalists" and capitalist American "Pop" by giving the stage to both of them as well as to all sorts of followers and hybridizations. In the proclamatory words of Charles Jencks, the result was the one of "radical eclecticism," the expression of a pluralist society in its diversity.[3] At the same time, Jencks candidly acknowledges the futility of both, pluralist society and its architectural double: "All these Post-Modern tendencies are trying to give birth to a new architecture before consumer society has given it a mandate; it is the sound, as the saying goes, of one hand clapping."[4] Post-modern architecture reveals itself

3
Kuehn Malvezzi, "Inside Out," installation view | Ausstellungsansicht, contribution for the "Vertical City" section at the Chicago Architecture Biennial 2017 | Beitrag zur „Vertical City" Sektion auf der Architekturbiennale Chicago 2017
© Laurian Ghinitoiu

as the flipside of a society devoid of any content worth expressing. In line with the spatial model of the "Strada Novissima" being a cozy amusement park set into the modernist void of Berlin-Alexanderplatz, Jencks identifies the contemporary space as a "museum city" in which "styles have lost their overall meaning and have instead become genres—classifiers of mood and theme."[5] Understood as a theme park or as an imaginary museum, the city is a display of multiple particular identities without relation: a collection without a collective. With regard to Portoghesi's Biennale, Sharon Johnston and Mark Lee explain: "Architecture's entry into the domain of the art biennial, almost 40 years ago in Venice, was marked by a reflection on the relationship of history and memory in architecture. During its inaugural edition in 1980, the Venice Architecture Biennale showcased an expanding repertoire of theatrical devices and scenographic modes of display. Today, the role of history in the field of architecture has changed, as has the role of the exhibition. On the one hand, the biennial format lies at the core of architecture's cultural and exhibitionary project: a forum to reach and produce new audiences. On the other, it replicates the enduring question of how to

2 Paolo Portoghesi, "The End of Prohibitionism," in: *The Presence of the Past: First International Exhibition of Architecture. Venice Biennale 80*, ed. Paolo Portoghesi, Vincent Scully, Charles Jencks et al. (Venice, 1980), pp. 9–14, esp. p.12.

3 Charles Jencks, "Towards Radical Eclecticism," in: *The Presence of the Past* (see note 2), pp. 30–37, esp. p. 30ff.

4 Ibid., p. 37.

5 Ibid.

1920er Jahre erleben wir nun ein Narrativ metropolitanen Hedonismus, das die rigorose Moderne intellektuell überwindet. Wolkenkratzer erscheinen als Exponate auf Sockeln in einem regelmäßigen Blockraster, das der individuellen Eitelkeit jede Möglichkeit zur Entfaltung auf ihrer privaten Parzelle verschafft. Die kapitalistische Stadt wurde Wirklichkeit in Form einer triumphalen Ausstellung. Der einzige europäische Teilnehmer am Wettbewerb 1922, der sich den amerikanischen Realismus zu eigen machte, ist Adolf Loos mit seinem Entwurf. Ein säulenförmiger Schaft auf rechteckigem Sockel zeigt den Wolkenkratzer als architektonisches Display zwischen kapitalistischem Exhibitionismus und einem radikalen Transfer von Duchamps Readymade in die Sphäre der Architektur.

2017–1980. Das kuratorische Konzept von Sharon Johnston und Mark Lee nimmt Bezug auf Paolo Portoghesis erste Architekturbiennale 1980. Die „Hypostyle Hall" ist ein *Re-enactment* von Portoghesis „Strada Novissima", indem sich die Stadtanalogie von der europäischen Straße zum amerikanischen Blockraster verschiebt. Doch die „Strada Novissima" war eigentlich keine Straße. Als Kulissenlandschaft von den Werkstätten der italienischen Traumfabrik „Cinecittà" gebaut, glich der Raum der allerersten Architekturbiennale eher einem Filmset. Als solcher war er weniger für einen Nutzer als für einen Zuschauer bestimmt. Wenn eine Ausstellung sich von einer Bühne wie ein realer Ort von einem Filmset darin unterscheidet, durch einen physisch aktiven Betrachter in Bewegung durch den Raum erfahren zu werden, ist die „Strada Novissima" eine Art Hybrid, weder ganz in der Ausstellung noch im Theater verwurzelt. Ihr Ziel war zuerst ideologisch: als grundlegende Voraussetzung einer Architekturausstellung sollte die Architektur der Stadt im Umgang mit Geschichte diskursiv etabliert werden. Mit der Aufforderung an eine begrenzte Zahl von Architektenkollegen, einen Fassadenentwurf für eine Straßenszenografie zu liefern, rief Portoghesi das Konzept einer typologisch getriebenen, in der Stadt verwurzelten Architektur aus, während er das Streben nach einem konkret-spürbaren, echten Stück Architektur mit dem Streben nach theatraler Illusion kreuzte: „Nach einer pflichtbewussten Huldigung Schinkels entdeckten wir in der Nähe des Alexanderplatzes zwischen dem Echo des späten Behrens und den Konturen der Stalinallee einen großartigen Rummelplatz mit einer kleinen Piazza, umschlossen von kleinen Ständen, die Hausfassaden in zeitgenössischen Materialien imitierten: das Erdgeschoss maßstabsgerecht, die anderen Geschosse im Maßstab 1 : 2; eine paradoxe Antwort auf eines der Bedürfnisse der Stadt, das Bedürfnis nach einem umschlossenen und einladenden Raum im Zentrum und an einem der Zentren der Architekturmoderne."[2] Portoghesis Darstellung des Augenblicks, in dem an einem Wintertag 1979 in Begleitung von Kollegen wie Aldo Rossi die Idee der „Strada Novissima" geboren wurde, offenbart die paradoxale Herkunft der konkreten Architekturerfahrung in Venedig von einem illusionistischen Rummelplatz im sozialistischen Ost-Berlin.

Portoghesis Ausstellung 1980 war als analoger Stadtraum konzipiert. In den Jahren vor der Biennale erschien umgekehrt die Stadt als Ausstellung: Während Aldo Rossis Città Analoga, O.M.Ungers' Grünes Stadtarchipel, Colin Rowes und Fred Koetters *Collage City* und Rem Koolhaas' *Delirious New York* die Stadt als Ausstellung im Maßstab 1 : 1 rekonzeptualisieren, wird mit der „IBA Berlin" gleichzeitig die reale Stadt als Ausstellung gebaut, und zwar überwiegend von jenen Architekten, die 1980 die „Strada Novissima" produzieren. Waren die 1970er Jahre vor allem in Europa ein Jahrzehnt der leidenschaftlichen Architekturdebatte, in dem wenig gebaut wurde, löst die Biennale 1980 den Disput zwischen den europäischen, zumeist marxistisch geprägten Rationalisten und dem amerikanisch-kapitalistischen Pop, indem sie die Bühne beiden wie auch einer Reihe von Kreuzungen gibt. In den proklamatorischen Worten von Charles Jencks war das Ergebnis ein „radikaler Eklektizismus", Ausdruck einer pluralistischen Gesellschaft in ihrer Diversität.[3]

Gleichzeitig bekennt Jencks freimütig die Vergeblichkeit einer pluralistischen Gesellschaft und ihres architektonischen Doppels: „Sämtliche postmodernen Strömungen unternehmen den Versuch, eine neue Architektur hervorzubringen bevor ihnen die Konsumgesellschaft ein Mandat dazu erteilt hat. Es ist, wie man so schön sagt, der Klang des einhändigen Klatschens."[4] Postmoderne Architektur erweist sich als die andere Seite einer Gesellschaft, deren Inhalte es nicht wert sind, architektonischen Ausdruck zu finden. In Übereinstimmung mit dem Raummodell der „Strada Novissima", einem gemütlichen Vergnügungspark, der in die modernistische Leere des Alexanderplatzes eingesetzt wird, identifiziert Jencks den zeitgenössischen Raum als *Museum City*, zu der er feststellt: „Stile haben ihre grundlegende Bedeutung verloren und sind stattdessen Genres geworden – Klassifikatoren von Stimmung und Themen."[5] Als Themenpark oder als Imaginäres Museum verstanden, ist die Stadt ein Display multipler partikulärer Identitäten ohne Beziehung zueinander: eine Kollektion ohne Kollektiv. Sharon Johnston und Mark Lee bemerken in Bezug auf Portoghesis Biennale: „Der Einstieg der Architektur in die Domäne von Kunstbiennalen begann vor fast vierzig Jahren in Venedig mit einer Reflexion über das Verhältnis von Geschichte und Gedächtnis in der Architektur. Die Veranstaltung präsentierte ein wachsendes Repertoire an theatralischen Mitteln und szenografischen Formen des Displays. Heute sind Rolle und Einfluss von Geschichte in der Architektur nicht mehr die gleichen, ebenso wenig trifft dies für Ausstellungen zu. Auf der einen Seite ist das Format der Biennale das Kernstück der Architektur als Kulturprojekt: ein Forum, das darauf aus ist, ein neues Publikum zu erreichen und zu gewinnen, war immer Teil des Ausstellungsprojekts. Auf der anderen Seite reproduziert es die immerwährende Frage danach, wie abwesende Bauwerke gezeigt und ihre Geschichten erzählt werden können. Diese Fragen sind mittels einer ganzen Reihe neuer Methoden beantwortet

2 Portoghesi, Paolo: „The End of Prohibitionism", in: Portoghesi, Paolo/Scully, Vincent/Jencks, Charles et al. (Hg.): *The Presence of the Past. First International Exhibition of Architecture. Venice Biennale 80*, Venedig 1980, 9–14, hier 12.

3 Jencks, Charles: „Towards Radical Eclecticism", in: *The Presence of the Past*, 30–37, hier 30ff (wie Anm. 2).

4 Ebd., 37.

5 Ebd.

showcase and tell stories about absent buildings. This question has been addressed by a suite of new modes to express and mine architecture's own traditions. Often, these new methods of communication reflect an intensified engagement with media and approaches traditionally seen as art practices. This sort of overlap has served to blur the expertise and responsibilities of distinct disciplines."[6]

The contradictions inherent in exhibiting architecture arise from the paradox of the simultaneous proximity and distance of the architectural object. The concrete present of the real space experienced by the visitor and the abstract present of a space on display, in itself absent, compete with one another, carrying the attached risk of canceling each other out. Confronting ourselves with the task of exhibiting architecture, we consequently need to position ourselves in-between two contrasting challenges: making space as an experiential event versus presenting the design of an absent space. Said otherwise, we need to determine if we are going to produce an exhibit or a display. Since the 1980 Venice "Biennale," architecture exhibitions have almost indiscriminately aimed at blurring the distinction between exhibit and display by fetishizing representation. Confronted with the quandary of not being able to exhibit the architectural object as such, architects and curators alike have developed multiple practices of enhancing the display of drawings, plans, and models, as well as, collages, renderings, material samples, and spatial installations into exhibits in and of themselves.

The practice of choosing the exhibition of architectural drawings as exhibits rather than documents in order to reach a level of political autonomy from which to articulate an architectural discourse, initially started as a political gesture when events such as "No-Stop City," "Architettura Razionale" or the "IAUS" activities made the claim of radical otherness vis-à-vis the commercial building industry post-1968. Since 1980 and Portoghesi's Biennale though, the claim for autonomy paradoxically brought about a tacit commodification of the architecture exhibit as an art object ready to enter the commodity market and, thus, to undergo a different sort of subjection. Periodic curatorial attempts to counteract this subjection proclaiming themes such as *Less Aesthetics, More Ethics* (2000) and *Reporting from the Front* (2016) foreseeably failed at the exhibition level. Instead, specific architectural interventions such as OFFICE KGDVS's "*1907 After the Party*," a transformation of the Belgian Pavilion at the Giardini in 2008, indicate concrete hypotheses about how to make the space of exhibiting also a way of exhibiting space. Accompanied by curator Moritz Küng, Kersten Geers and David Van Severen designed and built a patio that provided a display for the existing pavilion while they also produced a concrete exhibit in the form of an accessible and physically usable space for all visitors.[7]

In our contribution "Komuna Fundamento" for David Chipperfield's Biennale in 2012, we explored the possibility of producing a specific space while making the intervention invisible as such. The low brick element blocking the axis to the "Expo Pavilion" was experienced by most visitors as a bench. As an obstacle, it indirectly reorganized the visitor's parcours and the perception of the pavilion's entrance, while also offering a different perspective onto the Giardini. Oscillating between exhibit and display, the brick object produced spatial experiences in that it was actively being used and not only being looked at.[8]

2017–1922. The curators of the 2017 Chicago Biennial claim the section "Vertical City" to be a model. An urban model if seen as a grid of 16 high-rise models, but more so a conceptual model confronting contemporary architectural practice with the one practiced in 1922. It appears to fulfill the idea of staging a confrontation of 16 contemporary practices in a competition

4

OFFICE Kersten Geers David Van Severen, "After the Party,"
Belgian Pavilion, Biennale di Venezia 2008 | Belgischer Pavillon,
Architekturbiennale Venedig 2008 © Bas Princen

6 Sharon Johnston and Mark Lee, "Make New History," Chicago Architecture Biennal, accessed January 16, 2018, http://chicagoarchitecturebiennial.org/statement/.

7 See OFFICE Kersten Geers, David van Severen, "After the Party," Belgian Pavilion, Biennale di Venezia, 2008.

8 See also the accompanying publication: Kuehn Malvezzi, ed., *Komuna Fundamento* (Milan, 2012)

Kuehn Malvezzi, "Komuna Fundamento,"
Biennale di Venezia 2012 | Architekturbiennale Venedig 2012
© Giovanna Silva

worden, in denen die eigenen Traditionen der Architektur zum Ausdruck gebracht und ausgeschöpft werden. Oft reflektieren und intensivieren diese neuen Methoden der Kommunikation den Einsatz von Medien sowie von Konzepten, die traditionell den Praktiken der Kunst zugerechnet werden. Diese Art der Überlappung hat bewirkt, daß die Abgrenzung unterschiedlicher Disziplinen in Expertise und Zuständigkeit verwischt wurde."[6]

Die inhärenten Widersprüche des Ausstellens von Architektur entspringen dem Paradox der gleichzeitigen Nähe und Distanz des architektonischen Objekts. Die konkrete Gegenwart des real vom Besucher erfahrenen Raums und die abstrakte Gegenwart eines ausgestellten Raums, der selbst abwesend ist, stehen in Konkurrenz miteinander und riskieren, sich gegenseitig aufzuheben. Unsere Konfrontation mit der Aufgabe, Architektur auszustellen, macht es daher erforderlich, uns zwischen zwei kontrastierenden Herausforderungen zu positionieren: einen Raum zu schaffen als erfahrbares Ereignis auf der einen Seite, einen abwesenden Raum als Entwurf zu zeigen auf der anderen. Wir müssen bestimmen, ob wir ein Exponat produzieren oder ein Display. Seit der „Biennale di Venezia 1980" haben Architekturausstellungen fast unterschiedslos versucht, die Grenze zwischen Exponat und Display durch Fetischisierung der Darstellung zu verwischen. Mit dem Dilemma konfrontiert, das originale architektonische Objekt nicht als solches zeigen zu können, haben Architekten und Kuratoren gleichermaßen vielfältige Praktiken entwickelt, um Zeichnungen, Pläne und Modelle ebenso wie Collagen, Renderings, Materialmuster und räumliche Installationen in tatsächliche Exponate zu verwandeln.

Die Praxis, Architekturdarstellungen als Ausstellungsobjekte und nicht bloß als Dokumente zu betrachten, begann um 1968 als politische Geste, die dem marktliberalen Bauwirtschaftsfunktionalismus eine radikale Autonomie entgegensetzte: Ereignisse wie *No-Stop City, Architettura Razionale* oder die *IAUS* Aktivitäten erklärten Zeichnungen zu eigenständigen Werken, um die damit gewonnene politische Autonomie für den architektonischen Diskurs produktiv zu machen. Seit 1980 und Portoghesis Biennale jedoch hat die Autonomieforderung stillschweigend eine Kommodifizierung des Architekturexponats mit sich gebracht; das zum Kunstwerk mutierte Ausstellungsobjekt, das im Kunstmarkt gehandelt wird, erfährt paradoxerweise eine neuerliche marktliberale Unterwerfung. Wiederkehrende kuratorische Versuche, diese Unterwerfung mit Themen

wie „*Less Aesthetics, More Ethics*" (2000) und „*Reporting from the Front*" (2016) herauszufordern, scheiterten absehbar auf der Ausstellungsebene. Spezifische Biennale-Interventionen wie OFFICE KGDVSs „*1907 After the Party*", eine Transformation des belgischen Pavillons in den *Giardini* 2008, zeigen hingegen konkrete Hypothesen, wie der Raum des Ausstellens zugleich ein Ausstellen von Raum werden kann. Begleitet von Kurator Moritz Küng entwarfen und bauten Kersten Geers und David Van Severen einen Patio, der als Display den bestehenden belgischen Pavillon ausstellte und der zugleich als Exponat einen physisch erlebbaren Raum für die Besucher bot.[7]

In unserem Beitrag „Komuna Fundamento" für David Chipperfields Biennale 2012 haben wir Möglichkeiten erforscht, einen spezifischen Raum zu erzeugen, während wir die Intervention als solche unsichtbar machen wollten. Das niedrige Ziegelelement, das die Wegachse zum Expo-Pavillon blockierte, nahmen die meisten Besuchern als Bank wahr. Ein Hindernis, das die Bewegung der Besucher wie die Wahrnehmung des Pavilloneingangs indirekt anders als gewohnt organisierte, das aber auch einen neuen Blick auf die *Giardini* von dort aus erzeugte. Zwischen Display und Exponat oszillierend, produzierte das Ziegelobjekt Raumerfahrungen durch Benutzung statt nur betrachtet zu werden.[8]

2017–1922. Die Kuratoren der Chicago Biennale 2017 erklären, dass die Sektion „Vertical City" ein Modell sei. Ein Stadtmodell, wenn man es als Blockraster von 16 Hochhausmodellen sieht, mehr noch ein konzeptuelles Modell, das die zeitgenössische Architekturpraxis mit jener von 1922 konfrontiert. Es scheint der Idee gerecht zu werden, 16 zeitgenössische Positionen in einer Art Wettbewerb gegenüberzustellen, während die Beziehungen zwischen den 16 einzelnen Arbeiten schwieriger

6 Johnston, Sharon/Lee, Mark: „Make New History", Chicago Architecture Biennal, online unter: http://chicagoarchitecturebiennial.org/statement/

7 Vgl. OFFICE Kersten Geers, David van Severen: „After the Party", Belgischer Pavillon, Biennale di Venezia, Venedig 2008.

8 Vgl. dazu die gleichnamige Publikation: Kuehn Malvezzi (Hg.): *Komuna Fundamento*, Mailand 2012.

of sorts while the relations in-between the 16 singular works appear to be more difficult to discern.[9] The resulting spatial experience in the Chicago exhibition venue thus resembles the experience of architecture landmark buildings in downtown Chicago: no matter how peculiar, outstanding and engaged with the city any singular contribution may be, they are structurally dissociated and not driven by a collective objective. Rather than idealizing the "Vertical City" as an urban model, one may read it as an acute reflection on the contemporary city shaped by competitive parceling. As a consequence, the 16 contributions were not only expectedly diverse but also categorically divergent. 16 models as a sectional cut of an architects's generation reveal as much the connective aspects of specific attitudes and approaches as the necessary impasse in producing a significant whole. The "Vertical City," very logically, does not differ from the contemporary city as such.

Our approach thus departed from the idea of contributing one tower to a constellation of 16 in favor of conceiving a spatial alternative. Rather than exhibiting a model building, we conceived of exhibiting a reversed building turned inside out into a model space. Taking its starting point from the 1922 competition, the challenge of the "Chicago Tribune Tower" today is reconceptualizing urban space as the figure that takes shape in relation to the building ground. Applying the logic of Giambattista Nolli's 1748 plan of Rome, we read downtown Chicago and the vertical city as a Poché. We took the vertical urban block as solid mass without parceling, to be subsequently sculpted by way of subtraction. Raymond Hood's 1922 building was the starting point of a hollowing-out procedure involving the entire block. Leaving only the facades intact, the voided shell is read inside-out as a patio lined by the reversed facades:

"In 1922 America meets Europe in the Tribune Competition. Even more so, idealism meets realism. If Hood exemplifies an American take on the highrise beyond the Ayn Rand heroism, Loos projects the corporate tower beyond European modernism. Said otherwise, Hood differs from Wright as much as Loos differs from Hilberseimer. Today, the realists Hood and Loos will finally meet. Their encounter takes place at the historical site, witnessed by the real Chicago context and by two ideal European companions who haven't seen the light of day. Around 1922, the European modernists, except for Loos, conceived of the highrise as a typology that was key to redesigning the city as a different space, acting as decisive urban elements to replace the 19th century block. In contrast, Hood's tower and Loos' column do not pretend to make urban space. Rather, they provide iconic objects to grow from the extant reality of a generic urban block.
Meeting in 2017 at the Chicago block of the Tribune Tower, in part occupied by Hood's building but largely underdeveloped until now, the heterogenous Europeans set the stage for a new confrontation. It results in an unlikely turn. A bastard is going to be generated from the urban block and its reversal. Turning the volume inside out, what used to be the space in-between the highrises becomes building mass and will house the program surface of the *Chicago Tribune* offices. The building shells instead turn into high voids that act as urban squares, their facades being reversed. Figure becomes ground, solitary objects turn into spaces and vice versa. The result is a new piece of urban fabric. Where there used to be facades along the block perimeter, now there are sectional cuts, whereas inside the block we encounter the historical facades articulated towards the urban spaces enclosed by them."[10] ■

9 The 16 positions invited to form the "Vertical City" were: 6a architects, Barbas Lopes, Barozzi Veiga, Christ & Gantenbein, Ensamble Studio, Eric Lapierre Architecture, Go Hasegawa, Kéré Architecture, Kuehn Malvezzi, MOS, OFFICE KGDVS with Peter Wächtler and Michaël Van den Abeele, PRODUCTORA, Sam Jacob Studio, Sergison Bates, Serie Architects, Tatiana Bilbao Estudio.

10 Kuehn Malvezzi, "Inside Out," proposal for the contribution to "Vertical City," Chicago Architecture Biennial 2017, December 2016.

6

Hans Hollein, "Strada Novissima,"
Biennale di Venezia 1980 | Architekturbiennale Venedig 1980
© Archiv Hans Hollein

„Im Tribune-Wettbewerb 1922 treffen sich Amerika und Europa; mehr noch stoßen hier Idealismus und Realismus aufeinander. Zeigt Hoods Entwurf das amerikanische Hochhaus frei von Ayn-Rand-Heroismus, entwirft Loos einen *corporate tower* jenseits des europäischen Modernismus. Anders gesagt: Hood und Wright unterscheiden sich wie ihrerseits Loos und Hilberseimer. Heute treffen sich die Realisten Hood und Loos endlich. Ihre Begegnung findet am historischen Schauplatz statt und wird sowohl vom realen Kontext der Stadt Chicago als auch von zwei ideellen europäischen Weggefährten bezogen, die das Licht der Welt nie erblickt haben. Anders als Loos haben die europäischen Modernisten das Hochhaus 1922 als Typologie gesehen, mit der eine neue Stadt entworfen werden kann, indem das Hochhaus als urbanes Element den Block des 19. Jahrhunderts ersetzt. Im Gegensatz dazu geben Hoods Turm und Loos' Säule nicht vor, Stadtraum zu schaffen. Beide sind vielmehr ikonische Objekte, die sich aus der vorhandenen Realität des generischen urbanen Blockes entwickeln.

Bei ihrer Zusammenkunft im Chicagoer Block des Tribune Tower, der zum Teil von Hoods Gebäude besetzt aber bis heute stark unterentwickelt ist, schaffen die heterogenen Europäer 2017 die Voraussetzungen für eine erneute Konfrontation. Sie nimmt eine unerwartete Wendung. Aus dem urbanen Block und seiner Umkehrung entsteht ein Bastard. Das Volumen wird von innen nach außen gestülpt, der Raum zwischen den Hochhäusern wird Baukörper, der die Flächen für die Büros der Chicago Tribune stellt; umgekehrt werden die Gebäudehüllen zu großen Hohlräumen mit invertierten Fassaden, die als urbane Plätze dienen. Figur wird zu Grund, solitäre Objekte werden zu Räumen und umgekehrt. Das Ergebnis ist ein neues Stück urbaner Textur. Wo bisher Fassaden den Perimeter des Blocks markiert haben, sind jetzt Schnittflächen zu sehen, während wir im Inneren des Blocks auf die historischen Fassaden treffen, die neuartige urbane Plätze umschließen."[10] ∎

zu verstehen sind.[9] Die aus der Zusammenstellung der Einzelpositionen resultierende Raumerfahrung in den Ausstellungsräumen ähnelt daher der Erfahrung in Downtown Chicago: gleich wie besonders, hervorragend und auf die Stadt bezogen ein einzelner Beitrag sein mag, ist das Zusammenwirken ohne Struktur und ohne gemeinschaftliches Ziel. Statt die „Vertical City" als Stadtmodell zu idealisieren, kann man sie in ihrer kuratorischen Absicht als akute Reflektion der heutigen Stadt lesen, die von kompetitiver Parzellierung geformt wird. Folgerichtig waren die 16 Beiträge nicht nur erwartungsgemäß verschieden, sondern auch kategorial unterschiedlich. 16 Modelle als Querschnitt einer Architektengeneration offenbaren ebenso viel verbindende Aspekte spezifischer Haltungen und Herangehensweisen wie die Ausweglosigkeit, ein bedeutsames Ganzes zu produzieren. Die „Vertical City" unterscheidet sich damit nicht von der zeitgenössischen Stadt.

Unser Entwurfsansatz verabschiedet sich von der Vorstellung, einen Turm zu einer 16er-Konstellation beizutragen. Stattdessen suchten wir nach einer Möglichkeit, kein Baukörpermodell sondern ein Raummodell auszustellen. Ausgehend vom Wettbewerb 1922 ist für uns die Herausforderung des *Chicago Tribune Towers* heute, den Stadtraum als Figur zu rekonzeptualisieren, die im Verhältnis zum Gebäude-Grund Form annimmt. Mit der Logik von Giambattista Nollis 1748 Rom-Plan lesen wir Downtown Chicago und die vertikale Stadt als Poché. Wir nehmen den vertikalen Stadtblock als unparzellierte Masse, die wir in der Folge skulptieren. Raymond Hoods Gebäude von 1922 ist der Ausgangspunkt eines Entleerungsprozederes, das den gesamten Block involviert. Indem nur die Fassade intakt bleibt, wird die entleerte Hülle umgedreht als Patio gelesen, der von den umgekehrten Fassaden gefasst wird:

9 Die 16 Beiträge zur „Vertical City" kamen von 6a architects, Barbas Lopes, Barozzi Veiga, Christ & Gantenbein, Ensamble Studio, Eric Lapierre Architecture, Go Hasegawa, Kéré Architecture, Kuehn Malvezzi, MOS, OFFICE KGDVS mit Peter Wächtler und Michaël Van den Abeele, PRODUCTORA, Sam Jacob Studio, Sergison Bates, Serie Architects, Tatiana Bilbao Estudio.

10 Kuehn Malvezzi: „Inside Out", Ausstellungskonzept für „Vertical City", Chicago Architecture Biennale 2017, Dezember 2016.

And what, for example, am I now seeing?

Visual essay by **Armin Linke**,
designed by Žiga Testen

Armin Linke challenges the conventions of photographic practice whereby the questions of how photography is installed and displayed become increasingly important. In a collective approach with artists, architects, graphic designers, philosophers and curators Linke develops different approaches of dealing with visual archives and spatial concepts.

"The Appearance of That Which Cannot Be Seen" is an exhibiting process of activating the archive, i.e. the body of work of Armin Linke through dialogues. Armin sets the initial frame by sharing photographs with different thinkers from various fields and inviting them to react. By reading these images through their theories and concepts, each produces a selection. These selections form the exhibition organized as a changing topology of dialogues, transforming itself in space through new internal relationships and different modes of occupation.

The selection of images for this visual essay was produced by Armin Linke in a dialogue with graphic designer Žiga Testen and *GAM*.

ARN_000579_13, Angelo Mangiarotti, Chiesa Nostra Signora della Misericordia, also known as Glass Church, Baranzate (MI), Italy, 2009

ReN_005770_7, Bank of Italy, Palazzo Koch, Chinese Room (Oriental Room),
temporary simultaneous interpretation booth, Rome, Italy, 2007

ReN_006251_24, Museo della Calcografia Nazionale, printing plates archive,
Rome, Italy, 2008

ReN_007205_23, Colonial fascist sculpture, with the Ethopian Lion of Judah, Ethnographic Museum, Addis Abeba, Ethiopia, 2012

Praxis Reports / 1

On Thought Exhibitions[1]
Bruno Latour

Über Gedanken-ausstellungen[1]
Bruno Latour

I am not an artist and I am not a curator. I became a curator because I was interested to begin to understand contemporary art, and it seemed to me that the only way to do field work in contemporary art was to work with artists and curators. Together with Peter Weibel, we have been developing the "thought exhibition"—an approach to exhibition making inspired by the concept of the thought experiment in science. The thought experiment in science is a very traditional way of understanding a situation where you don't have the actual experimental apparatus to do the experiment, by imagining the situation of the experiment and what results could be obtained. This is a very powerful way to understand the exhibition. I understand it as a genre, as a media, but I am also interested in what can be done with it, and the thought experiment has the potential to explore topics which cannot be approached in any realistic way.

I have explored three different topics through thought exhibitions, all done at the Zentrum für Kunst und Medien (ZKM) in Karlsruhe in collaboration with Peter Weibel—"Iconoclash" (2002), "Making Things Public" (2005), and "Reset Modernity!" (2016) and the forth one is in preparation for 2019. All exhibitions were addressing topics which cannot be experimented with directly, for example, iconoclastic gesture, politics (and an alternative understanding thereof), or modernity in the moment of ecological mutation, but it was possible to do a little thought experiment in an enclosed space that is an exhibition. The nice thing about an exhibition is that it is an experimental space, a space in which you do not control, naturally, how people will behave in it.

What I tried to do was to share the curatorship with different people. We co-curated in order to make the audience part of the quasi-experimental laboratory, following the logic of a thought experiment. Each exhibition was a product of a durational process and the work on each lasted two, sometimes even three years. The one which is being developed now for 2019 will again be two years of work. The first attempt with the thought exhibition was "Iconoclash," the exhibition we did at ZKM in 2002. The idea was that we wanted to realize in the space of the exhibition a strange phenomenon which I called "the suspension of the iconoclastic gesture."

The exhibition was organized to resemble a fair, so that people could move around the space freely, as it is not necessary to always control the movement. The fair was built in such a way that everyone coming into the show was confronted with the contradiction that one's icon is someone else's fetish, and vice versa. We simultaneously always hold completely different registers, so there is this constant uncertainty between images and the power of iconoclasm. That is why the exhibition was called "Iconoclash." Not iconoclasm, because iconoclasm is pursuing the iconoclastic gestures until the end, and iconoclash is about suspension. It would be impossible to perform this type of gesture in any other medium, because you need to build a space where you travel through and continuously experience this experiment.

The second exhibition, "Making Things Public," was very different, but again, it was a thought experiment in the form of an exhibition. Spatially, it was built like a fair. There, I was the only curator with Peter Weibel, and what we were doing was to ask people to work in pairs (composed of young artists and academics) and to show, through their work, that there are many ways of assembling political assemblies, beside the official one—the parliament. The idea was to travel again, using the space of the exhibition itself to multiply the experiment of the multiplicity of ways through which politics is actually achieved, even if sometimes it is not recognized as politics. The idea was to do a fair, where the official space of politics, the parliament and the government, would merge with a multiplicity of other assemblages, non-directly coded as political.

The third exhibition, "Reset Modernity!," was built as an experiment in the experiment of a thought exhibition. This time we tried to build a space which in itself was a great work of art, and to integrate in it the works of artists which we had chosen together with the co-curators. The whole space was treated as a singular experiment which we called "Reset Modernity!," which is a strange term. The idea of reset is not tabula rasa, not a revolution, nor a break. It is a procedure to reset your instruments, so they will become sensitive again to information that was lost before, a technical metaphor. Modernity is going into so many directions and there are so many parallel interpretations that there is no way now to register the sent signal or distinguish it from those which are not at all going into the direction of modernity. A large part of the distressing situation in which we find ourselves is a sort of a general uncertainty about the quality of our instruments registering the signals that we hear, and if we cannot get the signals, we can try to reset and see if we can get them again. Part of the experiment was to equip the visitors with a field book, including instructions that enabled them to precisely follow the curators' line of thought, and thus also a different way of thinking. We built six procedures of reset and asked visitors to go through six procedures of reset, with the idea being that at the end, you have reset modernity and you have become able to register a signal you have not been able to register before. What we did was to simultaneously create the experience, the works of art, the interpretation of the work of art, and the possibility of a counter-interpretation. And it worked. The exhibition is a very powerful way to build a description of space. ∎

1 This statement is based on the transcription of the lecture "On the Concept of Thought Exhibitions" by Bruno Latour held at the Museum of Contemporary Art in Zagreb, September 23, 2017 organized by Multimedia Institute/mi2, Zagreb.

Ich bin weder Künstler noch Kurator. Ich wurde zum Kurator, weil ich ein besseres Verständnis zeitgenössischer Kunst gewinnen wollte und mir das Arbeiten mit KünstlerInnen und KuratorInnen als die einzige Möglichkeit erschien, Feldarbeit auf dem Gebiet zu machen. Mit Peter Weibel entwickelte ich die „Gedankenausstellung", einen Zugang zum Ausstellungsmachen, der von der Idee des Gedankenexperiments inspiriert ist. In der Wissenschaft ist das Gedankenexperiment eine altgediente Möglichkeit etwas zu verstehen, für dessen tatsächliche experimentelle Überprüfung einem der Apparat fehlt. Stattdessen stellt man sich die Versuchsanordnung und die damit erzielbaren Ergebnisse im Geist vor. Dieses Verfahren ist auch sehr gut auf die Ausstellung anwendbar. Ich begreife es als ein Genre, als Medium, interessiere mich aber auch dafür, was man damit machen kann. Das Gedankenexperiment gestattet einem, Themen zu erkunden, die real nicht zugänglich sind.

Ich habe Gedankenausstellungen zu drei verschiedene Themen gemacht, allesamt in Zusammenarbeit mit Peter Weibel am Zentrum für Kunst und Medien (ZKM) in Karlsruhe: „Iconoclash" (2002), „Making Things Public" (2005) und „Reset Modernity!" (2016). Eine vierte, für 2019 geplante befindet sich in Vorbereitung. Alle drei Ausstellungen behandelten Themen, mit denen man nicht direkt experimentieren kann: die ikonoklastische Geste, Politik (bzw. ein alternatives Verständnis davon) sowie die Moderne im Augenblick ihrer ökologischen Mutation. Möglich war allerdings die Durchführung eines kleinen Gedankenexperiments in dem begrenzten Raum, den eine Ausstellung darstellt. Das Schöne an einer Ausstellung ist, dass es sich dabei um einen Erfahrungsraum handelt, einen Raum, in dem man natürlich nicht kontrolliert, wie sich die BesucherInnen darin verhalten.

Ich versuchte, die Kuratorenschaft auf verschiedene Leute aufzuteilen. Das Co-Kuratieren sollte das Publikum – gemäß der Logik des Gedankenexperiments – zu einem Teil einer Art Versuchsanordnung machen. Jede Ausstellung war das Ergebnis eines längerfristigen Prozesses, der sich über zwei, manchmal sogar drei Jahre erstreckte. Die Arbeit an der jetzt für 2019 entwickelten Ausstellung wird ebenfalls zwei Jahre in Anspruch nehmen. Der erste Versuch einer Gedankenausstellung war die

Ausstellung „Iconoclash" 2002. Was wir im Ausstellungsraum zu realisieren versuchten war ein eigentümliches Phänomen, das ich als „Aufhebung der ikonoklastischen Geste" bezeichnet habe. Die Ausstellung war als eine Art Messe organisiert, bei der sich die Leute frei im Raum bewegen konnten; schließlich ist es nicht immer nötig, die Bewegung durch den Raum zu kontrollieren. Die „Messe" war so gebaut, dass alle, die die Schau besuchten, mit dem Umstand konfrontiert wurden, dass des einen Bild des anderen Fetisch ist und umgekehrt. Wir haben es gleichzeitig mit vollkommen verschiedenen Registern zu tun, so dass eine ständige Ungewissheit zwischen Bildern und der Macht des Bildersturms herrscht. Darum hieß die Ausstellung auch „Iconoclash" und nicht Ikonoklasmus. Der Ikonoklasmus führt die ikonoklastische Geste nämlich bis zum Ende aus, wogegen ihr der Iconoclash Einhalt gebietet. Es wäre unmöglich, so etwas in einem anderen Medium umzusetzen, weil man dazu einen Raum benötigt, der durchmessen und in dem das Experiment kontinuierlich erlebt werden kann.

Die zweite Ausstellung „Making Things Public" war ganz anders geartet, aber auch bei ihr handelte es sich um ein Gedankenexperiment in Form einer Ausstellung. Räumlich war sie erneut als Messe aufgebaut. In diesem Fall war ich der einzige Kurator neben Peter Weibel, und wir baten verschiedene junge KünstlerInnen und AkademikerInnen paarweise zu arbeiten, um mit ihrer Arbeit zu zeigen, dass es mehrere Möglichkeiten gibt, politische Versammlungen zu bilden, nicht nur die eine offizielle: das Parlament. Die Idee war wieder die einer Bewegung, das Nutzen des Ausstellungsraums selbst, um das Experiment über die vielfältigen Weisen, wie Politik tatsächlich entsteht, noch einmal zu vervielfältigen, auch wenn diese Politik manchmal nicht als solche erkannt werden mag. Es ging darum, eine Messe zu veranstalten, in der sich der offizielle Raum der Politik – Parlament und Regierung – mit der Vielfalt anderer Gefüge verbinden sollte, die nicht direkt politisch codiert sind.

Die dritte Ausstellung „Reset Modernity!" war als Experiment im Experiment einer Gedankenausstellung angelegt. Diesmal ging es darum, einen Raum zu schaffen, der selbst ein großes Kunstwerk sein sollte, und in ihn die Arbeiten von KünstlerInnen zu

integrieren, die wir zusammen mit unseren Co-KuratorInnen ausgewählt hatten. Der gesamte Raum wurde als ein einziges Experiment behandelt, das wir „Reset Modernity!" nannten. Was eine paradoxe Bezeichnung ist, denn ein Reset ist ja keine tabula rasa, keine Revolution und kein Bruch. Es ist ein Verfahren zum Neujustieren der Instrumente, damit sie wieder empfindlich werden für Informationen, die sie nicht mehr zu empfangen vermochten – eine technische Metapher. Die Moderne bewegt sich in so viele Richtungen und es existieren so viele Interpretationen davon nebeneinander, dass es heute kaum noch möglich ist, das von ihr ausgehende Signal zu empfangen oder es von Signalen zu unterscheiden, die ganz und gar nicht in Richtung Moderne gehen. Die betrübliche Lage, in der wir uns befinden, ist großenteils einer allgemeinen Verunsicherung in Bezug auf die Qualität der Instrumente geschuldet, mit denen wir die Signale empfangen, die bei uns ankommen, und wenn wir sie nicht mehr ankommen, können wir die Instrumente neu zu justieren versuchen und schauen, ob wir sie dann wieder reinkriegen. Ein Teil des Experiments bestand darin, die BesucherInnen mit einem Feldbuch auszustatten, das u.a. Anleitungen enthielt, mit denen sie präzise den Gedankengängen der KuratorInnen und damit einer anderen Denkweise folgen konnten. Wir erfanden sechs Reset-Prozeduren und forderten die BesucherInnen auf, sie alle durchzuspielen, mit der Idee, dass sie am Ende ein Reset der Moderne durchgeführt hätten und wieder imstande wären, ein Signal zu empfangen, das sie nicht mehr empfangen konnten. Wir schufen etwas, das das Erlebnis, die Kunstwerke, die Interpretation des Gesamtwerks und die Möglichkeit einer Gegeninterpretation in einem war. Und es funktionierte. Die Ausstellung ist ein äußerst wirkungsvolles Mittel, eine Raumbeschreibung zu erstellen. ∎

Übersetzung: Wilfried Prantner

1 Dieses Statement beruht auf der Transkription eines vom Multimedia Institute/mi2 organisierten Vortrags im Museum of Contemporary Art in Zagreb mit dem Titel „On the Concept of Thought Exhibitions".

Exhibition as a Philosophical Problem

Anna-Sophie Springer | Etienne Turpin

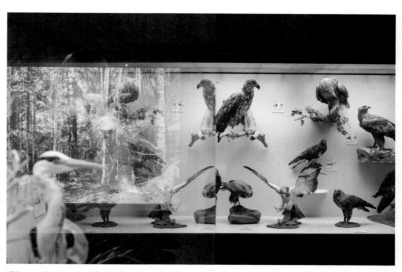

"Disappearing Legacies: The World as Forest" | „Verschwindende Vermächtnisse: Die Welt als Wald", curated by | kuratiert von Anna-Sophie Springer & Etienne Turpin, exhibition views | Ausstellungsansichten, Zoological Museum Hamburg | Zoologisches Museum Hamburg, 2017 © Michael Pfisterer/Reassembling the Natural

We have been very lucky to develop the *intercalations: paginated exhibition* series with a grant from the Schering Stiftung that allowed us to experiment with the book as a site for making exhibitions. Throughout the series of six—the last two are set for publication in Spring 2018—we accept the format of the codex while also attempting to experiment with adjacencies, rhythms, and relations among different regimes of knowledge that are normally in quite distant orbits. So, the exhibition mode is really about an ecology of attention that pulls and plys a theme but does not resolve into a linear narrative sequence. They are not chapters in an edited volume, but commissions, conversations, and provocations that can stand alone, but which, when read together, in any order, produce different, uncanny images. In the fourth volume, for example, we tried to do this with the forest; the forest is a vast topic that intersects any number of disciplines and fields, but we wanted to move through these as one moves in a forest. Not as a metaphor, but conceptually; not in an impressionistic way but to relay the affects of the forest in a way that is resonant and familiar, yet dis-located to the codex. These books have all taken years of research to be produced as we try to make a space for our various contributors and

interlocutors to say/do/make things that they wouldn't try in another space. In this sense, it is also an exhibition for disinhibiting friends and colleagues and collaborators. We are trying to conspire for ways to think and work otherwise, always with the conceptual and material horizon of the Anthropocene as a backdrop to these works.

When we were trying to describe our process with respect to more traditional exhibition making—that is, in an exhibition *space*, not through a book—Hammad Nasar's reference to an "exhibition-led" process of research seemed to bring into focus the way we were pursuing our work in that moment, and this is especially the case of projects like "Minor Ornithology" and "Reassembling the Natural."[1] For the latter, we have spent over four years working with dozens of collaborators, institutions, collections, funding agencies, and NGOs doing their own primary research, not to mention residencies, workshops, etc., so it is really an immersive process that the exhibition (or, in this case, five or more exhibitions) facilitate. So,

1 See Hammad Nasar in conversation with Anna-Sophie Springer and Etienne Turpin, "Intensive Geographies of the Archive," in *Fantasies of the Library*, Anna-Sophie Springer and Etienne Turpin, eds., 2nd ed. (Cambridge, 2016), pp. 32–48.

Die Ausstellung als philosophisches Problem

Anna-Sophie Springer | Etienne Turpin

Exhibitability and Performativity

Branislav Jakovljević

we believe the exhibition "leads" in our "exhibition-led inquiry" because during the process we play close, continual attention to how we can bring the insights and elements of the work, whether field research, ethnography, collections and archival research, or interviews and collaborations, into the space of the exhibition. Which is to say: toward a public or publics in the context of a spatial realization of research on a topic or theme. In the case of "Reassembling the Natural," we have been working on the meaning of natural history collections in the context of mass extinction and climate change (and, of course, the Anthropocene), so there is a tremendous range of sites and concerns; but, we are always thinking alongside the problem of presentation. How to present and disseminate this knowledge as a way of co-producing it? *Exhibition* is thus a philosophical problem that travels along with the thematic or conceptual research we do; what, when, and how to exhibit a given set of concerns or ways of working, of various epistemological trajectories or commitments, of intersecting or interfering versions of a given narrative? All of this provokes a persistent rhythm that drives and animates research; not that we only work through exhibition, of course we make books and workshops and lectures too. And, because of that, we are able to be quite precise about the composition of elements of a given work, although there is never an *a priori* formula for which aspect of research goes into which format of dissemination. We approach exhibitions, like any other philosophical problem, as a way of interfacing with what we don't yet know how to present, but that we nevertheless feel requires a form for exposition. ∎

Wir hatten das große Glück, mit einem Stipendium der Schering Stiftung die Reihe *intercalations: paginated exhibition* zu entwickeln, die es uns ermöglichte, weiter mit dem Buchformat als Ausstellungsort zu experimentieren. In der gesamten sechsteiligen Reihe – die Veröffentlichung der letzten beiden Bände ist im Frühjahr 2018 geplant – akzeptieren wir das Format des gebundenen Buches, während wir gleichzeitig versuchen, mit Nachbarschaften, Rhythmen und Beziehungen zwischen verschiedenen Wissensregimen zu experimentieren, die sich normalerweise in weit entfernten Umlaufbahnen befinden. In diesem Ausstellungsmodus geht es also wirklich um eine Aufmerksamkeitsökologie, die ein Thema aufgreift und verknüpft, sich aber nicht in eine lineare narrative Abfolge auflöst. Es handelt sich nicht um ein Kapitel in einem Sammelband, sondern um Auftragsarbeiten, Gespräche und Provokationen, die allein stehen können, die aber, wenn sie zusammen gelesen werden, in beliebiger Reihenfolge, unterschiedliche, unheimliche Bilder ergeben. Im vierten Band haben wir zum Beispiel versucht, dies mit dem Wald zu tun. Der Wald ist ein sehr weiter Themenbereich, in dem sich unzählige Wissenschaftszweige und Fachgebiete kreuzen und verästeln, doch wir wollten uns durch diese wie durch einen Wald bewegen. Nicht als Metapher, sondern konzeptionell; nicht impressionistisch, sondern um die Auswirkungen des Waldes in einer Art und Weise zu vermitteln, die ihren Nachhall findet und vertraut ist, doch verschoben auf die Buchform. Alle diese Bücher haben für ihre Produktion jahrelange Recherche und Auseinandersetzung in Anspruch genommen und wir haben versucht, einen Raum für unsere diversen Mitwirkenden und Gesprächspartner zu schaffen, um Dinge zu sagen/machen/schaffen, die sie in einem anderen Raum nicht ausprobieren würden. In diesem Sinne ist dies auch eine Ausstellung, die unseren Freunden, Kollegen und Kooperationspartnern andere Einstellungen gewähren soll. Wir versuchen, uns auf andere Denk- und Arbeitsweisen zu verständigen, immer mit dem konzeptuellen und materiellen Horizont des Anthropozäns als Hintergrund für diese Arbeiten.

Als wir versuchten, unseren Prozess in Bezug auf traditionelle Ausstellungsmacherei zu beschreiben – das heißt, in einem Ausstellungs*raum*, nicht durch ein Buch –, schien Hammad Nasars Bezugnahme auf einen „ausstellungsgesteuerten" Forschungsprozess die Art und Weise, wie wir unsere Arbeit in diesem Moment verfolgten, in den Fokus zu rücken, und dies gilt insbesondere für Projekte wie „Minor Ornithology" und „Reassembling the Natural".[1] Für letzteres haben wir über vier Jahre lang mit Dutzenden Mitwirkenden, Institutionen, Sammlungen, Geldgebern und NGOs zusam-

mengearbeitet, die ihre eigene Primärforschung betreiben, ganz zu schweigen von Residence-Stipendien, Workshops usw., so dass es wirklich ein immersiver Prozess ist, den die Ausstellung (oder in diesem Fall fünf oder mehr Ausstellungen) ermöglicht. Wir glauben also, dass die Ausstellung in unserer „ausstellungsgesteuerten Forschung" „steuert", weil wir im Verlauf des Prozesses immer wieder genau darauf achten, wie wir die Erkenntnisse und Elemente der Arbeit, ob Feldforschung, Ethnografie, Sammlungen und Archivforschung oder Interviews und Kollaborationen, in den Ausstellungsraum bringen können. Das heißt: gegenüber einer Öffentlichkeit oder Öffentlichkeiten im Rahmen einer räumlichen Umsetzung der Forschung zu einem Thema oder Themenbereich. Im Fall von „Reassembling the Natural" haben wir uns mit der Bedeutung von naturkundlichen Sammlungen im Kontext von Massenausrottung und Klimawandel (und natürlich dem Anthropozän) beschäftigt, so dass es eine enorme Vielfalt an Orten, Anliegen und Mitwirkenden gibt; doch geht unser Denken stets Hand in Hand mit dem Problem der Präsentation. Wie kann man dieses Wissen als eine Möglichkeit, es gemeinsam zu produzieren, präsentieren und verbreiten? Die *Ausstellung* ist somit ein philosophisches Problem, das mit der thematischen oder konzeptuellen Forschung, die wir betreiben, einhergeht: Mit welchem Inhalt, wann und wie lässt sich eine bestimmte Gruppe von Anliegen oder Arbeitsweisen, von verschiedenen erkenntnistheoretischen Bahnen oder Verpflichtungen, von sich kreuzenden oder sich gegenseitig störenden Versionen einer gegebenen Erzählung ausstellen? All dies löst einen beständigen Rhythmus aus, der die Forschung antreibt und belebt, nicht nur durch die Ausstellung, sondern natürlich auch durch Bücher, Workshops und Vorträge. Und deshalb können wir die Zusammensetzung der Elemente eines Werkes ziemlich genau bestimmen, obwohl es nie eine *A-priori*-Formel dafür gibt, welcher Forschungsaspekt in welches Verbreitungsformat einfließt. Wir nähern uns Ausstellungen, wie jedem anderen philosophischen Problem, als eine Möglichkeit, mit dem zu interagieren, von dem wir noch nicht wissen, wie wir es präsentieren sollen, wir aber dennoch das Gefühl haben, dass es eine Form der Ausstellung erfordert. ∎

Übersetzung: Otmar Lichtenwörther

1 Siehe Hammad Nasar im Gespräch mit Springer: Anna-Sophie/Turpin, Etienne: „Intensive Geographies of the Archive", in: ders./dies. (Hg.): *Fantasies of the Library*, Cambridge 2016, 32–48.

Since the beginning of the new millennium, live performance became a standard feature of gallery and museum exhibits. What started in the late 1960s as a gesture against the commodification of art—now proverbial *Six Years*[1]—half a century later became an integral part in the mechanism of art commerce. After it has been relegated to the margins of art industry for decades, performance had finally found its place in it, thanks to the logic of scarcity that drives this industry: while aesthetic objects are susceptible to endless replication and dissemination, curators and art dealers find that the new mark of uniqueness is precisely in that form of art which, due to its ephemeral nature, has only one "original." In the process, performance had to adapt to the rules of the exhibition: from an indeterminate and open event, it became a durational object limited in space and time. The political economy of museum display transformed the very nature of performance and forced it to accept that which it rejected in the first place: the text. It can be a text in the strict sense of the word: a set of instructions or a description; or a Text in Roland Barthes's sense: any structure-imparting set of traces, such as photographs, videos, or material residues. However, one form of text (written or even spoken) towers over all other: the contract between an individual artist and an art institution. This agreement or, to put it colloquially, the "deal," gives the institution an exclusive right to exhibit this copyrighted performance. In other words, it makes the performance exhibitable.

The museum and the market are based on something we can call "exhibitability," which is a correlate of collectability. Exhibitability, like collectability, demands of the work of art to be tangible, durable, and transportable. Each of these qualities pins the artwork in time and place and gives it the status of a commodity. Even on a grammatical level, the notion of exhibiting has a potential to release performance from these forces of aesthetization. In that sense, exhibiting can include all of those things that defy or exceed the discrete and bounded nature of an artwork the museum and the market require. This could apply to a range of phenomena that can have material as well as ephemeral form. An object too big for a museum or gallery display is perpetually on display: it has no beginning and no end; its exhibiting no "opening" or "closing." This also applies to those things that are only marginally material and durable: in entering a frame of visibility, a political process is necessarily exhibiting a problem; once it is on exhibit, it no longer belongs to politics, but to history. We can say that, while the *exhibition* belongs to the world of markets and business deals, *exhibiting* engages problem-solving performatively. ∎

1 *Six Years* relates to the name of the influental book by Lucy Lippard, *Six Years: The Dematerialization of the Art Object from 1966 to 1972* (New York, 1973) which documents six years of exhibitions and discussions that challenged the materiality of art and established what is now known as conceptual art.

Ausstellbarkeit und Performativität

Branislav Jakovljević

"If – A Speculative Proposal for an Exhibition that Might Never Happen"

Kate Strain

Seit Beginn des neuen Jahrtausends sind Live-Performances ein fester Bestandteil von Ausstellungen in Galerien und Museen. Was in den späten 1960er Jahren seinen Ausgang als gegen die Kommodifizierung der Kunst gerichtete Geste nahm – aus heutiger Sicht in den sprichwörtlichen „Six Years"[1] dokumentiert –, ist ein halbes Jahrhundert später zu einem festen Bestandteil im Mechanismus des Kunsthandels geworden. Nach ihrer jahrzehntelangen Verbannung in die Randbereiche der Kunstbranche hat die Performance dank der Knappheitslogik, die diese Branche antreibt, letztendlich ihren Platz in ihr gefunden: während ästhetische Objekte für unendliche Vervielfältigung und Verbreitung anfällig sind, finden Kuratoren und Kunsthändler, dass die neue Referenz für Einzigartigkeit gerade in jener Kunstform zu finden ist, die aufgrund ihres flüchtigen Wesens nur ein „Original" kennt. Dabei musste sich die Performance an die Regeln der Ausstellung anpassen: Aus einem unbestimmten und offenen Ereignis wurde ein zeitlich und räumlich begrenztes Dauerobjekt. Die politische Ökonomie der musealen Ausstellung hat das Wesen der Performance verändert und gezwungen, das zu akzeptieren, was sie von vornherein abgelehnt hatte: den Text. Dies kann ein Text im engeren Sinne des Wortes sein: eine Reihe von Anweisungen oder eine Beschreibung; oder ein Text im Sinne von Roland Barthes: jedwede Zusammenstellung von Spuren, wie zum Beispiel Fotografien, Videos oder Materialrückstände. Doch eine (schriftliche oder gar mündliche) Textsorte überragt alle anderen: der Vertrag zwischen dem/der einzelnen Kunstschaffenden und einer Kunstinstitution. Diese Vereinbarung oder, um es umgangssprachlich auszudrücken, dieser „Deal", gibt der Institution das Exklusivrecht, diese urheberrechtlich geschützte Performance auszustellen. Das heißt in anderen Worten, dass sie die Performance ausstellbar macht.

Museum wie Markt beruhen auf etwas, das wir „Ausstellbarkeit" nennen können, was ein Korrelat für Sammelbarkeit ist. Ausstellbarkeit wie Sammelbarkeit erfordern vom Kunstwerk Greifbarkeit, Dauerhaftigkeit und Transportfähigkeit. Jede dieser Eigenschaften fixiert das Kunstwerk in Raum und Zeit und verleiht ihm Warenstatus. Selbst auf grammatikalischer Ebene hat der Begriff des Ausstellens das Potenzial, die Performance von diesen Kräften der Ästhetisierung zu befreien. In diesem Sinne kann das Ausstellen all das umfassen, was der von Museum und Markt verlangten diskreten und begrenzten Natur eines Kunstwerkes widerspricht oder über sie hinausgeht. Dies könnte auf eine Reihe von Phänomenen zutreffen, die sowohl materielle als auch ephemere Formen annehmen können. Ein Objekt, das zu groß für eine Museums- oder Galerie-

ausstellung ist, wird ständig ausgestellt: es hat keinen Anfang und kein Ende, sein Ausstellen keine „Eröffnung" oder „Abschlussveranstaltung". Dies gilt auch für Dinge, die nur unwesentlich materiell und dauerhaft sind: Wenn ein politischer Prozess in einen Rahmen der Sichtbarkeit eintritt, stellt er notwendigerweise ein Problem aus; wenn er einmal ausgestellt ist, ist er nicht mehr Politik, sondern Geschichte. Wir können sagen, dass die *Ausstellung* der Welt der Märkte und Geschäftsabschlüsse angehört, wogegen sich das *Ausstellen* performativ an Problemlösungen beteiligt. ∎

Übersetzung: Otmar Lichtenwörther

1 Die „Six Years" verweisen auf Lucy Lippards einflussreiches Buch *Six Years: The Dematerialization of the Art Object from 1966 to 1972* (New York, 1973) das sechs Jahre Ausstellungen und Debatten dokumentiert, die die Materialität der Kunst infrage stellten und das etablierten, was heute als Konzeptkunst bezeichnet wird.

Soon after I began working at Grazer Kunstverein, at the beginning of 2017, we removed all of our non-load-bearing walls in an attempt to "open up" the building and let light in. The alteration exposed a pathway of steam radiators and beautiful windows along the entire West-facing stretch of our 500 square meter building. This incidental uncovering put me in mind of Michael Asher's legendary Kunsthalle Bern project – wherein he relocated the building's entire heating system to one central room. Asher was an American conceptual artist of seminal importance. He died in 2012 having never had the opportunity to present his work in Graz, or see our newly uncovered windows. His evasive legacy has influenced and inspired artists across time and space, both during his life and after his death. I wondered what kind of intervention Asher might propose for an institution like Grazer Kunstverein. Thinking about this seemed to provide a framework within which to develop a potential collaboration. My thoughts turned immediately to Shelly Bancroft and Peter Nesbett, AKA Triple Candie, a US based duo of art historians who traffic in evasive legacies. I reached out:

Are you saying you'd like us to curate a Michael Asher exhibition? ¶ Yes, what do you think? ¶ *Asher's work poses significant challenges for curators.* ¶ I know. ¶ *It was situational and temporary. You can't recreate it.* ¶ Yes but left untouched … ¶ *… it risks becoming defined exclusively by its documentation.* ¶ So how might we, as curators, animate the legacy? ¶ *Hmmm. Asher's work had philosophical implications, but not in an absolute sense. He embraced contingency, he privileged the fleeting over the permanent or timeless, and he pit the flicker of perception over the steady gaze*

of knowledge. In that sense, Asher picked at and began to unravel the modernist project, at times literally dismantling the white cube, removing walls, stripping away paint, etc. ¶ Exactly! So how might you propose addressing such a practice in the context of exhibition making? ¶ *We must imagine a speculative present that embodies such an ethos.* ¶ What if …? ¶ *Yes, what if Asher were alive? Let's realize your desire to work with him.* ¶ You will channel him? ¶ *As best we can. We'll propose ideas based on our research into his methodologies and approach to art making.* ¶ But let's realize four of the proposals, sequentially, to underscore the research-driven nature of the project. ¶ *What about the proposals that you reject because they exceed institutional limits, as Asher sometimes did?* ¶ We will exhibit those two to make the entire investigation public.

The idea of speculatively folding Michael Asher's legacy into our artistic programme is designed to actively investigate the methodologies of this artist, by performatively working through them in a series of propositions and interventions presented as exhibitions. Throughout 2018 Triple Candie will undertake an in-depth exploration of Michael Asher's methodological approach to art-making, his commitment to institutional critique as a practice, his widespread legacy as an artist, a teacher, and an agent of revelation, and his influence on contemporary art as we know it today. ∎

Grazer Kunstverein, 2017 © Christine Winkler, Courtesy Grazer Kunstverein | Mit freundlicher Genehmigung des Grazer Kunstvereins

Wenn – ein spekulativer Vorschlag für eine Ausstellung, die vielleicht niemals stattfinden wird

Kate Strain

Kurz nach Beginn meiner Tätigkeit im Grazer Kunstverein Anfang 2017 haben wir alle unsere nichttragenden Wände entfernt, um das Gebäude zu öffnen und das Licht hereinzulassen. Der Umbau legte einen Durchgang mit Heizkörpern und schönen Fenstern entlang der Westseite unseres 500 Quadratmeter großen Gebäudes frei. Diese zufällige Freilegung erinnerte mich an Michael Ashers legendäres Kunsthalle Bern-Projekt, bei dem er die gesamte Heizungsanlage des Gebäudes in einen einzigen zentralen Raum verlegte. Asher war ein richtungsweisender amerikanischer Konzeptkünstler. Er verstarb 2012 und hatte nie die Gelegenheit, seine Arbeiten in Graz zu präsentieren oder unsere neu entdeckten Fenster zu sehen. Sein an nichts so einfach festmachbarer Nachlass hat Kunstschaffende zeit- und raumübergreifend beeinflusst und inspiriert, sowohl zu seinen Lebzeiten als auch nach seinem Tod. Ich fragte mich, welche Art von Intervention Asher für eine Institution wie den Grazer Kunstverein vorschlagen könnte. Das Nachdenken darüber schien einen Rahmen für die Entwicklung einer möglichen Zusammenarbeit zu bieten. Ich dachte dabei sofort an Shelly Bancroft und Peter Nesbett, AKA Triple Candy, zwei in den USA lebende Kunsthistoriker und „Galeristen" solch evasiver Nachlässe. Und ich habe sie darauf angesprochen:

Wollen Sie damit sagen, dass wir eine Michael-Asher-Ausstellung kuratieren sollen? ¶ Ja, was halten Sie davon? ¶ Ashers Arbeit stellt Kuratoren vor große Herausforderungen. ¶ Ich weiß. ¶ Sie war situativ und temporär. Sie lässt sich nicht nachbilden. ¶ Ja, aber unberührt gelassen … ¶ … besteht die Gefahr, dass sie ausschließlich durch ihre Dokumentation definiert wird. ¶ Wie könnten wir also als Kuratoren dem Nachlass Leben einhauchen? ¶ Hmmm. Ashers Werk hatte philosophische Implikationen, aber nicht im absoluten Sinne. Er griff Zufälliges bereitwillig auf, er gab dem Flüchtigen den Vorzug gegenüber dem Dauerhaften oder Zeitlosen, und er stellte das Flimmern der Wahrnehmung über den steten Blick des Wissens. In diesem Sinne stocherte Asher im Projekt der Moderne herum und begann es zu entwirren; manchmal, indem er buchstäblich den White Cube niederriss, Wände demontierte, Wandfarbe entfernte usw. ¶ Genau! Welchen Vorschlag hätten Sie also dafür, wie man eine solche Praxis im Ausstellungskontext angehen könnte? ¶ Wir müssen uns eine spekulative Gegenwart vorstellen, die ein solches Ethos verkörpert. ¶ Was, wenn …? ¶ Ja, was, wenn Asher noch am Leben wäre? Lassen Sie uns Ihren Wunsch verwirklichen, mit ihm zu arbeiten. ¶ Werden Sie seinen Geist heraufbeschwören? ¶ So gut wir können. Wir werden Ideen vorschlagen, die auf unseren Forschungen über seine Methoden und seine Herangehensweise ans Kunstschaffen

beruhen. ¶ Aber lassen Sie uns vier der Vorschläge nacheinander realisieren, um den forschungsorientierten Charakter des Projekts zu unterstreichen. ¶ Was ist mit den Vorschlägen, die Sie ablehnen, weil sie die institutionellen Grenzen überschreiten, wie es Asher manchmal getan hat? ¶ Wir werden diese beiden ausstellen, um die gesamte Forschungsarbeit öffentlich zu machen.

Die Idee, Michael Ashers Nachlass spekulativ in unser künstlerisches Programm einzufügen, zielt darauf ab, die Methoden dieses Künstlers aktiv zu erforschen, indem man sie in einer Reihe von Vorschlägen und Interventionen, die als Ausstellungen präsentiert werden, performativ durcharbeitet. Im Laufe des Jahres 2018 werden Triple Candie die methodische Herangehensweise von Michael Asher ans Kunstschaffen, sein Engagement für Institutionskritik als Praxis, sein weitverbreitetes Vermächtnis als Künstler, Lehrer und Aufdecker sowie seinen Einfluss auf die zeitgenössische Kunst, wie wir sie heute kennen, eingehend untersuchen. ∎

Übersetzung: Otmar Lichtenwörther

Exhibiting as a Displaycing Practice, or Curatorial Politics

Doreen Mende

As a response to this issue's concern with "Exhibiting Matters" as a proposal for calling for its "trans-FORM-ation" and politically radical "FORM-ulation" as Griselda Pollock discussed with students last year,[1] I would like to propose some considerations on the entanglement of research processes with the exhibitionary complex that reason as to argue for a *non-representational* research as constitutive for contemporary curatorial politics. Six possible points of entry:

First. Non-representational research operates as a network of practices with lived experience, multi-perspective narrations, trans- or postdisciplinary labor as well as scientific implications. It contributes profoundly to curatorial politics that itself is a hybrid of various fields with the purpose to inhabit, process, and facilitate the practices of knowledge in a migratory world. The question of spatial practices is critical in particular for curatorial politics because we are concerned with making something public. This is an inherently political question, and thus, also the exhibition is an inherently political project. It is possible, therefore, to ask: What is a geopolitical or geo-spatial reading of an exhibition? Language is one possible terrain to map out the network of practices of knowledge: The non-representational constitutes a condition where research cannot do differently than to engage in the polyphony of knowledges as if it was the street. The term "struggle"—which I would like to take here as a fertile condition to remind us to be clear about our particular cause for independence in the expanded fields of arts and spatial practices—translates into "lutte" in French, "Kampf" in German, and "jihad" in Arabic. The condition of "struggle" is both disquieting and collectivizing, ready

Film Still from | aus Harun Farocki's "Before Your Eyes: Vietnam," 1982, 116 min

to galvanize knowledge from below the possession of the state. However, we have to repurpose existing vocabularies of "struggle" in a time when neo-fascists in Europe such as The Identitarian fight for reinstituting localism by the violent means of cultural homogenization while globally de-centralized movements such as Daesh operate a capitalist fundamentalism through the means of algorithmic infrastructures that turns religion

into an avatar to spread the call for "jihad" across the globe by contemporary media practices. Returning, thus, to "struggle" here for the question of "exhibiting matters", it seems fertile to begin the work of repoliticization of our vocabularies and tools for making exhibitions by crossing languages and fields towards the acknowledgment of the hybrid, not as a mish-mash but as an impure and webbed constellation in which "struggle" remains an active agent in a network of practices that refuse to be represented as a whole. There are many political urgencies for exhibiting today. However, what cause of independence are we committed to: Against what? With whom? *Where?*

Second. "It should be possible to empathize in such a way that it produces the effects of alienation."[2]

Third. In the migratory world that we live in today, it becomes difficult to inhabit and operate the "privilege of partial perspective" as Donna Haraway revolutionarily and helpfully proposed in 1988 as a feminist approach to the question of science.[3] There are two points that make today partiality difficult: Point one, migration—because of war violence, work, and climate—is a political condition for the majority of the world population. One can have a very precise elaboration of one's own embodied partial perspective, which is critical of course, but not enough as Haraway already mentioned (but did not elaborate further). Let's not give up on the problematization of the situated knowledge through the "partial perspective" though, because it necessitates from us today to rethink the politics of location in a migratory world of highly ramified quality (as if it was a computer game). This brings me to point two: Partiality is deranged and distorted under seemingly irreconcilable conditions of being literally "plugged-in" into globalizing channels and planetary processes, where we might not understand the language spoken at the Savar textile factory in Bangladesh, at Foxconn in Shenzhen, or the Agbogbloshie site in Accra i.e., when exploitation, extraction, and slavery is happening just right now while we are typing, downloading, or reading on a 21st century electronic device, full of rare earth material. When will the workers in the factories have access to our messaging

1 Griselda Pollock, "From the Virtual Feminist Museum to the Analysis of Biennale Culture: Curatorial Challenges and the Politics of Critical, Thinking Reading and Making Art," in *Thinking Under Turbulence. Geneva Colloquium*, ed. CCC Research Program, HEAD Genève and Motto Books (Berlin, 2017), p. 133.

2 Harun Farocki, "Einfühlung (Empathy)," trans. Michael Turnbull, in *100 Jahre Hebbel Theater. Angewandtes Theaterlexikon nach Gustav Freytag*, ed. Hebbel am Ufer (Berlin, 2008), pp. 21–22.

3 Donna Haraway, "Situated Knowledges: The Science Question in Feminism and the Privilege of PartialPerspective," in *Feminist Studies* 14, 3 (1988), pp. 575–599.

Vom Ausstellen, Verstellen und Einstellen, oder Kuratorische Politiken[1]

Doreen Mende

Film Still from | aus Harun Farocki's "Before Your Eyes: Vietnam," 1982, 116 min

...pps to speak up against the global class society? Recall the worker of Bravo Tekstil in Istanbul who sewed the message "I made this item you are going to buy, but I didn't get paid for it" into the clothes of a Spanish retailer selling in Berlin, Geneva, Graz …

Fourth. The question of geopolitical entanglements in processes of making things public, or curatorial politics, are not new. Global processes are inscribed in the biographies of European art institutions as well as in the architectures of art academies since their proto-economic forms depart from colonial rule. Perhaps, what we need today is not the exposure of the making of the exhibition as a form of "partial perspective" but the exposure of entanglements, ramifications, and relations between time-zones, languages, and geographies. Learning from Anna and Robert who discuss the classes of labor, the looting of knowledge and the limits of learning in Harun Farocki's *Before Your Eyes – Vietnam* (1981):

Robert: "I remember a book that defines the characteristics of an agricultural worker in difference to an industrial worker."

Anna: "The American method: the looting of hundreds of books for thousands of ideas attacking the object, the battle of material, the carpet bombing."

Film Still from | aus Harun Farocki's "Before Your Eyes: Vietnam," 1982, 116 min

Robert: "The Vietnamese method: We ought to read a short text again and again, to get along with a little amount of words."

Anna: "No, that does not work. It is not about either to read many books or only one page. It is about the entanglement of one with the other."

Fifth. We might well already understand the complexity, including the troubling degrees of violence and the possibilities of misunderstanding that come with the act of making public, i.e., the exhibition. I would like to connect such complexity with a practice that cross-reads the double activity of "to display"/"to displace" to deem the exhibition a displaycing practice. The neologism stemming from these two verbs is certainly visible—a kind of stumbling block in the routine of linguistic cognition—but not necessarily audible. In such a way, displaycing

Film Still from | aus Harun Farocki's "Before Your Eyes: Vietnam," 1982, 116 min

offers us a way to articulate the entanglement of a process and a manifestation at once that carries both the temporality of an irreducible displacement through the effort of a network of practices, as well as the particular display-time as part of the exhibiting moment. Such an entanglement suggests the conceptualization of *space* (e.g., exhibition space) as *spatiality* through performance, action, and practice: the term operates as a concept to give shelter for the network of practices as non-representational research that displaces places while remaining aware, entangled, and inevitably attached to the power of display. Thus, *spatiality* is a concept that links the spatial and political anew. Such a double gesture within the work of displacement projects its consequences back onto the one who displays. It necessitates a radical reinvention of one's own position in the exhibitionary complex by learning the "planetary subject"[4] as Gayatri Chakravorty Spivak proposed with her request of the planet to overwrite the globe: a subject that is plugged into global channels as well as planetary ecologies through a network of practices rehearsing the making of knowledge that potentially embraces, endangers, alienates and transFORMs the contemporary world.

Sixth. Much remains to be undone. Much remains to be unlearned. Much remains to emerge. ∎

4 Gayatri Chakravorty Spivak, *Death of a Discipline* (New York, 2003), pp. 72–73.

"Exhibiting Matters" – zum Thema dieser Ausgabe passend und als Aufruf zur „TransFORMation" und politisch radikalen „FORMulierung", wie dies schon Griselda Pollock im vergangenen Jahr in einem Gastseminar diskutierte,[2] möchte ich einige Überlegungen zu den Verflechtungen zwischen Forschungsprozessen und dem Ausstellungskomplex zur Sprache bringen, die das Eintreten für eine *nicht-repräsentationale Forschung* als wesentliche Grundlage für zeitgenössische Politiken des Kuratorischen begründen. Sechs mögliche Zugänge in narrativer Folge:

Erstens. Nicht-repräsentationale Forschung basiert auf einem Netzwerk aus gelebter Erfahrung, multiperspektivischer Narration, trans- oder postdisziplinärer Arbeit und wissenschaftlichem Diskussionsbedarf. Sie bildet die Grundlage für eine Politik des Kuratorischen, die sich selbst als ein aus einer Vielzahl an Disziplinen bestehendes Hybrid präsentiert, mit dem Ziel, diese Form von Forschung als ein Netzwerk aus Wissenspraktiken in einer von Migration geprägten Welt zu verinnerlichen, zu verarbeiten und zu artikulieren. Besonders für die Politik des Kuratorischen ist die Frage, wie mit Raum umzugehen wäre, von immenser Bedeutung, geht es doch darum, Dinge öffentlich zu machen. Da es sich beim Öffentlichmachen um ein immanent politisches Thema handelt, ist folglich auch das Ausstellen ein zutiefst politisches Unterfangen. Die Frage muss daher lauten: Was ist die geopolitische und räumlich-geografische Lesart einer Ausstellung? Ein mögliches Werkzeug, um das Netzwerk der Wissenspraktiken zu erfassen, ist die Sprache: Das Nicht-Repräsentationale stellt einen Zustand dar, in dem der Forschung nichts Anderes bleibt, als sich auf die Nichtübersetzbarkeit einer Polyphonie des Wissens einzulassen. Als passendes Beispiel, um den Grund für die Unabhängigkeit des erweiterten Feldes der Kunst und der räumlichen Praktiken in Erinnerung zu rufen, möchte ich hier den Begriff „Kampf" – auf Französisch „lutte", auf Englisch „struggle" und auf Arabischen „Dschihad" – heranziehen. Der Zustand des „Kampfes" ist sowohl beunruhigend als auch kollektivierend und dazu angetan, Wissen unterhalb der staatlichen Ebene zu aktivieren. Die Bedeutung des Wortes „Kampf" ist jedenfalls nicht zu definieren in Zeiten, in denen einerseits Neofaschisten in Europa, wie die sogenannten *Identitären*, sich vehement für einen neuen Lokalpatriotismus durch kulturelle Homogenisierung stark machen, während dezentralisierte Bewegungen wie der sogenannte *IS* weltweit mittels algorithmischen Infrastrukturen einen kapitalistischen Fundamentalismus betreiben, der sich der Religion wie eines Avatars bedient, um den Ruf nach dem „Dschihad" unter Nutzung digitaler Medien in die ganze Welt zu tragen. Wenn wir nun

zu dem Begriff „Kampf" im Zusammenhang mit „Exhibiting Matters" zurückkehren, erscheint es sinnvoll, die Repolitisierung der uns für das Ausstellungsmachen zur Verfügung stehenden Worte und Werkzeuge mit einer Konstellation von Sprachen und Bereichen zu beginnen, die auf die Anerkennung des Hybriden abzielt – nicht im Sinne eines Sammelsuriums, sondern geprägt von Differenz und Vernetzung. Diese Konstellation, in der der „Kampf" aktiver Bestandteil in einem Netzwerk von Praktiken bleibt, verweigert sich der Darstellung als einheitliches Ganzes oder basiert auf einem „common sense". Die politische Dringlichkeit, etwas öffentlich zu machen bzw. auszustellen, präsentiert sich heute auf vielfache und vor allem widersprüchliche Weise. Es stellt sich die Frage, welchem Prinzip der Unabhängigkeit wir verpflichtet sind: Wer oder was ist der erklärte Feind? Mit wem erkämpfen wir unsere Unabhängigkeitserklärung? Vor allem aber: *Wo* wäre die Unabhängigkeit zu artikulieren bzw. veröffentlichen?

Zweitens. „Es müsste gelingen sich in einer Weise einzufühlen, dass es den Effekt einer Verfremdung macht."[3]

Drittens. In der von Migrationstechnologien und -methoden geprägten Welt, in der wir heute leben, wird es schwierig, den von Donna Haraway formulierten feministischen Aufruf aus dem Jahr 1988 zum „situierten Wissen" und dem „Privileg einer partialen Perspektive" aufrechtzuerhalten.[4] Folgende Punkte problematisieren den Anspruch für Situiertheit als eine privilegierte Figur: Denken wir an die äußerst verzweigte geopolitische Räumlichkeit von Migration, die aufgrund von Kriegen, Gewalt, Arbeit und Klima für den Großteil der Weltbevölkerung zu einem politischen Zustand geworden ist. Nicht nur dauert es Tage, um von Mogadischu oder Bangladesh nach Europa zu kommen, wie es Bouchra Khalili's *Mapping Project* (2008–11) eindrücklich darstellt, sondern die weibliche Stimme in „Mapping #4" berichtet auf Italienisch über zahlreiche Orte, die sie durchkreuzte und durchkreuzen möchte, um in Norwegen oder Großbritannien anzukommen. Mit anderen Worten, aus der

1 Der Titel im englischen Originalmanuskript ist „Exhibiting as a Displaycing Practice, or, Curatorial Politics" lässt sich nicht wortwörtlich ins Deutsche übersetzen. Siehe Ausführung im Text.

2 Pollock, Griselda: „From the Virtual Feminist Museum to the Analysis of Biennale Culture. Curatorial Challenges and the Politics of Critical Thinking, Reading and Making Art", in: *Thinking under Turbulence. Geneva Colloquium*, hg. von CCC Research Program, HEAD Genève, Pully/Berlin 2017, 133.

3 Farocki, Harun: „Einfühlung (Empathy)", in: *100 Jahre Hebbel Theater. Angewandtes Theaterlexikon nach Gustav Freytag*, hg. von Hebbel am Ufer, Berlin 2008, 21–22.

4 Donna Haraway, „Situated Knowledges: The Science Question in Feminism and the Privilege of Partial Perspective", in: *Feminist Studies*, 14, 3 (1988), 575–599.

Situiertheit einer klar lokalisierbaren Position zu sprechen, die einhergeht mit dem Anspruch einer verortbaren Kultur des Wissens, als gäbe es eine permanente Adresse, ist entweder ein Privileg derer, deren Position nicht bedroht ist oder derer, die zurückbleiben müssen, wenn weder Mittel noch Möglichkeiten zur Verfügung stehen. Die eigene partiale Perspektive allein kann, wie Haraway bereits bemerkte, nicht genügen, sondern ruft nach einem Netz von Verbindungen („web of connections"). Natürlich dürfen wir nicht aufhören, uns mit dem emanzipierenden Potenzial des situierten Wissens mittels der „partialen Perspektive" auseinanderzusetzen. Was von uns jedoch heute mehr denn je gefordert ist, ist die Frage nach der Architektur des Standorts, der sich in einer stark verzweigten Welt in permanenter Bewegung oder an mehreren Orten gleichzeitig befindet. In welcher Weise könnte das Folgen haben für die räumliche Konzeptualisierung des Ausstellungsraums? Ein weiteres Beispiel dafür sind digitale Prozesse, die in der Lage sind, uns an mehreren Standorten gleichzeitig zu verorten (denken wir, beispielsweise, an den Standort des sprechenden Körpers am Computer-Bildschirm im Verhältnis zum Standort der Geolokation des Internet-Providers in kilometerweiter Entfernung im Verhältnis zum Standort der in Echtzeit übertragenen Stimme auf dem Computerbildschirm auf einem anderen Kontinent). Raum ist als verzweigte Örtlichkeit zu verstehen, als befänden wir uns in der Layer-Architektur eines Computerspiels. Das ist alles andere als einfach zu begreifen und bringt mich zu einem weiteren Punkt: Die partiale Perspektive wird durch das Zusammentreffen verschiedener Orte ver-rückt oder verstellt, so als ob die Linse der Fotokamera immer wieder neu skalieren muss: Zwar sind wir durch den Internetzugang, Proxy-Server, Touchscreen und die Web-Suchmaschine buchstäblich an globalisierte Kanäle und weltweite Prozesse „angeschlossen", verstehen aber die Sprache, die in der Textilfabrik von Savar, bei Foxconn in Shenzhen oder in der Deponie von Agbogbloshie in Accra gesprochen wird, nicht. Hierbei handelt es sich nicht um ein Ein- und Auszoomen, sondern um die Differenz, die aus der Skalierung unterschiedlicher Perspektiven folgt. Mit anderen Worten: Während wir auf den modernsten elektronischen Geräten, die voll von Edelmetallen und sogenannten „Seltenen Erdelementen" sind, unsere Texte tippen, downloaden oder lesen, wird gleichzeitig ausgebeutet, Raubbau und Sklaverei betrieben. Wann werden die Arbeiterinnen und Arbeiter in den Fabriken Zugang haben zu unseren Nachrichten-Apps, um ihre Stimme gegen die globale Klassengesellschaft zu erheben? Denken wir beispielsweise an die Beschäftigten von Bravo Tekstil in Istanbul, die im Herbst 2017 die

Nachricht „Ich habe dieses Stück, das Sie nun kaufen, hergestellt, aber ich wurde dafür nicht bezahlt" in die Kleider eines spanischen Unternehmens genäht haben, dessen Waren in Berlin, Genf, Graz … zum Kauf angeboten werden.

Viertens. Die Frage der geopolitischen Verflechtung in Prozessen der Öffentlichmachung oder der kuratorischen Politik ist nicht neu. Globale Prozesse sind sowohl Teil der Geschichte europäischer Kunstinstitutionen als auch in die Architektur von Kunstakademien eingeschrieben. Proto-globale bzw. koloniale Handelswege erwirtschafteten die Grundlage für kulturell-hegemoniale Prosperität von europäischer Kultur. Was heute vermutlich wichtiger ist als das Wissen um die Entstehung einer Ausstellung als Form der „partialen Perspektive", ist das Aufzeigen von Verflechtungen, Verzweigungen und Zusammenhängen zwischen Zeitzonen, Kulturen des Politischen, Sprachen, und Lernmethoden. Eine Diskussion zwischen Anna und Robert in Harun Farockis *Etwas wird sichtbar* (1981) ist hierfür aufschlussreich. Sie sprechen über Arbeitskategorien, die Ausbeutung des Wissens, die Grenzen des Lernens und ideologische Abgrenzungen:

Robert: „Ich erinnere mich an ein Buch, da werden die Eigenschaften des agrarischen Arbeiters im Gegensatz zu denen des industriellen definiert."

Anna: „Die amerikanische Methode: hunderte von Büchern plündern, mit tausend Ideen den Gegenstand angreifen, die Materialschlacht, das Flächenbombardement."

Robert: „Die vietnamesische Methode: wir sollten einen kurzen Text immer wieder lesen, mit wenigen Wörtern auskommen."

Anna: „Nein, das ist es nicht. Es geht nicht darum, entweder viele Bücher zu lesen oder nur eine Seite. Es geht darum, das eine mit dem anderen zu verbinden."

Fünftens. Der Komplexität des Themas sollten wir uns mittlerweile bereits bewusst sein – damit meine ich auch das besorgniserregende Ausmaß an Gewalt und die Missverständnisse, die der Prozess der Öffentlichmachung, d.h. das Ausstellen, mit sich bringt. Im Zusammenhang mit dieser Komplexität sei auch darauf verwiesen, dass Ausstellen immer auch damit verbunden ist, Dinge von einem Ort zu einem anderen zu transportieren. Das *Aus*stellen bedingt also auch ein *Ver*stellen: Wir können also vom Ausstellen sprechen als eine Praxis des Verstellens mittels einer Verschiebung ins Sichtbare. Im Englischen lässt sich dafür die Tätigkeit der *displaycing practice* erfinden: Ein Neologismus, der zwei Tätigkeiten in einem Verb kaum hörbar, aber sichtbar verknüpft – hier in seiner Verlaufsform *displaycing*. Das Verb „to displace" spricht vom Standort, der nicht mehr dort ist, wo er war. Das Verb „to display" spricht von der Falte, die nicht mehr gefaltet ist, sondern ihr Innerstes sichtbar

macht. Im Deutschen birgt das Verb „verstellen" eine weitere und hilfreich zweideutige Implikation, nämlich etwas zu verstellen bedeutet zum einen, etwas von A nach B zu bewegen, also eine Bewegung der Dislokation ähnlich wie in „to displace". Etwas verstellen kann aber auch bedeuten, etwas nicht komplett sehen zu können, da ein Objekt, eine Meinung, eine kulturelle Kodierung oder eine andere Person den Blick verstellt, und deshalb einen Wechsel der Perspektive erfordert. Solch eine Verflechtung von „ausstellen" und „verstellen", oder *displaying practices*, legt auch die Idee eines *Raumes* (etwa eines Ausstellungsraumes) als *verzweigte Örtlichkeit* durch Darbietung, Aktion und Praktik nahe: Dieser Begriff versteht sich als Konzept, das einem Netzwerk an Praktiken Raum bietet im Verhältnis zu nicht-repräsentationaler Forschung im Kontext des kuratorischen Arbeitens, d.h. eine Forschung, die sich des Verstellens bedient, sich aber gleichzeitig der Kraft des Ausstellens bewusst ist. Diese Form von Örtlichkeit, die nicht an einen einzigen Ort gebunden ist, ist folglich ein Konzept, das zwischen dem Örtlichen und dem Politischen neuerlich eine Verbindung herstellt. Die Verbindung ergibt ein Flechtwerk, welches das Ausstellen sowohl in seiner politischen Notwendigkeit des Sichtbarmachens anspricht als auch die Tätigkeit des Verstellens auf diejenigen zurückwirft, die ausstellen bzw. ausgestellt, verstellt, entstellt werden … Solch eine verzweigte Örtlichkeit erfordert eine radikale Neuausrichtung der eigenen Position im Ausstellungskomplex durch die Wahrnehmung des „planetarischen Subjekts"[5], wie es Gayatri Chakravorty Spivak in ihrer Forderung, den Globus mit dem Planeten zu überschreiben, vorschlägt: ein Subjekt, das an weltweite Kanäle und die globale Umwelt angeschlossen ist mittels eines Netzwerks an Praktiken, die die Generierung des Wissens proben. Ein Subjekt, das die heutige Welt in Bewegung begreift, indem sie die eigene Entfremdung von dieser Welt akzeptiert, da sie die Verflechtung einer verzweigten Örtlichkeit nicht mehr beherrschen kann: Etwas wird immer den Blick verstellen, während dieses Subjekt in planetarische oder erdumspannende Prozesse eingebettet ist – ob es will oder nicht. Hierfür gilt es, sowohl die Blindheit im Privileg der partialen Perspektive anzuerkennen als auch das Privileg der partialen Perspektive zu teilen bzw. zu kollektivieren. Denn dieses Subjekt existiert in Echtzeit an verschiedenen Orten gleichzeitig. Es hat die Kraft, die partiale Perspektive zu einem multi-perspektivischen Flechtwerk zu transFORMieren.

5 Spivak, Gayatri Chakravorty: *Death of a Discipline*, New York 2003, 72–73.

Sechstens.
Vieles muss entknotet werden.
Vieles muss umgelernt werden.
Vieles muss hervor treten. ∎

Übersetzung: Michaela Alex-Eibensteiner

Biennial Melancholy

Milica Tomić | Andrew Herscher

"In *All the World's Futures*, the aura, effects, affects, and specters of Capital will be felt in one of the most ambitious explorations of this concept and term. A core part of this program of live readings is 'Das Kapital' a massive meticulously researched bibliographic project, conceived by the artistic director in the Central Pavilion. This program, occurring everyday for nearly seven months, without stop, will commence with a live reading of the four volumes of Marx's *Das Kapital* and gradually expand into recitals of work songs, librettos, readings of scripts, discussions, plenaries, and film screenings devoted to diverse theories and explorations of Capital. Over the course of the 56th Art Biennale, theater ensembles, actors, intellectuals, students, and members of the public will be invited to contribute to the program of readings that will flood and suffuse surrounding galleries with voices in an epic display of orality …"[1]

We pose "biennial melancholy" as a contemporary version of what Walter Benjamin once termed "left-wing melancholy." Benjamin described left-wing melancholy as a means of avoiding contemporary political concerns by fetishizing aspects of the history of left politics.[2] Left-wing melancholy returns to the sites, events, practices, and texts that compose this history in the belief that such returns would somehow constitute political interventions; in Benjamin's words, left-wing melancholy is a "transposition of revolutionary reflexes … into objects of distraction, of amusement, which can be supplied for consumption."[3] Could there be a better example of this transposition than the "epic display of orality" ensuing from the live reading of the four volumes of Marx's *Das Kapital* in the 2015 Venice Biennale?

Like left-wing melancholy, biennial melancholy is a (re)action on the part of a consciousness that manifests its identification with the left by returning to forms and tactics endowed with left political "aura, effects, affects, and specters."[4] Biennial melancholy thereby capitalizes on the availability of biennial space and biennial time as enclaves for memory anti-politics. Biennial melancholy also points to an appropriation of the vocabulary, imagery, and tactics of the communist past on both the left and the right—parallel invasions into leftist thought through which left discourse, practice, and politics vanish. This destruction-through-appropriation is what Alpár Losoncz has called "retrospective normalization": an intervention into the past that serves to maintains an ideological apparatus in the present.[5]

As both a concept and lived reality, the biennial has always been a space of and for the reproduction of power relations. Where in this space is there a place for identification with the left? One of the most striking moments in the history of the Venice

Biennale of this identification was the protest that took place at the 1968 Biennale.[6] In a moment of global political unrest, artists formed solidarities with student movements and critiqued the Italian art establishment through boycotts and demonstrations at the Biennale. Artists foregrounded the complicity of the Biennale with colonial politics through the dependence of the Biennale on national pavilions, each underwritten in some way by the politics of the nation-states that were represented, as well as with the capitalist marketplace that constituted the fundamental context for the art that these pavilions displayed. If we take the "identification with the left" literally, this moment is one of the only grounds for identification with the "left" in the history of the Biennale—a moment that illuminates another kind of ideology and presents a legacy enabling another kind of thinking.[7]

To the extent that the biennial will be a space for the reproduction of power relations, art and theory in the biennial will merely be means of appropriation, of primitive accumulation in still unconquered territories. The concrete political meanings and stakes of ongoing class struggle, social inequality, and capital crises will not cause the biennial to close; rather, struggle, inequality, and crisis will furnish more material to exhibit. In contemporary biennials, today's so-called leftists enjoy exhibitions in national pavilions dedicated to human rights, identity politics, and even the good old socialist days, as if in so doing they could somehow be unburdened from the terror of contemporary capitalist reality. ∎

1 "Capital: A Live Reading," http://www.labiennale.org/en/art/2015/intervento-di-okwui-enwezor.

2 Walter Benjamin, "Left-Wing Melancholy," in *The Weimar Republic Sourcebook*, ed. Anton Kaes, Martin Jay, and Edward Dimendberg (Berkeley, 1994).

3 Ibid., 351.

4 We have here drawn upon and been inspired by Paige Sarlin's masterful analysis of what she calls "new left-wing melancholy" in contemporary reenactment art. See "New Left-Wing Melancholy: Mark Tribe's 'The Port Huron Project' and the Politics of Reenactment," in *Framework: The Journal of Cinema and Media* 50, 1–2 (2009), pp. 139–157.

5 Alpár Losoncz, "Stare/nove periferije Evrope," *Političke perspektive* 3 (2015), pp. 99–119, esp. p. 109.

6 Lisa Ponti, "68 in Venice," *Domus* 917 (2008), pp. 41–47.

7 The digital occupation of the U.S. Pavilion in the 2016 Venice Biennale of Architecture carried out by Detroit Resists, and described in this *GAM* issue, was another attempt to intervene in the space of the Biennale on the basis of an "identification with the left": see Andrew Herscher and Ana María León, "Exhibition as Occupation: Detroit Resists at the 2016 Venice Biennale of Architecture," in this *GAM* issue, pp. 82–97.

Biennalen-Melancholie

Milica Tomić | Andrew Herscher

„In *All the World's Futures* wird man der Aura, den Auswirkungen, den Emotionen und den Gespenstern des Kapitals in einer der ehrgeizigsten Erkundungen dieses Konzepts und Begriffs nachspüren können. Ein Herzstück dieses Programms von Live-Lesungen ist ‚Das Kapital', ein gewaltiges, akribisch recherchiertes bibliografisches Projekt, das vom künstlerischen Leiter für den Zentralen Pavillon konzipiert wurde. Dieses Programm, das fast sieben Monate lang täglich und ohne Unterbrechung stattfindet, wird mit einer Live-Lesung der vier Bände von Marx' *Das Kapital* beginnen und allmählich in Liederabende mit Arbeiterliedern, Librettos, Drehbücher-Lesungen, Diskussionen, Plenarveranstaltungen und Filmvorführungen ausweiten, die verschiedenen Theorien und Erforschungen des Kapitals gewidmet sind. Im Rahmen der 56. Kunstbiennale werden Theaterensembles, SchauspielerInnen, Intellektuelle, Studierende und das Publikum eingeladen sein, einen Beitrag zum Programm der Lesungen zu leisten, die in einer epischen Inszenierung von Oralität die umliegenden Galerien mit Stimmen überfluten und durchfluten werden […]."[1]

Wir werfen unseren Begriff „Biennalen-Melancholie" als eine zeitgenössische Version dessen auf, was Walter Benjamin einst als „linke Melancholie" bezeichnete. Benjamin beschrieb die linke Melancholie als Mittel, um zeitgenössische politische Anliegen zu vermeiden, indem man Aspekte der Geschichte der linken Politik zum Fetisch erhebt.[2] Die linke Melancholie kehrt zu den Orten, Ereignissen, Praxen und Texten zurück, die diese Geschichte ausmachen – in der Überzeugung, dass eine solche Rückkehr in irgendeiner Weise politische Interventionen darstellen würde. In Benjamins eigenen Worten ist die linke Melancholie die „Umsetzung revolutionärer Reflexe […] in Gegenstände der Zerstreuung, des Amüsements, die sich dem Konsum zuführen ließen".[3] Gibt es ein besseres Beispiel für diese Umsetzung als die „epische Inszenierung von Oralität", die sich aus der Live-Lesung der vier Bände von Marx' *Das Kapital* auf der Biennale von Venedig 2015 ergibt?

Wie die linke Melancholie ist die Biennalen-Melancholie eine (Wider-)Handlung eines Bewusstseins, das seine Identifikation mit der Linken manifestiert, indem es zu Formen und Taktiken zurückkehrt, die mit linker politischer „Aura, Auswirkungen, Emotionen und Gespenstern" ausgestattet sind.[4] Die Biennalen-Melancholie nutzt dabei die Verfügbarkeit des Raumes und der Zeit der Biennale als Enklave für Anti-Erinnerungspolitik. Biennalen-Melancholie verweist auch auf eine Aneignung des Vokabulars, der Bilder und Taktiken der kommunistischen Vergangenheit sowohl auf Seiten der Linken als auch der Rechten – parallele Invasionen in linkes Denken, durch die linker Diskurs, linke Praxis und Politik verschwin-

den. Diese Zerstörung durch Aneignung ist das, was Alpár Losoncz „retrospektive Normalisierung" genannt hat: eine Intervention in die Vergangenheit, die dazu dient, einen ideologischen Apparat in der Gegenwart aufrechtzuerhalten.[5]

Als Konzept und gelebte Realität ist die Biennale seit jeher ein Raum der und für die Abbildung von Machtverhältnissen. Wo in diesem Raum gibt es einen Ort für die Identifikation mit der Linken? Einer der prägnantesten Augenblicke dieser Identifikation in der Geschichte der Biennale von Venedig, war der Protest anlässlich der Biennale 1968.[6] In einem Augenblick politischer Konflikte rund um den Globus bildeten Künstler Solidaritäten mit Studentenbewegungen und verliehen ihrer Kritik des italienischen Kunst-Establishments durch Boykotte und Demonstrationen auf der Biennale Ausdruck. Durch die Abhängigkeit der Biennale von nationalen Pavillons, die jeweils in gewisser Weise der Politik der vertretenen Nationalstaaten sowie dem kapitalistischen Marktplatz, der den fundamentalen Zusammenhang für die in diesen Pavillons gezeigte Kunst bildete, verpflichtet sind, rückten die Künstlerinnen und Künstler die Komplizenschaft der Biennale mit der Kolonialpolitik in den Vordergrund. Wenn wir die „Identifikation mit der Linken" wörtlich nehmen, ist dieser Augenblick einer der einzigen Gründe für die Identifikation mit der „Linken" in der Geschichte der Biennale – ein Augenblick, der ein Licht auf eine andere Art von Ideologie wirft und ein Vermächtnis darstellt, das ein anderes Denken ermöglicht.[7]

In dem Maße, wie die Biennale ein Raum für die Abbildung von Machtverhältnissen sein wird, werden Kunst und Theorie

1 „Capital: A Live Reading", in englischer Sprache online unter: http://www.labiennale.org/en/art/2015/intervento-di-okwui-enwezor.

2 Benjamin, Walter: „Linke Melancholie", in: *Angelus Novus (Ausgewählte Schriften)*, Frankfurt 1966.

3 Ebd., 458.

4 Wir haben uns hier von Paige Sarlins meisterhafter Analyse dessen, was sie als „neue linke Melancholie" in der zeitgenössischen Reenactment-Kunst bezeichnet, inspirieren lassen. Vgl. „New Left-Wing Melancholy: Mark Tribe's ‚The Port Huron Project' and the Politics of Reenactment", in: *Framework: The Journal of Cinema and Media* 50, 1–2 (2009), 139–157.

5 Losoncz, Alpár: „Stare/nove periferije Evrope" in: Matan, Ana (Hg.): *Političke perspektive* 3 (2015), 99–119, hier 109.

6 Ponti, Lisa: „68 in Venice", in: *Domus* 917 (2008), 41–47.

7 Die von Detroit Resists durchgeführte und in dieser Ausgabe von *GAM* beschriebene digitale Besetzung des US-Pavillons während der Architekturbiennale Venedig 2016 war ein weiterer Versuch, auf der Grundlage einer „Identifikation mit der Linken" in den Raum der Biennale einzugreifen. Vgl. Herscher, Andrew/León, Ana María: „Ausstellung als Okkupation: Detroit Resists bei der Architektur-Biennale Venedig 2016" in dieser Ausgabe von *GAM*, 82–97.

Curating in Time-Specific Mode
Ekaterina Degot

Kuratieren im zeitspezifischen Modus
Ekaterina Degot

in der Biennale lediglich Mittel der Aneignung, der primitiven Akkumulation in noch nicht eroberten Territorien sein. Die konkreten politischen Bedeutungen und Herausforderungen des andauernden Klassenkampfes, der sozialen Ungleichheit und der Kapitalkrisen werden der Biennale kein Ende setzen; vielmehr werden Kampf, Ungleichheit und Krise mehr Material für Ausstellungen liefern. In den zeitgenössischen Biennalen genießen die heutigen so genannten Linken Ausstellungen in nationalen Pavillons, die den Menschenrechten, der Identitätspolitik und sogar der guten alten Zeit des Sozialismus gewidmet sind, als ob sie dadurch irgendwie von den Schrecken der gegenwärtigen kapitalistischen Realität entlastet werden könnten. ∎

Übersetzung: Otmar Lichtenwörther

The temporal aspect of an exhibition usually goes unacknowledged. It is a secret professional share, trying to check how long a visit to an exhibition, let alone to a Biennial, would take. Unlike with theater shows and even performances, this information is never made public. Still, exhibitions nowadays can be time consuming—because of films, obviously, but also because of research installations that might include texts, audiorecordings, newspaper clippings and other elements (if one bothers to read them or listen to them), as well as long comments written by curators themselves.

However, we are oblivious about it. The site-specific aspect of an exhibition is usually well perceived: the tension between an artwork on display and its physical, let's say postindustrial, or other desolate, surroundings, is what "makes" a Biennial, for many. But exhibitions are also what I would call time-specific. They address, invade, and question the time of the viewer, and they are also positioned in "real time," open, complex, difficult to grasp.

The time of an exhibition is not abstracted, it is not a "white cube" time with isolated elements immediately structured. It exceeds human limitations: today, large-scale exhibitions are not meant to be seen as a whole, even by professional reviewers, who can state in their reviews that they have not seen all of documenta. Let's imagine a literary critic would say in his or her review, he or she skipped a couple of chapters—that would hardly be acceptable.

In that durational (and often frustrating) aspect, exhibitions confront, sometimes aggressively, limitations dictated by the viewers's mortality. Among other things, it makes them accept these limitations and reflect upon them.

An exhibition is that "multi-dimensional space" that Roland Barthes in his seminal text "The Death of the Author," described as the space that cannot be fully *deciphered*," but only *disentangled*" and read in fissures of meaning.[1] If, as Jens Hofmann suggests, a curated entity is a "discursive argument realized through the display of artworks,"[2] then this argument is by definition incomplete and open. There have been debates whether curators could (or should) be called artists, or it would have been unethical, but, to some extent, this discussion misses the point: it is not like curators want to take the place of a traditional autonomous creator, it is the product of curators (a non-autonomous, heterogeneous display) that is seen as the new form of an artwork now. Although the exhibition is, as said before, always a narrative, it is almost impossible to indicate the clear order in which elements of a show have to be seen. This is something curators try to control, but they have to accept that this control can be only very limited. The elements a show is built upon

(formerly known as individual art works) often have been, and certainly will be, parts of different combinations that might turn out to be more memorable than the combination on display in this particular exhibition; the exhibition these art works are part of now will be dismantled. It is also very difficult, if not impossible, to document in the full spectrum of different factors that play a role (for instance, quality of light, the amount of visitors, rhythm of movement inside the space, combinations of works seen in time etc.).

As a result, the exhibition is fragmented, open, temporary. Misreadings and rewritings are consequences that curators also have to accept. Exhibitions will be read in different ways and sometimes will even be reproduced differently. Moreover, the contemporary institutional landscape of discourse production makes every artist, every curator, every participant in the art world curated at some point (as part of a book, or a conference, or of a complex show including different parts) and curating on another, or even the same, occasion. A curator can be a full-power convener of an exhibition, as well as one of the authors in the book curated by someone else, or one of the characters of an artist's research project. As a result, when a project is a curated whole with subcurated elements done by other curators, the final product has by definition multiple overlapping authorships. So, there is no point in complaining about curators being dictators. In fact, they are rather modest creators who, from the very beginning, accept that their work and their authorship will be extremely precarious, as human life itself. ∎

1 Roland Barthes, "The Death of the Author," in *Image Music Text*, ed. and trans. Stephen Heath (London, 1977), pp. 142–148, esp. p. 147.

2 Jens Hoffmann, *(Curating) from A to Z* (Zurich, 2014), p. 15.

Der zeitliche Aspekt einer Ausstellung bleibt meist unbeachtet. Er ist ein Geheimnis unter Fachleuten, die versuchen herauszufinden, wie lange ein Besuch einer Ausstellung, geschweige denn einer Biennale dauern würde. Anders als bei Theateraufführungen und sogar Performances werden diese Informationen nie öffentlich gemacht. Dennoch können Ausstellungen heutzutage zeitaufwändig sein – natürlich aufgrund von Filmen, aber auch aufgrund von Forschungsinstallationen, die Texte, Tonaufnahmen, Zeitungsausschnitte und andere Elemente enthalten können (falls man diese lesen oder hören will), sowie langen Kommentaren, die von den Kuratoren selbst verfasst wurden.

Wir sind uns dessen jedoch nicht bewusst. Der ortsspezifische Aspekt einer Ausstellung wird in der Regel gut wahrgenommen: Die Spannung zwischen einem gezeigten Kunstwerk und seiner physischen, sagen wir postindustriellen oder sonstwie desolaten Umgebung ist das, was für viele eine Biennale „ausmacht". Aber Ausstellungen sind auch das, was ich als zeitspezifisch bezeichnen würde. Sie nehmen die Zeit des Betrachters in Angriff, dringen in sie ein, hinterfragen sie, und sie sind auch in der „Echtzeit" angesiedelt, offen, komplex, schwer fassbar.

Die Zeit einer Ausstellung ist nicht abstrahiert, sie ist keine „White Cube"-Zeit mit unmittelbar strukturierten isolierten Elementen. Sie geht über die menschlichen Grenzen hinaus: Großausstellungen sind heute nicht mehr dazu bestimmt, zur Gänze angesehen zu werden, auch nicht von professionellen Rezensenten, die in ihren Rezensionen durchaus feststellen können, dass sie nicht die gesamte documenta gesehen haben. (Stellen wir uns vor, ein/e Literaturkritiker/in würde in seiner/ihrer Rezension sagen, dass er oder sie ein paar Kapitel übersprungen hat – das wäre kaum akzeptabel.)

In dieser durationalen (und oft frustrierenden) Hinsicht, stellen sich Ausstellungen bisweilen aggressiv, gegen von der Endlichkeit der Betrachter diktierten Grenzen. Unter anderem bringen letztere sie dazu, diese Einschränkungen zu akzeptieren und über sie nachzudenken.

Eine Ausstellung ist jener „vieldimensionale Raum", den Roland Barthes in seinem richtungsweisenden Text „Der Tod des Autors" als den Raum beschrieben hat, der nicht vollständig „entziffert" sondern nur „entwirrt und in den Rissen der Bedeutung gelesen werden kann.[1] Wenn, wie Jens Hoffman anregt, etwas Kuratiertes ein „diskursives Argument ist, das durch die Ausstellung von Kunstwerken realisiert wird",[2] dann ist dieses Argument per definitionem unvollständig und offen. Es gab Debatten darüber, ob Kuratoren als Künstler bezeichnet werden könnten (oder sollten), oder ob das unmoralisch wäre, aber in gewisser Weise geht diese Diskussion an der Sache vorbei: Es ist nicht so, dass Kuratoren den Platz eines traditionellen autono-

men Schöpfers einnehmen wollen, sondern es ist das Produkt von Kuratoren (eine nicht-autonome, heterogene Ausstellung), das jetzt als die neue Form eines Kunstwerks angesehen wird. Obwohl die Ausstellung, wie gesagt, immer eine Erzählung ist, ist es fast unmöglich, die klare Reihenfolge anzugeben, in der die Elemente einer Ausstellung betrachtet werden müssen. Das ist etwas, was Kuratoren zu kontrollieren versuchen, aber sie müssen akzeptieren, dass diese Kontrolle nur sehr begrenzt sein kann. Die Elemente, auf denen eine Ausstellung aufgebaut ist (vormals bekannt als einzelne Kunstwerke), waren und sind oft Teile verschiedener Kombinationen, die sich als denkwürdiger erweisen könnten als die in genau dieser Ausstellung gezeigte Kombination; die Ausstellung, in der diese Kunstwerke jetzt zu sehen sind, wird abgebaut werden. Es ist auch sehr schwierig, wenn nicht gar unmöglich, das gesamte Spektrum der verschiedenen Faktoren, die eine Rolle spielen, zu dokumentieren (z.B. Qualität der Beleuchtung, Besucherzahlen, Bewegungsrhythmus im Raum, Kombinationen von Werken, die in der Zeit gesehen werden usw.).

Infolgedessen ist die Ausstellung fragmentarisch, offen, temporär. Fehlinterpretationen und Neuschreibungen sind Konsequenzen, die auch Kuratoren in Kauf nehmen müssen. Ausstellungen werden auf unterschiedliche Art und Weise gelesen und manchmal sogar anders reproduziert. Darüber hinaus macht die zeitgenössische institutionelle Landschaft der Diskursproduktion jede/n KünstlerIn, jede/n KuratorIn, jede/n TeilnehmerIn in der Kunstwelt zu einem bestimmten Zeitpunkt (als Teil eines Buches, einer Konferenz oder einer komplexen Ausstellung mit verschiedenen Teilen) zu einer kuratierten Person und zu einem anderen, oder sogar demselben, Anlass zum Kurator oder zur Kuratorin. Ein Kurator kann ein vollwertiger Organisator einer Ausstellung sein, ebenso wie einer der Autoren des von jemand anderem kuratierten Buches oder einer der Charaktere des Rechercheprojekts eines Künstlers. Wenn ein Projekt ein kuratiertes Ganzes mit subkuratierten Elementen ist, die von anderen Kuratoren erstellt wurden, hat das Endprodukt per definitionem mehrere sich überlagernde Autorschaften. Es hat also keinen Sinn, sich darüber zu beschweren, dass Kuratoren Diktatoren sind. Tatsächlich sind sie eher bescheidene Schöpfer, die von Anfang an akzeptieren, dass ihr Werk und ihre Autorschaft äußerst prekär sein werden, wie das menschliche Leben an sich. ∎

Übersetzung: Otmar Lichtenwörther

Barthes, Roland: „Der Tod des Autors", in Jannidis, Fotis/Lauer, Gerhard/Martinez, Mathias/Winko, Simone (Hg.): *Texte zur Theorie der Autorschaft*, Stuttgart 2000, 185–193.

Hoffmann, Jens: *(Curating) from A to Z*, Zürich 2014, 15.

Curating Does Not Mean Endorsing, Pontificating, Including or "Giving Voice" (on Exposing, not Exhibiting)

Antonia Majača

Curating, as far as I'm concerned, is not necessarily endorsing. Understanding curating in terms of endorsing, promoting, and pontificating comes from a liberal mindset and the ingrained logic resting on either the figure of an omniscient curator-cum-savior-connoisseur or counts with the figure of the curator as the mediator between the artist/public institutions and the market. The two are of course often congruent, and reinforce each other in the conditions of global, capitalist multicultural optimism. Now, if you are uninterested in curating as one of the above, then doing it differently does not simply mean curating as a form of an uncontroversial eulogizing, sentimental endorsement or non-committal "engagement" with whatever content, no matter how much "extensive research" went into it. To curate beyond endorsing is a serious, often self-torturous process. To come up with the ways to expose the "contested" and "contestable" content means finding a way, I suppose, to show not only the "material" itself but also make evident some of the interpretational conundrums and difficulties behind the decision to "expose" it in the first place. It is a precarious choreography—this delicate placement of objects and their shadows into a meta-stable system where they suddenly become exposed to unexpected encounters. If we are lucky, these enter, as if by some autonomously acting spell, into a choreography of their own making. This, at least in my experience, allows for a whole new chain of dis-identifications and interpretational slippages. One must of course, be ready to take risks and be prepared for an outright disaster. But I do not see how we can do this otherwise. Art institutions have historically had the task of deciding what is valuable and worthy of keeping for posterity and what not. The Western institutions of art are, of course, institutions of Western capitalism and the institutions of bourgeois taste. As such they are institutions of Western humanism, of Enlightenment and of the white, male subject of rational choice and consumer sovereignty. There are no easy ways to undermine and work against this seemingly all pervasive scheme. Galleries promote, art institutions pontificate. Exactly because of the entirely normalized persistence of this model, it seems to me, that the exhibition must turn into a form of exposure and self-exposure. Therefore, "exposing," instead of "exhibiting," means a commitment to working against the violent reductions of (Western) humanism, the semiotics of morality, and the melodramatics of the Western psyche and its eternal stare into the godless abyss of capitalist modernity. ∎

Kuratieren bedeutet nicht Befürwortung, Dozieren, Einschluss oder „eine Stimme verleihen" (vom Exponieren, Nicht-Ausstellen)

Antonia Majača

Kuratieren ist, soweit es mich betrifft, nicht unbedingt Befürwortung. Das Verständnis von Kuratieren im Sinne von Befürworten, Fördern und Dozieren entspringt einer liberalen Denkweise und einer tief verwurzelten Logik, die entweder auf der Figur eines allwissenden Kurators/Heilsbringers/Kenners beruht oder auf die Figur des Kurators als Vermittler zwischen Künstler/öffentlichen Institutionen und dem Markt zählt. Die beiden sind natürlich oft deckungsgleich und verstärken sich gegenseitig unter den Bedingungen eines globalen, kapitalistischen multikulturellen Optimismus. Wenn man nun kein Interesse daran hat, als einer der oben genannten Kuratorentypen zu arbeiten, dann heißt „es anders machen" nicht einfach Kuratieren als Form nicht kontroverser Lobpreisung, sentimentaler Befürwortung oder unverbindlichen „Engagements" mit beliebigen Inhalten, egal wieviel „umfassende Forschungsarbeit" in sie eingeflossen ist. Kuratieren jenseits der Befürwortung ist ein ernsthafter, selbstquälerischer Prozess. Möglichkeiten finden, wie man „umstrittene" und „anfechtbare" Inhalte exponiert, heißt wohl einen Weg finden, nicht nur das „Material" selbst zu zeigen, sondern auch einige der interpretatorischen Rätsel und Schwierigkeiten ersichtlich zu machen, die hinter der Entscheidung stehen, sie überhaupt zu „exponieren". Das ist eine prekäre Choreografie – diese heikle Platzierung von Objekten und ihren Schatten in einem metastabilen System, in dem sie plötzlich unerwarteten Begegnungen ausgesetzt werden. Wenn wir Glück haben, treten diese, wie durch einen autonomen Zauber, in eine aus eigener Kraft geschaffene Choreografie ein. Dies ermöglicht, zumindest nach meiner Erfahrung, eine völlig neue Kette von Fehlerkennungen und interpretativen Abweichungen. Natürlich muss man bereit sein, Risiken einzugehen, und auf eine völlige Katastrophe gefasst sein. Aber ich sehe nicht, wie wir das anders machen können. Historisch gesehen haben und hatten Kunstinstitutionen die Aufgabe zu entscheiden, was wertvoll und von Wert für die Nachwelt ist und was nicht. Die westlichen Kunstinstitutionen sind natürlich Institutionen des westlichen Kapitalismus und die Institutionen des bürgerlichen Geschmacks. Als solche sind sie Institutionen des westlichen Humanismus, der Aufklärung und des weißen, männlichen Subjekts mit rationaler Wahlmöglichkeit und Konsumentensouveränität. Es gibt keine einfachen Möglichkeiten, dieses offenbar allgegenwärtige System zu untergraben und zu bekämpfen. Galerien fördern, Kunstinstitutionen dozieren.

Gerade wegen der völlig normierten Beständigkeit dieses Modells scheint mir, dass sich die Ausstellung zu einer Form der Exponierung und Selbstentblößung wandeln muss. Daher bedeutet „Exponieren" statt „Ausstellen" eine Verpflichtung, gegen die gewaltsamen Reduktionen des (westlichen) Humanismus, die Semiotik der Moral und die Melodramatik der westlichen Psyche und ihren ewigen Blick in den gottlosen Abgrund der kapitalistischen Moderne zu arbeiten. ∎

Übersetzung: Otmar Lichtenwörther

Notes on the Research-Based Exhibition: Dialectical Optics and the Problems of Positivism[1]

Anselm Franke

I'm going to sketch a few basic thoughts that accompany me in the process of permanent doubt that I tried to make productive in my curatorial work. The widespread concern with the thematic exhibition and displaying research is that these kinds of exhibitions tend to illustrate theory or curatorial thoughts. It is a fair concern, but it has never been my starting point. Firstly, because the idea of what illustration means has never been taken radically to its conclusions. And secondly, because I was much more concerned with the "positivism problem," I try to challenge the idea that one could represent and to do so effectively and unambiguously. This challenge has been driving my approach to what a thematic exhibition can and should be.

I also look for ways in my curatorial work to evade the dictate of communication, beyond what Francesco Manacorda named the "imperative of effectively sharing."[2] A troublesome side effect of the new institutionalization of research-based practices is that it becomes increasingly difficult for artists, curators, and especially publicly funded institutions to be difficult and non-understandable. I do not mean to suggest that we do not have a responsibility toward our public. But research-based practices are subject to a logic of justification and narratability that often lies square to art. I mean that specific forms of resistance operate by evasion and hermeticism, and perhaps an entire arsenal of expressions of negativity is getting lost, and with it art as an ontologically disrupting force is endangered, disappearing, and being corrupted. I try to bring research-based practices together with the genealogy of hermeticism and negativity to combine them in resistance against the dictate of communication. I attempt to make exhibitions that are simultaneously directed against a certain idea of autonomous art and a heavy-handed "contentism."

My approach to thematic exhibitions has been initially shaped by collaborations with theatre-makers and with architects, who are less burdened in their treatment of the exhibition, but therefore also closer to a certain naive positivism—as if one could simply exhibit something without that something undergoing a profound transformation, one that is conditioned by two centuries of institutional exhibitionary practices that formed the conventions and disciplinarizations of what an exhibition can be, and what makes it legible. Yet the artistic resistance against conventions of representation—what one could call the hermetic tradition of the avant-garde—are more foreign to them, as are the rituals of purification surrounding "art." This was an important initial impetus of taking the liberty to use different sources to approach the question of what an exhibition can be and

to cross and question various boundaries and demarcations. For architects, the exhibition is a laboratory, a space for modelling. In this respect, my continuous collaboration with Eyal Weizman,[3] an architect as well as a political theorist and thinker who has developed a lot of challenging thoughts around mapping, effective making of fact-based displays, is very important. Coming from a totally different genealogy from the one emphasizing artistic autonomy, he is working seriously with the idea of overcoming the inconsequentiality that characterizes the modern, bourgeois sphere of art. I wanted to bring this use of the exhibition as a space of models and cartographies together with the unique ability of artworks to dynamize, and ontologically destabilize subject/object relations. From this point, I began to treat the exhibition as a sort of laboratory for frontier historiographies, border regimes, and their architectures of mediation (central to which are subject/object relations). I wanted to deal with the question: is it possible to use the exhibition as a sort of ontological laboratory?

The most important thing for a reflective thematic exhibition is to induce a definitional crisis. What appears as simply given needs to become doubtful: not only what an object means, but also what it is. The givenness of art as a category is not to be excluded from this procedure. But above all, it concerns the theme of an exhibition, whose *exhibit-ability* as both subject matter and object needs to be questioned. What ought to be illuminated is how an object is coming into being, and how this process corresponds with the coming into being of subjects. That always goes along with destabilizing aesthetic experiences; what is at stake is an ontological destabilization of perception and categories of thought through the magic inherent in signs. It is said that art produces no unambiguous meanings, but throws us back onto our background assumptions, through which we create meaning in the first place. But to be thrown back thus is already an ontological destabilization. However, these tacit assumptions are by no means individual, they are collective and historical. What distinguishes the essay-exhibition is that it directly addresses these background assumptions, on equal footing with (art-)objects. It seeks to translate these assumptions into a narrative that in turn changes what we see. For instance, the process of "seeing-as"—that we are familiar with from so-called multistable figures—can be made to oscillate between image and narrative.

The essay-exhibition is a form of thematic exhibition that addresses itself to the positivism that historically has been inscribed into the format of the exhibition, particularly the bourgeois equation between the visible and the knowable.

Therefore, the point of departure are artistic methods of representational- and institutional critique, it is about the constitution of the gaze and of visibility, and about "showing showing" in the Brechtian sense. Essay-exhibitions use these artistic methods and apply them to the exhibition format; they reject narrative innocence and instead speak of the history of representational practice. In an essay-exhibition, art thus becomes "research," in the sense (and only in this sense) that art is exploring the limits of positive knowledge by resisting the closure of symbolic systems performed in the institutional frame. The difference between an essay-exhibition and any other thematic exhibition in whatever museum context lies in the status it grants artworks as art and epistemological models. Because works of art enable us to traverse different forms of knowledge, disciplines, and semiotic regimes. It is only through art that the exhibition becomes self-reflexive, and is capable of formulating a critic of positivist knowledge within the regime of visibility and objectivisism itself. What art gains by being framed thus is that it doesn't suffer from the usual syndrome of "death by musealization"—that the ability of art to challenge the givenness and facticity of things is not neutralized by the institutional frame, as happens so frequently.

The concept of the frontier is crucial, as it allows us to establish a coherent relation between the limits of communities and societies and aesthetic experiences. One can list numerous simple examples to illustrate this relation, the aesthetics of monsters for instance. It is known that every process of normalization results in the vanishing of the ability to perceive this close connection between aesthetics and social boundaries and differences, as part of an ontological stabilization. Therefore, the first step is to re-import all that has been exported or projected into an outside during these processes of normalization, in order to define a point without ontological presuppositions. It is a methodological necessity to depart from an imaginary point of the not-yet-differentiated, to be able to perceive the logic of differentiation and division. Otherwise, one never gets beyond the ontological fixation of reality, that is really just an effect of various, multilayered practices of division. What we perceive in terms of more or less clearly delineated entities is turned inside out by the concept of the frontier. No boundary is ever conclusive or non-ambiguous, there is always fluctuation, especially when you look closer.

A frontier history was criteria and principles of montage on which Diedrich Diederichsen and I constructed and built the materials that constituted the exhibition "The Whole Earth."[4] Perhaps this is the exhibition that came closest to the thing that

most teachers in curating advise against, that is an exhibition like a book. "The Whole Earth" was like an archive, an image space of an epistemic and pop-cultural epochal paradigm that linked a certain horizon of expectation to the photograph of planet Earth from space. Organized in some ten chapters, with numerous artworks in between, the exhibition recounted the story of an epochal transformation of the frontier as it played out in geographically in California. That was the transformation of the horizontal, expansive colonial frontier—that was so crucial to the formation of the U.S in their current shape and also corresponds to linear models of time, with progress and causality—first, into the infinite verticality of space, and then into a planetary envelope, folding back upon Earth. The frontier has since become a planetary, technological volume, and the turning of the gaze back to Earth in the Apollo missions is paradigmatic for it. This envelope is also called "Anthropocene." Every transformation of a frontier, however, corresponds with a transformation in thinking and the thinkable: in this case we are dealing with circular models that are typical for cybernetics.

Yet another essay-exhibition in this sense was "Animism."[5] Animism, as a term, is itself a frontier device that you cannot even use without enacting distinctions, boundaries, separations that themselves are part of a large historical formation—a colonial modernity. The key border is of course the one between life and non-life, and then between persons and things, subjects and objects: Animism is a name for the absence or transgression of these distinctions "proper," and this is what makes the term itself an instrument of the frontier. The most demonic face of that frontier is that which ties a genealogy of thought and a tradition of aesthetics, to a genocidal continuum in modernity or of the modern

1 This text is based on a lecture given at the symposium "Between the Discursive and the Immersive: Research in 21st Century Art Museums," at the Louisiana Museum of Modern Art, Copenhagen, December 3–4, 2015. The lecture can be accessed online at: https://vimeo.com/157267704.

2 This phrase was introduced by Francesco Manacorda at the same symposium.

3 Eyal Weizman and Anselm Franke co-curated the exhibitions "Territories," KW Berlin 2003 and "Forensis," HKW Berlin, 2014.

4 "The Whole Earth" exhibition curated by Anselm Franke and Diedrich Diederichsen at the Haus der Kulturen der Welt/HKW, Berlin in April 26–July 7, 2013.

5 The exhibition "Animism" was curated by Anselm Franke first at the Extra City Kunsthal, Antwerpen from Jan 22–May 2, 2010 and subsequently at the Generali Foundation, Vienna; Kunsthalle Bern; HKW, Berlin; e-flux, New York; Ashkal Alwan, Beirut; OCAT, Shenzhen; and the Ilmin Museum of Art, Seoul.

Anmerkungen zur recherchebasierten Ausstellung: Dialektische Optik und die Probleme des Positivismus[1]

Anselm Franke

rontier, of that which has to go, that which has to make place for the arrival of modernity. In the *Dialectics of Enlightenment* by Adorno and Horkheimer it sounds like this: "The program of the Enlightenment was the disenchantment of the world," and further, "the disenchantment of the world is the extirpation of animism."[6] From there it s not far to the readiness for the extirpation of actual animists, that is, of all those hat do not separate and divide the world n the sense of capitalist-instrumentality. Now do these boundary processes relate o aesthetics? One example is the category of the "uncanny" as described by Freud n his essay. It is a good backdrop to draw connection between the aesthetics, subect-formation, and colonial frontier. For the xperience of the uncanny is described by reud as a transgression in which a historcally and personally surmounted animism eturns, as dead objects suddenly appear s alive and endowed with subjectivity. And this transgression is as central to aesetic experience as it is for the stability of he bourgeois subject. The exhibition then ried to reconstruct the relation between he aesthetic question of animation and the olonial frontier. And, of course, animism is ot only the negative horizon of modernity, hat which has to be left behind in order to ecome modern. We also encounter animism in the future projected by moderns, s a utopian horizon, for instance, when Marx speaks about the rehumanisation of he world. We have, furthermore, made he term the point of departure for reflecons on "mediality," to use it as a concept f an expanded mediality and its paradoxial status in modernity, between capitalist bstraction, social delimitation, and disciinary measures.

To conclude, I want to speak of a uote that has proven to be a useful tool of hought in challenging representational trimphalism in framing frontier histories. It is y Michel Foucault:

"One could write a history of limits—of nose obscure gestures, necessarily forgotn once they are accomplished, through vhich a culture rejects something that for is the Exterior; and right throughout its istory, this void that has been created, nis blank space through which it isolates self, describes it just as much as its vales do. Because it receives and maintains s values in the continuity of history; but in nis region that we are trying to describe, exercises its essential choices, it creates ne division which gives it its positive face; ere we find the original density by which is formed [...]."[7]

This quote circumscribes very clearly ne challenges of a historiography of froners: its labor against a fundamental kind f oblivion, and a labor on gestures that nediate between what can be spoken and

shown and its other. The essay-exhibition has to be a dialectical image space, which traces divisions from a point prior to division, without fixating or accepting them as given. Every division therefore is to be negated: limitation and delimitation encounter each other in the nexus of subject and object which is opened up by art. ∎

Ich möchte einige der Grundüberlegungen in jenem Prozess des permanenten Zweifels skizzieren, den ich in meiner kuratorischen Arbeit produktiv zu machen suche. Häufig wird gegen thematische, recherchebasierte Ausstellungen angeführt, dass diese dazu neigen, als bloße Veranschaulichung von Theorie oder kuratorischen Überlegungen zu dienen. Das ist ein berechtigtes Bedenken, aber das war nie mein Ausgangspunkt. Erstens, weil der Gedanke, was Veranschaulichung bedeutet, selten radikal zu Ende gedacht wird. Und zweitens, weil mir das „Positivismusproblem" viel mehr am Herzen liegt. Ich möchte die positivistische Vorstellung problematisieren, dass man etwas darstellen könnte und dies effektiv und eindeutig tun könnte. Diese Herausforderung hat mich dazu veranlasst, mich mit der Frage auseinanderzusetzen, was eine thematische Ausstellung sein kann und sein sollte.

Ich suche desweiteren nach Wegen in meiner kuratorischen Arbeit, dem Diktat der Kommunikation zu entkommen, jenseits dessen, was Francesco Manacorda das „Gebot des wirkungsvollen Teilens"[2] nannte. Ein besorgniserregender Nebeneffekt des neuen Trends zur Institutionalisierung recherchebasierter Praktiken ist, dass es für Kunstschaffende, KuratorInnen und vor allem öffentlich finanzierte Institutionen immer schwieriger wird, schwierig oder gar unverständlich zu sein. Ich meine nicht, dass wir als Institutionen nicht Verantwortung gegenüber unserem Publikum tragen. Aber recherchebasierte Praktiken unterliegen einer Logik der Rechtfertigung und auch der Erzählbarkeit, die oft quer zur Kunst selbst liegt. Ich meine, dass dabei bestimmte Formen des Widerstands durch Entzug und Hermetik, vielleicht ein ganzes Arsenal an Artikulationen von Negativität verlorengeht, und damit Kunst als ontologisch störende Kraft gefährdet ist, verschwindet und korrumpiert wird. Ich versuche dagegen, recherchebasierte Praktiken und die avantgardistischen Genealogien des Hermetischen und der Negativität zu vereinen und gegen das Diktat der Kommunikation zu verbinden. Ich versuche Ausstellungen zu machen, die sich gegen die Idee autonomer Kunst ebenso richten wie gegen einen plumpen Inhaltismus.

Meine Herangehensweise an thematische Ausstellungen wurde wesentlich geprägt von der Zusammenarbeit mit Theater- und Architekturschaffenden, die unbesorgter mit dem Format umgehen. Aber sie sind einem gewissen naiven Positivismus daher auch eher zugeneigt – so als ob man einfach etwas ausstellen könne, ohne dass dieses Etwas dabei eine grundsätzliche Transformation durchliefe, konditioniert durch zweihundert Jahre institutioneller Praxis, in denen dasjenige, was eine Ausstellung überhaupt sein kann und lesbar

macht, sich erst als Konvention und Disziplinierungsform herausgebildet hat. Der künstlerische Widerstand gegen Konventionen der Darstellung – was man die hermetische Tradition der Avantgarde nennen könnte – ist ihnen dabei erstmal fremd. Auch die Rituale der Purifikation, die Reinheit der Kunst sind nicht die ihren. Die Zusammenarbeit mit Architekten war ein wichtiger erster Anstoß, sich die Freiheit zu nehmen, sich der Frage, was eine Ausstellung sein kann, mit verschiedenen Quellen zu nähern und verschiedene Grenzen und Demarkationslinien zu überschreiten und zu hinterfragen. Für Architekturschaffende ist die Ausstellung ein Labor, ein Modellraum. In dieser Hinsicht am bedeutsamsten für mich ist meine Zusammenarbeit mit Eyal Weizman,[3] einem Architekten und politischen Theoretiker und Denker, der viele herausfordernde Gedanken rund um die Kartografie und effektive Produktion von faktenbasierten Ausstellungen entwickelt hat. Aus einer ganz anderen Genealogie als der künstlerischen Autonomie kommend, wird hier ernsthaft mit der Idee gearbeitet, aus der Belanglosigkeit des modernen Kunstraums auszubrechen. Ich wollte diese Verwendung der Ausstellung als kartografischen Modellraum zusammenbringen mit der Fähigkeit von Kunstwerken, das Subjekt/Objekt-Verhältnis zu dynamisieren und ontologisch zu destabilisieren. Daraus hat sich für mich die Haltung entwickelt, die Ausstellung als eine Art Labor für die Geschichtsschreibung der Grenzzonen oder „Frontiers", der Grenzregime und ihrer medialen Architekturen (zu denen Subjekt/Objekt-Verhältnisse natürlich primär gehören) zu verstehen. Und danach zu fragen, ob die Ausstellung nicht als eine Art ontologisches Labor funktionieren könnte?

Das wichtigste in der Entwicklung einer reflexiven thematischen Ausstellung ist die Produktion einer Definitionskrise. Was zu Beginn als faktisch Gegeben erscheinen mag, muss radikal in Zweifel gezogen werden: nicht nur die Bedeutung z.B. eines Objekts, sondern das, was es ist. Dazu gehört die Gegebenheit der Kunst natürlich auch, aber zuallererst ist es immer das Thema einer Ausstellung, dessen Ausstellbarkeit *als Gegenstand* infrage gezogen werden

6 Max Horkheimer and Theodor W., Adorno, *Dialectic of Enlightenment*, trans. by John Cumming, (New York, 1972), p. 3.

7 This quote was taken from the first preface to Michel Foucault's, *Madness and Unreason* (Paris, 1972), later renamed as Madness and Civilization.

1 Der vorliegende Text beruht auf einem Vortrag anlässlich des Symposiums „Between the Discursive and the Immersive: Research in 21st Century Art Museums" im Louisiana Museum of Modern Art, Kopenhagen, 3.–4. Dezember 2015. Der Vortrag kann online unter https://vimeo.com/157267704 aufgerufen werden.

2 Von Francesco Manacorda beim selben Symposium eingebrachte Formulierung.

3 Eyal Weizman und Anselm Franke ko-kuratierten die Ausstellungen „Territories", KW Institute for Contemporary Art, Berlin 2003 und „Forensis", HKW Berlin, 2014.

muss. Die Objektwerdung gilt es zu beleuchten, und mit der Subjektwerdung zu verbinden, und das ist fast immer mit destabilisierenden ästhetischen Erfahrungen verbunden, es geht also um eine ontologische Destablisierung der Wahrnehmung und Denkkategorien über die in der Repräsentation wirkende Zeichenmagie. Man sagt ja auch, Kunst produziere keine eindeutigen Bedeutungen, sondern werfe uns auf unsere Hintergrundannahmen zurück, über die wir erst Bedeutung produzieren. Auch das ist schon eine Destabilisierung. Aber diese Hintergrundannahmen sind ja keineswegs etwas rein Individuelles: sie sind vielmehr kollektiv und historisch. Das besondere an der sogenannten Essay-Ausstellung ist, dass sie neben den (Kunst-)objekten diese Hintergrundannahmen gleichermaßen adressiert. Die durch Kunst reflektierten Hintergrundannahmen müssen gleichsam aufgefangen werden und in eine Erzählung überführt werden, die dann umgekehrt das Sehen verändert, etwa indem der Prozess des „Aspektwechsels", den man von sogenannten Kippbildern kennt, zwischen Bild und Erzählung oszillieren lässt.

Die Essay-Ausstellung ist eine Form der thematischen Ausstellung, die sich primär an den Positivismus wendet, der sich im Format der Ausstellung selbst historisch eingeschrieben hat, vor allen Dingen über die für die Ausstellung so relevante bürgerliche Gleichsetzung von Wissen und Sichtbarkeit. Der Ausgangspunkt sind deshalb auch die künstlerischen Methoden der Repräsentations- und gar der Institutionskritik und auch die Brecht'schen Methode „Das Zeigen muss gezeigt werden!" Essay-Ausstellungen lehnen narrative Unschuld ab, um anstelle dessen von der Geschichte von Repräsentationspraktiken zu sprechen. In einer Essay-Ausstellung wird die Kunst zu einem Medium der Forschung, in genau (und ausschließlich) dem Sinne, wie sie Grenzen positiven Wissens überschreitet und sich der Schließung symbolischer Systeme widersetzt. Der Unterschied zwischen einer Essay-Ausstellung und jeder anderen Form thematischer oder kultur- und wissenschaftshistorischer Ausstellung liegt in dem Status, den sie der Kunst als Kunst und als epistemologischem Model zugesteht. Kunst durchquert die Wissensformen, Disziplinen und Zeichenregimes. Durch die Kunst erst wird die Ausstellung in die Lage versetzt, ein reflexiver Raum zu werden und eine Kritik positivistischen Wissens im Regime der Sichtbarkeit und des Objektivismus selbst zu artikulieren. Die Kunst kann durch diese Form der „Rahmung" dem üblichen „Tod durch Musealisierung" entgehen. Ihre Fähigkeit, Faktizität als solche herauszufordern und die Gegebenheit von etwas grundlegend infrage zu stellen, wird nicht quasi disziplinarisch kaltgestellt, wie das so häufig passiert.

Der Begriff der „Frontier" ist nun wesentlich, um innerhalb der Ausstellung ein kohärentes Verhältnis herstellen zu können zwischen den Grenzen von Gemeinschaft und Gesellschaft und ästhetischen Erfahrungen. Es gibt zahlreiche einfache Beispiele, um dieses Verhältnis zu veranschaulichen: die Ästhetik von Monstern etwa. Es ist bekannt, dass jeder Normalisierungsprozess die Wahrnehmbarkeit dieser engen Verbindung von Ästhetik und sozialen Grenzen und Differenzen im Rahmen einer ontologischen Stabilisierung zum Verschwinden bringt. Es gilt erst einmal all das, was während des Prozesses der Normalisierung nach außerhalb projiziert und ausgelagert wurde, zu re-importieren, um zu einem Punkt ontologischer Voraussetzungslosigkeit zu gelangen. Es ist methodisch notwendig, vom imaginären Standpunkt eines Ungeteilten auszugehen, um auf die Logik von Teilungen zu blicken – sonst kommt man über die ontologische und ideologische Fixierung der Wirklichkeit, als einem Effekt von Grenzpraktiken, nicht hinaus. Was wir als mehr oder weniger klar gezogene Linien zwischen existierenden Entitäten wahrnehmen, wird durch den Begriff der Frontier aufgespalten und wie von Innen beleuchtet. Denn Grenzziehungen sind niemals eindeutig, sondern immer fluktuierend, je näher man an sie herantritt.

Die Ausstellung „The Whole Earth", die Diedrich Diederichsen und ich 2013 realisiert haben, war eine solche Geschichte einer „Frontier".[4] Vielleicht ist dies die Ausstellung, die der Sache am nächsten kam, von der die meisten Lehrmeister des Kuratierens abraten, eine Ausstellung wie ein Buch. „The Whole Earth" war ein Archiv, ein Bildraum eines epistemisch-popkulturellen Epochenparadigmas, das mit der Fotografie der Erde aus dem All einen Erwartunghorizont verband. Organisiert in knapp zehn Kapiteln und mit zahlreichen Kunstwerken dazwischen erzählte die Ausstellung von einer epochalen Transformation der „Frontier", die wir geografisch mit Kalifornien in Verbindung bringen können: die Transformation der für die USA so identitätsstiftenden horizontal-expansiven kolonialen Frontier, die auch mit linearen Zeitmodellen der Kausalität und des Fortschritts korrespondiert, zur zuerst ins Weltall erweiterten und dann auf die Erde zurückgefalteten und diese einhüllenden Frontier. Sie ist zu einem planetarischen, technologischen Volumen geworden, in dem wir uns bewegen – und das auch den Namen „Anthropozän" trägt. Den Transformationen der Frontier entsprechen aber immer auch Transformationen des Denkens und des Denkbaren: in diesem Fall findet das seinen Niederschlag in den zirkulären Modellen, wie sie für die Kybernetik kennzeichnend sind, die ja auch Modelle einer Einschließung sind.

Eine weitere Essay-Ausstellung in diesem Sinne war „Animismus".[5] Animismus

als Begriff ist selbst ein Instrument der Grenze, das man nicht einmal verwenden kann, ohne Unterscheidungen zu treffen, Abgrenzungen und Trennlinien zu ziehen, die selbst Teil einer großen historischen Genese sind – einer kolonialen Moderne. Die zentrale Grenze ist natürlich die zwischen Leben und Nicht-Leben, und zwischen Ding und Person, Subjekt und Objekt: Animismus bezeichnet meist die Abwesenheit oder Transgression dieser Unterscheidungen, und damit wird er selbst als Begriff zu einem Instrument der „Frontier". Das dämonischste Gesicht dieser Grenze ist dasjenige, das eine Genealogie des Denkens und eine Tradition der Ästhetik mit einem Kontinuum des Völkermords in der Moderne oder in den Grenzzonen der Moderne mit dem verbindet, was der Moderne quasi unweigerlich weichen muss. In der *Dialektik der Aufklärung* von Adorno und Horkheimer heisst das dann: „Aufklärung ist die Entzauberung der Welt", und „die Entzauberung der Welt ist die Ausrottung des Animismus."[6] Von da ist es nicht weit zur Bereitschaft zur Ausrottung sogenannter Animisten, d.h aller derjenigen, die die Welt nicht im instrumentell-kapitalistischen Sinne trennen. Wie verhalten sich diese Grenzziehungsprozesse zur Ästhetik? Im Fall etwa von Freuds Aufsatz über „Das Unheimliche" lässt sich das nachvollziehen und eine Verbindung herstellen zwischen Ästhetik, Subjektkonstitution und kolonialer „Frontier". Der Moment des „Unheimlichen" nämlich wird von Freud als eine Grenzüberschreitung beschrieben, in der der „überwundene" Animismus wiederkehrt, und das tote Objekt plötzlich wieder subjektive Züge trägt und animiert wird. Und diese Überschreitung ist zentral für die ästhetische Wahrnehmung ebenso wie für die Stabilität des bürgerlichen Subjekts. Die Ausstellung versuchte also, die ästhetische Frage der Animation in ein Verhältnis zu setzen mit der kolonialen „Frontier". Dabei ist der Animismus natürlich nicht nur der negative Horizont der Moderne, den man hinter sich lassen und zerstören muss, um modern zu werden. Sondern er begegnet uns auch in der Zukunftsvorstellung der Moderne: als utopischer Horizont, etwa bei Marx im Sinne einer „Rehumanisierung" der Welt. Desweiteren habe ich versucht, den Begriff zum Ausgangspunkt für Reflektionen über Medialität zu machen, eben zum Begriff einer entgrenzten Medialität und deren paradoxem Status in der Moderne, zwischen kapitalistischer Abstraktion und Entgrenzung, und disziplinarischer Zurichtung.

Abschließend möchte ich auf ein Zitat zu sprechen kommen, das ein wichtiges Denkwerkzeug darstellt, um den repräsentativen Triumphalismus in der Rahmung von Geschichtsschreibungen der Grenzzone herauszufordern. Es stammt von Michel Foucault:

„Man könnte eine Geschichte der Grenzen schreiben – dieser obskuren Gesten, die, sobald sie ausgeführt, notwendigerweise schon vergessen sind – mit denen eine Kultur zurückweist, was für sie außerhalb liegt; und während ihrer ganzen Geschichte sagt diese geschaffene Leere dieser freie Raum, durch den sie sich isoliert, ganz genau soviel über sie aus wie über ihre Werte; denn ihre Werte erhält und wahrt sie in der Kontinuität der Geschichte aber in dem Gebiet, von dem wir reden wollen, trifft sie ihre entscheidende Wahl. Sie vollzieht darin die Abgrenzung, die ihr den Ausdruck ihrer Positivität verleiht."[7]

Dieses Zitat umschreibt sehr deutlich, was die Herausforderungen an die Historiografie der „Frontier" sind: Eine Arbeit gegen ein fundamentales Vergessen und eine Arbeit an Gesten, die zwischen dem Sag- und Zeigbaren und seinem Anderen vermitteln. So wird deutlich, dass die Essay-Ausstellung ein dialektischer Bildraum sein muss, der vom Ausgangspunkt der Ungetrenntheit die Trennungen nachvollzieht, ohne diese dabei festzuschreiben und als gegeben zu akzeptieren. Jede Trennung wird als negiert: Begrenzung und Entgrenzung treffen aufeinander in jenem medialen Nexus zwischen Subjekt und Objekt, den die Kunst aufmacht. ∎

Übersetzung: Anselm Franke

4 „The Whole Earth", Ausstellung kuratiert von Anselm Franke und Diedrich Diederichsen im Berliner Haus Kulturen der Welt/HKW vom 26. April bis 7. Juli 2013

5 Erstmals kuratiert von Anselm Franke in der Extra City Kunsthal, Antwerpen, von 22. Januar–2. Mai 2010 und danach in der Generali Foundation Wien, der Kunsthalle Bern, dem Haus der Kulturen der Welt, Berlin; e-flux, New York; Ashkal Alwan, Beirut; OCAT, Shenzhen und dem Ilmin Museum of Art, Seoul.

6 Adorno, Theodor W./Horkheimer, Max: *Dialektik der Aufklärung. Philosophische Fragmente*, Amsterdam 1968, 19f.

7 Foucault, Michel: *Wahnsinn und Gesellschaft*, Frankfurt 1969, 9.

Exhibiting
—
Sites of Departure

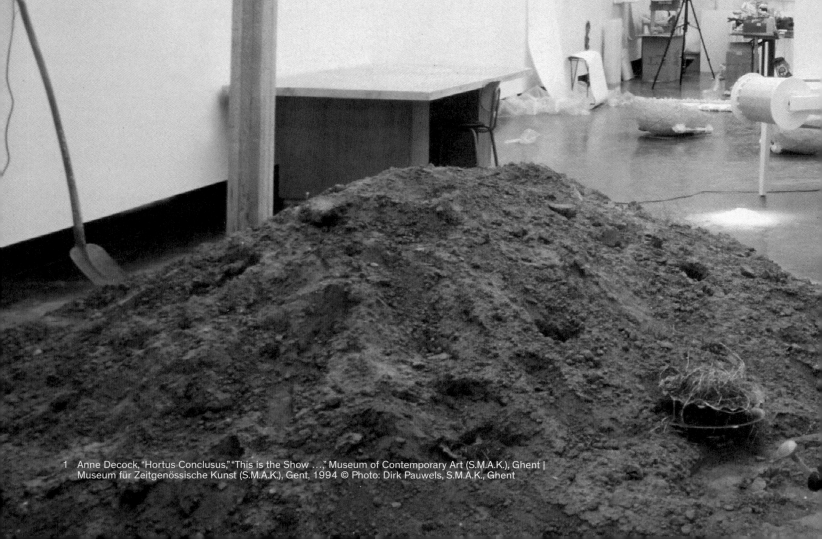

For an "Enacted Space in Which the Work of Art Can Happen Together with Us"

Für einen „inszenierten Raum, in dem sich das Kunstwerk gemeinsam mit uns ereignen kann"

Bart De Baere (BDB), Director of the Museum of Contemporary Art Antwerp (M HKA) |
Direktor des Museums für zeitgenössische Kunst Antwerpen (M HKA) in Conversation with |
im Gespräch mit **Milica Tomić** und | and **Dubravka Sekulić (GAM)**

1 Anne Decock, "Hortus Conclusus," "This is the Show ...," Museum of Contemporary Art (S.M.A.K.), Ghent | Museum für Zeitgenössische Kunst (S.M.A.K.), Gent, 1994 © Photo: Dirk Pauwels, S.M.A.K., Ghent

While the role of the exhibition as a media form and its history have only come to be examined in depth in the last decade, this renewed interest can invariably be traced back to the 1994 exhibition "This is the Show and the Show is Many Things"[1] at the Museum of Contemporary Art (S.M.A.K.) in Ghent. By treating the structure of the exhibition as a "flexible matter" in which the space of relations was continuously re-defined through an open exposure model and the "real-time" work of artists, curators, outside people and authors, and, vitally, the visitors interacting with the artworks, curator Bart De Baere blurred the traditional boundaries of the "exhibition," refuting not only the conception of art as a final product, but also the supremacy of authorship. In this conversation, de Baere joins *GAM* to discuss the past and future trajectory of "This is the Show ..." as well as curatorial practice and its socio-political implications.

GAM: Can we consider your exhibition, "This is the Show and the Show is Many Things," held in 1994 at S. M. A. K. in Ghent, as a research model in which contemporary art as we knew it can have turned into a societal place, a space not locked in by bourgeois structuring—that it was an attempt to think of an exhibition outside of a materialistic value system and the conventional attitudes within a traditional museum?

BDB: At that moment I just said: I have a naïve dream, and I will share this with artists and we will develop the way to go about this together. It was the time of the "exhibition maker," heroes like Harald Szeeman or Jan Hoet that were at par with artists, preceding the notion of the curator as the main author enrolling works of art and other people in their project. I decided to be open. During the exhibition trajectory, several artists wanted me to be more pro-active and Jason Rhoades even became quite angry with me, because I refused to take upon myself the role of a director, to steer and decide when there were conflicts. I thought, "If I intervene, the space will close down." I wanted the show to be a heterotopia, not a success. Part of that was the idea, a threat that any moment of the exhibition can become a commodity, a product. If we speak, if you speak, if I say something, if you move, if I move, even if it would only last a second, that may be commodified.

In a certain way, I had a trust in visitors—or perhaps even more so, in art—and I believed that attentive visitors would be able to distinguish between the most emphemeral expressions of art on the one hand, and the most long lasting expressions on the other, and many different modes of existence in between those two, and that the difference between them would enhance clarity,

artistic proposals generating a space precisely because of their difference, like an ecosystem, with very diverse kinds of artistic proposals at the same time that would co-exist and might even literally overlap one another without disturbing one another.

GAM: In 1992 you were a part of Jan Hoet's curatorial team at documenta IX, which was considered to be one of the ground breaking documenta exhibitions. How did this curatorial task change or influence your approach to exhibiting?

BDB: The experience at documenta IX was, of course, a major influence on me. At the same time, this was happening at a very strange moment in history, the end of the bipolar world system, and it marked the beginning of a new epoch. Jan Hoet, the artistic director of documenta IX, invited three curators from different areas of Europe. I was a northern one, with Pier Luigi Tazzi and Denys Zacharopoulos coming from Southern Europe, Italy, and Greece. Additionally, we were from three different generations, me being the youngest, and, most importantly, each of us was standing for different attitudes in relation to art.

Working on a documenta is an amazing experience, it is a kind of continuing stream of enhanced reality. It was even more so at that moment, when the internet was not yet there. When

1 In the following abbreviated as "This is the Show ...".

2–4

(2) Jason Rhoades, Mark Manders, Maria Roosen | (3) Mark Manders | (4) Honoré d'O
"This is the Show ...," Museum of Contemporary Art (S.M.A.K.), Ghent |
Museum für Zeitgenössische Kunst (S.M.A.K.), Gent, 1994
© Photos: Dirk Pauwels, S.M.A.K., Ghent

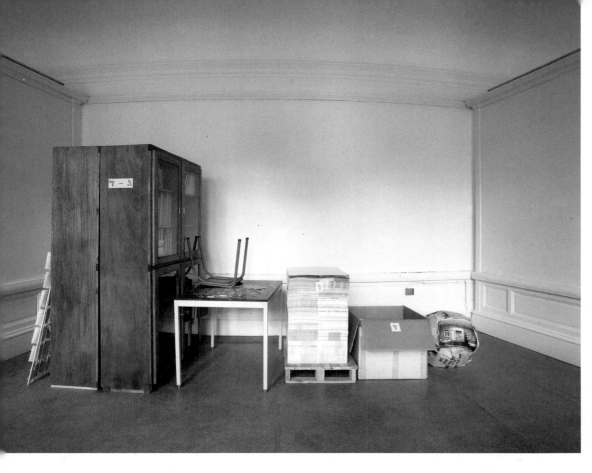

Obwohl die Rolle der Ausstellung als mediale Form und ihre Geschichte erst im letzten Jahrzehnt eingehender untersucht wurde, verweist dieses jüngste Interesse immer wieder auf die 1994 gezeigte Ausstellung „This is the Show and the Show is Many Things"[1] im Museum für zeitgenössische Kunst Ghent (S.M.A.K.). Indem ihr Kurator Bart De Baere die Struktur der Ausstellung als „elastische Materie" betrachtete, in der der Raum der Beziehungen durch ein offenes Präsentationsmodell und die „Echtzeit"-Arbeit der KünstlerInnen, KuratorInnen, Außenstehenden und AutorInnen, und vor allem der BesucherInnen, die mit den Kunstwerken interagieren, immer wieder neu definiert wurde, verwischte er die traditionellen Grenzen der „Ausstellung" und kritisierte damit nicht nur die Vorstellung von Kunst als Endprodukt, sondern auch die Dominanz der Autorenschaft. Mit *GAM* spricht de Baere über die historische und aktuelle Bedeutung von „This is the Show …", über den Stellenwert der kuratorischen Praxis, sowie deren gesellschaftspolitische Implikationen.

GAM: Können wir Ihre Ausstellung „This is the Show and the Show is Many Things", die 1994 im Museum für Zeitgenössische Kunst Gent stattfand, als ein Forschungsmodell betrachten, in dem die zeitgenössische Kunst, wie wir sie kannten, zu einem sozialen Ort werden kann, zu einem Raum, der nicht in bürgerliche Strukturen eingesperrt ist – dass es ein Versuch war, an eine Ausstellung außerhalb eines materialistischen Wertesystems und der konventionellen Standpunkte in einem traditionellen Museum zu denken?

BDB: Damals sagte ich nur: Ich habe einen naiven Traum, und ich werde ihn mit KünstlerInnen teilen, und wir werden ein Konzept dafür entwickeln, wie wir das gemeinsam angehen können. Es war die Zeit des „Ausstellungsmachers", dem die Vorstellung vorausging, dass der Kurator der ultimative Autor, der ultimative Held sei, wie Harald Szeeman oder Jan Hoet, die Kunstwerke und andere Menschen in ihr Projekt einschrieben. Ich entschied mich für Offenheit. Während der Ausstellungsdauer wollten mehrere KünstlerInnen, dass ich proaktiver agiere und Jason Rhoades wurde sogar ziemlich wütend auf mich, weil ich mich weigerte, die Rolle des Leiters zu übernehmen, zu steuern und zu entscheiden, wann immer es Konflikte gab. Ich dachte: „Wenn ich eingreife, wird der Raum geschlossen." Ich wollte, dass die Schau eine Heterotopie wird, kein Erfolg. Dazu gehörte auch die Idee, die Gefahr, dass jeder Augenblick der Ausstellung zur Ware, zum Produkt werden kann. Wenn wir sprechen, wenn Sie sprechen, wenn ich etwas sage, wenn Sie sich bewegen, wenn ich mich bewege, wenn auch nur für eine Sekunde, dann kann das eine Kommodifizierung sein.

In gewisser Weise hatte ich Vertrauen in die Besucher – oder vielleicht sogar noch mehr in die Kunst – und ich glaubte, dass aufmerksame Besucher in der Lage sein würden, zwischen den flüchtigsten Ausdrucksformen der Kunst auf der einen Seite und den langlebigsten Ausdrucksformen auf der anderen, und vielen verschiedenen Existenzformen zwischen diesen beiden zu unterscheiden, und dass der Unterschied zwischen ihnen die Klarheit verstärken würde, künstlerische Vorschläge, die gerade wegen ihrer Verschiedenheit einen Raum erzeugen, der sich wie

1 Im Folgenden abgekürzt als „This is the Show …".

you are at the center, when you are organizing the Olympic games for Contemporary Art, so to say, and you are the one who is deciding who is participating and who is not, anyone, any kind of piece of information you can imagine, is steered to you. All expectations are focused on you.

The pre-internet world was different in many ways from the world today. And within that documenta IX was a very particular experience, with a nearly religious zeal. You cannot imagine the intensity of the way in which documenta was prepared. It was a kind of military discipline, seven days a week. It would start between eight and nine o'clock in the morning, when Jan Hoet would drive by with his van and pick up Pier Luigi Tazzi and me, as we were living together at the time, and it would most often go on until eleven in the evening, when we would be dropped by the same van and go to sleep. What we basically did was discuss art, artists, their works, their meaning, and their possibilities. Over and over again. Day after day. Jan said that the four of us had to be convinced by each artist. All artists who were included in the show were decided by consensus with the four of us. If any one of us, Jan, or Pier Luigi, or Denys, or me, was not convinced, the artist was not included. The exhibition's hypothesis was gradually formulated during endless discussions. Also, I think it was the last exhibition in which gallerists were excluded. If they came to Kassel, they could not take part in the discussion when we were speaking about

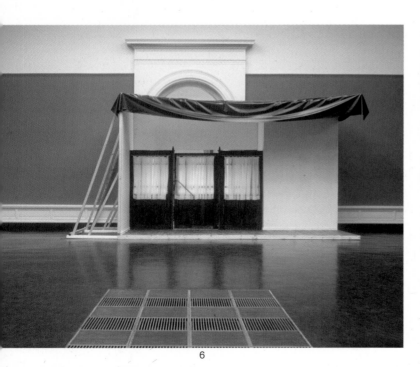

6

Fabrice Hybert, "Les vacances de Monsieur Hulot," "This is the Show …,"
Museum of Contemporary Art (S.M.A.K.), Ghent |
Museum für Zeitgenössische Kunst (S.M.A.K.), Gent, 1994
© Photo: Dirk Pauwels, S.M.A.K., Ghent

the exhibition with the artists, the gallerists were simply not allowed on the premises. So it was also really wanting to shape a space for art that was free, that was apart from the kind of commercialization of art that was unfolding at a high pace at that very moment.

GAM: Would you say that your exhibition "This is the Show …" was a radical follow-up to your work at documenta IX?

BDB: It was informed by it. The challenge for me was to find a different space to present art at large, a space that would not only be open to kinds of art I felt to be "classical" but also sensitive to different kinds of presences, for artists and projects that I had wanted to include in documenta, for example Mona Hatoum or young Gabriel Orozco, but had failed to get in. Or for artistic proposals that were part of it but were barely noticed, such as Eran Schaerf. In that sense, it was geared to the notion of exhibiting art, not to the exhibition as a format. The exhibition as a format was the tool. The notion of exhibiting was the target. For me it was really about basic questions: Can we generate a different kind of space in which art can appear differently? Can we make a different kind of museum based upon the specificity of artistic presences rather than the standardisation of exhibition codes?

"This is the Show …" was technically the first of the "process exhibitions," it became rapidly categorized as such, but it intended consciously to move beyond that. I was aware of the fact that in the early '90s we came out of a period in which art had been reduced to commodity and objecthood in a way that had been unseen in the decades before. So art was glossy and shiny. It doesn't take much intelligence to intuit that the next thing is going to be the opposite: "process." But then you are also aware that most often, the "next thing," will actually be immediately reduced to something akin to the same thing as before. So I could easily predict that probably the next thing lining up to be commodified was going to be something like a process, which is also what happened. I thought, can't we do something that is so precise that it avoids this double reduction?

GAM: Peggy Phelan in her essay "The Ontology of Performance" uses the term "performance" in a broader sense, not only as a media-specific category, but as a singular moment, as an act and space of exposure. For Phelan, performance is thus that which disappears. It produces blind images and un-static objects which cannot be caught on media. Through the attempt to enter into the economy of reproduction through registration, performance

152

ein Ökosystem verhält, mit sehr unterschiedlichen künstlerischen Vorschlägen, die gleichzeitig nebeneinander existieren und sich sogar buchstäblich überlappen, ohne sich gegenseitig zu stören.

GAM: 1992 gehörten Sie zum Kuratorenteam von Jan Hoet auf der documenta IX, die als eine der bahnbrechenden documenta-Ausstellungen gilt. Wie hat diese kuratorische Aufgabe Ihren Zugang zum Ausstellen verändert oder beeinflusst?

BDB: Die Erfahrung auf der documenta IX hat mich natürlich stark beeinflusst. Gleichzeitig geschah dies zu einem sehr merkwürdigen Zeitpunkt in der Geschichte, dem Ende des bipolaren Weltsystems, und er markierte den Beginn einer neuen Epoche. Jan Hoet, der künstlerische Leiter der documenta IX, lud drei Kuratoren aus verschiedenen Teilen Europas ein. Ich war der aus dem Norden, Pier Luigi Tazzi und Denys Zacharopoulos kamen aus Südeuropa, aus Italien und Griechenland. Außerdem gehörten wir drei verschiedenen Generationen an, wobei ich der Jüngste war, und jeder von uns vertrat eine andere Einstellung zur Kunst.

jeder Künstler uns alle Vier überzeugen musste. Alle KünstlerInnen, die an der Schau teilnahmen, wurden von uns Vieren einstimmig berufen. Wenn einer von uns, Jan, Pier Luigi, Denys oder ich, nicht überzeugt war, dann war der Künstler/die Künstlerin nicht dabei. Die Hypothese der Ausstellung wurde in endlosen Diskussionen nach und nach formuliert. Außerdem glaube ich, dass es die letzte Ausstellung war, in der Galeristen ausgeschlossen waren. Wenn sie nach Kassel kamen, konnten sie nicht an der Debatte teilnehmen, wenn wir mit den KünstlerInnen über die Ausstellung sprachen. Die GaleristInnen durften einfach nicht aufs Gelände. Es war also wirklich auch der Wunsch, einen Raum für freie Kunst zu gestalten, fernab der Formen der Kommerzialisierung von Kunst, die sich gerade in jenem Moment mit hohem Tempo entfalteten.

GAM: Würden Sie sagen, dass Ihre Ausstellung „This is the Show …" eine radikale Fortsetzung Ihrer Arbeit auf der documenta IX war?

BDB: Sie war davon durchdrungen. Die Herausforderung für mich bestand darin, einen anderen Raum zu finden, um Kunst

7–9

"This is the Show …," installation views | Ausstellungsansichten, (7) Anne Decock | (8–9) Mark Manders, Museum of Contemporary Art (S.M.A.K.), Ghent | Museum für Zeitgenössische Kunst (S.M.A.K.), Gent, 1994 © Photos: Dirk Pauwels, S.M.A.K., Ghent

Die Arbeit auf einer documenta ist eine unglaubliche Erfahrung, eine Art kontinuierlicher Strom erweiterter Wirklichkeit. Umso mehr in jener Zeit, als das Internet noch nicht da war. Wenn man im Zentrum steht, wenn man sozusagen die Olympischen Spiele für zeitgenössische Kunst organisiert und man selbst entscheidet, wer teilnimmt und wer nicht, dann wird man auf jeden Fall auf jede erdenkliche Information aufmerksam gemacht. Alle Erwartungen sind auf dich gerichtet.

Die Welt vor dem Internet war in vielerlei Hinsicht anders als die heutige Welt. Und der documenta IX wohnte eine ganz besondere Erfahrung inne, die von einem fast religiösen Eifer angetrieben wurde. Man kann sich die Intensität der Vorbereitung auf die documenta gar nicht vorstellen. Das war eine Art militärischer Drill, sieben Tage die Woche. Es ging zwischen acht und neun Uhr morgens los, wenn Jan Hoet, Pier Luigi Tazzi und mich mit seinem Van abholte, da wir damals zusammenwohnten, und es ging meistens bis elf Uhr abends weiter, wenn wir vom selben Van abgesetzt wurden und schlafen gingen. Was wir im Grunde genommen taten, war, über Kunst, KünstlerInnen, ihre Werke, ihre Bedeutung und ihre Möglichkeiten zu diskutieren. Immer und immer wieder. Tagein, tagaus. Jan sagte, dass

im großen Stil zu präsentieren, einen Raum, der nicht nur für Kunstrichtungen offen sein würde, die ich als „klassisch" empfand, sondern auch für andere Formen der Präsenz, für KünstlerInnen und Projekte, die ich in die documenta aufnehmen wollte, wie z.B. Mona Hatoum oder den jungen Gabriel Orozco, aber letztlich nicht konnte. Oder für künstlerische Positionen, die dabei waren, aber kaum wahrgenommen wurden, wie beispielsweise Eran Schaerf. In diesem Sinne orientierte sie sich an der Vorstellung, Kunst auszustellen, nicht an der Ausstellung als Format. Die Ausstellung als Format war das Instrument. Die Vorstellung vom Ausstellen war das Ziel. Für mich ging es wirklich um grundlegende Fragen: Können wir einen anderen Raum erzeugen, in dem Kunst anders erscheinen kann? Können wir eine andere Art von Museum schaffen, die auf der Spezifik der künstlerischen Präsenzen und nicht auf der Standardisierung von Ausstellungscodes beruht?

„This is the Show …" war technisch gesehen die erste „prozessuale Ausstellung" und wurde rasch als solche kategorisiert, wollte aber bewusst darüber hinausgehen. Mir war bewusst, dass wir Anfang der 1990er Jahre aus einer Zeit kamen, in der die Kunst auf eine Art und Weise, wie sie in den Jahrzehnten

diminishes the promise that lies in its characteristic ontology. In a way, you refused to document the exhibition "This is the Show …". This was an interesting moment, because for art and art history, documentation plays a crucial role. Do you consider the processes of recording, documenting, or archiving counterproductive to your approach of exhibiting and, if so, why?

BDB: I was from the beginning aware that we were part of interesting developments in contemporary arts and that the exhibition might raise interest in the future, documenta IX was somehow a turning point and so was the whole period, the post Second World War system was falling apart and a much more open world starting to appear. If I had just kept all of my sheets of paper and photos, I guess now I would have a major archive that I could sell to the Getty. One of the artists that has been important for me very early on was Thierry De Cordier. I was discussing with him, how do you want to document a perfor-

GAM: What would be, in your opinion, the difference between conventional and procedural exhibitions? In "This is the Show …," I felt the process was rather delivered as a kind of accidental necessity of what happened there.

BDB: If I'm not mistaken it was the first exhibition ever that had extensive side programs, something that by now has become a standard practice for large exhibitions. Now it's normal to have an exhibition and you have two or three people coming to speak in the evenings. It didn't happen at that time. But in "This is the Show …" there were about 40 or 50 of these events. I tried to massively cultivate and stimulate that. I wrote letters to all the professors of the university asking, "Would you be interested in coming to speak about something, within this frame?" and some of them reacted.

To my knowledge, it was the first time ever that there was a whole dance section in an exhibition of contemporary art. Meg Stuart and Damaged Goods, a large company of a leading

10–12

"This is the Show …," installation views | Ausstellungsansichten, (10) Honoré d'O, Suchan Kinoshita, Dirk Pultau | (11) Suchan Kinoshita, Anne Decock, Mri Tzaig | (12) visitors | BesucherInnen, Museum of Contemporary Art (S.M.A.K.), Ghent | Museum für Zeitgenössische Kunst (S.M.A.K.), Gent, 1994 © Photos: Dirk Pauwels, S.M.A.K., Ghent

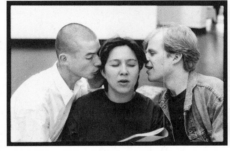 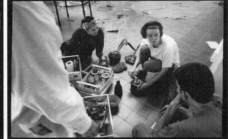 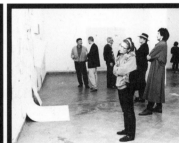

mance? Do you want to document a performance or does it actually become stronger if there is no documentation of it whatsoever, but only the memory, only the narrative. That was part of my mind set at that moment. So I decided not to do that for "This is the Show …" and to just let it … But at the same time I was happy there was a very good photographer around, Dirk Pauwels, who really understands art and who does document things to some extent. I'm well aware of the fact that nowadays the production of a reflection frame, the reflection around your work, may be part of the work. I also tried not to produce that. I withheld the main text I had written for myself in preparation of the event, to publish it only afterwards in *Art & Museum* journal. Like I decided not to be a "director." And I decided not to be a archivist because then you somehow lose the space of life, and I wanted to give myself some relativity to think through.

choreographer, came for a whole weekend and danced all over the exhibition. Donna Uchizono, a New York based choreographer who had been visiting the preparation to "This is the Show …" before it opened, worked with Christine de Smedt, a Belgian choreographer, sending her the exhibition choreographical proposals by fax. Christine would then dance them in the exhibition during the opening hours. She was giving feedback and there was dance coming back. We also invited the Israeli dance theoretician Amos Hetz to discuss his notation system for dance. So, dance was a kind of specific section within all these temporary events.

There was not only one point in which things were happening, but all of the time, and in different spaces, even outside of the building, and in the evening, not only during the opening hours. So, it started before it started and it continued after it ended.

Mark Manders was showing a film he had made. There were all kinds of ephemeral things happening, some announced

zuvor nicht zu sehen war, auf Ware und Objekthaftigkeit reduziert worden war. So war Kunst funkelnd und auf Hochglanz poliert. Es braucht nicht viel Intelligenz, um zu erahnen, dass das nächste große Ding das Gegenteil sein würde: „Prozess". Aber dann ist einem auch bewusst, dass das nächste Ding eigentlich zumeist sofort auf etwas reduziert wird, was dem vorherigen ähnlich ist. So konnte ich leicht voraussagen, dass wahrscheinlich das nächste, was sich auf dem Weg zur Kommerzialisierung befand, so etwas wie ein Prozess sein würde, was auch passiert ist. Ich dachte, können wir nicht etwas tun, das so präzise ist, dass es diese doppelte Reduktion vermeidet?

GAM: In ihrem Essay „The Ontology of Performance" verwendet Peggy Phelan den Begriff „Performance" in einem weiteren Sinne, nicht nur als medienspezifische Kategorie, sondern als singulären Augenblick, als Akt und Raum der Exponierung. Für Phelan ist Performance also das, was verschwindet. Sie erzeugt blinde Bilder und unstatische Objekte, die sich nicht auf Medien einfangen lassen. Durch den Versuch, durch ihre Aufzeichnung in die Ökonomie der Reproduktion einzutreten, schmälert die Performance das Versprechen, das in ihrer spezifischen Ontologie liegt. In gewisser Weise haben Sie sich geweigert, die Ausstellung „This is the Show …" zu dokumentieren. Das war ein interessanter Moment, denn für Kunst und Kunstgeschichte spielt die Dokumentation eine entscheidende Rolle. Halten Sie die Prozesse der Aufzeichnung, Dokumentation oder Archivierung für kontraproduktiv zu Ihrem Ausstellungsansatz und wenn ja, warum?

BDB: Mir war von Anfang an bewusst, dass wir an interessanten Entwicklungen in der zeitgenössischen Kunst beteiligt waren und dass die Ausstellung das Interesse für die Zukunft wecken könnte. Die documenta IX war irgendwie ein Wendepunkt, wie die Zeit damals überhaupt: Das Nachkriegssystem zerfiel und eine viel offenere Welt begann in Erscheinung zu treten. Wenn ich nur alle meine Blätter und Fotos behalten hätte, würde ich jetzt wohl ein großes Archiv haben, das ich an Getty Images verkaufen könnte. Einer der Künstler, der mir schon sehr früh wichtig war, war Thierry De Cordier. Ich habe mit ihm diskutiert, wie wir eine Performance dokumentieren wollten. Wollen

wir eine Performance dokumentieren oder hinterlässt sie eigentlich einen stärkeren Eindruck, wenn es keine Dokumentation gibt, sondern nur die Erinnerung, nur die Erzählung? Das war ein Teil meiner Denkweise damals. Also entschied ich mich, das für „This is the Show …" nicht zu tun und es einfach zu lassen. Aber gleichzeitig war ich froh, dass es einen sehr guten Fotografen gab, Dirk Pauwels, der Kunst wirklich versteht und die Dinge teilweise dokumentierte. Ich bin mir der Tatsache bewusst, dass heutzutage die Schaffung eines Reflexionsrahmens, die Reflexion um deine Arbeit herum, Teil der Arbeit sein kann. Ich habe auch versucht, ihn nicht zu schaffen. Den Haupttext, den ich zur Vorbereitung der Veranstaltung für mich selbst geschrieben hatte, habe ich zurückgehalten, um ihn erst danach in der Zeitschrift *Art & Museum* zu veröffentlichen. Genauso wie ich beschloss, kein „Leiter" zu sein. Und ich beschloss, kein Archivar zu sein, weil man dann irgendwie den Raum zum Leben verliert, und ich wollte mir selbst etwas Relativität zum Durchdenken einräumen.

GAM: Was wäre Ihrer Meinung nach der Unterschied zwischen konventionellen und prozessorientierten Ausstellungen? In „This is the Show …" empfand ich den Prozess eher als eine Art zufällige Notwendigkeit dessen, was dort geschah.

BDB: Wenn ich mich nicht irre, war das die erste Ausstellung überhaupt mit einem umfangreichen Rahmenprogramm, was mittlerweile zum Standard für große Ausstellungen geworden ist. Heute ist es normal eine Ausstellung zu haben, in der abends dann zwei drei Leute einen Vortrag halten. Damals war das nicht gang und gäbe. Aber im Rahmen von „This is the Show …" gab es etwa 40 oder 50 solcher Veranstaltungen. Ich habe versucht, das massiv zu kultivieren und zu fördern. Ich schrieb Briefe an alle Lehrenden der Universität, in denen ich fragte: „Wären Sie daran interessiert, in diesem Rahmen über etwas zu sprechen?" Und einige von ihnen reagierten darauf.

Meines Wissens war es das erste Mal, dass es in einer Ausstellung zeitgenössischer Kunst eine komplette Tanzsparte gab. Meg Stuart and Damaged Goods, eine große Kompanie

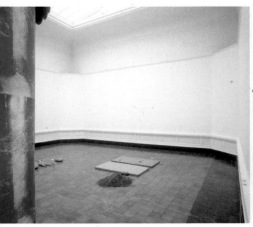

13–15

Mark Manders, "Moment Machine," "This is the Show …," Museum of Contemporary Art (S.M.A.K.), Ghent | Museum für Zeitgenössische Kunst (S.M.A.K.), Gent, 1994
© Photos: Dirk Pauwels, S.M.A.K., Ghent

and some unannounced. In a way, we tried to find the largest conceivable scope between the short momentary performance and those works done by artists like Donald Judd, with also art that was still being made.

The idea was that things have different ways of existing in time and that they might change, rather than that it would be about process. The initial proposal, developed together with the majority of the artists during a preliminary meeting, was that artists would come one month before the opening with materials that were nearly ready to become works of art, and that we would work on for one month. Then, at a certain moment, the exhibition would open, and after that the work would continue. Not by reducing the process, nor by celebrating it, but rather by aiming to be precise in every moment.

Artists are aspiring for very precise proposals. And part of such a proposal is always the way in which something wants to be presented. I believed, and still believe, that the constitution of art happens within any moment that expresses art. Any gesture that expresses art can be called an artwork, and any artwork is always more than itself. I'm not interested in what is seen as a commodity. Works of art are always more than mere commodities, you know, even if they look like commodities. The distinction between an artwork befitting to be a commodity and a so-called alternative to that categorized as a process is then made by asking a reductive, formalist, question: Does it move or does it not move? That is technical. There may be more interesting questions to be asked. How does it radiate? What would it want to happen? What are the possibilities that are offered here? And as a consequence: Where might we hang it or position it, or what kind of light might it like? Would it like to be positioned in a kind of a shade? Works of art don't necessarily want to be highlighted. Any work of art, any artistic gesture, allows for these kinds of speculations and that is a way to enhance the understanding of the work itself. I hope this doesn't sound too mystical. For example, "This is the Show ..." had Louise Bourgeois's spider family on display for the first time. That is amazing, I think. I put it in a cellar, because that's where it wanted to be. It had been made in the studio of Louise Bourgeois, which felt in the same way, kind of a cellar, so we placed it on the lower level, where you go to the restoration department, without daylight. That's as close as I could get to how her studio felt from which her spider family had emerged. Perhaps you can say that it's about finding a place that is fitting not only for the artwork but also for its mental place of origin.

16

Jason Rhoades, "PIG (Piece in Ghent)," "This is the Show ...," Museum of Contemporary Art (S.M.A.K.), Ghent | Museum für Zeitgenössische Kunst (S.M.A.K.), Gent, 1994 © Photo: Dirk Pauwels, S.M.A.K., Ghent

GAM: In a talk recently organized by Afterall in the "Exhibition History" series you said that "This is the Show ..." was also an attempt to investigate how different kinds of public space might be developed. You said that this exhibition was not thought of as a model for the future Museum of Contemporary Art in Ghent, but as a new space of art. Were all these side programs, together with what we today call the discursive part of an exhibition, an attempt to produce another kind of space, a societal space?

BDB: The initial image I had was that of an exhibition without walls, of a presentation of art, a space for art without walls. It is not about the architecture, that was part of it from the onset. It is about the art, it is the art that makes the space for art. When you radicalize that, you cease to think about walls. After having considered more radical spaces, such as an old fairground hall, I decided to do this exhibition in the museum, to avoid for it to be categorised as "alternative." The Contemporary Art Museum was then located in the spaces in the backside of the Fine Art Museum, a building that is an epitome of the late 19th century bourgeois museum. At that moment, pre-restoration, that building was magic, pure magic, with all its imperfections, the music of the loose tiles, the vibrations of the floors. Yet I had decided not to take seriously the setting of the bourgeois museum. Because of it being the setting and the friction to our aspiration, I also became aware of the fact that the Fine Art Museums of the 19th century were one of the public places of that bourgeois society, like the zoos founded by it, or the public squares of the time, these were places for the bourgeoisie to stroll and be visible and meet up, to own the public space in a certain way.

einer führenden Choreografin, kamen für ein ganzes Wochenende und tanzten im gesamten Ausstellungsbereich. Donna Uchizono, eine in New York lebende Choreografin, die die Vorbereitungen für „This is the Show …" vor der Eröffnung besucht hatte, arbeitete mit Christine de Smedt, einer belgischen Choreografin, zusammen und schickte ihr die choreografischen Vorschläge für die Ausstellung per Fax. Christine würde sie dann während der Öffnungszeiten in der Ausstellung tanzen. Sie gab Feedback, das als Tanz zurückgegeben wurde. Wir haben auch den israelischen Tanztheoretiker Amos Hetz eingeladen, um sein Notationssystem für Tanz zu diskutieren. Tanz war also eine Art spezifische Sparte innerhalb all dieser temporären Ereignisse.

Es gab nicht nur einen Punkt, an dem sich etwas ereignet hat, sondern die ganze Zeit über und an verschiedenen Orten passierte etwas, auch außerhalb des Gebäudes und am Abend, nicht nur während der Öffnungszeiten. Es ging also los, bevor es losging und ging weiter, nachdem es vorbei war. Mark Manders zeigte einen Film, den er gedreht hatte. Alle mögliche flüchtige

bringt, kann als Kunstwerk bezeichnet werden, und jedes Kunstwerk ist immer mehr als es selbst. Mich interessiert nicht, was als Ware angesehen wird. Kunstwerke sind bekanntlich immer mehr als bloße Waren, auch wenn sie wie Waren aussehen. Die Unterscheidung zwischen einem Kunstwerk, das sich als Ware eignet, und einer sogenannten Alternative zu dem, was als Prozess kategorisiert wird, erfolgt dann durch das Stellen einer reduktiven, formalistischen Frage: Bewegt es sich oder bewegt es sich nicht? Das ist technischer Natur. Es gibt vielleicht interessantere Fragen, die man stellen könnte. Welche Ausstrahlung hat es? Was würde es denn wollen? Welche Möglichkeiten bieten sich hier an? Und als Konsequenz daraus: Wo könnten wir es aufhängen oder platzieren, oder was für ein Licht könnte ihm gefallen? Möchte es in einer Art Schatten platziert werden? Kunstwerke wollen nicht unbedingt hervorgehoben werden. Jedes Kunstwerk, jede künstlerische Geste lässt solche Spekulationen zu, und das ist eine Möglichkeit, das Verständnis für das Werk selbst zu vertiefen. Ich hoffe, das klingt jetzt nicht zu

 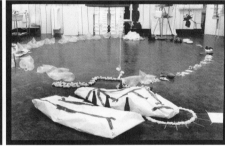

17—19

(17) Central Storage Space |
(18) Jason Rhoades "PIG" |
(19) Honoré d'O, installation,
"This is the Show …,"
Museum of Contemporary
Art (S.M.A.K.), Ghent |
Museum für Zeitgenössische
Kunst (S.M.A.K.), Gent, 1994
© Photos: Dirk Pauwels,
S.M.A.K., Ghent

Dinge passierten, manche angekündigt und manche unangekündigt. In gewisser Weise haben wir versucht, den größten denkbaren Rahmen zwischen der Kurzperformance des Augenblicks und den Arbeiten von Künstlern wie Donald Judd zu finden, auch mit Kunst, die noch im Entstehen begriffen war.

Die Idee war, dass die Dinge unterschiedliche Arten haben, in der Zeit zu existieren und dass sie sich ändern könnten, anstatt dass es sich um einen Prozess handeln würde. Der ursprüngliche Vorschlag, der zusammen mit der Mehrheit der Künstler in einem Vorgespräch entwickelt wurde, war, dass die Künstler einen Monat vor der Eröffnung mit Material kommen sollten, das fast bereit war, Kunst zu werden, und dass wir einen Monat lang daran arbeiten würden. Dann würde die Ausstellung zu einem bestimmten Zeitpunkt eröffnet werden und die Arbeit danach weitergehen. Nicht, indem man den Prozess reduziert oder feiert, sondern indem man versucht, in jedem Augenblick präzise zu sein.

Künstler streben nach sehr präzisen Positionen. Und Teil einer solchen Position ist immer die Art und Weise, wie etwas präsentiert werden will. Ich bin immer der Ansicht gewesen, dass sich die Kunst in jedem Augenblick konstituiert, der Kunst zum Ausdruck bringt. Jede Geste, die Kunst zum Ausdruck

mystisch. So zeigte „This is the Show …" zum Beispiel erstmals die erste Spinnenfamilie von Louise Bourgeois. Ich denke, das ist großartig. Ich habe sie in einen Keller gestellt, weil sie dort sein wollte. Sie war im Atelier von Louise Bourgeois entstanden, das sich auf die gleiche Weise wie ein Keller anfühlte, also haben wir sie auf der unteren Ebene platziert, wo man zur Restaurierungsabteilung geht, ohne Tageslicht. Das war meine größtmögliche Annäherung an die Atmosphäre ihres Ateliers, aus dem ihre Spinnenfamilie hervorgegangen war. Vielleicht kann man sagen, dass es darum geht, einen Ort zu finden, der nicht nur für das Kunstwerk, sondern auch für seinen geistigen Ursprungsort geeignet ist.

GAM: In einem Vortrag, der kürzlich von Afterall im Rahmen der „Exhibition Histories" Reihe organisiert wurde, sagten Sie, dass „This is the Show …" auch ein Versuch war, zu untersuchen, wie verschiedene Formen von öffentlichem Raum entwickelt werden könnten. Sie sagten, dass diese Ausstellung nicht als Modell für das zukünftige Museum für zeitgenössische Kunst in Gent gedacht war, sondern als ein neuer Kunstraum. Waren all diese Nebenprogramme, zusammen mit dem, was wir heute den Diskurs-Teil einer Ausstellung nennen, ein Versuch, einen anderen Raum, einen gesellschaftlichen Raum zu schaffen?

Belgium is the epitome of the bourgeois tradition. When the country was founded in 1830, it was basically run like a private company. There were 30,000 people who had voting rights, they were the shareholders, and the king was the CEO of the company, and these people thought, in their paternalistic superiority, that they were the public. Remember, Antwerp, the city I am living and working in now, is the place where Thomas Moore wrote *Utopia*, but it is also intimately linked to Joseph Conrad's *Heart of Darkness*. Antwerp is in its present shape, like the whole of Belgium, a physical emanation of colonialism. And you have to be aware of all of this when you are starting something there. This dream of the museum is the dream of reflexivity. While I wanted to go radically beyond the bourgeois museum, in retrospect, I think I was also informed by it. Of course, what I really wanted was a future form of a public square. Publicness in the sense of a place of awareness, believing also that art can indicate things about how society might function, how we might look at the world, all these kinds of existential questions. The space of art and for art, the space made by art, might be a space that, in an intense way, would be loaded with the intensity that is the potential of art.

Together with the artists we developed a radical functional differentiation of the spaces but beside that there was also this kind of strangeness, an organic coming about of a vast program of moments and activities, of which part corresponded with what would later become the side programs in exhibitions.

works and artists in a dynamic and open way. Using the Creative Commons license, the M HKA Ensembles application builds a sustainable infrastructure that can be seen as the extension and contribution of the museum to public space. Did you see "Ensembles" as a necessity to challenge exhibitions as a form, an how does it change the institution, where you have been director since 2002?

BDB: I think "Ensembles" is a different take. Exhibitions ought to change after we had been able to ask ourselves "What is a kind of enacted space in which the work of art can happen together with us?" It is very strange for me that curators who came into existence after this moment conceive their exhibitions without an audience. For me it is all about a kind of dance between people, the experiences of the world, and the art. It is about experience and reflection.

"Ensemble" is a different, reflective space. By changing the notion of exhibiting into an endless multitude of presences, of intensities, of reflecting on a moment, I tried to take the complexity of art seriously. If you do that, if you look even a little tiny bit attentively to what artists are doing, not too seriously, just a little bit, you'll see that what artists offer is infinitely more complex than anything the art markets are accepting. It is the same whether it is the market of buyers, of private collectors, the market of media attention, the market of exhibitions on

20—22

(20) Honoré d'O | (21) Louise Bourgeois | (22) Maria Roosen, "This is the Show …," Museum of Contemporary Art (S.M.A.K.), Ghent | Museum für Zeitgenössische Kunst (S.M.A.K.), Gent, 1994 © Photos: Dirk Pauwels, S.M.A.K., Ghent

GAM: Following M HKA's core task to "present an art hypothesis to the public" based on the understanding that a museum of contemporary art must continually challenge its views on artists, the public, and society, as well as on the past, present, and future, you have been developing your own digital platform, M HKA Ensembles, where the insight and vision of art can continuously live, and be reconsidered and reformulated. The M HKA Ensembles bring together in digital form the immaterial heritage related to what is considered "secondary sources" related specific art works and artists, seeing them as often equally important manifestations of artistic energy that enable correlations and connections between

offer, because they are all markets in some way. The complexity of what artists are doing is of such a vastly higher dimension than what any of these markets is accepting. If you would take art seriously, in a reflective way, you could try to look a little bit at what one specific artist is proposing, in all the diversity and specificity of that proposal, which includes being a bit attentive to the titles, to how artists speak about their work, to how they put it in space and in time and how they relate it to

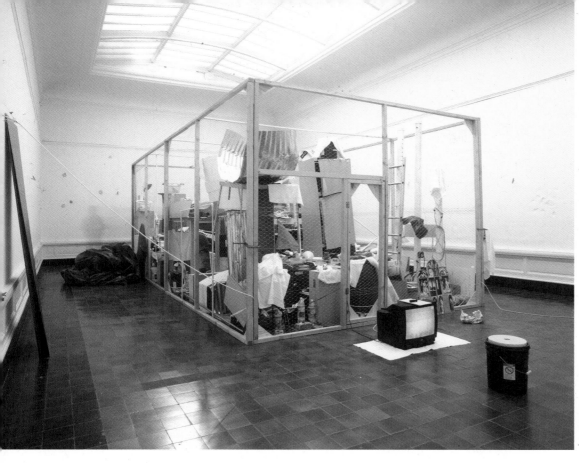

23

Jason Rhoades, "PIG (Piece in Ghent),"
"This is the Show …," Museum of
Contemporary Art (S.M.A.K.), Ghent |
Museum für Zeitgenössische
Kunst (S.M.A.K.), Gent, 1994
© Photo: Dirk Pauwels, S.M.A.K., Ghent

BDB: Das erste Bild, das ich hatte, war das einer Ausstellung ohne Wände, einer Präsentation von Kunst, eines Raumes für Kunst ohne Wände. Es geht nicht um die Architektur, die von Anfang an ein Teil davon war. Es geht um die Kunst. Es ist die Kunst, die den Raum für die Kunst macht. Wenn man das radikal denkt, hört man auf, über Wände nachzudenken. Nachdem ich radikalere Orte in Erwägung gezogen hatte, wie zum Beispiel eine alte Jahrmarktshalle, beschloss ich, diese Ausstellung im Museum zu machen, um zu vermeiden, dass sie in die Schublade „alternativ" gesteckt wird. Das Museum für zeitgenössische Kunst befand sich dann in den Räumen auf der Rückseite des Museums für bildende Kunst, einem Gebäude, das den Inbegriff des bürgerlichen Museums des ausgehenden 19. Jahrhunderts darstellt. In jener Zeit, vor der Restaurierung, war dieses Gebäude magisch, reine Magie, mit all seinen Unvollkommenheiten, seiner Musik der losen Fliesen, den Schwingungen der Fußböden. Dennoch hatte ich mich dazu entschlossen, den Schauplatz des bürgerlichen Museums nicht ernst zu nehmen. Weil es Schauplatz und Reibefläche unserer Bestrebungen war, wurde ich mir auch der Tatsache bewusst, dass das Museum für bildende Kunst des 19. Jahrhunderts einer der öffentlichen Orte dieser bürgerlichen Gesellschaft war. Wie die von derselben gegründeten Zoos oder die öffentlichen Plätze der damaligen Zeit, war dies ein Ort, an dem die Bourgeoisie spazieren gehen und sichtbar sein und sich treffen konnte, um den öffentlichen Raum in gewisser Weise in Besitz zu nehmen.

Belgien ist der Inbegriff bürgerlicher Tradition. Als das Land 1830 gegründet wurde, wurde es im Grunde wie ein privates Unternehmen geführt. Es gab 30.000 Menschen mit Stimmrecht, sie waren die Aktionäre, und der König war der CEO des Unternehmens. Und diese Leute dachten in ihrer paternalistischen Erhabenheit, sie seien die Öffentlichkeit. Denken Sie daran, dass Antwerpen, die Stadt, in der ich jetzt lebe und arbeite, der Ort ist, an dem Thomas Moore *Utopia* geschrieben hat, aber es ist auch eng mit Joseph Conrads *Herz der Finsternis* verbunden. Antwerpen ist in seiner jetzigen Form, wie ganz Belgien, eine physische Verkörperung des Kolonialismus. Und man muss sich all dessen bewusst sein, wenn man dort etwas angeht. Dieser Traum vom Museum ist der Traum von Reflexivität. Obwohl ich radikal über das bürgerliche Museum hinausgehen wollte, glaube ich im Nachhinein, das auch ich von ihm durchdrungen war. Was ich natürlich wirklich wollte, war eine zukünftige Form eines öffentlichen Platzes. Öffentlichkeit im Sinne eines Ortes des Bewusstseins, auch unter der Annahme, die Kunst könne etwas darüber aussagen, wie die Gesellschaft funktionieren könnte, wie wir die Welt betrachten könnten, all diese existenziellen Fragen. Der Raum der Kunst und für die Kunst, der von der Kunst geschaffene Raum, könnte ein Raum sein, der ganz stark mit der Intensität aufgeladen ist, die das Potenzial der Kunst ausmacht.

Zusammen mit den Künstlern entwickelten wir eine radikale funktionale Differenzierung der Räume, aber daneben

people, to how they pay attention to artist books, invitations, posters …

The meaning of each of these elements within the totality of the artistic proposal differs from one artist to another. If you become responsible for an institution that has to present a proposal about art in the public domain, then you say, well, this might be our task. Because, in this way, we get closer to art, closer to how art wants to be, and thus also closer to what an artwork may offer. In this way, we may be complementary to those markets.

"Ensembles" allows the exhibiting of what is traditionally named a permanent collection, a bit closer to this kind of experiential understanding that "This is the Show and the Show is Many Things" was searching for. So, there are two elements:

first, it is a take a different, more reflective perspective, but you may also see it as a way to make the complexity that was addressed, that was aspired by "This is the Show …" more sustainable. "This is the Show …" changed the scope of the grammar of the museum, I think.

GAM: And what of the reconsideration of exhibition in terms of "exhibiting" …

BDB: I have in the past reacted quite vehemently against the notion of the exhibition as something pornographic. It's part of the bourgeois' structuring of the world, in which the gaze is a power tool. And you have the object and the subject. I hate it. I hate it in a naïve and simple, visceral way. I tried to do away with both notions, exhibiting and the exhibition, not using the word "exhibition" anymore within the museum, but

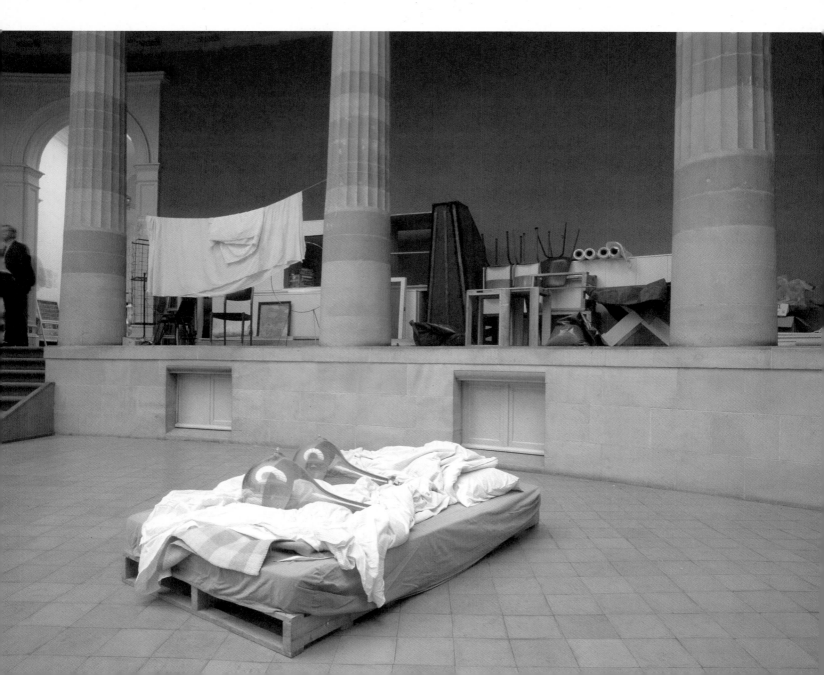

gab es auch diese Art von Fremdartigkeit, ein organisches Zustandekommen eines gewaltigen Programms von Momenten und Aktivitäten, von denen ein Teil sich mit dem deckte, was später in Rahmenprogramme zu Ausstellungen münden sollte.

GAM: Der Kernaufgabe des Museums für zeitgenössische Kunst (M HKA) folgend „der Öffentlichkeit eine Hypothese von Kunst zu präsentieren", basierend auf der Erkenntnis, dass ein Museum für zeitgenössische Kunst seine Ansichten über Künstler, Öffentlichkeit und Gesellschaft sowie über Vergangenheit, Gegenwart und Zukunft ständig hinterfragen muss, haben Sie eine eigene digitale Plattform entwickelt, M HKA Ensembles, auf der die Erkenntnis und Vision von Kunst kontinuierlich gelebt, überdacht und neu formuliert werden kann. Die M HKA Ensembles vereinen in digitaler Form das mit den spezifischen Kunstwerken und Künstlern in Verbindung stehende immaterielle Erbe, das als „sekundäre Quellen" bezeichnet wird, und sehen es als ebenso wichtige Manifestation künstlerischer Energie, die auf dynamische und offene Weise Zusammenhänge und Verbindungen zwischen Werken und Künstlern ermöglicht. Lizenziert unter der Creative-Commons-Lizenz baut die M HKA Ensembles-App eine nachhaltige Infrastruktur auf, die als Erweiterung und Beitrag des Museums zum öffentlichen Raum verstanden werden kann. Haben Sie Ensembles als eine Notwendigkeit gesehen, Ausstellungen als Format zu hinterfragen, und in welcher Art und Weise ändert das die Institution, die Sie seit 2002 leiten?

BDB: Ich glaube „Ensembles" stellt eine andere Sichtweise dar. Ausstellungen sollten sich ändern, nachdem wir uns die folgende Frage stellen konnten: „Was ist eine Art von inszeniertem Raum, in dem sich das Kunstwerk gemeinsam mit uns ereignen kann?" Für mich ist es sehr merkwürdig, dass KuratorInnen nach diesem Augenblick ihre Ausstellungen noch immer ohne Publikum kon-

25–26

) Suchan Kinoshita
ustelle/Staubstelle"
| (26) Luc Tuyman
nis is the Show …,"
Museum of
Contemporary Art
(S.M.A.K.), Ghent |
Museum für
Zeitgenössische
Kunst (S.M.A.K.),
Gent, 1994
© Photos:
Dirk Pauwels,
S.M.A.K., Ghent

a Roosen, „Het bed," „This is the Show …,"
eum of Contemporary Art (S.M.A.K.), Ghent |
eum für Zeitgenössische Kunst (S.M.A.K.), Gent, 1994
hoto: Dirk Pauwels, S.M.A.K., Ghent

zipieren. Alles, worum es mir geht, ist eine Art Tanz zwischen Menschen, Welterfahrungen und Kunst. Es geht um Erfahrung und Reflexion.

Das „Ensemble" ist ein anderer Raum, ein Raum, der zum Nachdenken anregt. Indem ich den Begriff des Ausstellens in eine unendliche Vielzahl von Gegenwarten, von Intensitäten, von Reflexionen über einen Moment verwandelte, versuchte ich, die Komplexität der Kunst ernst zu nehmen. Wenn man das tut, wenn man auch nur ein klein wenig aufmerksam darauf schaut, was Künstler tun, nicht zu ernst, nur ein bisschen, dann sieht man, dass das, was Künstler anbieten, unendlich viel komplexer ist als alles, was die Kunstmärkte akzeptieren. Es ist dasselbe, ob es sich um den Markt der Käufer, der privaten Sammler, den Markt der Medienaufmerksamkeit, den Markt der angebotenen Ausstellungen handelt, denn es handelt sich in gewisser Weise immer um Märkte. Die Komplexität dessen, was Künstler tun, ist von einer so weitaus höheren Dimension, als die, die jeder dieser Märkte akzeptiert. Wenn man Kunst ernst nehmen würde, könnte man versuchen, ein wenig auf das zu schauen, was ein bestimmter Künstler vorschlägt, in all der Vielfalt und Besonderheit dieses Vorschlags, zu dem auch gehört, dass man ein wenig auf die Titel achtet, darauf, wie Künstler über ihre Arbeit sprechen, wie sie sie in Raum und Zeit verorten und wie sie sie mit den Menschen in Beziehung setzen, wie sie auf Künstlerbücher, Einladungen, Poster achten.

Die Bedeutung jedes dieser Elemente innerhalb der Gesamtheit der künstlerischen Position unterscheidet sich von Künstler zu Künstler. Wenn man für eine Institution die Verantwortung übernimmt, die eine Position zu Kunst im öffentlichen Raum vorlegen muss, dann sagt man, naja, das könnte unsere Aufgabe sein. Denn so kommen wir näher an die Kunst heran, näher an das, was Kunst sein will, und damit auch näher an das, was ein Kunstwerk bieten kann. Auf diese Weise könnten wir diese Märkte ergänzen.

„Ensembles" ermöglicht ein Ausstellen dessen, was traditionellerweise Dauerausstellung genannt wird, was ein wenig näher an jene Art von auf Erfahrung beruhenden Verstehen herankommt, nach der in „This is the Show …" gesucht wurde. Es gibt also zwei Elemente: Erstens, eine Sichtweise, eine andere reflektiertere Perspektive, aber man kann es auch als eine Möglichkeit sehen, die von „This is the Show …" angesprochene und erstrebte Komplexität nachhaltiger zu gestalten. Ich glaube, „This is the Show …" veränderte den Rahmen einer Grammatik des Museums.

GAM: Und was ist mit der Überlegung, Ausstellung im Sinne von „Ausstellen" neu zu denken?

BDB: Ich habe in der Vergangenheit sehr vehement gegen die Vorstellung der Ausstellung als etwas Pornografisches reagiert. Sie ist Teil der bürgerlichen Strukturierung der Welt, in der der Blick ein Machtwerkzeug ist. Und man hat das Objekt und das

rather using "presentation." It has been a long lasting effort, and I didn't succeed.

GAM: Why presentation?

BDB: I feel it is more generous. Your differentiation between *exhibiting*, as a durational process, and *exhibition* as its public moment and site of production is also an effective one. However, that's the most important question here, how can we formulate our field in such a way that we might be more challenging to ourselves. I tried to get away from the notion of "exhibitions" because it is so "exhibitionist," it has the aspiration to make something 100% visible. It is more interesting then to be aware of the fact that things are never 100% visible. But that is the wrong question anyway. The question here might rather be "Does something find a good setting?" In that sense, what was very beautiful about the participation of Luc Tuymans at the "This is the Show ..." was that he made a reversal of his painting. He made stamps, huge linocuts of 70 or 80 centimetres, with motives like a lamp or a landscape. He had also manipulated the top light all over the museum, with thin cloth in different hues over the skylights. In the space where we worked the daylight had thus become a cold northern evening light. In this classical 19th century museum, there were intricate wainscotings everywhere to hang the huge bourgeois paintings, and above the space envisaged for paintings there was another layer of stiles ending the wall. Tuymans printed his motives there, a single gesture of printing each, high up and in the same tonalities as the light, on the verge of disappearance. A similar game with the borders of visibility is often played in mannierist painting, for example, with the "Visitation" by Jacopo da Pontormo. If you look at it in the church and you turn off the electric light, you have to take time, but after a while you begin to see, in the background, an entering figure, almost as if it is coming out of the architecture, while never really being certain that you see it. That light is what the painting was made for. That is how it is alive and happening. Pontormo is not made for photographic light, that did not exist at the time. It uses its limits to be alive.

GAM: And the limits of that would be called exhibition.

BDB: Yes, exactly. The exhibition does not allow it. The exhibition undresses, it shows everything.

GAM: ... and also blends it out.

BDB: Exactly, if everything is 100% visible, there is nothing happening anymore.

GAM: Theorist and curator Vincent Normand[2] proposed to look back to Bertolt Brecht and the notion that theatre might become political in the moment when one accepts the separation from society and makes visible this separation and the way this immediacy itself is mediated or produced. How is your approach is different with the possibilities of the presence of the society or the connection with the society?

BDB: I asked my colleague Anders Kreuger, who is a curator and an editor and much more, for a thought paper leading up to the new policy plan and he started with an aphorism by Adorno: "Art is the social antithesis of society, not directly deducible from it."[3] That interests me more than saying that you have to cultivate the awareness of the fact that it is different from society. M HKA was the whitest museum in the world when one walked into it in the mid-1980s. Even the floors were white. At that moment contemporary art in our region was striving for hegemony, it was striving to save art from the market while at the same time also striving to be successful in that market, and the outcome was an art that was saying it wanted to be away from the world and that was urging from the museum the same stance. M HKA was an outcome of that, separating art from society. This is the building in which we are now, with the building saying: "Don't come in!" We're still in that building but we don't respect it's programme. We do aim to link up art-specific and societal lines of questioning and development. We know their relation is not one on one, is not even guaranteed, but we also know it is a real possibility and we try to build bridges over and again. We navigate in between poles and that leads to a productive tension. But we're more messy than separation wanted us to be.

GAM: Thank you for the interview. ■

2 See also the interview with Vincent Normand in this *GAM* issue, pp. 30–43.

3 Theodor W. Adorno, *Aesthetic Theory*, trans. Robert Hullot-Kentor (London, 2004), p. 9.

Subjekt. Ich hasse das. Ich hasse das auf eine naive und einfache, instinktive Art und Weise. Ich versuchte, beide Begriffe, Ausstellen und Ausstellung, zu verwerfen, indem ich im Museum das Wort „Ausstellung" nicht mehr verwendete, sondern „Präsentation". Es war ein langwieriges Unterfangen, und es gelang mir nicht.

GAM: Warum Präsentation?

BDB: Ich finde, das ist großzügiger. Ihre Unterscheidung zwischen dem *Ausstellen* als andauernder Prozess und *Ausstellung* als dessen öffentlicher Moment und Produktionsort ist auch probat. Aber das ist hier die wichtigste Frage: Wie können wir unser Feld so formulieren, dass wir uns selbst vielleicht stärker herausfordern können? Ich habe versucht, mich von dem Begriff „exhibition" zu lösen, weil er so „exhibitionistisch" ist *[A.d. Ü: so viel Zurschaustellung in sich birgt]*, er birgt den Anspruch in sich, etwas 100%ig sichtbar zu machen. Es ist interessanter, sich der Tatsache bewusst zu sein, dass die Dinge nie zu 100% sichtbar sind. Doch das ist ohnehin die falsche Frage. Die Frage hier könnte eher lauten: „Findet etwas einen guten Rahmen?" In diesem Sinne war das Schöne an der Teilnahme von Luc Tuymans an „This is the Show …", dass er eine Umkehrung seiner Malerei vollzog. Er fertigte Stempel an, riesige 70 oder 80 Zentimeter große Linolschnitte, mit Motiven wie einer Lampe oder einer Landschaft. Er hatte auch das Oberlicht im gesamten Museum manipuliert, mit dünnen Tüchern in verschiedenen Farbtönen über den Oberlichtern. In dem Raum, in dem wir arbeiteten, war so das Tageslicht zu einem kalten nördlichen Abendlicht geworden. In diesem klassischen Museum des 19. Jahrhunderts gab es überall aufwändige Vertäfelungen, um die riesigen bürgerlichen Gemälde aufzuhängen, und über dem Raum, der für die Gemälde vorgesehen war, befand sich eine weitere Schicht mit Absätzen, die die Wand abschlossen. Tuymans druckte dort seine Motive, eine einzige Geste des Druckens, hoch oben und in den gleichen Farbnuancen wie das Licht, am Rande des Verschwindens. Ein ähnliches Spiel mit den Grenzen der Sichtbarkeit wird in der manieristischen Malerei oft gespielt, zum Beispiel in der „Heimsuchung" von Jacopo da Pontormo. Wenn man es in der Kirche betrachtet und das elektrische Licht ausschaltet, muss man sich Zeit nehmen, aber nach einer Weile beginnt man im Hintergrund eine Figur zu sehen, die den Raum betritt, fast so, als ob sie aus der Architektur herauskäme. Und man ist sich nicht wirklich sicher, dass man sie sieht. Genau für jenes Licht wurde das Gemälde einst geschaffen. So ist es lebendig und ereignet sich vor dem Betrachter. Pontormo malte nicht für fotografische Ausleuchtung, die es damals noch gar nicht gab. Seine Malerei nutzt dessen Einschränkungen, um lebendig zu sein.

GAM: Und die Grenzen davon würde man Ausstellung nennen.

BDB: Ja, genau. Die Ausstellung lässt das nicht zu. Die Ausstellung zieht die Dinge aus, sie zeigt alles.

GAM: … und blendet es auch aus.

BDB: Genau, wenn alles zu 100% sichtbar ist, passiert nichts mehr.

GAM: Der Theoretiker und Kurator Vincent Normand[2] hat vorgeschlagen, auf Bertolt Brecht und die Vorstellung zurückzublicken, dass Theater in dem Moment politisch werden könnte, in dem man die Trennung von der Gesellschaft akzeptiert und diese Trennung und die Art und Weise, wie diese Unmittelbarkeit selbst vermittelt oder produziert wird, sichtbar macht. Wie unterscheidet sich Ihr Ansatz von den Möglichkeiten der Präsenz der Gesellschaft oder der Verbindung mit der Gesellschaft?

BDB: Ich habe meinen Kollegen Anders Kreuger, der Kurator, Herausgeber und vieles mehr ist, um ein Thesenpapier gebeten, das zum neuen Strategieplan führt, und er begann mit einem Aphorismus von Adorno: „Kunst ist die gesellschaftliche Antithesis zur Gesellschaft, nicht unmittelbar aus dieser zu deduzieren."[3] Das interessiert mich mehr als zu sagen, dass man das Bewusstsein dafür pflegen muss, dass sie anders ist als die Gesellschaft. Das M HKA war das weißeste Museum der Welt, als man es Mitte der 1980er Jahre betrat. Sogar die Fußböden waren weiß. In jener Zeit strebte die zeitgenössische Kunst in unserer Region nach Hegemonie, sie strebte danach, die Kunst vom Markt zu retten und gleichzeitig auf diesem Markt erfolgreich zu sein. Und was herausgekommen ist, war eine Kunst, die sagte, sie wolle sich von der Welt fernhalten, und die vom Museum die gleiche Haltung einforderte. Das M HKA war ein Ergebnis davon und trennte die Kunst von der Gesellschaft. Das ist das Gebäude, in dem wir uns jetzt befinden, mit der Aussage des Gebäudes: „Kommen Sie nicht rein!" Wir sind immer noch in diesem Gebäude, aber wir respektieren dessen Programm nicht. Unser Ziel ist vielmehr, kunstspezifische und gesellschaftliche Stränge der Hinterfragung und Entwicklung miteinander zu verknüpfen. Wir wissen, dass ihr Verhältnis nicht eins zu eins ist, nicht einmal garantiert ist, aber wir wissen auch, dass es eine reale Möglichkeit ist, und wir versuchen, immer wieder Brücken zu bauen. Wir navigieren zwischen den Polen und das führt zu einer produktiven Spannung. Aber wir sind chaotischer, als diese Trennung es von uns wollte.

GAM: Vielen Dank für dieses Interview. ∎

Übersetzung: Otmar Lichtenwörther

2 Siehe auch das Interview mit Vincent Normand in dieser Ausgabe von *GAM*, 30–43.

3 Adorno, Theodor W.: *Ästhetische Theorie*, Frankfurt 1970, 19.

"My Sweet Little Lamb (Everything We See Could Also Be Otherwise)"

What, How and for Whom/WHW in collaboration with |
in Zusammenarbeit mit Kathrin Rhomberg

1 Edward Krasiński "Retrospective" 1984 "My Sweet Little Lamb" Episode 1, Softić Apartment, Zagreb, 2016 © Damir Žižić

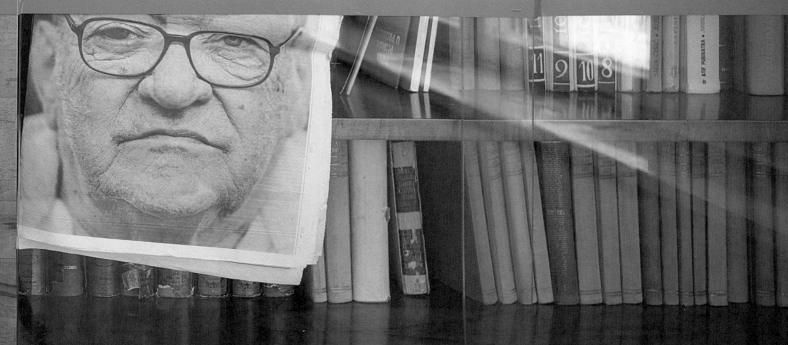

Conceived as "an exhibition in time," "My Sweet Little Lamb (Everything We See Could Also Be Otherwise)" unfolded in six episodes that, from November 2016 to May 2017, took place in numerous independent art spaces, artists' studios, and private apartments in Zagreb, and culminated in September 2017 with an epilogue staged at The Showroom, London.[1]

As a point of departure, the exhibition took works from Kontakt Art Collection that feature seminal conceptual, post-conceptual, and experimental artistic practices from Central, Eastern, and Southeast Europe from the 1960s onwards.[2] Since its inception, the collection has been operating nomadically and without a permanent display.[3] Its geographical focus and the choice of venues for presenting it inevitably reflect the historical position of Vienna as the center of an Empire, as well as its more recent cultural ambitions that followed the routes of expansion of capitalist economy after the collapse of socialism. This made the collection a suitable starting point to critically approach the very notion of Eastern European Art as a shorthand for the geopolitical paradigm and ideological framework in which it is contained, and to reflect upon the mechanisms of filtering local practices to international prominence within circuits of communication, distribution, and exchange in the art world.

Critically questioning the collection's geo-fictional modalities, "My Sweet Little Lamb (Everything We See Could Also Be Otherwise)" engaged in decentralized formats of exhibiting, that resulted in a continuous flow of exhibitions which influenced, contradicted and reinforced each other. The project looked into themes recurring through the collection, such as radical utopianism, the figure of dissident artist, questions of gendered bodies, political subjectivities and engagement, the status of public space, and provided varied readings that opposed interpreting these gestures solely as brave, heroic individual acts rebelling against "totalitarian" communist systems.

Titled after a work by Mladen Stilinović (1947–2016), to whom the exhibition project was dedicated, all episodes of the project encompassed his pivotal cycles engaging with subjects of work, money, pain, poverty, death and inequality. His strong presence in the exhibition created "an exhibition within the exhibition," a retrospective of sorts, stretched over time and dispersed in various locations. A quiet but shrewd rebellion against social conventions and the conventions of art determined his long-term anti-systemic artistic approach and geared the project toward less formal, undisciplined modes of exhibiting. Stilinović's humorous approach and sense for poetry, his ability to resettle the habitual relationship between the viewer and the viewed, functioned as an ongoing invitation to rethink the exhibition format otherwise.

Juxtaposing the collection's canonical works with a number of works from other contexts and geographies, the series of exhibitions developed dense and overlapping displays that undermined the status of works as autonomous objects and created an interfering field of their mutual frictions. This direction resulted in contrasted constellations among the works from the collection and the ones not included in it, that aimed to challenge and reformat the collection as a finalized and ordered body of knowledge. The two main venues, Gallery Nova[4] and Apartment Softić formed the core of each episode and anchored the continuous flow of exhibitions. Gallery Nova, as many other independent organizations in Zagreb, is in a continuous state of precarity and unfinished process of institutionalization, whose unresolved status and basic functioning are additionally jeopardized by the rise of right-wing politics in Croatia.

Apartment Softić—a private space named after its former owners and situated in a modernist building built in the 1930s, with a panoramic view of the main city square—was used throughout the project as a continuous venue that enabled more intimate conditions for conceiving the various displays. The space of the apartment was in continuous transformation: in the first episode, the furniture and found living situation of the flat were used as an exhibition backdrop that was gradually dissolved by further artistic and curatorial interventions. The project replaced the format of linear presentation with a syncopated rhythm of exhibiting, moving away from a white cube museum context. Dispersed throughout the city's most active independent cultural initiatives, various stages of the project took place at the Institute of Contemporary Art, Gallery Forum, Gallery Greta, Gallery VN, GMK, Home of the Croatian Association of Artists/HDLU, Pogon—Jedinstvo, Sanja Iveković's studio, Gallery SC, and the Tomislav Gotovac Institute. Due to the precarity of the independent cultural scene in Zagreb, the collection was displayed in venues that most often lacked the material and security conditions for hosting it, which would be required by usual museum standards for exhibiting a collection of such value. On the other hand, the initial character of the works in the collection, that were often made of cheap materials,

1 The project's epilogue at The Showroom, London was co-curated with Emily Pethick.

2 The Kontakt Art Collection is initiated by Erste Foundation in 2004 in Vienna. Members of its advisory committee are: Silvia Eiblmayr, Georg Schöllhammer, Jiří Ševčík, Branka Stipančić and Adam Szymczyk. http://www.kontakt-collection.net/.

3 In the past decade, the trajectories of presenting the collection took an itinerary starting from Vienna to the places of its origins: Belgrade, Sofia, or, in this case, Zagreb.

4 Gallery Nova is a city-owned non-profit space that whose program WHW has been directing since 2003.

„My Sweet Little Lamb (Everything We See Could Also Be Otherwise)" wurde als eine „Ausstellung zur rechten Zeit" konzipiert, die sich über einen gewissen Zeitraum entwickelt und sich über zahlreiche unabhängige Kunsträume, Künstlerateliers und Privatwohnungen in Zagreb ausdehnt. Die Ausstellung entfaltete sich in sechs Episoden, die von November 2016 bis Mai 2017 in Zagreb stattfanden, und gipfelte im September 2017 in einem Epilog im Showroom in London.[1]

Ausgangspunkt der Ausstellung waren Arbeiten aus der Kontakt Kunstsammlung in Wien,[2] die wegweisende konzeptuelle, postkonzeptionelle und experimentelle künstlerische Praxen aus Mittel-, Ost- und Südosteuropa ab den 1960er Jahren zeigen. Seit ihrer Gründung operiert die Sammlung nomadisch ohne permanente Ausstellung und institutionelle Verankerung, wobei die Gastkuratoren ständig miteinbezogen werden, um sie neu zu interpretieren.[3] Der geografische Schwerpunkt der Sammlung und die Auswahl der Orte für ihre Präsentation spiegeln unweigerlich die historische Lage Wiens als Zentrum eines Großreiches und seine neueren kulturellen Ambitionen wider, die den Expansionswegen der kapitalistischen Wirtschaft nach dem Zusammenbruch des Sozialismus folgten. Dies machte die Sammlung zu einem geeigneten Ausgangspunkt, um sich kritisch mit dem Begriff der osteuropäischen Kunst als Kürzel für das geopolitische Paradigma und den ideologischen Rahmen, in dem sie enthalten ist, auseinanderzusetzen und über die Mechanismen der Filterung lokaler Praxen auf internationale Bekanntheit in neuen Kreisläufen der Kommunikation, der Verbreitung und des Austauschs in der Kunstwelt nachzudenken.

Die kritische Hinterfragung der eigenen geofiktionalen Modalitäten der Sammlung innerhalb von „My Sweet Little Lamb" führte zu einer weiteren Sondierung dezentraler Ausstellungsformate in einem kontinuierlichen Fluss von Ausstellungen, die sich gegenseitig beeinflussen, widersprechen und verstärken. Das Projekt stellte die immer wiederkehrenden ikonischen Themen der Sammlung wie radikale Utopie, die Figur des dissidenten Künstlers, Fragen nach geschlechtsspezifischen Körpern, politischen Subjektivitäten und Engagement, und den Status der komplexen politischen Lesarten des öffentlichen Raumes der Interpretation dieser Gesten nur als mutige, heroische Einzelakte der Auflehnung gegen „totalitäre" kommunistische Systeme gegenüber.

Benannt nach einer Arbeit von Mladen Stilinović (1947–2016), dem das Ausstellungsprojekt gewidmet war, umfassten alle Episoden seine zentralen Zyklen, in denen er sich mit einer Reihe von Themen wie Arbeit, Geld, Schmerz, Armut, Tod und Ungleichheit beschäftigte, die seine Arbeit bestimmten. Seine starke Präsenz in der Ausstellung schuf „eine Ausstellung in der Ausstellung", eine Art Retrospektive, die sich über die Zeit erstreckte und über verschiedene Orte verstreut war. Seine leise aber kluge Rebellion gegen gesellschaftliche Konventionen und die Konventionen des Kunstfeldes schuf einen langfristigen antisystemischen künstlerischen Ansatz und richtete das Projekt auf weniger formale, undisziplinierte Ausstellungsmodi aus. Seine humorvolle Herangehensweise und sein Sinn für Poesie, seine Fähigkeit, das gewohnte Verhältnis zwischen Betrachter und

Betrachtetem neu zu besiedeln, waren eine fortwährende Einladung, das Ausstellungsformat zu überdenken.

Diese Versuche führten zu gegensätzlichen Konstellationen zwischen den Werken außerhalb und innerhalb der Sammlung und veränderten die gewohnten Bedingungen für den Blick auf die Kunst. Insbesondere wurde dadurch die Sammlung als abgeschlossener und geordneter Wissensbestand neu formatiert und ein Feld ihrer Überlagerungen von gegenseitigen Berührungspunkten geschaffen. In ihrer Gegenüberstellung kanonischer Werke der Sammlung mit einer Reihe von Werken aus anderen Kontexten und Regionen entwickelte sich die Ausstellung zu einer unorthodoxen Schau, die deren fixe Präsentationen und vorherrschende Interpretationen in der internationalen Kunstszene infrage stellte und die Sammlung als abgeschlossene und geordnete Wissensformation neu strukturierte. Die beiden Hauptausstellungsorte, Galerie Nova[4] und Apartment Softić, bildeten den Kern jeder Episode und verankerten die kontinuierliche Folge der Ausstellungen. Die Galerie Nova befindet sich, wie viele andere unabhängige Organisationen in Zagreb, in einem Zustand fortwährender Prekarität und in einem unvollendeten Prozess der Institutionalisierung mit ungeklärtem Raum- und Eigentumsstatus, dessen Funktionieren zusätzlich durch den Aufstieg rechter Politik in Kroatien gefährdet ist.

Eine Privatwohnung, nach ihren früheren Besitzern Apartment Softić benannt, die sich in einem modernistischen Gebäude aus den 1930er Jahren befindet und einen Panoramablick auf den Hauptplatz der Stadt bietet, wurde für die gesamte Ausstellungsdauer als permanenter Ausstellungsort angemietet, der intimere Bedingungen der Werkbetrachtung ermöglichte. Dieser Wohnraum befand sich in ständigem Wandel: Anfangs wurde das vorhandene Inventar als Kulisse genutzt, die man sich durch künstlerische und kuratorische Eingriffe nach und nach angeeignet hat. Das Projekt ersetzte das Format der linearen Präsentation durch einen synkopierten Ausstellungsrhythmus, der vom musealen White Cube-Kontext abrückte. Verteilt auf die aktivsten unabhängigen Kulturinitiativen der Stadt fanden verschiedene Etappen des Projekts am Institut für Zeitgenössische Kunst, in der Galerie Forum, in der Galerie Greta, in der Galerie VN, in der GMK, im Heim kroatischer bildender

1 Dieser Epilog des Projekts im Showroom in London wurde in Zusammenarbeit mit Emily Pethick realisiert.

2 Die Kontakt Kunstsammlung wurde von der Erste Foundation 2004 in Wien ins Leben gerufen. Mitglieder ihres Boards sind: Silvia Eiblmayr, Georg Schöllhammer, Jiří Ševčík, Branka Stipančić und Adam Szymczyk. http://www.kontakt-collection.net/

3 In den letzten zehn Jahren haben die Bahnen der Sammlungspräsentation einen Weg von Wien und einem globaleren internationalen Parcours zu ihren „Ursprungsorten" wie Belgrad, Sofia oder in diesem Fall Zagreb genommen.

4 Die Galerie Nova ist ein mittelgroßer, stadteigener Non-Profit-Raum, dessen Programmierung seit 2003 von WHW geleitet wird.

created and exhibited in private spaces, and that become canonized with fixed modes of presentation only years later by entering the art market, found their more "natural habitat" in this non-institutional setting.

Thus, recasting the exhibition as a spatial phenomenon dispersed through the city, the project, in an indirect way, echoed the spatial character of artistic practices of the 1960s and 1970s, that often resulted in the temporary occupation of unexpected spaces and locations. Situating the exhibition in a private apartment did not rely on the echoes of the tradition of apt-art.[5] Rather, the aim was to point to the present local conditions under which contemporary art is effectively put in a position of dissidence by being recast as an elitist field of internationalist and cosmopolitan leftists who undermine values of national culture.

Immediately receiving public attention, in just a few months the apartment involuntary profiled itself as a "new art space," used by other initiatives in the city, only to lose, shortly after the project closure, its experimental character, sadly but predictably indicating the unsustainable status of "alternative" cultural spaces in the wider context.

In the conflictual cultural and political landscape marked by a palpable threat of institutional closures, "My Sweet Little Lamb (Everything we see could also be otherwise)," without offering immediate remedy, served as a temporary intervention. With its accelerated rhythm of exhibiting, it rather created a sense of alarming urgency that catalysed the new perspectives and alliances. Drawing attention to local non-profit spaces, in a moment when the future of many of them was being very much

3

"My Sweet Little Lamb," exhibition opening | Ausstellungseröffnung, November 4–6, 2016, Episode 1, Softić Apartment, Zagreb, 2016 © Ivan Kuharić

under threat, the exhibition correlated them with the space of the apartment, not only as a place of possible withdrawal and refuge, but as a place of ambiguity, bringing together many unresolved tensions related to wider relations of art and politics.

1st episode. *In the first episode, entanglements of then and there and here and now whisper and shout at each other. Who is listening?*

In an analogy with the format of a TV series, the first episode acted as a kind of pilot that in a condensed way introduced dominant motives, plots, and key protagonists, through the recurring themes of gender and sexuality, the role of institutions, the status of history and amnesia, legacies of historical avant-gardes, and the politics of collecting and display, that would later be reworked in subsequent iterations. The first episode introduced the method of supporting or commissioning programs by other organizations, such as the independently curated programs in GMK, the archival exhibition "Private Documents" by Sanja Iveković at her studio, and interventions in public space.

At Gallery Nova, a dense display in a deliberately confined situation presented a large number of the collection's conceptual "masterpieces" whose proverbial whiteness and self-referential frameworks were disrupted by the insertions of contemporary works. Halil Altindere's video "Homeland" (2016) structured around a rap song performed by the Berlin based Syrian refugee Mohammad Abu Hajar, formed the loud and colorful contrast to other works.

2

Mária Bartuszová, "Untitled," 1986, "My Sweet Little Lamb," Episode 1, Softić Apartment, Zagreb, 2016 © Ivan Kuharić

5 In Zagreb there is no tradition of apartment exhibitions. Mladen Stilinović's exhibitions in his apartment that he organized from 2003 onwards, are an exception, conceived as part of his appropriation of symbols and signs of the Soviet avant-garde and a way to exercise and experiment with forms of sociability.

Künstler/HDLU, im Pogon – Jedinstvo, im Atelier von Sanja Iveković, in der Galerie SC und im Tomislav Gotovac Institut statt. Wegen der prekären Situation der unabhängigen kulturellen Szene in Zagreb wurde die Sammlung an Orten ausgestellt, an denen die materiellen und sicherheitstechnischen Voraussetzungen für die Unterbringung der Sammlung zumeist fehlten. Andererseits fand der ursprüngliche Charakter dieser oft aus billigen, leichten Materialien gefertigten und oft in privaten Räumen geschaffenen und ausgestellten Werke der Sammlung, die erst später durch den Eintritt in den Kunstmarkt mit festen Präsentationsformen kanonisiert oder in Auflagen limitiert wurden, seinen „natürlichen Lebensraum" in jenen nicht-institutionellen Räumen und Privatwohnungen.

So ließ die Umgestaltung der Ausstellung in ein Phänomen, das die Stadt durchdringt, indirekt den räumlichen Charakter künstlerischer Praxen der 1960er und 1970er Jahre nachhallen, die oft zur temporären Okkupation von unerwarteten Räumen und Orten führten. Die Ausstellung in einer Privatwohnung zu verorten, stützte sich nicht auf Anklänge an die Tradition der Apt-Art (Wohnungskunst).[5] Es ging eher um lokale Bedingungen, unter denen die zeitgenössische Kunst in eine Position der Dissidenz gebracht und als elitäres Feld internationalistischer und kosmopolitischer Linker umgestaltet wird, die nationale kulturelle Werte untergraben. Die Wohnung erregte erwartungsgemäß öffentliche Aufmerksamkeit, so dass sie sich während und unmittelbar nach dem Projekt beinahe als „neuer Kunstraum" profilierte, den viele andere Initiativen nutzen wollten, nur um kurz nach dem Ende des Projekts ihren experimentellen Charakter wieder zu verlieren – ein trauriger aber vorhersehbarer Vorgang, der den wenig nachhaltigen Status von „alternativen" kulturellen Orten in einem größeren Zusammenhang anzeigt.

In einer von der drohenden Schließung von Institutionen geprägten konfliktreichen kulturellen und politischen Landschaft diente „My Sweet Little Lamb" als temporäre Intervention, die nicht nach Abhilfe strebte, sondern vielmehr durch ihren beschleunigten Rhythmus von Ausstellungen ein Gefühl der Dringlichkeit schuf, als Zwischenraum, der neue Perspektiven und Allianzen katalysierte. Indem die Ausstellung aus der spekulativen Perspektive ihres möglichen Verschwindens Aufmerksamkeit auf lokale Non-Profit-Räume lenkte, korrelierte sie mit dem Raum einer Wohnung, nicht nur als Ort des möglichen Rückzugs und der Zuflucht im Falle ihrer Aufkündigung, sondern auch als ein höchst vieldeutiger Ort, der mehrere Schichten latenter Spannungen mit den erweiterten Beziehungen von Kunst und Politik verband.

Episode 1. *In der ersten Episode flüstern und schreien sich Verstrickungen von dort und dann und hier und jetzt gegenseitig an. Gehen Sie hier entlang, aber wer hört zu?*
In Analogie zum Format Fernsehserie fungierte die erste Episode als eine Art Pilotfilm, in dem in verdichteter Form

die vorherrschenden Motive und Handlungsstränge und einige der Schlüsselfiguren durch die wiederkehrenden Themen Geschlecht und Sexualität, die Rolle der Institutionen, den traumatischen Status von Geschichte und Amnesie, Vermächtnisse historischer Avantgarden und die Politik des Sammelns und der Ausstellung vorgestellt wurden, die in den darauffolgenden Durchläufen überarbeitet werden würden. In der ersten Episode wurde die Methode vorgestellt, Programme anderer Initiativen und Organisationen zu unterstützen oder in Auftrag zu geben, wie z.B. die unabhängig kuratierten Programme in der GMK, Sanja Ivekovićs Archivausstellung „Private Documents" in ihrem Atelier und die Interventionen im öffentlichen Raum.

In der Galerie Nova schuf eine dichte Ausstellung eine Atmosphäre wie in einer Wunderkammer, die in einer bewusst beengten Situation eine große Sammlung von „Meisterwerken" der Konzeptkunst präsentierte, deren sprichwörtliche

4

"My Sweet Little Lamb," installation view | Ausstellungsansicht, Episode 1, Gallery Nova | Galerie Nova, Zagreb, 2016 © Damir Žižić

Weiße und deren autoreferenzielle Rahmen durch die Einfügung der zeitgenössischen Werke gestört wurden, wie Halil Altinderes Video „Homeland" (2016), das nach einem Rap-Song des in Berlin lebenden syrischen Flüchtlings Mohammad Abu Hajar strukturiert ist und einen lauten und farbenfrohen Kontrast zu anderen Werken bildete.

Die Einrichtung in der Wohnung, abgestimmt auf die Atmosphäre der eindeutig bürgerlichen Wohnung aus einer anderen Epoche, blieb nahezu intakt. Die Einfügung von Kunstwerken, die sich mit Fragen des Todes, der Ökonomie, der Revolution und der Menschenrechte auseinandersetzten, in die

5 In Zagreb haben Wohnungsausstellungen keine Tradition. Mladen Stilinovićs Ausstellungen in seiner Wohnung, die er ab 2003 organisierte, sind eine Ausnahme, konzipiert als Teil seiner Aneignung von Symbolen und Zeichen der sowjetischen Avantgarde und als Möglichkeit, Formen der Gesellschaft zu üben und mit diesen zu experimentieren.

The interior of the apartment attuned to the atmosphere of the clearly bourgeois flat from another era, was almost left intact. The insertion of artworks dealing with questions of death, economy, revolution and human rights among the dated everyday objects surrounding them, created different levels of friction pointing towards a need to complicate discussions on the artistic practices of the 1960s and 1970s within the framework of mythical dissidence and simplified narratives on their struggle for freedom, including the freedom of art, against the pressures of the state apparatus.

The gestures of occupying the public space problematized various violent suppressed histories that resurface in the present moment. On the main city square, at the balcony of the building[6] across Apartment Softić, Július Koller's flag "Question Mark Cultural Situation (UFO)" (1992) with a recurring motive of a question mark that permeates his oeuvre was symbolically inserted to ask about the building's relation to capital and politics in past and present times, creating at the same time what Koller called a "new cultural situation." The interweaving of personal and collective memories and histories was further accentuated by a performance entitled "Whispering History" by Oliver Frljić, conceived as a city walk that by revisiting suppressed historical episodes of the Ustaše[7] crimes in public space related them to a more recent historical context marked by nationalism.

2nd episode. *In the second episode, bodies, sex, politics, aging and death come together to get confused by each other, but promise is in the air.*

The second episode was built around the Tomislav Gotovac Institute, an independent micro-institution that operates from the apartment where the performer and film director Tomislav Gotovac (1937–2010) had spend his last years and whose

6 Marcello Piacentini, one of the main proponents of Italian fascist architecture, designed the building in late 1930s for Zagreb headquarters of Italian insurance company Assucurazioni Generali (known today as Generali Group). Allegedly, the balcony was designed with a purpose to host Mussolini's speech in Zagreb, whose visit in Zagreb did not happen.

7 The Ustaše was a Croatian ultra-right, fascist, nationalist and racist organization active between 1929 and 1945 that came to power during the Second World War in Nezavisna Država Hrvatska (NHD), a Nazi Germany puppet state in Croatia.

altmodischen Alltagsgegenstände, die sie umgaben, schuf verschiedene Reibungsebenen, die auf die Notwendigkeit hindeuteten, die Diskussionen über die künstlerischen Praxen der 1960er und 1970er Jahre im Rahmen mythischer Dissidenz und vereinfachter Erzählungen über den Kampf um Freiheit, einschließlich der Freiheit der Kunst, gegen den Druck des Staatsapparates zu verkomplizieren.

Die Gesten der Okkupation des öffentlichen Raums problematisierten seine verschiedenen gewaltsam verdrängten Geschichten, die im gegenwärtigen Augenblick wieder auftauchen. Auf dem Hauptplatz wurde Július Kollers Flagge „Question Mark Cultural Situation (UFO)" mit dem sein Schaffen durchdringenden wiederkehrenden Motiv eines Fragezeichens auf dem Balkon des repräsentativen Gebäudes[6] gegenüber des Apartment Softić symbolisch angebracht, um nach dem Verhältnis des Gebäudes zu Kapital und Politik in Vergangenheit und Gegenwart zu fragen und gleichzeitig das zu schaffen, was Koller als „neue kulturelle Situation" bezeichnete. Die Verflechtung von persönlichen und kollektiven Erinnerungen und Geschichte(n) wurde weiter verstärkt durch die Performance „Whispering History" von Oliver Frljić, die als Stadtrundgang konzipiert war und die Orte verdrängter historischer Ustascha-Verbrechen[7] im öffentlichen Raum aufsuchte und mit einem jüngeren historischen Kontext verband, der durch Nationalismus gekennzeichnet ist.

Episode 2. *In der zweiten Episode kommen Körper, Sex, Politik, Altern und Tod zusammen, um sich gegenseitig zu verwirren, aber ein Versprechen liegt in der Luft.*

Die zweite Episode wurde um das Tomislav Gotovac Institut konzipiert, eine unabhängige, kleine Institution, deren Sitz in der Wohnung des Performance-Künstlers und Filmregisseurs Tomislav Gotovac (1937–2010) liegt, in der Gotovac seine letzten Jahre verbracht hat. Seine Küche ist als ein installativer Raum erhalten, in dem sich unterschiedliche gesammelte oder gefundene Gegenstände befinden, die er obsessiv hortete und damit die Grenzen zwischen Kunst und Leben aufhob. Die Auswahl seiner Werke geschah im Hinblick auf die Ikonografie seiner bekannten Untersuchungen des nackten Körpers im öffentlichen Raum. Obwohl diese Arbeiten nicht in der Ausstellung gezeigt wurden, wurden sie als Hintergrund für die Auseinandersetzung mit Fragen des Körpers im öffentlichen Raum von vielen anderen Arbeiten der Ausstellung genutzt, wie z.B. von Mladen Stilinovićs Collagen „Taken out from the Crowd" und „Loneliness II" (beide 1976), die sich mit der Dialektik von Menschenmengen und Individuen auseinandersetzen. Dieses Thema wurde auch in Ewa Partums Fotoserie „Self-Identification" (1980) aufgegriffen, die Fotos des nackten Körpers der

Künstlerin in die urbane Szenerie Warschaus einfügte; es fungierte darüber hinaus als ein Leitmotiv aller drei Ausstellungsorte: der Galerie VN, der Galerie Greta und des Tomislav Gotovac Instituts.

Im Institut wurden in Anlehnung an Motive aus Gotovacs Arbeiten mit dem nackten Körper, die nicht gezeigt wurden stattdessen Motive eines nackten weiblichen Körpers gezeigt, der aus der Perspektive einer neoliberalen Gegenwart weniger als Ausdruck von Dissens und mehr als Marker eines Raums des Konsums und des zwanghaften Genusses erscheint. Diese Konstellation warf Fragen nach der Gültigkeit eines Klischees auf, das Ausdrucksformen von Sexualität im Sozialismus als Strategien der Subversion und Rebellion gegen die ideologische Kontrolle des autoritären (und puritanischen) Staates versteht.

Gotovacs fortwährende Auseinandersetzung mit kleinbürgerlichen Vorurteilen wurde in einer ortsspezifischen Installation von Nikolay Oleynikov, „Bathers–1: Five Steps to Defeat Both Fascism and Indifference (Senza titolo)" (2016) weiter verfolgt, in dem der Künstler eine Kombination aus erotischen Intensitäten und der Sinnlichkeit politischer Revolten verknüpft. In der Galerie VN reflektiert Oleynikovs Serie von Zeichnungen mit dem Titel „Nightmare of the Burning Soldier" (2014–15) die Episode, in der Chto Delats in Berlin errichtetes Papierdenkmal für einen queeren antifaschistischen Soldaten von unbekannten Tätern verbrannt wurde Gotovacs ikonische Serie „Inhaling Air" (1962), die neben Oleynikovs Zeichnungen gehängt wurde, bekräftigte jubilierend die transformative Sinnlichkeit des Lebens, indem sie den einfachen Akt des Atmens als eine freudvolle, vor Leben strotzende Handlung darstellte. Geta Bratescus Fotoserien „Self-Portrait, Towards White" (1975) und „Legs in the Morning" (2009) stellt ihnen Themen des Alterns und des Verschwindens in der Abstraktion gegenüber. Dieselbe widersprüchliche Stimmung eskaliert in der urkomischen Erzählung eines imaginären perfekten Todes und Begräbnisses durch die Protagonistin von Tim Etchells' Video „So Small" (2003).

In der Galerie Greta weicht „Humor" (1970), eine weitere aus kleinen Collagen mit obszöner Sexualität bestehende Serie von Tomislav Gotovac, aus heutiger Sicht von den typischen Sexualfantasien der 1960er Jahre als befreiende Strategie ab. In diesen Collagen wird Sex nicht als Substanz behandelt, sondern als Diskurs, durch den Beziehungen – von und zur Macht – verstanden werden. Hier wurde neben Tibor Hajas' Video „Self Fashion Show" (1976), das sich mit der Produktion von Identitäten und deren Manipulation beschäftigt, mit Menschen, die auf einem freudlos belebten Platz in Budapest posieren, gemeinsam mit Ewa Partums „Self-Identification" gezeigt.

6 Marcello Piacentini, einer der Hauptvertreter der italienischen faschistischen Architektur, entwarf das Gebäude Ende der 1930er Jahre für den Hauptsitz der italienischen Versicherungsgesellschaft Assicurazioni Generali (heute Generali Group) in Zagreb. Angeblich wurde der Balkon für Mussolinis Rede in Zagreb entworfen. Dessen Besuch in Zagreb kam aber nie zustande.

7 Die Ustascha (Ustaše) waren eine kroatische ultrarechte, faschistische, nationalistische und rassistische Organisation, die zwischen 1929 und 1945 aktiv war und im USK (Unabhängiger Staat Kroatien; kroatisch Nezavisna Država Hrvatska, kurz NDH) einem nationalsozialistischen deutschen Marionettenstaat in Kroatien während des Zweiten Weltkriegs, an die Macht kam.

kitchen has been kept as an installation of sorts, comprised of disparate found and everyday materials that he had obsessively collected, dissolving boundaries between art and life. The choice of his works bypassed the iconography of his iconic investigations of the naked body in public space and instead was used as a backdrop to approach questions pertaining to the body in public space by many other works included in the exhibition like, for example, Mladen Stilinović's collages "Taken out from the Crowd" and "Loneliness II" (both from 1976) that deal with the dialectics of crowds and individuals. This was also echoed in Ewa Partum's "Self–Identification" (1980), a series that inserted the photo of the artist's naked body in urban Warsaw sceneries, and which served as a leitmotif of all three venues: VN Gallery, Greta Gallery, and Tomislav Gotovac Institute.

By omitting the motives of Gotovac's naked body as an emblematic trademark of his practice and showing instead the motives of a naked female body, from the perspective of a neoliberal present figured less as an expression of dissent and more as a marker of a space of consumption and compulsive enjoyment. This constellation raised questions about the validity of a cliché that understands expressions of sexuality in socialism as strategies of subversion and rebellion against ideological control of the authoritarian (and puritanical) state.

Gotovac's continuous confrontation with petty-bourgeois prejudices were pursued further in the site-specific installation by Nikolay Oleynikov "Bathers–1: Five Steps to Defeat Both Fascism and Indifference (Senza titolo)" (2016) that interweaved erotic intensities with the sensuousness of political revolts. In VN gallery, Oleynikov's series of drawings "Nightmare of the Burning Soldier" (2014–15) reflected on the episode when Chto Delat's monument to a queer antifascist soldier erected in Berlin was burnt by unknown perpetrators. Set up next to Oleynikov's drawings, Gotovac's series "Inhaling Air" (1962) jubilantly affirmed the transformative sensuality of living depicted in the simple act of breathing, while they were juxtaposed with themes of aging and disappearance into abstraction in Geta Bratescu's photo series "Self-Portrait, Towards White" (1975) and "Legs in the Morning" (2009). The same contradictory mood escalated in the hilarious narration of an imagined perfect death and funeral by the female protagonist of Tim Etchell's video "So Small" (2003).

In Gallery Greta, Tomislav Gotovac's "Humor" (1970), consisting of small collages of obscene sexuality, treated sex not as substance or as a typical 1960 phantasy of achieving liberation through sexual practice, but as a discourse through which relations—of and to power—are understood. Tibor Hajas's video

"Self Fashion Show" (1976), dealing with the production of identities and their manipulation, with people posing in a cheerless busy square in Budapest, was shown along with Ewa Partum's "Self-Identification." If in Tomislav Gotovac Institute Partum's work offered itself to interpretations concerned with artistic subjectivity, and in VN Gallery the work was inscribed in the exhibition narrative of gender confrontations, at Gallery Greta, it casted further doubts on ideas of the pure, natural state of sex repressed by social norms and the state and, as such, in need of liberation.

3rd episode. *In the third episode, the bodies and institutions dance against each other and collective struggle is hard to start.*

The third episode attempted to mark a horizon where ideas about the radical politicization of artistic production connected with those of withdrawing into the private sphere. What in previous episodes was only hinted at through works voicing discontent with gender and sexual policing, doubts about sexual liberation, or evocations of the queer body as a militant body, episode three framed within what Lyotard called "libidinal economy," an understanding of capital as libidinally desired. The paradoxes of a libidinal economy, its institutional investments and settings, and an enjoyment of collectivity, were the issues raised by diverse works displayed in Gallery Nova, Apartment Softić and POGON Jedinstvo.

Apartment Softić was transformed by BADco.'s examinations of relationships between work, productivity, and the institutionalization of contemporary art practices that were juxtaposed to Ashley Hans Scheirl's installation comprised of her monumental paintings interwoven with films, photographs, sculptures and texts that colonized the old-fashioned middle class apartment with loud expressions of the social construction of gender, sexuality, and power.

At Gallery Nova, Eva Koťátková's installation "Unsigned (Gugging)" (2011) that focuses on the Gugging Center for Art and Psychotherapy that pioneered experimentation with artistic expression in a psychiatric context, was set up against greenish walls reminiscent of institutions such as schools and hospitals. In the black basement of Gallery Nova historical works by Mladen Stilinović, KwieKulik, and Sanja Iveković tackled the intersections of privacy and social control, along with Keti Chukhrov's video "Love Machines" (2013) examining the influence of capitalism on social and intimate human relationships that within post-human condition appear as outdated and generally belonging to low culture and unprivileged social classes.

Wenn sich Ewa Partums Werk im Tomislav Gotovac Institut für Interpretationen künstlerischer Subjektivität anbot und in der Galerie VN die Arbeit in die Ausstellungserzählung der Geschlechterkonfrontation eingeschrieben war, so wurden in der Galerie Greta weitere Zweifel an den Vorstellungen vom durch gesellschaftliche und staatliche Normen unterdrückten reinen, natürlichen Zustand des Geschlechts, der als solcher befreiungsbedürftig ist, geweckt.

Episode 3. *In der dritten Episode tanzen Körper und Institutionen gegeneinander und der kollektive Kampf lässt sich kaum in Gang bringen.*

Die dritte Episode versuchte einen Horizont zu definieren, an dem Ideen über die radikale Politisierung der künstlerischen Produktion mit denen des Rückzugs in die Privatsphäre verbunden waren.

Was in früheren Episoden nur durch Werke angedeutet wurde, die Unzufriedenheit mit der Kontrolle von Gender und Sexualität, Zweifel an der sexuellen Befreiung oder Heraufbeschwörungen des queeren Körpers als militantem Körper zum Ausdruck brachten, wurde in Episode 3 in jenen Rahmen gefasst, den Lyotard „libidinöse Ökonomie" nannte, ein Verständnis von Kapital als libidinös begehrt. Die Paradoxien einer libidinösen Ökonomie, ihre institutionellen Investitionen und Einstellungen sowie die Freude an der Kollektivität waren die Themen, die von den verschiedenen Werken in der Galerie Nova, dem Apartment Softić und POGON Jedinstvo aufgeworfen wurden.

Für diese Episode wurde das Apartment Softić mit neu in Auftrag gegebenen Arbeiten von BADco. transformiert, die Beziehungen zwischen Arbeit, Produktivität und Institutionalisierung zeitgenössischer Kunstpraktiken untersuchten. Als Gegenposition stand Ashley Hans Scheirls Installation aus Gemälden, Filmen, Fotografien, Skulpturen und Texten inmitten der altmodischen Wohnungseinrichtung dem gegenüber und eroberte das altmodische Mittelklasseapartment mit ausdrucksstarken Gesten der sozialen Konstruktion von Geschlecht, Sexualität und Macht.

In der Galerie Nova wurde die Installation von Eva Kot'átková aus der Sammlung „Unsigned (Gugging)" (2011), die den institutionellen Rahmen des Zentrums für Kunst und Psychotherapie in Gugging in den Blick nimmt, das als Pionier des Experimentierens mit künstlerischem Ausdruck in einem psychiatrischen Kontext gilt, gegen grünliche Wände gesetzt, die an Einrichtungen wie Schulen und Krankenhäuser erinnerten, während im schwarzen Keller der Galerie historische Arbeiten von Mladen Stilinović, KwieKulik und Sanja Iveković die Schnittstellen von Privatsphäre und gesellschaftlicher Kontrolle in Angriff nahmen. Keti Chukhrovs Video „Love Machines" (2013) untersuchte den Einfluss des Kapitalismus auf soziale und intime Beziehungen und die Möglichkeiten ethischen Verhaltens, welche innerhalb des zeitgenössischen Posthumanismus als nicht mehr zeitgemäß und allgemein als einer niedrigen Kulturstufe und unprivilegierten Gesellschaftsschichten zugehörig erscheinen.

In der innovativen Kulturinstitution POGON Jedinstvo, die von der lokalen unabhängigen Kulturszene Zagrebs mitfinanziert wird, wurde Chto Delats Videoinstallation „The Excluded: In a Moment of Danger" (2014) gezeigt. Sie hinterfragte die Notwendigkeit einer Revolte und der Artikulation eines kollektiven Kampfes und bot eine Art Synthese der in den Ausstellungen der dritten Episode zirkulierenden Erzählungen. Die in Chto Delats Video behandelten Fragen beziehen sich zunächst auf die Situation in Russland, aber aufgrund der Besonderheit des Ausstellungsortes auch deutlich auf die lokale unabhängige Szene. Das Video artikulierte eindringlich einen allgemeineren und gemeinsamen Aufruf zur Schaffung von Plattformen der Solidarität, des Austausches und der Kritik.

Episode 4. *Die vierte Episode, in der die Körper noch da sind, aber viele tot sind. Der Kampf ist ruhig, Versuch der Auferstehung. Die Kriegstrommeln werden in der Ferne geschlagen, wie so oft, wie immer, aber mehr.*

Die vierte Episode bestand aus zwei Personalen, Goran Trbuljak in der Galerie Forum und Josef Dabernig in der Galerie Nova, Gruppenausstellungen im Apartment Softić und im Institut für Zeitgenössische Kunst (ICA) sowie einer von der GMK eigenständig kuratierten Ausstellung, in der die Kunstschaffenden Ana Vuzdarić und Marko Gutić Mižimakov präsentiert wurden. Die vorherrschendenThemen dieser Episode waren die Verschränkung von Kunst und Politik historisch und in der Gegenwart, genauer gesagt, die Auseinandersetzung mit der historischen Avantgarde und die explizite revolutionäre Art des Verhältnisses der Kunst zur Politik.

Dieses Gefühl der Loslösung und Spannung zwischen dem Wunsch, die avantgardistischen Verpflichtungen der Avantgarde gegenüber dem revolutionären Wandel und dem Wandel der Kunst auf den neuesten Stand zu bringen, und dem klaren Fehlen einer revolutionären Bewegung und der Heraufkunft politischer Horizonte, drückte sich in der physischen Umgebung des Apartments Softić aus, in dem die Möbel verschoben und abgedeckt wurden, als ob sie verlassen oder aufgegeben würden, bis das Leben zurückkehrt. Diese Anhäufung von Möbeln, Geistern der Geschichte, melancholisch und unheimlich zugleich, diente als Requisite für eine kritische Komödie über Rekonstruktionen und Rückzüge, Absenzen und Brüche, Hindernisse und Durchbrüche. Diese Anhäufung wurde auch von Goran Petercol in seiner Installation „Symmetry, Doubling and Finished with the First One" (2017) verwendet, die sich mit der Wiederholung und Rekonstruktion von Abwesenheiten beschäftigt.

Ein Dialog zwischen der Sammlung und anderen historischen und zeitgenössischen Werken prägte weiterhin die vierte Episode und überlagerte die Begegnungen mit Nachklängen aus verschiedenen emanzipatorischen Bewegungen, wie z.B. der jugoslawischen Partisanenkunst des Zweiten Weltkriegs, um

At the innovative cultural institution cofounded by the local independent scene, POGON Jedinstvo – Zagreb Center for Independent Culture and Youth, Chto Delat's video installation "The Excluded: In a Moment of Danger" (2014) was displayed. Pointing toward the necessity of revolt and the articulation of collective struggles, it offered a sort of synthesis of narratives circulating through the exhibitions that comprised the third episode. The questions tackled in Chto Delat's video initially pertain to the Russian situation, but in the specific setting of the venue strongly related to the local independent scene, it poignantly addressed a more general and common call for creating platforms of solidarity, exchange, and critique.

4th episode. *The fourth episode, in which bodies are still here but many are dead. The struggle is quiet, resurrection attempted. Drums of war are beating in the distance, like often, like always, but more.*

The fourth episode was comprised of two solo exhibitions, Goran Trbuljak's in Gallery Forum and Josef Dabernig's in Gallery Nova, group exhibitions at the Apartment Softić and the Institute for Contemporary Art (ICA), and an exhibition independently curated by GMK, presenting the artists Ana Vuzdarić and Marko Gutić Mižimakov. The dominant themes of this episode were the entanglement of art and politics historically and in the present, or more specifically, an engagement with the historic avant-garde and the explicit revolutionary modalities.

This feeling of disjunction and tension between a desire to update avant-garde commitments to revolutionary change and the transformation of art, and the clear absence of revolutionary movement and the closing in of political horizons was expressed in the physical setting of Apartment Softić, where furniture was moved and covered, as if evacuated or abandoned until life returns. These piles of furniture, ghosts of history, both melancholic and eerie, served as a prop for a drama, or for a critical comedy, about reconstructions and retreats, absences and discontinuities, obstacles and breakthroughs. The piles were also utilized by Goran Petercol's installation "Symmetry, Doubling and Finished with the First One" (2017) dealing with the repetition and the reconstruction of absences. A dialogue between the collection and other historical and contemporary works, continued to shape the fourth episode and layered those encounters with reverberations from various emancipatory movements, such as Second World War Yugoslav partisan art, to consider the (im)possibilities of the revolutionary mode in the present moment. That was effectively articulated in Mladen Stilinović's seminal cycle *Exploitation of the Dead* (1984–1990) installed at the entrance of the apartment, in which he revisits the past poetics of Suprematism, socialist realism, and geometric abstraction exploring the landscape of dead signs, that continue to circulate devoid of their initial meaning. At the ICA, the intricacies of the historical avant-garde were reinforced by showing a work from the collection "The Last Futurist Exhibition." Based on the famous black and white photograph that documented the initial St. Petersburg exhibition from 1915, the exhibition repapered exactly after 70 years, restaged in an apartment in Belgrade and resurrected by a mysterious Belgrade Malevich.

The selection of partisan art from the Yugoslav People's Liberation Struggle of the Second World War in the apartment included the graphic map "Partisans"[8] (1945) by Đorđe Andrejević Kun, that was found in the family's library of Apartment Softić. Kun's partisan graphics were presented superimposed over Katalin Ladik's collages of visual poetry from the collection "Ausgewählte Volkslieder (Selected Folk Songs)" (1973–1975), composed of cut-ups of musical scores and clippings from women's magazines from socialist Yugoslavia. From the current perspective of identitarian politics prevailing in the post-Yugoslav context, this unexpected juxtaposition stressed the conjunctions and divergences between the antifascist revolutionary struggle and processes of socialist modernization and their unresolved tensions.

The exhibition also included Slavko Marić's painterly reminiscences of the lived experience of the partisan struggle in the painting "Column" (1976), borrowed from the Association of Antifascist Fighters and Antifascists of the Republic of Croatia—one of the rare paintings with partisan themes still displayed in a public space. Propaganda partisan prints by Vlado Kristl, mostly known as an influential avant-garde artist, (whose work was the starting point for Goran Trbuljak's solo exhibition at the Forum Gallery) indicated a necessity to look beyond the false dualism of socially engaged and autonomous art.

6

Mladen Stilinović, "Exploitation of the Dead," 1984–1990,
"My Sweet Little Lamb," Episode 4, Softić Apartment, Zagreb, 2017
© Damir Žižić

8 Printed in 5,000 copies immediately after the Second World War.

7

Paintings by Gülsün Karamustafa and partisan propaganda posters
by Vlado Kristl | Gemälde von Gülsün Karamustafa und
Propaganda-Partisanendrucke von Vlado Kristl, "My Sweet Little Lamb,"
Episode 4, Softić Apartment, Zagreb, 2017 © Damir Žižić

die (Un-)Möglichkeit(-en) des revolutionären Modus zum gegenwärtigen Zeitpunkt zu untersuchen. Das wurde in Mladen Stilinovićs bahnbrechendem Zyklus „Exploitation of the Dead" (1984–1990), der Im Eingangsbereich des Appartments installiert wurde, hervorragend künstlerisch artikuliert, in dem er Poetiken der Vergangenheit – des Suprematismus, des sozialistischen Realismus und der geometrischen Abstraktion – verwendet, um Landschaften toter Zeichen zu erforschen, die weiterhin zirkulieren, obwohl sie ihre eigentliche Bedeutung verloren haben. Am Institut für Zeitgenössische Kunst wurde das Thema der historischen Avantgarde weiter durch ein Werk aus der Sammlung „Die letzte futuristische Ausstellung" untermauert. Ausgehend von dem berühmten schwarz/weiß Foto, das die ursprüngliche Ausstellung in St. Peterburg 1915 dokumentiert, wurden die Ausstellungsobjekte genau 70 Jahre später in einem Belgrader Appartment neu auf Papier gebracht und aufgehängt, ausgegraben von einem mysteriösen Belgrader Malewitsch.

Die Auswahl aus Partisanenkunst aus dem Jugoslawischen Volksbefreiungskampf des Zweiten Weltkrieges in der Wohnung enthielt die grafische Karte „Partisanen" (1945)[8] von Đorđe Andrejević Kun, die in der Familienbibliothek des Apartment Softić gefunden wurde. Kun's Partisanengrafiken, die in der Ausstellung über eine Serie von Collagen aus der Sammlung von Katalin Ladiks Collagen visueller Poesie „Ausgewählte Volkslieder" (1973–1975) gelegt präsentiert wurden, zusammengesetzt aus Ausschnitten aus Partituren und Ausschnitten aus Frauenzeitschriften aus dem sozialistischen Jugoslawien. Aus der gegenwärtigen Perspektive von identitärer Politik, wie sie im post-jugoslawischen Kontext vorherrscht, erzeugte dies eine unerwartete Gegenüberstellung, die Widersprüche und Ähnlichkeiten zwischen dem antifaschistischen revolutionären Kampf und den Prozessen der sozialistischen Modernisierung sowie deren ungelöster Spannungen betonte.

Die Ausstellung beinhaltete ebenfalls die malerischen Reminiszenzen von Slavko Marić an seine prägende gelebte Erfahrung des Partisanenkampfes im Gemälde „Column" (1976), einer Leihgabe des Verbands der antifaschistischen Kämpfer und Antifaschisten der Republik Kroatien als eines der seltenen Gemälde mit Partisanenthemen, die noch immer im öffentlichen Raum zu sehen sind. Propaganda-Partisanendrucke von Vlado Kristl, der vor allem als einflussreicher Avantgardekünstler bekannt ist (dessen Arbeit für Goran Trbuljaks Ausstellung in der Galerie Forum von entscheidender Bedeutung war), wiesen auf die Notwendigkeit hin, über den falschen Dualismus zwischen gesellschaftlich engagierter und autonomer Kunst hinauszuschauen.

Es ging nicht darum, sich mit der Partisanenbewegung zu identifizieren oder die gesellschaftliche Transformation durch eine revolutionäre Rhetorik zu ersetzen, sondern Vergangenheit, Gegenwart und Zukunft zu verbinden, Fragen nach der gegenwärtigen Unmöglichkeit revolutionärer Bewegungen aufzuwerfen und sich den Pathologien des Augenblicks zu stellen. Dies wurde im letzten Raum des Apartments betont, wo eine Auswahl von Gülsün Karamustafas Gemälden und Collagen aus den 1970er Jahren gezeigt wurde, die sich auf die blutige Geschichte linker Bewegungen in der Türkei, ihre Proteste und Paraden beziehen. Das war der einzige Raum, der sich während des gesamten Projekts dem Charakter einer Wohnung entzog. Während er in den vorangegangenen Episoden in einen Vorführraum für Projektionen verwandelt worden war, wiesen nun die rote Farbe an den bemalten Wänden und der Teppichboden auf subtile Weise auf ein Museum hin, in dem „Alte Meister" hingen.

Episode 5. *Was kommt nach dem Sammeln?*

Die fünfte Episode bestand aus einem zweitägigen kollaborativ geplanten Seminar, bei dem Gespräche und Performances zu unterschiedlichen Facetten und Ebenen des Sammelns stattfanden, die den dominanten westlichen Kanon infrage stellten und Prozesse der Öffnung von Sammlungen für politisch insti tutionelle Zwecke diskutierten, die mit historischen, lokalen, politischen oder sozialen Notwendigkeiten verbunden sind. Die TeilnehmerInnen waren unter anderen Zdenka Badovinac, Charles Esche, Ana Janevski, Katalin Ladik, Tomislav Medak, Nikolay Punin, Erzen Shkololli, Kate Fowle, Kate Sutton und Manuel Pelmuş.

8 In einer Auflage von 5.000 Exemplaren unmittelbar nach dem Zweiten Weltkrieg gedruckt.

175

The point of showing these works was not to identify with the partisan movement, nor to replace social transformation with a revolutionary rhetoric, but rather to interconnect past, present, and future, to pose questions about current impossibilities of revolutionary movement and confront the pathologies of the moment. This was accentuated in the last room of the apartment, where a selection of Gülsün Karamustafa's paintings from the 1970s, referring to the bloody history of leftist movements in Turkey, its protests and parades, were displayed. That was the only room that throughout the project defied the character of the apartment. Whereas in the previous episodes it was turned into a projection room, the red color of its painted walls and its fitted carpet in this episode subtly referenced a museum where the "old masters" are hanging.

5th episode. *What comes after collecting?*

The 5th episode was a two-day seminar conceived in collaboration with that encompassed conversations and performances that problematized different facets and implications related to the notion of collecting such as the questioning of the dominant Western canon, the process of opening up collections to political institutional policies related to history, locality, political and social urgencies. The participants included Zdenka Badovinac, Charles Esche, Ana Janevski, Katalin Ladik, Tomislav Medak, Nikolay Punin, Erzen Shkololli, Kate Fowle, Kate Sutton, and Manuel Pelmuş.

6th episode. *Shipwrecked in the former museum of revolution, the finale does not tie up loose ends.*

By summarizing previous investigations, the sixth episode was staged as the project's finale at the Home of the

9

Boris Ondreička/Ján Zavarský/Vít Havránek, Discursive conclusion of Stano Filko's "White Space in a White Space," "My Sweet Little Lamb," Episode 6, Home of the Croatian Association of Visual Artists (HDLU) | Sitz der Kroatischen Gesellschaft der bildenden Künstler (HDLU), Zagreb, 2017 © Damir Žižić

Croatian Association of Artists/HDLU—one of the most historically laden buildings in Zagreb, as well as at Apartment Softić and Gallery Nova. After a number of dispersed presentations, the choice of HDLU as a main venue for the final episode was strategic: its size enabled creating a dialogue among a large number of works from the Kontakt Art Collection and just a brief glimpse at its history[9] sheds a significant light on the interconnectedness of art institutions and social circumstances.

The exhibition display structures in HDLU were conceptualized by the artist David Maljković and the architect Ana Martina Bakić. Maljković's artistic methodologies of creating an estrangement effect through "unsuitable" spatial constellations and the dislocation of the spectator's expectations were immediately visible. The visitors were met with an imposing and counter-intuitively positioned wall that required them to immediately "choose a side," and emphasized the impossibility of easily grasping the exhibition in its totality. In other exhibition areas, works were placed on fragments of earlier exhibition structures that have been torn down and built upon, transfigured and transformed, and there was an impression of being amidst the process of dissolving and rebuilding.

9 It was designed by Croatian sculptor Ivan Meštrović and opened as an art space called House of the Visual Arts of King Peter I, the Great Liberator in 1938. The name was shed just a few years later when the building was turned into a Mosque by the Croatian Nazi puppet state during the Second World War. Under socialism, it was the Museum of Socialist Revolution until 1990 when it was emptied of historical content and brought back to its current function as a Kunsthalle, most recently referred to as the Meštrović Pavilion.

8

Július Koller, "Question Mark Cultural Situation (U.F.O.)," "My Sweet Little Lamb," Episode 6, Home of the Croatian Association of Visual Artists (HDLU)| Sitz der Kroatischen Gesellschaft der bildenden Künstler (HDLU), Zagreb, 2017 © Damir Žižić

Tina Gverović/Siniša Ilić, "Collage from the Highw detail by Tina Gverović | Detail von Tina Gverović, "Substructure," 20 "My Sweet Little Lamb," Episode 6, Softić Apartment, Zagreb, 20 © Damir Ž

Episode 6. *Schiffbrüchig im vormaligen Museum der Revolution löst die letzte Etappe die offenen Probleme nicht.*

In ihrer Zusammenfassung der vorangegangenen Untersuchungen wurde die sechste Episode als Projektfinale im Heim kroatischer bildender Künstler/HDLU[9], einem der geschichtsträchtigsten Gebäude in Zagreb, inszeniert. Sie umfasste auch Schauplätze der vorherigen Episoden – das Apartment Softić und die Galerie Nova. Nach mehreren verstreuten Präsentationen war die Wahl des Heims kroatischer bildender Künstler als Hauptveranstaltungsort für die letzte Episode von strategischer Bedeutung: Die Größe des Heims ermöglichte es, einen Dialog zwischen einer großen Zahl von Werken der Kontakt Kunstsammlung zu schaffen, und schon ein kurzer Blick auf ihre Geschichte wirft ein deutliches Licht auf die Vernetzung von Kunstinstitutionen und gesellschaftlichen Verhältnissen.

Die Ausstellungsstrukturen im Heim kroatischer bildender Künstler wurden vom Künstler David Maljković und der Architektin Ana Martina Bakić konzipiert. Die künstlerischen Methoden von Maljković, durch „unpassende" Raumkonstellationen einen Entfremdungseffekt zu erzeugen, und die Verschiebung der Besuchererwartungen waren bereits am Eingang sichtbar. Eine hohe, kontraintuitiv positionierte Wand zwang die BesucherInnen dazu, sofort „eine Seite zu wählen", und betonte die Unmöglichkeit, die Ausstellung in ihrer Gesamtheit leicht

zu erfassen. In anderen Ausstellungsbereichen wurden Arbeiten auf Fragmente früherer Ausstellungsstrukturen platziert, die abgerissen und bebaut, umgestaltet oder gänzlich verwandelt wurden, und es entstand der Eindruck, als befände man sich mitten drin in einem Prozess der Auflösung und des Wiederaufbaus.

Die Gestaltung dieser „flüchtigen" Ausstellungsstrukturen entsprang dem Wunsch, sich mit dem formalen Charakter und dem Fluss der kreisförmigen Räume des Heims kroatischer bildender Künstler zu beschäftigen und nicht mit dessen ideologischer und historischer Last. An der Fassade, über dem Eingang des Gebäudes, wurde wiederum „Question Mark Cultural Situation (U.F.O.)" (1992) von Július Koller installiert, ein Werk, das die Offenheit der Ausstellung für unterschiedliche Interpretationen verkündete. Die auf der Treppe zu den Galerien im Obergeschoss platzierten „Cakes" (1993) von Mladen Stilinović waren eine Anspielung auf die Installation des vorherigen Autors am selben Ort. Die in vorherigen Episoden eingeführte Praxis

9 Es wurde vom kroatischen Bildhauer Ivan Meštrović entworfen und 1938 als „Haus der Bildenden Künste von Peter I., dem großen Befreier" eröffnet. Der Name wurde aber nur weniger Jahre später verworfen, als der kroatische Nazi-Marionettenstaat das Gebäude während des 2. Weltkriegs in eine Moschee umwandelte. Im Sozialismus war es bis 1990 das Museum der sozialistischen Revolution. Dann wurde es von historischen Inhalten befreit und in seine heutige Funktion als Kunsthalle zurückgeführt, zuletzt unter dem Namen Meštrović Pavillon (kroatisch: Meštrovićev paviljon).

The design of these "transitory" display structures came from a desire to engage with the formal character and flow of the circular space of the HDLU, rather than with its ideological and historical burden. At the facade, over the entrance to the building, the "Question Mark Cultural Situation (U.F.O.)" (1992) by Július Koller announced the exhibition's openness to different interpretations. "The Cakes" (1993) by Mladen Stilinović placed on the stairs leading to the upper floor galleries were a nod to the author's previous installation at the very same place. Many of the works that were shown in previous episodes, such as the sculptures of Mária Bartuszová or the blue line by Edward Krasiński, were exhibited again in different constellations. Repurposing of exhibition structures and the dehierarchization of content, used as a method by many artists presented in the exhibition throughout their practice, was taken as one of the main principles of the set-up at HDLU.

One of the performances at the opening, "Repetetio est Mater" (2000) by Sanja Iveković, was a reenactment of the artist's performance in 2000 at the opening of the first WHW's exhibition "What, How & for Whom, on the occasion of 152nd anniversary of the Communist Manifesto," presented in the same building. The performance reenacted the letter that female partisan Nada Dimić, killed in the Second World War by the Ustaše, wrote from the occupied city of Karlovac to her comrades from the Yugoslav Communist Party. Nearby, a graphic map with disastrous motives of the Second World War, entitled "Fruits of Excitement of 1941 and 1942" (1941/42) by Croatian artist Marijan Detoni was shown. Soon after the map had been produced (indecently in Karlovac, the same city where Dimić had written her letter), the artist joined the partisan struggle, so this work maps the tipping point that fuses art and life in an active act of struggle and participation.

Several other thematic threads ran through the show, resulting from similar sensibilities, obsessions, and methodologies of artists. These loose interconnected threads were related to interactions of abstraction and fiction, the relationship between public space and the individual, nature and the human body, cosmism and utopian ideas of science fiction.

At Apartment Softić, Tina Gverović and Siniša Ilić created an environment that emptied and transformed the seemingly enclosed space of the apartment, whereas at Gallery Nova, works by Boris Cvjetanović, Milica Tomić and Želimir Žilnik charted the way in which suppressed economic conflicts, aggravated by global crisis and industrial trends of the 1970s and 1980s, boiled over in violent identitarian politics and armed conflict in Yugoslavia during the 1990s.

Project's epilogue. *My sweet little lamb, what is the future of this?*

After six episodes taking place in Zagreb, the exhibition settled down at The Showroom, London, for the project's poetic epilogue reversing the original title "My Sweet Little Lamb (Everything we see could also be otherwise)" to "Everything we see could also be otherwise (My Sweet Little Lamb)." The exhibition included works by Stilinović that thematized relations between economy, money, and ideology, and generally looked into artistic anti-approaches from the 1960s and 1970s. With the artistic anti-systemic and anti-commodity strategies of the past, now largely commodified and assimilated in the market, the epilogue staged a search for available gestures of their revival. It was not a final word as much as the afterthought for a renewed investigation of the possible contemporary forms of anti-systemic modalities as well as uncertainties of the present time. The setting of the project's epilogue in Brexit London created a dense atmosphere in which the post-communist transition and its suppressed lessons posed questions about how this experience can be related to our common future.

11

"Everything we see could also be otherwise (My Sweet Little Lamb),"
epilogue | Epilog, installation view | Ausstellungsansicht,
The Showroom, London, 2017 © Daniel Brooke

der unerwarteten Gegenüberstellung setzte sich hier fort, und viele der zuvor gezeigten Werke, wie die Skulpturen von Mária Bartuszová oder die blaue Linie von Edward Krasiński wurden in verschiedenen Konstellationen wieder ausgestellt. Die von vielen Kunstschaffenden in der Ausstellung als Methode angewandte Umnutzung und Dehierarchisierung der Inhalte und des Kunstgegenstands an sich wurde als eines der Prinzipien des gesamten Set-ups aufgefasst. Eine der Performances bei der Eröffnung, „Repetetio est Mater" von Sanja Iveković, war eine Nachstellung der Performance der Künstlerin im Jahr 2000 bei der Eröffnung der ersten Ausstellung von WHW, „What, How & for Whom, anlässlich des 152. Jahrestages des Kommunistischen Manifests", die im selben Gebäude präsentiert wurde.

Die Performance war eine szenische Nachstellung des Briefes, den die im Zweiten Weltkrieg von den Ustascha ermordete Partisanin Nada Dimić aus der besetzten Stadt Karlovac an die Genossen der Kommunistischen Partei Jugoslawiens geschrieben hatte. Genau gegenüber zeigte die grafische Karte „Fruits of Excitement of 1941 and 1942" (1941/42) von Marijan

Detoni, einem weiteren Partisanenkünstler, die katastrophalen Auswirkungen des Zweiten Weltkriegs. Kurz nachdem die Karte (zufällig) ebenfalls in Karlovac hergestellt worden war, in der gleichen Stadt also, in der Dimić ihren Brief geschrieben hatte, schloss sich der Künstler dem Partisanenkampf an, so dass diese Karte einen Wendepunkt markiert, an dem eine Verschmelzung von Kunst und Leben in einem Akt des aktiven Kampfes und der Kriegsteilnahme stattfindet.

Eine Reihe weiterer thematischer Fäden, die sich aus ähnlichen Sensibilitäten, Obsessionen und Methoden von Kunstschaffenden ergeben hatten, zogen sich durch die Ausstellung. Diese lose verbundenen Fäden waren bezogen auf die Verflechtung von Abstraktion und Fiktion, die Beziehung zwischen öffentlichem Raum und Individuum, Natur und menschlichem Körper oder Kosmismus und utopischen Science-Fiction-Ideen.

Im Apartment Softić schufen Tina Gverović und Siniša Ilić eine Umgebung, die den scheinbar sicheren und geschlossenen Raum einer Privatwohnung leerte und verwandelte, während in der Galerie Nova Werke von Boris Cvjetanović,

The exhibition expanded the project's context by including several London-based artists of different generations, such as conceptual artist Stephen Willats, performer Tim Etechells as well as representatives of London based international artists such as Oscar Murillo or Vlatka Horvat. In a dense spatial configuration, the works inhabited the interior and exterior of The Showroom's building, confronting its architecture with an installation resembling a temporary occupation or the moving into a new space. This was highlighted by Marcus Geiger's installation "Untitled" (2013), also shown in the first episode in Zagreb, that entirely covered the floor of the gallery with material used to protect building sites.

The methodology from the Zagreb exhibition, that resulted in stretching the exhibition in time and various locations in the city, was amplified on the occasion of the project's epilogue, and experimenting with the exhibition format was translated into a format of a "totalizing exhibition." The exhibition spread out of the usual gallery's spatial parameters, utilizing its auxiliary facilities, such as offices and storage spaces, as a gesture of the de-musealisation. Treating the gallery walls as a porous membrane, it used the exterior of the building so the works were also shown outside. A series of black burnished paintings, "The Institute of Reconciliation" (2017) by Oscar Murillo were installed on a scaffolding structure that was re-used as a platform for presenting some of the legendary works from the 70s and 80s by Mladen Stilinović and Július Koller.

Questioning the shortcomings of a field of art in the mid-60s, Július Koller proposed a concept of "a new cultural situation" that can connect artists "to engage instead of to arrange,"[10] which brings to the fore the project's central question: how can contemporary art's regimes be renewed in a synergy with their institutions? Seen as a whole, "My Sweet Little Lamb (Everything we see could also be otherwise)" considered the prospects of reconfiguring the artistic and cultural production in present times. Emphasizing the pertinence and the capacities of small independent art institutions, "My Sweet Little Lamb (Everything we see could also be otherwise)" demonstrated that complex projects of a larger exhibitional scope should not depend on representational formats dictated by the museum context, that today appear more as spectacles of mass consumerist worship, rather than as places of complex cultural and social production. Deconstructing the idea of presenting the collection as a unifying entity and gradually building the exhibition as an extensive course of activities, the display and architectural reconfigurations became valuable allies in reformatting the exhibition as a continuous, overlapping stream of motives, people and ideas put in contact through the medium of the exhibition. This has affirmed that exhibitions perform themselves as perpetual rehearsals without a premiere. ∎

10 Georg Schöllhammer, "Engagement Instead of Arrangement: Julius Koller's Erratic Work on the Re-Conception of Aesthetic Space 1960ff," *Springerin* 2 (2003), pp. 2–9, esp. p. 4.

Milica Tomić und Želimir Žilnik die Art und Weise skizzierten, wie wirtschaftliche Konflikte, verschärft durch die globale Krise und die industriellen Trends der 1970er und 1980er Jahre, verdrängt wurden und im Jugoslawien der 1990er Jahren in einer gewalttätigen identitären Politik und einem bewaffneten Konflikt überkochten.

Epilog des Projekts. *Mein süßes kleines Lamm, wie sieht die Zukunft davon aus?*

Nach sechs Episoden, die in Zagreb stattgefunden hatten, fand sich die Ausstellung schließlich zur Realisierung des poetischen Epilogs im Showroom in London ein, der den Originaltitel „My Sweet Little Lamb (Everything We See Could also Be Otherwise)" in „Everything We See Could Also Be Otherwise (My Sweet Little Lamb)" umkehrte. Die Ausstellung umfasste Arbeiten von Stilinović, die sich mit dem Verhältnis von Ökonomie, Geld und Ideologie auseinandersetzen und künstlerische Anti-Ansätze aus den 1960er und 1970er Jahren untersuchen. Mit den künstlerischen Anti-System- und Anti-Konsumwaren-Strategien der Vergangenheit, die nun selbst weitgehend kommerzialisiert und vom Markt assimiliert worden sind, inszenierte der Epilog eine Suche nach verfügbaren Gesten ihrer Wiederbelebung. Der Londoner Epilog war kein Schlusswort, ebenso wenig wie der nachträgliche Gedanke an eine erneute Untersuchung der möglichen zeitgenössischen Formen von anti-systemischen Modalitäten sowie der Unsicherheiten der Gegenwart. Die Verlegung des Epilogs des Projekts nach London in Zeiten des Brexit schuf eine dichte Atmosphäre, in der der postkommunistische Übergang und seine verdrängten Lektionen die Frage aufwerfen, wie diese Erfahrung mit unserer gemeinsamen Zukunft in Verbindung gebracht werden kann.

Die Ausstellung erweiterte den Kontext des Projekts um mehrere in London lebende Kunstschaffende verschiedener Generationen, wie den Konzeptkünstler Stephen Willats, den Performance-Künstler Tim Etchells sowie Vertreter einer jüngeren Generation von in London lebenden internationalen Kunstschaffenden wie Oscar Murillo oder Vlatka Horvat.

In einer dichten räumlichen Konfiguration bewohnten die Arbeiten das Innere und Äußere des Gebäudes des Showrooms und konfrontierten seine Architektur mit einer Installation, die einer temporären Okkupation oder dem Umzug in einen neuen Raum ähnelte. Dies wurde durch Marcus Geigers bereits in der ersten Episode gezeigte Installation „Untitled" unterstrichen, die die Galerieböden vollständig mit Material zum Schutz von Baugeländen bedeckte.

Die Methodik der Zagreber Ausstellung, die dazu führte, dass sich die Ausstellung zeitlich und räumlich über verschiedene Schauplätze in der Stadt ausdehnte, wurde anlässlich der Londoner Ausstellung so erweitert, dass ein längeres Experimentieren mit dem Ausstellungsformat in Zagreb in London in das Format einer „totalisierenden Ausstellung" übersetzt wurde. Die Ausstellung erstreckte sich über die herkömmlichen räumlichen Parameter der Galerie hinaus und nutzte als Geste der Entmusealisierung Zusatzeinrichtungen wie Büros und Lagerräume. Die Ausstellung verwendete die Wände der Galerie als poröse Membran, so dass die Arbeiten auch im Freien installiert wurden. Eine Reihe von geschwärzten Gemälden, „The Institute of Reconciliation" (2017) von Oscar Murillo, wurden auf einem Gerüst installiert, das auch als Plattform für die Präsentation einiger der legendären Werke von Mladen Stilinović und Július Koller aus den 1970er und 1980er Jahren diente.

In seiner Hinterfragung der Unzulänglichkeiten des Kunstfeldes Mitte der 1960er Jahre schlug Július Koller das Konzept einer „neuen kulturellen Situation" vor, die Kunstschaffende zu „Engagement statt Arrangement" verbinden kann,[10] was die zentrale Frage des Projekts in den Vordergrund rückt: Wie lassen sich die Regime der zeitgenössischen Kunst in Synergie mit ihren Institutionen erneuern? Insgesamt betrachtet, untersuchte „My Sweet Little Lamb (Everything We See Could also Be Otherwise)" die Aussichten einer Neukonfiguration von künstlerischer und kultureller Produktion in der Gegenwart. Mit der Betonung ihrer Relevanz und der Fähigkeiten kleiner unabhängiger Kunstinstitutionen demonstrierte „My Sweet Little Lamb (Everything We See Could also Be Otherwise)", dass komplexe Projekte größeren Formats nicht von repräsentativen Museumsumgebungen abhängen sollten, die heute eher als Spektakel der Anbetung des Massenkonsums denn als Orte komplexer kultureller und sozialer Produktion erscheinen. Mit der Dekonstruktion der Idee, die Sammlung als eine verbindende Einheit zu präsentieren, und vielmehr die Ausstellung schrittweise zu einem umfassenden Parcours von Aktivitäten auszubauen, wurden die Ausstellungsgegenstände und die architektonischen Neukonfigurationen zu wertvollen Verbündeten bei der Neuformatierung der Ausstellung als ein kontinuierlicher ineinander greifender Fluss von Motiven, Menschen und Ideen, die durch das Medium Ausstellung miteinander in Kontakt gebracht werden. Dies hat die Auffassung bestätigt, dass sich Ausstellungen als immer wiederkehrende Generalproben ereignen, ohne dass je eine Premiere stattfände. ∎

Übersetzung: Otmar Lichtenwörther

10 Schöllhammer, Georg: „Engagement Instead of Arrangement. Julius Koller's Erratic Work on the Re-Conception of Aesthetic Space 1960ff", in: *Springerin* 2 (2003), 2–9, hier 4.

erything we see could also be otherwise
Sweet Little Lamb)," epilogue | Epilog,
allation view | Ausstellungsansicht,
Showroom, London, 2017
Daniel Brooke

1

„To Build a Gas Column",
Arbeit am Nachbau der
Gassäule des Krematoriums
des Vernichtungslagers
Auschwitz | Work on the
replica of the gas column
of the crematorium of the
Auschwitz extermination
camp, Anne Bordeleau/
Sascha Hastings/Donald
McKay/Robert Jan van Pelt,
The Evidence Room, Venice
Architecture Biennale, 2016
© Michael Nugent, Courtesy
of *The Evidence Room*,
School of Architecture,
University of Waterloo

Die Evidenz der Architektur

The Evidence of Architecture

Antje Senarclens de Grancy

Kurz nachdem er vom Komitee der Biennale di Venezia als Kurator für die Architekturbiennale 2016 beauftragt worden war, richtete Alejandro Aravena an den an der University of Waterloo in Kanada lehrenden Architekturhistoriker Robert Jan van Pelt die Einladung, sich an der Ausstellung zu beteiligen. Jahre zuvor hatte van Pelt, beeindruckt von der „ethical and imaginative dimension"[1] der Architekturpraxis Aravenas, diesem sein Buch *The Case for Auschwitz*[2] geschenkt. In diesem 2002 veröffentlichten Band dokumentierte van Pelt seine auf jahrzehntelangen Forschungen zur Architektur des Vernichtungslagers Auschwitz basierenden Zeugenaussagen im Londoner Gerichtsprozess des Holocaustleugners David Irving gegen eine amerikanische Historikerin und deren Verleger vor dem British High Court of Justice im Jahr 2000. Van Pelts Herangehensweise einer „reversed architectural logic"[3] bestand darin, durch Analyse von physischen Baurelikten, technischen Zeichnungen, Fotografien, schriftlicher Korrespondenz und Zeitzeugenskizzen die mörderische Zweckbestimmung der Architektur der Krematorien zu beweisen und das Projekt des Genozids quasi zurückzuspulen. Dieses Verfahren hat in den letzten Jahren eine ganze Reihe von Initiativen und Projekten vielfältig inspiriert, die mit einem steigenden Interesse der Architekturforschung am Raum des Lagers sowie dem an materiellen Spuren interessierten „Forensic Turn" innerhalb der Holocaust Studies korrelieren.[4]

Zur Vorbereitung der Biennale bat Aravena die eingeladenen Personen um eine erste Beschreibung ihres Kampfes („battle") – im Sinne des Biennaletitels „Reporting from the Front" – sowie ihrer Idee für eine Ausstellung. Auf seine Anregung hin entschied sich das Kuratorenteam, das von Robert Jan van Pelt zur Zusammenarbeit eingeladen wurde und sich aus Experten (Anne Bordeleau, Donald McKay, Sascha Hastings), Architekturstudierenden der Waterloo University und Handwerkern formierte, nicht die Beweisführung und Argumentation des „Irving Trials"[5] als Aktion „an der Front" zu zeigen, sondern die Beweise selbst ins Zentrum zu stellen. Dem entspricht der Titel der Ausstellung „The Evidence Room".[6]

Während es beim „Irving Trial" um den mit den Mitteln der historischen Architekturanalyse forensisch belegbaren Beweis der Existenz der Gaskammern gegangen war, kam es in Venedig im Kontext der Architekturveranstaltung zu einer

Schwerpunktverschiebung: Wie van Pelt immer wieder formuliert, wurde hier der Blick auf „das größte Verbrechen, das Architekten begangen haben",[7] gelenkt. Das bedeutete, Architektur – und damit Architekten als Akteure im Rahmen ihrer Profession – als zentrales Element der Ermordung von Millionen von Menschen zu erinnern. Gezeigt werden sollte, was evident, gleichzeitig aber nicht vorstellbar ist. „Evidence" bedeutete also das Sichtbarmachen des nicht mehr vorhandenen Materiellen (des von den Tätern Zerstörten, um die letzten Spuren zu verwischen), andererseits aber auch den Verweis auf das nicht Zeigbare: Es ging darum, wie der Bildtheoretiker Georges Didi-Huberman fordert, das Unvorstellbare „trotz allem"[8] vorzustellen.

Der Biennale-Beitrag bestand aus zwei Komponenten. Die eigentliche Ausstellung im Hauptpavillon in den Giardini wurde in den Medien stark wahrgenommen.[9] Die im „Irving Trial" vorgelegten Beweise sind hier in „greifbarer Evidenz" anwesend und können berührt und ertastet werden, erhalten jedoch den auratischen Charakter von Monumenten. Im Kontext der zeitgenössischen Erinnerungskultur steht die für die Ausstellung gewählte Form künstlerischen Praktiken wie dem als Betonskulptur ausgeführten Wiener Holocaust Memorial (2000) von Rachel Whiteread, das durch nach außen gewendete Bibliothekswände und somit im Verborgenen bleibende Bücher[10] Verlust und Abwesenheit thematisiert und auf Distanz zu den heroisierenden Denkmälern geht, näher als der performativen, durch

1 van Pelt, Robert Jan: *Hineni*: An Essay in Acknowledgment", in: Anne Bordeleau u.a., *The Evidence Room*, Toronto 2016, 163–169, hier 163.

2 van Pelt, Robert Jan: *The Case for Auschwitz. Evidence from the Irving Trial*, Bloomington/Ind. u.a. 2002.

3 Aravena, Alejandro: „No Hole, No Holocaust", in: ders. (Hg.), *Reporting from the Front. 15. Mostra Internazionale di Architettura*, Venedig 2016, 124.

4 Vgl. z.B. Weizman, Eyal: *Forensis. The Architecture of Public Truth*, Berlin 2014.

5 David Irving erhob Klage gegen Deborah Lipstadt und Penguin Books wegen Rufschädigung. Im Zuge des Gerichtsprozesses am High Court trat Robert Jan van Pelt als Architekturexperte auf und verteidigte im Kreuzverhör fünf Tage lang seinen 700-seitigen Bericht, in dem er mittels bauhistorischer und archäologischer Analysen die Existenz der Gaskammern beweisen konnte. Das Gericht wies Irvings Klage ab.

6 Mit diesem Begriff wird die Asservatenkammer bezeichnet, ein gesicherter Raum, in dem Beweisstücke für ein Gerichtsverfahren bereitgestellt werden. Der Ausstellungstitel bezieht sich aber auch auf andere Räume: den Raum der Gaskammer, den Gerichtssaal und den Ausstellungsraum auf der Biennale. „The Evidence Room", wurde von Juni 2017 bis Jänner 2018 auch am Royal Ontario Museum in Toronto gezeigt sowie in modifizierter Form als „Architecture as Evidence" von Juni bis September 2016 am Canadian Center for Architecture in Montreal.

7 „[…] the greatest crime ever committed by architects." Aus dem Klappentext von: Bordeleau u.a. (Hg.): *The Evidence Room* (wie Anm. 1).

8 Didi-Huberman, Georges: *Bilder trotz allem*, München 2007.

9 Vgl. z.B. Schuessler, Jennifer: „‚The Evidence Room': Architects Examine the Horrors of Auschwitz", in: *New York Times*, 14.06.2016.

10 Whiteread referierte hier auf die Charakterisierung des jüdischen Volkes als „Volk des Buches" und die Bedeutung des Buches für die Beziehung zur Vergangenheit innerhalb der jüdischen Tradition. Vgl. Young, James E.: „Memory and Counter-Memory. The End of the Monument in Germany", in: *Harvard Design Magazine* 9 (1999), 1–10; sowie allgemein: Wiesenthal, Simon (Hg.): Projekt: Judenplatz Wien, Wien 2000.

Shortly after being named curator by the committee of the Biennale di Venezia for the Architecture Biennale 2016, Alejandro Aravena sent an invitation to Robert Jan van Pelt, an architectural historian teaching at the University of Waterloo in Canada, to participate in the exhibition. Years earlier, Van Pelt had given Aravena his book *The Case for Auschwitz*,[1] having been impressed by the "ethical and imaginative dimension"[2] of Aravena's architectural practice. In this volume published in 2002, Van Pelt documented his witness testimony, based on decades-long research of the architecture of the Auschwitz extermination camp, in the case filed by the Holocaust denier David Irving in the British High Court of Justice, London, against an American historian and her publisher in the year 2000. Van Pelt's approach of a "reversed architectural logic"[3] entailed—through an analysis of physical construction relics, technical drawings, photographs, written correspondence, and sketches made by contemporary witnesses—proving the murderous purpose of the crematory architecture and basically rewinding the genocide project. This technique has inspired, in a multitude of ways, a whole series of initiatives and projects in recent years that correlate with a growing interest in camp space on the part of architectural research and also with the "forensic turn," focused on material traces, within Holocaust Studies.[4]

In preparation for the biennale, Aravena asked the invited persons to provide an initial description of their "battle"—along the lines of the biennale title "Reporting from the Front"—and of their idea for an exhibition. Based on Aravena's recommendation, the team of curators—which was invited by Robert Jan van Pelt and which was made up of experts (Anne Bordeleau, Donald McKay, Sascha Hastings), architecture students from the University of Waterloo, and craftsmen—decided not to show the proof and argumentation of the "Irving Trial"[5] as action "at the front," but rather to place the main focus on the evidence itself. This is reflected by the title of the exhibition: "The Evidence Room."[6]

While the "Irving Trial" was concerned with the existence of the gas chambers, providing forensically verifiable proof by means of historical architecture analysis, in Venice a shift in focus took place in the context of the architecture event: as Van Pelt has repeatedly noted, the gaze here was trained on "the greatest crime ever committed by architects."[7] This implied remembering architecture—and thus architects as players in the framework of their profession—as a main element involved in the murdering of millions of people. The idea was to show what was the evident yet unimaginable at the same time. Indeed, "evidence" implies making the no longer existing material form visible (that which was destroyed by the perpetrators in order to cover up all their tracks), but also making reference to the indemonstrable: it was a matter of imagining the unimaginable "in spite of all," as called for by Georges Didi-Huberman.[8]

The biennale contribution was comprised of two components. The actual exhibition in the Central Pavilion at the Giardini enjoyed a strong media presence.[9] The proof provided in the "Irving Trial" had a presence here as "tangible evidence" and could be touched and felt, while still maintaining the auratic character of a monument. In the context of contemporary culture of memory, the form of artistic practice selected for the exhibition—such as the Holocaust Memorial (2000) by Rachel Whiteread in Vienna, executed as a concrete sculpture and thematically exploring loss and absence with its library walls facing outward and thus books remaining hidden,[10] taking a distanced

1 Robert Jan van Pelt, *The Case for Auschwitz: Evidence from the Irving Trial* (Bloomington et al., 2002).

2 Robert Jan van Pelt, "*Hineni*: An Essay in Acknowledgment," in Anne Bordeleau et al., *The Evidence Room* (Toronto, 2016), pp. 163–69, esp. p. 163.

3 Alejandro Aravena, "No Hole, No Holocaust," in *Reporting from the Front: 15. Mostra Internazionale di Architettura* (Venice, 2016), p. 124.

4 See, for example, Eyal Weizman, *Forensis: The Architecture of Public Truth* (Berlin, 2014).

5 David Irving sued Deborah Lipstadt and Penguin Books for defamation. During the court proceedings at the High Court, Robert Jan van Pelt appeared as an architecture expert and spent five days of cross examination defending his 700-page report by proving the existence of the gas chambers based on architectural-historical and archaeological analyses. The court dismissed Irving's lawsuit.

6 This term is used to describe the room where items of evidence are stored for court proceedings. The exhibition title, however, references other spaces as well: the space of the gas chamber, the courtroom, and the exhibition space at the biennale. *The Evidence Room* was also shown from June 2017 to January 2018 at the Royal Ontario Museum in Toronto, as well as in modified form as *Architecture as Evidence* from June to September 2016 at the Canadian Center for Architecture in Montreal.

7 From the cover text from Bordeleau et al., *The Evidence Room* (see note 2).

8 Georges Didi-Huberman, *Images in Spite of All: Four Photographs from Auschwitz*, trans. Shane B. Lillis (Chicago and London, 2008).

9 See, for example, Jennifer Schuessler, "'The Evidence Room': Architects Examine the Horrors of Auschwitz," *The New York Times*, June 14, 2016.

10 Here, Whiteread was referencing the characterization of Jews as "People of the Book" and the significance of books in maintaining a relationship with the past within the Jewish tradition. See James E. Young, "Memory and Counter-Memory: The End of the Monument in Germany," *Harvard Design Magazine* 9 (1999), pp. 1–10; and, in general, see Simon Wiesenthal, ed., *Projekt: Judenplatz Wien* (Vienna, 2000).

2

Kriegshilfeausstellung
(War Aid Exhibition),
Empfangsraum mit Statistiken
zu den Flüchtlingsbewegungen
in Österreich-Ungarn |
Reception room with statistics
on the movement of refugees
in Austria-Hungary,
Wien | Vienna, 1915
© Österreichisches Staatsarchiv |
Austrian State Archives

Interaktion, Partizipation und öffentliche Autorschaft seit den 1970er Jahren generierten Wissensproduktion von Erinnerungsprojekten von Jochen Gerz.[11]

Wesentlich weniger Beachtung fand hingegen die zweite Komponente, ein gleichnamiges, schmales Buch zur Ausstellung,[12] das den fragilen Entstehungsprozess von „The Evidence Room" abzubilden versucht. Die Teammitarbeiter – Lehrende, Architekturstudierende und Handwerker – kommentieren hier ihre Handlungen und Reflexionen während Konzeption und Herstellung der Ausstellungsobjekte. Sie berichten vom Einsehen der prinzipiellen Unmöglichkeit eines dem unvorstellbaren Ereignis des Massenmordes in Auschwitz angemessenen kuratorischen Zugangs, von der Entscheidung, dennoch eine adäquate Form zu suchen, und vom individuellen Bewusstwerden der unvermeidbaren Paradoxien ihrer Tätigkeit.

Ausblendungen der Architektur(-Geschichte). Seit dem Zivilisationsbruch der Shoah schien es jahrzehntelang undenkbar, Lager als Architekturwerke zu verstehen, Auschwitz bildete einen blinden Fleck. Robert Jan van Pelt hatte bereits zu Beginn seiner Laufbahn als Architekturhistoriker die Notwendigkeit erkannt, die Vernichtungslager der Nationalsozialisten als Architektur zu deuten im Sinne eines kulturell hervorgebrachten baulichen Objekts, das uns existentiell berührt, und forderte seit Mitte der 1980er Jahre diese Sichtweise für die Architekturgeschichtsschreibung ein.[13] Die fünf Krematorien von Auschwitz seien nicht einfach nur Zweckbauten, sondern ebenso bedeutsam für unser Verständnis von Architektur wie die gotischen Kathedralen der Île de France, denn der Bau der Vernichtungslager und der Gaskammern habe den Sinn von Architektur und die Verfasstheit der Architekturgeschichtsschreibung von Grund auf verändert.

Seither hat die zeithistorische Forschung gezeigt, dass die Entstehungsgeschichte der nationalsozialistischen Konzentrations- und Vernichtungslager als Orte, wo „der Ausnahmezustand zur Regel"[14] wird, weit in das 19. und frühe 20. Jahrhundert zurückreicht, zu den kolonialen Lagern in Indien, Kuba und Afrika und den Internierungs- und Flüchtlingslagern im Ersten Weltkrieg, und dass auch die Architektur in diesem Zusammenhang eine lange und komplexe Vorgeschichte hat.[15]

Das „größte Verbrechen, das Architekten begangen haben"[16] als Kurator einer der international renommiertesten Architekturmanifestationen zentral zu fokussieren und damit unmissverständlich der eigenen Disziplin zuzuordnen, ist in diesem Sinn als politische Handlung zu verstehen. Alejandro

11 Zu den zahlreichen Projekten im öffentlichen Raum, die Jochen Gerz gemeinsam mit seiner Frau Esther unter aktiver Beteiligung des „Publikums" durchgeführt hat, gehört z.B. das Mahnmal gegen den Faschismus in Hamburg-Harburg (1986–1993), bei dem Anwohner und Besucher ihre Namen und Kommentare zur NS-Zeit in eine 12 Meter hohe, bleimantelte Säule ritzen konnten, die dann samt Beschriftungen in acht Etappen in den Boden versenkt wurde und heute nicht mehr sichtbar ist. Vgl. Museion – Museum für moderne und zeitgenössische Kunst (Hg.): *Jochen Gerz. Res publica. Das öffentliche Werk 1968–1999*, Ostfildern-Ruit 1999.

12 Bordeleau, Anne u.a. (Hg.): *The Evidence Room*, Toronto 2016.

13 Vgl. z.B. van Pelt, Robert Jan: „After the Walls Have Fallen Down", in: *Queen's Quarterly* 96/3 (1989), 641–660; van Pelt: *Case for Auschwitz*, 66 ff. (wie Anm.2).

14 Agamben, Giorgio: „Was ist ein Lager?", in: ders.: *Mittel ohne Zweck. Noten zur Politik*, Zürich–Berlin 2002, 37–43, hier 38.

15 Eine tatsächliche Vorbildwirkung der kolonialen Lager für die NS-Konzentrations- und Vernichtungslager ist hingegen ein Streitthema der Zeitgeschichte. Vgl. zusammenfassend Forth, Aidan: *Barbed-Wire Imperialism. Britain's Empire of Camps, 1876–1903*, Oakland 2017, 212 ff.; Kreienbaum, Jonas: „*Ein trauriges Fiasko". Koloniale Konzentrationslager im südlichen Afrika 1900–1908*, Hamburg 2015.

16 Klappentext von: Bordeleau: *The Evidence Room* (wie Anm. 7).

stance toward glorifying monuments—is more apt than the performative knowledge production, generated by interaction, participation, and public authorship since the 1970s, found in the memory projects by Jochen Gerz.[11]

In contrast, the second element received much less attention, a thin, eponymous book on the exhibition[12] that attempted to render the fragile process of becoming of *The Evidence Room*. Here, the team members—instructors, architecture students, and craftspeople—offered comments about their actions and reflections during the period in which the exhibition objects were conceived and produced. They talked about accepting that it was principally impossible to arrive at a curatorial approach that could appropriately access the unthinkable occurrence of mass murder in Auschwitz, and about the decision to nonetheless seek an adequate solution, and about how each individual became conscious of the inevitable paradoxes of their work.

Hiding (the History of) Architecture. After the Shoah as breach of civilization, for decades it seemed unthinkable to view the camps as works of architecture, so Auschwitz signified a blind spot. Early in his career as an architectural historian, Robert Jan van Pelt was already cognizant of the necessity of recognizing the extermination camps created by the National Socialists as architecture in the sense of a culturally induced architectural object that touches us existentially. In the mid-1980s, he started calling for this perspective to be integrated into architectural historiography.[13] According to Van Pelt, the five crematories in Auschwitz were not simply functional buildings, but in fact just as significant for our understanding of architecture as the Gothic cathedrals in Île de France. This is because the construction of the extermination camps and the gas chambers utterly and completely changed the meaning of architecture and the constitution of architectural historiography.

Ever since, contemporary history research has shown that the genesis of the National Socialist concentration and extermination camps, as places where "the state of exception starts to become the rule,"[14] goes back to the nineteenth and early twentieth century, to the colonial camps in India, Cuba, and Africa and to the internment and refugee camps in the First World War. And that architecture in this context has experienced a long and complex history.[15]

Essentially focusing on the "greatest crime committed by architects"[16] as curator of one of the most renowned architectural manifestations, and thus unequivocally associating it with one's own discipline, must be understood as a political action in this situation. Alejandro Aravena conceptualized the Architectural Biennale 2016 as a report from the "front line" in the battles fought by present-day architecture for quality of life and the quest for new fields of action—with a view to the urgency of topics like migration, segregation, natural catastrophes, and environment destruction, despite all limitations and paucity.[17] In this context, *The Evidence Room* references an aspect of ultimate societal relevance within architecture of the present and confronts the limits of its discipline.

The exhibition thematizes the role of architecture in mass murder as well as the disavowal thereof. Denying the function of the camps has many facets when viewed from a broader historical perspective. The demolition of the gas chambers, the destruction of the construction plans,[18] and the eradication of material traces are the final steps in a process of deceiving others and one's self. Playing out even earlier was the propagandistic trivialization of the living conditions in the camps, the concealment of their functions, but also the camouflaging of the buildings using architectural means.

11 Among the numerous projects in public space carried out by Jochen Gerz together with his wife Esther, with the active participation of the "audience," was for instance the memorial against fascism in the Harburg district of Hamburg (1986–93). Here, city residents and visitors could scratch their names and comments about the Nazi period into a 12-meter-high pillar coated in lead. The pillar, with its inscriptions, was then incrementally lowered into the ground in eight phases and is no longer visible today. See Museion – Museum für moderne und zeitgenössische Kunst, ed., *Jochen Gerz: Res publica: Das öffentliche Werk 1968–1999* (Ostfildern-Ruit, 1999).

12 Bordeleau et al., *The Evidence Room* (see note 2).

13 See, for example, Robert Jan van Pelt, "After the Walls Have Fallen Down," *Queen's Quarterly* 96, no. 3 (1989), pp. 641–60; Van Pelt, *Case for Auschwitz*, pp. 66ff. (see note 1).

14 Giorgio Agamben, *Means without End: Notes on Politics*, trans. Vincenzo Binetti and Cesare Casarino, vol. 20: *Theory out of Bounds* (Minneapolis and London, 2000), pp. 37–45, esp. p. 39.

15 An actual role-model effect of colonial camps for the Nazi concentration and extermination camps, on the other hand, is a contentious issue in contemporary history. For a summary, see Aidan Forth, *Barbed-Wire Imperialism: Britain's Empire of Camps, 1876–1903* (Oakland, 2017), pp. 212ff.; Jonas Kreienbaum, *"Ein trauriges Fiasko": Koloniale Konzentrationslager im südlichen Afrika 1900–1908* (Hamburg, 2015).

16 Cover text from Bordeleau et al., *The Evidence Room* (see note 7).

17 See Alejandro Aravena, "Rationale," in *Reporting from the Front: 15. Mostra Internazionale di Architettura* (Venice, 2016), pp. 21–24, esp. p. 23.

18 Auschwitz is an exception as compared to the other extermination camps, for the construction plans were not destroyed by the SS. See Annika Wienert, *Das Lager vorstellen: Die Architektur der nationalsozialistischen Vernichtungslager* (Berlin, 2015).

Aravena konzipierte die Architekturbiennale 2016 als Frontbericht von den Kämpfen aktueller Architektur um Lebensqualität und der Suche nach neuen Aktionsfeldern – angesichts der Dringlichkeit von Themen wie Migration, Segregation, Naturkatastrophen oder Umweltzerstörung und trotz aller Beschränkungen und Knappheiten.[17] „The Evidence Room" verweist in diesem Kontext auf einen Aspekt ultimativer gesellschaftlicher Relevanz der Architektur in der Gegenwart und führt an die Grenzen ihrer Disziplin.

Die Ausstellung thematisiert die Rolle der Architektur im Massenmord ebenso wie deren Abstreiten. Das Leugnen der Funktion der Lager hat, aus größerer historischer Perspektive betrachtet, viele Facetten. Die Sprengung der Gaskammern, die Zerstörung der Baupläne[18] und die Vernichtung materieller Spuren sind die letzten Schritte in einem Prozess der Fremd- und Selbsttäuschung. Davor stehen die propagandistische Verharmlosung der Lebensbedingungen in den Lagern, die Verschleierung ihrer Funktionen, aber auch die Tarnung der Gebäude mit architektonischen Mitteln.

Mit welchen Mitteln reagiert nun aber „The Evidence Room" auf das Ausgelöschte und der Erinnerung Entzogene? Auf welche Weise wird der verstellte, versperrte und verweigerte Blick auf das „Unvorstellbare" geöffnet? Um die „Gesten des Zeigens"[19] deutlicher herauszuarbeiten, möchte ich in einem Exkurs eine historische Ausstellung zu Hilfe nehmen, die Lager ebenfalls als Architekturwerke deutet, mit der Fokussierung auf die Architektur jedoch den eigentlichen Zweck eines konkreten Lagersystems zu legitimieren sucht. Beim Blick auf beide Ausstellungen wird es vor allem um zwei kuratorische Mittel gehen, die jeweils Aspekte des architektonischen Planens und Vermittelns aufgreifen: die Bedeutung der Wahl des Maßstabs und die Wirkung technischer Präzision im Detail.

Architektur als Verschleierung. 1915, im zweiten Jahr des Ersten Weltkriegs, fand in Wien die „Kriegshilfeausstellung" statt. Der Zweck dieser Propagandaausstellung lag darin, die humanitäre und kulturelle Großleistung des Ministeriums des Innern der österreichisch-ungarischen Monarchie errichteten Flüchtlingslager aufzuzeigen, de facto wurden deren reale Zustände jedoch verschleiert und ausgeblendet. Diese Ausstellung stellte ein Lagersystem „vor Auschwitz"[20], also vor der sich über viele Zwischenstufen prozesshaft herausbildenden Entscheidung der Nationalsozialisten, das Konzentrationslager zum Instrument des Massenmords auszubauen,[21] ins Zentrum, und zwar unter anderem dadurch, dass sie Lager, die der Isolierung von Menschen – in diesem Fall von Kriegsflüchtlingen – dienten, als Architektur präsentierte. Wie „The Evidence Room" markiert sie eine bestimmte Etappe jener Epoche, die Zygmunt Bauman 1994 als „das Jahrhundert der Lager"[22] bezeichnet hat –

jedoch in entgegengesetzter Weise: Sie ist Teil eines aus unzähligen Einzelhandlungen konstituierten Vorganges, bei dem Entscheidungsträger und rezipierende Öffentlichkeit das Lager als gesellschaftliche Notwendigkeit definieren und dazu die Legitimation entwickeln.

Geplant von beamteten Ingenieuren der Landesverwaltungen und akademisch ausgebildeten Architekten, bildeten die k.k. Flüchtlingslager im Ersten Weltkrieg ein ambivalentes Lagersystem, einerseits zur humanitären Unterbringung von Flüchtlingen aus den Kriegsgebieten der Monarchie, andererseits zu deren Internierung.[23] Es waren komplexe, von der übrigen Bevölkerung abgeschottete „Barackenstädte", die durch Stacheldrahtzäune und Lagerwachen als Kontroll- und Ordnungssystem und vermeintlicher Schutz der Bevölkerung vor Epidemien sowie als Teil einer Verdrängungs- und Verheimlichungsstrategie fungierten, um das Kriegs- und Flüchtlingselend unsichtbar zu machen.[24] Für die Flüchtlinge bedeutete das Leben im Lager dramatisch hohe Sterblichkeitsraten, Hunger, Überwachung, Strafmaßnahmen und Formen von Zwangsarbeit.[25]

Um die Einheit zwischen Front und „Heimatfront" zu beschwören und das Publikum von den von der Regierung geleisteten Versorgungsmaßnahmen der Hunderttausenden Flüchtlinge zu überzeugen,[26] veranstaltete das zuständige Ministerium 1915/16 die besagte Ausstellung.[27] Dazu griffen die Ausstellungsmacher verschiedene Traditionen des „Exhibitionary

17 Vgl. Aravena, Alejandro: „Rationale", in: *Reporting from the Front. 15. Mostra Internazionale di Architettura*, Venedig 2016, 21–24, hier 23.

18 Auschwitz ist hier eine Ausnahme im Vergleich mit den anderen Vernichtungslagern, die Baupläne wurden von der SS nicht zerstört. Vgl. Wienert, Annika: *Das Lager vorstellen. Die Architektur der nationalsozialistischen Vernichtungslager*, Berlin 2015.

19 Muttenthaler, Roswitha/Wonisch, Regina: *Gesten des Zeigens. Zur Repräsentation von Gender und Race in Ausstellungen*, Bielefeld 2006.

20 Vgl. Jahr, Christoph/Thiel, Jens (Hg.): *Lager vor Auschwitz. Gewalt und Integration im 20. Jahrhundert*, Berlin 2013; Greiner, Bettina/Kramer, Alan (Hg.): *Welt der Lager. Zur „Erfolgsgeschichte" einer Institution*, Hamburg 2013.

21 Nikolaus Wachsmann bezeichnet den Holocaust als „Kulmination eines dynamischen mörderischen Prozesses, vorangetrieben von zunehmend radikalen Initiativen von oben und unten". Wachsmann, Nikolaus: *KL. Die Geschichte der nationalsozialistischen Konzentrationslager*, München 2016, 342. Vgl. grundlegend: Benz, Wolfgang/Distel, Barbara (Hg.): *Der Ort des Terrors. Geschichte der nationalsozialistischen Konzentrationslager*, 9 Bde, München 2005.

22 Bauman, Zygmunt: „Das Jahrhundert der Lager?", in: Dabag, Mihran/Platt, Kristin (Hg.): *Genozid und Moderne*, Bd.1, Opladen 1998, 81–99.

23 Zur Architektur der k.k. Flüchtlingslager vgl. Senarclens de Grancy, Antje: „The Camp as ‚Housing Colony'. Refugee Camps in WWI", in: *zeitgeschichte* 46 (2019), in Vorbereitung.

24 Vgl. Mentzel, Walter: *Kriegsflüchtlinge in Cisleithanien im Ersten Weltkrieg*, Diss., Univ. Wien, 1997, 299.

25 Von den tatsächlichen Lebensbedingungen in den Lagern zeugen Zensurberichte, Berichte von Abgeordneten und privaten Hilfskomitees, Tagebucheinträge der Flüchtlinge sowie ab den 1980er Jahren geführte Interviews.

26 Vgl. Thorpe, Julia: „Der rote Faden der Vertreibung: Österreich-Ungarns Flüchtlinge im Ersten Weltkrieg und ihre Darstellung in der Kriegshilfeausstellung von 1915", in: Pallestrang, Kathrin (Hg.): *Stick- und Knüpfmuster ruthenischer Flüchtlinge im Ersten Weltkrieg. Aus der Sammlung des Volkskundemuseums Wien*, Wien 2014, 31–45.

27 Vgl. K.k. Ministerium des Innern: *Staatliche Flüchtlingsfürsorge im Kriege 1914/15*, Wien 1915.

So what approaches does *The Evidence Room* take in responding to that which has been obliterated and revoked from memory? How is the obscured, obstructed, and denied gaze toward the "unimaginable" opened? In order to more clearly map out the "gestures of showing,"[19] I would like to take a foray back to a historical exhibition that also considered camps to be architectural structures, with a focus on the architecture itself. This show, however, sought to legitimize the actual purpose of a specific camp system. The survey of the two exhibitions will first and foremost explore two curatorial approaches, with each seizing upon aspects of architectural planning and mediation: the significance of selecting a certain scale and the effects of detailed technical precision.

Architecture as Concealment. In 1915, during the second year of the First World War, the *Kriegshilfeausstellung* (War Aid Exhibition) was held in Vienna. The purpose of this propaganda exhibition was to show off the humanitarian and cultural achievements related to the refugee camps established by the Ministry of the Interior of the Austro-Hungarian Monarchy. However, the real state of affairs in these camps was de facto concealed and blocked out. This exhibition showcased a camp system "before Auschwitz"[20]—so before the processually evolving decision via many intermediate stages made by the National Socialists to expand the concentration camps as an instrument of mass murder[21]—by presenting the camps, which served to isolate people, in this case wartime refugees, *as architecture*. Like *The Evidence Room*, the propaganda exhibition marked a certain stage in the era that Zygmunt Bauman, in 1994, called "a century of camps"[22]—yet in an opposite way: it was part of a process made up of countless individual steps taken by decision-makers and the receptive public to define the camps as a societal necessity and to develop a sense of legitimation for them.

Designed by civil-servant engineers from the state governments and by academically trained architects, the refugee camps in the First World War reflected an ambivalent camp system. It provided, on the one hand, humanitarian accommodations for refugees from war zones within the monarchy, while also serving the purpose of interning these very refugees.[23] The camps were complex "cities of barracks" far isolated from the rest of the population. With their barbed-wire fences and camp guards, they were meant to function as systems of control and order, but also as supposed aim of protecting the people from epidemics and as part of a displacement and concealment strategy, in order to keep hidden the misery of war and refugee life.[24]

For the refugees themselves, life in the camps meant dramatically high death rates, hunger, surveillance, punitive measures, and forms of forced labor.[25]

To evoke unity between the front and the "home front," as well as to sell to the public the state-funded care measures for hundreds of thousands of refugees,[26] the responsible ministry held the said exhibition in 1915–16.[27] To this end, the exhibition-makers seized upon various traditions of the "exhibitionary complex"[28] from the nineteenth century. On the one hand, this tied into the hierarchy-based display and diversion strategies of colonial exhibitions, as well as the folkloric and ethnological presentations at world fairs, thus presenting the camp inhabitants as carriers of an exotic culture.[29] On the other, they used the effects of the architecture and urban-planning fairs that had also become popular in the preceding decades, aiming to present the camps as architecture along the lines of taking care of citizens' needs and addressing the collective task of providing residential dwellings in times of housing shortage. On the exhibition walls were numerous well-arranged photographs of the camp barracks, along with camp plans with layouts and sections of the various barrack types. This information was supplemented by statistics on rations, health conditions, and mortality, as well as graphic visualizations of the up- and downward flux of refugee flows.

19 Roswitha Muttenthaler and Regina Wonisch, *Gesten des Zeigens: Zur Repräsentation von Gender und Race in Ausstellungen* (Bielefeld, 2006).

20 See Christoph Jahr and Jens Thiel, eds., *Lager vor Auschwitz: Gewalt und Integration im 20. Jahrhundert* (Berlin, 2013); Bettina Greiner and Alan Kramer, eds., *Welt der Lager: Zur "Erfolgsgeschichte" einer Institution* (Hamburg, 2013).

21 Nikolaus Wachsmann calls the Holocaust "the culmination of a dynamic murderous process, propelled by increasingly radical initiatives from above." Nikolaus Wachsmann, *KL: A History of the Nazi Concentration Camps* (New York, 2015), p. 292. In general, see Wolfgang Benz and Barbara Distel, eds., *Der Ort des Terrors: Geschichte der nationalsozialistischen Konzentrationslager*, 9 vols. (Munich, 2005).

22 Zygmunt Bauman, "A Century of Camps?," in *The Bauman Reader*, ed. Peter Beilharz (Oxford: Blackwell, 2001), pp. 266–280.

23 On the architecture of the k.k. refugee camp, see Antje Senarclens de Grancy, "The Camp as 'Housing Colony': Refugee Camps in WW I," *zeitgeschichte* 46 (2019), forthcoming.

24 See Walter Mentzel, "Kriegsflüchtlinge in Cisleithanien im Ersten Weltkrieg" (PhD diss., University of Vienna, 1997), p. 299.

25 Attesting to the actual living conditions in the camps are censorship accounts, reports by representatives and private aid committees, diary entries by the refugees, and interviews conducted starting in the 1980s.

26 See Julia Thorpe, "Der rote Faden der Vertreibung: Österreich–Ungarns Flüchtlinge im Ersten Weltkrieg und ihre Darstellung in der Kriegshilfeausstellung von 1915," in *Stick- und Knüpfmuster ruthenischer Flüchtlinge im Ersten Weltkrieg: Aus der Sammlung des Volkskundemuseums Wien*, ed. Kathrin Pallestrang (Vienna, 2014), pp. 31–45.

27 See k.k. Ministerium des Inneren, *Staatliche Flüchtlingsfürsorge im Kriege 1914/15* (Vienna, 1915).

28 Tony Bennett, "The Exhibitionary Complex," in *Thinking about Exhibitions*, ed. Reesa Greenberg et al. (London and New York, 1996), pp. 81–112.

29 See Maureen Healy, "Exhibiting a War in Progress: Entertainment and Propaganda in Vienna, 1914–1918," *Austrian History Yearbook* 31 (2000), pp. 57–85.

Complex"[28] im 19. Jahrhundert auf. Sie schlossen zum einen an die hierarchisierenden Zeige- und Unterhaltungsstrategien von Kolonialausstellungen und volks- und völkerkundlichen Präsentationen auf Weltausstellungen an und präsentierten die Lagerbewohner als Träger einer exotischen Kultur.[29] Zum anderen nutzten sie die Effekte der in den Jahrzehnten davor ebenfalls beliebt gewordenen Architektur- und Städtebauausstellungen, um die Lager als Architektur zu zeigen, im Sinne bürgerlicher Daseinsfürsorge und der kollektiven Aufgabe des Wohnbaus in Zeiten der Wohnungsnot. An den Ausstellungswänden waren, übersichtlich geordnet, zahlreiche Fotos der Lagerbaracken, Lagerpläne sowie Grund- und Aufrisse der verschiedenen Barackentypen zu sehen, ergänzt durch Statistiken zu Verpflegung, Gesundheitsverhältnissen und Sterblichkeit sowie grafische Visualisierungen des An- und Abschwellens der Flüchtlingsströme.

Besondere Aufmerksamkeit fanden die detaillierten Baupläne, Schnitte und Ansichten der seriell und präfabriziert hergestellten Lagerbaracken für Wohn-, Küchen-, Bade-, Schul- und Spitalszwecke mit exakten Maßangaben. Sie fragmentierten das beunruhigende Gesamtbild des Lagers als Ansammlung von Zehntausenden Personen in überschaubare Einheiten.[30] In ihrer Geradlinigkeit, funktionellen Rasterung und planerischen Präzision vermittelten sie den Ausstellungsbesuchern ein Bild von Ordnung und suggerierten Beherrschbarkeit und Effizienz. In ihrer kalten, technischen Abstraktheit zeigten sie nichts von dem Chaos, von der Entrechtung, der Not und den Depressionen der Bewohner.

Der rational parzellierte Einheitsraum einer Wohnbaracke für 400 Personen mit matratzenlosen Holzpritschen ohne Sichtschutz erinnerte an die in zeitgenössischen Publikationen diskutierte Logistik von Lagerwirtschaft und Büroorganisation. Die sorgfältige, modellhafte Ausarbeitung der Pläne deutete darauf hin, dass hier ein Prototyp für weitere Nutzungen entwickelt worden war. In einer renommierten Wiener Architekturzeitschrift schrieb ein Architekturkritiker geradezu euphorisch über die „Raumwirkungen im Inneren der Gebäude, die trotz der Zweckbauweise, trotz starken Vortretens reiner Nutzformen nicht der Größe und Schönheit entbehren. Silhouettenwirkungen, die auch von der Einfachheit und Strenge des sparsam verwendeten Holzmaterials nicht nachteilig, sondern günstig beeinflusst wurden."[31]

Verkleinerung und Totalität. Zentrales Exponat der Propagandaausstellung war ein großes, aufwendig produziertes und koloriertes Architekturmodell, das ein für 20.000 Personen vorgesehenes Lager im Kronland Steiermark[32] in der damals bereits konventionellen Präsentationsart einer „normalen" städtebaulichen Planung zeigte und Besucher und Journalisten nachhaltig beeindruckte. Im Gegensatz zur Fragmentierung durch die Pläne führte die Vogelschau nun die *Ganzheit* des fürsorglichen Einsatzes als wiedererkennbares Bild der klar umgrenzten Stadt mit Kirche und Wohngebäuden vor Augen. Die Besucher konnten das Modell umrunden, wurden jedoch durch eine Glasabdeckung auf Abstand gehalten. Die Verkleinerung des Maßstabs und die „Miniaturisierung" des Lagers bot dem Publikum eine weitere Möglichkeit zur Distanzierung von den realen Zuständen. Tatsächlich schrieb eine Ausstellungsbesucherin: „Das prächtige Modell des Barackenlagers […] fesselt hier gleich unsere Aufmerksamkeit; ein Riesenspielzeug unter Glas, getreu bis ins kleinste."[33]

Gerade aufgrund der unangemessenen Wirkung der „Verniedlichung" und Bagatellisierung durch Miniaturen sind Architekturmodelle von Konzentrationslagern als Display in historischen Museen seit Jahrzehnten höchst umstritten.[34] Claude Lévi-Strauss beschreibt in *Das wilde Denken* das dialektische Verhältnis zwischen Größe und Qualität folgendermaßen: „[…] in der Verkleinerung erscheint die Totalität des Objekts weniger furchterregend; aufgrund der Tatsache, dass sie quantitativ vermindert ist, erscheint sie uns qualitativ vereinfacht. Genauer gesagt, diese quantitative Umsetzung steigert und vervielfältigt unsere Macht über das Abbild des Gegenstandes."[35] Mit seinem „Lego Concentration Camp Set" (1996) in Form eines Kinderspielzeugs gehört der polnische Künstler Zbigniew Libera zu jener Reihe von Künstlern, die seit den 1990er Jahren den Effekt einer Entdramatisierung und Entnaturalisierung einsetzen, um die Shoah zu thematisieren.

Es ist anzunehmen, dass die Verfahren, das Lager als rational und fürsorglich geplante architektonische Realität zu präsentieren – die kalte Abstraktion der Pläne, die Suggestion einer „normalen" Wohnsiedlung durch das Modell sowie dessen bagatellisierende Maßstabsverkleinerung –, mehr oder

28 Bennett, Tony: „The Exhibitionary Complex", in: Greenberg, Reesa u.a. (Hg.): *Thinking about Exhibitions*, London/New York 1996, 81–112.

29 Vgl. Healy, Maureen: „Exhibiting a War in Progress: Entertainment and Propaganda in Vienna, 1914–1918", in: *Austrian History Yearbook* 31 (2000), 57–85.

30 Die Pläne wurden publiziert in: Haimel u.a., Franz: *Flüchtlingslager Wagna bei Leibnitz. Mit einer Abhandlung über die Alt-Römerstadt Flavia Solva*, Graz 1915.

31 Fischel, Hartwig: „Bauanlagen der staatlichen Flüchtlingsfürsorge", in: *Der Architekt* 21 (1916/1918), 15–24, Taf. 5–6.

32 Es handelte sich um das ab Herbst 1914 errichtete k.k. Flüchtlingslager Wagna bei Leibnitz.

33 Lapenna, Tea: „Kriegshilfe", in: *Reichspost*, Morgenblatt, 16.12.1915, 1–2.

34 Vgl. Holert, Tom/Scholz, Danilo: „Mikro-Ökonomie der Geschichte. Das Unausstellbare en miniature", in: *Texte zur Kunst* 11/41 (2001), 57–68; Buschmann, Ulf: „Spielzeug und Modellbau in zeitgenössischer Kunst zum Holocaust", in: Stephan, Inge/Tacke, Alexandra: *NachBilder des Holocaust,* Köln/Weimar/Wien 2007, 284–298.

35 Lévi-Strauss, Claude: *Das wilde Denken*, Übers. von Hans Naumann, Frankfurt/M. 1997 [1962], 36.

3

Kriegshilfeausstellung
(War Aid Exhibition),
Modell und Pläne des
Flüchtlingslagers Wagna |
Model and plans of the
Wagna refugee camp,
Wien | Vienna, 1915
© Österreichisches Staatsarchiv |
Austrian State Archives

Special note was made of the detailed construction plans, sections, and views of serially produced and prefabricated camp barracks, featuring precise dimensions, for the purposes of housing, cooking, bathing, schooling, and medical care. This served to fragment the disquieting overall picture of camps as a cluster of ten thousands of people into units of manageable size.[30] With a straightforward approach, functional rasterization, and planning precision, this material conveyed to the exhibition visitors a picture of order and suggested controllability and efficiency. This cold, technical abstractness revealed nothing of the chaos, of the deprivation of rights, of the distress and depression to which the camp inhabitants were subjected.

The rationally subdivided uniform space of housing barracks for 400 persons, with wooden beds devoid of mattresses and without privacy screens, is reminiscent of the logistics of warehouse or office management discussed in contemporary publications. The meticulous, exemplary preparation of the plans seems to indicate that this had been developed as a prototype for other uses. In a renowned architecture journal from Vienna, an architectural critic wrote almost euphorically about the "spatial effects on the inside of the buildings, which retain their magnitude and beauty despite the functional building approach, despite the strong appearance of pure utilization forms. Silhouette effects that are also favorably rather than detrimentally influenced by the simplicity and stringency of the sparsely implemented wooden material."[31]

Reduction and Totality. A main exhibit at the propaganda exhibition was a large, elaborately produced and colored architectural model showing a camp planned to accommodate 20,000 people in the crown land of Styria.[32] The "normal" urban planning presentation form used was already conventional at the time and made a lasting impression on visitors and journalists. In contrast to the fragmentation arising from viewing many plans, a bird's-eye perspective now visualized the *wholeness* of the provident effort as a recognizable image of the clearly bordered town with church and housing structures. The visitors could encircle the model, yet were kept at a distance by a glass cover. The reduction of scale and the "miniaturization" of the camp offered the public another chance to distance themselves from the real conditions. An exhibition visitor actually wrote: "The magnificent model of the barracks camp … immediately captures our attention here; a giant toy under glass, true to the smallest detail."[33]

It is precisely due to this inappropriate effect of "minimization" and trivialization through miniatures that architectural models of concentration camps have been highly controversial

30 The plans were published in Franz Haimel et al., *Flüchtlingslager Wagna bei Leibnitz: Mit einer Abhandlung über die Alt–Römerstadt Flavia Solva* (Graz, 1915).

31 Hartwig Fischel, "Bauanlagen der staatlichen Flüchtlingsfürsorge," *Der Architekt* 21 (1916–18), pp. 15–24, plates 5–6.

32 This was the k.k. refugee camp Wagna near Leibnitz, erected in 1914.

33 Tea Lapenna, "Kriegshilfe," *Reichspost*, morning paper, December 16, 1915, pp. 1–2.

weniger bewusst kalkulierte Effekte waren. Die Realität des Lagers wurde fragmentiert, hinter Glasscheiben eingeschlossen, auf Distanz gehalten und vor den Augen des Publikums verborgen.[36] Die Fokussierung auf die Architektur diente in der Ausstellung der Rechtfertigung der autoritären Maßnahme der Lager, erbrachte quasi den Beweis für deren Rechtmäßigkeit und ermöglichte dem Publikum in einem Akt der Fremd- und wohl auch Selbsttäuschung gleichzeitig eine Distanzierung von deren tatsächlicher Realität.

Greifbare Evidenz. Kommen wir nun wieder zu „The Evidence Room" zurück. Gemeinsam und als Interaktion betrachtet, ergeben die unterschiedlichen kuratorischen Strategien der beiden Ausstellungen ein komplementäres Bild: Verbergen/Freilegen, Schließen/Öffnen. Die Propagandaausstellung von 1915 zielte darauf, ein Bild der Lager zu entwickeln, die Perspektive auf diese medial zu fixieren und somit zu schließen. Die Biennale-Ausstellung von 2016, die nicht auf Auschwitz als Lager im Allgemeinen, sondern auf die Gaskammern als Kulminationspunkt des Genozids fokussierte, konfrontierte die Besucher mittels greifbarer und visuell erfassbarer Artefakte mit den Beweisen für das „Unvorstellbare" und eröffnete gleichzeitig einen Diskurs um das Lager als Architekturwerk. Im Ausstellungsraum – dem 50 m² großen Raum Q des Hauptpavillons – dominierte die einheitliche weiße Farbe der Objekte, sie sollte, so die Kuratoren, den Raum von Sentimentalität reinigen[37] und hatte, auf die Gleichzeitigkeit von Abwesenheit und Präsenz verweisend, metaphorische Bedeutung.

In der Mitte bzw. am Rand des Raumes standen Repliken von architektonischen Elementen des Massenmordes im 1:1-Maßstab: einer gasdichten Tür zur Gaskammer mit einem Blickloch, das zum Schutz vor Rettungsversuchen der Opfer nach innen hin vergittert war, einer vergitterten Gassäule von Krematorium 2, durch die das tödliche Zyklon-B von oben in die Gaskammer eingeführt wurde, ein Stück Wand von Krematorium 5 mit einer gasdichten Klappe und einer Leiter zur Beförderung der Zyklon-B-Dosen durch einen SS-Mann. Im Gegensatz zur Verkleinerung und Distanzierung des Lagermodells hinter Glas in der Ausstellung von 1915 wurde hier scheinbar Unmittelbarkeit erzeugt („Heute habe ich die Gassäule berührt"[38], wie der Holocaust-Überlebende Elly Gotz nach einem Besuch in der Werkstatt der University of Waterloo School of Architecture schrieb, wo die Säule nachgebaut wurde). In der Konzeption dieser Objekte verdichteten sich die jahrzehntelange Recherchearbeit Robert Jan van Pelts und alle Erkenntnisse zur baulichen Gestalt der Gaskammern zu einer prinzipiell funktionsfähigen Realität. Es waren Objekte, die – wiewohl durch ihre weiße Farbe verfremdet – tatsächlich so, wie sie vorhanden waren, funktionieren *könnten*. Sie wurden von den Kuratoren nicht als Reproduktionen verstanden, sondern als architektonische Übersetzung der Notwendigkeit des Erinnerns.

Ohne maßstabsverkleinernde Vermittlung durch Pläne oder Fotos formte hier die visuelle als auch haptische Präsenz der lebensgroßen Objekte ein Bild des nicht Vorstellbaren. Wenn – mit Lévi-Strauss gesprochen – die Verkleinerung (durch Pläne, Fotos, Zeichnungen) die Totalität des Objektes weniger furchterregend macht, dann kann die reale Größe den Schrecken auslösen. Dabei waren sich die Kuratoren des Dilemmas bewusst, dass in den lebensgroßen Objekten die Gefahr von Erlebnischarakter und Fetischwirkung liegt. Donald McKay beschrieb das Ringen um die richtige Form folgendermaßen: „Diese Säule hätte so gemacht sein KÖNNEN. Es ist sehr wahrscheinlich. Das bedeutet nicht, dass sie so gemacht WAR. Aber es hätte so sein können. […] Wir sind Akrobaten, die auf einem Seil tanzen zwischen Wahrheit und Effekt, und wir bemühen uns jeden Tag darum, ehrlich dabei zu sein, wie wir diese Geschichte erzählen."[39]

An den Wänden des Raumes waren nach dem Konzept von Anne Bordeleau[40] Gipsabgüsse jener (hier als begreifbare Reliefs ausgearbeiteten) Pläne, Fotos, Zeichnungen, Briefe und Verträge, die van Pelt im Londoner Gerichtsprozess als Beweise vorgelegt hatte, aufgereiht. Sie belegten zentrale Tatsachen wie jene, dass die ursprünglich in den Raum aufgehende gasdichte Tür im Keller von Krematorium 2 nach der Funktionsänderung von einer Leichenhalle zur Gaskammer und nach einer Planänderung von SS-Architekt Walter Dejaco nach außen angeschlagen wurde, da sonst die Leichen der Opfer den Zugang versperrt hätten. Das in der Forensik sehr gebräuchliche Material Gips schuf im Ausstellungsraum die Evidenz einer sinnlich erfahrbaren Ebene, die sowohl das nicht mehr Vorhandene als Negativabdruck wieder sichtbar machte, wie auch das nicht Zeigbare der Shoah bezeugte.

36 Dass diese Strategie Erfolg hatte, verdeutlichen verschiedene Berichte der Tagespresse, die eine zum Teil völlige Ausblendung der Realität vorführten und die Lager als friedliche Wohnkolonien, als „ein Stück Schlaraffenland" und „gesünder als der gesündeste Luftkurort" beschrieben. Vgl. z.B. O.A., „Die Ausstellung in der Bognergasse (Flüchtlingsfürsorge)", in: *Neue Freie Presse*, 21. Jänner 1916, 1–3.

37 „We didn't want it to look like a reconstruction of the gas chamber […], we wanted to purge the room from sentimentality." Donald McKay zit. n. Szacka, Léa-Cathrine: „The Evidence Room", in: *Domus*, 17 (2016), online unter: https://www.domusweb.it/en/architecture/2016/08/17/the_evidence_room.html (Stand: 9. Oktober 2017).

38 „Today I touched the gas column […]." Gotz, Elly: „The Evidence Room Project", in: Bordeleau: *The Evidence Room*, 74–76, hier 75 (wie Anm.1).

39 „This column COULD have been made this way. It's very likely. It doesn't mean it WAS made this way. But it could have been. […] We are acrobats, dancing on a line between truth and effect, and we strive every day to be honest as we tell the story." McKay, Donald: „Correspondance", in: Bordeleau: *The Evidence Room*, 88–97, hier 97 (wie Anm.1).

40 Bordeleau, Anne: „The Casts Court", in: dies.: *The Evidence Room*, 112–118 (wie Anm. 1).

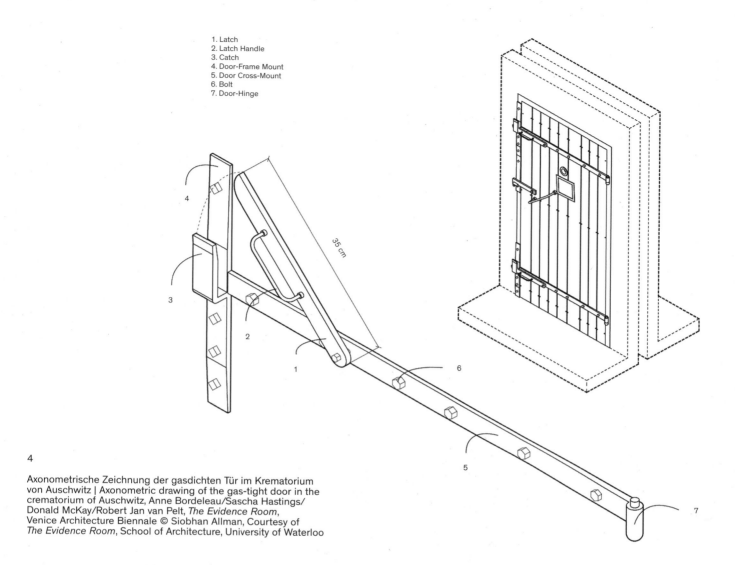

1. Latch
2. Latch Handle
3. Catch
4. Door-Frame Mount
5. Door Cross-Mount
6. Bolt
7. Door-Hinge

4

Axonometrische Zeichnung der gasdichten Tür im Krematorium
von Auschwitz | Axonometric drawing of the gas-tight door in the
crematorium of Auschwitz, Anne Bordeleau/Sascha Hastings/
Donald McKay/Robert Jan van Pelt, *The Evidence Room*,
Venice Architecture Biennale © Siobhan Allman, Courtesy of
The Evidence Room, School of Architecture, University of Waterloo

for decades as displays in historical museums.[34] In *The Savage Mind*, Claude Lévi-Strauss describes the dialectical relationship between size and quality as follows: "Being smaller, the object as a whole seems less formidable. By being quantitatively diminished, it seems to us qualitatively simplified. More exactly, this quantitative transposition extends and diversifies our power over a homologue of the thing, and by means of it the latter can be grasped, assessed and apprehended at a glance."[35] The Polish artist Zbigniew Libera, with his *Lego Concentration Camp Set* (1996) in the form of a children's toy, counts among a series of artists who since the 1990s have been exploring the effects of de-dramatization and de-naturalization in order to thematize the Shoah.

It is to be assumed that the processes involved in presenting the camps as a rational and carefully planned architectural reality—the cold abstraction of the plans, the suggestion of a "normal" housing estate thanks to the model, and the trivializing reduction of scale—were more or less consciously calculated effects. The reality of the camps was fragmented, enclosed behind panes of glass, kept at a distance, and concealed

from the eyes of the public.[36] In the exhibition, this focus on architecture served to justify the authoritarian measures of the camps, basically substantiating their legitimacy and enabling the public, in an act of deceiving both oneself and others, to simultaneously distance themselves from actual reality.

Tangible Evidence. Let us now return to *The Evidence Room*. Together, and from the perspective of interaction, the different curatorial strategies of these two exhibitions give rise

34 See Tom Holert and Danilo Scholz, "Mikro–Ökonomie der Geschichte: Das Unausstellbare en miniature," *Texte zur Kunst* 11, no. 41 (2001), pp. 57–68; Ulf Buschmann, "Spielzeug und Modellbau in zeitgenössischer Kunst zum Holocaust," in *NachBilder des Holocaust*, ed. Inge Stephan and Alexandra Tacke (Cologne, Weimar, and Vienna, 2007), pp. 284–98.

35 Claude Lévi–Strauss, *The Savage Mind* (1966; repr., Oxford and New York, 2004), p. 23.

36 The fact that this strategy was successful is illustrated by various reports in the daily news, at times demonstrating an utter masking of reality and describing the camps as peaceful residential colonies, as "a piece of paradise" and as "more healthy than the heathiest spa resort." See, for example, O.A., "Die Ausstellung in der Bognergasse (Flüchtlingsfürsorge)," *Neue Freie Presse*, January 21, 1916, pp. 1–3.

In diesem Teil der Ausstellung verstärkte der bewusste Verzicht auf jeglichen erklärenden Kommentar[41] die auratische Wirkung der Objekte. Ohne zwischen den ganz unterschiedlichen Perspektiven der Opfer und Täter zu differenzieren und ohne jegliche Information zum Entstehungskontext, standen der Plan des SS-Architekten und die ungelenke Erinnerungsskizze eines jungen Überlebenden, der die Gaskammer mit eigenen Augen zu sehen bekommen hatte, unvermittelt nebeneinander. Sie wurden hier einzig in ihrer Funktion als Beweise im Gerichtsprozess vorgeführt.

Wiederholen als Wissensproduktion. Aus der Perspektive einer interaktiven Wissensproduktion lag die Bedeutung der Ausstellung vor allem auf zwei Ebenen, die beide *außerhalb* des eigentlichen Ausstellungsraumes lagen: Zum Einen im Verlauf der Konzeption und Produktion der Ausstellung, im Experimentieren und Suchen nach Angemessenheit, die im Buch beschrieben werden – also zeitlich vor der Ausstellung; sowie in der politischen Dimension der grundsätzlichen kuratorischen Entscheidung Alejandro Aravenas, die gesellschaftliche Relevanz des Themas durch dessen Integration in das Feld der zeitgenössischen Architektur zu verdeutlichen.

Im Buch werden die fragilen, überkommenen Bruchstücke der historischen Realität von Auschwitz, die während des Gerichtsprozesses die Gestalt harter, handfester, gerichtlich vorlegbarer Beweise annehmen mussten und als solche in der Ausstellung monumentalisiert wurden, wieder zu dem, was Georges Didi-Huberman in Bezug auf Bilder als „Fetzen der Erinnerungen"[42] bezeichnet oder als Risse, die „einen Schein des Realen auflodern"[43] lassen. Zunächst entstehen jedoch aus dem Kaleidoskop von – sowohl notgedrungen vagen als auch präzisen – Informationen, die im Prozess versammelt wurden, ganz konkrete Handlungen architektonischer Büropraxis: Die Studenten der University of Waterloo hatten die Aufgabe, maßstäblich genaue Pläne zu erstellen, um die Gassäule und die gasdichte Tür als (prinzipiell) funktionierende Objekte bauen zu können. Aus der Vertrautheit der eigenen Disziplin heraus und in der gewohnten Praxis des Zeichnens und Berechnens am Computer eröffnete sich für die Ausführenden das unvorstellbare Kalkül

41 Einzige Ausnahme ist ein kurzer, einführender Raumtext.

42 Didi-Huberman, Georges: *Borken*, Konstanz 2012, 84.

43 Didi-Huberman: *Bilder trotz allem*, 121 (wie Anm. 8).

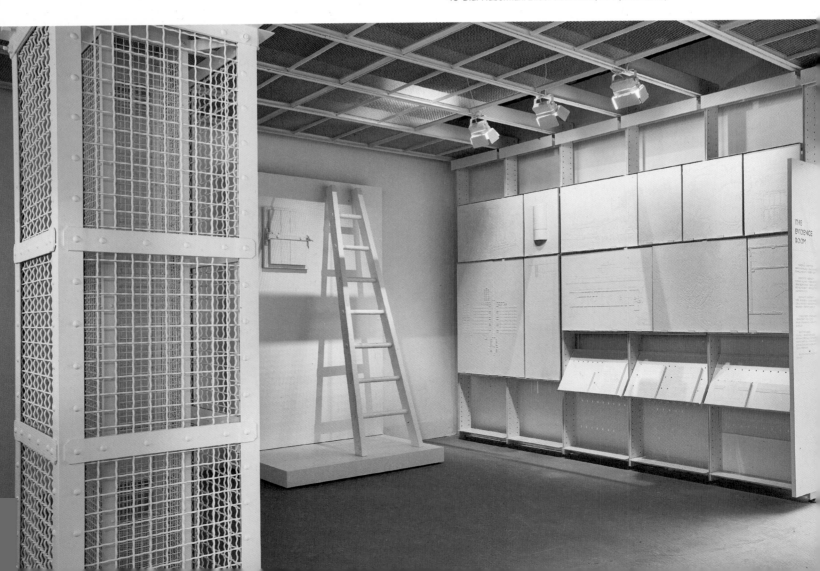

to a complementary impression: concealing/exposing, closing/opening. The propaganda exhibition of 1915 aimed to engender a picture of the camps, to freeze and thus close the perspective of the camps using media. The biennale exhibition of 2016, which was focused not on the camp Auschwitz in general but rather on the gas chambers as culmination point of the genocide, confronted the visitors with evidence of the "unimaginable" by means of tangible and visually ascertainable artifacts. At the same time, it fostered discourse on camps as works of architecture. Dominating the exhibition space—the 50 m² Room Q of the Central Pavilion—was the uniform white hue of the objects. According to the curators, the white was meant to purge the space from all sentimentality[37] and possessed, with the reference made to the simultaneity of absence and presence, metaphorical meaning.

Positioned in the middle and along the edges of the room were replicas of architectural elements of mass murder on a 1:1 scale: a gas-tight door to the gas chamber with a peephole that was latticed from the inside so as to protect against victims' attempts to save themselves, a barred gas column from Crematorium 2 through which the deadly gas Zyklon B was introduced into the gas chamber, a piece of the wall from Crematorium 5 with a gas-tight shutter, and a ladder used by SS men to transport the Zyklon B cans. As opposed to the reduction and distancing of the camp model behind glass as found in the 1915 exhibition, here a sense of apparent immediacy was engendered ("Today I touched the gas column,"[38] as the Holocaust survivor Elly Gotz wrote after visiting the workshop at the University of Waterloo School of Architecture, where the column was being replicated). In designing these objects, decades of research work by Robert Jan van Pelt and all findings related to the structural form of the gas chambers densified to create a principally functional reality. They were objects that *could* in fact function in their newfound form—despite a feeling of alienation due to the all-white color. The curators considered them not reproductions but rather architectural translations of the necessity of remembrance.

Without scaling-down mediation through plans or photos, the visual and haptic presence of the life-size objects gave rise to a picture of the unimaginable. When, to cite Lévi-Strauss, reduction (through plans, photos, drawings) makes the totality of the object less frightening, then the real size can certainly inspire terror. Here, the curators were well aware of

the dilemma that the life-size objects might harbor the danger of event character and fetish effect. Donald McKay described the struggle to find the right form as follows: "This column COULD have been made this way. It's very likely. It doesn't mean it WAS made this way. But it could have been. … We are acrobats, dancing on a line between truth and effect, and we strive every day to be honest as we tell the story."[39]

Lined up along the walls of the room, as per the concept by Anne Bordeleau,[40] were plaster casts of those plans, photos, drawings, letters, and contracts (here prepared as tangible reliefs) that Van Pelt had submitted to the London trial as evidence. They substantiated vital facts, such as how the gas-tight door in the basement of Crematorium 2, which had originally opened into the room, was then changed to latch from the outside—after the room's function was modified from morgue to gas chamber and after an amendment of the plans by SS architect Walter Dejaco—since the dead bodies of the victims would otherwise have inhibited access. Plaster, a material commonly used in forensic science, created in the exhibition space the evidence of a sensorily experienceable plane that made visible once again the no-longer-existing as a negative imprint, while also bearing witness to undemonstrable aspects of the Shoah.

In this part of the exhibition, the purposeful decision to omit any explanatory comments[41] heightened the auratic effect of the objects. Without differentiating between the very different perspective of victim and perpetrator, and without any information on the context of origin, the plan drafted by the SS architect and the clumsy sketch from memory by a young survivor, who had seen the gas chamber with his own eyes, were suddenly positioned adjacently. They were presented here solely in their function as evidence for the trial.

Repetition as Knowledge Production. From the perspective of an interactive production of knowledge, the significance of the exhibition was evident primarily on two levels, both resting outside of the actual exhibition space: for one, in the process of conceptualizing and producing the exhibition, in the experimentation and quest for appropriateness described in the book, that is, at a point in time *before* the exhibition; and

37 "We didn't want it to look like a reconstruction of the gas chamber … we wanted to purge the room from sentimentality." Donald McKay cited in Léa-Cathrine Szacka, "The Evidence Room," *Domus* 17 (2016), https://www.domusweb.it/en/architecture/2016/08/17/the_evidence_room.html (accessed October 9, 2017).

38 Elly Gotz, "*The Evidence Room* Project," in Bordeleau et al., *The Evidence Room*, pp. 74–76, esp. p. 75 (see note 2).

39 Donald McKay, "Correspondance," in Bordeleau et al., *The Evidence Room*, pp. 88–97, esp. p. 97 (see note 2).

40 Anne Bordeleau, "The Casts Court," in Bordeleau et al., *The Evidence Room*, pp. 112–18 (see note 2).

41 The only exception is a brief introductory wall text.

des Verbrechens. Das ganz genaue Hinsehen auf kleinste Details der technischen Planung, das Wiederholen des Planzeichnens und das Nachvollziehen der dahinter stehenden Logik löste erschütternde Irritationen und Erkenntnisprozesse aus.

Aus den Statements der studentischen Mitarbeiter im Buch lässt sich das Potenzial der Vorgehensweise von „The Evidence Room" ablesen. Michael Nugent übernahm gemeinsam mit seinem Vater, einem Handwerker, die Aufgabe, die Gassäule zu bauen. In seinem Essay „To Build a Gas Column"[44] beschreibt er, wie er sich bei der Arbeit, beim Schweißen der Metallstücke, in einen Panzer aus Lachen, schwarzem Humor und alltäglichem Geplänkel einhüllte. Doch plötzlich verstand er, was er da tat: „Dann schaue ich eines Tages auf den Haufen Stahl, an dem ich arbeite, und zum ersten Mal verstehe ich wirklich, was das ist. Ich kann mich nicht mehr länger von dem distanzieren, was ich tue."[45] Der Stolz auf die gelungene handwerkliche Arbeit wich Erkenntnis über die Paradoxie des Tuns, Entsetzen vor dem Grauen und Traurigkeit. Siobhan Allman hatte die Aufgabe, ein in Bezug auf seine Ausmaße kleines Detail der Lagerplanung von Auschwitz zu dimensionieren, den Türriegel für die gasdichte Tür zur Gaskammer. „Die Haptik des Griffs erschütterte meine Gefühle."[46] Sie erkannte im Nachvollziehen der mechanischen Funktion eines Dings, das hinter vielen Tausenden Menschen die Tür zur tödlichen Gaskammer schließt, die ethische Verantwortung eines Planers.

Alexandru Vilcu war mit der digitalen Übertragung des Grundrisses von Krematorium 4 für die Gipsabgüsse betraut. Beim Eingeben der Daten fiel ihm auf, dass der Zeichner des Originalplans bei den üblichen Türmaßen „90/205" in einem Fall „9/205" angegeben hatte. Dadurch berechnete das Computerprogramm den gesamten Plan falsch. „Diese Ungenauigkeit zerschmetterte die Wände, knickte die Säulen und verzerrte die Linien, die in meinem Kopf die Herstellung von Krematorium 4 wiedergaben. Dieser winzige Fehler offenbarte die große Wahrheit – dieses Versehen war menschlich, und das Fleisch der Hand, die diese Mordmaschinerie hervorbrachte, hatte einen Abdruck auf dem Pergament hinterlassen. Es folgten Zorn und Ungläubigkeit – Zorn auf den Architekten hinter den Zeichnungen, die diese grausame Konstruktion ermöglichten, und Ungläubigkeit, weil dieser Architekt dieselben menschlichen Züge hatte wie wir alle – Vergesslichkeit und Irrtum. […] Mir wurde bewusst, wie fragil und kostbar Details sind."[47]

Welche Front? Während der eigentliche Ausstellungsraum auf der Biennale – in der Opposition von Exhibition und Exhibiting – eine eher statische künstlerische Position einnahm, fügten sich die Aktionen und Reflexionen, die im Begleitbuch *The Evidence Room* festgehalten sind, gemeinsam mit den durch Gerichtsprozess und van Pelts Buchveröffentlichung (*The Case for Auschwitz*) ausgelösten Interaktionen, den Vorträgen, Publikationen, Diskussionen und individuellen Gedankengängen zu einem aus vielen Akteuren bestehenden Netzwerk zusammen. Das Projekt „The Evidence Room" auf der Biennale berichtete nicht nur von einem Kampf – dem forensischen Nachweis des in Auschwitz vollzogenen Genozids mit den Mitteln der bauhistorischen und archäologischen Analyse und damit auch der Rolle der Architektur im Holocaust während des „Irving Trials". Vielmehr führte es, allein durch seine Präsenz innerhalb der Architekturbiennale, selbst einen politischen Kampf, nämlich den gegen eine Ausblendung des Lagers, und in letzter Konsequenz von Auschwitz, aus dem Gegenstandsbereich der Architektur. Die Wiener Propagandaausstellung von 1915 lässt sich als zeitlose Manifestation der Spielräume der Architektur deuten, sie zeigte, wie Architektur zur Formung des Lagers genutzt wird und gleichzeitig die Verschleierung der Vorgänge möglich macht. Die Ausstellung in Venedig 2016 führte an die Grenzen der Architektur – als Disziplin ebenso wie als Profession –, indem sie erinnerte und gleichzeitig vergegenwärtigte, dass es eben *keine* Grenzen der *conditio humana* gibt, die nicht mit Hilfe der Architektur überschritten werden könnten. ∎

44 Nugent, Michael: „To Build a Gas Column", in: Bordeleau: *The Evidence Room*, 98–103 (wie Anm. 1).

45 „Then one day I look down at the pile of steel I am working and, for the first time, I truly understand what it is. I can no longer distance myself from what I am doing." Ebd., 102.

46 „The tactility of the handle jerked my emotions." Allman, Siobhan: o.T., in: Bordeleau u.a. (Hg.), *The Evidence Room*, 138 (wie Anm. 1).

47 „This inaccuracy shattered the walls, buckled the columns, and distorted the lines that represented the making of Crematorium 4 inside my head. This minuscule fault revealed the grand truth – this mistake was human and the flesh of the hand that authored this murdering machine was imprinted on the vellum. Anger and disbelief followed – anger with the architect behind the markings that made up this cruel construction and disbelief because this architect shared the same human traits as all of us – forgetfulness and error. […] I realized just how fragile and precious details are." Vilcu, Alexandru: o.T., in: Bordeleau: *The Evidence Room*, 142 (wie Anm. 1).

also in the political dimension of the fundamental curatorial decision made by Alejandro Aravena to illustrate the relevance this topic holds for society by integrating it into the field of contemporary architecture.

In the book, the fragile fragments of historical reality passed down about Auschwitz, which during the court proceedings inevitably assumed the form of hard, tangible evidence suitable for a court of law and which were monumentalized as such in the exhibition, once again became that which Georges Didi-Huberman, in reference to images, calls "a fragment of memory"[42] or tears "from which a fragment of the real escapes."[43] Initially emerging, however, from the kaleidoscope of—both unavoidably vague and also precise—information collected during the case were very concrete practices from architectural firms: the students at the University of Waterloo were given the task of developing true-to-scale plans in order to be able to construct the gas column and the gas-tight door as objects that function (in principle). Arising through the familiarity of one's own discipline and in the familiar practice of using a computer to create drawings and make calculations, the individuals doing this work were confronted with the unfathomable horror of this meticulously calculated crime. An extremely close look at the most minute details of the technical planning, the repeated drafting of the plan, and the comprehension of the logic behind this material triggered a harrowing sense of irritation and awareness.

The potential of the approach taken by "The Evidence Room" is clear from the statements in the book made by the students collaborating on the exhibition project. Michael Nugent, together with his father, who is a craftsman, took on the task of building the gas column. In his essay "To Build a Gas Column,"[44] Nugent describes how he erected around himself a shell of laughter, black humor, and everyday banter while working, while welding the metal pieces. Yet suddenly he understood what he was doing: "Then one day I look down at the pile of steel I am working and, for the first time, I truly understand what it is. I can no longer distance myself from what I am doing."[45] Pride in the successful craftsmanship gave way to an awareness of the paradox inherent to his activity, to dismay about the horror and sadness. Siobhan Allman had the task of scaling a detail of the Auschwitz camp plans, small in size yet of great magnitude: the bolt latching the gas-tight door of the gas chamber. "The tactility of the handle jerked my emotions."[46] In retracing the mechanical function of a thing that closed the door behind many thousands of people in the deadly gas chamber, Allman became cognizant of the ethical responsibility of a planner.

Alexandru Vilcu was entrusted with the digital transferring the floor plan of Crematorium 4 for the plaster casts.

While entering the data, he noticed that the drafter of the original plan had entered, in one case, the typical door dimensions "90/205" as "9/205" instead. Because of this discrepancy, the program calculated the entire plan incorrectly. "This inaccuracy shattered the walls, buckled the columns, and distorted the lines that represented the making of Crematorium 4 inside my head. This minuscule fault revealed the grand truth—this mistake was human and the flesh of the hand that authored this murdering machine was imprinted on the vellum. Anger and disbelief followed—anger with the architect behind the markings that made up this cruel construction and disbelief because this architect shared the same human traits as all of us—forgetfulness and error. … I realized just how fragile and precious details are."[47]

Which Front? While the actual exhibition space at the biennale—in the opposition of exhibition and exhibiting—assumed a more static artistic position, the actions and reflections captured in the accompanying book *The Evidence Room* merged, together with the interactions, lectures, publications, discussions, and individual thought processes triggered by the lawsuit and Van Pelt's book release (*The Case for Auschwitz*), to form a network made up of many players. Not only did the project "The Evidence Room" at the biennale tell of a struggle—that of the forensic proof of genocide in Auschwitz using means of architectural-historical and archaeological analysis, and thus also of the role played by architecture in the Holocaust as cited in the "Irving Trial." It also led—even just due to its presence within the architecture biennale—to a new political struggle, namely, against the suppression of the memory of the camps, ultimately of Auschwitz in particular, within the scope of architecture. The propaganda exhibition of 1915 in Vienna may be considered a timeless manifestation of the latitudes of architecture; it shows how architecture was used in the formation of the camps and, at the same time, how it enabled the operations carried out there to be concealed. The 2016 exhibition in Venice probed the limits of architecture—both as a discipline and a profession—by reminding and, at the same time, envisioning that there are truly *no* limits to the *conditio humana* that could not be transgressed with the help of architecture. ∎

Translation: Dawn Michelle d'Atri

42 Georges Didi-Huberman, *Bark*, trans. Samuel E. Martin (Cambridge, MA, 2017), p. 5.

43 Didi-Huberman, *Images in Spite of All*, pp. 80–81 (see note 8).

44 Michael Nugent, "To Build a Gas Column," in Bordeleau et al., *The Evidence Room*, pp. 98–103 (see note 2).

45 Ibid., p. 102.

46 Siobhan Allman, in Bordeleau et al., *The Evidence Room*, p. 138 (see note 2).

47 Alexandru Vilcu, in Bordeleau et al., *The Evidence Room*, p. 142 (see note 2).

Exulting Matters
Zur räumlichen Doxologie alpiner Klänge
On the Spatial Doxology of Alpine Sounds

Christoph Walter Pirker

Die textlichen Schichten des folgenden Beitrages folgen Protokollen werdender Subjektivität. Innerhalb von drei Jahren beginnt der Autor ab Sommer 2014 die Südtiroler Dolomiten als Begegnungsort mit dem Alpinen, seiner Materialität und spezifischen Diesheit wahrzunehmen. Im speziellen entfalten sie die Einbettung in eine Landschaft kultureller Ökologie, die in ihrer ideologischen Überformung nicht nur ausgestellt werden will, sondern durch ein ihr eigenes Jubeln sogar neue Welten offenbart.

///

Prolog. Mit all dem im Hinterkopf war der Weg steil. Es schien mit jedem Schritt, dass die Kiefern endlich aufhörten, zu wachsen und der Weg frei würde für das, worin ich dachte, unsere Welt zu finden: in den Schotterfeldern, die sich unaufhörlich bewegten und mich beinahe in den Abgrund stürzen ließen, und in den Felswänden, die auf mühsam gesammelten Fotos versprachen, mehr zu sein, als tatsächlich erkannt werden konnte. Doch der Weg wand sich und ließ mich nicht dort ankommen, wo ich glaubte, mit einem Blick erkennen zu können, dass es so war, wie ich es mir dachte. Es verband sich vielmehr eins mit dem anderen und als ich zum Lago dell'Orso hinabstieg, war es nicht ein hehres Seesein, das mich dort erwartete, sondern eine Wasseroberfläche, worin sich die Felswände und die Schilfwände und die Wände bewegender Insekten gleichermaßen spiegelten. Als mein gewandeltes Spiegelbild in das Wasser traf, schien ich in Cremoninis Gemälde einzutreten, nur um zu erfahren, dass es *schon dort* war, wo ich meine Füße hinlenken ließ. See und Spiegel waren beide rund.[1]

Dennoch führte mein Weg mich weiter, hinauf, bis die Fülle dieser optischen Fruchtbarkeit einem haptischen Karst gewichen war, hinter dem sich die Türme des Gesteins in den Himmel schraubten und der meiner Hand die plastischen hundertfachen Schatten greifen ließ, die diese grauschattierte Unwirtlichkeit beleuchteten. Der Weg hatte seine wogende Weichheit zurückgelassen und die sonnenharte Straße – am Abhang liegend hin und wieder von gemauerten Viadukten gestützt – bewegte mich wie auf einem Seil zwischen dem festen Berg und dem leeren offenen Raum, in dem die Stimme eines kleinen Kindes aus dem Tal widerhallte. Hier waren Felswände detoniert und hatten den ursprünglichen Weg begraben; dort tanzte ich zum ersten Mal. Die schlanken, in Beton gegossenen Pfeiler seitlich der Straße dienten mir als Orientierung zwischen den Schneeplanken, die noch schmelzen wollten und dem Rinnsal, das der Wind bald zu Eis gießen würde. Ich war alleine unterwegs.

Das Sublime der Berge konnte dabei nur dröhnendes Metrum sein, das jeden, der dort umherirrte, mitriss in seine Ganzheit und blind werden ließ für den Hauch des Raumes, den ich schon lange vor meiner Ankunft verspürt hatte. Ich wusste, dass *ich* diese Landschaft war und sie mir so entgegentrat, dass ihr Gesicht, das schon vor der letzten Kehre für einen Moment sichtbar wurde, mich nicht freudig überraschte, sondern, im Gegenteil, in mir eine Furcht aufzusteigen begann, denn es war *mein*

Gesicht, das in der Felswand vor mir lag, und *meine* Augen, die mich in diesen Körper hineinzogen, nur um mich zu vernichten. Ich trat näher. Hier also, an der unsichtbaren Grenzlinie zwischen den zwei Ländern wich das Dröhnen einem lautlosen Puls, der nicht nur innerlich, sondern in jeder Brechung des mich Umgebenden resonierte und mich einschwingen ließ in den Rhythmus der Begegnung, die schon begonnen hatte. Es war eher still.

Was vor mir lag, war etwas, das mir in jeder Sekunde dieses Augenblicks zu entgleiten schien.[2] Es war keine Geschichte, kein Wissen und kein Ding. Nur der Hauch, der aus diesen Augen wehte, aus diesem Berg, der vor mir lag, setzte sich in mir fest und ich hätte ihn nicht spüren können, hätte sein Hauch nicht schon dereinst, hunderte Kilometer entfernt, mein Fenster geöffnet und meinen Körper gefüllt. Es kam nicht darauf an, jetzt da zu sein, denn ich wusste, dass es kommen würde, hatte es viele Male gedacht, und jedes Mal überkam mich Angst um mein Leben. Damit der Hauch mich anwehen konnte, *musste* es diese Augen geben, mein Werden, mein Sein und mein Vergehen hingen an ihnen und ihr Blick schoss durch mich hindurch.[3] Nicht dieser Augenblick, der flüchtige, war es, der mich in sie aufnahm, sondern mein Warten und Zögern, mein Atmen und Schauen, das die Gegenwart zäh werden und das Ticken augenblicklicher Sekundenschläge verstummen ließ.

In diese Stille hinein, in dem Hauch der Augen stehend vernahm ich, immer noch *außen* stehend, ein Singen von *innen* her, eine Melodie, so leise und so laut zugleich. Dieses Singen war ein reines Singen[4], ein bloßes, das nur von diesem Ort kommen konnte und dennoch in jedem Ton jeden Faden der Welt verwob zu dem filigransten Gewebe, dem Körper, der vor mir lag, grau und fest. (Wie viele Fäden hier zusammenliefen, konnte ich *zunächst* nicht ausmachen). In seinen Augen war es dunkel, und in ihnen, so tief, dass ich es nicht schätzen konnte, traf eine Träne in eine Lache, die ich hörte und mein Gesicht zum letzten Mal trocknete. Woher die Tränen wohl kamen, fragte ich mich, und obwohl ich wusste, dass es der Berg war, der sich nun über meine Wangen schlängelte, war es doch, als schmeckte ich in ihm nicht das Salz der Erde[5], sondern das Salz, das seinen Geschmack verloren hatte, die Trauer der Weggeworfenen, den Tod der Zertretenen. Ein Salz ohne Geschmack, eine Träne ohne Wasser, ein Auge ohne Licht. Dorthin ging ich, und die wenigen

1 Vgl. Althusser, Louis: „Cremonini, Painter of the Abstract", in: ders.: *Lenin and Philosophy and Other Essays*, New York 1971, 235.

2 Vgl. Heidegger, Martin: „Was ist Metaphysik?", in: ders.: *Wegmarken*, Frankfurt/M. 1976, 113.

3 Vgl. Hoffmann, E.T.A.: *Der Sandmann*, Stuttgart 2003, 5.

4 Vgl. Heidegger, Martin: „Wozu Dichter?", in: ders. *Holzwege*, Frankfurt/M. 1977, 317.

5 Die Bibel, NT, Mt 5,13.

2

Christoph W. Pirker, „Performance Kreuzbergpass",
Croda Sora i Colesei, Südtirol/Veneto, 2017 © Fabian Dankl

The textual strata of the following contribution observe protocols of becoming subjectivity. Over the course of three years, starting in the summer of 2014, the author begins to perceive the South Tyrolean Dolomites as a place of encounter with the Alpine landscape, with its materiality and specific haecceity. Unfolding here, in particular, is an embeddedness in a landscape of cultural ecology, which, in its ideological overformation, not only begs to be exhibited, but also seeks to manifest new worlds through its very own act of rejoicing.

///

Prologue. With all that in the back of my mind, the path was arduous and steep. Thus progressing, it seemed as if the pines had finally stopped growing, freeing up the path along which I thought to find our world: in the fields of boulders shifting incessantly and almost knocking me over the precipice, and in the rock faces that promised, in painstakingly collected photos, to be more than what could be actually identified. Yet the path twisted and turned, not allowing me to arrive there where I believed to recognize the state I had construed in my mind. Indeed, one thing led to another, and as I descended to Lago dell'Orso it was not a sublime lake-being awaiting me there, but rather a surface of water mirroring walls of rock and walls of reeds and walls of moving insects. As my altered mirror image touched the water, I appeared to be entering Cremonini's paintings, only to experience that it was *already there*, where I led my feet to. Lake and mirror were both round.[1]

My path, however, took me further, upward, until the richness of this visual fecundity gave way to a haptic karst, behind which the towers of stone twisted up into the sky and

which allowed my hand to be gripped in sculptural, hundred-fold shadows that illuminated this gray-shaded inhospitality. The path had left behind its undulating smoothness, and the sun-hardened road (situated along the slope and occasionally supported by stonewalled viaducts) led me along like on a rope between the solid mountain and the empty, open space in which the voice of a small child echoed up from the valley. Here, the cliff walls had been blasted and now buried the original path; it was there that I danced for the first time. The slender, cast-concrete pillars along the road's edge helped me to navigate between the swathes of snow starting to melt and the rivulet that the wind was soon to mold into ice. I was traveling alone.

The mountains' sublimity could only be a noisy meter that swept anyone roaming about there into its wholeness, blinding them to the breath of space that I had already sensed long before my arrival. I knew that I was this landscape and that it was facing me in such a way that its features, briefly visible even before the last hairpin bend, evoked in me a rather unpleasant surprise. A sense of dread arose in me, for it was *my* face in the crag before me and *my* eyes drawing me into this body, even destroying myself. I stepped closer. So here, at the invisible borderline between the two countries, the noise gave way to a silent pulse that resonated not only inside, but also in every refraction of my surroundings, tuning me up into the rhythm of the encounter already begun. It was quite tranquil.

Facing me was something that appeared to slip away during each second of this very moment.[2] It was no story, no knowledge, and no thing. Just the breath wafting out of these eyes, of this mountain before me, became rooted within me, and I would not have been able to feel it had it not opened my window and drenched my body, one day, hundreds of kilometers away. The point was not to be there now, for I knew that it would come; I had thought it many times, each time overcome with a fear for my life. For this breath to waft over me, these eyes *had to* exist. My becoming, my being, and my decay were tied to them, and their gaze shot right through me.[3] It was not this moment, this fleeting moment, that allowed it to embrace me, but rather my pausing and hesitation, my breathing and watching, which lent the present a sense of viscosity and allowed the momentary ticking of seconds to fall silent.

Into this silence, standing in the eyes' breath, I noticed, while still standing *outside*, a singing from *inside*, a melody both quiet and loud. This singing was pure singing[4] that could

1 See Louis Althusser, "Cremonini, Painter of the Abstract," in *Lenin and Philosophy and Other Essays* (New York, 1971), p. 235.

2 See Martin Heidegger, "What Is Metaphysics," in *Basic Writings*, ed. David Farrell Krell (New York, 2008), p. 102.

3 See E.T.A. Hoffmann, *Der Sandmann* (Stuttgart, 2003), p. 5.

4 See Martin Heidegger, "What Are Poets for?," in *Poetry, Language, Thought*, trans. Albert Hofstadter (1971; repr., New York, 2001), p. 136.

Schritte, die ich zu tun hatte, füllten sich mit Blei, der Rhythmus pulsierte schneller, der Blutwind rauschte, der Stein rollte und ich trat durch die halb geöffnete Tür.

///

Zu Beginn des Jahres 1931 erlässt das italienisch-faschistische Kriegsministerium ein Rundschreiben an den italienischen König und die höchsten italienischen Minister, Beamte und Institutionen, in dem festgelegt wird, dass es fortan „zu empfehlen ist […] auf Höhlen und Kasematten aus Beton zurückzugreifen".[6] Dieses Schreiben scheint in all seiner Ernsthaftigkeit zu spät zu kommen, indem es sich nicht nur in den zementen Tropfsteinen des Landschaftsplastikers August Dirigl wiederfindet, die sich bereits fünfzig Jahre zuvor im bayerischen Schloss Neuschwanstein von der Decke winden, sondern auch in der Künstlichkeit all jener Räume, die während des gesamten 19. Jahrhunderts zu menschgeformten Höhlen, Felsen und Gewölben gewandelt werden.[7] Dennoch muss differenziert werden: Wenn sich nämlich der Blick des Bayernkönigs aufmacht, seine Grotte zu verlassen, um weit über die Fensterflächen des daran anschließenden Wintergartens hinauszugehen und schließlich an einem grauen Massiv verhaften bleibt, dann sind es die entfernten Alpen, wohin die Sehnsucht jenes effektvoll mit Farben beleuchteten Raumes in Wahrheit weist. Umso erstaulicher ist, dass jenes Rundschreiben, das sich vehement für die Ausbildung künstlicher alpiner Räume einsetzt, sich *in ebendiesen Alpen selbst* ereignet und so radikalisiert, dass ein „möglichst häufiger Rückgriff auf Arbeiten *in den Felsen* (bei jeder Art von Bauwerk)"[8] befohlen wird. Der Blick auf das Entfernte, Irreale und Schöne, auf das Alpenmassiv als Objekt der Begierde, wird aufgegeben und die vorherrschende Blickrichtung ändert sich: die Augen blicken nicht länger auf etwas, sondern nun direkt aus ihm heraus.

Die entstehenden Konstruktionen *in den Alpen* sind der erste Versuch, eine Räumlichkeit herzustellen, die sich in den absoluten Charakter der Alpen einbettet und nicht von außen, sondern von ihrer Innerlichkeit heraus gedacht und erkannt wird. Eine solches innerliches Denken und Sein bedeutet darüberhinaus die Aufhebung eines gegenständlich begreifbaren Raumes, der analysiert, kategorisiert und beschrieben werden könnte. Zum ersten Mal spinnt sich der Gedanke, dass der Ort der Alpen und der in ihnen entstehende Raum kein Objekt ist, das separiert von der Welt (und ihm selbst) im blendenden Licht informativer Aufklärung auf einem Sockel präsentiert wird. Es zeigt sich vielmehr eine Verflochtenheit, in der die Gegenständlichkeit in einem Fluss unbestimmter innerer Tiefe verwoben ist. Mit Maurice Merleau-Ponty scheint es, als ob der bisher noch klar und deutlich erscheinende Gegenstand von der Nacht umhüllt würde, die selbst kein Gegenstand mehr ist, sondern ein Zustand, etwas, das Gegenständlichkeit, Eigenschaft und Identität erlöschen lässt. Gleichzeitig liegt in dieser Umhüllung eine unmittelbare reale Dimension, worin die alpine Nacht selbst diejenige ist, „die mich anrührt".[9] Der bisher objektiv-klare Raum verdunkelt sich und

3

Christoph W. Pirker, „Performance Kreuzbergpass", Croda Sora i Colesei, Südtirol/Veneto, 2017 © Fabian Dankl

unter seinem schwarzen Himmel steht er unter dem „Befehl auszuruhen, sogar zu sterben, oder weiterzugehen".[10]

Zwischen 1931 und 1942 wird das gesamte Alpenmassiv, das die Nordgrenze Italiens bestimmt, in mehreren Phasen zu einem System an Befestigungsbauten, Bunkeranlagen und Tötungsmaschinen transformiert, die sich so zu tarnen wissen, dass der verbündete Feind direkt in sein Verderben läuft. Indem die Achse Berlin-Rom ab 1936 nicht nur gestärkt, sondern drei Jahre später in Stahl gegossen wird[11], sodass „uns nichts mehr trennen [kann]"[12], verlagert das italienisch-faschistische Kriegsministerium den Bau dieser die gegnerische Seite anlockenden Räume in diesem Jahr noch weiter *in die Materialität der Alpen* selbst, die mehr ist, als zunächst erfahren werden kann.

Georg Simmel benennt die Alpen und die Lebendigkeit ihrer Materie als formlos, was in einem heideggerschen Sinn nicht die Negation der Form (die immer noch die Bejahung der

6 Vgl. „Circolare 200: Direttive per la organizzazione difensiva permanente in montagna", in: Bagnaschino, Davide: *Il Vallo Alpino a Cima Marta*, Arma di Taggia 2002, 165–166.

7 Vgl. Berger, Julia: „Die Grotte im Schloss Neuschwanstein. Zur Vorstellung der Venusgrotte in der Tannhäuser-Sage und -Oper" in: *ZfK – Zeitschrift für Kulturwissenschaften* 2 (2014), 31–49.

8 Vgl. „Circolare 15000: Fortificazione permanente alle frontiere alpine", in: Bernasconi, Alessandro/Muran, Giovanni: *Le fortificazioni del Vallo Alpino Littorio in Alto Adige*, Trento 1999, 315. [Hervorhebung durch den Autor]

9 Merleau-Ponty, Maurice: *Phänomenologie der Wahrnehmung*, Berlin 1966, 329.

10 Ebd., 334.

11 Die Unterzeichnung des sogenannten Stahlpaktes am 22.5.1939 besiegelte die Loyalität zwischen Italien und Deutschland für den bald darauf folgenden Ausbruch des 2. Weltkrieges.

12 Ciano, Galeazzo: *Tagebücher 1939–1943*, Bern 1947, 158–159.

only come from this place and yet with each tone wove every thread of the world into the most delicate tissue, the body reposing in front of me, gray and firm. (How many threads ran together here I could not *at first* discern.) Inside its eyes it was dark, and in them, eyes so deep that I could not even guess the depth, a tear melded into a laugh which I heard while drying my face for the last time. Whence these tears had come, I asked myself, and although I knew it was the mountain now meandering along my cheeks, it was as if I had here tasted not the salt of the earth,[5] but salt despoiled of its taste, the sorrow of the discarded, the death of the trodden. A salt without taste, a tear without water, an eye without light. There I went, and the few steps I had to take were weighted with lead, the rhythm pulsed faster, the blood wind roared, the stone rolled, and I stepped through the half-open door.

///

Early in the year 1931, the Italian fascist ministry of war issues a circular letter to the Italian king and the highest-ranked Italian ministers, civil servants, and institutions detailing the decision that "it is recommended … to fall back on caves and casemates made of concrete."[6] This circular seems, despite its serious nature, to come too late, for it is found not only in the cement stalactites of the landscape sculptor August Dirigl (which fifty years earlier are already coiling from ceilings in the Bavarian castle Neuschwanstein), but also in the artificiality of all the spaces transformed throughout the nineteenth century into man-made caves, cliffs, and vaults.[7] One must nonetheless take a differentiated view: when the gaze of the Bavarian king is inspired to depart its grotto, moving beyond the window panes of the adjacent conservatory before finally coming to rest on a gray massif, then it is to the distant Alps which the yearning of that effectively illuminated space is really pointing. In this regard, it is even more remarkable that this circular, which vehemently calls for the formation of artificial Alpine spaces, takes place *in precisely these Alps* themselves and is radicalized in such a way that an "especially frequent recourse to work *in the rocks* (for any kind of structure)" is ordered.[8] The sight of the distant, the illusive, and the beautiful—of the Alpine massif as object of desire—is abandoned, and the prevailing line of vision shifts: instead of the eyes looking on something, they now directly look out of it.

The emerging constructions *in* the Alps are the first attempt to create a spatiality embedded in the absolute character of the Alps, conceived and recognized not from outside, but rather from its interiority. Even more, such interior thought and being implies the revocation of an objectified space to be analyzed, categorized, and described. For the first time, the thought arises that the place of the Alps and its emerging space is not an object presented on a pedestal, separate from the world (and from oneself), in the dazzling light of informative enlightenment. On the contrary, there is apparent here an entanglement where objectivity is woven into a flow of undefined inner depth. With Maurice Merleau-Ponty in mind, it seems as if the hitherto clear and distinctly appearing object were enfolded by the night, which itself is no longer an object but rather a condition, something that may actually vanish objectivity, quality, and identity. Present in this enfolding is, at the same time, a dimension immediate and real, in which the Alpine night is itself the one "in contact with me."[9] The space formerly so objective and clear now darkens and, under its black sky, is subjected to "an order either to rest or die, or else to push on further."[10]

Between 1931 and 1942 the entire range of the Alps, which lends Italy its northern border, is transformed, over several phases, into a system of fortifications, bunkers, and killing machines, so well camouflaged that the allied enemy walks straight into perdition. With the axis Berlin–Rome not only being fortified starting in 1936, but actually cast in steel three years later[11] so that "nothing [can] divide us,"[12] the Italian fascist ministry of war relocates, this very same year, the construction of these luring spaces even further *into* the materiality of the Alps themselves, a materiality being more than can be experienced initially.

Georg Simmel calls the Alps—and the vibrancy of their material—formless, which in a Heideggerian sense means not the negation of form (which still presupposes the affirmation of form), but the *slipping away* of form, which transpires everywhere form—in an indefinite temporal duration—steplessly recedes into the groundless or into the "Other."[13] In this distinctive Alpine simultaneity of "sheer material mass" and "celestial

5 The Bible, NT, Matthew 5:13.

6 See "Circolare 200: Direttive per la organizzazione difensiva permanente in montagna," in Davide Bagnaschino, *Il Vallo Alpino a Cima Marta* (Arma di Taggia, 2002), pp. 165–66.

7 See Julia Berger, "Die Grotte im Schloss Neuschwanstein: Zur Vorstellung der Venusgrotte in der Tannhäuser-Sage und -Oper," *ZfK – Zeitschrift für Kulturwissenschaften* 2 (2014), pp. 31–49.

8 See "Circolare 15000: Fortificazione permanente alle frontiere alpine," in Alessandro Bernasconi and Giovanni Muran, *Le fortificazioni del Vallo Alpino Littorio in Alto Adige* (Trento, 1999), p. 315. Emphasis added by the author.

9 Maurice Merleau-Ponty, *Phenomenology of Perception*, trans. Colin Smith (1962; repr., London and New York, 2005), p. 330.

10 Ibid., p. 335.

11 The signing of the so-called "Pact of Steel" on May 22, 1939, set the seal on the loyalty between Italy and Germany for the soon-to-follow onset of the Second World War.

12 Galeazzo Ciano, *Tagebücher* 1939–1943 (Bern, 1947), pp. 158–59.

13 See Georg Simmel, "The Alps," *Qualitative Sociology* 16, no. 2 (June 1993), pp. 179–84, esp. p. 182.

Form voraussetzt), sondern die *Entgleitung* der Form bedeutet, die sich überall dort ereignet, wo die Form stufenlos, in einer undefinierten zeitlichen Dauer in das Gegenstandslose oder das „Andere"[13] zurücktritt. In diese andersartige alpine Gleichzeitigkeit der „bloßen materiellen Masse" und des „überirdisch Aufstrebenden"[14] werden innerhalb von zwanzig Monaten Räume getrieben, die auf keine tatsächlich bestimmbare Substanz verweisen können. Nicht nur der weitere Verlauf des Zweiten Weltkriegs, sondern auch die alpine Formlosigkeit selbst verlangen bis Oktober 1942 schließlich den Abbruch aller Arbeiten. Als nach der Landung der Alliierten in Sizilien, ein dreiviertel Jahr später, deutsche Truppen das Alpenmassiv überstürmen, um den Feind aufzuhalten, sind die künstlichen Felsen nur mehr Kulisse. Weit davon entfernt, ein „superfortress"[15] zu sein, das fliegend *von oben* die Welt überblickt und die totale Zerstörung in die geologischen Schichten des Planeten einschreibt, blicken die betonierten Höhlen *von innen* auf die Welt, die sich in ihrer Gegenständlichkeit selbst tötet. Die alpinen Bunker haben keine andere Wahl, als unbenutzt zu bleiben, indem sie als Räumlichkeit für sich selbst und in sich selbst stehen. Eine solche verinnerlichte Autonomie formuliert trotz ihrer notwendigen Materialität einen räumlichen Zustand, der jeglicher Greifbarkeit entgleitet. Viel eher als determinierte Frequenzen zu sein, umfassen die Räumlichkeiten des Alpenmassivs die Ganzheit eines Klanges – ohne es zu wollen, resoniert das Rundschreiben des Jahres 1931 weit in das Territorium des Feindes. Leichte Schwingungen ziehen sich in diesem Moment über die Wasseroberfläche der Grotte von Neuschwanstein.

///

Eine Dekade zuvor sind die Alpen noch friedlich. „Ich dachte nur immer an meine Alpenidee und habe jedem einen Vortrag gehalten, dass die Völker Europas bloß aus Langeweile Krieg führen, weil sie nichts Rechtes in ihrem Kopf hätten. Ich will ihnen eine Aufgabe geben [...]."[16] Unter dem Titel der „Alpinen Architektur" entstehen in der Karwoche 1918 pazifistische Entwürfe in der Form eines groß angelegten zeichnerischen Werkes. Sein Autor, der Architekt Bruno Taut, imaginiert in den Zeichnungen nichts weniger als den Umbau der Alpen, der die durch den ersten Weltkrieg entzweiten Menschen zu einer neuen brüderlichen und bauenden Gemeinschaft verbinden soll. Das idealistische Projekt wird nicht umgesetzt, doch sind Tauts Entwürfe indirekt von großer Wichtigkeit. Sie folgen nämlich nicht einem bloßen Verbinden des Subjektiven mit dem Objektiven, das schließlich einen kollektiv-ereignishaften Raum menschlicher Relationalität erschließen würde. Stattdessen notiert Tauts Arbeit in aller Deutlichkeit das *klangliche Sein* der Alpen, das in seiner Autonomie die Transversalität von Objekt und Subjekt übersteigt. Es ist die Notation einer Klanglichkeit, die etablierte Dichotomien von Hülle und Inhalt aufhebt. Die „Alpine Architektur" verkündet als fundamentalen Einschnitt in reduzierende Formen ästhetischer Modelle, dass die Alpen nicht mit einer Substanz angefüllt sein können, die auf eine greifbare Stofflichkeit schließen ließe und positionieren sie jenseits erfassbarer

Objektivität. Vielmehr sind sie *doxologisch* zu begreifen. Das Lob jedes Erdenteils an seinen himmlischen Schöpfer lässt sich als kosmische Verherrlichung, als ekstatisches Wort der Ehre oder als Klang des Jubels bezeichnen. Taut verzeichnet am Blatt der Zeichnung „Bergnacht" folgende Notiz: „Nur Gäste sind wir auf dieser Erde, und eine Heimat haben wir nur im Höheren, im Aufgehen darin und im Unterordnen."[17] Den Alpen in ihrer Doxologie zu begegnen bedeutet zunächst, ihre Materialität als Ausdruck einer intensiven Orientierung auf das Höhere zu wissen, die „Berge und alle Hügel, Fruchtbäume und alle Zedern"[18] erklingen lässt. Tauts Zeichnungen erschließen den Kosmos einer bislang unbekannten klanglich-lobenden Räumlichkeit.

Die alpine Doxologie zu begreifen fordert, die physische Präsenz des Geschriebenen, Gebauten und Entstandenen zurückzulassen und stattdessen die *Realität der Doxologie*, den Augenblick des jubelnden Klanges als die *tatsächliche* plastische und räumliche Manifestation der Alpen zu erkennen. Es verwundert nicht, dass eine solche alpin-klangliche Autonomie sich jeder ideologischen Vereinnahmung entgegensetzt. Pazifistische lebende Felsen wandeln sich einen Augenblick später zu donnernden Steinen, die das gläsern-bunte „Reich der Gewaltlosigkeit"[19] mit einem Mal in Scherben legen. Die Alpen lassen sich vom Menschen nicht vereinnahmen, sie sind kein Ding, sondern *die Realität selbst*, indem sie den Frieden wie auch den Krieg gleichermaßen ignorieren. Die Alpen sind nicht für den Menschen gemacht und besitzen ihr eigenes doxologisches Sein.[20] Die Begegnung geschieht nicht länger mit einem bekannten Du, das sich dem Begegnenden auftut, sondern mit einer Sequenz „lauter Er, lauter Es, verstehst du, lauter Sie, und nichts als das".[21] Der Klang, der in Tauts „Alpiner Architektur" notiert wird, lässt auf einen alpinen Klang schließen, der sich nicht *hinter* der Künstlichkeit der Form verbirgt, sondern vor ihr offenbart: „der Fels kommt zum Tragen und Ruhen und wird so erst Fels; die Metalle kommen zum Blitzen und Schimmern, die Farben zum Leuchten, der Ton zum Klingen, das Wort zum Sagen."[22]

13 Vgl. Simmel, Georg: „Die Alpen", in: ders./Kramme, Rüdiger/Rammstedt, Otthein (Hg.): *Gesamtausgabe. Band 14. Hauptprobleme der Philosophie. Philosophische Kultur*, Frankfurt/M. 1996, 300.

14 Ebd., 299.

15 Die Atombombenabwürfe auf Hiroshima und Nagasaki im August 1945 wurden von den Langstreckenbombern Boeing B-29 „Superfortress" durchgeführt.

16 Taut, Bruno/Schirren, Matthias (Hg.): *Bruno Taut: Alpine Architektur. Eine Utopie – A Utopia*, München 2004, 120.

17 Ebd., 86.

18 Die Bibel, AT, Psalm 148, 9.

19 Taut, Bruno/Conrads, Ulrich (Hg.): *Frühlicht. Eine Folge für die Verwirklichung des neuen Baugedankens. 1920 – 1922*, Berlin 1963, 11.

20 Vgl. Celan, Paul: „Gespräch im Gebirg", in: ders.: *Gesammelte Werke in fünf Bänden*, Bd. 3, Frankfurt/M. 1986, 172.

21 Ebd., 171.

22 Heidegger, Martin: „Der Ursprung des Kunstwerkes", in: ders.: *Holzwege*, Frankfurt/M. 1977, 32.

soaring,"[14] spaces are pushed within a twenty-month period that cannot refer to any actually specifiable substance. Not only the continued progression of the Second World War but the Alpine formlessness itself lead, ultimately, to the discontinuation of all work by October 1942. When, after the Allies land in Sicily, nine months later, German troops storm the Alps in order to intercept the enemy, the artificial rocks are no more than a scenic backdrop. Far from being a "Superfortress"[15] that, flying, surveys the world *from above* and inscribes the total destruction in the planet's geological structures, the concrete caves glimpse *from inside* the world that, in its objectivity, is killing itself. The Alpine bunkers have no other choice but to remain unused, standing as spatiality both for and in themselves. Such an internalized autonomy articulates, despite its necessary materiality, a spatial state that slips away from any kind of tangibility. Rather than being determined frequencies, the spatialities of the Alpine massif encompass the wholeness of a sound; without ever meaning to, the 1931 circular letter resonates deep into enemy territory. At this very moment, light oscillations extend across the water surface of the grotto at Neuschwanstein.

///

A decade before, the Alps are still peaceful. "My Alpine idea was continually on my mind, and I lectured everyone that the nations of Europe were waging war out of sheer boredom since their heads contained nothing worth mentioning. I'm going to give them an assignment …"[16] Under the title *Alpine Architektur* (Alpine Architecture), pacifist drafts in the form of a large-scale drawing work are created in the Holy Week, 1918. The author, the architect Bruno Taut, imagines in the drawings nothing less than a rebuilding of the Alps meant to connect those peoples divided by the First World War, giving rise to a new brotherly, cooperative coexistence. The idealistic project is not implemented, yet Taut's drafts are indirectly of great importance, for they do not follow a mere connection of the subjective with the objective, which ultimately would open up a collective, eventful space of human relationality. Instead, Taut's work clearly notates the *sonic being* of the Alps, which, in its autonomy, transcends the transversality of object and subject. It is the notation of a sonority that rescinds established dichotomies of container and content. The *Alpine Architektur* announces, as a fundamental break in reduced forms of aesthetic models, that the Alps can no longer be filled up by a substance that is suggestive of a tangible materiality and positions them beyond the scope of discernible objectivity. In fact, they must be considered *doxological*. The praise heralded by each part of the earth to its heavenly creator may be called a cosmic exaltation, an ecstatic word of honor, or a sound of rejoicing. Taut writes the following

note on the sheet containing the drawing *Bergnacht* (Mountain Night): "We are merely guests on this Earth, and have a home only in the Highest, in merging with it and subordination to it."[17] Encountering the Alps in their doxology initially means accepting their materiality as an expression of an intensive orientation toward the Highest, allowing the "mountains and all hills, fruit trees and all cedars"[18] to resound. Taut's drawings unfold the cosmos of a previously unknown, sonic and exalting spatiality.

Understanding Alpine doxology requires one to leave behind the physical presence of the written, built, and created in order to instead recognize the *reality of doxology*, the moment of exultant sound as the *actual* plastic and spatial manifestation of the Alps. It is no wonder that such sonic Alpine autonomy runs counter to any ideological appropriation. Pacifist, animate boulders impetuously change into thundering rocks, shattering to pieces the glassily colorful "kingdom without force."[19] The Alps elude monopolization by humans; they are not a thing but *reality itself*, in that they ignore peace and war in equal measure. The Alps are not made for humans, and they embody their own doxological state of being.[20] The encounter no longer occurs with a familiar You facing the one being encountered, but with a sequence of "nothing but He, nothing but It, you understand, and She, nothing but that."[21] The sound notated in Taut's *Alpine Architektur* suggests an Alpine sound that, instead of hiding *behind* the artificiality of form, opens up *in front of* it: "The rock comes to bear and rest and so first becomes rock; metals come to glitter and shimmer, colors to glow, tones to sing, the word to say."[22]

14 Ibid., p. 181.

15 The atomic bombs dropped over Hiroshima and Nagasaki in August 1945 were released by the Boeing B-29 Superfortress long-range bombers.

16 Bruno Taut and Matthias Schirren, ed., *Bruno Taut: Alpine Architektur; Eine Utopie – A Utopia* (Munich, 2004), p. 120.

17 Ibid., p. 86. Translation modified by the author.

18 The Bible, OT, Psalms 148:9.

19 Ulrich Conrads, ed., "Bruno Taut: Frühlicht (Daybreak)," in *Programs and manifestoes on 20th-century architecture*, trans. Michael Bullock (Cambridge, MA, 1971), p. 58.

20 See Paul Celan, "Conversation in the Mountains," in *Paul Celan: Selections*, ed. Pierre Joris (Berkley et al., 2005), p. 152.

21 Ibid., p. 151.

22 Martin Heidegger, "The Origin of the Work of Art," in *Basic Writings*, ed. David Farrell Krell (New York, 2008), p. 171.

Klanglichkeit bedeutet die Abkehr vom Symbolismus eines an räumliche Koordinaten gebundenen Objektes, indem sie in ihrer klingenden Vergänglichkeit eine eigene Realität formuliert und eine eigene Welt eröffnet. Die Alpen sind kein Gegenstand, kein Objekt, auch keine pantheistische Transzendenz: weit davon entfernt, von einer künftigen Welt zu sprechen, von dem Idealismus des Friedens oder der Tötungsmaschine des Krieges, lassen sie nur den Moment und die Realität des Klanges zu. Die Felsen hallen nicht nur wider, sondern sind sogar die eigentliche Welt. Die Relevanz von Tauts „Alpiner Architektur" liegt nicht im Entwurf alpiner Kristallhäuser begründet, sondern darin, einen doxologischen alpinen Kosmos erschlossen zu haben, in dem die Alpen miteinander klingen. Die Felsen nehmen dabei sowohl eine aktive wie eine passive Rolle ein, sie sind Klang und Notation gleichzeitig. Sogar kann es im Spielen dieser alpinen Partitur geschehen, dass der Spieler selbst zum Felsen wird.[23] Eine schwarze Alpendohle singt im Schatten der apokalyptischen schwarzen Sonne, die die alpine Landschaft schwach beleuchtet: Noch bevor ein dreifaches Heilig[24] ertönt, ziehen ihre felsigen Flügel die Linien eines klingenden Raumes in die kosmischen Lüfte. Die Alpen sind im Klang.

///

Metalog. Dort, wo die Sinneswahrnehmung jener Augen, in die ich eingetreten war, zu einem Bild verarbeitet wurde, war es schwarz. Sie schien etwas zu verarbeiten, das hier, *in ihr*, absolute Dunkelheit war. Ich ging, und ohne zu wissen, wohin ich ging, wie lange, wie weit oder wie tief, kam der Klang aus meinem Mund. Er verband sich mit meinem tastenden Gehen, das ein anderes Tanzen war als jenes im gleißenden Sonnenlicht zuvor. In ihm lag eine Bestimmtheit, die sich nicht nur in meiner Bewegung ausdrückte, sondern mich derart atmen ließ, dass der Ton, die Melodie und der Klang nur aus mir kommen *konnten*. Dieses Gehen war ein Gehen in das Unbestimmte, und ich bereitete mich auf eine Begegnung vor, in der ich sterben könnte. Aber in dieser massakrierenden Atmosphäre lag der Hauch, der bald von hier, bald von dort auf mich zuströmte und dieses Lied aus meinem Innersten kommen ließ, das erneut wiederzugeben ich nicht mehr imstande bin. Ich lag in einem Ort, der ich selbst wurde. Als ich wenig später, in diesem zähen äonischen Rauch von Zeit, worin mein Atem kondensierte und in dem ich für sehr lange, zumindest so lange, dass meine Glieder von der Kühle brennend zu zucken begannen, den Finger bewegte und ein wenig Staub aufwirbelte, wusste ich, dass ich in diesem Moment all das war, was man vergeblich versucht hätte, darzustellen. Ich war mehr als eine Darstellung. Später würde ich sagen, dass ich an diesem und jenem Ort gewesen, ihn gesehen, gemessen und gespürt hatte. Doch in diesem Moment wurde der Ort, an den ich mich jetzt erinnere, an mir, wie ich an ihm wurde. Er zeigte sich an mir, wie ich mich an ihm zeigte. Dabei starb und lebte ich gleichzeitig, und in dieser Gleichzeitigkeit sang ich in jeder Form meiner Bewegungen den Raum, der soeben entstand.

///

Die doxologische Klanglichkeit besitzt als ihre innerste Eigenschaft, dass sie einen werdenden Raum entstehen lässt. Olivier Messiaens 13-teiliger Zyklus „Catalogue d'oiseaux" nimmt sich diesem Paradox einer Räumlichkeit an, die in Bewegung begriffen ist, und lässt diesen Zyklus nicht zufällig von dem Gesang alpiner Vögel einleiten.[25] Seit 1941, spätestens jedoch seit „Reveil des oiseaux" (1953) sind Vögel tatsächlich im Erwachen begriffen und bestimmen nahezu ein Jahrzehnt das Schaffen des französischen Komponisten. Die Integration des Vogelgesangs in einen kompositorischen Prozess weist jedoch weit über das reine Reproduzieren hinaus. Der Rhythmus, die fließenden Intervalle, die Frequenzen und das spezifische Timbre des Vogels machen eine bloße Kopie unmöglich.[26] Im Klang des Vogels scheint eine Fülle zu liegen, die ein direktes analytisches Begreifen unmöglich macht. Die Singularität des Vogels und die Autonomie seines Klanges sprengen etablierte Apparaturen, wie auch jene, die Angelo Mosso in seinem Plein-air-Laboratorium am Monte Rosa mit sich führt. Die Entwicklung einer Studie über die Ermüdung des menschlichen Auges und der menschlichen Muskelkraft in der alpinen Umgebung ist dabei das zentrale Anliegen seiner Forschungen. Entgegen der Annahme, die Ermüdung des menschlichen Auges würde ein Nachlassen der Farbunterscheidung mit sich bringen, charakterisiert sich die Ermüdung, die in den Alpen aufgezeichnet wird, im Gegenteil durch eine *gesteigerte* Farbempfindlichkeit.[27] Mosso begegnet einem alpinen Überfluss, der sich direkt in der Körperlichkeit seiner Studienteilnehmer widerspiegelt. Ohne es genau benennen zu können, offenbart sich hier ein Zustand, der sich nicht auf einzelne alpine Eigenschaften – die Höhe der Berge, die Farbe der Felsen, die Temperatur der Luft oder die Beschaffenheit des Weges – zurückführen lässt, sondern als Ganzheit einer alpinen Fülle erfahrbar ist. Die Lebendigkeit und die Größe der Alpen liegen in dieser klanglichen Augenblicklichkeit und es ist im Gesang der Alpendohle, der Messiaens Zyklus einleitet, worin diese Fülle einer auf das Höhere weisenden Intensität für den Bruchteil eines Momentes klanglich hörbar wird. Messiaen weiß um diesen alpinen Klang, der erst transkribiert werden muss. Es handelt sich dabei um die klangliche Interaktion mit dem Kosmos, die sich im Vogel ausdrückt. Die musikalische Niederschrift dieses Zusammenspiels – Fels, See, Stille, Vogel, Luft, Berg, Geröll – fasst er in Noten, als Fragment einer alpinen Doxologie oder Teil einer „abgrundtiefen Unregelmäßigkeit".[28]

23 Vgl. Thoreau, Henry David: *The Maine Woods*, Princeton 2004, 71.

24 Vgl. Taut, Bruno: *Die Auflösung der Städte oder Die Erde – eine gute Wohnung oder auch: Der Weg zur Alpinen Architektur in 30 Zeichnungen*, Hagen in Westfalen 1920, 29.

25 Vgl. Messiaen, Olivier: „Le Chocard des Alpes" in: ders.: *Catalogue d'oiseaux pour piano. Chants d'oiseaux des provinces de France*, Paris 1964, 1–12.

26 Vgl. Bogue, Ronald: *Deleuze on Music, Painting and the Arts*, New York 2003, 29.

27 Vgl. Felsch, Philipp: „Der Löwe kommt. Nervöse Topologien bei Angelo Mosso" in: Dotzler, Bernhard J./Schmidgen, Henning (Hg.): *Parasiten und Sirenen. Zwischenräume als Orte der materiellen Wissensproduktion*, Bielefeld 2008, 54.

28 Laruelle, François: „Der Begriff der Non-Photographie", in: ders.: *Non-Photographie/Photo-Fiktion. Aus dem Französischen übersetzt von Ronald Voullié*, Berlin 2014, 107.

Sonority signifies a renunciation of the symbolism of an object tied to spatial coordinates, by formulating a unique reality and opening up a unique world through its sonic transience. The Alps are in no way an object, nor do they reflect pantheistic transcendence: far from speaking of a future world, of the idealism of peace or the killing machine of war, they only permit the moment and the reality of sound. Not only do the rocks echo; they are in fact the world per se. The relevance of Taut's *Alpine Architektur* lies not in the drafting of Alpine crystal buildings, but in the act of opening up a doxological Alpine cosmos in which the Alps sound together. Here, the rocks assume both an active and a passive role; they are at once both sound and notation. In playing this Alpine score, it can even happen that the player himself turns to stone.[23] A black Alpine chough sings in the shadow of the apocalyptic black sun gently illuminating the Alpine landscape: even before a triple Holy[24] resounds, its craggy wings draw the lines of a sonic space in the cosmic skies. The Alps are permeated with sound.

///

Metalogue. Where the sensory perception of those eyes that I had entered was processed as an image, it was black. It appeared to be processing something that here, *in it*, was absolute darkness. I walked, and without knowing where I was going, how long, how far or how deep, the sound poured out of my mouth. It coalesced with my groping walk, which was a different kind of dance than the one previously in the dazzling sunlight. In it lay a certainty that was expressed not only through my movement, but that allowed me to breathe in such a way that the tone, the melody, and the sound *could only* come from my most inner self. This walking entailed walking into the obscure, and I prepared myself for an encounter that could easily spell death for me. But in this massacring atmosphere lay the breath that soon rushed at me, from here, from there, allowing this song to arise from my inner being, which I am unable to render yet again. I lay in a place that I became. When a bit later, in this viscous, aeonian glimmer of time, in which my breath condensed and my finger raised a bit of dust—for a very long time, at least as long as it took for my limbs to begin to searingly twitch from the cold—I knew that in this very moment I was

everything that one had tried in vain to represent. I was more than a representation. Later I would say that I had been at this or that place, seen it, measured it, felt it. Yet in this moment, the place that I can still remember became me, and I became it. We mutually were demonstrating each other. And in the process I died and lived simultaneously; and in this simultaneity I sang in all the movements I made—the space that had just been created.

///

The innermost quality of doxological sonority is that it allows a becoming space to emerge. Olivier Messiaen's thirteen-part cycle *Catalogue d'oiseaux* (Catalogue of Birds) embraces this paradox of spatiality, caught in motion, and ensures that this cycle is not introduced by the sound of Alpine birds by chance.[25] Since 1941, and at the very latest since *Reveil des oiseaux* (Awakening of the Birds, 1953), birds indeed enjoy an awakening and impact the creative work of the French composer. However, the integration of birdsong in a compositional process points far beyond the pure act of reproduction. The rhythm, the flowing intervals, the periodicities, and the specific timbre of birds make a mere copy impossible.[26] Inherent to the sound of birds appears to be a fullness that rules out direct analytical understanding. The birds' singularity and the autonomy of their sound cause established apparatuses to burst, such as those carried by Angelo Mosso in his plein air laboratory at Monte Rosa. The development of a study on fatigue of the human eye and human muscle strength in the Alpine environment is a key issue in his research. Contrary to the assumption that this fatigue of the human eye goes hand in hand with a diminished capacity for differentiating color, the eye fatigue noted in the Alps is instead characterized by *enhanced* color sensitivity.[27]

23 See Henry David Thoreau, *The Maine Woods* (Princeton, 2004), p. 71.

24 See Bruno Taut, *Die Auflösung der Städte oder Die Erde – eine gute Wohnung oder auch: Der Weg zur Alpinen Architektur in 30 Zeichnungen* (Hagen in Westfalen, 1920), p. 29.

25 See Olivier Messiaen, "Le Chocard des Alpes," in *Catalogue d'oiseaux pour piano: Chants d'oiseaux des provinces de France* (Paris, 1964), pp. 1–12.

26 See Ronald Bogue, *Deleuze on Music, Painting and the Arts* (New York, 2003), p. 29.

27 See Philipp Felsch, "Der Löwe kommt: Nervöse Topologien bei Angelo Mosso," in *Parasiten und Sirenen: Zwischenräume als Orte der materiellen Wissensproduktion*, ed. Bernhard J. Dotzler and Henning Schmidgen (Bielefeld, 2008), p. 54.

4

Christoph W. Pirker, „Performance Kreuzbergpass",
Croda Sora i Colesei, Südtirol/Veneto, 2017 © Fabian Dankl

Wenn der Gesang der Alpendohle gespielt wird, ist dies keine Kopie eines bereits stattgefundenen Ereignisses. Vielmehr verhält es sich viel umfassender: In der Augenblicklichkeit des Spielens *entsteht* der alpine Raum, baut sich vor dem Spieler auf und nimmt den Spieler in sich. Dieser alpine Klang kann nie vollständig sein, doch er trägt immer das Ganze in sich, wie fragmentiert er auch immer sein mag. Der Gesang des Vogels ist lange vorbei, doch er kehrt wieder, in einer anderen Form, aber in all seiner Intensität. In dieser Realität entstehen die Alpen, in der Stimme der Alpendohle, die von den weiß-schwarzen Tasten in die Finger des Spielers strömt. Solche Spieler „werden den Berg nicht vergessen und werden ihn jetzt noch ernster betrachten, wenn sie in dem Garten sind, wenn wie in der Vergangenheit die Sonne sehr schön scheint, der Lindenbaum duftet, die Bienen summen, und er so schön und so blau wie das sanfte Firmament auf sie herniederschaut".[29] Das Engagement mit dem von Messiaen notierten Klang stößt nicht auf eine passive Rezeption, sondern spannt aktiv einen Raum auf. Das Spielen des fragmentierten alpinen Kosmos in der Form des Gesangs der Alpendohle bettet den Spieler in das große doxologische Kontinuum ein, das sich als alpine Räumlichkeit vor ihm entfaltet. Der zeitgenössische räumliche Diskurs wird ein wesentlich klanglicher sein.

///

Der Akt des Spielens kann sich, wie es Isabelle Stengers formuliert, nur als Molltonart verdeutlichen.[30] Wiewohl Messiaens Kompositionen sich überhaupt durch das Fehlen einer jeglichen harmonischen Zuordnung charakterisieren, bedeutet Stengers Aufforderung nicht etwa, das etablierte Dur zu negieren, sondern die Rolle harmonischer Zentralität und der damit verbundenen dichotomischen Gegensätzlichkeit aufzuheben. Das Spielen der Alpen und das klangliche Aufgehen in ihnen bedeutet stattdessen eine ökologische Praxis, ein Denken, in dem ein horizontaler Mittelpunkt verschwunden ist und sich das individuelle Handeln in einem zusammenhängenden umgebenden Ganzen vollzieht. Eine solche Einbettung findet sich in John Cages Begriff der *Performance* wieder, der etablierte Formen des Ausstellens und des Repräsentierens neu definiert: „[...] each performer when he performs in a way consistent with the composition as written, will let go of his feelings, his taste, his automatism, his sense of the universal, not attaching himself to this or to that, leaving by his performance no traces, providing by his actions *no interruption to the fluency of nature*."[31] Cages Anweisung birgt eine entscheidende Veränderung für die Bedeutung des künstlerisch Ausführenden.

Das performative Spielen besteht in der Auflösung einer aufoktroyierenden zentralen Interpretationsebene, wie auch in der Auflösung musikalisch-technischer Fertigkeiten insgesamt. Der Spieler, der alles hinter sich zurücklässt, bettet sich vorsichtig, ohne Spuren zu hinterlassen, in ein natürliches klangliches Kontinuum ein. Durch den performativen Akt verräumlicht er die Strukturen einer musikalischen Partitur, tritt selbst in den plastischen Kosmos des Klanges ein und wird selbst zum Raum. „Ich dürste, o Erde, und hingeneigt zu deinen reinsten und ewigen Quellen trinke ich, trinke von deinem Blute, o Erde, das Blut von meinem Blute ist."[32] Wieder sind es die Alpen, die dieses

performative Werden möglich machen. Giovanni Segantini zeigt im „Alpentriptychon", das zwischen 1896 und 1899 entsteht, das ganze Leben – Werden, Sein und Vergehen – als Einbettung in das natürliche Fließen des alpinen Klanges. Diesen Klang evoziert Segantini immer wieder, wenn er von der Synthese alpiner Harmonien spricht, die sich in monumentaler Größe auf dem dreiteiligen Werk vereinen.[33] Die dargestellte Körperlichkeit der gemalten Figuren weist auf ein grundlegendes Prinzip, von dem Segantinis Gemälde zeugen: nicht das Bild, nicht sein künstlerischer Ausdruck oder seine technische Ausführung sind es, die ausgestellt werden. Vielmehr ist es die Verräumlichung und Verkörperlichung des alpinen Klanges, die Segantini in seinem gesamten Werk zeigt. Segantinis Figuren sind *performer* durch und durch, fließende Teile eines großen Ganzen, die in der Dauer der Augenblicklichkeit die Alpen neu entstehen lassen.

Performance bedeutet die Auflösung des Eigenen und des Anderen, die Aufhebung jeder Form von Objektivität und die Redefinierung dessen, was Körperlichkeit genannt wird. Der Mensch steht nicht mehr mit seinem eigenen Körper einem anderen Körper gegenüber, womöglich noch in einer den anderen dominierenden Haltung. Vielmehr stehen die beiden Körper in einer sich bildenden neuen Körperlichkeit, einer Räumlichkeit, die sich im zeitlichen Moment, in der performativen Bewegung bildet. Körperlichkeit und Räumlichkeit sind komplementär. Die Berg-Werdung des Körpers und die Körper-Werdung des Berges stehen an diesem Punkt der Neubildung von Identität. In einer solchen Augenblicklichkeit zeigen sich *andere Identitäten*, die abgeschlagen von einer dominierenden Norm dasjenige herausfordern, was zeitlich objektiv, räumlich bestimmt und körperlich lebend klassifiziert wurde. Sie verstecken ihre Performativität nicht länger hinter einer Schablone bestehender Konventionen, sondern verdeutlichen ein Leben, das sich in den werdenden Bewegungen zu einer neuen Körperlichkeit und einer neuen Räumlichkeit materialisiert. Segantini weiß: Berg, Raum und Mensch sind eins. Der performative Körper erschließt einen werdenden Raum, eine Atmosphäre doxologischer Materie, eine Plastizität vibrierender Verflechtungen. Der Berg (der Raum, der Mensch) ist in einen Zustand eingetreten, worin er in der Fülle und Dynamik einer das Höhere preisenden Schöpfung steht, in der die Blumen zu Augen werden, die Tränen zu Steinen, die Himmel zu Menschen und die Tode zu Räumen. Die Bewegung durch diese lebend-sterbende Landschaft vernimmt noch vage die Schwingung jenes alpinen Klanges, in die der werdende Körper eingetreten ist. Die Welt wird deutlich.

///

29 Stifter, Adalbert: *Bergkristall*, Stuttgart 2001, 64.

30 Vgl. Stengers, Isabelle: „Introductory Notes on an Ecology of Practices", in: *Cultural Studies Review* 11,1 (2005), 183–196.

31 Cage, John: „Composition as Process", in: ders. *Silence. Lectures and Writings*, London 2015, 39. [Hervorhebung durch den Autor]

32 Zehder-Segantini, Bianca (Hg.): *Giovanni Segantinis Schriften und Briefe*, Leipzig 1912, 55.

33 Vgl. Zbinden, Hans: *Giovanni Segantini. Leben und Werk*, Bern 1964, 48.

Mosso encounters an Alpine fullness that is directly reflected in the corporeality of his study participants. Without being able to place one's finger on it, a condition emerges here that focuses not on isolated Alpine properties—the elevation of the mountains, the color of the rocks, the temperature of the air, or the condition of the path—but is instead experienceable as holistic Alpine fullness. The vibrant and sheer dimensions of the Alps rest in this sonic momentariness, and it is in the song of the Alpine chough, introducing Messiaen's cycle, in which this fullness of intensity pointing toward the Highest is sonically audible for a moment's fraction. Messiaen is aware of this Alpine sound that must first be transcribed. It is the interaction with the cosmos through sound that is expressed in the birds. He captures musically the notation of this synergy—rocks, lakes, tranquility, birds, air, mountains, boulders—as a fragment of Alpine doxology or a component of "abyssal irregularity."[28]

When the song of the Alpine chough is played, it does not signify a copy of an event taken place. Instead, it is much more comprehensive: Alpine space *emerges* in the momentariness of playing, gaining momentum in the presence of the player and fully embracing him. This Alpine sound can never be complete, yet it always carries the whole within itself, as fragmented as it may be. The birdsong is long since over, yet it returns, in a different form, but in all of its intensity. It is from this reality that the Alps emerge, in the voice of the Alpine chough flowing from the white-and-black keys into the fingers of the player. Such players "can never forget the mountain, and earnestly fix their gaze upon it when in the garden, when as in times past the sun is out bright and warm, the linden diffuses its fragrance, the bees are humming, and the mountain looks down upon them as serene and blue as the sky above."[29] The act of engaging with the sound notated by Messiaen does not encounter passive reception, but rather actively opens up a space. Playing the fragmented Alpine cosmos in the form of Alpine chough birdsong embeds the player in the great doxological continuum unfolding before him as Alpine spatiality. The contemporary spatial discourse will considerably be a sonic one.

///

The act of playing, as Isabelle Stengers phrases it, only functions "in minor key."[30] Although Messiaen's compositions are characterized in the first place by an omission of any kind of harmonic ascription whatsoever, Stengers's assertion does not mean negating the established major key, but overriding harmonic centrality and the related dichotomous polarity. Playing the Alps and rising up in their sound indicates an ecological practice, a mindset, where a horizontal center point has disappeared and individual action takes place in a cohesive, surrounding whole.

Such embedment is found in John Cage's concept of *performance*, which redefines the established forms of exhibiting and representing: "… each performer when he performs in a way consistent with the composition as written, will let go of his feelings, his taste, his automatism, his sense of the universal, not attaching himself to this or to that, leaving by his performance no traces, providing by his actions no *interruption to the fluency of nature*."[31] Cage's directive bears a decisive change in the meaning of the artistic performer.

Performative playing involves the dissolution of an essential, imposing plane of interpretation, but also the dissolution of musical-technical skills in general. The player, who leaves everything behind, carefully embeds himself, without leaving any traces, into a natural sonic continuum. Through the performative act, he spatializes the structures of a musical score, stepping into the plastic cosmos of sound and thus becoming space by himself. "Ich dürste, o Erde, und hingeneigt zu deinen reinsten und ewigen Quellen trinke ich, trinke von deinem Blute, o Erde, das Blut von meinem Blute ist."[32] Again, it is the Alps that make this performative genesis possible. Giovanni Segantini, in his *Alpine Triptych* made between 1896 and 1899, shows all of life—becoming, being, and decay—as embedment in the natural flow of Alpine sound. He evokes this sound again and again when speaking of the synthesis of Alpine harmonies that monumentally come together in the tripartite work.[33] The rendered corporeality of the painted figures points to a fundamental principle to which Segantini's paintings attest: being exhibited is not the image, not its artistic expression or its technical execution. Segantini rather shows, in all of his work, the spatialization and embodiment of Alpine sound. Segantini's figures are quintessential *performers*, fluent parts of a unified whole that allows the Alps to reemerge in the moment's duration.

Performance means the dissolution of one's own self and that of others, the revocation of any kind of objectivity, and the redefinition of what is called corporeality. The human body no longer stands opposite another body, possibly still in a dominating posture. Rather, the two bodies are engaging in a newly

28 François Laruelle, *The Concept of Non-Photography*, trans. Robin MacKay (Falmouth and New York, 2011), p. 126.

29 Adalbert Stifter, *Rock Crystal*, trans. Elizabeth Mayer and Marianne Moore (1945; repr., New York, 2008), p. 76.

30 Isabelle Stengers, "Introductory Notes on an Ecology of Practices," *Cultural Studies Review* 11, no. 1 (2005), pp. 183–96.

31 John Cage, "Composition as Process," in *Silence: Lectures and Writings* (London, 2015), p. 39. Emphasis added by the author.

32 Bianca Zehder-Segantini, ed., *Giovanni Segantinis Schriften und Briefe* (Leipzig, 1912), p. 55.

33 See Hans Zbinden, *Giovanni Segantini: Leben und Werk* (Bern, 1964), p. 48.

Epilog. Ich fand den Ausgang nicht leicht. Welchen Weg ich auch nehmen wollte, er führte mich in die Dunkelheit hinaus, in die ich vor langer Zeit, die länger dauerte, als ich denken konnte, eingetreten war. Ich bemerkte, dass das Dunkel im Innen und das Dunkel im Außen dasselbe Dunkel war, in das ich langsam meine schweren Schritte setzte. Es war Nacht geworden. Das Licht verschwand hinter dem Berg, aus dem ich gekommen war und dessen Rücken mich zum letzten Mal wärmte. Der Körper, aus dem ich trat, dieses Lebende, Pulsierende, Bewegende gab mir diesen *neuen Körper*, der mich umhüllte. Wohin ich ging, konnte ich nicht länger feststellen, denn ich dachte wie der Berg, der ich geworden war. Auf der Schaukel, die *von oben* herabhing, schwang ich mich vor und zurück, doch nicht diese oder jene Richtung, in die das schwebende Brett mich trug, waren es, die mich immer weiter in diese nachtschwarze Landschaft hinaufschwingen ließen, sondern einzig die Bewegung selbst, die von mir und meinem geologischen Körper ausging.[34] Die Schaukel musste oft zum Schwingen gebracht werden. In mir schwand das letzte menschliche Licht und der Klang der Welt ließ alle Kosmologien hinter sich, von denen ich früher gehört hatte. Ich schwang mich hinauf und jeder Schwung talwärts ließ nachtschwarze rasiermesserscharfe Schatten entstehen,[35] als wäre ein Tropfen in diese Unendlichkeit gefallen, in der ich mich in meinem Körper bewegte. Es war nicht so, als sähe ich den Berg immer weiter von unten, und obwohl der Anschein hätte erweckt werden können, dass der Berg sich immer weiter von mir zu entfernen schien, war es doch so, als trüge ich ihn in diesem schaukelnden Spiel in mir, in meinem Herz aus Stein.[36] Dieses steinerne Fleisch pochte anders, es klang mit dieser gemeinsamen Allheit, auch später noch, als ich in diesem Bett lag, dessen Korpus tiefer war, als jener eines musikalischen Instrumentes. Eine Kälte hatte mich gepackt, in der ich innerlich glühte und mit meinen schwarzen Augen sah ich den, der wartend, zögernd, und atmend vor mir war, bereit, in meine Augen zu schauen. Seitdem stand ich als Berg in der Welt. Ich hatte aufgehört, das, was um mich war, in dieser gelechzten Subjektivität zu begreifen, oder allem, was ich sah, seinen objektiven Sinn zuzuschreiben. Ich war *näher* als all das, und nicht die kleinste Unterscheidung, nicht die kühnste Forderung, diese Blume, die in diesem Moment von der reflektierenden Sonne mittelstark beleuchtet wurde, als etwas zu sehen, das mir gegenüberstand, als ein auf Augenhöhe positioniertes, gleichsam ausgestelltes Gegenüber, das nach genauer Beobachtung mir die Welt und ihr bewegendes Sein erschließen könne, ließ meinen Blick heben. Als ich in diesem Moment jedoch den Staub sah, war es er, der in meine Lungenflügel einatmend, mich dort schwirren ließ, wo einst zwei ungleiche Parkettbretter zusammenstießen. Einem Menschen stand ich in einem Raum als solches Staubpartikel gegenüber, als dieser bloß meinte: „Ihm ist nicht wohl.“[37] Nicht alle waren dem Berg nahe, nicht dem Staub, nicht dem Leben. Die Tür stand weit offen.

///

Dort, wo Dokumente aufbewahrt wurden, die anzeigten, wie ein Berg zu einem Raum geformt werden konnte, standen einige Menschen im Kreis um einen annähernd quadratischen Tisch. Auf ihm hatten sie ein papierenes Rundschreiben ausgebreitet, das, mit vielen Stempelabdrücken versehen, eine einigermaßen große Wichtigkeit zu haben schien. Doch was mit diesem Papier geschehen war, konnten sie, auch wenn der Tag schon fortgeschritten war, nicht begreifen: Die Zeit verging und die Geräusche, die aus dem Hintergrund der großen Stadt zwar matt, aber doch deutlich hereinströmten, verblassten mit jedem Ticken der Uhr, die einige Meter weiter auf dem Flur ihre Schläge tat. Es war, als ob dieses Dokument, das bislang unter der Inventarnummer Doc. 18/D/A in dem Archiv jener Institution vermerkt war und jetzt in seiner vollen Körperlichkeit ausgebreitet vor den Augen der Menschen lag, nicht mehr sichtbar, gleichsam unsichtbar ausgebrannt worden war. Etwas derartiges war noch nicht vorgekommen. Der gezeichnete Körper, den die Gruppe ursprünglich hinsichtlich einer Anfrage aus … zu untersuchen hatte und der der eigentliche Grund des Aushebens des vorliegenden Rundschreibens gewesen war, war verschwunden. Von der weißen Fläche vor ihnen ging Angst und Spannung aus. „Was ist das hier?“, fragte einer und wischte sich, um besser sehen zu können, den klingenden Staub von der heißkalten Brille. Im Fensterrahmen gegenüber zeigten sich, weit im Hintergrund, die Profile der Südtiroler Dolomiten. ∎

5

Christoph W. Pirker, „Performance Kreuzbergpass", Croda Sora i Colesei, Südtirol/ Veneto, 2017 © Fabian Dankl

34 Vgl. Arlander, Annette: „Performing Landscape – Swinging Together or Playing with Projections", in: *Body, Space, & Technology Journal* 16 (o.J), o.S., <http://people.brunel.ac.uk/bst/vol16/cover.html>, (25.7.2017)

35 Vgl. Barad, Karen: *Meeting the Universe Halfway. Quantum Physics and the Entanglement of Matter and Meaning*, Durham 2007, 76.

36 Die Bibel, AT, Ez 36,26.

37 Kafka, Franz: „Die Verwandlung", in: ders.: *Erzählungen und andere ausgewählte Prosa. Herausgegeben von Roger Hermes*, Frankfurt/M. 1996, 104.

arising corporeality, a spatiality that forms in the temporal moment, in the performative movement. Corporeality and spatiality are complimentary. The becoming-mountain of the body and the becoming-body of the mountain stand at this point of a new formation of identity. Apparent in such momentariness are *other identities* which, far behind a dominating norm, challenge that which might be taxonomized as temporally objective, spatially determined, and corporeally alive. Instead of continuing to hide their performativity behind a template of existing conventions, they exemplify a life that materializes in the becoming movements as a new corporeality and a new spatiality. Segantini knows that mountain, space, and human are one. The performative body unfolds a becoming space, an atmosphere of doxological matter, a plasticity of vibrating entanglements. The mountain (the space, the human) has entered a state where it engages with the fullness and dynamic of a genesis praising the Highest, where flowers turn to eyes, tears to stones, heavens to humans, and deaths to spaces. Movement through this vibrantly dying landscape can still vaguely hear the oscillation of the Alpine sound into which the becoming body has entered. The world becomes clear.

///

Epilogue. Finding the way out was not easy. Regardless of the path I wanted to take, it led me out to the darkness into which I had entered ages ago, lasting longer than I could think. I noticed that the dark inside and the dark outside were the very same darkness, which I was slowly marking with my heavy steps. Night had fallen. The light disappeared behind the mountain I had come from, its back warming me one last time. The body from which I stepped, this living, pulsating, moving being, gave me this *new body*, which enfolded me. No longer could I tell where I was going, for I was thinking like the mountain I had become. On the swing hanging down *from above*, I swung back and forth; yet it was not any given direction, in which the suspended plank carried me, allowing me to swing up into this pitch-black landscape, but only the movement itself, emerging from me and my geological body.[34] The swing often had to be brought to oscillate. Within me, the last human light disappeared and the sound of the world left behind all cosmologies of which I had once heard. I kept swinging upward and each sweep downward left behind pitch-black, razor-sharp shadows,[35] as if a drop had fallen into this eternity in which I was moving my body. It was not as if I were seeing the mountain from ever further down, and although it might have appeared that the mountain was slowly disappearing, I was actually carrying it within me through this swinging play, within my heart of stone.[36] This stony flesh was throbbing differently, resounding with this shared allness, even later when I was lying in this bed whose corpus was deeper than that of a musical in-

strument. I was caught in the throes of a frigidity in which I was glowing from within, and with my black eyes I saw the one waiting, lingering, and breathing before me, ready to look me in the eye. Since this moment I have been standing as a mountain in the world. I had stopped grasping everything around me with this craved subjectivity, or ascribing objective meaning to everything I saw. I was *closer* than all of this, and nothing caused me to raise my gaze, not the smallest distinction, not the boldest demand to see this flower, which in this moment the reflecting sun was moderately illuminating, as something standing opposite to me, as a counterpart positioned at eye level and exhibited, as it were, which after precise observation could open up the world and its moving being. Yet as I saw the dust in that very moment, it was this dust, inhaled into my lungs, that sent me whirring where once two uneven parquet planks had collided. I stood in a space, as just such a dust particle, facing someone who simply said: "He isn't well."[37] Not all were close to the mountain, to the dust, to life. The door was opened wide.

///

At the place where documents were stored showing how a mountain could be formed into a space, several people were standing in a circle around a roughly square table. Spread out on the table was a circular letter on paper, which, furnished with various stamps, appeared to be of reasonably great importance. Yet, though it was late in the day, they could not fathom what had happened to this piece of paper: time elapsed and the sounds streaming in from the backdrop of the big city, faint but nonetheless clear, faded with each tick of the clock situated several yards away in the hallway. It was as if this document—up until now filed away in the archive of this institution under the inventory number Doc. 18/D/A and now spread out in its lush corporeality in sight of these human eyes—were no longer visible, as if it had been invisibly burned away. Nothing of the kind had ever happened before. The drawn body which the group had originally set out to examine with regard to an inquiry from …, and which was the actual reason for drawing out this particular circular, had disappeared. The white surface before them exuded angst and tension. "What is going on here?" asked someone, wiping away the dust clinging to his hot-cold spectacles in order to see better. Filling the window frame across the room was the profile, far in the background, of the South Tyrolean Dolomites. ∎

Übersetzung: Dawn Michelle d'Atri

34 See Annette Arlander, "Performing Landscape: Swinging Together or Playing with Projections," *Body, Space, & Technology Journal* 16 (n.d.), n.p., http://people.brunel.ac.uk/bst/vol16/cover.html (accessed July 25, 2017).

35 See Karen Barad, *Meeting the Universe Halfway: Quantum Physics and the Entanglement of Matter and Meaning* (Durham, 2007), p. 76.

36 The Bible, OT, Ezekiel 36:26.

37 Franz Kafka, "The Metamorphosis," in *The Metamorphosis and Other Stories*, trans. Joyce Crick (Oxford, 2009), p. 35.

Praxis Reports / 2

Exhibiting at the "Trowel's Edge"

Ana Bezić

"For although in a certain sense and for light-minded persons non-existent things can be more easily and irresponsibly represented in words than existing things, for the serious and conscientious historian it is just the reverse. Nothing is harder, yet nothing is more necessary, than to speak of certain things whose existence is neither demonstrable nor probable. The very fact that serious and conscientious men treat them as existing things brings them a step closer to existence and to the possibility of being born."

Hermann Hesse, *The Glass Bead Game*[1]

Through site-specific performances, installations, buildings and sculptures, art transforms our knowledge of material places, and by providing a significant new dimension to its understanding and interpretation, it re-inscribes them deeply.[2] Well then, cannot art be put to work to investigate those very places of re-inscription? By places of re-inscription I refer to the exhibition spaces that render what is contested and not-yet-there possible to circulate in the form of visual representation. The production of visual display mobilizes many resources and yet, while producing the visual display, the artists and the resources mobilized are not visible or forefronted. I propose the concept of "interpretation at trowel's edge" as used in contextual archaeology to aid in navigating the shift from the exhibition to exhibiting and to re-position reflexivity as litmus paper, the tracing agent of missing things.

If we reconsider the exhibition space as the "equivalent of a laboratory, [a] place of trials, experiments and simulations"[3] they no longer can be thought as places of knowledge reproduction. Rather, through the processes of exhibiting (as in the production of visual display) these spaces generate new knowledges and new things. Hermann Hesse, in his novel *The Glass Bead Game*, has poignantly written that by treating things "whose existence is neither demonstrable nor probable [...] as existing things"[4] we come one step closer to their existence. How to translate this into the exhibition space? How to make space that traces the steps of the process of exhibiting?

In approaching the exhibition space we are already creating, arranging, assembling or, in other words, interpreting. The word "exhibit," deriving from its Latin root *exhibere (ex- "out" + -habere "to hold")*, makes space for the exhibition that *holds out* objects and presents them (as evidence in court, as facts that speak for themselves). It is expected of them to speak, and rather than being actors in their own rights, they continue to act as vehicles of human intentions. For objects to "speak" it requires human modification and so all these objects held out and exhibited are in need of interpretation. Bruno Latour argues that objects behave in "the most undisciplined ways, blocking the experiments, disappearing from view, refusing to replicate, dying, or exploding ... they always resist"[5] our interpretation. Being a stand in, they object to what is being told about them, they multiply, they become something else.

This hidden geography of objects was also explored in Peter Weibel and Bruno Latour's "Making Things Public" 2005 exhibition at ZKM – Museum of Contemporary Art. They used a museum to stage an exhibition experiment where "the ability of artists, politicians, philosophers, scientists and the visitors" was tested to make "the shift from the aesthetics of objects to the aesthetics of things."[6] The exhibition was based on the notion of assembly, that is, the power of objects to gather around themselves a different assembly, to conceptualize exhibitions as spaces of enactments, which open new alliances between authors, works, and visitors.[7] In it, some worlds are heavily intertwined, others vaguely, and some completely separated from each other. As Latour explains:

"Things-in-themselves? But they're fine, thank you very much. And how are you? You complain about things that have not been honored by your vision? You feel that these things are lacking the illumination of your consciousness? If you miss the galloping freedom of the zebras in the savannah this morning, then so much worse for you; the zebras will not be sorry that you were not there, and in any case you would have tamed, killed, photographed, or studied them. Things in themselves lack nothing."[8]

As much as we want to observe galloping zebras in the savannah, they are not concerned about us in order to exist. With objects presented as possessing unique qualities in and of themselves, the position has shifted from the singular/human privileged knowledge production to the more democratic forms of knowledge also known as *flat ontology*.[9] In this paradigm, each voice, be it historical, archaeological, social or spanning diverse disciplinary understanding is valid. Within this displacement of human-thing center, archaeology brings in a particular way of thinking and engaging with things in which human and things are entangled and dependent on one another.[10] The notion of entanglement serves as an integrating concept to describe and analyze the dynamic relationship, "the dialectic of dependence and dependency between humans and things."[11] Unlike Latour's mixing of humans and things in networks of interconnections, the concept of entanglement, as used by Hodder, is a sticky environment, one where entities are both things and objects, "they are both relational and they 'object', oppose and entrap."[12] Instead of an entirely relational treatment of matter, the position taken by Latour and ANT (Actor-Network Theory), the emphasis is on affordance and potentialities things give to humans and on the power of things to entrap.[13]

In archaeology—here seen as a way of thinking and engaging with things—the significance lies in the process of doing it, more so than the results of the endeavor. A substantial proportion of primary data collection takes place through excavation and surface survey. At its center are the context, a nexus of entanglements both past and present, and reflexivity with its continuing integration in every aspect of archaeological "doing." Contextual archaeology is focused on an interpretative practice that is both making sense of the past while being firmly grounded in the present. By interpretation I mean thick descriptions[14] and follow Hodder who argues that interpretative judgments are made even at the most descriptive of statements.[15] He gives an example of codified soil description where the grittiness, amount of inclusions, etc. involves subjectivity in describing it. Furthermore, site reports, long seen as nothing but descriptive accounts, are depersonalized and generalized, made to look as if anyone could do them. Interpretation cannot easily be separated from description.

The archaeologist makes sense of the past, provides orientations, significance, knowledge and meanings relevant to understanding it. The notion of entanglement, as described above, involves dependency and entrapment, histories that need interpreting. Interpretation is then making sense of this process, where meaning is the product of the context, and is continually produced through the working set of relationships we establish.[16]

"As the hand and trowel move over the ground, decisions are being made about which bumps, changes in texture, colors to ignore and which to follow ... how we excavate (trowel, shovel, sieving) depends on an interpretation of context ... But the interpretation of context depends on knowing about the objects within it. So ideally we would want to know everything that is in the pit before we excavate it"

1 Herman Hesse, *The Glass Bead Game* (London, 2000), p. 2.

2 See John Schofield, "Constructing Place: When Artists and archaeologists meet," in *Aftermath. Readings in the Archaeology of Recent Conflict*, ed. John Schofield (New York, 2008), pp. 185–196.

3 Bruno Latour, *Reassembling the Social: An Introduction to Actor-Network Theory* (Oxford, 2005), p. 159.

4 Hesse, *The Glass Bead Game* (see note 1).

5 Bruno Latour, "When Things Strike Back: A Possible Solution of 'Science Studies' to the Social Sciences," *The British Journal of Sociology* 51, no. 1 (2000), pp. 107–123, esp. p. 116.

6 Peter Weibel and Bruno Latour, "Experimenting With Representation: *Iconoclash* and *Making Things Public*," in *Exhibition Experiments*, eds. Sharon McDonald and Paul Basu (Oxford, 2007), p. 106.

7 See ibid.

8 Bruno Latour, *The Pasteurization of France* (Cambridge, 1998), p. 193.

9 Manual De Landa, *Intensive Science and Virtual Philosophy* (London, 2013).

10 See Ian Hodder, *Studies in Human-Thing Entanglement* (Chichester, 2016).

11 See ibid., p. 5.

12 See ibid., p.18.

13 See ibid.

14 See Clifford Geertz, *The Interpretation of Cultures: Selected Essays* (New York, 1973).

15 See Ian Hodder, *The Archaeological Process: An Introduction* (Oxford, 1999), pp. 68–69.

16 See Julian Thomas, *Time, Culture and Identity* (London, 1996), p. 236.

This it the hermeneutic conundrum: the interpretation is only possible once interpretation has begun … In practice we have to excavate without knowing what we are excavating, and we have to define contexts without understanding them."[17]

Archaeological interpretation, as any other interpretation, always takes place from the vantage point of the present and it points to the situated character of historical, social, and scientific understanding. This new reflexive methodology in archaeology includes ongoing and constantly changing "interpretation at the trowel's edge," with computer diaries written by the excavators, video recording of discussions about interpretation and methodology carried out in the trenches, and constant interactions among scientists, locals, politicians, and other groups who claim some "ownership" of the past. Reflexivity, here, refers to a recognition of positionality—that one's position or standpoint affects one's perspective.[18] It is the insistence on systematic and rigorous revealing of methodology and the self as the instrument of data collection and generation. It is the positioned subject who makes the interpretations that are provisional and always incomplete.[19]

The process of exhibiting can be viewed as more than simply presenting things. It is about a positioned subject making a statement and a dialogue between and among exhibits, people, and things. Therefore, exhibiting becomes a process of tracing and making new things. Exhibiting is also thoroughly interpretative. Because not everything can be presented, we are left with something, some aspect that cannot be translated/inscribed. These interpretative processes leave us with excess that is uninscribable and untranslatable. And if difference always remains,[20] how to capture this excess in the exhibition space? When does the interpretative moment begin, and in what ways can it be exhibited?

Archiving, filing, processing, recording, writing, drawing, painting, cutting, emailing, and all the work involved in the exhibiting process prior to the exhibition is about making the significance of one thing over the other, about playing down or suppressing other things that do not interest us. The excess of meanings and things that are made in the process of exhibiting

only show the necessity with continual engagement with interpretation. Latour has thoroughly hermeneuticized the laboratory, the inscription[21] process, and the instrument itself is already a hermeneutic device: "What is behind a scientific text? Inscriptions. How are these inscriptions obtained? By setting up instruments. This other world just beneath the text is invisible as long as there is no controversy. A picture of moon valleys and mountains is presented to us as if we could see them directly. The telescope that makes them visible is invisible and so are the fierce controversies that Galileo had to wage centuries ago to produce an image of the Moon."[22] By making the instrument visible or forefronted, we would be positioning ourselves to the things left out. And if interpretation occurs at "the trowel's edge"[23] it means that it already begins with the process of exhibiting and happens at every step of the way. How to highlight and show colors to all the things left out? Or, in other words, the exhibiting is not only about sizing and zooming of frames (contexts). Because frames (contexts), Latour argues, impose restrictions to the possible connections, exhibiting could set to investigate this through the process of shifting frames (contexts) and the movement, the flow, and the changes observed in the process.[24] So we can now begin to view exhibiting as a thing (via Latour), a thing in conflict rather than stasis, a matter of concern rather than a matter of fact.[25] How to demonstrate the existence of all the things involved in assembling exhibiting. And once demonstrated, how can they be exhibited? Can the politics of exhibiting at the trowel's edge carve a platform for a more democratic and inclusive exhibition space where people will be free to make their own assemblies of things, with everyone as curator? ∎

17 Hodder, *The Archaeological Process* (see note 15), p. 92.

18 See Renato Rosaldo, *Culture and Truth: The Remaking of Social Analysis* (Boston, 2000).

19 See ibid., p. 8.

20 See Hans-Georg Gadamer, *Truth and Method* (London and New York 1975) and Gaetano Chiurazzi: "The Universality without domain: The Ontology of Hermeneutical Practice," *The Journal of the British Society for Phenomenology*, vol. 48,3 (2017), pp. 198–208.

21 Latour's inscription is a result of series of transformations/translations and Latour defines translation as "the interpretation given by the fact-builders of their own interests and that of the people they enroll." Bruno Latour, *Science in Action* (Harvard, 1988), p. 108.

22 Latour, *Science in Action* (see note 21), p. 69.

23 Hodder, *The Archaeological Process* (see note 15), p. 92.

24 See Bruno Latour, *Reassembling the Social. An Introduction to Actor-Network-Theory* (Oxford, 2005), p. 143.

25 See Bruno Latour, "Why Has Critique Run Out of Steam? From Matters of Fact to Matters of Concern," *Critical Inquiry* 30 (2004), pp. 225–248.

Ausstellen an der „Kellenkante"

Ana Bezić

„[…] denn mögen auch in gewisser Hinsicht und für leichtfertige Menschen die nicht existierenden Dinge leichter und verantwortungsloser durch Worte darzustellen sein als die seienden, so ist es doch für den frommen und gewissenhaften Geschichtsschreiber gerade umgekehrt: nichts entzieht sich der Darstellung durch Worte so sehr und nichts ist doch notwendiger, den Menschen vor Augen zu stellen, als gewisse Dinge, deren Existenz weder beweisbar noch wahrscheinlich ist, welche aber eben dadurch, daß fromme und gewissenhafte Menschen sie gewissermaßen als seiende Dinge behandeln, dem Sein und der Möglichkeit des Geborenwerdens um einen Schritt näher geführt werden."
Hermann Hesse, *Das Glasperlenspiel*[1]

Durch ortsspezifische Performances, Installationen, Bauten und Skulpturen transformiert die Kunst unser Wissen über materielle Orte, und indem sie ihrem Verständnis und ihrer Interpretation eine signifikante neue Dimension verleiht, schreibt sie diese wieder tief ein.[2] Kann man nun Kunst nicht an die Arbeit lassen, um genau diese Orte der Wiedereinschreibung zu erforschen? Mit Orten der Wiedereinschreibung beziehe ich mich auf Ausstellungsräume, die die Verbreitung dessen, was umstritten und dort noch nicht möglich gewesen ist, in Form von visueller Darstellung ermöglichen. Die Produktion visueller Darstellungen mobilisiert viele Ressourcen, und dennoch sind die Kunstschaffenden und die mobilisierten Ressourcen während der Produktion der visuellen Darstellungen nicht sichtbar und werden nicht in den Vordergrund gerückt. Ich schlage das Konzept der „Interpretation an der Kellenkante" vor, wie es in der kontextuellen Archäologie verwendet wird, um beim Übergang vom Begriff Ausstellung zum Ausstellen eine Orientierungshilfe zu geben und Reflexivität als Lackmuspapier, als Instrument zur Suche nach den fehlenden Dingen, neu zu positionieren.

Wenn man den Ausstellungsraum als „Äquivalent eines Laboratoriums, […] eine

1 Hesse, Hermann: *Das Glasperlenspiel*, Frankfurt 1971, 3.

2 Vgl. Schofield, John: „Constructing Place. When Artists and Archaeologists Meet", in: ders.: *Aftermath. Readings in the Archaeology of Recent Conflict*, New York 2008, 185–196.

Stätte für Versuche, Experimente und Simulationen"[3] neu überdenkt, kann man diese nicht mehr als Orte der Wissensreproduktion betrachten. Vielmehr erzeugen diese Räume durch die Prozesse des Ausstellens (wie bei der Produktion von visuellen Darstellungen) neue Wissensformen und neue Dinge. In seinem Roman *Das Glasperlenspiel* hat Hermann Hesse dies pointiert beschrieben: Indem wir die Dinge, "deren Existenz weder beweisbar noch wahrscheinlich ist [...] als seiende Dinge behandeln"[4], kommen wir ihrem Sein einen Schritt näher. Wie lässt sich dies in den Ausstellungsraum übersetzen? Wie schafft man einen Raum, der die Schritte des Ausstellungsprozesses nachzeichnet?

Schon bei der Annäherung an den Ausstellungsraum gestalten wir, ordnen wir, fügen wir zusammen, oder in anderen Worten, interpretieren wir. Das vom lateinischen *exponere (ex- "heraus" + -ponere "stellen")*, abgeleitete englische Zeitwort "expose" schafft Raum für die "exposition" (Ausstellung), die Objekte *herausstellt* und präsentiert (als Beweismittel vor Gericht, als Tatsachen, die für sich selbst sprechen). Von ihnen wird erwartet, dass sie sprechen, doch statt Akteure aus eigenem Recht zu sein agieren sie weiterhin als Träger menschlicher Absichten. Damit Objekte "sprechen" können, bedarf es menschlicher Modifikation, und somit bedürfen all diese herausgestellten und ausgestellten Objekte einer Interpretation. Bruno Latour behauptet, Objekte verhalten sich "höchst undiszipliniert, indem sie die Experimente blockieren, aus dem Blickfeld verschwinden, sich weigern, sich zu reproduzieren, sterben oder explodieren ... sie widersetzen sich immer"[5] unserer Interpretation. Als Stellvertreter wenden sie sich gegen das, was über sie gesagt wird, sie vermehren sich, sie werden zu etwas anderem.

Diese verborgene Geografie der Objekte wurde auch in Peter Weibels und Bruno Latours 2005 im ZKM – Museum für Neue Kunst gezeigten Ausstellung "Making Things Public" erforscht. In einem Museum inszenierten sie ein Ausstellungsexperiment, in dem "die Fähigkeit von Künstlern, Politikern, Philosophen, Wissenschaftlern und Besuchern" erprobt wurde, "den Wechsel von der Ästhetik der Objekte zur Ästhetik der Dinge" zu vollziehen.[6] Die Ausstellung basierte auf dem Begriff der Assemblage, d.h. der Fähigkeit der Objekte, um sich selbst eine andere Zusammenstellung zu versammeln, Ausstellungen als Inszenierungsräume zu konzipieren, die neue Allianzen zwischen Autoren, Werken und Besuchern eröffnen.[7] In ihr sind einige Welten stark miteinander verflochten, andere vage, und einige sind völlig voneinander getrennt. Latour erklärt dies folgendermaßen:

"Die Dinge an sich? Aber es geht ihnen gut, vielen Dank. Und wie geht es Ihnen? Sie beklagen sich über Dinge, die von Ihrem Blick noch nicht gewürdigt worden sind? Sie meinen, diesen Dingen fehle die Erleuchtung Ihres Bewusstseins? Falls Sie heute Morgen die Freiheit der in der Savanne galoppierenden Zebras vermissen, dann ist das umso schlimmer für Sie; den Zebras wird es nicht leid tun, dass Sie nicht dort waren, und auf jeden Fall würden Sie sie gezähmt, getötet, fotografiert oder studiert haben. Den Dingen an sich fehlt nichts."[8]

So sehr wir auch die galoppierenden Zebras in der Savanne beobachten wollen, müssen sich diese keine Gedanken um uns machen, um existieren zu können. Mit Objekten, die als Dinge mit wirklich einzigartigen Eigenschaften präsentiert werden, hat sich die Position von der privilegierten singulären/menschlichen Wissensproduktion zu demokratischeren Wissensformen verschoben, die auch als "flache Ontologie" bezeichnet werden.[9] In diesem Paradigma ist jede Stimme gültig, sei sie historisch, archäologisch, sozial oder disziplinenübergreifend. Die Archäologie bringt in diese Verschiebung des Zentrums des Menschlichen eine besondere Art des Denkens und der Auseinandersetzung mit Dingen ein, in der Mensch und Dinge verschränkt und voneinander abhängig sind.[10] Der Begriff Verschränktheit dient als integratives Konzept zur Beschreibung und Analyse dieser dynamischen Beziehung, "der Dialektik der positiven und negativen Abhängigkeit zwischen Menschen und Dingen".[11] Im Gegensatz zu Latours Vermischung von Menschen und Dingen in Netzwerken von Verbindungen ist das Konzept der Verschränkung, wie es von Hodder verwendet wird, eine heikle Umgebung, eine Umgebung, in der Entitäten sowohl Dinge als auch Objekte sind, "sie sind wohl relational aber sie widersprechen [A.d.Ü. "object" im Englischen], sie widersetzen sich und verstricken sich".[12] Anstelle einer rein relationalen Behandlung der Materie, wie sie Latour und die Akteur-Netzwerk-Theorie (ANT) vertreten, liegt der Schwerpunkt auf der Aufforderung und auf den Möglichkeiten, die Dinge den Menschen geben können, und auf der Fähigkeit der Dinge sich zu verstricken.[13] In der Archäologie – hier als Denkweise und Auseinandersetzung mit den Dingen gesehen – liegt die Bedeutung mehr im Arbeitsprozess als im Resultat dieser Bemühungen. Ein erheblicher Teil der Primärdatenerhebung erfolgt durch Ausgrabungen und Oberflächenvermessungen. In deren Zentrum stehen der Kontext, ein Nexus von Verstrickungen aus Vergangenheit und Gegenwart, und die Reflexivität mit ihrer fortwährenden Integration in jeden Aspekt des archäologischen "Tuns". Die kontextuelle Archäologie konzentriert sich auf eine interpretative Praxis, die sowohl der Vergangen-

heit einen Sinn gibt, als auch fest in der Gegenwart verankert ist. Mit Interpretation meine ich dichte Beschreibungen[14] und schließe mich hierin Hodder an, der argumentiert, dass interpretative Urteile selbst bei den deskriptivsten Aussagen getroffen werden.[15] Er gibt ein Beispiel für eine festgeschriebene Bodenbeschreibung, bei der Subjektivität in die Beschreibung der Sandigkeit, der Anzahl der Einschlüsse usw. einfließt. Darüber hinaus sind Ausgrabungsberichte, die lange Zeit als reine Beschreibungen betrachtet wurden, entpersonalisiert und verallgemeinert, um so auszusehen, als ob sie jeder erstellen könnte. Interpretation lässt sich nicht ohne Weiteres von Beschreibung trennen.

Der Archäologe gibt der Vergangenheit einen Sinn, liefert Orientierungen, Aussagekraft, Erkenntnis und Bedeutungen, die für ihr Verständnis relevant sind. Der Begriff der Veschränktheit, wie oben beschrieben, birgt Abhängigkeit und Verstrickung in sich, Geschichten, die einer Interpretation bedürfen. Interpretation ist dann sinnvoll in diesem Prozess, in dem Bedeutung das Produkt des Kontexts ist, und durch die von uns aufgebauten Arbeitsbeziehungen fortwährend erzeugt wird.[16]

"Während sich die Hand und die Kelle über den Boden bewegen, werden Entscheidungen darüber getroffen, welche Unebenheiten, Veränderungen in der Textur, Farben zu ignorieren und welchen nachzugehen ist [...] wie wir graben (Kelle, Schaufel, Sieb) hängt von einer Interpretation des Kontexts ab [...] Doch die Interpretation des Kontexts hängt davon ab, ob man über die darin befindlichen Objekte Bescheid weiß. Im Idealfall würden wir alles, was sich in der Grube befindet, kennen wollen, bevor wir sie ausheben! Dies ist das hermeneutische Rätsel: Die Interpretation ist erst möglich, wenn die Interpretation begonnen hat [...] In der Praxis müssen wir graben, ohne zu wissen, was wir ausgraben, und wir müssen Zusammenhänge definieren, ohne sie zu verstehen."[17]

Archäologische Deutung, wie jede andere Deutung, äußert sich immer aus dem Blickwinkel der Gegenwart und verweist auf das ortsgebundene Wesen des historischen, sozialen und wissenschaftlichen Verständnisses. Diese neue reflexive Methodik in der Archäologie inkludiert eine permanente und sich ständig verändernde "Interpretation am Kellenrand", mit von den Ausgräbern geführten Computer-Tagebüchern, Videoaufzeichnungen von Diskussionen über die bei den Ausgrabungen zur Anwendung kommende Interpretation und Methodik und fortwährende Interaktion zwischen Wissenschaftlern, Einheimischen,

Politikern und anderen Gruppen, die ein gewisses "Eigentumsrecht" auf die Vergangenheit für sich beanspruchen. Reflexivität bezieht sich hier auf das Erkennen de Verortung – d.h. dass der eigene Ort ode Standpunkt die eigene Perspektive beeinflusst.[18] Sie ist hier eher ein systematisches und rigorosen Offenlegung der Methodik und des Selbst als Instrument de Datenerhebung und -generierung. Das verortete Subjekt ist es, das die vorläufige und stets unvollständigen Interpretationen vornimmt.[19]

Der Prozess des Ausstellens lässt sich als mehr als eine bloße Präsentation von Dingen verstehen. Er handelt von einem verorteten Subjekt, das eine Aussage trifft und einem Dialog der Exponate untereinander, mit den Menschen und anderen Dingen. Somit wird das Ausstellen zu einem Prozess der Spurensucher und der Schaffung neuer Bedeutung. Darüber hinaus ist das Ausstellen äußerst interpretierend. Da nicht alles präsentiert werden kann, bleibt uns ja was/ein Ding übrig, irgendein Aspekt, der sich nicht übersetzen/einschreiben lässt. Diese Interpretationsprozesse hinterlassen einen Überschuss, der sich nicht einschreiben und übersetzen lässt. Und wenn die

3 Latour, Bruno: *Eine neue Soziologie für eine neue Gesellschaft. Einführung in die Akteur-Netzwerk-Theorie*, Frankfurt/M. 2007, 258.

4 Hesse: *Das Glasperlenspiel* (wie Anm. 1).

5 Latour, Bruno: "When Things Strike Back: A Possible Solution of ,Science Studies' to the Social Sciences", in: *The British Journal of Sociology* 51,1 (2000), 107–123, hier 116.

6 Weibel, Peter/Latour, Bruno: "Experimenting With Representation: *Iconoclash* and *Making Things Public*", in: McDonald, Sharon/Basu, Paul (Hg.): *Exhibition Experiments*, Oxford 2007, 106.

7 Vgl. ebd.

8 Latour, Bruno: *The Pasteurization of France*, Cambridge 1998, 193.

9 DeLanda, Manuel: *Intensive Science and Virtual Philosophy*, London 2013.

10 Vgl. Hodder, Ian: *Studies in Human-Thing Entanglement*, Chichester 2016.

11 Vgl. ebd., 5.

12 Vgl. ebd., 18.

13 Vgl. ebd.

14 Vgl. Geertz, Clifford: *The Interpretation of Cultures. Selected Essays*, New York 1973.

15 Vgl. Hodder, Ian: *The Archaeological Process. An Introduction*, Oxford 1999, 68–69.

16 Thomas, Julian: *Time, Culture and Identity* (London 1996), 236.

17 Hodder: *The Archaeological Process* (wie Anm. 15), 92.

18 Vgl. Rosaldo, Renato: *Culture and Truth: The Remaking of Social Analysis*, Boston 2000.

19 Vgl. ebd., 8.

Premises of a History of Exhibiting

Maria Bremer

Differenz immer bestehen bleibt,[20] wie lässt sich dieser Überschuss in der Ausstellung erfassen? Wann setzt der interpretierende Moment ein und auf welche Weise kann er ausgestellt werden?

Archivieren, Bearbeiten, Aufzeichnen, Schreiben, Zeichnen, Malen, Schneiden, E-Mailen und alle Arbeiten, die mit dem Ausstellungsprozess vor der Ausstellung zu tun haben, haben zum Ziel, die Bedeutung des einen über das andere zu stellen, andere Dinge herunterzuspielen oder zu unterdrücken, die uns nicht interessieren. Der Überschuss an Bedeutungen und Dingen, die im Prozess des Ausstellens geschaffen werden, zeigt nur die Notwendigkeit der permanenten Auseinandersetzung mit der Frage der Interpretation. Latour hat das Laboratorium und den Einschreibungsprozess[21] und das Instrument selbst gründlich hermeneutisiert, und das Instrument selbst ist bereits ein hermeneutisches Mittel: „Was steht hinter einem wissenschaftlichen Text? Einschreibungen. Wie kommen diese Einschreibungen zustande? Durch die Einrichtung von Instrumenten. Diese andere Welt gleich unter dem Text ist unsichtbar, solange es keine Kontroversen gibt. Ein Bild von Mondtälern und -bergen wird uns so präsentiert, als ob wir sie direkt sehen könnten. Das Teleskop, das sie sichtbar macht, ist unsichtbar, ebenso wie die heftigen Kontroversen, die Galileo vor Jahrhunderten führen musste, um ein Bild des Mondes zu erzeugen."[22] Indem wir das Instrument sichtbar machen oder in den Vordergrund stellen, würden wir uns neben die weggelassenen Dinge stellen. Und wenn sich Interpretation an der „Kellenkante" vollzieht,[23] bedeutet dies, dass sie bereits mit dem Prozess des Ausstellens beginnt und sich auf jedem Schritt des Weges ereignet. Wie lassen sich die Farben all der ausgelassenen Dinge hervorheben und zeigen? Oder anders ausgedrückt: Beim Ausstellen geht es nicht nur um das Dimensionieren und Zoomen der Rahmen (Kontexte). Weil Rahmen (Kontexte) Latours Argumentation folgend mögliche Verbindungen Einschränkungen auferlegen, könnte das Ausstellen beginnen, den Prozess des Verschiebens von Rahmen (Kontexten) und der in diesem Prozess beobachteten Bewegungen, Flüsse und Veränderungen zu untersuchen.[24] Nun können wir also anfangen, Ausstellen als Ding zu betrachten (via Latour), als Ding im Konflikt anstatt im Stillstand, als Beziehung statt als Tatsache.[25] Wie lässt sich die Existenz aller Dinge demonstrieren, die mit der Assemblage des Ausstellens zu tun haben? Und wie lassen sie sich ausstellen, nachdem dies erwiesen ist? Lässt sich mit der Politik des Ausstellens an der Kellenkante eine Plattform für einen demokratischeren und integrativeren Ausstellungsraum schaffen, in dem es den Menschen freisteht, aus den Dingen ihre eigenen Assemblagen zu schaffen, und wo jeder sein eigener Kurator ist? ▪

Übersetzung: Otmar Lichtenwörther

20 Vgl. Gadamer, Hans-Georg: *Wahrheit und Methode* (Tübingen, 1960) und Chiurazzi, Gaetano: „The Universality without Domain. The Ontology of Hermeneutical Practice", in: *The Journal of the British Society for Phenomenology* 48,3 (2017), 198–208.

21 Latours Einschreibung ist das Ergebnis einer Reihe von Transformationen/Übersetzungen und Latour definiert Übersetzung als „die von den Faktenschaffern gegebene Interpretation ihrer eigenen Interessen und jene der Menschen, die sie einstellen". Latour: *Science in Action* (Harvard, 1988), 108.

22 Latour: *Science in Action* (wie Anm. 21), 69.

23 Vgl. Hodder: *The Archaeological Process* (wie Anm. 15), 92.

24 Latour, Bruno: *Eine neue Soziologie für eine neue Gesellschaft. Einführung in die Akteur-Netzwerk-Theorie*, Frankfurt/M. 2007, 242.

25 Latour, Bruno: „Why Has Critique Run Out of Steam? From Matters of Fact to Matters of Concern", in: *Critical Inquiry* 30 (2004), 225–248.

The suggestion of the editors of this magazine to shift the focus from the results and authors of exhibitions and their symbolic and economic marketability to the political potentialities of the process takes up discussions about a post-representative understanding of curation. Since the 1990s, artists, curators, architects, designers, and scenographers—motivated by issues ranging from institutional and representational critique to activism—have been reflecting on the modalities and consequences of their contributions to the exhibition format in the wake of "new institutionalism" and "new museology." Since exhibitions bring together production, distribution, and consumption, they significantly inform the fostering and shifting of meaning in the art field. The application of a post-representative position means allowing the instances of mediation involved in the exhibition to emerge. Object-based statements and the concomitant truth claims are meant to fall into the background; and, in lieu of representative objectives, the relational potential of the exhibition is explored instead. The exhibition thus takes on a new motivation through the mode of action rather than just the mode of display.

Under these conditions, formats that are discursive, performative, and that decidedly intervene in the present are currently finding favor. What is more, curatorial studies informed by the cultural and social sciences along with curatorial research in the German-speaking countries are advancing critical reflection about the act of exhibiting and the exhibitions themselves. So practitioners and theorists alike are addressing the issue of which possibilities appear on the horizon *after* the exhibition or which path lends itself to further thought on the social dimension of exhibiting while maintaining a certain distance to the conventional exhibition format.[1]

With the post-representative argument and the related thought collectives rising to this challenge, what they are challenging, too, is the art history of the present, and this in a way that has to date enjoyed too little consideration. Evident in art-historical research alongside the rise of curatorial studies is, in fact, an intensified broadening of interest in exhibition history. Exhibitions are increasingly being analyzed and reconstructed in terms of related sources, yet the studies usually reflect a linear history of art movements and tendencies and thus delineate canons of exhibition history accordingly. Here, a modernistic innovation principle remains implicit, which, considering the current state of art-historical research, inevitably appears problematic. Exhibitions are focused and sequenced as individual events; the notion of exhibition is presupposed instead of historically surveyed and newly specified in each case.[2]

By contrast, the current reflexive tendencies in the expository realm quite obviously illustrate that not only the exhibition but also the actual act of exhibiting is subject to transformations and therefore must be considered in its historical dimension as well. It thus seems pertinent to more firmly place the *history of exhibited art* into relation with a *history of exhibiting*—not only because, at least since the 1960s, artistic practices have been increasingly devoted to modes of publication, but also because a history of exhibiting could integrate those formats whose contours do not coincide with the traditional conventions of art exhibitions in Western countries. Furthermore, such an approach would do better justice to action-oriented formats and their potential to not just render, pass down, or transform history—but to *engender* history via a present made tangible. ▪

Translation: Dawn Michelle d'Atri

1 See for instance Nora Sternfeld and Luisa Ziaja, "What Comes After the Show? On Post-Representational Curating," in *Dilemmas of Curatorial Practices, World of Art Anthology*, ed. Barbara Borčić and Saša Nabergoj (Ljubljana, 2012), pp. 62–64; Beatrice von Bismarck et al., eds., *Cultures of the Curatorial* (Berlin, 2012); Jean-Paul Martinon, ed., *The Curatorial: A Philosophy of Curating* (London et al., 2013); Kai-Uwe Hemken, ed., *Kritische Szenografie: Die Kunstausstellung im 21. Jahrhundert* (Bielefeld, 2015).

2 See Felix Vogel, "On the Canon of Exhibition History," in *Re-envisioning the Contemporary Art Canon: Perspectives in a Global World*, ed. Ruth E. Iskin (London and New York, 2017), pp. 189–202.

Prämissen einer Geschichte des Ausstellens

Maria Bremer

Der Vorschlag der Herausgeberinnen dieses Hefts, den Fokus vom Ergebnis und Autor des Ausstellens und ihrer symbolischen und ökonomischen Vermarktbarkeit auf die politischen Potenzialitäten des Prozesses zu verlegen, greift die Diskussionen um ein postrepräsentatives Verständnis von Kuration auf. Seit den 1990er Jahren reflektieren institutions- und repräsentationskritisch bis aktivistisch motivierte KünstlerInnen, KuratorInnen, ArchitektInnen, DesignerInnen, und SzenografInnen im Zuge eines *New Institutionalism* und einer *New Museology* über die Modalitäten und Konsequenzen ihres Mitwirkens im Format der Ausstellung. Da Ausstellungen Produktion, Distribution und Konsumption zusammenführen, tragen sie maßgeblich zu Stiftung und Wandel von Bedeutungen im Kunstfeld bei. Der Einsatz einer postrepräsentativen Position besteht darin, die in die Ausstellung involvierten Vermittlungsinstanzen in Erscheinung treten zu lassen. Objektbasierte Aussagen und die damit einhergehenden Wahrheitsansprüche sollen in den Hintergrund treten und anstatt repräsentativer Zielsetzungen das relationale Potenzial der Ausstellung ausgelotet werden. Somit wird die Ausstellung im Modus des Handelns und nicht mehr nur im Modus des Zeigens neu begründet.

Unter diesen Voraussetzungen verbreiten sich derzeit diskursive, performative sowie dezidiert in die Gegenwart eingreifende Formate. Zudem treiben die kultur- und sozialwissenschaftlich informierten *Curatorial Studies* und die kuratorische Forschung im deutschsprachigen Raum eine kritische Reflexion über das Ausstellen und die Ausstellung voran. Praktizierende und TheoretikerInnen wenden sich also gleichermaßen der Frage zu, welche Möglichkeiten sich *nach* der Ausstellung am Horizont abzeichnen bzw. auf welchem Wege sich die soziale Dimension des Ausstellens in einer gewissen Distanz zum konventionellen Format der Ausstellung weiter denken lässt.[1]

Indem sich das postrepräsentative Argument und die entsprechenden Denkkollektive dieser Herausforderung stellen, fordern sie zugleich auch die Kunstgeschichte der Gegenwart heraus, und dies auf eine bislang unzureichend berücksichtigte Weise. Zwar lässt sich in der Kunstgeschichte zeitgleich zum Emporkommen der *Curatorial Studies* eine intensivierte Interessenserweiterung in Richtung Ausstellungsgeschichte verzeichnen. Ausstellungen werden zunehmend in den Blick genommen und quellenkundlich rekonstruiert, jedoch spiegeln die Studien meistens eine lineare Geschichte von Kunstbewegungen und -tendenzen und bilden entsprechende Kanons der Ausstellungsgeschichte aus. Hierbei bleibt implizit ein modernistisches Innovationsprinzip tragend, das angesichts des aktuellen Stands kunsthistorischer For-

schung problematisch erscheinen muss. Ausstellungen werden als Einzelereignisse fokussiert und aneinandergereiht; der Ausstellungsbegriff wird vorausgesetzt anstatt historisch befragt und jeweils neu spezifiziert zu werden.[2]

Dagegen verdeutlichen die aktuellen reflexiven Tendenzen im Bereich des Expositorischen auf augenscheinliche Weise, dass nicht nur die Ausstellung, sondern auch das Ausstellen Transformationen unterworfen ist und daher in seiner historischen Dimension berücksichtigt werden müsste. So scheint es sinnvoll, die *Geschichte der ausgestellten Kunst* dezidierter in Verhältnis zu einer *Geschichte des Ausstellens* zu setzen. Nicht nur, weil sich künstlerische Praktiken spätestens seit den 1960er Jahren verstärkt den Modi der Veröffentlichung widmen, sondern auch weil eine Geschichte des Ausstellens jene Formate einbeziehen könnte, deren Konturen mit den tradierten Konventionen westlicher Kunstausstellungen nicht übereinstimmen. Darüber hinaus würde ein solcher Ansatz handlungsorientierten Formaten und ihrem Potenzial eher gerecht werden, Geschichte *qua* spürbar gemachter Gegenwart zu *erzeugen* – nicht nur abzubilden, zu tradieren oder zu transformieren. ∎

1 Vgl. etwa Sternfeld, Nora/Ziaja, Luisa: „What Comes After the Show? On Post-Representational Curating", in: Borčić, Barbara/Saša Nabergoj, Saša (Hg.): *Dilemmas of Curatorial Practices, World of Art Anthology*, Ljubljana 2012, 62–64; von Bismarck, Beatrice u.a. (Hg.): *Cultures of the Curatorial*, Berlin 2012; Martinon, Jean-Paul (Hg.): *The Curatorial. A Philosophy of Curating*, London u.a. 2013; Hemken, Kai-Uwe (Hg.): *Kritische Szenografie. Die Kunstausstellung im 21. Jahrhundert*, Bielefeld 2015.

2 Vgl. Vogel, Felix: „On the Canon of Exhibition History", in: Iskin, Ruth E. (Hg.): *Re-envisioning the Contemporary Art Canon. Perspectives in a Global World*, London/New York 2017, 189–202.

Mirror, Mirror

Ana Miljački

"OfficeUS" curated by | kuratiert von Eva Franch i Gilabert/Ana Miljački/Aschley Schafer, The US Pavilion at the 14th Venice Architecture Biennale | Der US-amerikanische Pavillon auf der 14. Architekturbiennale, 2014 © Ana Miljački

In 1979, rejecting the typical expectation of the curator to advocate for, validate, or appraise the work on display, MOMA's then chief architecture curator, Arthur Drexler opted to cast light on the realities of contemporary architectural production through the distancing tactics of multiplication, repetition, and leveling.[1] As he would later defend his photographic exhibition which included images of 406 international projects produced in the previous two decades—against criticism mounted most vehemently by participating architects and their friends—in this instance he explicitly declined to act as a missionary. "The first is that father or mother will tell you what to do: the missionary role."[2] He refused to provide authoritative guidance of that kind. Instead, in his exhibition "Transformations in Modern Architecture" he opted for presenting an index of contemporary architectural production, "in many ways an analog of the real world."[3] He described the desired cognitive and aesthetic response to "Transformations" as "bewildering, profuse, overloaded, contradictory."[4] He had various motivations for this, including a critique of late modernist architecture and a subsequent "missionary" celebration of postmodernism. But his adamant, albeit momentary, refusal to use his cultural position in order to act through validation is important to hold onto. For, a curatorial mirror, enchanted to tell the truth—not only to fairytale witches, but also to an audience lulled to self-satisfaction by easy thumbs up consensus—is invaluable in our current political and cultural condition.

Whatever else it was, Drexler's posture of non-mediation—the idea that one could produce an exhibit that is "an analogue of the world"—was also an invitation to its visitors to consider their own role within that world. It is important to extract

from "Transformations," beyond it, the possibility that placing a little bit of the world on view, unmediated, though recontextualized by the mere act of being plucked out of the flows of daily life and placed "as-found" within the framework of a gallery, might be able to preserve historical dimensionality of entanglements in that sample of the world. So that those entanglements too may be contemplated: Who built that? What got erased in the process? Who benefits most from it? Who gets to legislate its value? How have we come to understand it? And again: What got erased in the process?

It seems today that our future depends on our ability to understand our compromised, problematic, entangled contemporaneity, in opposition to the sanitized, "polite architectural modernity" that we have inherited and have had our share of celebrating. Unaccompanied by the friendly "like," "heart" or "follow" function now common for all of our presentations of self, contemplating our role in contemporary developments will likely provoke bewilderment and confusion and sometimes guilt as well. We should welcome those responses, for only mirrors that don't adjust to our own narcissistic projections of ourselves will encourage an adequate retooling of our individual and disciplinary self-awareness and action. ∎

1 Arthur Drexler in an interview with Andrew MacNair, "Response: Arthur Drexler on 'Transformations,'" *Skyline* (1979), p. 6.

2 Ibid.

3 Ibid.

4 Ibid.

5 Ananya Roy, "The Infrastructure of Assent: Professions in the Age of Trumpism," *The Avery Review* 21 (2017), p. 11.

Spiegel, Spiegel
Ana Miljački

The Exhibition as Relational Structure
Barbara Steiner

Arthur Drexler sprach sich 1979 in seiner damaligen Funktion als Chefkurator für Architektur des MOMA dafür aus, die Gegebenheiten der zeitgenössischen Architekturproduktion zu beleuchten und dafür Disanzierungsstrategien wie Multiplikation, Wiederholung und Angleichung[1] heranzuiehen, und wies damit das, was man typicherweise von Kuratoren erwartet, d.h. die usgestellten Arbeiten zu verteidigen, zu betätigen und zu beurteilen, zurück. Auch ls er zu einem späteren Zeitpunkt seine otoausstellung bestehend aus 406 interationalen Projekten, die in den zwei daorliegenden Dekaden umgesetzt worden varen, gegenüber der von teilnehmenden rchitekten und deren Freunden äußerst ehement vorgebrachten Kritik verteidige, wollte er sich ausdrücklich nicht als Missionar verstanden wissen. Diese Rolle omme dem Vater oder der Mutter zu, die inem sagen, was man zu tun habe.[2] Diee Art autoritativer Führung lehnte er ab. ielmehr präsentierte er in seiner Ausstelung „Transformations in Modern Archiecture" einen Index der zeitgenössischen rchitekturproduktion, der in vielerlei Hinicht der realen Welt entspreche.[3] Die gevünschte kognitive und ästhetische Rektion auf „Transformations" beschrieb er ls „verwirrend, unmäßig, überladen, wiersprüchlich".[4] Unter den zahlreichen Movationen hierfür findet sich die Kritik an er modernen Architektur und am daraufolgenden „missionarischen" Zelebrieren er Postmoderne. Es ist jedoch wesentch, seine – wenn auch nur momentane – Veigerung, seine kulturelle Position zu Bevertungen zu nützen, weiterzuverfolgen. enn ein verzauberter Kuratorenspiegel, er – nicht nur Hexen, sondern auch einem urch eine allgemein vorherrschende Dauen-hoch-Stimmung in Selbstzufriedenheit ingelullten Publikum – die Wahrheit sagen oll, ist angesichts unserer derzeitigen potischen und kulturellen Lage unbrauchbar.

Wie auch immer Drexlers Haltung des ichtvermittelns zu verstehen war – die Idee, n Ausstellungsstück zu produzieren, das eine Nachbildung der Welt" darstellt, war denfalls eine Einladung an die Besuchennen und Besucher, ihre eigene Rolle in er Welt zu hinterfragen. Was darüber hiaus aus den „Transformations" mitgenomen werden sollte: Die Option, ein kleines tück der Welt zwar ohne Vermittlung, aber neuem Kontext – wird es doch aus dem ltäglichen Leben herausgenommen und vie gefunden" in eine Galerie platziert – zur chau zu stellen, ermöglicht es vielleicht, e historische Dimension der Verflechtunen an diesem Muster der Welt zu konsereren und sich somit auch Gedanken über ese Verflechtungen machen zu können: Ver hat das gebaut? Was ist in diesem Proess gestrichen worden? Wer profitiert daon? Wer bestimmt den Wert? Wie haben

wir es geschafft, das zu verstehen? Und wiederum: Was ist in diesem Prozess gestrichen worden?

Unsere Zukunft scheint heute von unserer Fähigkeit abzuhängen, unser gefährdetes, problematisches und verwobenes Heute zu verstehen, im Gegensatz zur sterilen, artigen architektonischen Moderne, die uns hinterlassen wurde und die wir durchaus auch zelebriert haben.[5] Eine eingehende Betrachtung unserer eigenen Rolle in den derzeitigen Entwicklungen wird ohne die freundlichen, allgegenwärtigen „Like"-, „Herz"- und „Follow"-Funktionen, derer wir uns für unsere Selbstpräsentationen gerne bedienen, vermutlich Verwirrung und Bestürzung, gelegentlich sogar Schuldgefühle hervorrufen. Wir sollten diese Reaktionen dankbar annehmen, denn nur Spiegel, die sich nicht unseren eigenen narzisstischen Vorstellungen unseres Selbst anpassen, werden dazu anregen können, unsere individuellen und fachspezifischen Selbstwahrnehmungen und Handlungen entsprechend zu überdenken. ∎

Übersetzung: Michaela Alex-Eibensteiner

1 Vgl. Arthur Drexler in einem Interview mit Andrew MacNair: „Response: Arthur Drexler on ‚Transformations'", *Skyline* (1979), 6.

2 Vgl. ebd.

3 Vgl. ebd.

4 Ebd.

5 Vgl. Roy, Ananya: „The Infrastructure of Assent: Professions in the Age of Trumpism", in: *The Avery Review* 21 (2017), 11.

Parallel and in connection with *Up into the Unknown*, an exhibition dedicated to the Kunsthaus and its unique genesis, the Kunsthaus is also presenting the show *Graz Architektur: Rationalisten, Ästheten, Magengrubenarchitekten, Demokraten und Mediakraten* (Graz Architecture: Rationalists, Aesthetes, Gut Instinct Architects, Democrats, Mediacrats).[1] Featured here are works from seven Graz-based architects born in the 1930s and 1940s belonging to the generation of Peter Cook and Colin Fournier. A considerable number of professional and private ties among the British and Austrian architects becomes evident due to the close connections between the two exhibitions.

Graz Architektur introduces a broad spectrum of different approaches, which are tangential in certain places, yet very far apart in others. In the exhibition, "nodes" are formed that suggest links between the different considerations and projects. Instead of limiting itself to works from the 1960s and 1970s, *Graz Architektur* sheds light on the development and transformation of ideas over the course of time into the present day and of contexts back then in comparison to today.

Both exhibitions show numerous projects and works from the field of architecture, yet the approach taken to viewing architecture—situating a relational structure at the heart of the exhibitions and conveying this through exhibits, statements by involved persons, and constellations of work—is owed to experience with the visual arts and contemporary curating. The continuous change in perspective—speaking not from a single perspective, but rather allowing divergent points of view about the building of the Kunsthaus or about *Graz Architektur*—is related to current discourses on exhibiting.

Space, display, exhibits, and text are interrelated accordingly. The first spatial impression invites the viewers to embark on a journey of discovery. In *Graz Architektur* only seven positions are shown in total, yet forty-eight projects—so as to cultivate an impression of the richness and diversity of the activity, both past and present, of the protagonists. This makes room for in-depth exploration and for moving through the exhibition along singular objects—almost randomly, as it were.

The starting point for the display system used for *Graz Architektur* is an orthogonal grid, originally developed by the architects Cook and Fournier, with suspension points on the ceiling of the exhibition room. All key elements are made of horizontal and vertical full-surface modules in aluminum or perforated sheeting and hover in space. These elements function as spatial and visual partitioning and also as connectors between the positions. Colored acrylic glass facilitates orientation within the space and

is used in connection with biographical data and information about the objects.

The text plane is autonomous *and* set in relation to the objects, in equal measure. Taken together with the exhibits, the text offers contextual information that, in a figurative sense, can be taken in or passed over. What is more, the texts may be employed as elements structuring space visually and spatially. The self-interpretation of the protagonists becomes adjacent to the curatorially and art-institutionally fostered perception, the view of the exhibition designers Rainer Stadlbauer and Anna Lena von Helldorff adjacent to that of the invited visual artists. Anna Meyer, Arthur Zalewski, Julia Gaisbacher, and Oliver Hangl were commissioned to explore the exhibited architectural positions from a present-day perspective and from the perspective of the visual arts. Their role can best be described with that of commentators.

Both exhibitions are essentially the spatial and material expression of a relational structure: both between Peter Cook / Colin Fournier and those individuals involved in building the Kunsthaus as well as between Peter Cook / Colin Fournier and the protagonists of *Graz Architektur*, and, not least, among the Graz-based architects themselves. This relational structure is continued in the exhibition design: forms of showing and mediating were developed in a collaborative working process. Various types of expertise interacted—including that of architects, designers, graphic designers, curators—with the respective roles and related ascriptions being mutually transformed over the course of the working process. ∎

Translation: Dawn Michelle d'Atri

1 The title of the show originates from the book *Architektur-Investitionen: "Grazer Schule," 13 Standpunkte* (Graz, 1984).

Die Ausstellung als Beziehungsgefüge

Barbara Steiner

The Garden as Thing and Reference

Christian Inderbitzin | Katharina Sommer

Parallel und in Verbindung zu „Up into the Unknown", einer Ausstellung, die dem Kunsthaus und seiner ungewöhnlichen Entstehungsgeschichte gewidmet ist, zeigt das Kunsthaus „Graz Architektur. Rationalisten, Ästheten, Magengrubenarchitekten, Demokraten und Mediakraten"[1], Werke von sieben in den 1930er und 1940er Jahren geborenen, in Graz ansässigen Architekten, die der Generation von Peter Cook und Colin Fournier angehören. Zwischen den britischen und den österreichischen Architekten findet man eine beachtliche Anzahl an beruflichen und privaten Verbindungen, die durch die enge Verzahnung der beiden Ausstellungen besonders deutlich werden.

Vorgestellt wird eine große Bandbreite an unterschiedlichen Herangehensweisen, die sich an gewissen Stellen berühren, an anderen jedoch sehr weit auseinanderliegen. In der Ausstellung werden „Knoten" gebildet, die Verknüpfungen zwischen den Überlegungen und Projekten vorschlagen. „Graz Architektur" beschränkt sich nicht auf Arbeiten der 1960er und 1970er Jahre, sondern beleuchtet vielmehr die Entwicklung und Verwandlung von Ideen im Laufe der Zeit bis heute und von Kontexten damals im Vergleich zur Gegenwart.

Die Ausstellungen zeigen mehrheitlich Projekte und Werke aus dem Bereich der Architektur, doch die Art und Weise auf Architektur zu schauen – ein Beziehungsgefüge in den Mittelpunkt der Ausstellungen zu stellen und dieses durch Exponate, Aussagen der Beteiligten und Werkkonstellationen zu vermitteln – verdankt sich Erfahrungen mit der bildenden Kunst und zeitgenössischem Kuratieren. Der ununterbrochene Perspektivenwechsel – nicht aus einer Perspektive zu sprechen, sondern sehr unterschiedliche, auch widersprüchliche Sichtweisen auf den Bau des Kunsthauses oder die „Graz Architektur" zuzulassen – hat mit aktuellen Diskursen ums Ausstellen zu tun.

Raum, Display, Exponate und Text sind entsprechend aufeinander bezogen. Der erste Raumeindruck soll dazu motivieren, sich auf eine Entdeckungsreise zu begeben. In „Graz Architektur" werden insgesamt nur sieben Positionen, aber 48 Projekte gezeigt – um einen Eindruck von der Reichhaltigkeit und Vielfalt der vergangenen, aber auch gegenwärtigen Tätigkeit der Protagonisten zu bekommen. Eine Vertiefung ist genauso möglich wie sich entlang einzelner Objekte – gleichsam stichprobenartig – durch die Ausstellung zu bewegen.

Ausgangsbasis für das Displaysystem ist ein von den Architekten Cook und Fournier vorgesehenes, orthogonales Raster aus Hängepunkten an der Decke des Ausstellungsraumes. Alle wesentlichen Elemente bestehen aus horizontalen und vertikalen, vollflächigem Aluminium- oder Lochblech-Modulen, die frei im Raum schweben. Diese fungieren dabei als räumliche und visuelle

Trennung wie auch Verbindung zwischen den Positionen. Farbiges Acrylglas dient der Orientierung im Raum und wird in Zusammenhang mit biografischen Angaben und Objektinformation eingesetzt.

Die Textebene ist eigenständig *und* in Beziehung zu den Objekten gleichermaßen angelegt. Mit den Exponaten zusammengelesen hält der Text kontextuelle Informationen bereit, die im übertragenen Sinn ein- oder ausgeblendet werden können. Die Texte werden darüber hinaus als visuell und räumlich strukturierendes Element eingesetzt. Die Selbstinterpretation der Protagonisten rückt neben die kuratorisch und kunstinstitutionell begründete Wahrnehmung, der Blick der Ausstellungsgestalter Rainer Stadlbauer und Anna Lena von Helldorff neben jenen der eingeladenen bildenden Künstlerinnen und Künstlern. Deren Rolle kann man am ehesten mit Kommentierenden vergleichen. Anna Meyer, Arthur Zalewski, Julia Gaisbacher und Oliver Hangl wurden beauftragt, sich aus heutiger Perspektive und aus Perspektive der bildenden Kunst mit den ausgestellten architektonischen Positionen zu befassen.

Beide Ausstellungen sind wesentlich räumlicher und materieller Ausdruck eines Beziehungsgefüges: sowohl zwischen Peter Cook/Colin Fournier und den am Bau des Kunsthaus Beteiligten als auch zwischen Peter Cook/Colin Fournier und den Protagonisten der „Graz Architektur" und nicht zuletzt zwischen den Grazer Architekten selbst. Das Beziehungsgefüge setzt sich in der Ausstellungsgestaltung fort: Formen des Zeigens und Vermittelns wurden in einem gemeinsamen Arbeitsprozess erarbeitet. Verschiedene Expertisen – von ArchitektInnen/DesignerInnen/GrafikerInnen/KuratorInnen wirkten zusammen; wobei sich die jeweiligen Rollen- und Rollenzuschreibungen im Verlaufe des Arbeitsprozesses wechselseitig transformieren. ∎

1 Der Titel der Schau stammt aus dem Buch *Architektur-Investitionen. „Grazer Schule" 13 Standpunkte*, Forum Stadtpark, Graz 1984.

Exhibition | Ausstellung „Garten", Architektur Galerie Berlin, 2016 © Jan Bitter

How may architecture be exhibited? This question is not new but has arisen since the first architecture exhibitions.[1] The Berlin gallerist Ulrich Müller advocates the stance that architecture itself cannot be exhibited, only certain aspects of architecture, for instance its process of formation. At the Architektur Galerie Berlin, he therefore invites contemporary architecture firms to mediate their work through an exploration of the exhibition space and to find their own unique language in doing so. This past year, Edelaar Mosayebi Inderbitzin Architekten were invited to tackle this challenge. We took the invitation as an occasion to conceptualize a new, stand-alone project for this gallery space that focuses not on architecture itself, but on a specific viewpoint that is relevant to many of our designs, namely, our interest in gardens.[2] The creation of this project and the radical transformation of the gallery space spotlights a potential approach to thematically investigating architecture above and beyond the traditional forms taken by an exhibition.

An exhibition is meant to mediate and to establish connections. Its quality is related to the authenticity of the exhibits and thus to the immediacy fostered between them and the recipient. So the point is to facilitate a direct encounter with the original material, access to which we are usually otherwise denied. Exhibiting and mediating architecture plays a special role in this context. It is not possible to exhibit architecture in its original state, and the act of making it accessible is likewise not applicable in this form, for architecture, once built, is visible and does not require presentation in the framework of an exhibition in order

to make it experienceable. There is, however, the opportunity to reproduce smaller structures or parts of buildings. An example of this is Le Corbusier's Cabanon, which he first built in 1952 as a holiday home in Roquebrune-Cap-Martin. The Italian furniture company Cassina then, in 2006, had a replica of this house made for the Triennale di Milano, which was shown there under the title "Le Corbusier's Cabanon 1952/2006. The interior 1:1" and later at various other exhibitions. Yet this was a replica that had been removed from its context and thus no longer had any claim to immediacy. By the same token, the representation of architecture in the form of plans, models, and pictures often appears, in our eyes, to be incomplete since such architects' tools serve only the purpose of mediation.

So neither its replicas nor its copies do justice to architecture in terms of complexity and spatial perceptibility, because they both lack the desired sense of immediacy. With these reflections as our point of departure, we felt that the only interesting form of presentation for our work would be installation. As a three-dimensional, usually site-specific presentation form, it enabled us to conceptualize the show in the gallery as a new, autonomous project that makes the space itself the subject of the exhibition.

It was for this reason that we subjected the gallery space to a radical change and transformed it into a living garden for the duration of the exhibition. This was a reference to a recurrent motif in our projects that plays an important role in our understanding of architecture: gardens fascinate us as ideational concepts, realms of imagination and built space, both in theoretical work and in built projects. In our designs, we are extremely interested in the relationship between architecture and gardens—and we view the term "garden" in a broad and emblematic way, so that it may also signify urban space. Ideally, architecture and garden meld into an inseparable entity and mutually define each other. We thus refrained from providing the exhibition visitors with a likeness of architecture. Instead, they were encouraged to explore the gallery space and—through this confrontation with the things themselves, the arrangement of the room, and the real garden—to think about relations between architecture and nature, house and garden, interior and exterior, clean and dirty. "What distinguishes this exhibition is the fact that it is not based on plans and photographs but on the things themselves. We are confronted with the actual subject matter in question,"[3] commented the Swiss architectural theorist Martin Steinmann. Fully in line with Umberto Eco's "open work," the installation was solidified as "history" through its reception.

The appeal of the project also lay in the deceptively real emulation of a growing garden

Der Garten als Ding und Verweis

Christian Inderbitzin | Katharina Sommer

en, which, like a real garden, changed over the course of the exhibition, growing, blossoming, withering, as well as in the play with illusion and reality. Its realization reminds of the devices like the panorama or the diorama. The latter engenders, by blurring the boundary between three-dimensional foreground and one-dimensional background, the illusion of a seamless transition.[4] The gallery space in Berlin was dissolved, as it were, through the realistically designed interior space—with its greenery, soil, gravel, water basin, its scents and sounds—in connection with exterior space taking the form of a wall picture photographed at the Seleger Moor park near Zurich. Inversion and alienation were framing the topos of the garden and presented its intrinsic value. Or as Martin Steinmann phrased it: "when we stand outside and look through the window we do not see a room but a garden, another outside, which is an additional level and an answer to what the exhibition is about. I think the exhibition emphasises the relationship by alienating it or, in the words of Russian formalism, de-automatizing it."[5]

The concept of alienation was first defined as an aesthetic category in 1916 by the Russian formalist Victor Shklovsky in his essay "Art as Technique." It is based on the theory that we only "acquire the status of recognition'"[6] yet without seeing what is familiar to us. The purpose of art as a alienation technique, therefore, is to break through this pattern.[7] By inverting the division into interior and exterior space so familiar to us, a dual sense of alienation arose in the exhibition at the Architektur Galerie: "We stand in a garden, but the garden has been planted in a room! … On one hand, it is a real garden and not a picture of one; on the other, it is unreal, so it is a picture after all and not a garden, a kind of *tableau vivant*."[8]

Also to be considered as alienation, in reference to Shklovsky's definition, is here the decision not to show any finished architecture or related renderings in the sense of something "made," but instead to focus on a specific interest underlying our architecture in the sense of "making" something. The exhibition thus features two levels: a mediating one and an immediate one. It conveys, in this exploration of the garden theme, a specific understanding of architecture to the exhibition visitors, yet it also facilitates an immediate experience of space and thus, accordingly, an architectural experience. As such, the exhibition stands alone, showing no replication of or reference to a certain project, but rather focusing on itself and on a thematic issue. Is in this immediate confrontation with the things themselves" that its value rests. ∎

Translation: Dawn Michelle d'Atri

1 With the founding of the Académie Royale d'Architecture in Paris in the year 1671, the first regular architectural exhibitions were shown, which starting in the eighteenth century were increasingly accessible to the public. On this, see Carsten Ruhl and Chris Dähne, eds., *Architektur ausstellen: Zur mobilen Anordnung des Immobilen* (Berlin, 2015), pp. 6–7.

2 The exhibition *Garten* was created in collaboration with the landscape architect Daniel Ganz and was shown from November 4 to December 17, 2016, at the Architektur Galerie Berlin.

3 Edelaar Mosayebi Inderbitzin Architekten, ed., *Garden* (Zurich, 2017), p. 41.

4 The diorama, a neologism from the Greek words *diá* (through) and *hórama* (sight), was originally a backlit, partly translucent painting shown in special settings (dioramas). The term was coined by Daguerre and Bouton, who in 1822 opened the first diorama in Paris. See Alexander Gall and Helmuth Trischler, eds., *Szenerien und Illusion: Geschichte, Varianten und Potenziale von Museumsdioramen* (Göttingen, 2016), pp. 27ff.

5 Edelaar Mosayebi Inderbitzin, *Garden*, p. 43 (see note 3).

6 See Viktor Shklovsky, "Art as Device," in *Theory of Prose*, trans. Benjamin Sher (Champaign, IL, and London, 1991), p. 6.

7 "The purpose of art is to impart the sensation of things as they are perceived and not as they are known. The technique of art is to make objects 'unfamiliar,' to make forms difficult, to increase the difficulty and length of perception because the process of perception is an aesthetic end in itself and must be prolonged. *Art is a way of experiencing the artfulness of an object; the object is not important.*" Victor Shklovsky, "Art as Technique," in *Russian Formalist Criticism: Four Essays*, trans. Lee T. Lemon and Marion J. Reis (Lincoln, NB, 1965), p. 12.

8 Edelaar Mosayebi Inderbitzin, Garden, p. 41 (see note 3).

Wie lässt sich Architektur ausstellen? Die Frage ist nicht neu, sondern existiert seit es Architekturausstellungen gibt.[1] Auch der Berliner Galerist Ulrich Müller vertritt die Haltung, Architektur selbst könne nicht ausgestellt werden, jedoch bestimmte Aspekte von ihr, wie zum Beispiel ihr Entstehungsprozess. In der Architektur Galerie Berlin lädt er daher zeitgenössische Architekturbüros ein, ihre Arbeit über die Auseinandersetzung mit dem Ausstellungsraum mittelbar zu machen und dafür eine jeweils eigene Sprache zu finden. Im letzten Jahr wurden Edelaar Mosayebi Inderbitzin Architekten angefragt, sich dieser Herausforderung zu stellen. Wir nahmen die Einladung zum Anlass um ein eigenständiges, neues Projekt für diesen Galerieraum zu konzipieren, das nicht Architektur selbst, sondern einen spezifischen, für viele unserer Entwürfe relevanten Blickpunkt in das Zentrum stellt, nämlich unser Interesse für Gärten.[2] Anhand der Entstehung dieses Projekts und der radikalen Transformation des Galerieraumes wird ein möglicher Ansatz aufgezeigt, wie Architektur jenseits tradierter Formen in einer Ausstellung thematisiert werden kann.

Eine Ausstellung soll vermitteln und neue Zusammenhänge herstellen. Ihre Qualität liegt dabei in der Authentizität des Ausstellungsgegenstandes und damit in der Unmittelbarkeit zwischen diesem und dem Rezipienten. Es geht also um eine direkte Begegnung mit Originalen, zu denen uns der Zugang für gewöhnlich verwehrt ist. Das Ausstellen und Vermitteln von Architektur nimmt in diesem Kontext eine besondere Rolle ein. Architektur im Original auszustellen ist nicht möglich und im Sinne des zugänglichen Machens auch nicht in dieser Form notwendig. Denn Architektur ist, einmal gebaut, sichtbar und bedarf nicht erst der Präsentation im Rahmen einer Ausstellung, um erfahrbar zu werden. Zwar besteht die Möglichkeit, kleinere Bauten oder Teile davon nachzubilden. Ein Beispiel wäre Le Corbusiers Cabanon, das er 1952 in Roquebrune-Cap-Martin als Ferienhaus gebaut hat. Der italienische Möbelhersteller Cassina ließ 2006 für die Triennale di Milano eine Kopie von diesem Haus erstellen, die unter dem Titel „Le Corbusier's Cabanon 1952/2006. The interior 1:1" gezeigt und anschließend in verschiedenen Ausstellungen zu sehen war. Es handelte sich dabei aber um ein Replikat, das seinem Kontext entnommen worden war und damit keine Unmittelbarkeit mehr besaß. Ebenso wirkt die Darstellung von Architektur in Form von Plänen, Modellen oder Bildern in unseren Augen vielfach unvollständig, da diese Werkzeuge des Architekten ausschließlich der Vermittlung dienen.

Weder ihre Repliken noch ihre Abbilder werden also der Architektur in ihrer Komplexität und räumlichen Erfahrbarkeit gerecht, da beide nicht über die gewünschte Unmittelbarkeit verfügen. Ausgehend von diesen Überlegungen erschien uns die einzig interessante Form zur Präsentation unserer Arbeit die der Installation. Als dreidimensionale, meist ortsgebundene Darstellungsform erlaubte sie es uns, die Präsentation in der Galerie als eigenständiges, neues Projekt zu denken, das den Raum selbst zum Gegenstand der Ausstellung macht.

Wir unterzogen den Galerieraum daher einer radikalen Veränderung und verwandelten ihn für die Dauer der Ausstellung in einen lebendigen Garten. Dieser verweist auf ein wiederkehrendes Motiv in unseren Projekten, das in unserer Architekturauffassung eine wichtige Rolle spielt: Gärten beschäftigen uns als ideelle Konzepte, Vorstellungskategorie und gebaute Räume, in theoretischen Arbeiten wie auch bei gebauten Projekten. In unseren Entwürfen interessiert uns das Verhältnis von Architektur und Garten in hohem Maß – wobei wir den Begriff „Garten" umfassend und sinnbildlich verstehen, sodass damit auch ein städtischer Raum gemeint sein kann. Idealerweise verklammern sich Architektur und Garten zu einer untrennbaren Einheit und bedingen sich gegenseitig. Den Besuchern der Ausstellung legten wir deshalb kein Abbild von Architektur vor, vielmehr waren sie eingeladen, den verwandelten Galerieraum zu erkunden und in dieser Konfrontation mit den Dingen selbst, dem gestalteten Raum und dem realen Garten, über das Verhältnis von Architektur und Natur, Haus und Garten, Innen und Außen, sauber und dreckig nachzudenken. „Das Besondere an der Ausstellung ist, dass wir nicht vor Plänen und Fotos von Dingen stehen, um die es geht. Wir sind mit den „Dingen selbst" konfrontiert,"[3] kommentierte der Schweizer Architekturtheoretiker Martin Steinmann. Ganz im Sinne Umberto Ecos „offenem Kunstwerk" wurde die Installation über Rezeption als „Geschichte" verfestigt.

Der Reiz des Projekts lag auch in der täuschend echten Nachahmung eines gewachsenen Gartens, der sich ähnlich einem realen Garten über die Dauer der Ausstellung veränderte, wuchs, blühte, verblühte, sowie im Spiel mit Illusion und Wirklichkeit. Die Umsetzung erinnert an Mittel des Panoramas bzw. Dioramas. Letzteres erzeugt

1 Mit Gründung der Académie Royale d'Architecture 1671 in Paris, wurden erstmals regelmäßig Architekturausstellungen gezeigt, die ab dem 18. Jh. zunehmend auch für die Öffentlichkeit zugänglich waren. Vgl. dazu Ruhl, Carsten/Dähne, Chris (Hg.): *Architektur ausstellen. Zur mobilen Anordnung des Immobilen*, Berlin 2015, 6f.

2 Die Ausstellung „Garten" entstand in Zusammenarbeit mit dem Landschaftsarchitekten Daniel Ganz und wurde vom 4. November bis 17. Dezember 2016 in der Architektur Galerie Berlin gezeigt.

3 Edelaar Mosayebi Inderbitzin Architekten (Hg.): *Garten*, Zürich 2017, 43.

durch das Verwischen der Grenze zwischen dreidimensionalem Vordergrund und eindimensionalem Hintergrund die Illusion eines nahtlosen Übergangs.[4] Der Galerieraum in Berlin wurde durch den realistisch gestalteten Innenraum – mit seiner Bepflanzung, der Erde, dem Kies, dem Wasserbecken, den Gerüchen und Geräuschen – in Verbindung mit dem fotografischen Außenraum in Form eines Wandbildes – aufgenommen im Seleger Moor bei Zürich – gleichsam aufgelöst. Die Umkehrung und Verfremdung rahmte den Topos des Gartens und präsentierte seinen eigenen Wert. Oder wie Martin Steinmann es formulierte: „Wir schauen von außen durch die Fenster nicht in ein Zimmer, sondern in einen Garten, in ein anderes Außen. Das ist die andere Ebene und eine Antwort auf die Frage, was die Ausstellung soll. Ich denke, sie handelt von dieser Beziehung, indem sie diese verfremdet, mit dem Wort des russischen Formalismus: desautomatisiert."[5]

Der Begriff der Verfremdung wurde erstmals 1916 vom russischen Formalisten Viktor Šklovskij in seinem Aufsatz „Kunst als Verfahren" als ästhetische Kategorie definiert und beruht auf der These, dass wir uns Bekanntes nur noch „wiedererkennend wahrnehmen,"[6] nicht jedoch sehen. Aufgabe der Kunst ist es daher, als Verfahren der Verfremdung dieses Muster zu durchbrechen.[7] Durch die Umkehrung der für uns gewohnten Unterteilung in Innen- und Außenraum entstand in der Ausstellung in der Architektur Galerie eine zweifache Verfremdung: „Wir stehen in einem Garten, der Garten aber ist in einem Raum angelegt! […] zum einen ist er real, er ist ein Garten, nicht das Bild davon, zum anderen ist er irreal, also doch Bild und nicht Garten, eine Art *tableau vivant*."[8]

Bezugnehmend auf Šklovskijs Definition kann auch die Entscheidung als Verfremdung gesehen werden, im Sinne von etwas „Gemachtem" keine fertige Architektur bzw. Abbilder von dieser zu zeigen, sondern im Sinne des „Machens" ein spezifisches Interesse in das Zentrum zu rücken, das unserer Architektur zugrunde liegt. Die Ausstellung besitzt somit zwei Ebenen: eine vermittelnde und eine unmittelbare. Zum einen vermittelt sie den Besuchern in der Auseinandersetzung mit der Thematik des Gartens ein spezifisches Verständnis von Architektur. Zum anderen ermöglicht sie eine unmittelbare Raumerfahrung und demzufolge ein architektonisches Erlebnis. Sie steht damit für sich, zeigt keine Nachbildung oder verweist auf ein bestimmtes Projekt, sondern auf sich selbst und auf ein thematisches Interesse. In dieser unmittelbaren Konfrontation mit den „Dingen selbst" liegt ihr Wert. ∎

4 Das Diorama, ein Neologismus aus den griechischen Wörtern *diá* (durch) und *hórama* (Anblick), also „Durchschaubild", war ursprünglich ein hinterleuchtetes halbtransparentes Bild, das in speziellen Räumen (Dioramen) gezeigt wurde. Geprägt wurde der Begriff von Daguerre und Bouton, die 1822 das erste Diorama in Paris eröffneten. Vgl. Gall, Alexander/Trischler, Helmuth (Hg.): *Szenerien und Illusion. Geschichte, Varianten und Potenziale von Museumsdioramen*, Göttingen 2016, 27 ff.

5 Edelaar Mosayebi Inderbitzin: *Garten*, 45 (wie Anm. 3).

6 Vgl. Šklovskij, Viktor: „Kunst als Kunstgriff", in: ders.: *Theorie der Prosa*, Hg. und Übers. aus dem Russischen von Gisela Drohla, Frankfurt/M. 1966, 15.

7 „Ziel der Kunst ist es, ein Empfinden des Gegenstands zu vermitteln, als Sehen, und nicht als Wiedererkennen; das Verfahren der Kunst ist das Verfahren der ‚Verfremdung' der Dinge und das Verfahren der erschwerten Form, ein Verfahren, das die Schwierigkeit und Länge der Wahrnehmung steigert, denn der Wahrnehmungsprozess ist in der Kunst Selbstzweck und muss verlängert werden; die Kunst ist ein Mittel, das Machen einer Sache zu erleben; das Gemachte hingegen ist der Kunst unwichtig.", Šklovskij, Viktor: „Die Kunst als Verfahren", in: Striedter, Jurij (Hg.): *Russischer Formalismus. Texte zur allgemeinen Literaturtheorie und zur Theorie der Prosa*, 5. Auflage, München 1994, 15.

8 Edelaar Mosayebi Inderbitzin: *Garten*, 43 (wie Anm. 3).

Exhibiting: The Expansion and Drift of Meanings
Nicole Yi-Hsin Lai

The exhibition is often thought of as a location or context for art displays, productions of meaning and knowledge, as well as a medium where art can meet its audiences. In recent years, from my experience of working in the Taiwanese scene, there are more and more artists and curators who are starting to consider exhibitions as not only a way of presentation, but also a dynamic process for producing and engaging with different layers of creative possibilities and critical interpretations. Working with this idea, the exhibition can be turned into a more progressive concept, bursting with possibilities for different processes and shifts in meanings. By reconsidering and discussing the idea of the "exhibition," firstly we can look into how "exhibiting" can take place within a fluid and open platform that invites audience engagement and participation at the time, rather than being constrained by a fixed interpretation. In some projects, artwork will only start to generate meaning when audiences start to participate on site in workshops. Furthermore, the process of engagement does not end when the event finishes, but rather it continues with further involvement by different audiences at different stages. This allows participants to bring their individual experiences into the works and to reflect their own ideas of value, as well as to produce different interpretations and forms of knowledge, instead of a fixed statement provided by curators and artists. In this sense, the meanings and content of the artwork can expand and drift with every exhibition. As Susan Sontag writes, "Art is not only about something: it is something. A work of art is a thing in the world, not just a text or a commentary on the world … Which is to say that the knowledge we gain through art is an experience of the form of style of knowing something, rather than knowledge of something (like a fact or a moral judgement in itself)."[1]

Furthermore, in the wake of the discussions described above, some artists are beginning to reflect on their own roles and the systems of hierarchies between exhibition, artists, and audiences within the art scene itself. In some community projects in particular, some participating artists consciously resist the idea of artwork being displayed along with the name of art/artist in the typical white cube exhibition space, separated from where works are conducted and experiences are encountered. For them, community art projects only become meaningful when the works are located in the site of residents' daily life, and produce the most meaning when engaging with their experiences. Those projects bring the idea of "site" and "residents as participants" into the process of producing artworks and they're intended to help strengthen the inner bonds of the community and to produce artistic and cultural values for the whole project. By reconsidering and redefining the concept of "the exhibition" we, as artists, curators or audiences can all help to bring a more progressive thinking to bear on the production of artwork, and can help to shape how artwork is viewed not just from a creative or aesthetic perspective but also, in a broader sense, as a method of promoting and disseminating knowledge and wisdom, and as a reflection of the social and cultural ties that bind all together as communities and as people. ∎

1 Susan Sontag, "On Style," in *Aesthetic Theory: Essential Texts for Architecture and Design*, ed. Mark Foster Gage (New York and London, 2011) pp. 226–248, esp. p. 232.

Ausstellen: Über die Erweiterung und Verschiebung von Bedeutungen

Nicole Yi-Hsin Lai

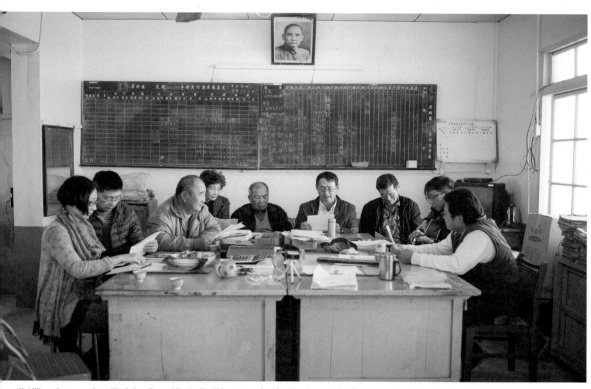

ong-Kai Wang, Sugarcane Song Workshop Dongshih, Yunlin, Taiwan, 2016 for | für "Southern Clairaudience – Some Sound Documents for a Future Act," Documenta 14, assel, 2017 © Chen You-Wei

Ausstellungen werden häufig sowohl s Ort oder Kontext für das Darstellen von unst, der Produktion von Bedeutung und Vissen, sowie als Medium betrachtet, in em Kunst auf ihr Publikum trifft. Meine Arbeitserfahrung in der Kunstszene Taiwans at gezeigt, dass es in den letzten Jahren ermehrt KünstlerInnen und KuratorInnen bt, die damit beginnen, Ausstellungen cht nur als eine Art der Präsentation zu egreifen, sondern als einen dynamischen rozess, um etwas herzustellen und mit erschiedenen Ebenen kreativer Möglichiten und kritischer Interpretationen zu erbinden. Arbeitet man mit dieser Idee, nnte das Ausstellen in ein progressiveres Konzept verwandelt werden, das unzähle Möglichkeiten für andere Prozesse und edeutungsverschiebungen eröffnet. Beim berdenken und Diskutieren des Formats Ausstellung" können wir zuerst einen Blick arauf werfen, wie „ausstellen" in einer eßenden und offenen Plattform stattfinen kann, die zur Publikumsbeteiligung und ilnahme einlädt und nicht von einer festelegten Interpretation eingeschränkt wird. manchen Projekten generiert ein Kunstrk erst dann eine Bedeutung, wenn das ublikum beginnt, vor Ort an Workshops ilzunehmen. Der Beteiligungsprozess enet aber nicht, wenn die Veranstaltung hließt; vielmehr setzt er sich mit der Ein-

beziehung anderen Publikums in anderen Phasen fort. Dies erlaubt TeilnehmerInnen ihre individuellen Erfahrungen in die Arbeiten mit einzubringen und ihre eigenen Vorstellungen über den Wert eines Kunstwerks zu reflektieren, sowie verschiedene Interpretationen und Wissensformen anstelle der von KuratorInnen und KünstlerInnen festgelegten Sichtweisen zu produzieren. In diesem Sinne können die Bedeutungen und der Inhalt eines Kunstwerks sich mit jeder Ausstellung erweitern und in neue Richtungen entfalten. Wie Susan Sontag es formuliert: „Kunst handelt nicht nur von etwas; sie ist etwas. Ein Kunstwerk ist ein Teil der Welt, nicht bloß ein Text oder Kommentar über die Welt. [...] Das Wissen, das uns die Kunst vermittelt, [ist] ein Erlebnis des Stils oder der Form des Wissens, nicht aber der Kenntnis einer Sache (wie eines Faktums oder eines moralischen Urteils)."[1]

In Folge der oben beschriebenen Diskussion beginnen manche Künstler damit, über ihre eigenen Rollen und die hierarchischen Systeme zwischen Ausstellung, KünstlerInnen, dem Publikum und der Kunstszene selbst, nachzudenken. Speziell in kollaborativen Projekten widersetzen sich einige teilnehmende KünstlerInnen bewusst der Idee, das Kunstwerk gemeinsam mit dem Namen des Künstlers oder der Künstlerin im traditionellen räumlichen Format eines

White Cube auszustellen – abgeschnitten von dem Ort, an dem die Werke entstehen und Erfahrungen gemacht werden. Für sie werden gemeinschaftliche Kunstprojekte erst dann sinnvoll, wenn die Arbeiten dort exponiert sind, wo das tägliche Leben der BewohnerInnen stattfindet, mit deren Erfahrungen sie in Beziehung treten. Diese Projekte bringen die Idee des „Standorts" und der „BewohnerInnen als Teilnehmer" in den Produktionsprozess von Kunstwerken ein und erfüllen damit die Funktion, die innere Bindung der Gemeinschaft zu stärken und künstlerische und kulturelle Werte für das ganze Projekt zu schaffen. Mit dem Überdenken und der Neudefinition des Konzepts der „Ausstellung" können wir alle als KünstlerInnen, KuratorInnen und Publikum helfen, die Produktion von Kunstwerken progressiver zu gestalten und damit auch dazu beitragen, die Wahrnehmung eines Kunstwerks zu formen, nicht nur aus einer kreativen oder ästhetischen Perspektive, sondern auch, im weiteren Sinne, als Methode zur Förderung und zur Verbreitung von Wissen und Weisheit, sowie als Reflexion über die sozialen und kulturellen Bindungen, die uns als Gesellschaft und als Menschen zusammenhalten. ∎

Übersetzung: Philipp Sattler

1 Sontag, Susan: „Über den Stil", in: *Kunst und Antikunst. 24 Literarische Analysen*. Frankfurt/M. 2009, 23-47, hier 25.

The Exform

Nicolas Bourriaud

Aus dem Französischen von
Erik Butler | Translated from
French by Erik Butler

London/New York: Verso, 2016

Englisch, 128 Seiten o. Abb.,
broschiert | English, 128 pages
without illustrations, paperback

ISBN 978-1-78478-380-8

EUR 11,49 | EUR 11.49

Komplexität und zeitgenössische Kunst

Margareth Otti

The Exform ist die aktuellste Publikation des Kurators Nicolas Bourriaud, Mitbegründer des Palais de Tokyo in Paris, ehemaliger Direktor der École Nationale Supérieure des Beaux Arts und Gulbenkian Kurator für Zeitgenössische Kunst der Tate Britain. Er etablierte sich bereits mit den Büchern *Altermodern* (2009), *Postproduction* (2002) und *Relational Aesthetics* (2002) als wichtiger Kunsttheoretiker. Den Zugang zur zeitgenössischen Kunstproduktion versucht Bourriaud in *The Exform* nicht über eine Analyse von Kunstwerken, um anhand dieser eine These herzuleiten. Vielmehr wählt er den deduktiven Weg: „I began with a vague idea and confronted it with clear images."[1]

Der Essay besteht aus einer Einleitung und drei Kapiteln. Die Einleitung mit dem Titel „The Exform" dient der Erklärung dieses Neologismus: So wie nach Walter Benjamin Geschichte nicht als linear betrachtet werden könne, beschreibe auch Karl Marx im *Kapital* Ökonomie als ideelle Form („spectral dance"). Diese zentrifugale Form, die man sich bildlich als dynamische Spirale mit Zentrum und Peripherie, mit einem Innen und Außen, sinnbildlich für die Mechanismen des Ausschließens und Inkludierens, vorstellen kann, beschreibt Bourriaud als Vorbild für ein Denkmodell der Gegenwart. Das durch Ideologie vorgegebene „Ideal" der Gesellschaft in Form von politischer Macht, gesellschaftlichen Hierarchien und Institutionen liege im Zentrum. Das „Ausgeschlossene", also Gruppen am Rand der Gesellschaft, Verdrängtes, Müll, das Unbewusste, politischer Widerstand, treibe am Rand. Diese These erinnert stark an Zygmunt Baumans *Wasted Lives: Modernity and Its Outcasts* (2004),[2] den Bourriaud aber nicht erwähnt. Die Exform liefere eine Möglichkeit der Verbindung dieses Innen und Außen. Bourriaud beschreibt sie als Hülse („socket") oder Stecker („plug"), in dem Zentrum und Peripherie in Form von zeitgenössischer Kunst zusammenkommen.

Die These des Buches verfolgt die Idee, dass Ideologie, Psychoanalyse und Kunst gegenwärtig die „fields of battle for realist thinking" (S. IX) darstellen. Karl Marx und Sigmund Freud, aber auch Gustave Courbet, der Begründer der modernen realistischen Malerei, würden die Strategie des „realist thinking" anwenden. „Realist thinking" definiert die Ablehnung der von der Gesellschaft als Ideal vorgegeben Hierarchien, eine Hinterfragung der Voraussetzungen, über die die Mechanismen von Ausschließung funktionieren und deren Enttarnung. In der zeitgenössischen Kunst betrachtet Bourriaud diese „realist strategy" als Grundlage für eine politische Kunsttheorie. Angewandt findet man sie nach Bourriaud in Arbeiten, die über das simple politisch Korrekte hinausgehen und deren ästhetische Prinzipien die Mechanismen von Ausschließung, Autorität oder Unterdrückung offenlegen. Kunstwerke, die versuchen, über die Exform die Komplexität der Gegenwart darzustellen und das „Unterdrückte", den metaphorischen Müll am Rand der Zentrifuge, in den Mittelpunkt zu transferieren.

Das erste Kapitel mit dem Titel „The Proletarian Unconscious" vertieft sich sehr in die Philosophie Louis Althussers und deren Verzweigungen. Althusser verschwand von der Bildfläche der Philosophie, nachdem er seine Ehefrau getötet hatte und als „apparatchik of the French Communist Party and a notorious psychotic" wahrgenommen wurde (S. XIII). Bourriaud erachtet die Wiederentdeckung seiner Gedanken zu Ästhetik und Politik, Form und Theorie, Ideologie und Praxis als wichtig – „to see the complex relations between art and politics with fresh eyes" (S. XIV). Was folgt, ist eine *tour de force* rund um die Erörterung des Begriffs der Ideologie bei Althusser. Viel Raum erhält die literarische Analyse der letzten Autobiografie Althussers, *The Future Lasts Forever*, geschrieben 1985, ediert 1992. Bourriaud interessiert sich besonders für die literarische Form dieses posthum

1 „Il faut confronter des idées vagues avec des images claires" findet sich an einer Wand in Jean-Luc Godards *La Chinoise* (1967).

2 Zygmunt Baumann: *Verworfenes Leben. Die Ausgegrenzten der Moderne*, Hamburg 2006.

erschienenen, als eine Art psychoanalytischer Kraftakt geschriebenen Werks. Althussers Lebensgeschichte folgt nicht der Logik eines Beginns (einer Idee), sondern einer Logik der Notwendigkeit, irgendwo zwischen Philosophie und Verrücktheit angesiedelt. Nach Bourriaud folgt die Autobiografie dem Konzept des „aleatory materialism", einem Begriffs Althussers: Aus dem Nichts beginnend, einer Theorie des Chaos folgend, in konzentrischen Kreisen wachsend, entsteht aus den zufälligen Verbindungen von Fakten und Geschichten in diesem Buch etwas Neues (eine Neukonzeption von Erinnerung).

„Aleatory materialism" verweist auf die Exform und die zeitgenössische Kunst: nichtchronologisches Denken, das Öffentliche, das Ausgeschlossene und deren Grenze. Bourriaud verlinkt auch Theorien und Anekdoten von Althussers Zeitgenossen und Schülern wie Jacques Derrida, Michel Foucault, Jacques Rancière, Alain Badiou und Chantal Mouffe; Gedanken zu Walter Benjamins *Lumpensammler*, zu Georges Batailles Begriff der *Heterologie* und springt zu den Anfängen der Cultural Studies und der Popkultur.

Das Kapitel „The Angel of the Masses" verweist auf Benjamins Ausführungen zum „Engel der Geschichte" in dessen Aufsatz „Über den Begriff der Geschichte", die sich auf die Zeichnung *Angelus Novus* des von Benjamin verehrten Paul Klee bezieht. Hier geht es das vorangegangene theoretische Zerpflücken der Begriffe „Ideologie" und „Psychoanalyse" in präzise Beschreibungen zur Kunst und zum Zustand der Gegenwart im Allgemeinen über. Als Beispiele für die Ausführungen dienen jedoch weniger Werke der zeitgenössischen bildenden Kunst als vielmehr Filme der Populärkultur, wie *The Matrix* oder *Twelve Monkeys*. Erst im letzten Kapitel, „The Realist Project", geht es im Wesentlichen um eine Analyse der aktuellen Kunst, um das nicht-chronologische Verständnis von Kunstgeschichte, die Vielfältigkeit der Kunstproduktion und den Einfluss von Web 2.0. Im Gegensatz zu Gustave Courbets *Das Atelier des Künstlers* (1855), dem mehrere Seiten gewidmet sind, werden zeitgenössische Kunstwerke allerdings nur in wenigen Sätzen abgehandelt. Dies

folgt zwar der Logik der Methode, erscheint aber als etwas enttäuschend: Die Diagnose der Situation der Gegenwartskunst folgt nicht aus einer genauen Beobachtung und Analyse der Kunstwerke heraus. Die Kunst dient eher der beiläufigen Bebilderung der verfolgten These. So bleiben die Kunstwerke eher *links*, die beiläufig angeklickt werden, um schnell zum nächsten Argument weiter zu springen. *My Hand Is the Memory of Space* (1991) von Gabriel Orozco wird in der Kürze sogar falsch beschrieben.[3] Manche der erwähnten Künstler und Künstlerinnen scheinen in ihren Arbeiten formal die Exform aufzunehmen, wie Sarah Sze oder Jason Rhoades: Rhizome, schwebende räumliche Anordnungen, multiple Konstellationen, erlauben innerhalb des Kunstwerks vielfältige Bezüge und Assoziationen, bezeichnet als „heterochronies" (S. 46). Zudem bestätigt sich, was Bourriaud als „hyper-production" (S. 48) beschreibt: Manche der Arbeiten und auch der erwähnten Filme wurden, obwohl erst wenige Jahre alt, von der rasanten Kunstproduktion überrollt und es scheinen noch treffendere, aktuellere, aussagekräftigere Beispiele vorhanden zu sein.

Bourriaud definiert zeitgenössische Kunst als „optical machinery" (S. VIII), als Sehhilfe, um die Komplexität der Gegenwart zu verstehen und den Finger auf die virulenten Punkte zu legen, wie Hypermobilität, digitale Bilderwelten, gegenwärtige Machtverhältnisse, kulturelle, soziale und politische Ausschließungsmechanismen und die Herausforderungen des Anthropozäns, dessen ökologische, ökonomische und politische Folgen außer Kontrolle geraten sind. Die Exform definiert eine Denkform der Gegenwart, die es ermöglicht, Kunstgeschichte neu zu lesen, sowie in Zukunft jenseits von Chronologien neu zu schreiben und die zudem eine andere Perspektive auf die Verbindung zwischen Kunst und Politik eröffnet. ∎

Complexity and Contemporary Art

The Exform is the most recent publication by the curator Nicolas Bourriaud, co-founder of the Palais de Tokyo in Paris, former director of the École Nationale Supérieure des Beaux Arts, and Gulbenkian curator for contemporary art at Tate Britain. He already established himself as an important art theorist with books like *Altermodern* (2009), *Postproduction* (2002), and *Relational Aesthetics* (2002). In *The Exform*, Bourriaud attempts to access contemporary art production not through an analysis of artworks with the aim of drafting a theory. Instead, he takes the deductive path: "I began with a vague idea and confronted it with clear images."[1]

The essay is composed of an introduction and three chapters. With its title "The Exform," the introduction serves to explain this neologism: just as history cannot be viewed linearly, according to Walter Benjamin, Karl Marx in *Captial* also describes the economy as an immaterial form ("spectral dance"). This centrifugal form—which can be figuratively imagined as a dynamic spiral with center and periphery, with an interior and exterior, symbolic of the mechanisms of exclusion and inclusion—is described by Bourriaud as an archetype for a conceptual model of the present. At the center rests the "ideal" of society dictated by ideology in the form of political power, societal hierarchies and institutions. Situated along the periphery are the "excluded," that is, the groups at the margins of society, the suppressed, the rubbish, the subconscious, the political resistance. This theory strongly reminds of Zygmunt Bauman's *Wasted Lives: Modernity and Its Outcasts* (2004),[2] which is,

3 Es handelt sich nicht um konische Eiswaffeln, wie im Buch beschrieben, sondern um Holzstielchen, die das Kunstwerk bilden.

1 "Il faut confronter des idées vagues avec des images claires" is found on a wall in Jean-Luc Godard's *La Chinoise* (1967).

2 Zygmunt Bauman, *Wasted Lives: Modernity and Its Outcasts* (Cambridge, 2004).

however, not mentioned by Bourriaud. The exform provides an opportunity to connect this interior and exterior. Bourriaud describes them as "socket" and "plug" that can come together, in the center and along the periphery, in the form of contemporary art.

This book argues the idea that ideology, psychoanalysis, and art currently represent the "fields of battle for realist thinking" (p. IX). Karl Marx and Sigmund Freud, but also Gustave Courbet, the founder of modern realist painting, would adopt the strategy of "realist thinking." Realist thinking defines the rejection of the hierarchies dictated by society as ideals, thus scrutinizing the premises on which the mechanisms of exclusion function and their exposure. In the context of contemporary art, Bourriaud views this "realist strategy" as a foundation for a political theory of art. According to Bourriaud, we find it applied in works that go beyond the mere politically correct and whose aesthetic principles reveal the mechanisms of exclusion, authority, or oppression—works of art that try to render the complexity of the present by using the exform and try to move the "oppressed," the metaphorical rubbish at the edge of the centrifuge, into focus.

The first chapter, titled "The Proletarian Unconscious," delves deep into the philosophy of Louis Althusser and its bifurcations. Althusser dropped off the radar of philosophy after having killed his wife and being perceived as the "apparatchik of the French Communist Party and a notorious psychotic" (p. XIII). Bourriaud considers important the rediscovery of his thoughts on aesthetics and politics, form and theory, ideology and practice—"to see the complex relations between art and politics with fresh eyes" (p. XIV). What follows is a tour de force of discussion of Althusser's concept of ideology. The literary analysis of the last autobiography by Althusser, *The Future Lasts Forever*, written in 1985, edited in 1992, is also explored thoroughly. Bourriaud is especially interested in the literary form of this written work published posthumously, as a kind of psychoanalytical feat of strength. Althusser's life story follows not the logic of genesis (an idea), but rather the logic of necessity, situated somewhere between philosophy and madness. Bourriaud notes that the autobiography follows the concept of "aleatory materialism," a term coined by Althusser: starting from nothing, following a theory of chaos, growing in concentric circles, in this book something new (a new concept of memory) arises from the random connections between facts and histories.

"Aleatory materialism" references the exform and contemporary art: non-chronological thinking, the public, the excluded, and their borders. Bourriaud also links theories and anecdotes by Althusser's contemporaries and students, such as Jacques Derrida, Michel Foucault, Jacques Rancière, Alain Badiou, and Chantal Mouffe; thoughts on Walter Benjamin's *Lumpensammler* (rag-picker), on Georges Bataille's concept of "heterology;" and then jumps to the early stages of cultural studies and pop culture.

The chapter "The Angel of the Masses" alludes to Benjamin's statements about the "angel of history" in his essay "On the Concept of History," which references the drawing *Angelus Novus* by Paul Klee, whom Benjamin admired. Here, the previous act of theoretically picking the terms "ideology" and "psychoanalysis" to pieces transitions into precise descriptions of art and of the state of the present day in general. Serving as examples for his remarks, however, are films from popular culture, such as *The Matrix* or *Twelve Monkeys*, rather than works from the contemporary visual arts. Only the last chapter, "The Realist Project," essentially deals with an analysis of today's art, with the non-chronological understanding of art history, the diversity of art production, and the influence of Web 2.0. In contrast to Gustave Courbet's *The Painter's Studio* (1855), to which several pages are devoted, contemporary artworks are given only a few sentences of treatment each. While this follows the logic of the method, it is still a bit disappointing: the diagnosis of the situation of contemporary art does not ensue from a precise observation and analysis of the artwork, but rather the art serves to more casually illustrate the pursued argumentation. Therefore, the works of art are usually on the *left*, skimmed in passing before the reader moves on to the next argument. *My Hand Is the Memory of Space* (1991) by Gabriel Orozco is even cited incorrectly in its brief description.[3] Some of the artists mentioned seem to formally integrate the exform in their work, such as Sarah Sze or Jason Rhoades: rhizomes, floating spatial arrangements, multiple constellations foster diverse references and associations within the artwork, called "heterochronies" (p. 46). Also, what Bourriaud describes as "hyper-production" (p. 48) is confirmed: some of the works and also the selected films, despite being only a few years old, have already been overrun by fast-paced art production, and it seems that more apt, more current, and more telling examples could have been chosen.

Bourriaud defines contemporary art as "optical machinery" (p. VIII) for understanding the complexity of the present and for identifying virulent aspects like hypermobility, digital imagery, current power relations, cultural, social, and political mechanisms of exclusion, and the challenges of the Anthropocene, whose ecological, economic, and political consequence have spiraled out of control. The exform defines a new, present-day way of thinking, which makes it possible to reread and, in the future, to rewrite art history. It also reveals a different perspective on the connection between art and politics. ∎

Margareth Otti (Translation: Dawn Michelle d'Atri)

3 The artwork is formed not by cone-shaped
 ice cream wafers, as described in the book,
 but by small wooden sticks.

Cedric Price Works 1952–2003:
A Forward-Minded Retrospective
Samantha Hardingham (Hg. | ed.)
London: Architectural Association
Publications/Montreal: Canadian
Centre for Architecture, 2016
Englisch, Band 1: 912 Seiten,
Band 2: 512 Seiten, 1255 teilw.
farbige Abbildungen, gebunden
und broschiert in Schuber |
English, vol. 1: 912 pages,
vol. 2: 512 pages, 1,255 illustra-
tions, some in color, hardback
and paperback in slipcase
ISBN 978-1-907896-43-9
EUR 168,00 | EUR 168.00

Thing Twice,
It's All Right

Ingrid Böck

„Theatre? A lot of people facing the same direction watching a forgone conclusion", übt Cedric Price Kritik an der traditionellen Architektur des Theaters, als Gegenentwurf entwickelte er die interaktive, flexible Raumbühne des Fun Palace, der entscheidenden Einfluss auf Richard Rogers und Renzo Pianos Entwurf des Centre Georges Pompidou in Paris hatte (Bd. 1, S. 47). Widerspruch und Kritik des Etablierten sind für Price der Nährboden für eine neue, eigene Version moderner Architektur, die den Benutzern großzügige Spielräume eröffnet. Während einer Diskussion mit Walter Gropius Anfang der 1960er Jahre an der Architectural Association ist Price der einzige im Publikum (Bd. 2, S. 12–13), der in eine andere Richtung blickt als der anerkannte Meister der Moderne, bemerkt Brett Steele (Bd. 1, S. 10).

Die von Samantha Hardingham herausgegebene, zweibändige und über 1400 Seiten umfassende Opus Magnum *Cedric Price Works 1952–2003* zeigt erstmals das Gesamtwerk samt Vorträgen und Artikeln des britischen Architekten Cedric Price (1934–2003). Der Umfang der beiden Bände erinnert an die ebenfalls annähernd 1400 Seiten von Rem Koolhaas's *S, M, L, XL*, ein Buch das nicht nur dokumentiert, sondern auch die Figur des Architekten erfindet – hier jedoch wird nach der Architektenkarriere des selbsternannten „anti-architect number 1" eine beinahe anti-monografische Leistungsschau vorgelegt (Bd. 1, S. 10).

Im ersten Band mit 912 Seiten werden 112 Projekte in chronologischer Reihenfolge präsentiert, wobei die ikonischen, weithin bekannten Entwürfe, wie der Fun Palace, Inter-Action, Non-Plan und der Potteries Thinkbelt, nur einen kleinen Teil der Produktion seines Büros CPA darstellen. Das Cedric Price Archiv in Montreal umfasst mehr als 20.000 Zeichnungen, mehr als 50 Modelle und 5.000 Dias, welche die gebauten und nicht realisierten Entwürfe von Price darstellen. Zusätzlich sind auch eine

Vielzahl von Textdokumenten und audiovisuelle Aufnahmen von Prices Vorträgen, Lehrveranstaltungen, Publikationen und Ausstellungen. Im einleitenden Aufsatz „Good and Bad Manners: The Education of an Architect"[1] beschreibt Hardingham Prices Studentenarbeiten während seiner Ausbildung an der Architectural Association in London, aber auch seine ersten Aufträge, die aus Umbauten von Wohnhäusern und Geschäften bestanden.

Der Untertitel *A Forward-Minded Retrospective* nimmt Prices Formulierung für die methodische Unterscheidung verschiedener Arten von Zeichnungen, Skizzen, Collagen und Cartoons auf: „forward-minded retrospect" nennt Price Zeichnungen „in which to trace reflections and advance improvements; these take the form of diagrams and annotated project summaries" (Bd. 1, S. 15). Daran anknüpfend meint Hardingham, die insgesamt sechs Jahre im Cedric Price Archiv des Canadian Centre of Architecture in Montreal das Material aufgenommen und analysiert hat, ein wesentliches Ziel ihrer Forschungsarbeit sei es, das volle Spektrum der von Price angewandten Entwurfsmethoden und Darstellungsformen zu zeigen.

In den Diagrammen, die an Christopher Alexanders *Pattern Language* erinnern, entwirft er neue Bewegungsmuster, wie beispielsweise die Zeichnung der Verkehrsströme des Entwurfs British Airway Authority (Bd. 1, S. 156) oder der Dockplan des Konzepts Haven (Bd. 1, S. 791). Die Grundrisspläne, Ansichten und Axonometrien werden als konzeptionelle Skizzen verwendet und überzeichnet, beschriftet, überklebt, zerschnitten oder dienen als Ausgangsmaterial für die nächsten Entwürfe. Eine zentrale Rolle nehmen jedoch Prices Fotocollagen ein, die oft aus einer weiten Perspektive des urbanen Kontextes, wie einem Luftbild des Trafalgar Square in London, und seinem freihändigen Entwurf, manchmal auch Textteilen oder einer einfachen Beschriftung, zusammengesetzt sind (Bd. 1, S. 572, 575). Andere Handzeichnungen können wie Cartoons gelesen werden und beschreiben den Ablauf eines Vorhabens oder einer Intervention

1 Der Titel lehnt sich an das von Prices oft zitierte Buch *Good and Bad Manners in Architecture* von Trystan Edwards an (vgl. Bd. 1, S. 14).

(Bd. 1, S. 872–875). Zahlreiche Abbildungen des Buches zeigen auch Price selbst wie er den Raum und die Stadt als Bühne nutzt, beispielsweise sein Treffen mit dem Anti-Apartheid-Aktivisten Jake Brown am Trafalgar Square (Bd. 1, S. 866).

Neben Prices zeichnerischen Entwurfsinstrumenten nehmen für Hardingham jedoch auch seine wortgewandten und oft polemischen Texte eine Schlüsselrolle im Verständnis des Œuvre ein: „Words were something he toyed with, invented and deployed in swathes (with varying degrees of accuracy)" (Bd. 1, S. 15). Auch die einzelnen Kapitel, die jeweils eine Zeitspanne von annähernd zehn Jahre umspannen, benennt Hardingham nach Prices Leitideen für seine Entwürfe, wie „The People Are In Control", „Calculated Uncertainty" und „Concentrate" aus. Zu einigen Entwürfen verfasste Price auch tabellarische Listen für Entwurfsvorgaben, wie „A ‚fuzzy' brief & friendly check list" für das Projekt Berlin 92 mit den Unterteilungen *site*, *ideal*, *desirable*, *constraints*, *constituents*, *design aid*, *hidden assets* und *remember* (Bd. 1, S. 786). Price verwendete ein eigenes begriffliches Vokabular, das sich nicht nur ständig weiterentwickelte, sondern sich oft auch durch eine Widersprüchlichkeit, absichtliche Mehrdeutigkeit und feine Nuanciertheit auszeichnet.

Der zweite, 512 Seiten umfangreiche Band widmet sich den oft pointierten Aufsätzen, Vorträgen und Diskussionen von Price und umspannt wie der erste Band einen Zeitraum von fünf Jahrzehnten. In Architekturmagazinen zu publizieren kam Prices Arbeitsweise entgegen, da er zum einen den oft in Listen und Statements formulierten Entwurfsprozess reflektierte und gemeinsam mit anderen kritisch hinterfragte. Zum anderen entsprach der flüchtige und schnelllebige Charakter des Mediums auch dem Wesen seines sich ständig weiterentwickelnden architektonischem Denkens. Auch Projekte, an denen sein Büro gerade arbeitete veröffentlichte er als *work in progress* und lud die Leser, ähnlich einer Zwischenpräsentation an Hochschulen, zu Kommentaren ein. Mitte der 1980er Jahre führte er in *Building Design* gar eine eigene satirische (Klatsch-)kolumne über aktuelle Ereignisse in der Tradition von politischen Journalisten (Bd. 2, S. 382–402).

Einer der der bekanntesten und kontroversesten Artikel ist der von Price gemeinsam mit Reyner Banham, Paul Parker und Peter Hall verfasste Beitrag „Non-Plan: An Experiment in Freedom", der die Stadt als sich ständig veränderndes System portraitiert und die Planer dazu auffordert, den Bewohnern ihre Umgebung weitgehend selbst gestalten zu lassen (Bd. 2, S. 110–121). Prices letzter Text ist der titelgebende Buchbeitrag „Friendly Alien" zum 2004 veröffentlichten Buch über das Grazer Kunsthaus von Peter Cook und Colin Fournier: „a friendly alien has arrived in Graz […] a city with history galore and an extraordinary appetite for the new and the experimental" (Bd. 2, S. 507).

Neben Hardinghams Meilenstein in der Aufarbeitung des Price Archivs stellt Tanja Herdts Werkbiografie *The City and the Architecture of Change: The Work and Radical Visions of Cedric Price* von 2017 einen weiteren wesentlichen Beitrag in der wissenschaftlichen Erforschung von Prices Lebenswerk dar.[2] Herdt analysiert Prices Stadtkonzepte unter dem Blickwinkel sozio-technischer Systeme, den Einfluss des Wandels zur Informationsgesellschaft und untersucht Case Studies einzelner Entwürfe wie Fun Palace und Potteries Thinkbelt.

Hardinghams umfangreiche Herausgabe und kritische Kommentierung des Gesamtwerkes ermöglicht eine Neubewertung der Arbeiten von Price sowie seines Einflusses auf den Architekturdiskurs seit den frühen 1960er Jahren. Durch diese Grundlagenforschung legte die Herausgeberin auch den Grundstein für weitere wissenschaftliche Studien über einen Architekten und Autor, der als Eisberg beschrieben wurde – „his ideas are still afloat" (Bd. 1, S. 511). Er kann durch sein kaltes frisches Wasser im Meer oft weit entfernt vom Ursprung Verwirbelungen und neue Meeresströmungen erzeugen. ∎

2 Herdt, Tanja: *The City and the Architecture of Change. The Work and Radical Visions of Cedric Price*, Zürich 2017.

Thing Twice, It's All Right

"Theatre? A lot of people facing the same direction watching a forgone conclusion," remarks Cedric Price critically of the traditional architecture of theater. As an alterative concept, he developed the interactive, flexible spatial stage of the Fun Palace, which clearly influenced Richard Rogers and Renzo Piano's design of the Centre Georges Pompidou in Paris (vol. 1, p. 47). For Price, dissent and criticism of the establishment are the breeding ground for a new, personal version of modern architecture, one that opens up generous scope for the users. During a discussion with Walter Gropius in the early 1960s at the Architectural Association, Price was the only member of the audience (vol. 2, pp. 12–13) to be looking away from the respected master of modernism, notes Brett Steele (vol. 1, p. 10).

The two-volume opus magnum *Cedric Price Works 1952–2003*, edited by Samantha Hardingham and boasting over 1,400 pages, now shows for the first time the full oeuvre of the British architect Cedric Price (1934–2003), including his lectures and articles. The magnitude of the two volumes is reminiscent of Rem Koolhaas's *S, M, L, XL*, also nearly 1,400 pages long—a book that serves not only to document but also to invent the figure of the architect. However, in the case of Cedric Price, an almost anti-monographic description of works follows a detailing of the architecture career of the self-proclaimed "anti-architect number 1" (vol. 1, p. 10).

Presented in the first volume with 912 pages are 112 projects in chronological order, with the iconic, quite well-known designs—like Fun Palace, Action, Non-Plan, and Potteries Thinkbelt—making up but a small portion of the productions by his firm CPA. The Cedric Price Archive in Montreal is home to more than 20,000 drawings, over 50 models, and 5,000 slides representing Price's built and non-realized designs. There is also a large number of text documents and audiovisual recordings of Price's lectures, seminars, publications, and exhibitions. In the introductory

"Good and Bad Manners: The Education of an Architect,"[1] Hardingham describes Price's student work during his training at the Architectural Association in London, but also his first commissions, which involved renovations to residential buildings and shops.

The subtitle *A Forward-Minded Retrospective* adopts Price's phrasing for methodically differentiating between different kinds of drawings, sketches, collages, and cartoons: "forward-minded retrospect" is what Price called drawings "in which to trace reflections and advance improvements; these take the form of diagrams and annotated project summaries" (vol. 1, p. 15). Taking up this idea, Hardingham, who spent a total of six years viewing and analyzing this material in the Cedric Price Archive at the Canadian Centre of Architecture in Montreal, asserts that an essential goal of her research activity is to show the full spectrum of the design methods and forms of representation used by Price.

In diagrams that remind of Christopher Alexander's *Pattern Language*, Price drafted new patterns of movement, such as the drawing of traffic flow for the British Airway Authority design (vol. 1, p. 156) or the dock plan for the Haven concept (vol. 1, p. 791). The floor plans, views, and axonometries are taken as conceptual sketches and overdrawn, labeled, pasted over, cut up, or used as source material for the next designs. Playing a central role, however, are Price's photo collages, which are assembled from a broad perspective of an urban context, such as an aerial view of Trafalgar Square in London, and from his freehand design, sometimes also with snippets of text or a simple label (vol. 1, pp. 572, 575). Other drawings by hand can be read as cartoons and describe the process of an endeavor or an intervention (vol. 1, pp. 872–75). Numerous illustrations in the book also render Price himself, such as how he used the city as stage like in the case of his meeting with the anti-apartheid activist Jake Brown at Trafalgar Square (vol. 1, p. 866).

In Hardingham's view, what also plays a key role in understanding his oeuvre, aside from Price's design instruments, are his articulate and frequently polemic texts: "Words were something he toyed with, invented and deployed in swathes (with varying degrees of accuracy)" (vol. 1, p. 15). Hardingham has also titled the individual chapters, each of which spans a time period of approximately ten years, after Price's guiding ideas for his designs, such as "The People Are In Control," "Calculated Uncertainty," and "Concentrate." For some designs, Price compiled tabular lists for design specifications, such as "A 'fuzzy' brief & friendly check list" for the project Berlin 92, with the subcategories *site*, *ideal*, *desirable*, *constraints*, *constituents*, *design aid*, *hidden assets*, and *remember* (vol. 1, p. 786). Price developed his own conceptual vocabulary, which not only continually evolved but was also characterized by inconsistency, purposeful ambiguity, and refined subtlety.

The second volume, with its 512 pages, is devoted to Price's often keenly articulate essays, lectures, and discussions. Like the first volume, it encompasses a five-decade time frame. Publishing in architectural magazines fit well with Price's working approach, for on the one hand he could reflect on, and critically analyze, the design process that was often already formulated in lists and statements. On the other hand, the transient and fast-paced character of the medium also correlated to the essence of his ever-developing architectural thinking. He even published projects that his firm was presently working on as a "work in progress" and invited readers to offer comments, similar to an interim presentation at a university. In the mid-1980s, Price even wrote, in the tradition of political journalism, his own satirical (gossip) column in *Building Design* about current events (vol. 2, pp. 382–402).

One of Cedric Price's most famous and controversial articles is "Non-Plan: An Experiment in Freedom," a contribution jointly penned with Reyner Banham, Paul Parker, and Peter Hall.

Here, the city is portrayed as a constantly changing system, and planners are encouraged to allow residents to design their own environment to the greatest extent possible (vol. 2, pp. 110–21). Price's last text is the contribution "Friendly Alien"—which also served as the title for the book published in 2004—in which he wrote the following about the Kunsthaus Graz by Peter Cook and Colin Fournier: "a friendly alien has arrived in Graz … a city with history galore and an extraordinary appetite for the new and the experimental" (vol. 2, pp. 507).

Next to Hardingham's milestone of processing the Price Archive, Tanja Herdt's biography *The City and the Architecture of Change: The Work and Radical Visions of Cedric Price*, released in 2017, represents another essential contribution to the scholarly research of Price's lifework.[2] Herdt analyzes Price's urban concepts under the vantage point of sociotechnical systems, the influence of the transition to an information society, and she explores case studies of specific designs like Fun Palace and Potteries Thinkbelt.

Hardingham's comprehensive publication and critical commentary on Price's oeuvre facilitates a reevaluation of both his work and his influence on architectural discourse since the early 1960s. Thanks to this foundational research, the editor has also laid the cornerstone for further scholarly studies about an architect and author who is described as an iceberg: "his ideas are still afloat" (vol. 1, p. 511). With his fresh, cold water in the sea, he can generate eddies and new sea currents, often far away from the wellspring. ∎

Ingrid Böck (Translation: Dawn Michelle d'Atri)

1 The title is an allusion to a book frequently cited by Price, *Good and Bad Manners in Architecture* by Trystan Edwards (see vol. 1, p. 14).

2 Tanja Herdt, *The City and the Architecture of Change: The Work and Radical Visions of Cedric Price* (Zurich, 2017).

Rudolf Schwarz and the Monumental Order of Things
Adam Caruso/Helen Thomas
(Hg. | eds.)
Mit Fotografien von |
With photographs by
Hélène Binet
und Texten von | and texts by
Adam Caruso, Maria Conen,
Wolfgang Pehnt, Maria Schwarz,
Rudolf Schwarz, Helen Thomas
Zürich | Zurich: gta Verlag, 2016
Englisch, 334 Seiten, 163 Fotografien und Zeichnungen, Hardcover |
English, 334 pages, 163 photographs and drawings, hardcover
ISBN 978-6-85676-362-6
EUR 85,00 | EUR 85.00

Alternative Moderne

Claudia Gerhäusser

Rudolf Schwarz and the Monumental Order of Things ist ein dickes Buch, schwer von Gewicht, mit auffällig senfgelbem Gewebeeinband und aufkaschiertem Foto. Es ist kein Buch, das man eben mal durchblättert und dann wieder zur Seite legt. Die Herausgeber Adam Caruso und Helen Thomas lassen keinen Zweifel daran, dass dieses Buch Bedeutung haben soll. Immerhin geht es um einen der prägendsten Deutschen Kirchenarchitekten und Städtebauer des 20. Jahrhunderts – so ein Buch kann schon etwas wiegen.

Was da wiegt, ist vornehmlich eine Sensation, die weniger in den Inhalten an sich besteht, als vielmehr im Vorhaben, die Werke Rudolf Schwarz' zum ersten Mal detailliert dem englischen Sprachraum und damit einem wesentlich größeren und globalen Publikum zugänglich zu machen. Diese Grundidee der Herausgeber ist wesentlich für eine Einschätzung des Buches. Sie verschafft einem außergewöhnlichen Vorbild späte Würdigung und schließt eine Lücke in der internationalen Architekturrezeption, die lange genug geklafft hat. Dass das Buch gerade jetzt, in Zeiten einer vermehrt kritischen Reflexion der Moderne des 20. Jahrhunderts erscheint, zeugt von einem guten Gespür der Herausgeber. Rudolf Schwarz versuchte sich aus den sozialen und technischen Euphorien und Ideologien der Moderne herauszuhalten. Er stand der Massen-Produktivität der Nachkriegszeit ebenso wie einem dem CIAM verpflichteten, funktionalistischen Wiederaufbau der Städte skeptisch gegenüber. Beständig fragte er, ob es denn eine „architecture of our times" (Baukunst der Gegenwart) gäbe und stellte offen die Begebenheiten, Architekturströmungen und Moden seiner eigenen Zeit infrage. Aus diesem Grund stießen die Arbeiten Rudolf Schwarz' auf Interesse bei den Herausgebern, die im gta Verlag an der ETH Zürich eine Publikationsreihe herausgeben, in der sie Architekten, die Alternativen zur klassisch-europäischen Moderne suchten, erforschen.

Ein Blick in das Inhaltsverzeichnis des Buchs zeigt eine gut verständliche Struktur. Die

Werke Rudolf Schwarz' wurden zeitlich bzw. thematisch sortiert. In drei Kapiteln – „Kirchen der Zwischenkriegszeit", „Kirchen der Nachkriegszeit", „Öffentliche Bauten" – werden die Bauwerke von Schwarz in großformatigen, seitenfüllenden, wenn auch nüchternen Fotografien der Fotografin Hélène Binet gezeigt. Es sind Spaziergänge um und durch die Gebäude hindurch, die deren Kontext, deren räumlichen Charakter und deren Materialität vermitteln. Den Fotografien zugeordnet sind Texte von Rudolf Schwarz, Übersetzungen von Gebäudebeschreibungen, die seiner eigenen Werkmonografie entnommen sind.[1] Vervollständigt werden die Texte und Fotografien durch neugefertigte, computergezeichnete Pläne – Lagepläne, Grundrisse, Schnitte. Am Ende des Buches werden Abbildungen der Originalzeichnungen und -pläne beschriebener Gebäude als „Archival Material" zusammengefasst. Diese kontrastieren die nachgezeichneten Pläne und wirken wie Beweismaterial für die Thesen, die Adam Caruso und Helen Thomas in ihrem Text „History Lost and Regained" und Wolfgang Pehnt in dem Beitrag „Another Modern"[2] über die Auffassungen und Architekturen von Rudolf Schwarz aufstellen. Der Abdruck – in englischer Sprache – der Vorlesung „Architecture of Our Times" („Die Baukunst der Gegenwart"), 1958 an der Staatlichen Kunstakademie Düsseldorf von Schwarz gehalten, liest sich als eine Ergänzung zu den Werkdarstellungen und erklärt die Motivation und das Denken des Architekten und Hochschullehrers. Mit der Einleitung gelingt den Herausgebern zudem eine gut nachvollziehbare und informative Einordnung der Position Rudolf Schwarz' zwischen Moderne und Postmoderne.[3] Sie lokalisieren ihn zwischen Deutschem Werkbund und Bauhaus Debatte, zwischen Henry van der Velde und Walter

1 Vgl. Schwarz, Rudolf: *Kirchenbau. Welt vor der Schwelle*, Heidelberg 1960.

2 Vgl. Pehnt, Wolfgang: „Rudolf Schwarz, Architekt einer anderen Moderne", in: ders./Strohl, Hilde: *Bewohnte Bilder. Rudolf Schwarz 1897–1961. Architekt einer anderen Moderne*, Ostfildern 1997, 10–197.

3 Caruso und Thomas beschreiben die Position Rudolf Schwarz in folgender Art: „He was working in the strange, untheorized and even ahistorical pause that lay between the utopian Modernist city and the contradictory Postmodern city." (S.10)

Gropius und außerhalb des architektonischen Mainstreams der Mitte des 20. Jahrhunderts.

Es ist diese Art der Zusammenstellung von Text, Bild und Zeichnung, die das Buch wertvoll und aufschlussreich macht, da bestehendes Material mit einer Überarbeitung desselben ergänzt wird. Dabei bleibt aber kritisch anzumerken, dass die neu erstellten Lagepläne im Verhältnis zu den Material und Detailierung präzise wiedergebenden Originalplänen des Architekten recht undifferenziert wirken und die exaltierte Farbwahl einzelner Seitenabschnitte mindestens gewöhnungsbedürftig ist. Das schmälert allerdings die wesentliche und grundlegende Leistung dieses Buches kaum – die der Aufarbeitung der Werke und Texte von Schwarz für einen mit diesem Architekten bis dato kaum vertrautem Sprachraum. Ein E-Book wäre angesichts der Masse des Buches zu empfehlen. Das könnten dann die englischsprachigen Architekturreisenden mitnehmen in die Kirchen und Städte, die Rudolf Schwarz geprägt hat: Köln, Essen, Aachen, Bottrop, Düsseldorf, Düren, Frechen, Duisburg, Krefeld, Wuppertal … ∎

Alternative Modernity

Rudolf Schwarz and the Monumental Order of Things is a thick, heavy book, with a striking mustard-yellow fabric cover and an applied photo. It is not a book that one skims through and then puts it aside again. The editors Adam Caruso and Helen Thomas leave no doubt that this book is supposed to hold meaning. Considering that it is devoted to one of the most influential German church architects and urban planners of the twentieth century—the book certainly should carry some weight.

Of weight here is primarily a sensation that is present less in the content itself than in the endeavor to make Rudolf Schwarz's accessible, for the first time in detail, to the English-speaking countries, and thus to a much broader, global public. An awareness of this basic idea pursued by the editors is essential when assessing the book. It provides an unusual model of late recognition and closes a gap in the international reception of architecture, which has long been gaping. The fact that the book was published just now, in times of heightened critical reflection on the modernity of the twentieth century, attests to good intuition on the part of the editors. Rudolf Schwarz tried to stay out of the social and technical euphorias and ideologies of modernity. He was skeptical toward the mass productivity of the postwar era and also toward the functionalist rehabilitation of cities indebted to CIAM. Schwarz was perennially questioning whether there is an "architecture of our times" and openly challenged the occurrences, architectural currents, and styles of his own time. It was for this reason that the work of Rudolf Schwarz caught the attention of the editors, who edit a series of books for gta Verlag at ETH Zürich, devoted to research on architects who sought alternatives to the classically European modernity.

A view of the book's table of contents reveals an easily understandable structure. The works of Rudolf Schwarz were arranged according to time period and theme. In three chapters—"Inter-war Churches," "Post-war Churches," "Public Buildings"—the architectural structures designed by Schwarz are shown in large-format, page-filling, yet sober photographs by photographer Hélène Binet. These are walks around and through the buildings, conveying the involved context, spatial character, and materiality. Accompanying the

photographs are texts by Rudolf Schwarz, translations of building descriptions excerpted from his own monograph of works.[1] The texts and photographs are rounded off by newly drafted, computer-generated plans: site maps, floor plans, sections. At the end of the book, copies of the original drawings and plans of featured buildings are compiled as "Archival Material." This material contrasts with the redrafted plans and seems like supportive evidence for the theories fielded by Adam Caruso and Helen Thomas in their text "History Lost and Regained" and by Wolfgang Pehnt in the contribution "Rudolf Schwarz: Architekt einer anderen Moderne" ("Another Modern")[2] about the opinions and architectures of Rudolf Schwarz. The reprint of the lecture "Architecture of Our Times," in English, held by Schwarz in 1958 at the Staatliche Kunstakademie Düsseldorf, reads like a supplement to the representations of the architectural work and explains the motivation and the thinking of the architect and university professor. Moreover, in the well-written and informative introduction, the editors succeed in situating Rudolf Schwarz's position between

modernity and postmodernity.[3] They localize him between the Deutscher Werkbund and the Bauhaus, between Henry van der Velde and Walter Gropius, yet outside the architectural mainstream of the mid-twentieth century.

It is this approach to compiling text, imagery, and drawing that makes the book valuable and insightful, for existing material is supplemented by a reworking of the same material. Here, it bears critically noting that the newly drafted site maps seem rather undifferentiated in comparison to the material and detailing of the architect's precisely rendered original plans, and that the eccentric color selection of certain page sections certainly needs some getting used to. However, this hardly diminishes the essential and fundamental achievement of this book—that of preparing Schwarz's work and texts for a language region that has hardly been exposed to this architect to date. Considering the bulk of the book, an e-book would be recommended, so that English-speaking architecture travelers could take it with them into the churches and cities shaped by Rudolf Schwarz: Cologne, Essen, Aachen,

Bottrop, Düsseldorf, Düren, Frechen, Duisburg, Krefeld, Wuppertal … ▪

Claudia Gerhäusser
(Übersetzung: Dawn Michelle d'Atri)

1 See Rudolf Schwarz, *Kirchenbau: Welt vor der Schwelle* (Heidelberg, 1960).

2 See Wolfgang Pehnt, "Rudolf Schwarz, Architekt einer anderen Moderne," in *Bewohnte Bilder: Rudolf Schwarz 1897–1961: Architekt einer anderen Moderne*, eds. Wolfgang Pehnt and Hilde Strohl (Ostfildern, 1997), pp. 10–197.

3 Caruso and Thomas describe Rudolf Schwarz's position as follows: "He was working in the strange, untheorized and even ahistorical pause that lay between the utopian Modernist city and the contradictory Postmodern city." (p. 10)

Welche Denkmale welcher Moderne? Zum Umgang mit Bauten der 1960er und 70er Jahre

Frank Eckardt/Hans-Rudolf Meier/Ingrid Scheurmann/ Wolfgang Sonne (Hg. | eds.)

Berlin: Jovis Verlag, 2017

Deutsch, 324 S., ca. 165 Farb- und SW-Abbildungen, Hardcover | German, 324 pages, ca. 165 color and b/w illustrations, hardcover

ISBN 978-3-86859-443-0

EUR 38,00 | EUR 38.00

Bauliche Spurensuche

Claudia Volberg

Wie umgehen mit den Bauten der 1960er und 70er Jahre? Dieser Frage widmet sich das Buch *Welche Denkmale welcher Moderne?*, das nun als Abschlusspublikation des vom Bundesministerium für Bildung und Forschung (siehe www.bmbf.de) geförderten Kooperationsprojektes (kurz: WDWM) der Bauhaus Universität Weimar und der Technischen Universität Dortmund vorliegt. Von 2014 bis 2017 untersuchte dieser Forschungsverbund in der jeweiligen Hochschule zugeordneten Teilprojekten – unter der Leitung von Wolfgang Sonne mit Ingrid Scheurmann an der TU Dortmund und Hans-Rudolf Meier mit Frank Eckardt an der Bauhaus Universität Weimar – die Wahrnehmung, Akzeptanz sowie Weiternutzung des baulichen Bestandes seit den 1960er Jahren erstmals in europäischer Perspektive.

Über die Gliederung der Publikation in die zwei grundsätzlichen Fragen „Welche Moderne?" und „Welche Denkmale?" wird das vielschichtige Thema unterteilt. Die Aufsätze in den Teilprojekthemen schlüsseln diese beiden Themenfelder prismatisch auf und werden um Beiträge europäischer KollegInnen ergänzt, wodurch eine nachvollziehbare Strukturierung dieser umfangreichen und interdisziplinären Querschnittsmaterie gelingt. Der Titel des ersten Kapitels „Welche Moderne?" verweist auf eine vermeintliche Homogenität der Moderne, die aber einer inhaltlichen Untersuchung der Zeitspanne bedarf um Charakteristika gesellschaftlicher und architektonischer Einflüsse auszumachen. Denn erst so lassen sich repräsentative Baudenkmäler für diese Zeit bestimmen. Die dabei ersichtlich werdende Vielfalt an Schaffensprozessen in parallelen und sich wechselseitig beeinflussenden Architekturströmungen zwischen 1960 und 1980 belegt, dass wissenschaftlich etablierte Ordnungskriterien sowie Versuche einer Epochenfestlegung nicht möglich sind. Diese Pluralität charakterisiert generell die Moderne und ihre kultur- und architekturrelevanten Qualitäten. Für Sonne soll die „architekturhistorisch begründete Vielfalt der Überlieferung durch herausragende bauliche Repräsentanten" Aufgabe der Denkmalpflege sein.

Diese Aufgabenstellung illustriert das folgende Glossar über die maßgeblich prägenden typologischen und technisch-konstruktiven Innovationen der damaligen Wohnkonzepte ebenso pointiert wie stichhaltig (S. 40–53). Die soziale Dimension von Alltagsbauten als „Erinnerungsräume" deckt der Beitrag von Scheurmann auf, die – ähnlich wie die Identitäts-Diskussionen – einem Wertewandel unterliegen, von dem aus sich kein ästhetischer Begriff als festere Größe etablieren lässt. Eine Erweiterung des Denkmalbegriffs in Richtung einer Denkmalvielfalt, kein dogmatisches Festhalten an etablierten Kriterien, fordert entsprechend die Autorin. Dieser Forderung wird auch durch das Negieren der Bedeutung identitätsprägender Bauten der Migrationsgeschichte Deutschlands Nachdruck verliehen. Die subjektiv und/oder politisch angeleiteten Sortierungen und Beurteilungen des Bestandes seit dem Denkmalschutzjahr 1975 bis in die 1990er Jahre ließen einen transnationalen, sozialpolitischen Ansatz unbeachtet, dessen überregionales Potenzial nicht aufgrund sozio-politischer Entwicklungen vor Ort reduziert werden sollte (was zu den heterogenen Narrativen hinsichtlich der Bauproduktion nach 1960 in Europa und der oftmaligen Exklusion ganzer Bevölkerungsgruppen aus dieser Geschichte führte). Die Aufgabe der Denkmalpflege als „Change Management" müsse hier auch im Aufzeigen von Strategien für das Nutzbarmachen dieser Potenziale liegen, was der abschließende Artikel im ersten Kapitel mit dem Motto des Europäischen Kulturerbejahrs 2018, *Sharing Heritage*, einfordert und als Schwerpunkt auf Vermittlungsarbeit und den Bedarf an interdisziplinärer Zusammenarbeit und Einbindung der Öffentlichkeit aufgrund der gesellschaftlichen als auch konstruktiv-technischen Komplexität des Erbes sieht.

Nach der Herausarbeitung der Spezifika der Spätmoderne, wird im zweiten Kapitel der Frage „Welche Denkmale?" nachgegangen. Hierfür werden Strategien unter Hinzunahme vergleichbarer europäischer Vorgangsweisen diskutiert, die ein objektives Erfassen, Bewerten und Kommunizieren (so auch der Untertitel des Projekts WMWD) potenzieller Bauten ermöglichen.

Die Beiträge über Archivmethoden im sowohl interdisziplinären Vergleich als auch im bestehenden universitären Rahmen des Bauarchivs *A:AI* bieten aufgrund ihrer erörterten Kriterien Einblick in konkrete Praktiken. Die Dokumentation der Planung gibt dabei zusätzlich Aufschluss über konstruktiv-technische Innovationen – ein kultureller Wert, den es über Ausstellungskonzepte ebenso zu vermitteln gilt. Die offene Herangehensweise ehemaliger Sowjetstaaten bietet wie Tentativlisten Strategien für ein frühes Erfassen potenzieller Bauten und Möglichkeiten zur Einbindung der Bevölkerung. Praktische Vorgehensweisen für ein „Herausfiltern" übertragbarer Methoden bieten länderspezifische Beiträge. So zeigt etwa Sonja Hnilica eine strukturelle Methodik möglicher Eingriffe zur Umnutzung der oft als Altlast titulierten, prägnanten aber auch problematischen Großbauten auf. Die Konsequenz aus der Heterogenität bestehender Narrative und Begrifflichkeiten lautet Polarisierung und Ausgrenzung, was einmal mehr den Bedarf an einem Konsens über „Conservation Canons" (S. 141) verdeutlicht und fachliche Unterstützung der Öffentlichkeit erfordert, um durch integrative Zusammenarbeit subjektive Geschichtsschreibungen aufzubrechen.

Durch die Schlussbetrachtung gelingt es Scheurmann und Meier die Vielschichtigkeit und Kontroversen verstärkt zu betonen, die einen Paradigmenwechsel in der Haltung und im Umgang mit der „unvollendeten Moderne" notwendig macht. Als ergänzenden Abschluss untermauert die Heterogenität der Fallbeispiele des Katalogs „Erhaltensformen" (S. 273–316) diesen Bedarf und spricht für die dargelegte Herangehensweise. Durch diese Kombination mit Erläuterungsmethoden vermittelt das Buch die komplexe Materie ebenso anschaulich wie fundiert und liefert damit über Bildbände oder regionale Fachpublikationen hinaus eine gute Basis für die Zusammenarbeit von Wissenschaft, Behörden und Öffentlichkeit. Zudem wird erstmals eine nicht konkurrierende Beziehung zwischen der öffentlichen und fachlichen Debatte hergestellt, die in der Rolle der Denkmalpflege als fachlicher Berater zur Herausarbeitung der Qualitäten und möglichen Weiternutzungen der Bauten begründet liegt. Dies positioniert die Forschungsgruppe und ihre Publikation innerhalb des fachlichen Diskurses – kritisch gegenüber historisierenden Haltungen, aber auch gegenüber visuell trendgebunden begründeten oder funktional reduzierten Beurteilungen des Erbes. Hierbei ist das Aufzeigen von Strategien ein wichtiger konstruktiver Schritt zur Integration der Bauten als gesellschaftliches Erbe – richtungsweisend für das Europäische Kulturerbejahr. ∎

Architectural Pathfinding

How to deal with architectural structures from the 1960s and 1970s? The book *Welche Denkmale welcher Moderne?* (Which monuments, which modernity?) is devoted to this question, and it is now available as a publication concluding the eponymous cooperation project (short form: WDWM) by the Bauhaus University Weimar and the Technical University Dortmund, which was funded by the German Federal Ministry of Education and Research (see www.bmbf.de). From 2014 to 2017, in sub-projects assigned to the respective universities, this research alliance investigated the perception, acceptance, and continued use of built structures since the 1960s, for the first time from a European perspective. The projects were supervised by Wolfgang Sonne with Ingrid Scheurmann at the TU Dortmund and Hans-Rudolf Meier with Frank Eckhardt at the Bauhaus University Weimar.

The publication structure divides the multilayered topic according to the two fundamental questions "Which modernity?" and "Which monuments?" The essays written about the sub-project topics prismatically break these two thematic fields down and are supplemented by contributions from European colleagues, succeeding in providing a comprehensible structure for this extensive and interdisciplinary cross section of material. The title of the first chapter, "Which modernity?," references a supposed homogeneity of the Modern Movement, which, however, also requires a content-based review of the time period in order to identify characteristics of societal and architectural influences, for only in this way can representative architectural monuments be defined for this period. The diversity of creative processes in the parallel and mutually influential architectural currents between 1960 and 1980, made evident through this process, proves that scientifically established classification criteria and attempts to specify an epoch are not feasible. This plurality is generally characteristic for Modernism and its culturally and architecturally relevant qualities. For Wolfgang Sonne, the "diversity of tradition, rooted in architectural history, passed down through outstanding structural representatives," should be the task of monument preservation.

This task is illustrated by the glossary that follows, just as pointed as it is sound, about the strongly influential typological and technical-structural innovations of the housing concepts of the time (pp. 40–53). The social dimension of everyday buildings as "memory spaces" is covered by the contribution by Ingrid Scheurmann. Such structures, similar to the discussions on identity, are subject to a shift in values, a position from which no aesthetic concept may become established as a more permanent factor. Expanding the concept of the monument to include monument diversity, rather than dogmatically holding fast to established criteria, is thus also demanded by the author. This demand is likewise reinforced by negating the significance of identity-forming buildings from German migration history. The

subjectively and/or politically guided sorting and evaluation of the inventory, starting with the European Year of the Preservation of Monuments in 1975 and extending into the 1990s, ignored a transnational, sociopolitical approach whose transregional potential should not be downplayed due to local sociopolitical developments (which led to the heterogeneous narratives related to construction activity after 1960 in Europe and to the frequent exclusion of entire population groups from this history). The objective of monument preservation as "change management" should here too rest in an identification of strategies for making these potentials appropriable. This issue is addressed by the article concluding the first chapter with the motto of the European Year of Cultural Heritage 2018, "Sharing Heritage." Emphasis is placed on mediation work and on the need for interdisciplinary collaboration and integration of the public due to the societal and technical-structural complexity of this heritage.

After elaborating on the specifics of late modernism, in the second chapter the question "Which monuments?" is explored. To this end, strategies are discussed, including comparative European approaches, that facilitate the objective understanding, evaluating, and communicating (thus the subtitle of the WMWD project) of potential architecture. The contributions about archival methods—in both interdisciplinary comparison and in the existing university framework of the construction archive called A:AI—offer insight into concrete practices thanks to the criteria discussed. Here, the planning documentation provides additional information about technical-structural innovations—a cultural value that also needs to be conveyed above and beyond the exhibition concepts. The open approach favored by the former Soviet states offers strategies, like tentative lists, for an early identification of potential buildings and possibilities for involving the population. Practical strategies for "filtering out" transferable methods are cited by country-specific contributions. Sonja Hnilica, for example, presents a structural methodology of possible interventions for repurposing the eye-catching but also problematic large-scale structures so often considered inherited burdens. The consequences of existing narratives characterized by heterogeneity are polarization and marginalization, which once again illustrate the need for a consensus on the "conservation canons" (p. 141) and necessitate professional support of the public in order to pry open subjective historiography by way of inclusive cooperation.

In their concluding remarks, Scheurmann and Meier succeed in strongly emphasizing the complexity and controversies that make necessary a paradigm shift in the stance and treatment of the "incomplete modernity." As a supplementary conclusion, the heterogeneity seen in the case studies of the catalogue's "forms of preservation" (pp. 273–316) substantiates this need and speaks for the stated approach. Through this combination with explanatory methods, the book mediates the complex material in a way that is as clear as it is well founded and thus delivers, in addition to photobooks or regional specialist publications, a strong basis for collaboration between the sciences, government bodies, and the public. Also, for the first time a noncompetitive relationship between public and specialist discourse is established, which is rooted in the role of patrimony preservation as an expert advisor for identifying the qualities and possible continued use of the structures. This positions the research group and its publication within the context of specialist discourse—critical toward historicizing positions, but also toward assessments of the heritage founded in visual trends or functionally reduced. In this respect, pointing out strategies denotes an important and constructive step toward integrating the buildings as cultural heritage—indeed, pointing the way toward the European Year of Cultural Heritage. ∎

Claudia Volberg (Translation: Dawn Michelle d'Atri)

Building upon Building

Jantje Engels/Marius Grootveld
(Hg. | ed.)

Rotterdam: NAI010 Publishers, 2016

Englisch, 206 Seiten, SW-Abbildun-
gen, Softcover | English, 206 pages,
b/w illustrations, softcover

ISBN 978-9-46208-284-7

EUR 19,95 | EUR 19.95

Bauen ist die Antwort – aber was war die Frage?

Sophia Walk

Es kommt vor, dass man während des Le-
sens Verknüpfungen zu anderen gelesenen Text-
passagen, Artikelschnipseln oder Wortfetzen her-
stellt. Charles Landrys „Creativity is not only
about a continuous invention of the new. But also
how to deal appropriately with the old"[1] beispiels-
weise ist eine solche Verknüpfung. Oder „Wieviel
kann man wegnehmen, damit alles bleibt?"[2], was
man in Bezug auf *Building upon Building* sicher-
lich umkehren muss: Wenn man etwas hinzufügt,
wie viel bleibt von dem, was man vorgefunden hat?
Und inwiefern ist es überhaupt die Intention,
dass etwas bleibt? Diese Verknüpfungen, die sich
beim Lesen einstellen, haben damit zu tun, was
in *Building upon Building* passiert: Die Heraus-
geber Jantje Engels und Marius Grootveld gaben
45 europäischen Architekten verschiedener Ge-
nerationen die Aufgabe, eine fiktionale Erweite-
rung eines Bauwerks zu entwerfen. Der Entwurf
sollte die Prinzipien der bestehenden Architektur
aufgreifen und fortsetzen. Eine Aufgabe, die die
Architekten zur Reflektion über die eigene Arbeit
aufruft, und so generationenübergreifend gemein-
same Arbeitsweisen aufdeckt. Da wird Goethes
Gartenhaus in Weimar dupliziert und kleiner
skaliert oder die Scuola Grande di San Rocco in
Venedig abstrahiert erweitert. Die Rotterdamer
Architekten Monadnock um Job Floris und Sandor
Naus vertikalisieren den Komplex aus Senatsge-
bäude und Mauritshuis Museum in Den Haag.
Stephen Bates passt die Fensteröffnungen eines
Londoner Stadthauses aus dem 18. Jahrhundert
der dahinterliegenden Nutzung an. Baukuh las-
sen den Architekten Gunnar Asplund mit seinen
eigenen Erweiterungsplänen von 1928 für die
Stadtbibliothek in Stockholm antworten. Und
OFFICE Kersten Geers David Van Severen fül-
len eine unbebaute Fläche neben Mies van der
Rohes Seagram Building in New York. Schinkels
nicht umgesetzter Entwurf des „Hauses für den
Maschinenmeister" wird nun gebaut. Der Wohn-
komplex Robin Hood Gardens in London (des-
sen Abriss im Sommer 2017 begonnen hat) wird
so wertgeschätzt, dass er kilometerlang weiterge-
baut wird und Metzendorfs Katalog der Möglich-
keiten wird fortgeführt.

Es ist, als höre man Engels und Grootveld
zu diesen Architekten sagen: „Unterbrecht mal
eure Arbeit, um über euer Schaffen nachzuden-
ken." Das Ergebnis ist ein Dialog zwischen gegen-
wärtig tätigen Architekten und Bauten unserer
Vergangenheit. Der Fokus liegt dabei weniger auf
dem gebauten Werk dieser Architekten, sondern
wirft sie alle gleichermaßen zurück auf dieselbe
Aufgabe – nämlich Architektur nicht als losge-
koppelte Projekte zu verstehen, sondern Analo-
gien zu einem jeweiligen Kontext herzustellen.
Zwischen diesem zweiten Kapitel, das zugleich
den größten Teil des Buches ausmacht und dem
Vorwort der Herausgeber, bilden vier Essays das
erste Kapitel: Lara Schrijver fragt in „The Per-
ceptive Professional Architecture as the Art of
Seeing", was Architektur leisten kann, wenn ihre
Notwendigkeit schwindet. In Christophe Van
Gerreweys „Highest Fidelity" wird die Erweite-
rung von Bauwerken zum Balanceakt zwischen
der Anlehnung an die und einem radikalen Bruch
mit der Vergangenheit. Die Geschichte des Städ-
tebaus in Amsterdam behandelt Dorine van
Hoogstraten in „The Living Gistorical City".
Und in „Towards an Architecture of Accumula-
tion" stellt Arjan Hebly nachvollziehbar die The-
se auf, dass die Bauwerke, Städte und Landschaf-
ten, die die meisten Menschen besuchen möchten,
gewachsener, heterogener Struktur sind: d.h. die
Summe aus Zeitschichten, Baustilen und Maß-
stäben darstellen.

Was verankert die Architektur in der Ge-
genwart? Ihre Historie? Ihre Veränderungen?
Engels und Grootveld gehören einer Generation
von Architekten an, die nicht viel bzw. kommer-
ziell baut, zu Teilen ihr Einkommen durch Lehr-
tätigkeit sichert und ihre Praxistätigkeit – über-
spitzt ausgedrückt – eher als Hobby betreiben.

1 Charles Landry: *The Creative City – A Toolkit for
 Urban Innovators*, London 2000, S. 7.

2 Siehe den Beitrag *Subversiver Humor und bayerische
 Melancholie* über den Bildhauer Martin Wöhrl in
 Capriccio – Das Kulturmagazin des BR Fernsehens
 am 27. April 2017, http://www.br.de/mediathek/
 video/sendungen/capriccio/capriccio-martin-
 woehrl-102.html (Stand: 7. August 2017)

Ihr Buch ist Teil eines weitgreifenderen Anliegens, das sie von Gent aus mit ihrem 2015 gegründeten Büro Veldwerk verfolgen. Dabei geht es ihnen in ihrer Arbeit um den Kontext – zeitlich und örtlich: Ein Gebäude ist für sie kein unabhängiges Gebilde, sondern steht im Dialog mit seiner Umgebung. Architektur lehren, Vorträge halten und Ausstellungen kuratieren sind ebenso Formen dialogbasierter Arbeit, die sie in der von ihnen co-kuratierten Ausstellung „Maatwerk/Massarbeit – Architektur aus Flandern und den Niederlanden" (im Winter 2016/17 im Deutschen Architekturmuseum in Frankfurt am Main) thematisieren. Im Preludetext „Eine webende Generation" schreiben sie über holländische und belgische Kollegen ihrer Generation, dass ihr gemeinsames Ziel „eine Neubewertung von Geschichte, durch Assoziation, Typologiekonzepte, Kontextorientierung, Handwerkstradition und Kunstvielfalt eine breitere Perspektive einzunehmen [ist]. Anstatt etwas Neues und Isoliertes zu schaffen, suchen sie eher nach vorhandenen Ansätzen und verbinden, verknüpfen diese."[3] Hierzu findet sich auch eine deutliche Parallele in *Building upon Building*: „How do we absorb former insights and weave together the city of the past with the stories of our present?" (S. 13).

In ihrer Absicht, gegenwärtiges Architekturschaffen näher zu definieren, arbeiten die Herausgeber aktiv an einer Tendenz mit und beschränken sich nicht auf das Aufzeigen und Beschreiben einer Generation von Architekturschaffenden. Sie treffen eine Auswahl an Architekturproduzierenden, die in ihrem Schaffen auf viele kleine Fragen antworten, statt auf die eine große. Ein dem architektonischen „Handwerk" verbundenes, poetisches Verweben von Vorgefundenem und entwerferischer Beifügung lässt sich dabei als geteiltes Architekturthema ausmachen – gerade weil die gegenwärtige Stadt(landschaft) viel zu viele Möglichkeiten bietet und als beliebige Ansammlung von beliebigen Einzelobjekten ohne Beziehung zueinander bleibt. (S. 15)

Es gibt Dutzende Bezeichnungen für Eingriffe an bestehenden Gebäuden: Umbau, Zubau, Erweiterung, Renovierung, Sanierung, Restaurierung – sie alle sagen etwas über Art, Umfang und Technik des Eingriffs aus, nicht aber über die Haltung mit der an das zu ändernde Bauwerk

herangegangen wurde. Ihre Haltung beschreiben die Architekten in *Building upon Building* in Kurztexten, indem sie ihre Vorgehensweise erläutern. Alle Abbildungen sind in schwarzweiß gehalten und werden auf der Folgeseite weitergeführt – ist die Seite zu Ende, läuft das Bild auf der nächsten Seite weiter. Auch dies: ein Statement, eine Haltung zur Fortschreibung.

Dieses Buch, das in Romanabmessung daherkommt, ist eines von denen, das gefehlt hat. Ein Buch über den Umgang mit Bauten aus vergangener Zeit. Sein Thema: Haltung. Haltung gegenüber der Vergangenheit von Bauten, gegenüber der Gegenwart des konkreten architektonischen Eingriffs und gegenüber dessen Zukunft: Bietet der jetzige Eingriff auch und erneut die

Möglichkeit zum Weiterdenken, Weiterbauen, Weiternutzen? Abseits der Produktion von vermeintlich immer Neuem wirft dieses Buch die Frage auf: Was macht in den 2010er Jahren die Stadt aus? Was fügt die derzeit tätige Architektengeneration in unserer Gegenwart der Stadt hinzu? *Building upon Building* ist kein Lehrbuch, aber eine Aufforderung zur Auseinandersetzung mit der eigenen Haltung und eine Erinnerung daran, dass wir mittendrin sind in der Fortschreibung der Architekturgeschichte. ∎

3 Prelude: Eine webende Generation, *MAATWERK/MASSARBEIT – Architektur aus Flandern und den Niederlanden*, Ausstellung, DAM Deutsches Architekturmuseum Frankfurt am Main, 8. Oktober 2016–12. Februar 2017

Building Is the Answer—But What Was the Question?

While reading, associations are often made with other read text passages, snippets of articles, or word fragments. An example of such an association is Charles Landry's "Creativity is not only about a continuous invention of the new. But also how to deal appropriately with the old."[1] Or "Wieviel kann man wegnehmen, damit alles bleibt?"[2] (How much can be taken away so that everything remains?), which surely must be inverted in reference to *Building upon Building*: If something is added, how much remains of what was found to begin with? And is the intention even there that something should remain? Such associations that arise while reading have to do with what plays out in *Building upon Building*: the editors Jantje Engels and Marius Grootveld tasked forty-five European architects from different generations with designing a fictional add-on to a building. It was stipulated that the design had to build on and continue the principles of the existing architecture—a task that called upon the architects to reflect on their own work, thus exposing cross-generational working approaches. For example, Goethe's Gartenhaus in Weimar is duplicated and scaled down or the Scuola Grande di San Rocco in Venice extended in an abstract way. Monadnock verti-

calizes the complex that includes senate buildings and the Mauritshuis Museum in The Hague. Stephen Bates adapts the window openings of a London townhouse from the eighteenth century to the utilization area behind the structure. Baukuh has Gunnar Asplund respond to the task with his own extension plans from 1928 for the Stockholm Public Library. OFFICE Kersten Geers David Van Severen fills a barren plot next to Mies van der Rohe's Seagram Building in New York. Schinkel's non-implemented design of the "Haus für den Maschinenmeister" (House for the Master Machinist) is now built. The housing complex Robin Hood Gardens in London (where demolition started in the summer of 2017) is so cherished that it is extended for kilometers, and Metzendorf's catalogue of possibilities is expanded as well.

It's as if we could hear Engels and Grootveld telling these architects: "Stop your work for a

1 Charles Landry, *The Creative City: A Toolkit for Urban Innovators* (London, 2000), p. 7.

2 See the contribution "Subversiver Humor und bayerische Melancholie" (Subversive Humor and Bavarian Melancholy) about the sculptor Martin Wöhrl in *Capriccio – Das Kulturmagazin des BR Fernsehens*, April 27, 2017, http://www.br.de/mediathek/video/sendungen/capriccio/capriccio-martin-woehrl-102.html (accessed August 7, 2017).

moment to think about your creative process." The result is a dialogue between architects active in contemporary times and buildings from our past (p. 13). Here, the focus is placed less on the built work of these architects, for it brings all back to the same task equally: understanding architectural structures as analogies to a respective context rather than as uncoupled projects. Between this second chapter, which takes up the greater share of the book, and the introduction written by the editors, four essays comprise the first chapter. In "The Perceptive Professional Architecture as the Art of Seeing," Lara Schrijver asks what architecture can achieve when the need for it dwindles. In Christophe Van Gerrewey's "Highest Fidelity," the expansion of architectural structures becomes a balancing act between a dependence on and a radical break from the past. The history of urban planning in Amsterdam is explored by Dorine van Hoogstraten in "The Living Gistorical City." And in "Towards an Architecture of Accumulation," Arjan Hebly plausibly suggests that the buildings, cities, and landscapes which most people want to visit, are of an evolved, heterogeneous structural nature, that is, the sum of layers of time, architectural styles, and different scales.

What anchors architecture in the present day? Its history? Its changes? Engels and Grootveld are from a generation of architects who do not build a lot, at least not commercially, who earn income partly through teaching positions, and who carry out their architectural practice as more of a hobby, to use a slight exaggeration here. The book is part of a broader cause that they are pursuing from their base in Ghent, at the Veldwerk office founded in 2015. Their work is strongly focused on context, both temporal and spatial:

in their view, a building is not an autonomous entity but in fact engages in dialogue with its surrounding environment. Teaching architecture, giving lectures, and curating exhibitions are likewise forms of dialogue-based work, which they thematize in their co-curated exhibition *Maatwerk/ Massarbeit: Architektur aus Flandern und den Niederlanden* (Custom Made Architecture from Flanders and the Netherlands), shown at the Deutsches Architekturmuseum in Frankfurt am Main during the winter of 2016–17. In reflecting on their Dutch and Belgian cohorts of the same generation, they note that their mutual goal is "to regain a wider perspective by re-evaluating the overall history and through association, the notion of typology, the specifics of context, the tradition of craft and the richness of art. Rather than creating something new and isolated, they look for the threads already there and weave them together."[3] A clear parallel to this is found in *Building upon Building*: "How do we absorb former insights and weave together the city of the past with the stories of our present?" (p. 13).

In their attempt to more closely define present-day architectural activity, the editors are actively engaging in a trend, and doing more than just pointing out and describing a generation of architectural creatives. They have made a selection of individuals producing architecture who, in their work, respond to many small questions instead of a single large one. A poetic weaving of found material and design-related additions indebted to the architectural "craft" gives rise to a cleft in architecture—especially because today's cities (or urban landscapes) offer far too many opportunities and remain a random conglomeration of random individual objects that are unrelated (p. 15).

There are dozens of expressions for interventions on existing buildings: conversion, addition, expansion, renovation, refurbishing, restoration. All of these terms say something about the intervention type, scope, and technique involved, yet nothing about the posture taken on the structure being altered. In *Building upon Building*, architects describe their respective mindset by explaining their approach in short texts. All illustrations are in black and white and continued on the subsequent page—so when a page ends, the image is resumed on the next page. This, too, is a statement or attitude about continuation.

This book, which boasts the dimensions of a novel, is one that had been missing: a book about dealing with buildings from earlier times. Its topic: architectural approach. The posture taken on buildings' past, on the present use of the concrete architectural intervention, and on its future. Does the present intervention also, and once again, offer an opportunity for continued thinking, continued building, continued utilization? Above and beyond the production of the supposedly ever new, this book poses the question: What constitutes our cities in the 2010s? What can the presently active generation of architects add to the current state of our cities? *Building upon Building* is not a textbook, but rather an invitation to explore one's own architectural approach and a reminder that we are fully immersed in the continuation of architectural history. ∎

Sophia Walk (Translation: Dawn Michelle d'Atri)

3 "Prelude: A weaving generation," *MAATWERK/ MASSARBEIT – Custom Made Architecture from Flanders and the Netherlands*, exhibition at Deutsches Architekturmuseum (DAM), Frankfurt am Main, October 8, 2016 – February 12, 2017.

**Seamless: Digital Collage
and Dirty Realism in
Contemporary Architecture**
Jesús Vassallo (mit einem Vorwort |
with a foreword by Juan Herreros)
Zürich | Zurich: Park Books, 2016
Englisch, 200 Seiten, 164 Farb-
und 7 SW-Abbildungen, Hardcover |
English, 200 pages, 164 color
and 7 b/w illustrations, hardcover
ISBN 978-3-03860-019-0
EUR 38,00 | EUR 38.00

Nahtlose Übergänge:
Fotografie und Architektur im Dialog

Eva Sollgruber

Jesús Vassallo, spanischer Architekt und Assistant Professor an der Rice University in Houston, widmet sich in seiner ersten Monografie *Seamless: Digital Collage and Dirty Realism in Contemporary Architecture* Arbeiten von zeitgenössischen Architekten und Fotografen und deren gegenseitiger Beeinflussung. Vassallo promovierte 2014 bei Juan Herreros über das Verhältnis von Architektur und Fotografie im 20. Jahrhundert.[1] Im vorliegenden Buch – mit einem Vorwort von Herreros – macht der Autor den Schritt in die Gegenwart und untersucht drei Kollaborationen zwischen jeweils einem Architekten bzw. einem Architekturbüro und einem Fotografen: der belgische Fotograf Filip Dujardin und Jan De Vylder von dem belgischen Architekturbüro De Vylder Vinck Taillieu, der Schweizer Bildkünstler Philipp Schaerer und der Schweizer Architekt Roger Boltshauser, sowie der niederländische Fotograf Bas Princen und das belgische Architekturbüro OFFICE Kersten Geers David Van Severen. Jedem dieser Paarungen ist ein eigenes Kapitel gewidmet, das mit einer Bilderserie der Arbeiten der Protagonisten eingeleitet wird. In einem abschließenden Aufsatz resümiert der Autor die Themenkreise und setzt die Arbeiten seiner Akteure in einen historischen sowie theoretischen Kontext.

Seit den Anfängen der Fotografie ist die Architektur nicht nur eines ihrer zentralen Sujets, sondern auch ihre wichtigste Auftraggeberin. Ursprünglich als Werkzeug für die Dokumentation unserer gebauten Umwelt verstanden, erkannten ArchitektInnen früh die verführerische Kraft der Fotografie, mit der sie ihre Projekte einem breiten Publikum näher bringen konnten. Heute ist die Fotografie eines der wichtigsten Medien um Architektur nicht nur zu erfassen und zu dokumentieren sondern auch um architektonische Konzepte und Visionen zu vermitteln. Sie ist untrennbar mit der Architekturproduktion verbunden, prägt mit ihren Bildern unser Verständnis

von der Disziplin und ist – denkt man etwa an Lucien Hervés Fotografien von Le Corbusiers Projekten – die entscheidende Komplizin in der Ikonisierung von Architekturprojekten sowie von ArchitektInnen. Einerseits liefert die Architektur den Bildinhalt, der mit Fotografien in Szene gesetzt wird, andererseits können diese – mit dem subjektiven Blick der/des FotografIn – in Szene gesetzten Bilder wiederrum Denkanstöße und Arbeitsmaterial für die Architektur liefern. Genau dieser Bereich eines über das fotografische Bild vermittelten Austauschs von fotografischen und architektonischen Denk- und Arbeitsprozessen ist der Untersuchungsgegenstand des vorliegenden Buches.

Den Kapiteln über die jeweiligen Kollaborationen liegen Interviews mit den Protagonisten zugrunde, in denen Vassallo versuchte Einblicke in die Wechselbeziehungen und Arbeitsprozesse der Architekten und Fotografen zu erhalten. Die Übergänge zwischen den Disziplinen werden dabei auf zwei Ebenen konstatiert: auf der technischen und der inhaltlichen. Seit dem Auftreten der digitalen Technologien haben sich die Bildproduktion in der Fotografie und Architektur sowie die fotografische Repräsentation der Architektur durch Bilder entscheidend verändert. Über die Technik der digitalen Collage wird die Verbindung zwischen dem Foto und der Realität „aufgeweicht", denn die Welt wird in Fotos nicht mehr einfach nur abgebildet, sondern mit neuen, im digitalen Raum entworfenen, Welten überlagert. (S. 171) Innerhalb des fotografischen Bildes lässt sich über zukünftige Welten spekulieren: der Übergang zwischen Fiktion und Realität scheint somit nahtlos – seamless – geworden zu sein. Dieses Phänomens bedient sich der Autor auch bei der Zusammenstellung der Bilderserien, welche die jeweiligen Kapitel einleiten. Vassallo lässt die Arbeiten seiner Protagonisten für sich sprechen, ohne Bildtitel oder Beschreibungen. Durch das Fehlen der Bezeichnungen treten die Bilder unmittelbar in einen Dialog und es ist auf dem ersten Blick nicht erkennbar welche Bilder im virtuellen Raum des Computers geschaffen

1 Die Dissertation wurde unter dem Titel „Reality Bites: Documentary Photography and Architectural Realism" veröffentlicht. http://oa.upm.es/30896/1/JESUS_VASSALLO_FERNANDEZ.pdf (Stand: 15. August 2017)

wurden und welche die Realität abbilden. Genauso wenig ist es deutlich ablesbar welche Bilder Arbeiten des Architekten und welche die des Fotografen zeigen. Mit diesen Bildersammlungen wird nicht nur der technische Aspekt des Übergangs zwischen den Disziplinen eindrücklich veranschaulicht, sondern vor allem die inhaltliche Verwandtschaft der jeweiligen Kollaborationspartner.

Unter dem Kapitel „Identity Theft" erörtert Vassallo den intellektuellen Austausch zwischen dem Fotografen Filip Dujardin und dem Architekten Jan De Vylder. Beide setzen sich intensiv mit den Bedingungen des Ortes, in dem sie agieren, auseinander und schöpfen daraus ihr Repertoire für ihre Architektur- oder Bildentwürfe: durch die Rekombination und Interpretation von Fragmenten der vorgefundenen Realität wird der bestehende Kontext transformiert und diesem eine weitere Bedeutungsebene hinzugefügt. Im zweiten Kapitel „Control Game" geht Vassallo unter anderem der Konzeption der Ausstellung „Transformator" für die Architektur Galerie Berlin im Jahre 2012 nach, bei der Philipp Schaerer das gebaute Oeuvre des Architekten Boltshauser einer radikalen Neuinterpretation unterwirft. (S. 103f.) Entgegen den Praktiken der kommerziellen Architekturfotografie „entmystifiziert" (S. 109) der Bildkünstler die architektonischen Projekte und führt sie damit wieder näher an die Quintessenz der ursprünglichen Entwurfsidee und Boltshausers entwurfstheoretischen Kernthemen heran. Zu guter Letzt illustriert Vassallo in dem Kapitel „Broken Promise" den Übergang von Denk- und Arbeitsprozessen zwischen den Disziplinen anhand der Kollaboration von Bas Princen und OFFICE Kersten Geers David Van Severen beispielhaft: Fotos von Princen – seien es Auftragsarbeiten für die Architekten oder freie künstlerische Arbeiten – sind häufig Inspirationsquelle und thematischer Ausgangspunkt für Entwürfe des Architekturbüros und gleichzeitig fotografische Grundlage für Collagen anhand derer die Entwürfe visualisiert werden. Die Arbeiten von Princen haben für OFFICE „the capacity […] to become the embodiment of strong ideas – we could almost say diagrams – to which the architects respond in their projects" (S. 153).

Der Einfluss der Fotografie auf die Architekturproduktion und -forschung ist keineswegs neu – man denke etwa an die Bedeutung von Ed Ruschas Fotos auf die städtebauliche Forschung von Robert Venturi und Denise Scott Brown –, aber ihr heutiger Einfluss auf das architektonische Entwerfen ist mit den drei untersuchten Paarungen so und in diesem Umfang noch nicht dokumentiert und reflektiert worden. Vassallo liefert mit dem ansprechend gestaltetem Buch eine tiefgreifende Untersuchung der gegenwärtigen Arbeit von europäischen Architekten und Fotografen und illustriert erfolgreich die produktiven und intellektuellen Wechselbeziehungen zwischen den Disziplinen.

Es macht nicht nur Spaß gemeinsam mit dem Autor in die Gedanken- und Bildwelt der Protagonisten einzutauchen und der Entstehung ihrer Projekte zu folgen, auch der eigene, entwerferische Blick lässt sich mit diesem, für die gegenwärtige Architekturproduktion aufschlussreichen, Buch schärfen. ∎

Seamless Transitions: Photography and Architecture in Dialogue

Jesús Vassallo, a Spanish architect and assistant professor at Rice University in Houston, has devoted his first monograph—titled *Seamless: Digital Collage and Dirty Realism in Contemporary Architecture*—to correlations in the work of select contemporary architects and photographers. Vassallo earned his doctorate in 2014, studying under Juan Herreros, on the relationship between architecture and photography in the twentieth century.[1] With the book reviewed here, which includes a foreword by Herreros, he takes a step into the twenty-first century by examining three collaborations, in each case between an architect or an architectural firm and a photographer: the Belgian photographer Filip Dujardin and Jan De Vylder from the Belgian architectural firm De Vylder Vinck Taillieu; the Swiss visual artist Philipp Schaerer and the Swiss architect Roger Boltshauser; and the Dutch photographer Bas Princen and the Belgian architectural firm OFFICE Kersten Geers David Van Severen. Each of these pairings is featured in its own chapter, introduced by an image series presenting the work of the involved individuals. In a concluding essay, the author looks back on the related topics and places the work of his protagonists into a historical and theoretical context.

Since the early days of photography, architecture has been one of its main subjects, but also an important client. Originally conceived as a tool for documenting our built environment, architects recognized early on the seductive power of photography, which they could use to familiarize a broad public with their projects. Today photography is

1 Jesús Vassallo, "Reality Bites: Documentary Photography and Architectural Realism" (PhD diss., Universidad Politécnica de Madrid, 2014), http://oa.upm.es/30896/1/JESUS_VASSALLO_FERNANDEZ.pdf (accessed December 10, 2017).

one of the most important media not only for capturing and documenting architecture, but also for mediating architectural concepts and visions. It is inseparably connected to architectural production, it shapes our understanding of the discipline thanks to its images, and it is—in the case of, for instance, Lucien Hervé's photographs of Le Corbusier's projects—the paramount accomplice in iconizing architectural projects as well as architects themselves. On one hand, architecture delivers the image content, which is staged in photographs; on the other, these images—staged through the subjective gaze of the photographer—in turn provide food for thought and working material for architecture. Precisely this realm of exchange between conceptual and working processes in photography and architecture, as mediated by the photographic image, is the subject of the book *Seamless*.

The chapters about the respective collaborations are based on interviews with the protagonists, through which Vassallo tries to gain insight into the reciprocal relations and working processes of the architects and photographers. Here, the transitions between the disciplines are established on two levels: technical and content-related. Since the emergence of digital technology, image production in photography and architecture has decisively changed, as has the photographic representation of architecture in pictures. Using the technique of digital collage, the connection between photograph and reality is "softened," for the world is no longer merely rendered through photos but also overlaid with new images and worlds designed or found in digital space (p. 171). Within photographic images we can speculate about future worlds without the crossover between fiction and reality being apparent, for it seems to transition *seamlessly*. The author avails

himself of this phenomenon in the compilation of image series introducing the chapters. Vassallo allows the work of his protagonists to speak for itself—without captions or descriptions. Due to this lack of designations, the images enter into a dialogue that does not reveal which images were created in the virtual space of the computer and which ones depict reality. Equally unclear is which images show the work of the architects or of the photographers respectively. These visual compilations thus clearly illuminate the technical aspects of the crossover between the disciplines, but also a kinship of content among the collaboration partners.

In the chapter "Identity Theft," Vassallo discusses the intellectual exchange between the photographer Filip Dujardin and the architect Jan De Vylder. Both individuals intensively explore the conditions of the site they are navigating and draw from this a repertoire for their architectural or photographic designs: by recombining and interpreting fragments of encountered reality, the existing context is transformed and imbued with another level of meaning. In the second chapter "Control Game," Vassallo traces, among other things, the concept of the exhibition *Transformator* for the Architektur Galerie Berlin in the year 2012, where Philipp Schaerer subjected the built oeuvre of Boltshauser Architekten to a radical reinterpretation (pp. 103–4). Contrary to the practices of commercial architectural photography, the visual artist "demystifies" (p. 109) the architectural projects and thus brings them closer to the quintessence of Boltshauser's design-theoretical core topics. In the chapter "Broken Promise," Vassallo illustrates the transition from conceptual and working processes among the disciplines by citing the exemplary collaboration between Bas Princen and OFFICE

Kersten Geers David Van Severen: the photos taken by Princen, be it commissioned work for the architects or freelance artistic work, are often a source of inspiration and a thematic starting point for the designs by the architectural firm, and at the same time a photographic basis for collages used to visualize their work. For OFFICE, the photographs by Princen have "the capacity … to become the embodiment of strong ideas—we could almost say diagrams—to which the architects respond in their projects" (p. 153).

The fact that photography can strongly influence architectural production and research is certainly not new—just consider the significance that Ed Ruscha's photographic work held for the urban-planning research conducted by Robert Venturi and Denise Scott Brown—but its present-day impact on architectural design, shown by example of the three studied pairs, has not previously been documented and analyzed to this extent. With this appealingly designed book, Vassallo delivers an in-depth study of the contemporary work of European architects and photographers and, in the process, illustrates the productive and intellectual interrelations between the disciplines. Not only is it enjoyable to join the author in plunging into the mental and visual worlds of the protagonists and in following the origination of their projects; this book, by offering insights on contemporary architectural production, also allows one's own designing eye to become more focused. ∎

Eva Sollgruber (Translation: Dawn Michelle d'Atri)

Infrastructure Space
Ilka und | and Andreas Ruby
(Hg. | eds.)
Mit einem Visual Atlas von |
With a Visual Atlas by
Something Fantastic
Berlin: Ruby Press, 2017
Englisch, 421 Seiten, zahlr. Foto-
grafien und Illustrationen, Hardcover |
English, 421 pages, numerous pho-
tographs and illustrations, hardcover
ISBN 978-3-944074-18-4
EUR 48,00 | EUR 48.00

Anatomie des infrastrukturellen Raums

Evelyn Temmel

Andreas Ruby, seit Mai 2016 Direktor des SAM, Schweizerisches Architekturmuseum in Basel, und Ilka Ruby sind mit ihrem 2008 gegründeten Verlag Ruby Press die Herausgeber dieser Publikation zum 5. internationalen *LafargeHolcim Forum for Sustainable Construction*. Beide sind neben ihrer Verlagsarbeit auch als Kritiker, Kuratoren, Moderatoren und Lehrende tätig und geben nach *Urban_Trans_Formation* (2007), *Re-inventing Construction* (2010) und *The Economy of Sustainable Construction* (2013) diesen vierten Band des triennalen Forums heraus. Die LafargeHolcim Foundation mit Sitz in Zürich versteht sich als Netzwerk aus internationalen Experten der Bau- und Architekturbranche mit dem Ziel, ein größeres Bewusstsein für die zentrale Rolle von Architektur, Ingenieurswesen, Raumplanung und Städtebau für eine nachhaltig gestaltete Umwelt zu schaffen. Dazu veranstaltet sie seit 2004 im Dreijahresrhythmus das interdisziplinäre *Forum for Sustainable Construction*, zuletzt eben 2016 mit rund 300 Beiträgen zum Thema „Infrastructure Space" in Detroit.

Der Aufbau des Buches begegnet der Vielschichtigkeit des Themas mit jeweils sechs bis acht Beiträgen in vier Kapiteln, deren Titel Hinweise auf die jeweils adressierte Auffassung infrastrukturellen Raums geben. Ein visueller Atlas des Berliner Architektur- und Designbüros Something Fantastic gliedert das Buch und stellt mit Fokus auf die ästhetischen Qualitäten infrastruktureller Räume assoziative Verbindungen zwischen den unterschiedlichen Beiträgen her. Zusätzlich werden die Buchteile von einem im Blattformat etwas kleineren „Document" eingeleitet und bilden eine Art programmatischen Prolog zum jeweilig folgenden Kapitel.

Unter „Scales of Infrastructure" werden in vier kurzen Essays unterschiedliche Dimensionen von Infrastruktur und deren Wirkungsbereiche einleitend behandelt. Infrastruktur wird zum einen als Faktor beschrieben, der durch seine Präsenz bzw. Nicht-präsenz für die Funktion und Leistungsfähigkeit von Räumen und Gebäuden grundlegend ist. Zum anderen prägten gerade die technologisch-infrastrukturellen Umwälzungen die Entwicklung der Architektur der letzten 200 Jahre wesentlich tiefgreifender als etwa stilistische Strömungen.

Dem Zusammenhang von Kontrollmacht, Gewalt und Infrastruktur wird im Beitrag „The Production of Territory" von Kathy Velikov und Geoffrey Thün nachgegangen, die Infrastruktur als primäre Technologie territorialer Prozesse beschreiben, die aktiv geo- und biopolitische Beziehungen (re-)strukturieren. Die bekannte Diagnose einer Auflösung der Dichotomie von Stadt und Land setzten Neil Brenner und Christian Schmid unter „Planatery Urbanization" in einen sozialräumlichen und ökologischen Kontext, wenn sie mit Verweis auf Henri Lefebvres These der vollkommenen Urbanisierung ein radikales, erkenntnistheoretisches Umdenken einfordern, das weg von der Analyse von Urbanisierungsphänomenen hin zur Untersuchung von Urbanisierungsprozessen schreiten sollte.

Während die Organisation des Forums einer thematischen Gliederung in Infrastrukturmaßstäbe – der architektonischen, urban/metropolitanen, regional/territorialen und globale/planetaren Größenordnungen entsprach – wurde für das Buch in Folge ein eher systemischer Ansatz gewählt. Marc Angélil und Cary Siress stellen in der Einleitung einen Bezug zu Jean Luc Godards Arbeit her, der beeindruckt von einem der größten Schweizer Infrastrukturprojekte – dem Staudamm Grande Dixence – den Einfluss infrastruktureller Räume auf den Alltag der modernen Gesellschaft, immer wieder filmisch thematisiert. Dieser Auffassung folgen die Titel der drei Hauptkapitel der Publikation mit „Infrastructure as Thing", „Infrastructure as Network" und „Infrastructure as Agency".

„Infrastructure as Thing" versammelt Fallbeispiele – implementierte, dezentralisierte Infrastruktur neuer Siedlungskolonien in New Dehli und Lima, Infrastruktur der Besetzung im Grenzland zwischen den USA und Mexiko, die temporäre Stadt Kumbh Mela die alle zwölf Jahre für rund acht Wochen an den Ufern des Ganges für 20 Millionen Menschen entsteht, architektonische Lösungen von Klimatisierung, Wasserversorgungs-

projekte im Niltal. Interessant ist hier auch Milicia Topalović Beitrag „Land as Project: On Territorial Construction" in dem sie einen Überblick über die Geschichte der Landgewinnung und den daraus resultierenden geopolitischen Verstrickungen gibt, die am Ende durch eine Bildstrecke des bekannten niederländischen Fotografen Bas Princen eindrücklich illustriert wird.

Im Kapitel „Infrastructure as Network" sind drei Beiträge besonders hervorzuheben: Kathy Velikov und Geoffrey Thün beschäftigen sich in ihrem Text mit unterschiedlichen Arten der Repräsentation von Infrastruktur in Karten und Diagrammen und wie durch neue Methoden der Kartografie Zusammenhänge besser erkennbar gemacht werden können, die auch neue Entwurfsansätze generieren könnten. Tom Avermaete bezieht in seinem Beitrag das Thema der Infrastruktur am deutlichsten auf den architektonischen Maßstab – was in der Summe der Beiträge durchaus erfrischend wirkt – und liefert einen Auszug aus Projekten von Constantinos A. Doxiadis, Michel Ecochard, Otto Koenigsberger, Georges Candilis, Shadrach Woods, Maxwell Fry und Jane Drew, um zu beschreiben wie (infra-)strukturelle Ansätze ein klassisches Thema in der Planung von Wohnraum bzw. von Primärstrukturen für zukünftige Wachstumsprozesse waren und nach wie vor sein können: Wohninfrastruktur als Mediator und Instrument der Stadtplanung, als Unterstützung kollektiver, öffentlicher Lebensräume etc. Ein weiterer, anregender Artikel stammt von Keller Easterling, die in „Split Screen" dafür plädiert Infrastruktur als die unsichtbare Matrix eines Operationssystems zu verstehen, dass es genau zu studieren gilt, um es klug und listig für die eigenen Zwecke zu manipulieren.

Manche der Beiträge ergänzen oder beziehen sich aufeinander, manche stehen eher für sich, zeigen dabei jedoch auf, wie weit die thematischen Verästelungen reichen können. In manchen wird der Fokus auch auf eine grafisch-narrative Vermittlung gelegt, wie zum Beispiel in „Geography and Oil: The Territory of Externatlities" von Rania Ghosn und El Hadi Jazairy, die aufbauend auf geschichtlichen Fakten, Prozesse der Ölförderung nachzeichnen und sie als mögliche Szenarien einer undefinierten Zukunft weiterdenken. Der „Visual Atlas" von Something Fantastic ist dabei auch angesichts der Fülle der Beiträge ein gutes Bindeglied. Er führt Themen auf einer intuitiveren Ebene zusammen und stellt der anspruchsvollen Dichte und enormen Breite der Texte zugleich den unbestreitbaren ästhetischen Reiz vieler Infrastrukturprojekte entgegen.

Die vielschichtige Betrachtung von Infrastruktur – der Elemente und Netzwerke die sie erzeugen aber auch der Leitungen, Verkabelungen, Straßen, Schienen, Brücken und Knotenpunkten nationaler und übernationaler Versorgungsleitungen und all der anderen Formen die sie annehmen kann – spannt ein weites Feld auf und macht die globale, soziale und politische Reichweite infrastrukturellen Raums sichtbar. An der Versammlung der vielen namhaften Experten, Universitäten und Forschungseinrichtungen, die an dem Forum in Detroit teilnahmen und im weiteren Material für die Publikation beisteuerten, lässt sich die Aktualität des Themas im avancierten Architektur- und Städtebaudiskurs nachvollziehen. Dieses Buch ermöglicht durch die Beleuchtung der vielfältigen Aspekte von Infrastruktur so etwas wie eine „graue Anatomie" (S. 21) des infrastrukturellen Raums und bietet interessante Erkenntnisse und Einblicke die dienlich sein können um die Herausforderungen in der Gestaltung und Bändigung dieses körperlosen Raums, der den gesamten Planeten umfasst und bis in den letzten Winkel unseres Alltags reicht, anzunehmen. ∎

Anatomy of Infrastructure Space

Andreas Ruby, since May 2016 director of the SAM, Swiss Architecture Museum in Basel, and Ilka Ruby—with their Berlin-based publishing house Ruby Press, founded in 2008—are the editors of this publication commemorating the 5th international LafargeHolcim Forum for Sustainable Construction. Alongside their publishing activity, both individuals also work as critics, curators, moderators, and teachers. They have edited *Infrastructure Space* as the fourth volume of the triennially held forum, following *Urban_Trans_Formation* (2007), *Re-inventing Construction* (2010), and *The Economy of Sustainable Construction* (2013). The LafargeHolcim Foundation, based in Zurich, was conceived as a network of international experts from the construction and architecture sector with the aim of raising greater awareness for the pivotal role of architecture, engineering, spatial planning, and urban development in creating a sustainably designed environment. To this end, they have been organizing the interdisciplinary Forum for Sustainable Construction every three years since 2004; the last iteration, with around 300 contributors on the theme "Infrastructure Space," took place in 2016 in Detroit.

The arrangement of the book engages with the multidimensional nature of the topic, with six to eight contributions in four chapters, whose titles hint at the differently addressed conceptions of infrastructure space. A visual atlas by Something Fantastic, an architecture and design firm from Berlin, lends structure to the book and establishes, with a focus on the aesthetic qualities of infrastructure spaces, associative connections between the various contributions. In addition, the book sections are introduced by a somewhat smaller "document" in sheet format, providing a kind of programmatic prologue to each of the subsequent chapters.

Under the chapter title "Scales of Infrastructure," the various dimensions of infrastructure and the related spheres of action are introduced in four short essays. Infrastructure is described, on the one hand, as a factor that, through its presence or non-presence, is primal for the function and performance capacity of spaces and buildings. On the other hand, the technological, infrastructural revolutions in particular have impacted the development of architecture much more profoundly over the last 200 years than, for example, stylistic currents.

The correlation between the power of control, violence, and infrastructure are examined in the contribution "The Production of Territory" by Kathy Velikov and Geoffrey Thün, who describe infrastructure as a primary technology for territorial processes that actively (re)structure geo- and biopolitical relations. Neil Brenner and Christian Schmid, in turn, situate the well-known diagnosis of a dissolution of the city/land dichotomy in a sociospatial and ecological context in their essay "Planetary Urbanization." The authors, in referencing Henri Lefebvre's theory of complete urbanization, call for a radical, epistemological change in thinking that should pursue an investigation of urbanization processes in lieu of an analysis of urbanization phenomena.

While the organization of the forum followed a thematic segmentation into scales of infrastructure—aligned to architectural, urban/metropolitan, regional/territorial, and global/planetary dimensions—a more systemic approach was taken in the book. Marc Angélil and Cary Siress establish in their introduction a relation to Jean-Luc Godard's work, whose enthusiasm for one of the largest Swiss infrastructure projects—the Grande Dixence Dam—made him thematize the influence of infrastructure spaces on everyday life within modern society in his movies. The titles of the three main chapters also follow this notion: "Infrastructure as Thing," "Infrastructure as Network," and "Infrastructure as Agency."

"Infrastructure as Thing" compiles case studies: dezentralized infrastructure implemented at new settlements in New Delhi and Lima, infrastructure of occupation in the borderland between the United States and Mexico, the temporary city Kumbh Mela, which is erected every twelve years for around eight weeks for 20 million people along the bank of the Ganges River, architectural solutions to climate control, a water supply project in the Nile Valley. Of particular interest here is Milicia Topalovic's essay "Land as Project: On Territorial Construction," in which she provides an overview of the history of land reclamation and the resulting geopolitical entanglements. The contribution concludes with an impressively illustrated array of pictures by the well-known Dutch photographer Bas Princen.

In the chapter "Infrastructure as Network," three contributions are especially notable. Kathy Velikov and Geoffrey Thün explore, in their text, the different ways of representing infrastructure in maps and diagrams, and also how new cartographic methods can help to make contexts more transparent, which might bring forth new design approaches. Tom Avermaete, in his essay, most clearly connects the topic of infrastructure to the architectural scale, which is quite refreshing considering the number of texts in the book. He presents excerpts from projects by Constantinos A. Doxiadis, Michel Ecochard, Otto Koenigsberger, Georges Candilis, Shadrach Woods, Maxwell Fry, and Jane Drew, with the aim of describing how (infra)structural approaches were (and still may be) a classic theme in the planning of living space or primary structures for future growth processes: housing infrastructure as mediator and instrument of urban planning, as a support for collective, public living spaces, et cetera. Another fascinating article was written by Keller Easterling, who in "Split Screen" argues for infrastructure to be understood as the invisible matrix of an operation system, which should be studied accurately so as to manipulate it cleverly and slyly for one's own purposes.

Some of the contributions complement or even reference each other, yet others stand alone while also showing how far the thematic bifurcations can reach. In some texts the focus is on a graphically narrative mediation of content, such as in "Geography and Oil: The Territory of Externalities" by Rania Ghosn and El Hadi Jazairy, who trace processes of oil production based on historical facts and then reconsider them as potential scenarios of an undefined future. The "Visual Atlas" by Something Fantastic serves as a good nexus, especially considering the abundance of contributions. It brings topics together on a more intuitive level and juxtaposes the ambitious density and the enormous breadth of texts with the undeniable appeal of many of the infrastructure projects.

The multifaceted view of infrastructure—of the elements and networks that create them, but also the pipes, cables, streets, railway tracks, bridges, and hubs, as well as all the other forms it might take—covers a broad sphere and makes visible the global, social, and political scope of infrastructure space. The gathering of the many renowned experts, universities, and research institutions that participated in the forum in Detroit, and that later provided material for the book, underscores the relevance of the topic in advanced architectural and urban-planning discourse. By illuminating the diverse aspects of infrastructure, this book gives rise to something like a "gray anatomy" (p. 21) of infrastructure space and offers interesting knowledge and insights which can be useful for meeting the challenges encountered when designing and taming this incorporeal space that encompasses the entire planet and extends into the smallest corners of our everyday lives. ∎

Evelyn Temmel (Translation: Dawn Michelle d'Atri)

**The Icon Project:
Architecture, Cities, and
Capitalist Globalization**
Leslie Sklair
New York: Oxford University
Press, 2017
Englisch, 342 Seiten, 55 SW-
Abbildungen, Hardcover |
English, 342 pages, 55 b/w
illustrations, hardcover
ISBN 978-0-19-046418-9
EUR 31,49 | EUR 31.49

Globalisiert und konsumistisch – Architektur des „Transnational Style"

Stefan Fink

Leslie Sklair, renommierter Soziologe und Professor emeritus der London School of Economics, legt mit *The Icon Project* – erschienen 2017 bei Oxford University Press – die Ergebnisse seiner mehr als ein Jahrzehnt andauernden Beschäftigung mit zeitgenössischen Architekturikonen und dem Phänomen „StararchitektIn" bzw. „Starachitektur" in Buchform vor. Zu diesem Thema existieren mittlerweile zahlreiche Veröffentlichungen, die mitunter selbst bereits den Status einer Ikone genießen – man denke nur an *Iconic Building* von Charles Jencks. Trotz der guten publizistischen Abdeckung ortet Sklair eine wesentliche Forschungslücke, die er mit *The Icon Project* zu schließen verspricht: die soziologische Untersuchung der Produktion von „ikonischer Architektur" sowie ihrer zentralen Rolle für die Entwicklung globalisierter Städte. Die bereits 2005 formulierte und publizierte Kernthese lautet dabei, dass der – mindestens seit Bilbao anhaltende – Boom von ikonischen Bauwerken der architektonische Ausdruck der gegenwärtigen Vorherrschaft eines transnationalen, globalisierten Kapitalismus ist.[1] Gesteuert und vorangetrieben wird dieses weltumspannende „Icon Project" von übernational agierenden Konzernen und Organisationen, die Sklair als „Transnationale kapitalistische Klasse (TCC)" identifiziert und bereits 2001 ausführlich beschrieben hat.[2]

The Icon Project gliedert sich in acht Kapitel und lässt sich grob in zwei Abschnitte einteilen. Nach der Pflichtübung eines allgemeinen Überblicks über die Geschichte des Begriffs „Ikone" in der Architektur wird in den ersten vier Kapiteln eine originäre und differenzierte Analyse ikonischer Architektur der Gegenwart geboten, die schließlich den Schlüssel für das Verständnis des aktuellen Architekturgeschehens insgesamt liefert. Als Material dienen Leslie Sklair neben der typischen Fachliteratur insgesamt 75 anonymisierte Interviews mit Akteuren aus dem Architekturbereich sowie eine umfangreiche Datensammlung,

die auf der Basis der Auswertung von wesentlichen Fachzeitschriften und Internetquellen erstellt wurde. Gestützt durch diese empirischen Daten unterscheidet Sklair zwei unterschiedliche Typen von Architekturikonen: die „typische Ikone" („Typical Icon") und die „einzigartige Ikone" („Unique Icon"). „Typische Ikonen" kopieren dabei lediglich Elemente von „einzigartigen Ikonen", die wiederum höchste architektonische Qualität und weltweite Bekanntheit vereinigen. Durch diese Differenzierung lässt sich auch die globale Architekturindustrie in drei Hauptgruppen einteilen. Die erste und kleinste Gruppe besteht aus lediglich vier StararchitektInnen („Starchitects"), die jeweils bereits zahlreiche „einzigartige Ikonen" entwerfen und realisieren konnten: Frank Gehry, Norman Foster, Rem Koolhaas und Zaha Hadid. Einer zweiten Gruppe von ungefähr 30 ArchitektInnen mit unverwechselbarer Handschrift („Signature Architects") gelingt das zumindest fallweise. Hierzu zählen beispielsweise Peter Eisenman, Bjarke Ingels/BIG oder Daniel Libeskind. Die dritte und größte Gruppe von ArchitektInnen produziert kommerziell sehr erfolgreich „typische Ikonen" in großer Zahl bei vergleichsweise geringer medialer Resonanz. Ein typischer Vertreter dafür ist das Architekturbüro Gensler. Diese Einteilung spiegelt sich auch in der Abdeckung bestimmter Bauaufgaben wider: Besonders im Bereich von Infrastrukturbauten entstehen Sklair zufolge vielfach „typische Ikonen", wie beispielsweise Brücken à la Calatrava, die er als Beispiel für derartige „berühmte Infrastrukturbauten" („Celebrity Infrastructure") anführt. Insgesamt liefert dieser erste Teil von *The Icon Project* eine teilweise verblüffende Perspektive auf das aktuelle weltweite Architekturgeschehen, die vor allem der sehr schlüssigen und überzeugenden Anwendung typisch soziologischer Methoden zu verdanken ist.

Die zweite Hälfte des Buches widmet sich anschließend der Analyse verschiedener Facetten

1 Vgl. Sklair, Leslie: „The transnational capitalist class and contemporary architecture in globalizing cities", in: *International Journal of Urban and Regional Research* 29,3 (2005), S. 485–500.

2 Vgl. Sklair, Leslie: *The transnational capitalist class*, Oxford 2001.

des „Icon Project" und folgt dabei im Wesentlichen einer antikapitalistischen Argumentation. Die im vierten Kapitel beschriebenen vier globalen StararchitektInnen unserer Zeit – Gehry, Foster, Koolhaas und Hadid – gehören (bzw. gehörten) aus dieser Perspektive betrachtet selbst der unternehmerischen Fraktion der „Transnationalen Kapitalistischen Klasse" (TCC) an. Als „prototypische" Stararchitekten und damit historische Vorläufer dieser Gruppe werden sehr plausibel Frank Lloyd Wright und Le Corbusier dargestellt. Die darauffolgenden drei Kapitel widmen sich den weiteren Fraktionen der TCC. Dabei zeigt sich, wie das „Icon Project" von der Politik durch gigantische Stadtentwicklungsprojekte – siehe China – vorangetrieben und von global agierenden Professionisten forciert wird. Zu letzteren zählen auch ArchitektInnen und StadtplanerInnen selbst. Letztendlich dienen alle diese Bemühungen dem Bereich des Konsums, der zum alleinigen Maßstab auch von Architektur und Stadtplanung wird. Damit beschreibt Sklair nicht nur seine Beobachtung, dass gegenwärtig sämtliche Gebäudefunktionen dem Verkauf untergeordnet sind und beispielsweise Museen primär als Shops funktionieren müssen, sondern verweist auf eine immanente konsumistische Logik: Architekturentwürfe müssen sich in erster Linie „verkaufen" lassen und ArchitektInnen sind davon abhängig, dass ihnen ihre auch Entwürfe „abgekauft" werden – und das gleichermaßen von Auftraggebern wie vom Fachpublikum und der Gesamtöffentlichkeit. „Verkauft" wird durch das „Icon Project" jedoch nichts anderes als das System des transnationalen, globalisierten Kapitalismus selbst. Dessen Schattenseiten, wie gravierende globale Problem gesellschaftlicher, wirtschaftlicher und ökologischer Natur, haben daher auch ArchitektInnen mitzuverantworten, da sie durch die Produktion von Architekturikonen – „einzigartigen" wie „typischen" – zur Absicherung des Status quo beitragen.

Einen Ausweg aus dieser Sackgasse skizziert Leslie Sklair im achten und letzten Kapitel von *The Icon Project*, indem er der gegenwärtigen „konsumistisch-oppressiven Stadt" („consumerist/oppressive city") das Modell einer „funktionalemanzipatorischen Stadt" („functional/emancipatory city") gegenüberstellt. Getragen würde

eine solche alternative Form eines nachhaltigen globalisierten Urbanismus durch ein Wirtschaftssystem, das auf vernetzten Konsumgenossenschaften basiert. In einer solchen Gesellschaft und in solchen Städten wäre dann auch Platz für neue Formen von Architekturikonen. Mit dieser – wie auch der Autor selbst zugibt – fantastisch anmu-

tenden Zukunftsvision schließt das trotz einiger „typischer" Versatzstücke insgesamt „einzigartige" Buch. Ob sich *The Icon Project* selbst zu einer Ikone der Architekturpublizistik entwickelt, wird sich weisen, Leslie Sklair etabliert sich jedenfalls auch im Architekturdiskurs als „unverwechselbarer" Autor. ∎

Globalized and Consumerist: Architecture of the "Transnational Style"

In *The Icon Project* — published in 2017 by the Oxford University Press — Leslie Sklair, a renowned sociologist and professor emeritus at the London School of Economics, presents in book form the results of his study of contemporary architectural icons and the phenomenon of the "starchitect" or "starchitecture," reflecting research conducted for more than a decade. Quite a few publications meanwhile exist on this topic, some of which in turn enjoy iconic status, such as *Iconic Building* by Charles Jencks. Despite the strong breadth of publications, Sklair localizes a significant gap in research, which he promises to close with *The Icon Project*: the sociological analysis of the production of "iconic architecture" along with its pivotal role for the development of globalized cities. The core statement already drafted and published in 2005 asserts that the boom of iconic structures — persisting at least since Bilbao — is the architectural expression of the current prevalence of a transnational, globalized capitalism.[1] This global "icon project" is guided and propelled by transnationally active corporations and organizations that Sklair identifies as the "transnational capitalist class (TCC)" and that he already described extensively in 2001.[2]

The Icon Project is arranged into eight chapters and can be roughly divided into two sections. After the formality of giving a general overview of the history of the term "icon" in architecture,

an original and differentiated analysis of iconic architecture of the present is offered in the first four chapters, which ultimately provides the key to understanding current architectural activity on the whole. Serving as material for Leslie Sklair, besides the typical specialist literature, are seventy-five anonymized interviews with players from the field of architecture as well as a comprehensive collection of data that was compiled based on an analysis of significant trade journals and Internet resources. Supported by this empirical data, Sklair differentiates between two types of architectural icons: the "typical icon" and the "unique icon." Typical icons merely copy elements from unique icons, which in turn unite the highest quality of architecture with global renown. This differentiation also allows the architectural industry worldwide to be split into three main groups. The first and smallest group is comprised of only four "starchitects," each able to design and build numerous unique icons: Frank Gehry, Norman Foster, Rem Koolhaas, and Zaha Hadid. The second group features around thirty architects with a distinctive style ("signature architects"),

1 See Leslie Sklair, "The Transnational Capitalist Class and Contemporary Architecture in Globalizing Cities," *International Journal of Urban and Regional Research* 29, no. 3 (September 2005), pp. 485–500.

2 See Leslie Sklair, *The Transnational Capitalist Class* (Oxford, 2001).

who have succeeded in certain cases at least, such as Peter Eisenman, Bjarke Ingels/BIG, or Daniel Libeskind. Architects from the third and largest group produce large numbers of typical icons that are very successful commercially despite the comparatively meager resonance from the media. A typical example here is the architectural office Gensler. This division is also mirrored by the coverage of certain building tasks: according to Sklair, many typical icons are created in the area of infrastructure buildings especially, such as bridges in the style of Santiago Calatrava, cited by Sklair as examples of such "celebrity infrastructure." All in all, this part of *The Icon Project* delivers a sometimes baffling perspective on the architectural activity currently in play throughout the world. This is owed in particular to the highly coherent and convincing application of typical sociological methods.

The second half of the book is then devoted solely to the analysis of different facets of the "icon project" and here essentially follows an anti-capitalist line of argumentation. Viewed from this perspective, the four starchitects of our time described in the fourth chapter—Gehry, Foster, Koolhaas, and Hadid—themselves belong (or belonged) to the entrepreneurial faction of the "transnational capitalist class" (TCC). Frank Lloyd Wright and Le Corbusier are very plausibly introduced as "prototypical" starchitects and thus historical

forerunners of this group. The subsequent three chapters are dedicated to other TCC factions. It becomes clear here that the "icon project" is furthered by politics through gigantic urban-development projects—see China—and driven by globally operating tradesmen. Counting among the latter are also the architects and urban planners themselves. Ultimately, all of these endeavors feed into the realm of consumption, which then becomes the sole criterion of architecture and urban planning as well. In this context, Sklair not only describes his observation that all building functions currently play a secondary role to sales, and that museums, for example, primarily have to function as shops; he also pays reference to an intrinsic consumerist logic: architectural designs must first and foremost be "sellable," and architects have to rely on their designs actually being "bought"—both by clients and a specialist audience, and by the public at large. Being "sold" through the "icon project," however, is nothing other than the system of translational, globalized capitalism itself. The responsibility for the related drawbacks, such as severe global problems of societal, economic, and ecological nature, is thus shared by architects since they help to sustain the status quo through the production of architectural icons that are "unique" and "typical."

One way out of this dead end is sketched by Leslie Sklair in the eighth and final chapter of

The Icon Project. He contrasts the contemporary "consumerist/oppressive city" with the model of the "functional/emancipatory city." Such an alternative form of a sustainable, globalized urbanism would be borne by an economic system that is based on networked consumer cooperatives. In such a society and in such cities, there would thus be room for new kinds of architectural icons. It is with this fantasy-filled vision of the future—as the author himself admits—that this "unique" book comes to a close, despite some "typical" clichés. It remains to be seen whether *The Icon Project* itself will become an icon of architectural journalism, but in any case Leslie Sklair has established himself in architectural discourse as a "signature" author. ∎

Stefan Fink (Translation: Dawn Michelle d'Atri)

Bauen für Demenz
Christoph Metzger
Berlin: Jovis, 2016
Deutsch, 159 Seiten, ca. 20 farbige
und 100 SW-Abbildungen, kartoniert |
German, 159 pages, ca. 20 color and
100 b/w illustrations, paperback
ISBN 978-3-86859-389-1
EUR 30,70 | EUR 29.80

Sinnlich Bauen?

Sigrid Verhovsek

Derzeit nimmt durch den soziodemografischen Wandel nicht nur der Anteil der Älteren und Ältesten zu, sondern konjunkturbedingt auch die Fachliteratur über Wohnformen und -modelle für die „Generation 55+". Ein Titel wie „Bauen für Demenz" stellt zunächst die Frage: Baut man für die Krankheit Demenz oder für jene, die an Demenz erkrankt sind? Und ist es heute noch zielführend, von einer Krankheit zu sprechen, oder sollte man Demenz als Überbegriff für Formen altersbedingter kognitiver Einschränkung, sozusagen als natürliche Begleiterscheinung des Alterns, ansehen? Gute Architektur in Form stimulierender Raumbildung ist für jedes Alter wesentlich. Aber gerade weil ältere Menschen solange wie möglich in ihrer gewohnten Umgebung bleiben möchten, ist dafür eine sorgsame Planung erforderlich, die die Möglichkeit des Alterns ausreichend berücksichtigt. Will man das erreichen, darf nicht nur von einem „notwendigen Wandel im Verständnis und in der Umsetzung von *Altenwohnen*" (S. 13) gesprochen werden, vielmehr wäre ein immer noch allzu funktionalistischer Planungsdiskurs für das Thema „Multisensorik" zu sensibilisieren.

Das ist die Zielsetzung des 2016 erschienenen Buchs *Bauen für Demenz*, das als Fortsetzung der an der BTU Cottbus entstandenen Arbeit über „Architektur und Resonanz" konzipiert ist. Autor Christoph Metzger ist kein Architekt, sondern Musikwissenschaftler, der sich allerdings im Fach Architekturtheorie habilitierte und als Professor für Kunstwissenschaft mit dem Schwerpunkt Geschichte und Theorie der Klangkunst an der Hochschule für Bildende Künste in Braunschweig tätig ist. Sein Forschungsschwerpunkt ist die Raumgestaltung nach akustischen Aspekten – schwingungsfähige und angeregte Körper als und im Raum. Bewegung ist dementsprechend auch ein zentrales Motiv in *Bauen für Demenz*.

Für Metzger bedeutet gute Architektur einen „potenziellen Bewegungsraum, der kommunikative und motorische Anregungen zu bieten vermag" (S.12) schlechte Architektur dagegen verhindert das sensorische Erleben und beengt bzw. fixiert die Menschen im Raum. In diesem Sinn erläutert Metzger im einleitenden Kapitel „Architektur neu denken" einige seiner Intentionen. In den folgenden beiden Kapiteln, „Lebenswege und Pfade" und „Körper in Bewegung – Stimulanzen", verbinden sich biografische Elemente und persönliche Erfahrungen des Autors mit Hinweisen auf die Wechselwirkungen zwischen körperlichem und räumlichem Empfinden. Das Kapitel „Alter und Orientierung" informiert über den Zusammenhang zwischen Erinnerung und Orientierung im Raum, das anschließende Kapitel „Kognitive Kompetenzen" summiert das 2017 von Metzger erscheinende Buch *Neuroarchitektur* und beschreibt detailliert, wie unser Gehirn Oberflächen und räumliche Systeme aufnimmt, um unsere Lebenswelt zu speichern und zu ordnen.

Ein besonders interessantes Kapitel des Buches behandelt die „Lokalisation akustischer Ereignisse im Raum", in dem der Autor sein Fachwissen überzeugend einsetzen kann: Die allzu selbstverständlich scheinende Tatsache des Hörens mit unseren Ohren wird hier mit der synästhetischen Empfindung von Schall mit dem ganzen Körper in seinem ganzen, außergewöhnlichen Umfang beleuchtet. Daraus resultiert auch ein „Mehr", als nur die stereotype Planungsempfehlung für „akustisch gute Räume" (hohe Sprachqualität, wenig Reflexionen und Störgeräusche). Vielmehr geht es in diesem multisensorischen Zusammenhang um die teils unbewusste Hinwendung zu Schallquellen für deren Ortung, um jene Frequenzen, die sich dem Körper über die Hohlräume in seinen Knochen mitteilen, um erinnerbare räumliche Resonanzen, die durch Oberflächenmaterialien entstehen, und schließlich um Störungen des Hörsinns bzw. ein Leben ohne akustische Orientierung. Über das akustische Rauschen (bzw. die bei gesunden Menschen dennoch funktionierende Mustererkennung) kommt der Autor hier aber überraschenderweise wieder auf das Kognitive Training zurück und endet mit Gedächtnis, Erinnern und Handeln, ohne dabei aber das eben besprochene „Hören" nochmals in Beziehung dazu zu setzen.

Metzger beschreibt nun die „Formen des Altenwohnens" und damit die bekannte und

traurige Geschichte der Altenverwahrung über mehrere Generationen. Die aktuelle Aufgabe, alten Menschen ein „wohlverdientes Leben *in Gemeinschaft* zu ermöglichen", überantwortet Metzger heute aber nicht der (Gesellschafts-) Politik, da Städte „wegen zunehmender Verdichtung und steigender Grundstückspreise" quasi gezwungen sind, ihre älteren Einwohner in weniger attraktive Lagen auszusiedeln, sondern der Bürgerschaft. Ein Leben in „Sicherheit, Orientierung und Wohnlichkeit" (S. 84) sollte für die nun kommende sechste Generation des Altenwohnens zudem durch multisensorische Architektur möglich werden, wobei der Autor in Assistenzsystemen und Smart Homes einen wesentlichen Lösungsweg sieht: „Selbständigkeit" bleibt vermeintlich gewahrt, wenn mein Heim technisch gut genug gerüstet ist, wenn nicht, falle ich Angehörigen und PflegerInnen zur Last. Natürlich sind Überwachungsfunktionen praktisch – Notfallsensoren über dem Herd, die nichtausgeschaltete Platten melden etc. – aber bei aller Technikbegeisterung: Kann es Bau- und Planungsziel sein, mit „liebevoller" Robotik menschliches oder auch tierisches Gegenüber, Berührung und Austausch zu ersetzen? Dieser Zweischneidigkeit ist sich der Autor bewusst, thematisiert sie aber nicht oder unbewusst, wenn etwa Smart-Home-Komponenten auf „diskrete" Art integriert werden, oder ein „kleiner Hofstaat" nahezu unsichtbar bleibt. Erst im letzten Kapitel klingt mit einem Zitat aus *Die Poetik des Raumes* von Bachelard eine auch kritischere Sicht auf die Technologisierung des Alltags durch: „Alles ist hier Maschine, und das intime Leben verflüchtigt sich überall." (S. 145f)

Bauen für Demenz ist für Architektinnen und Architekten mit Interesse an Aspekten der akustischen Wahrnehmung ein empfehlenswertes Buch, auch weil hier tatsächlicher Bedarf an planerischer Sensibilisierung besteht. Das Buch hilft, das Bewusstsein für die Tatsache zu schärfen, dass „altengerecht" nicht mit „barrierefrei" gleichzusetzen bzw. abzuhaken ist. Aber *Bauen für Demenz* ist weder ein Planungshandbuch noch ein praxistauglicher Leitfaden für die vielfältige und anspruchsvolle Entwurfsaufgabe „Wohnen im Alter", wie es der Titel suggeriert. Es ist eher eine Art Nachschlagewerk, in das man gerne wieder hineinblättert und umblättert – vielleicht auch wegen des Raschelns der Seiten? ∎

Sensory Building?

At present, not only is the share of elderly citizens growing due to sociodemographic change, but so is, due to market conditions, the specialist literature about housing forms and models for the "Generation 55+." A title like *Bauen für Demenz* (Building for Dementia) initially gives rise to the question: Are we building for dementia as a disease or for those who are suffering from dementia? And is it still appropriate today to speak of a disease, or should we view dementia as an umbrella term for forms of age-related cognitive impairment, as natural symptoms that accompany the aging process? Good architecture in the form of stimulating space formation is vital for all age brackets. However, especially since older people prefer to stay in a familiar environment for as long as possible, careful planning is necessary that satisfactorily takes the possibility of aging into account. In order to attain this goal, one must speak not only of a necessary shift in understanding and in the realization of *Altenwohnen* [elderly housing] (p. 13), but it is also important to sensitize planning discourse (which is all too focused on functionalism) to the issue of multisensory architecture.

This is the objective of the book *Bauen für Demenz* (forthcoming in English as *Building for Dementia*), which was conceived as a continuation of work on "Architektur und Resonanz" (Architecture and Resonance) at the Brandenburg University of Technology in Cottbus. The author Christoph Metzger is a musicologist rather than an architect, yet he conducted his postdoctoral studies in the field of architectural theory. Currently he is a professor of art history and aesthetics specialized in the history and theory of sound art at Braunschweig University of Art. His research focus is on spatial design attuned to acoustic aspects: vibratory and vivified bodies as space and in space. Accordingly, motion is a central motif in *Bauen für Demenz*.

To Metzger, good architecture means potential space for movement that aims to facilitate communicative and motoric stimuli (p. 12), while bad architecture inhibits sensorial experience and restricts or holds people in place. In this sense, Metzger explains some of his intentions in the introductory chapter called "Architektur neu denken" (Re-Thinking Architecture). In the following

two chapters, "Lebenswege und Pfade" (Life Journeys and Paths) and "Körper in Bewegung – Stimulanzen" (Bodies in Motion – Stimulants), biographical elements and the author's personal experiences are linked to information about the interdependencies between bodily and spatial sensation. The chapter "Alter und Orientierung" (Age and Orientation) informs about the correlation between memory and orientation in space, whereas the final chapter "Kognitive Kompetenzen" (Cognitive Competences) summarizes the book *Neuroarchitektur* (Neuroarchitecture) published by Metzger in 2017 and describes in detail how our brains absorb surfaces and spatial systems in order to memorize and structure our lifeworld.

An especially interesting chapter of the book involves the "Lokalisation akustischer Ereignisse im Raum" (Localization of Acoustic Events in Space), where the author is able to convincingly apply his specialist knowledge. The fact of hearing with our ears, which seems overly self-evident, is illuminated here through the synesthetic experience of acoustic noise by the entire body in its holistic, remarkable magnitude. This results in "more" than just the stereotypical planning recommendations for acoustically favorable spaces (high language quality, minimal reflections, and disruptive sounds). Moreover, this multisensory context deals with the partially subconscious turn toward sound sources in order to localize them, with those frequencies conducted into the body via bone cavities, with remembered spatial resonances that arise through surface materials,

and finally with hearing disorders or life without acoustic orientation. Surprisingly, by way of acoustic noise (or pattern recognition still functioning in healthy individuals), the author finds his way back to cognitive training and concludes with memory, recollection, and action, yet without interrelating this with the topic of "hearing" that had just been discussed.

Metzger now describes the "Formen des Altenwohnens" (Forms of Elderly Housing) and thus the familiar and sad story of custody of the elderly over several generations. He does not, however, give the present task of offering older people a well-deserved life within a community over to (social) politics—for cities are basically forced, due to increasing densification and the rising price of lots, to relocate their elderly residents to less attractive sites—but rather to the citizens themselves. A life lived in security, with good orientation, and a cozy atmosphere (p. 84) should also be made possible through multisensory architecture for the soon to be sixth generation of geriatric housing. Here, the author sees a significant solution in assistance systems and smart homes: "independence" supposedly remains intact when my home is adequately technically equipped; when not, then I will end up being a burden to relatives and caregivers. It goes without saying that monitoring functions are practical, such as emergency sensors installed above a stove to report hotplates that have not been turned off. But all enthusiasm for technology aside: Can it be a building or planning goal to replace human

or even animal counterparts, touch, and exchange with "caring" robotics? The author is full aware of this duality, yet he refrains from discussing it, or does so only unwittingly, for instance when smart home components are integrated in a "discrete" way, or when a "small court" remains almost invisible. Not until the last chapter does a more critical view of the technologization of everyday life shine through, with a quote from *The Poetics of Space* by Gaston Bachelard intimating that everything here relates to machines, and intimate life is vanishing everywhere (pp. 145–46).

Bauen für Demenz is to be recommended for architects who are interested in aspects of acoustic perception, not least because there is actually a need for sensitization to this topic in a planning context. The book helps to raise awareness of the fact that "older-generation friendly" cannot be equated or checked off with "barrier-free." Yet *Bauen für Demenz* is neither a planning handbook nor a practice-based guide for the diverse and challenging design task of creating housing for the aging population, as the title suggests. It is more of a reference-type book that readers like to leaf through and peruse—perhaps because of the rustling pages? ∎

Sigrid Verhovsek (Translation: Dawn Michelle d'Atri)

Faculty News

Faculty

Harald Egger © alumni TUGraz 1887

Danke Harald Egger
* 8. Juli 1931 | † 22. März 2017

1975 gehörte ich zur ersten Generation seiner Studierenden an der Technischen Hochschule Graz in einem Fachgebiet, das nicht unbedingt zu den Lieblingsfächern von Architekturstudierenden zählt: der Tragwerkslehre. Harald Egger hat es schnell geschafft, uns klar zu machen, dass man sich davor nicht fürchten muss, sondern – mit etwas Interesse – entdecken kann, wie spannend dieses Gebiet ist. Dabei waren seine reiche Berufserfahrung ebenso wertvoll, wie sein persönlicher Zugang zur Lehre. Diese Ausgewogenheit zwischen notwendiger Kenntnis eines Faches und dessen Anwendung im späteren Berufsleben, war beeindruckend. Harald Egger studierte von 1950 bis 1956 an der Technischen Hochschule Graz Bauingenieurwesen, wo er auch 1966 promovierte. Von 1957 bis 1960 arbeitete er als Statiker und Konstrukteur für Stahlbrücken- und Stahlhochbau bei der Waagner-Biro AG in Graz, bevor er in die Ingenieurgemeinschaft Leonhardt-Andrä nach Stuttgart wechselte.

Mit der Realisierung seiner Konstruktion für den Deutschen Pavillon für die Weltausstellung in Montreal 1967 (Architekten: Otto Frei und Rolf Gutbrod) gelang ihm bei Leonhardt-Andrä ein Meilenstein in der Entwicklung von weitgespannten Membrankonstruktionen, die mit dem Bau des Olympiadachs für die Olympischen Spiele in München 1972 (Architektur: Behnisch & Partner) einen Höhepunkt erreichte. Von 1968 bis zu seiner Berufung als Ordentlicher Universitätsprofessor für Tragwerkslehre im Jahr 1975 war Harald Egger Technischer Leiter des Österreichischen Stahlbauverbandes mit Sitz in Wien, wo er als Zivilingenieur auch ein eigenes Ingenieurbüro leitete.

Bereits 1976 wurde ich – noch als Student – Mitarbeiter seines im Aufbau befindlichen Instituts. Harald Egger war als Chef ein ähnliches Erlebnis wie als Lehrender für die Studierenden, wenn auch facettenreicher. Es gab immer klare Vorgaben, wer was warum bis wann macht. Eine geordnete Institutsstruktur, aber mit großen

persönlichen Freiräumen und einem Chef, der nicht nur der Vorstand des Instituts war, sondern ein echter Partner für seine Belegschaft. Verständnis für besondere Lebenslagen seiner MitarbeiterInnen (mit Ausnahme von Liesl Moser im Sekretariat bestand die damalige „Mannschaft" aus Herren) war ihm ebenso gegeben, wie die Schaffung einer erfolgreichen und nahezu familiären Atmosphäre am Institut. Wo er fördern oder helfen konnte, tat er das ohne Aufsehen, dafür sehr wirkungsvoll. Dies galt auch für seine Rolle in diversen anderen universitären Leitungsfunktionen. Betrachtet man die Liste der Dekane an unserer Universität, könnte man meinen, Herta Firnberg hätte das UOG 1975 für Harald Egger gemacht. Denn in den 26 Jahren, die Professor Egger mit dem Universitätsorganisationsgesetz 1975 (UOG 75) zu arbeiten hatte, war er mit zwölf Jahren als Dekan und vier Jahren als Prodekan eine jener Persönlichkeiten unserer Universität, die diese Aufgaben am längsten wahrgenommen hat und damit die Geschicke der Architekturfakultät maßgeblich beeinflusste. Auch die Studienkommission, also jenes Gremium, das für die Gestaltung der Lehrpläne zuständig ist, hat er 14 Jahre geleitet. Harald Egger stand nicht nur für die Fakultät – er war die Fakultät! Die Worte: „Geht nicht!" – waren bei ihm undenkbar! (Eher kam die Einschränkung: „nicht besonders sinnvoll …") Ein Ingenieur im besten Sinn des Wortes!

Mit seinem Tod im März 2017 hat die Technische Universität Graz eine außergewöhnlich aktive, aufmerksame akademische Persönlichkeit verloren, die zeitlebens seiner Fakultät besonders verbunden war. Uns allen bleibt die Erinnerung an einen wunderbaren und vielseitig engagierten Lehrer und besonders liebenswerten Menschen! ∎

Wolfgang Heusgen

Thank you, Harald Egger
* July 8, 1931 | † March 22, 2017

In 1975, I belonged to the first generation of his students at the Technische Hochschule Graz, in a field that doesn't necessarily count among the favorites of architecture students: structural design. Harald Egger quickly succeeded in making it clear to us that it was nothing to be afraid of, but that—with a touch of interest—one can discover how exciting this field really is. In achieving this, his rich professional experience was just as valuable as his personal approach to teaching. This balance between necessary knowledge of a subject and its application to later professional life was remarkable.

Harald Egger studied civil engineering at the Technische Hochschule Graz from 1950 to 1956, where

he also earned his doctorate in 1966. From 1957 to 1960, he worked as a structural and design engineer for steel bridge engineering and structural steelwork at the Waagner-Biro AG in Graz, before moving to the engineering partnership Leonhardt-Andrä in Stuttgart. The realization of his construction plans for the German Pavilion at the Expo 67 in Montreal (architects: Otto Frei and Rolf Gutbrod) signified, during his tenure at Leonhardt-Andrä, a milestone in the development of long-span membrane structures that culminated in the building of the so-called Olympiadach (Olympia roofing) for the 1972 Munich Olympic Games (architecture: Behnisch & Partner). From 1968 to his calling as a full university professor for structural design in the year 1975, Harald Egger served as technical director of the Austrian Steel Construction Association with its headquarters in Vienna, where he also ran his own engineering firm as a civil engineer.

Already in 1976, while still a student, I was hired as an employee in his university institute. As institute head, Harald Egger offered an experience similar to that of an instructor for students, yet marked by even more diversity. Clear guidelines were always in place, defining who was to do what by when and why. It was a well-planned institute structure, but with great personal freedom and a head who was not only director of the institute, but also a true partner for his staff. He also possessed a strong understanding for the special life circumstances of his staff members (with the exception of Liesl Moser in the secretariat, the "team" at the time was made up solely of men), as well as an ability to foster a successful and almost familial atmosphere within the institute. Whenever possible he would offer encouragement or support without attracting attention, yet still very effectively.

This also applied to his role in various other university management functions. If we run through the list of deans at our university, one might think that Herta Firnberg had written the UOG 1975 for Harald Egger. For in the twenty-six years that Professor Egger worked under the Universitätsorganisationsgesetz 1975 (UOG 75)—including as dean for twelve years and vice-dean for four years—he was one of those personalities at our university who took care of these responsibilities for the longest time and thus substantially influenced the fortune of the Department of Architecture. He even headed the Academic Commission—the body responsible for drafting curricula—for fourteen years. Harald Egger not only represented the department—he was the

department! The phrase "Not possible!" was inconceivable to him! (Instead, he might say: "Not especially sensible …") An engineer in the best sense of the word!

With his death in March 2017, Graz University of Technology lost an extraordinarily active, attentive academic personality who had been especially devoted to his department his entire life. We are all left with the memory of a wonderful and all-round engaged teacher and an especially beloved person! ∎

Wolfgang Heusgen

Für einen mehrgeschossigen Holzbau in der Stadt
Tom Kaden (TK) im Gespräch mit Daniel Gethmann (GAM)

Tom Kaden ist Professor für Architektur und Holzbau am Institut für Architekturtechnologie der Technischen Universität Graz. Die Einrichtung dieser Stiftungsprofessur wurde an der TU Graz durch die Arbeitsgemeinschaft der österreichischen Holzwirtschaft proHolz, gemeinsam mit der Wirtschaftskammer Steiermark und dem Land Steiermark ermöglicht.

Nach seinem Designstudium an der Kunsthochschule Weißensee hat sich Tom Kaden seit über 25 Jahren intensiv mit Holzbau beschäftigt und mehrere Architekturbüros mitgegründet, die sich dem Holzbau widmeten, zuletzt im Jahre 2015 das Büro Kaden + Lager mit Sitz in Berlin. Tom Kaden ist seit 2014 in der Hochschullehre zum Thema Holztechnik und Holzbau tätig und wurde 2016 als Mitglied in den Konvent der Bundesstiftung Baukultur berufen. Im Jahr 2015 erhielt sein Büro den Deutschen Holzbaupreis sowie den Vorarlberger Holzbaupreis für das Gebäude „c13".

GAM: Nach dem Ruf auf die Stiftungsprofessur Architektur und Holzbau an die TU Graz zum 1. September 2017 bist Du als Mitinhaber des Architekturbüros Kaden + Lager GmbH in Berlin mit derzeit 35 festangestellten Mitarbeitern auf zweifache Weise mit dem Thema Holzbau befasst. In diesem Zusammenhang ist es interessant, dass Du bereits vor etwa 25 Jahren Dein erstes Gebäude – als Deinen ersten Holzbau – im familiären Umfeld errichtet hast.

TK: Das ist tatsächlich so. Aufgrund meiner ersten Anstellung in einem Architekturbüro in Eisenhüttenstadt ergab sich die Notwendigkeit, in ein dörfliches Umfeld im Land Brandenburg zu ziehen. Damals galt für mich eigentlich schon der architektonische Duktus, nie ein Einfamilienhaus bauen zu wollen. Dann änderte sich meine Lebenssituation.

Ich habe während der Wende in Deutschland Design an der Kunsthochschule Berlin studiert, wo man sich damals am Lehrprinzip vom Bauhaus Dessau orientierte, also eher ein Studium Generale absolviert wurde und fachliche Grenzen zumindest in den Jahren 1988–1991 verschwammen. Ab dem dritten Semester begann – auch angeregt durch Prof. Heinz Hirdina und meine erste Reise nach Wien zu einer Ausstellung über Adolf Loos – meine intensive Hinwendung zum Raum. Eben dieser Adolf Loos bildete dann auch neben Gottfried Semper und Theo van Doesburg das Thema meiner Diplomarbeit. 1991 kam meine erste Anstellung in einem Architekturbüro. Die Aufgaben im ersten Büro waren anfangs städtebaulicher Art und bezogen sich eher auf Stahlbeton und Ziegel; Holzbau spielte keine Rolle. 1994 entstand dann mein erstes Holzhaus – eine zweigeschossige Holzrahmenkonstruktion in einem kleinen Angerdorf in Brandenburg: Eine „Wohnscheune" im Sinne des „einfachen" und „ländlichen Bauens". Genau in diese Zeit fiel auch der Beginn meiner Freiberuflichkeit, die praktisch gleichzusetzen ist mit der ausschließlichen Hinwendung zum Holzbau.

GAM: In Deiner freiberuflichen Tätigkeit bist Du ja relativ bald zum mehrgeschossigen Wohnbau übergegangen bzw. hast, was den Holzbau angeht, in dieser Richtung Konzepte entwickelt und dann deren Realisierung angestrebt. Dabei kam es zu einer interessanten Kombination von konstruktivem Holzbau und partizipativen Planungsansätzen mit den Bauherren. Wie verlief die Entwicklung der Planung von Einfamilienhäusern hin zu mehrgeschossigen, größeren Objekten?

TK: Das hängt durchaus mit dem Standort Berlin zusammen. Berlin war schon am Beginn der 2000er Jahre in einer Situation des Wohnraummangels. Es gab durch die Hauptstadtentscheidung relativ viel Zuzug und wir haben uns in unserem Berliner Büro gefragt, weshalb wir eigentlich den Werkstoff Holz nur am Stadtrand verwenden? Das damalige und immer noch aktuelle Baurecht sieht in Berlin maximal eine 5-Geschossigkeit für Holzkonstruktionen vor. Die klassische Berliner Baulücke generiert aber im Prinzip 5–8-geschossige Gebäude. Wir haben also gemeinsam mit unseren Ingenieuren darüber nachgedacht, wie das Berliner Baurecht diesbezüglich „zu interpretieren" ist.

Genau in diese Zeit fiel die Anfrage einer Baugruppe, welche ein Grundstück in Berlin gekauft hatte und dort ein 7-geschossiges Holzhaus errichten wollte. Im Jahr 2006 haben wir den Auftrag erhalten und in der Zusammenarbeit mit Julius Natterer für das Tragwerk und Dehne, Kruse für den Brandschutz das Objekt entwickelt. Wir stellten dann unsere neue baurechtliche und materialtechnische Idee der unteren Bauaufsicht vor, die unsere Pläne natürlich erst einmal ablehnte – es sei doch bitte strikt nach Berliner Baurecht zu verfahren. Letztlich ist es uns aber gelungen, auch unter kompetenter

Mithilfe der Berliner Feuerwehr, das Projekt 2008 fertigzustellen.

Nach Eröffnung des Projektes „e3" brach eine Welle des öffentlichen Interesses sprichwörtlich über uns zusammen, die sich ein kleines unbekanntes Büro zwar wünscht, auf der anderen Seite aber auch daran zerbrechen kann. Und das wäre auch fast passiert. Wir haben dann nach und nach neue Mitarbeiter gesucht und uns eine Struktur gegeben, die uns diese Aufgaben vor allem mit dem heutigen Büro Kaden + Lager bewältigen lassen.

GAM: Inwiefern fließen diese Erfahrungen aus Deiner beruflichen Tätigkeit mit dem Holzbau und auch mit mehrgeschossigen Bauformaten, mit partizipativen Elementen und natürlich auch mit der baukulturellen Historie in Deine Professur an der TU Graz ein?

TK: Es sind zunächst meine konkreten Erfahrungen aus der Büroarbeit, die ich hier einbringen möchte. Es geht natürlich in erster Linie um die bauliche Vielfalt des Werkstoffs Holz; es geht aber ebenso um die für mich wichtige Überlegung, für wen wollen wir eigentlich bauen? Da komme ich zurück zum Thema des partizipativen Bauens im Allgemeinen und zum Thema Baugruppe im Besonderen. Ab etwa 2005 spielte diese Form der städtischen Aneignung eine nicht unerhebliche Rolle, hat aber letztlich die in diese Bewegung gesetzten Hoffnungen nicht erfüllt: es gab einfach zu wenige „freie" Grundstücke, um eine kritische Masse zu erzeugen. Die Baugruppen von 2006 waren zudem andere als heute, vor zehn Jahren ging es noch um ein gewisses Maß an Miteinander, um fast genossenschaftliche Ideen. Die heutige Baugruppe ist mittlerweile eine Ansammlung von Individualisten, die für relativ wenig Geld eine höchst individuelle Wohnung realisieren wollen. Das Thema des Wirkens in die Stadt spielt de facto keine Rolle mehr und bestimmte Stadtbezirke in Berlin sind gebaute Lehrbücher der Gentrifizierung.

Wir sind also sehr froh, zunehmend für städtische Wohnungsbaugesellschaften und Genossenschaften entwerfen und bauen zu dürfen und den Holzbau somit auch dem breiten „normalen" Wohnungsmarkt anheimstellen zu können.

GAM: Welche Programmatik ergibt sich daraus hinsichtlich der Ausbildung der Studierenden?

TK: Holzbau und „das Recht auf Stadt" sind die beiden Themen, die ich an die Studenten herantragen möchte. Wir müssen uns im Klaren sein, dass der Holzbauanteil in den Städten der Schweiz, Österreichs und Deutschlands bei marginalen 2 bis 5 Prozent liegt. Und damit einher geht das Thema des industrialisierten Bauens. Per se ist der Holzbau bereits wesentlich besser aufgestellt im Sinne der Präfabrikation. Trotzdem muss man kritisch betonen, dass es keine industrielle Vereinheitlichung, keine Regeldetails und kaum Mustersysteme

gibt, an denen sich Architekten und Ausführende orientieren können und die zu vereinfachten behördlichen Genehmigungsverfahren führen könnten. Das ist ein großes Problem, über das wir auch mit der Politik reden müssen, weil ich glaube, dass die aktuellen Baurechtsnormen die Leistungsfähigkeit des modernen Holzbaus nicht mehr abbilden. Das heißt, wir müssen aufgrund rückschrittlicher Baunormen Dinge realisieren, die den Holzbau auch wirtschaftlich ins Hintertreffen geraten lassen und zwischen 2 bis zu 10 Prozent gegenüber anderen Systemen verteuern.

GAM: Deine Professur hat eine Pionier- und Vorreiterrolle in Österreich, da es die erste österreichische Professur für Architektur und Holzbau ist, vergleichbar im Ausland zum Beispiel mit der Professur für Entwerfen und Holzbau an der TU München. Neben der Sensibilisierung für Belange des Holzbaus von der Architekturlehre bis in den politischen und baurechtlichen Rahmen steht auch der Bereich des industriellen Bauens auf Deiner Agenda?

TK: Die Gratwanderung zwischen hoher architektonischer Baukultur und industriellem Bauen ist bekanntlich eine sehr schwierige. Walter Gropius hat sich sehr intensiv mit den Themen Wohnungsnot und industrielles Bauen beschäftigt. Da führt er als Beispiel möglicher Grundmodule auf einer Seite acht Ziegelformate vor und auf der nächsten Seite die mögliche Variabilität und bauliche Vielfalt, die sich aus diesen wenigen Grundmodulen ergibt. Das ist für mich ein Schlüsselbeitrag, um diese Gratwanderung zu bewältigen. Wenn Architekten vom industriellen Bauen hören, haben sie europaweit leider nur negative Assoziationen. Mir geht es um systemische Präfabrikation, eine modulare wiederholbare Grundidee, die für alle städtischen Anwendungsfälle wie Lücke, Solitär, Anbau, Aufstockung oder Implantation anzuwenden ist.

GAM: Die angesprochene Bezugnahme auf die frühen Bauhauskonzepte, in denen die Frage der Modularisierung und des industriellen Bauens erstmals gedacht wurde, ist in ihren Konsequenzen bedeutsam. Insbesondere hinsichtlich der Frage, dass seinerzeit bereits eine andere Programmatik in der Architekturlehre gefordert wurde, die einer individuellen baukünstlerischen Ausbildung zur Seite treten könnte. Daraus haben sich ganz unterschiedliche Konzepte entwickelt, deshalb stellt sich die Frage, wie Du diese Konzepte in Projektübungen an der TU Graz, also in zeitlich intensive Entwurfskurse, die ein ganzes Semester laufen, integrieren möchtest?

TK: Da ist die Bauhauspädagogik durchaus ein guter, weil nicht nur gestalterischer, sondern auch politischer Ansatz. Wenn ich über das Bauhaus spreche, meine ich nicht die Weimarer Zeit, sondern denke eher an das Dessauer Bauhaus, wo genau diese Idee des industriellen Produzierens in jedem Detail, sei es bei der Tasse, der Lampe, dem Teppich, der Türklinke oder dem Haus Gültigkeit besaß. Es ging letztlich darum,

gut gestaltete Produkte für den Massenbedarf zu entwickeln. Dass dies letztlich nicht gelungen ist, kann man dem Bauhaus nicht vorwerfen.

Aus diesen Grundsätzen eine Architektur-Lehre zu entwickeln, erfordert allgemeiner gesagt die „semesterfüllende" Beschäftigung mit den Themen Theorie, Geschichte, Gesellschaft, Material und Tektur. Daraus folgt konkret, erstens die reichhaltig vorhandenen Traditionen des mehrgeschossigen Holzbaus in den Städten zu studieren, die teilweise seit mehr als 500 Jahren schon in unterschiedlichsten funktionalen und tektonischen Situationen existieren. Des Weiteren gilt es, sich die letzten intensiven zehn Jahre des urbanen Holzbaus und natürlich wichtige aktuelle Projekte weltweit anzuschauen, diese Erkenntnisse zu abstrahieren und in eigene architektonisch-systemische Überlegung zu überführen – im Sinne von präfabrizierten Holzkonstruktionen mit fünf bis zwölf Geschossen als allgemeingültige Antwort auf die aktuellen städtebaulichen Herausforderungen.

GAM: Die Professur für Architektur und Holzbau ist in einer Dualität von Forschung und Lehre angesiedelt, wodurch bestimmte Forschungsschwerpunkte sich auch in der Lehre ansprechen lassen. So stellt sich die Frage, ob es im Hinblick auf Architektur und Holzbau neben den bereits angesprochenen Aspekten weitere Themen gibt, zu denen nach Deiner Auffassung dringend mehr Forschung betrieben werden sollte?

TK: Das Thema der industriellen Vorfertigung sehe ich immer noch am Anfang seiner Erforschung, obwohl große Betriebe in Österreich und Deutschland hier schon sehr gut unterwegs sind. Holzbau verstehe ich nicht nur als puristische Tätigkeit, bei dem ein Gebäude, überspitzt gesagt, aus einem ganzen Stamm geschnitzt wird. Ich glaube vielmehr, dass gegenwärtig das hybride Bauen, also eine Mischung von Materialien miteinander mit ihren jeweiligen Vorteilen, die spannende Zukunft des Holzbaus ist. Holzbetondecken kennt mittlerweile schon fast jeder, auch da stehen wir eigentlich noch am Anfang, während wir über andere hybride Situationen wie Holz und Glas, Holz und Stahl oder das Thema der Verklebung intensiver nachdenken müssen. Auf diesem Gebiet gibt es riesige Forschungslücken, die wir auf längere Sicht schließen möchten.

GAM: Dabei sind sicherlich zahlreiche Kooperationen mit industriellen, handwerklichen und wissenschaftlichen Partnern von Materialforschung bis zu konstruktiven Holzbaufirmen notwendig. Will die Professur für Architektur und Holzbau dazu eine bestimmte Programmatik vorgeben und so versuchen, partiale Forschungsgebiete oder konkrete Materialforschung zu vernetzen, um eine erweiterte Perspektive bzw. Innovation für Architektur und Holzbau entstehen zu lassen?

TK: Absolut. Es geht gar nicht anders und der Holzbau ist auch bereits sehr intensiv dabei. Im Prinzip reden wir ab dem ersten Strich für das Projekt X schon

mit Ingenieuren über Brandschutz und Tragwerksplanung. Das erste Projekt, das wir hier gemeinsam angehen, geht noch ein Stück weiter, da wir auch die bauwirtschaftliche Seite dazu nehmen wollen. Es gereicht uns in der öffentlichen Diskussion und auch in Teilen des Holzbaus durchaus zum Nachteil, dass wir zwischen 2 und 10 Prozent teurer sind. Wie wir schon besprochen haben, sind diese Kosten auch baurechtlich determiniert, da wir bestimmte Auflagen haben, die nicht mehr dem Stand der Technik entsprechen. Deswegen bin ich sehr froh, dass wir bei dem ersten gemeinsamen Forschungsprojekt alle relevanten und am späteren Objekt Beteiligten mit im Boot haben; passenderweise gibt es hier an der TU ja eine lange Tradition im Holzbau. Die in Graz herrschenden Bedingungen sind diesbezüglich fantastisch und so möchte ich intensiv anregen, den Dialog zwischen Architekten und Ingenieuren sehr viel intensiver zu führen. Man muss durchaus sagen, dass in der architektonischen Realität manchmal die Dinge eher linear betrachtet werden, zunächst einen Entwurf zu machen und danach erst mit einem Ingenieur über die Realisierung zu sprechen. Das ist im Holzbau ganz anders. Am besten ist es, wenn von Anfang an auch die ausführende Holzbaufirma mit am Tisch sitzt, aber das widerspricht den aktuellen markttechnischen Überlegungen, die man durchaus sehr kritisch betrachten kann.

GAM: Vielen Dank für das Gespräch. ∎

Tom Kaden © Frankl, TU Graz

For Multistory Wood Architecture in Cities
Tom Kaden (TK) in Conversation with Daniel Gethmann (GAM)

Tom Kaden is professor for architecture and timber construction at the Institute of Architecture Technology at Graz University of Technology. The establishment of this endowed professorship at TU Graz was made possible thanks to the Association of the Austrian Timber In-

dustry, proHolz, together with the Austrian Federal Economic Chamber of Styria and the Province of Styria.

Following his design education at the Weißensee Academy of Art Berlin, Tom Kaden has spent over twenty-five years intensively focused on wood architecture. He has co-founded several architecture firms devoted to wood architecture, most recently the firm Kaden + Lager in 2015, based in Berlin. Since 2014 Tom Kaden has been teaching classes at a university level on wood technology and wood architecture, and in 2016 he was appointed as a member of the convention of the Federal Foundation of Baukultur. In the year 2015, his firm received the German Wood Construction Prize and also the Vorarlberg Wood Construction Prize for the "c13" building.

GAM: In addition to accepting the endowed professorship for architecture and wood architecture at Graz University of Technology as of September 1, 2017, you are a co-owner of the architecture firm Kaden + Lager GmbH in Berlin with thirty-five salaried employees at present. So you are exploring the field of wood architecture from a dual perspective. In this context, it is interesting to note that you already erected your first building—as your first wooden structure—in a domestic setting twenty-five years ago.

TK: Yes, this is true. Because of my first job at an architecture firm in the town of Eisenhüttenstadt, it was necessary to move to a village setting in the state of Brandenburg. At the time, I was already adhering to the architectural ductus of never wanting to build a single-family home. Then my life situation changed.

Around the time that the Berlin Wall fell, I was studying design at the Academy of Art in Berlin, where the teaching orientation back then was oriented to the Bauhaus Dessau, so with more of a general studies focus and with blurred boundaries between the disciplines, at least during the years 1988 to 1991. My intensive turn to space started in the third semester—not least inspired by Prof. Heinz Hirdina and my first trip to Vienna to see an exhibition on Adolf Loos. And it was precisely Adolf Loos, together with Gottfried Semper and Theo van Doesburg, who was the topic of my diploma thesis. In 1991 I was hired for the first time by an architecture firm. The projects I worked on in the first firm were initially of an urban planning nature and dealt mostly with reinforced concrete and brick; there was no wood architecture involved. In 1994 my first wooden building was built—a two-story timber frame construction in Angerdorf a small village in Brandenburg: a "residential barn" in the sense of a "simple" and "rural building." This period coincided with the beginning of my free-

lancing activity, which can basically be equated with my new-found exclusive turn to wood architecture.

GAM: You soon turned to multistory housing in your freelance work, that is, as far as wood architecture is concerned, you developed concepts in this direction and then endeavored to bring them to fruition. This led to an interesting combination of structural wood architecture and participative planning approaches with the clients. How did the development evolve from planning single-family homes to creating larger multistory structures?

TK: This definitely had to do with Berlin as location. Already at the onset of the first decade of the twenty-first century, Berlin was experiencing a housing shortage situation. Due to the decision to make Berlin the capital city again, there was a relatively strong influx of people, and in our Berlin office we asked ourselves: Why are we only using the raw material of wood in the city outskirts? The building laws in place at the time (and still applicable today) stipulate that wood constructions may only have a maximum of five stories. But the classic empty site in Berlin principally generates a building with five to eight stories. So we brainstormed with our engineers about how the Berlin building laws were "to be interpreted" in this respect.

It was at just this time that we received an inquiry from a building group that had purchased a plot in Berlin and wanted to build a seven-story wooden building. In the year 2006 we were granted the commission and planned the building in collaboration with Julius Natterer for structural design and Dehne, Kruse for fire protection. We then presented our new idea for building laws and materials technology to the lower construction supervision authority, which of course first rejected our proposal—requesting that we proceed strictly according to the Berlin building laws. However, we were ultimately succeeding in completing the project in 2008, not least thanks to the competent assistance of the Berlin Fire Department.

After the opening of the project "e3," a wave of public interest literally engulfed us, something that a small, unknown firm may wish for, but which can also cause it to fracture. And this almost happened to us. We then sought new team members bit by bit and established an internal structure that allows us to manage these commissions, especially together with what is today the firm Kaden + Lager.

GAM: In what way do these experiences from your professional activity with wood architecture and with multistory building formats, with participative elements, and of course also with the history of building culture, flow into your professorship at Graz University of Technology?

TK: Initially, I would like to contribute my concrete experiences from working in the firm. The main issue, of course, is the structural diversity of wood as a raw material. But I am likewise concerned with the crucial consideration: For whom are we actually building? This brings me back to the topic of participative building in general and to the topic of building groups in particular. Since around 2005 this form of urban appropriation has played a quite significant role, yet ultimately it has not fulfilled the inspired hopes: there just were not enough "free" plots of land to generate a critical mass. Also, the building groups of 2006 were different than today; ten years ago there was still a certain measure of collectivity, of almost co-op-type housing ideas. Today's building groups are meanwhile a gathering of individualists who want to realize highly individual housing for relatively little money. The topic of having an effect on the city de facto no longer plays any kind of role, and certain neighborhoods in Berlin are really textbook gentrification in built form.

So we are very happy and honored to be increasingly designing and building for urban housing associations and cooperatives, and thus to also be integrating wood architecture into the broad "normal" housing market.

GAM: What objectives emerge from this when it comes to educating students?

TK: Wood architecture and "the right to the city" are the two topics I wish to bring to the students' attention. It is important to be aware that the percentage of wood architecture in the cities of Switzerland, Austria, and Germany is only at 2 to 5 percent. And this relates to the topic of industrialized building. Wood architecture per se is already significantly better positioned in terms of prefabrication. Nonetheless, one must critically emphasize that there is no industrial standardization, no details of rules, and hardly any prototype systems to which architects and executing persons can orient themselves, and which might actually lead to simplified regulatory approval processes. This is a serious problem that we must also discuss in a political context, for I believe that the current building-law norms no longer reflect the performance capacity of modern wood architecture. This means that, due to unprogressive building norms, we must create things that make wood architecture fall economically behind, and that increases related prices between 2 to 10 percent as compared to other systems.

GAM: Your professorship has a pioneering and leading role in Austria, for it is the first Austrian professorship for architecture and timber construction—comparable abroad, for example, with the professorship for architectural design and timber construction at the Technical University of Munich. Besides pursing a sensitization for wood architecture issues ranging from the study of architecture to the political and building-law context, does your agenda also include the field of industrial building?

TK: The balancing act between high architectural building culture and industrial building is of course very challenging. Walter Gropius concentrated very intensely on the issues of housing shortage and industrial building. He presented as an example of possible basic modules eight brick sizes on one page, and on the next page the possible variability and architectural diversity resulting from these few basic modules. In my eyes, this is a key contribution for mastering this balancing act. When architects hear about industrial building, unfortunately only negative associations are triggered throughout Europe. I am interested in systemic prefabrication, a modularly repeatable basic idea that is applicable to all urban application scenarios like a vacant space, solitary building, annex, addition of another story, or implantation.

GAM: The aforementioned reference to early Bauhaus concepts, where the question of modularization and industrial building was first explored, is significant in terms of its ramifications—especially with respect to the issue that in those days other objectives in architecture teaching were being postulated, which could accompany an individual architectural education. This gave rise to very different concepts, which is why the question arises as to how you plan to integrate these concepts into project exercises at Graz University of Technology, including in time-intensive design classes running over a full semester.

TK: Bauhaus pedagogy is certainly a good approach here, since it is not only design-related but also political. When I talk about the Bauhaus, I do not mean the Weimar period but I am rather thinking of the Bauhaus in Dessau, where the validity of precisely this idea of industrial production was expressed in every single detail, be it a cup, lamp, carpet, door handle, or building. The point was ultimately to develop well-designed products for the masses based on need. The Bauhaus really cannot be blamed for the fact that this was not ultimately successful.

Developing an approach to teaching architecture from these fundamentals requires, generally speaking, the "semester-filling" activity of covering the topics of theory, history, society, materials, and Tektur. This results, first, in the concrete study of widely existing traditions of multistory wood architecture in cities which have sometimes already been employed for even more than 500 years in the most diverse functional and tectonic situations. Furthermore, the idea is to look at the last intensive ten years of urban wood architecture, naturally including important current projects throughout the world, to then abstract these findings, and to translate them into one's own architectural-systemic reflections—along the lines of prefabricated wooden constructions with five to twelve stories as a universally valid response to the current urban-planning challenges.

GAM: The professorship for architecture and timber construction is situated within a duality of research and teaching, with certain research interests also being addressed in the teaching context. So the question arises as to whether, with regard to architecture and wood architecture, there are other topics besides the aspects already discussed that, in your opinion, are in strong need of more research activity?

TK: In my opinion, the issue of industrial prefabrication is still in the beginning stages of exploration, although large companies in Austria and Germany are making very good progress in this respect. I view wood architecture not only as a puristic activity where, to say it in an exaggerated way, a building is carved from an entire tree trunk. Rather, I believe that hybrid construction—meaning a blend of materials, each with its own advantages—presently represents the exciting future of wood architecture. By now, almost everyone has heard of ceilings made of a wood-concrete composite, and here, too, we are still in the early stages. And we must really start thinking more intensively about other hybrid situations like wood and glass, wood and steel, or the topic of adhesion. This area exhibits giant research gaps, which we would like to fill in the long run.

GAM: Surely many cooperative relationships with industrial, artisan, and scientific partners are necessary, from materials research to wood architecture construction companies. Does the professorship for architecture and timber construction specify particular objectives here and thus try to interconnect partial research areas or concrete materials research, in order to allow an expanded perspective or innovation for architecture and wood architecture to emerge?

TK: Absolutely. This is the only way, and wood architecture is already very strongly engaged in this process. Basically, from the first stroke onward for "Project X" we are already speaking with engineers about fire protection and structural engineering. The first project that we tackle together here takes this even a step further, because we also want to involve the building industry. It is certainly a disadvantage in public

discussion and in areas of wood architecture that we are between 2 and 10 percent more expensive. As we have already discussed, these costs are determined by the buildings laws, since we have to meet certain requirements that no longer correlate with the current state of technology. This is why I am very pleased that, for our first joint research project, all relevant parties are on board who will also be involved with the structure at a later date. Fittingly, here at Graz University of Technology there is a long tradition of working with wood architecture. The conditions prevailing in Graz are fantastic in this regard, and so it is my aim to strongly encourage architects and engineers to much more intensively engage in dialogue. One must really say that things are sometimes viewed more linearly in architectural reality, first creating a design and then starting to talk with an engineer about its realization. In a wood architecture context, this is completely different. It is best if the executing wood architecture company is also at the table from the very outset, however this contradicts the current market-related considerations, something that must be viewed very critically.

GAM: Many thanks for the talk! ∎

Gastprofessur Martin Knight

Martin Knight war im Sommersemester 2017 Gastprofessor am Institut für Tragwerksentwurf an der Technischen Universität Graz. Als einer der führenden Akteure auf dem Gebiet Brückendesign gab er im Rahmen der Lehrveranstaltungen „Neue Werkstoffe und Bauweisen von Tragkonstruktionen" und dem Masterstudio den Studierenden die Möglichkeit, eine Fußgängerbrücke bzw. Brücke für RadfahrerInnen für die slowenische Stadt Maribor zu entwerfen. Der integrative Designprozess, der durch den Ort mit seiner Geschichte und anspruchsvolle Fragen der technologischen Herangehensweise ausgezeichnet war, hat durch den Dialog zwischen ArchitektInnen und IngenieurInnen Platz für hervorragende Projekte geschaffen. Den Studierenden wurde Wissen auf hohem Niveau über Materialeigenschaften, statische Verhältnisse, Ökologie, energetische Aspekte des Bauens und Technologie nähergebracht.

Martin Knight ist ein britischer Architekt, der 2006 das Büro Knight Architects gründete, das viele außergewöhnliche und preisgekrönte Brückenprojekte weltweit entworfen hat. Zuvor war er neun Jahre bei Wilkinson Eyre Architects tätig. Seine Entwurfsphilosophie setzt auf die praktische Umsetzung künstlerischer

Prinzipien, die in unterschiedlichsten Dimensionen – von einer kleinen Fußgängerbrücke bis zu mächtigen Infrastrukturbauwerken wie Autobahnbrücken – zur Anwendung kommen. Er ist Mitglied des Royal Institute of British Architects (RIBA) und der International Association for Bridge and Structural Engineering (IABSE) und wurde im Jahr 2013 zum „Companion of the Institution of Structural Engineers" ernannt. ∎

Andreas Trummer

Martin Knight © Helena Chateau/Knight

Visiting Professor Martin Knight

In summer semester 2017, Martin Knight was a guest professor in the Institute of Structural Design at Graz University of Technology. As one of the leading players in the field of bridge design, he taught the class "New Materials and Methods of Building Supporting Structures" and the master studio, giving the students an opportunity to design a bridge for pedestrians and cyclists for the Slovenian city of Maribor. The integrative design process, which was impacted by the town with its history and by challenging questions related to the technological approach taken, has created room for outstanding projects through dialogue among architects and engineers. The students were familiarized with high-level knowledge about material properties, static relationships, ecology, and energy-related aspects of building and technology.

Martin Knight is a British architect who founded Knight Architects in 2006, which has designed many unique and award-winning bridge projects around the world. He had previously worked at Wilkinson Eyre Architects for nine years. His design philosophy is focused on the practical implementation of artistic principles that are applied in highly varying dimensions—from a small footbridge to massive infrastructure projects like highway bridges. He is a member of the Royal Institute of British Architects (RIBA) and the International Association for Bridge and Structural Engineering (IABSE), and in the year 2013 he was named "Companion of the Institution of Structural Engineers." ∎

Andreas Trummer

Gastprofessur Boštjan Vuga

Im Rahmen einer Gastprofessur am Institut für Architekturtechnologie hat der slowenische Architekt Boštjan Vuga im Sommersemester 2017 die Projektübung „Haludovo: Possible Futures" abgehalten. In Kollaboration mit den Architekturfakultäten in Zagreb und Ljubljana entwickelten die Studierenden Entwicklungsszenarien für das von Boris Magaš's geplante und heute verlassene Hotel „Haludovo Palace" auf der kroatischen Insel Krk. Die Ergebnisse der Lehrveranstaltung wurden am 22. September 2017 im Kunstkino in Rijeka gezeigt. Ausgewählte Arbeiten sollen auch in einem Buch veröffentlicht werden, um die architektonische Reaktivierung des Hotelkomplexes anzuregen.

Boštjan Vuga hat an der Architekturfakultät in Ljubljana und der Architectural Association in London studiert. Gemeinsam mit Jurij Sadar hat er 1996 das Büro SADAR+VUGA gegründet. Er hat außerdem am Berlage Institute in Rotterdam, am IAAC in Barcelona, an der TU Berlin, der MSA in Münster und der Architekturfakultät in Ljubljana unterrichtet. Zudem war er 2014 als Co-Kurator des Pavillons von Montenegro bei der 14. Architekturbiennale in Venedig beteiligt. Seit 2014 leitet er das Kuratorium des Museums für Architektur und Design von Slowenien (MAO). ∎

Žiga Kreševič

Visiting Professor Boštjan Vuga

During the summer semester 2017, the Institute of Architecture Technology was hosting Boštjan Vuga as a visiting professor. His master studio, "Haludovo:

Boštjan Viga © Fulvio Grissoni

Possible Futures" was organized as a collaborative studio with the architecture faculties from Zagreb and Ljubljana in which students had to propose a possible future development for the hotel complex "Haludovo Palace" (designed by Boris Magaš's) which today lies abandoned on the island of Krk. The results were presented on September 22th, 2017 in the Croatian Art Cinema in Rijeka and selected projects will also be featured in a book, hoping to spark the reactivation of the hotel complex.

Boštjan Vuga studied at the Faculty of Architecture in Ljubljana and at the AA School of Architecture in London. In 1996, together with Jurij Sadar, he founded the architectural office SADAR+VUGA. He has taught at the Berlage Institute Rotterdam, the IAAC Barcelona, the Faculty of Architecture Ljubljana, TU Berlin and MSA Muenster. Boštjan Vuga also participated as a co-curator at the Montenegro Pavilion, at the 14th Venice Biennale of Architecture, Venice 2014. Since 2014, he has been president of the council of the MAO Museum of Architecture and Design of Slovenia. ▪

Žiga Kreševič

Gastprofessorin Femke Snelting

Als Gastprofessorin des Instituts für Zeitgenössische Kunst (IZK) bot Femke Snelting im Sommersemester 2017 den Workshop „Let's Build a Library Together!" in Kooperation mit Marcell Mars und Tomislav Medak an. Dem Slogan: „Dies ist eine Zeit der Krise und des Kampfes um öffentliche Bibliotheken. Wir wollen gemeinsam eine Bibliothek errichten" folgend, brachte dieser Workshop Medientheorie, (die Praxis eines Laien-) Bibliothekswesen(s), politischen Aktivismus, Design und Architektur in einen Dialog mit den realen physischen und institutionellen/schulischen Bedingungen des IZK . Der Workshop basiert auf „Amateur Librian – Ein Kurs in Kritischer Pädagogik", einem Vorschlag für ein Curriculum im Laienbibliothekswesen.

Femke Snelting entwickelt Projekte an der Schnittstelle zwischen Design, Feminismus und freier Software. Sie ist Mitglied von Constant, einer Künstler-geführten Non-Profit-Organisation in Brüssel und Mitbegründerin des Design/Forschungsteams Open Source Publishing (OSP), sowie der Libre Graphics Research Unit. Diese erforscht, wie digitale Tools und kreative Praxis sich wechselseitig konstruieren. Mit den Abgeordneten Jara Rocha, Seda Gürses und Miriyam Aouragh ist sie Teil der Darmstadt Delegation, die mit der Erforschung techno-politischer und sozio-emotionaler Beziehungen zwischen Aktivismus und technologischer Praxis betraut ist. Femke Snelting engagiert sich in der „Mondotheque", einem gemeinschaftlichen Projekt, das sich um den Nachlass des belgischen Pioniers des Informationsmanagements, Paul Otlet, kümmert. Sie war Art, Science and Business Fellow an der Akademie Schloss Solitude und unterrichtet zur Zeit am The Piet Zwart Institute (Experimentelles Publizieren in Rotterdam) und a.pass (Fortgeschrittene Performance und Szenografiestudien, Brüssel). ▪

Dubravka Sekulić

Femke Snelting © Femke Snelting

Visiting Professor Femke Snelting

As a visiting professor at the Institute of Contemporary Art (IZK) in the summer semester 2017 Femke Snelting offered the workshop "Let's Build a Library Together!" in cooperation with Marcell Mars and Tomislav Medak. Following the slogan, "this is a time of crisis and struggles for public libraries. We want to build a library together.", this transdisciplinary research workshop combines media theory, (practice of an amateur) librarianship, political activism, design and architecture in dialogue with the real physical and institutional/educational conditions of IZK. The workshop is based on "Amateur Librarian – A Course in Critical Pedagogy," a proposal for a *curriculum* in *amateur librarianship*.

Femke Snelting develops projects at the intersection of design, feminism and Free Software. She is a member of Constant, a non-profit, artist-run organisation based in Brussels. She co-initiated the design/research team Open Source Publishing (OSP) and the Libre Graphics Research Unit to investigate the way digital tools and creative practice might co-construct each other. With delegates Jara Rocha, Seda Gürses and Miriyam Aouragh she takes part in the Darmstadt Delegation, assigned to explore techno-political and socio-emotional relationships between activist and technological practice. Femke is involved in Mondotheque, a collaborative project that grew out of a shared concern with the heritage of the Belgian pioneer of information science, Paul Otlet. She was an Art, Science and Business fellow at Akademie Schloss Solitude and currently teaches at The Piet Zwart Institute (experimental publishing, Rotterdam) and a.pass (advanced performance and scenography studies, Brussels). ▪

Dubravka Sekulić

Research

Die Tempelanlage von Alchi in Ladakh/Nordindien. Räumliches Modell auf Basis digitaler Vermessungen | Temple complex of Alchi in Ladakh/North India, Spatial model based on digital calibrations, TU Graz 2013 © Neuwirth/Auer, TU Graz 2013

Buddhistische Architektur im Westlichen Himalaya: Architekturforschung in Dolpo/Nepal

Ein Projekt des **Instituts für Architekturtheorie, Kunst- und Kulturwissenschaften**

Seit 1999 wurden an der Technischen Universität Graz mehrere Forschungsprojekte zum Thema „Buddhistische Architektur im Westlichen Himalaya" durchgeführt, die vom FWF finanziert wurden. Diese Projekte konzentrierten sich auf Sakralbauten des Königreiches Guge-Purang, das zwischen dem 10. und 15. Jahrhundert die politische und religiöse Macht in Westtibet repräsentierte. Die anhaltende Bedrohung dieser signifikanten Baudenkmäler macht eine Fortsetzung der Forschungstätigkeit dringend erforderlich. Nach wesentlichen Dokumentationen in Nordindien und Westtibet konzentriert sich dieses Projekt nun auf Nepal, insbesondere auf das Gebiet von Dolpo, um das bestehende Forschungsmaterial zu erweitern.

Dolpo ist eine kulturell tibetisch geprägte Region und umfasst vier Täler, die im Grenzgebiet zur Autonomen Region Tibet (China) liegen. Über 90 Prozent dieses Gebiets liegen auf einer Seehöhe von über 3500 Metern. Weniger als 5000 Menschen leben hier, wodurch Dolpo die geringste Bevölkerungsdichte aller nepalesischen Gebiete aufweist. Das Forschungsprojekt wird sich auf das Gebiet des Nankhong-Tales im Norden Dolpos konzentrieren, da sich hier der älteste Baubestand erhalten hat.

Im Rahmen der geplanten Feldforschung soll zuerst eine umfangreiche Bestandsdokumentation der unterschiedlichen Sakralbauten dieses Gebiets erhoben werden. Im folgenden Schritt werden ausgewählte, signifikante Bauwerke mit einer angemessenen Genauigkeit vermessen und dokumentiert. Das ausgearbeitete Material wird in der Folge eine eingehende Analyse der Bauwerke ermöglichen und aufzeigen, wie sich verschiede-ne Bautypen in diesem Gebiet herausgebildet haben. Dadurch kann die Grundlage für zukünftige Bauforschung und notwendige Restaurierungsmaßnahmen in Dolpo erarbeitet werden.

Die Resultate des Forschungsprojekts sollen außerdem die kontextuellen Zusammenhänge und Besonderheiten der Buddhistischen Architektur in Nepal, Nordindien und Westtibet verdeutlichen und so einen weiteren Schritt zur Erstellung einer umfangreichen Typologie der frühen Buddhistischen Architektur im Westlichen Himalaya leisten. ∎

Projektlaufzeit:
April 2018 bis März 2021
Finanzierung:
Fonds der Förderung der wissenschaftlichen Forschung (FWF)
(Fördersumme EUR 375.032,70)
Projektteam:
Anselm Wagner (Leitung), Carmen Auer, Holger Neuwirth
Projektpartner:
Christian Luczanits, School of Oriental and African Studies (SOAS) an der Universität von London
www.archresearch.tugraz.at

Carmen Elisabeth Auer

Buddhist Architecture in the Western Himalaya: Architectural Research in Dolpo, Nepal

A project by the **Institute of Architectural Theory, History of Art and Cultural Studies**

Since 1999 several research projects have been carried out at Graz University of Technology on the topic "Buddhist Architecture in the Western Himalaya,"

funded by the Austrian Science Fund (FWF). These projects concentrated on sacral architecture from the Guge-Purang kingdom, which represented political and religious power in western Tibet between the tenth and fifteenth centuries. The continued endangerment of these important architectural monuments makes a continuation of the research activity vital. After compiling essential documentation in northern India and western Tibet, this project is now focusing on Nepal, especially the Dolpo region, in order to expand the existing research material.

Dolpo is a region culturally influenced by Tibet and encompasses four valleys situated in the territory bordering the Tibet Autonomous Region (China). More than 90 percent of this area is over 3,500 meters above sea level. Less than 5,000 people reside here, with Dolpo exhibiting the lowest population density of all Nepalese areas. The research project will be concentrated on the Nankhong Valley in northern Dolpo, since it is here that the oldest architectural structures remain.

In the scope of the planned field research, the idea is to first gather extensive documentation of the state of the various sacral buildings in this area. In a subsequent step, certain significant structures will be surveyed and documented with appropriate precision. The prepared material will then enable a detailed analysis of the architectural structures and show how different building types evolved in this region. This will lay a foundation for future building research and for the necessary restoration measures in Dolpo.

The results of this research project are also intended to illustrate the context-related correlations and features of Buddhist architecture in Nepal, northern India, and western Tibet. This represents another step in the establishment of a comprehensive typology of early Buddhist architecture in the Western Himalaya. ∎

Project duration:
April 2018 to March 2021
Funding:
Austrian Science Fund (FWF)
(Funding amount: EUR 375,032.70)
Project team:
Anselm Wagner (lead), Carmen Auer, Holger Neuwirth
Project partner:
Christian Luczanits, School of Oriental and African Studies (SOAS) at the University of London
www.archresearch.tugraz.at

Carmen Elisabeth Auer

Sonneneinstrahlung auf eine Fassadenfläche | Solar radiation on a facade © Martin Kaftan, IGE 2017

VITALITY – Design Regeln für BIPV im frühen Planungsstadium
Institut für Gebäude und Energie

Für die Gebäudeplanung im urbanen Raum ist eine möglichst frühe und integrale Planungsbegleitung für die erfolgreiche Umsetzung Bauwerkintegrierter Photovoltaik (BIPV) nötig. Ein bestehendes Hemmnis sind fehlende Tools und einfach anzuwendende Regeln zur Planungsbegleitung, vor allem für Nicht-PV-Spezialisten im frühen Planungsstadium. Ziel des Projekts „Vitality" ist es, Designregeln und Parameterbereiche technisch sinnvoller Planung für exemplarische Use-Cases mit urbanem Kontext zu entwickeln. In diesem Zusammenhang wird der Einfluss von BIPV auf weitere Planungsparameter von Gebäuden (wie thermischer Komfort, Elektrischer Ertrag) untersucht. Dabei spielt die Nutzbarkeit oder Relevanz für BIM-Systeme eine wesentliche Rolle.

Gemäß der Definition der Klimaziele der Europäischen Union 2009, 2011 und 2015 ist der flächendeckende Einsatz von Bauwerkintegrierter Photovoltaik unumgänglich. Ebenso erfordert die Europäische Gebäuderichtlinie den verpflichtenden Einsatz von BIPV oder anderer aktiver energieerzeugender Maßnahmen. Als wesentlicher Punkt wird auf der Technologieplattform Photovoltaik (TPPV) die Einbeziehung der BIPV Planung in die Neubauplanung als Chance für die österreichische BIPV Entwicklung genannt.

„Vitality" liefert einen wichtigen Schritt um diese Anforderungen und Ziele zu erreichen. Es zielt darauf ab, Tools für die integrale Planung zu ermöglichen. „Vitality" erzeugt numerische aber vereinfachte Regeln, die eine verfeinerte BIPV-Planung schon im Designprozess erlauben. ∎

Projektlaufzeit:
Februar 2017 bis Januar 2019
Finanzierung:
FFG; Klima- und Energiefonds
(Fördersumme TU Graz: EUR 83.062; Fördersumme gesamt: EUR 343.735)
Projektpartner:
AIT Austrian Institute of Technology GmbH (Konsortialführung) (AT)
EURAC Research Bozen – Institute für Erneuerbare Energie (IT)
Lund University – Faculty of Engineering, Department of Architecture and Built Environment (SE)
teamgmi Ingenieurbüro GmbH (AT)
ATB-Becker e.U. (AT)
Projektteam:
AIT (Konsortialführung): Tim Selke, Markus Rennhofer, Thomas Schlager, Sean Phillipp
TU Graz: Sebastian Sautter, Martin Kaftan
EURAC: Marco Lovati
Lund University: Jouri Kanters
teamgmi: Anita Preisler
ATB-Becker: Gernot Becker
http://www.ige.tugraz.at/vitality.html#forschung_vit

Sebastian Sautter

VITALITY – Design Rules for BIPV in the Early Planning Phase
Institute of Buildings and Energy

In the planning process of buildings an early and integrative planning guideline is required to successfully

implement Building-Integrated Photovoltaics (BIPV). Currently existing shortcomings are a lack of tools and a lack of a set of rules that can be easily applied in order to support planners at an early stage and who are not experienced in the field of photovoltaics. VITALITY aims at developing design rules and parameter areas for technically founded planning to be applied in exemplary use-cases within an urban context. Further, the influence of BIPV on further planning parameters of buildings (like thermal comfort, electrical yield) are evaluated. The usability and relevance for Building Information Modeling (BIM systems) will play an essential role in the project.

According to the definitions of Climate Targets of the European Union (2009, 2011 and 2015), the area-wide implementation of BIPV is a must. At the same time, the European Building Directive foresees the compulsory implementation of BIPV or similar active energy generation measures. The Austrian Technology Platform Photovoltaics (TPPV) has defined the integration of BIPV in the planning of new buildings as an important research topic and central cornerstone to foster the Austrian BIPV market. VITALITY addresses the elaboration of tools for an integrative planning process, offering an important step in the right direction. The results of the project are a set of numerical but simplified rules that allow a refined BIPV planning already during the design process. ∎

Project duration:
February 2017 to January 2019
Funding:
Austrian Research Promotion Agency (FFG); Climate and Energy Fund
(Funding amount, TU Graz: EUR 83.062; total funding amount: EUR 343.735)
Project partners:
AIT Austrian Institute of Technology GmbH
(Konsortialführung) (AT)
EURAC research Bozen – Institute for Renewable Energy (IT)
Lund University – Faculty of Engineering, Department of Architecture and Built Environment (SE)
teamgmi Ingenieurbüro GmbH (AT)
ATB-Becker e.U. (AT)
Projektteam:
AIT (consortium manager): Tim Selke, Markus Rennhofer, Thomas Schlager, Sean Phillipp
TU Graz: Sebastian Sautter, Martin Kaftan
EURAC: Marco Lovati
Lund University: Jouri Kanters

teamgmi: Anita Preisler
ATB-Becker: Gernot Becker
http://www.ige.tugraz.at/vitality.html#forschung_vit

Sebastian Sautter

„Das Unberechenbare"
Institut für Zeitgenössische Kunst

Das kunstbasierte Forschungsprojekt „The Incomputable", finanziert vom FWF-PEEK Programm, untersucht die Genealogie der Wechselbeziehung zwischen Kybernetik und Subjektivität und die Resonanzen dieser Beziehung in den zeitgenössischen Formen datengesteuerter Kultur. Deren neue epistemische Regime konfrontieren die menschliche Subjektivität mit einer Dialektik paradoxer „asymmetrischer Symmetrie" wenn es um Verfahren der Selbstregulierung, Kontrolle und Transparenz geht. Das Langzeitforschungsprojekt unter der Leitung von Antonia Majača, wurde in Zusammenarbeit mit einer Gruppe internationaler Gesprächspartner und Mitarbeiter wie Luciana Parisi, Tiziana Terranova, Susan Schuppli und anderen entwickelt. Es wird aus mehreren transdisziplinären Workshops bestehen und in einer umfassenden Publikation und Konferenz in Graz enden. ∎

Projektlaufzeit:
März 2016 bis Juni 2020
Finanzierung:
Fonds zur Förderung der wissenschaftlichen Forschung (FWF)
Programm für kunstbasierte Forschung (PEEK)
(Fördersumme: EUR 336.753)
Antragsteller/Projektleitung:
Institut für Zeitgenössische Kunst (IZK), TU Graz
Projektleitung: Antonia Majača, Kuratorin und Kunsthistorikerin
Projektassistenz: Dejan Marković, Bildender Künstler
Projektpartner:
Zentrum für Architekturforschung, Goldsmiths University of London (GB)
Staatliche Hochschule für Gestaltung Karlsruhe (DE)
Department of Human and Social Sciences, University of Naples (IT)
Namur Digital Institute (NADI), Université de Namur (BE)
Zentrum für Kulturwissenschaften, Goldsmiths University of London (GB)

Antonia Majača

"The Incomputable"
Institute of Contemporary Art

The arts-based research project "The Incomputable," funded by the FWF – PEEK Program, will investigate the genealogies of interrelation between cybernetics and subjectivity, and the resonances of this relation within the contemporary conditions of data-driven culture. In this new epistemic regime, human subjectivity enters into a dialectic of paradoxical "asymmetric symmetry" when it comes to regimes of self-regulation, control and transparency. The long term research project, led by Antonia Majača and developed in collaboration with a group of international interlocutors and collaborators, including Luciana Parisi, Tiziana Terranova, Susan Schuppli and others, will consist of several transdisciplinary workshops and result in a comprehensive publication and conference in Graz. ∎

Project duration:
March 2016 to June 2020
Funding:
The Austrian Science Fund (FWF)
Programme for Arts-based Research (PEEK)
(Funding amount: EUR 336.753)
Submitter:
IZK Institute of Contemporary Art, TU Graz
Project leader: Antonia Majača, curator and art historian
Project assistant: Dejan Marković, visual artist
Project partners:
Centre for Research Architecture, Goldsmiths University of London (GB)
Staatliche Hochschule für Gestaltung Karlsruhe (DE)
Department of Human and Social Sciences, University of Naples (IT)
Namur Digital Institute (NADI), Université de Namur (BE)
Centre for Cultural Studies, Goldsmiths University of London (GB)

Antonia Majača

SONTE – Sondierung Smarte Modernisierung Terrassenhaussiedlung
Institut für Gebäude und Energie

Die Terrassenhaussiedlung in Graz-St. Peter ist mit über 500 Wohnungen und mehr als 1.000 BewohnerInnen

Terrassenhaussiedlung Graz, Foto- und Thermografie | Photographic and thermographic survey © Alexander Eberl, IGE auf Basis eines Fotos von Walter Kuschel, Werkgruppe Graz | Alexander Eberl, IGE based on a photo by Walter Kuschel, Werkgruppe Graz

die größte und international bekannteste Wohnsiedlung der Steiermark. Nach über 40-jähriger Nutzung der Siedlung stellt sich die Frage einer smarten Modernisierung. Die „SONdierungsstudie TErrassenhaussiedlung – SONTE" setzt sich zum Ziel, eine Entscheidungshilfe zur Abschätzung der Modernisierungsmöglichkeiten von partizipativ entworfenen Bestandswohngebäuden zu entwickeln. Die Terrassenhaussiedlung Graz-St. Peter dient dabei als Entwicklungs- und Testfeld zugleich. Mittels zeitgemäßer Beteiligungsmethoden wird die bestehende BewohnerInnengemeinschaft für den Dialog mit Planern und Technikern aktiviert und intensiv in die Ausarbeitung des Konzeptes eingebunden. Thematisch werden die Bereiche Gebäude und Energie, Grün- und Freiraum, urbane Mobilität sowie Information und Kommunikation behandelt. Das Institut für Gebäude und Energie befasst sich mit der thermischen Sanierung der Wohnanlage. Es werden Sanierungsszenarien entwickelt, die dem baukulturellen Wert der Anlage angemessen sind und ihren architektonischen Ausdruck möglichst wenig beeinträchtigen. Besonderes Augenmerk liegt dabei auf der konstruktionsbedingten Wärmebrückenproblematik. ∎

Projektlaufzeit:
März 2017 bis Februar 2018
Finanzierung:
Österreichische Forschungsförderungsgesellschaft (FFG); Klima- und Energiefonds
(Fördersumme TU Graz: EUR 29.991; Fördersumme gesamt: EUR 186.554)
Projektpartner:
Institut für Wohnbauforschung, Graz (Konsortialführung)
StadtLABOR Graz – Innovationen für urbane Lebensqualität
NEXT Vertriebs- und Handels GmbH, Graz
Haus der Architektur (HDA), Graz
Architekt Eugen Gross
Karoline Kreimer-Hartmann

Projektteam:
Konsortialführung: Andrea Jany und Christina Kelz-Flitsch, Institut für Wohnbauforschung, Graz
Arbeitsbereich Gebäude und Energie: Alexander Eberl und Edina Majdanac, Institut für Gebäude und Energie, TU Graz; Eugen Gross, ehemaliges Mitglied der Werkgruppe Graz
Arbeitsbereich Grün- und Freiraum: Nana Pötsch, Stadtlabor Graz und Karoline Kreimer-Hartmann
Arbeitsbereich urbane/nachhaltige Mobilität: Christina Freitag, NEXT Vertriebs- und Handels GmbH, Graz
Arbeitsbereich Information und Kommunikation: Andrea Jany und Christina Kelz-Flitsch, Institut für Wohnbauforschung, Graz; Pierre Flitsch, Markus Bogensberger, HDA Graz, Nana Pötsch, Stadtlabor, Graz
http://www.smartcities.at/stadt-projekte/smart-cities/smarte-modernisierung-terrassenhaussiedlung-graz/
http://www.ige.tugraz.at/sonte.html#forschung_sonte

Alexander Eberl

SONTE – Smart Modernization Terrassenhaussiedlung
Institute of Buildings and Energy

The *Terrassenhaussiedlung* in Graz-St. Peter is the largest and internationally most renowned housing estate of Styria, containing more than 500 apartments and more than 1,000 residents. After 40 years of use, the issue of modernization in terms of energy and sustainability is now being assessed. The exploratory study "Smart Modernization Terrassenhaussiedlung – SONTE" has the goal to develop a general guideline for determining the modernization possibilities of participatory inventory designed residential buildings. The *Terrassenhaus-*

siedlung Graz-St. Peter serves as a development and test bed at the same time. By using modern participation techniques, the existing community will be re-enabled to connect with key stakeholders and intensively involved in the drafting of the modernization concept. As relevant fields of action, the focus is on building and energy, green and open spaces, urban mobility as well as information and communication. The role of the Institute of Buildings and Energy is to develop thermal rehabilitation strategies for the estate. Rehabilitation scenarios will be developed which are appropriate to the building's cultural value and which do not compromise its architectural expression. Special attention is given to the many construction-related thermal bridges. ∎

Project Duration:
March 2017 to February 2018
Funding:
Austrian Research Promotion Agency (FFG); Climate and Energy Fund
(Funding amount, TU Graz: EUR 29,991; total funding amount: EUR 186,554)
Project partners:
Institute of Housing Research, Graz (consortium leadership)
The City LAB, Graz
NEXT Vertriebs- und Handels GmbH, Graz
Haus der Architektur (HDA), Graz
Eugen Gross, Dipl.-Ing. architect
Karoline Kreimer-Hartmann, Mag.
Project team:
Consortium leadership: Andrea Jany and Christina Kelz-Flitsch, Institute of Housing Research, Graz
Workgroup building and energy: Alexander Eberl and Edina Majdanac, Institute of Buildings and Energy, Graz University of Technology; Eugen Gross, former member of Werkgruppe Graz
Workgroup green and open space: Nana Pötsch, The City LAB, Graz and Karoline Kreimer-Hartmann;
Workgroup urban/sustainable mobility: Christina Freitag, NEXT Vertriebs- und Handels GmbH, Graz
Workgroup information and communication: Andrea Jany and Christina Kelz-Flitsch, Institute of Housing Research, Graz; Pierre Flitsch, Markus Bogensberger, HDA Graz, Nana Pötsch, The City LAB, Graz
http://www.smartcities.at/stadt-projekte/smart-cities/smarte-modernisierung-terrassenhaussiedlung-graz/
http://www.ige.tugraz.at/en/sonte.html#forschung_sonte

Alexander Eberl

G2G Innovationsachse Graz-Gleisdorf

Institut für Städtebau

Die prognostizierte dynamische Bevölkerungs- und Wirtschaftsentwicklung für den urbanen Agglomerationsraum um Graz stellt gesellschaftliche Herausforderungen hinsichtlich des Ressourcenverbrauchs, Ver- und Entsorgungsinfrastruktur, Mobilität und leistbarem Wohnraum dar. Das S-Bahnnetz der Steiermark, das die Landeshauptstadt Graz mit den umliegenden Gemeinden und Städten verbindet, besitzt ein immenses Zukunftspotenzial.

Ziel des Projekts war die Entwicklung von Test- und Demonstrationsgebieten entlang der Innovationsachse Graz-Gleisdorf. Für ausgewählte Entwicklungsvorhaben im Umfeld von S-Bahnknoten wurde ein Innovations- und Technologieportfolio mit dem Fokus auf die Bereiche smarter Stadtraum, kompakte Siedlungsstruktur, Nutzungsmix - Stadt der kurzen Wege, intermodale Mobilität, Energie und Gebäudetechnologie entwickelt, sowie die Umsetzung als Test- bzw. Demonstrationsgebiete vorbereitet. Es wurden Maßnahmen und Technologien erarbeitet, die im Umfeld von S-Bahnhaltestationen vorgenommen werden können, um die Attraktivität dieser Bereiche zu erhöhen und damit den öffentlichen Verkehr zu stärken, sowie einen Beitrag zum Erreichen der nationalen und internationalen Klimaziele zu leisten. Besonderen Stellenwert für die urbane nachhaltige Entwicklung der Innovationsachse Graz-Gleisdorf haben die Grundprinzipien von „T.O.D. Transit Oriented Development". T.O.D. befasst sich mit der Zielsetzung einer optimalen urbanen Entwicklung rund um S-Bahnhaltestationen innerhalb eines übergeordneten öffentlichen Verkehrsnetzwerkes in Agglomerationsräumen (Stadtregionen).

Als finales Ergebnis liegt ein Umsetzungskonzept zu den Innovations- und Technologieportfolios an zwei ausgewählten S-Bahnknoten Murpark Graz und Bahnhof Gleisdorf vor. Mit den eingebundenen Akteuren konnten das Bewusstsein für eine gemeinsame, abgestimmte Vorgehensweise bei Projektentwicklungen geschärft und Stakeholdernetzwerke aufgebaut bzw. intensiviert werden, sodass eine nachfolgende schrittweise Umsetzung des Technologie- und Innovationsportfolios wahrscheinlich ist. ∎

Projektlaufzeit:

Juni 2016 bis September 2017

Finanzierung:

bmvit – Stadt der Zukunft

FFG Forschungs- und Entwicklungsdienstleistung (Fördersumme: EUR 146.000)

Projektteam:

StadtLABOR Graz (Leadpartner)

AEE INTEC Gleisdorf

PLANUM Fallast, Tischler & Partner GmbH
Technische Universität Graz, Institut für Städtebau,
URBA Graz (Ernst Rainer und Michael Malderle)

Ernst Rainer / Michael Malderle

G2G Innovation Axis Graz-Gleisdorf

Institute of Urbanism

The anticipated dynamic population and economic development for the urban agglomeration surrounding Graz presents societal challenges in terms of resource consumption, supply and disposal infrastructure, mobility, and affordable living space. The S-Bahn (commuter train) network in Styria, which connects the state capital of Graz with the surrounding municipalities and cities, offers immense future potential. The objective of this project was to develop test and demonstration areas along the innovation axis Graz-Gleisdorf. For select development projects in the vicinity of S-Bahn hubs, an innovation and technology portfolio was created with a focus on the areas of smart urban space, compact settlement structure, utilization mix, city of short paths,

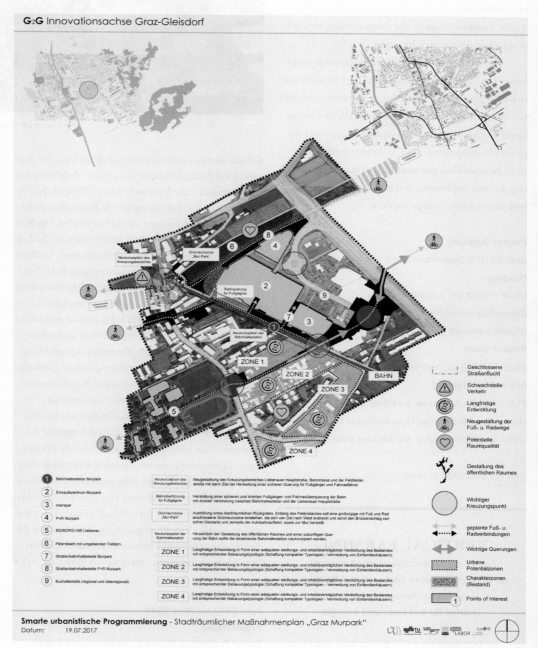

Ergebnisse der smarten urbanistischen Programmierung am S-Bahnknoten Graz Murpark | Results of smart urbanistic programming at the S-Bahn hub Graz Murpark © Institut für Städtebau | Institute of Urbanism, URBA Graz, Michael Malderle & Ernst Rainer

intermodal mobility, energy, and building technology. Also, preparations were made for implementation as test or demonstration areas. Specific measures and technologies were devised that could be carried out in the vicinity of S-Bahn stations in order to enhance the attractiveness of these areas and thus to strengthen public transport, while also helping to reach the national and international climate goals.

Holding special significance for the sustainable urban development of the innovation axis Graz-Gleisdorf are the basic principles of Transit Oriented Development (T.O.D.), which addressed the target objectives of optimal urban development near S-Bahn stations within a superordinate public transportation network in agglomeration areas (city regions).

The final result was an implementation concept focused on the innovation and technology portfolios at two particular S-Bahn hubs: Murpark Graz and Bahnhof Gleisdorf. With the involved individuals, awareness could be raised for a joint, coordinated approach to project developments. Also, stakeholder networks could be established and intensified so that a subsequent, step-by-step implementation of the technology and innovation portfolio is probable. ∎

Project duration:
June 2016 to September 2017
Funding:
bmvit – Stadt der Zukunft
Austrian Research Promotion Agency (FFG)
(Funding amount: EUR 146,000)
Project team:
StadtLABOR Graz (lead partner)
AEE INTEC Gleisdorf
PLANUM Fallast, Tischler & Partner GmbH
University of Technology Graz, Institut of Urbanism,
URBA Graz (Ernst Rainer and Michael Malderle)

Ernst Rainer/Michael Malderle

VERTICAL FARMING
Ermittlung der Anforderungsbedingungen
zur Entwicklung eines „Vertical Farm"-Prototyps
zur Kulturpflanzenproduktion
Institut für Gebäude und Energie

Im Mittelpunkt steht die Erforschung von Grundlagen für eine neue Gebäudetypologie, die Vertikale Farm.

Vertical Farm © Daniel Podmirseg 2016

Urbane vertikale Lebensmittelproduktion kann zur Steigerung der Energieeffizienz von und zur Reduktion des Landverbrauchs durch Städte beitragen. Wesentliche Einflussfaktoren zur Erreichung dieser Ziele sollen durch diese Grundlagenforschung offengelegt werden. Das Sondierungsprojekt versteht sich als Vorbereitung für die Entwicklung einer prototypischen Vertikalen Farm für Wien.

Der Schwerpunkt des Sondierungsprojekts liegt in der Erforschung der Grundlagen, welche notwendig sind, um eine Vertikale Farm für das urbane Umfeld im Rahmen eines kooperativen F&E-Projekts zu entwickeln. Wesentliche pflanzenphysiologische und architekturtypologische Überlegungen, Potenzialanalysen klimatischer Bedingungen, Konzeptuierung nötiger Gebäudetechnik sowie Kommunikations- und Regelungstechnik umfassen die inhaltliche Auseinandersetzung.

Das Projekt hat sich zum Ziel gesetzt „Vertical Farm" mit Wohnen und Büros zu erweitern und die synergetischen Interaktionen dieser Bereiche offenzulegen. Es werden Potenziale hinsichtlich der Steigerung der Gesamtenergieeffizienz urbaner dezentraler Lebensmittelproduktion anhand eines zu entwickelnden Hybridgebäudes, dem „Hyperbuilding" ermittelt. Im Speziellen wird der Frage nachgegangen, inwieweit sich die Energieflüsse der drei Funktionen ergänzen können bzw. wie hoch die daraus resultierenden Synergien sind. ∎

Projektlaufzeit:
April 2017 bis März 2018
Projektleiter:
Daniel Podmirseg, Institut für Gebäude und Energie, Technische Universität Graz

Projektpartner:
vertical farm institute, Wien
Department für Nutzpflanzenwissenschaften (DNW),
Abteilung Gartenbau, BOKU, Wien
SIEMENS AG, Wien
http://www.ige.tugraz.at/vertical-farming.html#forschung_vf

Daniel Podmirseg

VERTICAL FARMING
An Investigation on the Requirements of a Vertical Farm-Prototype Development for Crop Plant Production
Institute of Buildings and Energy

This project focusses on the investigation of the fundamental principles for a new building typology – the vertical farm. As urban vertical food production can contribute to more energy efficient cities by concurrently reducing land use, the substantial influencing factors to achieve these goals are intended to be revealed. This exploratory study is defined as the preparation for a prototypical Vertical Farm in Vienna. The main research goal is to unveil the principles which are essential to develop a Vertical Farm within an urban context beyond a cooperative R&D-project. This project investigates all crucial influencing parameters in plant physiology, building typology, climatic conditions, as well as conceptual investigations in building services, communication technology and control engineering.

The central idea of the project is to bring to light the synergetic interactions between the facilities of food production, apartments, and offices. The concentration on vertical farming is based on the consortium's decision to aim for a realization—towards a "proof of concept" within a cooperative R&D-project—of a hyperbuilding, a building typology which unifies the three different functions named above.

The study reveals the potentials of a hyperbuilding and aims to show how the overall energy efficiency could be increased throughout urban decentralized food production. In particular, the project investigates the question to what extend the energy flows operating between these three functions could complement each other. ∎

Project Duration:

April 2017 to March 2018

Project Management:

Daniel Podmirseg, Institute of Buildings and Energy, Graz University of Technology

Project partners:

vertical farm institute, Vienna

Department of Crop Sciences (DNW), Division of Vegetables and Ornamentals, University of Natural Resources and Life Sciences, Vienna

SIEMENS AG, Vienna

http://www.ige.tugraz.at/vertical-farming.html#forschung_vf

Daniel Podmirseg

Pufferzonen zur thermischen Gebäudesanierung
Errichtung eines Demonstrationsbaus
im Rahmen des Smart Cities Projekts STELA
Institut für Gebäudelehre

Im Zuge des Smart Cities Projekts „STELA" in Leoben entwickelt das Institut für Gebäudelehre der Technischen Universität Graz gemeinsam mit Projektpartnern eine alternative Methode zur thermischen und technischen Gebäudesanierung. Als grundlegende Idee ist die Umhüllung eines Bestandsgebäudes mit einer benutzbaren Pufferzone vorgesehen. Die wärmedämmende Funktion wird dabei durch die thermische Wirkung der Luftschicht zwischen neuer und bestehender Fassade erzielt. Mit dieser Pufferzone, die je nach Witterung geöffnet oder geschlossen werden kann, ist eine Reduktion des Heizwärmebedarfs im gleichen Maße möglich wie mit einer herkömmlichen Sanierung mit Wärmedämm-

verbundsystemen. Neben den ökologischen Vorteilen dieses Konzepts ist der zusätzlich gestaltbare Lebensbereich ein weiterer Gewinn, der auch essenziell zur Steigerung der Lebensqualität der Bewohnerinnen und Bewohner in den bestehenden Wohngebäuden beitragen kann. Im Sommer 2017 konnte durch die finanzielle Unterstützung des Klima- und Energiefonds eine Demonstrationsanlage als Anschauungsobjekt für eine Wohnung im Projektgebiet Judendorf – Leoben realisiert werden. Diese Vorzeige-Pufferzone umfasst in etwa 30 Quadratmeter, die der angrenzenden Wohnung als erweiterter Aufenthaltsbereich zur Verfügung steht und veranschaulicht die räumlichen Vorteile und atmosphärischen Qualitäten der Sanierungsmethode. Mit diesem Demonstrationsbau lassen sich außerdem sämtliche technischen Details, die raumklimatischen Bedingungen sowie das Konstruktionsprinzip an sich im Maßstab 1:1 überprüfen. ∎

Projektlaufzeit:

2014 bis 2017

Finanzierung:

Eine Förderung des Klima- und Energiefonds im Zuge der Smart Cities Initiative

Projektleitung am Institut für Gebäudelehre:

Hans Gangoly

Gernot Reisenhofer

Projektpartner:

Institut für Tragwerksentwurf, TU Graz

Außenansicht der installierten Demonstrationsanlage zur Veranschaulichung der erforschten thermischen Sanierungsmethode | Exterior view of the demonstration unit installed in summer 2017 to illustrate the researched thermal restoration method © Alexander Gebetsroither

IBO – Österreichisches Institut für Baubiologie und Bauökologie

Stadtgemeinde Leoben

Montanuniversität Leoben

Gangoly & Kristiner ZT-GmbH

Vatter & Partner ZT-GmbH

Norbert Rabl ZT-GmbH

www.smartcities.at/stadt-projekte/smart-cities/stela/

Gernot Reisenhofer

Buffer Zones for Thermal Building Restoration
Erection of a demonstration building
in the scope of the Smart Cities project STELA
Institute of Design and Building Typology

As part of the Smart Cities project STELA in Leoben, the Institute of Design and Building Typology at Graz University of Technology developed, in collaboration with its project partners, an alternative method for thermal and technical building restoration. As a fundamental idea, the cladding of an existing building with a utilizable buffer zone was planned. The heat-insulating function here is achieved by the thermal effect of the air layer between the new and the existing façades. This buffer zone, which, depending on the weather, can be opened or closed, enables a reduction of heating demand that equals that of a conventional restoration with a thermal insulation system. Aside from the ecological advantages of this concept, the additionally configurable living area is a further plus, for it may well essentially contribute to the enhancement of the residents' quality of life in the existing buildings. In summer 2017, thanks to the financial support of the Climate and Energy Fund, a demonstration unit was realized as a showpiece for an apartment in the project area of Judendorf–Leoben. This flagship buffer zone comprises around 30 square meters, which is available to the adjacent apartment as an extended common area and illustrates the spatial advantages and atmospheric qualities of this restoration method. Moreover, this demonstration structure allows all technical details, room-climate parameters, and the construction principles to be examined at a 1:1 scale. ∎

Project duration:

2014 to 2017

Funding:

Climate and Energy Fund as part of the Smart Cities Initiative

Project lead at Institute of Design and Building Typology:

Hans Gangoly

Gernot Reisenhofer

Project partners:

Institute of Structural Design, Graz University of Technology

IBO – Österreichisches Institut für Baubiologie und Bauökologie

Municipality of Leoben

Montanuniversität Leoben

Gangoly & Kristiner ZT-GmbH

Vatter & Partner ZT-GmbH

Norbert Rabl ZT-GmbH

www.smartcities.at/stadt-projekte/smart-cities/stela/

Gernot Reisenhofer

Habilitation

Andreas Lechners Habilitationsschrift beschreibt den architektonischen Entwurf als Transformationsprozess von lose vorliegenden Elementen, Mustern und Präzedenzen zur Raumbildung und -abschirmung in erneute Vorschläge für feste Fügungen an konkreten Orten in zwei Teilen: Zum einen in Form einer gezeichneten Gebäudelehre, die dazu Anschauungsmaterialien in der traditionellen Notationsform architektonischer Ideen liefert: Grundrisse, Schnitte und Ansichten von zwölf vielfach klassischen Architekturprojekten in zwölf öffentlichen Nutzungszusammenhängen – Theater,

Museum, Bibliothek, Staat, Büro, Freizeit, Religion, Einzelhandel, Fabrik, Bildung, Kontrolle und Krankenhaus. Zum anderen in drei Aufsätzen, die Entwerfen zunächst als Kennenlernen logistischer und ästhetischer Bandbreiten als kultureller Dimension des Bauens begreifen. Typologien nehmen dabei eine zentrale, retro- und prospektive Rolle ein – zwischen empirischer Beobachtung (induktive Realtypen), theoretischen Vorannahmen (deduktive Idealtypen) und gesellschaftlichen Rangbemessungen. Das Erkenntnisinteresse und damit Ziel von Typologien – Wissensgewinn durch Informationsreduktion – steht aber nicht im Mittelpunkt dieser auch als Handreichung für das Entwerfen und die Entwurfslehre konzipierten Arbeit. Vielmehr möchten die versammelten Formen und Funktionen auf die Komposition als ästhetische Festlegung der Form aufmerksam machen, die sich gerade in der innerdisziplinären Auseinandersetzung mit baukünstlerischen Erinnerungslektionen als unscharfes und deshalb produktives Verhältnis zu Nutzungszusammenhängen herausstellt. Dieser für eine Thematisierung der Architektur grundlegende Umstand kann auch der smarten Bildlosigkeit stadtlandschaftlicher Zersiedlung Impulse zu dezentraler baulicher Verdichtung geben: Die zwölf mal zwölf gezeichneten Projekte liefern als Tableaus aus Formen und Programmen entwerferische Hinweise für Vergleich und Anknüpfung ebenso wie für das Ziehen neuer Verbindungslinien, um die Normalität Suburbias mit blickräumlich bedeutsamen, kommunalen Programmen zu unterbrechen.

Eine überarbeitete Fassung der Habilitationsschrift erschien Anfang 2018 im Züricher Verlag Park Books unter dem Titel *Entwurf einer architektonischen Gebäudelehre*. ∎

Andreas Lechner (2016)

Überlegungen zum Entwurf einer architektonischen Gebäudelehre, Institut für Gebäudelehre

712 Seiten mit 144 Projekten in Grundrissen, Schnitten und Ansichten, Deutsch

Habilitationskommission:

Aglaée Degros, Hans Gangoly, Roger Riewe, Daniel Gethmann, Natascha Spitzer

GutachterInnen:

Anne-Julchen Bernhardt (RWTH Aachen), Dietmar Eberle (ETH Zürich), Elli Mosayebi (TU Darmstadt)

Habilitation

Andreas Lechner's habilitation describes architectural design as a transformation process of loosely present elements, patterns, and precedents for spatial formation and shielding in renewed suggestions for fixed alignments at concrete sites in two parts. Firstly, in the form of a sketched building typology that offers illustrative materials in the traditional form of notating architectural ideas: floor plans, sections, and views of twelve (in many cases) classical architectural projects in twelve contexts of public use—theater, museum, library, state government, office, leisure, religion, retail, factory, education, supervision, and hospital. Secondly, in three essays that initially conceive design as a familiarization of logistical and aesthetic scopes as a cultural dimension of building. Here, typologies assume a central, retrospective, and prospective role—between empirical observation (inductive ideal types), theoretical presuppositions (deductive ideal types), and assessment of position within society. However, the knowledge interest and thus the objective of typologies—knowledge gain through information reduction—are not the focus of this work, which is also conceived as a guiding hand for design and design theory. On the contrary, the forms and functions collected here aim to call attention to the composition as aesthetic determination of form, which is presently emerging in the innerdisciplinary exploration of architectural memory lessons as a vague and thus productive relationship to contexts of use. This circumstance, which is fundamental for a thematic exploration of architecture, can also provide, for the smart nonpictorial nature of urban landscape sprawl, impulses for decentralized building densification. The projects drafted twelve-times-twelve deliver, as tableaus of forms and programs, design-related hints for comparison and association, as well as for the drawing of new connecting lines in order to disrupt the normalcy of *suburbias* with visually meaningful municipal programs. ∎

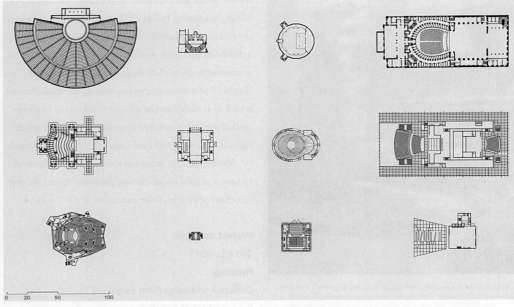

Maßstäbliches Tableau aus zwölf Theatergrundrissen | True-scale tableau comprising twelve floor plans of theatres © Andreas Lechner

A revised edition of the habilitation thesis was published in early 2018 by the Zurich publishing company Park Books under the title *Entwurf einer architektonischen Gebäudelehre (Design of an Architectural Building Typology)*. ▪

Andreas Lechner (2016), *Überlegungen zum Entwurf einer architektonischen Gebäudelehre (Reflections on the Design of an Architectural Building Typology)*, Institute of Design and Building Typology
712 pages with 144 projects in floor plans, sections, and views, German
Habilitation committee:
Aglaée Degros, Hans Gangoly, Roger Riewe, Daniel Gethmann, Natascha Spitzer
Reviewers:
Anne-Julchen Bernhardt (RWTH Aachen), Dietmar Eberle (ETH Zürich), Elli Mosayebi (TU Darmstadt)

Dissertationen

Erich Wutscher (2017), *Demontage und Recycling im Gebäudesektor – Eine Bewertung am Beispiel des Brettsperrholz-Bausystems*, Institut für Architekturtechnologie; Betreuer: Roger Riewe, 1. Gutachter: Stefan Peters, 2. Gutachter: Mike Schlaich; 242 Seiten, Deutsch.

Martina Spies (2017), *Plätze und Identitäten – Eine architektonische-soziologische Aufnahme von fünf ausgewählten Plätzen innerhalb der informellen Siedlung Dharavi, Mumbai*, Institut für Architekturtechnologie; 1. Gutachter: Peter Schreibmayer, 2. Gutachter: Alexander Hamedinger; 506 Seiten, Deutsch. ▪

Dissertations

Erich Wutscher (2017), *Dismantling and recycling in the building sector – An approach assessing the example of the cross-laminated timber system*, Institute of Architecture Technology; Reviewer: Roger Riewe, 1st reviewer: Stefan Peters, 2nd reviewer: Mike Schlaich; 242 pages, German.

Martina Spies (2017), *Places and Identities – An Architectural and Sociological Survey of five selected Places within the Informal Settlement Dharavi, Mumbai*, Institute of Architecture Technology; 1st reviewer: Peter Schreibmayer, 2nd reviewer: Alexander Hamedinger; 506 pages, German. ▪

Publications

Concrete Tower Lannach Knock on Wood
Herausgegeben von Roger Riewe und Armin Stocker

Concrete Tower Lannach Knock on Wood

Roger Riewe/Armin Stocker (Hg. | eds.)
Graz: Verlag der Technischen Universität | Publishing Company of Graz University of Technology, 2017
Deutsch, 61 Seiten, kartoniert | German, 61 pages, paperback
Print: ISBN 978-3-85125-537-2
E-Book: ISBN 978-3-85125-537-9
DOI 10.3217/978-3-85125-537-2
EUR 14,00 | EUR 14.00

Kann Architektur erzählt werden? Ist es möglich, architektonische Räume und Entwürfe mittels narrativer Texte zu entwickeln und somit fiktionale, gedachte Räume in ein realweltliches Pendant zu überführen? Wie kann Architektur aus dem Ort heraus gedacht und geschrieben werden und können die so entstandenen Raumentwürfe mit architekturadäquaten Mitteln dargestellt und in ein Projekt umgesetzt werden? Diese Fragestellungen, basierend auf der Annahme, dass Kultur im Wesentlichen Kommunikation ist und Kommunikation vornehmlich sprachbasiert[1] ist, bildeten die Grundlage und den Ausgangspunkt einer Entwurfsübung am Institut für Architekturtechnologie an der TU Graz.

Beispiele von Michel Houellebecq, Georges Perec, Ernest Hemingway, Paul Auster und Franz Hessel dienten der Auseinandersetzung mit dem Konzept des erzählten Raums und der fiktiven Wirklichkeitserschließung mittels literarischer Textformen.

Die nun in Buchform vorliegenden Semesterarbeiten zeigen, dass die Fiktion als Ausgangspunkt der Wirklichkeitserschließung als erster Schritt zum architektonischen Entwurf ein taugliches Mittel sein kann.

1 Vgl. Eco, Umberto/Trabant, Jürgen: *Einführung in die Semiotik*, Paderborn 2002.

Ideen und Möglichkeiten, die zur Entwicklung und Materialisierung des architektonischen Raums führen, werden zuerst in Handlungs- und Bewegungsräumen gedacht und geschrieben. Und danach von der Skizze zum Entwurf geführt. ∎

Roger Riewe ist Architekt, Universitätsprofessor und Vorstand des Instituts für Architekturtechnologie. **Armin Stocker** ist Architekt und Universitätsassistent am Institut für Architekturtechnologie.

Can architecture be mediated narratively? Is it possible for architectural spaces and designs to be developed through narrative texts and thus to transpose fictional, conceptual spaces into a real-world equivalent? How can architecture be conceived and written from within the site, and can the spatial designs created in this way be rendered with means adequate for architecture and then implemented in a project? These explorative questions—based on the assumption that culture is essentially communication and that communication is chiefly language-based[1]—forms the basis and the point of departure for a design exercise in the Institute of Architecture Technology at Graz University of Technology.

Exemplary projects by Michel Houellebecq, Georges Perec, Ernest Hemingway, Paul Auster, and Franz Hessel serve to explore the concept of narrative space and the fictive extrapolation of reality by means of literary text forms.

The semester theses now compiled in book form illustrate how fiction can be a suitable agent as a starting point for tapping into reality and a first step in developing an architectural design. Ideas and possibilities that lead to the development and materialization of architectural space are first conceived and written down in spaces of agency and movement. The subsequent step leads from sketch to design. ∎

Roger Riewe is an architect, university professor, and chair of the Institute of Architecture Technology. **Armin Stocker** is architect and associate professor at the Institute of Architecture Technology.

1 See Umberto Eco and Jürgen Trabant, eds., *Einführung in die Semiotik* (Paderborn, 2002).

Brian Cody

Form
Follows
Energy

Using natural forces to
maximize performance

Form follows Energy:
Using natural forces
to maximize performance

Brian Cody
Birkhäuser, 2017
Englisch, 260 Seiten, gebunden | English,
260 pages, hardcover
Hardcover: ISBN 978-3-99043-202-0
EUR 79,95 | EUR 79.95
Taschenbuch/Softcover: ISBN 978-3-0356-1405-3
EUR 49,95 | EUR 49.95
E-Book: ISBN 978-3-0356-1411-4
EUR 49,95 | EUR 49.95

Architektur ist Energie. Linien auf dem Papier oder dem Computerbildschirm repräsentieren nicht nur ein architektonisches Konzept, sie bedeuten auch gleichzeitig jahrzehnte- oder gar jahrhundertelange Energie- und Materialflüsse. Das Buch *Form follows Energy* untersucht die Optimierung von Energieflüssen in Gebäuden und Städten sowie die Auswirkungen der Optimierung auf deren Form und Konfiguration.

Das Buch basiert auf 30 Jahren Erfahrung in Praxis, Forschung und in der Lehre. Es richtet sich an Architektinnen und Architekten wie Ingenieurinnen und Ingenieure gleichermaßen und zeigt, wie Entwurfsstrategien genutzt werden können, um die Energieperformance von Gebäuden zu maximieren und gleichzeitig eine neuartige ästhetische Qualität sowie Formensprache in der Architektur und im Städtebau zu schaffen. Es wird ein Verständnis für die natürlichen physikalischen Grundlagen vermittelt, deren Gesetzen der Energieverbrauch in Gebäuden unterliegt, und es werden Strategien untersucht, die es erlauben, natürliche Kräfte

beim Entwurf von Gebäuden zu analysieren und zu manipulieren.

Form follows Energy bietet einen prägnanten, interdisziplinären Überblick über die komplexen Beziehungen zwischen Energie und gebauter Umwelt. Es erklärt, wie wir natürliche Kräfte nutzen können, anstatt uns immer effektivere Mittel auszudenken, um uns gegen diese zu schützen. Statt sich darauf zu konzentrieren die negativen Auswirkungen auf die Gebäude, die wir entwerfen, zu minimieren, ist es das Ziel, die positiven Aspekte zu maximieren. ∎

Brian Cody ist Universitätsprofessor an der Technischen Universität Graz und leitet das Institut für Gebäude und Energie.

Architecture is energy. Lines on paper or a computer screen representing an architectural concept also imply decades and sometimes centuries of associated energy and material flows. *Form follows Energy* examines the optimization of energy flows in building and urban design and the implications for form and configuration.

The book's philosophy is based on the guiding principles underlying 30 years work in practice, research and teaching. It speaks to both architectural and engineering audiences and shows how design strategies can be used to maximize the energy performance of our built environment while at the same time leading to new aesthetic qualities and new forms in architecture and urban design. After building an understanding of the physical laws of nature underlying energy use in the built environment, ways and means to allow the analysis and manipulation of natural forces in the design of buildings and cities are explored. The book offers a concise interdisciplinary overview on the subject of energy and the built environment and examines and explains the complex relationships between energy and architecture. *Form follows Energy* explains how we can use natural forces, instead of devising ever more effective means of protecting ourselves against them. Instead of concentrating on minimizing the negative impact on the environment of the buildings we design, the goal is to maximize their positive impact. ∎

Brian Cody is professor at Graz University of Technology and heads the Institute of Buildings and Energy.

The Maya Temple-Palace of Santa Rosa Xtampak, Mexico
Dokumentation und Rekonstruktion der Form, Konstruktion und Funktion | Documentation and Reconstruction of Form, Construction, and Function

Hasso Hohmann
Graz: Verlag der TU Graz | Publishing Company of Graz University of Technology, 2017
Englisch, Textband und Plantasche mit 13 groß-formatigen Plänen, 152 Seiten Hardcover |
English, text volume and portfolio with 13 large-format blueprints, 152 pages, paperback
ISBN 978-3-85125-457-0
ISBN 978-3-901519-44-4 Academic Publishers Graz
EUR 75,00 | EUR 75.00

Die Arbeit stellt das Resultat eines mehrjährigen österreichischen Forschungsprojekts des Wiener Wissenschaftsfonds vor. Sie dokumentiert den etwa 1300 Jahre alten Bestand eines rund 17 m hohen, 50 m langen und 30 m breiten, dreigeschossigen Maya-Palasts im Regenwald von Campeche/Mexiko in rund 70 großformatigen Grundrissen, Schnitten und Ansichten. Der Tempel-Palast ist eine Kombination aus sakraler und profaner Architektur. Er verfügt über fast 50 Räume, zwei Treppenhäuser, vier Freitreppen zu der Sockelplattform, 14 extrem steile Scheintreppen und eine zentrale, schwer begehbare Freitreppe mit einer Steigung von 60°, die über zwei Geschosse auf einen riesigen Rachendurchgang zuläuft. Zeichnerisch werden beschädigte oder verlorengegangene Architekturteile rekonstruiert. Architekturfragen an den Komplex werden besprochen und im Vergleich mit Bauten anderer Maya-Städte aus Sicht eines Technikers diskutiert. Danach wird der Tempel-Palast hinsichtlich Form, Konstruktion und Funktion analysiert. Die Form entspricht einer Kombination von sieben Tempelpyramiden und zahlreichen in Stein geformten Maya-Hütten unterschiedlicher Ausformung auf einem künstlich terrassierten Hügel. Alle Räume haben als Decke eine Kraggewölben-Konstruktion. Als statische Merkmale und Besonderheiten gibt es klare Hinweise, dass ursprünglich auf dem Palast-Dach ein hoher Dachkamm geplant war. In der Konstruktion finden sich jedoch Belege dafür, warum dieser nicht zur Ausführung kam. Die Gewölbebalken des Palastes zeigen, dass sie keine statische Funktion übernehmen. Für die Bestimmung der Funktion der Räume werden mehrere Möglichkeiten angeboten. Es handelt sich meist um wenig beachtete Architekturelemente, wie Gewölbebalken, Stabhalter oder Seilhalter. Aber auch andere Details liefern klare Hinweise auf die ehemalige Funktion der Räume, manchmal auch auf Teile der einstigen Einrichtung der Räume. ▪

Hasso Hohmann ist Architekt und lehrt das Fach außereuropäische Baukulturen am Institut für Stadt- und Baugeschichte der TU Graz.

This book reflects the results of an Austrian research project lasting several years that was funded by the Austrian Science Fund in Vienna. It documents the three-story Maya palace in the rainforest of Campeche, Mexico, which is around 1,300 years old and measures about 17 meters in height, is 50 meters long, and 30 meters wide. The documentation takes the form of around seventy large-format flood plans, sections, and views. The temple-palace is a combination of sacral and profane architecture. It has nearly fifty rooms, two staircases, four open stairways to the base platform, fourteen extremely steep pseudo-stairs, and a central accessible stairway that is difficult to navigate at a 60-degree gradient, leading up across two stories to a giant monster mouth passageway. In the book, damaged or lost architectural components are reconstructed in drawings. Architecture issues related to the complex are discussed and analyzed from the perspective of an engineer in comparison to buildings from other Mayan cities. Then the temple-palace is analyzed in terms of form, construction, and function. The form reflects a combination of seven temple pyramids and numerous differently shaped Maya huts built of stone on a man-made terraced hill. All rooms feature ceilings with a corbeled vault construction. As static properties and characteristic features there are clear indications that a high roof comb was originally planned for the palace roof. In the structure, however, evidence is found of why these plans were not carried out. The vault beams of the palace reveal that they could not assume a static function. Several possibilities arise for determining the function of the rooms, usually involving less noted architectural elements like vault beams, rod sockets, or court holders. But other details likewise offer clear hints as to the former function of the rooms, and sometimes also to some of the past room furnishings. ▪

Hasso Hohmann is an architect who teaches the subject Non-European Building Cultures at the Institute of Urban and Architectural History.

Wolfgang Heusgen, 2002–04, „Hammer mit Kopf", H/B/T: 82/55/24 cm,
Sammlung | Collection Museum Liaunig, Neuhaus, Kärnten
© Helmut Tezak

Geschweißte Skulpturen. Ergebnisse aus 25 Jahren „Arbeiten mit Stahl"

Wolfgang Heusgen
Graz: Verlag TU Graz/Publishing Company of
Graz University of Technology, 2017
Deutsch, 92 Seiten, gebunden | German,
92 pages, hardcover
ISBN 978-3-85125-506-5
EUR 59,00 | EUR 59.00

Der gebürtige Kapfenberger Wolfgang Heusgen
stellt in diesem außergewöhnlich gestalteten Werkbuch
eine Auswahl eigener Arbeiten vor, die im Umfeld sei-
ner Lehrtätigkeit an der Architekturfakultät der TU Graz
entstanden sind. Heusgen, selbst auch gelernter Schlos-
ser, betreut seit mehr als 25 Jahren ein Seminar mit dem
Titel „Arbeiten mit Stahl", daher sind auch seine Arbei-
ten Stahlskulpturen, geschweißte Skulpturen. Die Fotos
von Helmut Tezak – der ihn seit fast 30 Jahren fotogra-
fisch begleitet – zeigen die Arbeiten unmittelbar nach
Fertigstellung, aber auch mit den „Spuren des Alters".
Texte von Friedrich Achleitner, Günther Holler-Schuster
und Rudolf Kedl ergänzen die Bilder. Kurze, eigene
Hinweise „erzählen" über die Entstehung der Skulp-
turen. Ein sehr persönliches Buch, das Freude macht. ∎

In this unusually designed catalogue *Geschweißte
Skulpturen. Ergebnisse aus 25 Jahren „Arbeiten mit
Stahl"* (*Welded Sculptures: Results from 25 Years of
"Working with Steel"*), Kapfenberg-born Wolfgang
Heusgen introduces a selection of his own works cre-
ated in the scope of his teaching activity in the Depart-
ment of Architecture at Graz University of Technology.
Heusgen, who is a trained metalworker, has been teach-
ing a seminar titled "Arbeiten mit Stahl" (Working with
Steel) for over twenty-five years now, so his works are
also steel and welded sculptures. The photos by Helmut
Tezak—who has been photographically accompany-
ing Heusgen for nearly thirty years—show the works
immediately after completion, but also with "traces of
age." Texts by Friedrich Achleitner, Günther Holler-
Schuster, and Rudolf Kedl complement the pictures.
Short, personal notes "narrate" the genesis of the sculp-
tures. A very personal book that inspires joy! ∎

Mondadori Electa SpA, Milano, © Alessandra Chemollo, Venezia

Carlo Scarpa. Canova Museum Possagno

Gianluca Frediani
Electaarchitecture
Mailand | Milan: Mondadori Electa, 2016
Englisch, 144 Seiten, gebunden |
English, 144 pages, hardback
ISBN 978-88-918-1070-0
EUR 42,00 | 42.00

Mit der Erweiterung des Canova Museums in
Possagno im Jahre 1957 ergänzte der venezianische
Architekt Carlo Scarpa seine Serie von meisterhaften
Entwürfen und machte den Erweiterungsbau zu einem
seiner berühmtesten Arbeiten. Trotz umfangreicher
wissenschaftlicher Forschungen über Scarpas Werk hat
die komplexe historische Überlagerung des Ortes, an
dem das Museum liegt, bislang noch viele Fragen unbe-
antwortet gelassen. Begleitet von einer umfangreichen
ikonografischen Dokumentation untersucht der zentra-
le Essay von Gianluca Frediani die historischen Zusam-
menhänge des Museums und erforscht das enge Ver-
hältnis des Gebäudes zur Landschaft, wie auch seinen
Bezug zum Klassizismus und zur Moderne. Das Buch
wird durch einen kurzen Essay von Susanna Pasquali
abgeschlossen und ist mit fotografischen Arbeiten von
Alessandra Chemollo reich illustriert. ∎

Gianluca Frediani ist Architekt und lehrt „Entwerfen"
an der Universität Ferrara. Seit 2002 ist er Universitäts-
dozent am Institut für Stadt- und Baugeschichte an der
Technischen Universität Graz.

With the addition to The Canova Museum of
Possagno in 1957, the Venetian architect Carlo Scarpa
inaugurates his series of masterpieces and makes it one
of his most famous works. Despite of the extensive
scientific literature on Scarpa's oeuvre, the complex
historical stratification of the place where it is located
has left many questions unanswered. Accompanied
by a wide iconographic repertoire, the central essay of
Gianluca Frediani examines the historic consistency of
the museum and explores the building's close relation-
ship to the landscape as well as its references to classicism
and to the modern movement. The volume, concluded
by a brief essay by Susanna Pasquali, is richly illustrated
by the photographic work of Alessandra Chemollo. ∎

Gianluca Frediani is an architect and teaches Architec-
tural Design at the University of Ferrara. Since 2002
he has been professor at the Institute of Urban and
Architectural at Graz University of Technology.

Awards

Teilnehmer und Betreuer vor dem Pavillon | Participants and supervisors in front of the pavilion © Koen

Tongji – International Construction Festival 2017

2. Platz für das Projekt „**P-Cubed: ply-polypropylene**" des **Instituts für Grundlagen der Konstruktion und des Entwerfens**

Bereits zum zweiten Mal wurde die Architekturfakultät der TU Graz zur Teilnahme am „International Construction Festival 2017" an der Tongji University in Shanghai eingeladen. Die fünf teilnehmenden Studierenden wurden in einem anonymen Wettbewerbsverfahren am Institut für Grundlagen der Konstruktion und des Entwerfens unter den Studierenden des 2. Semesters ausgewählt. Das Thema des Construction Festivals war der Entwurf und Bau eines Pavillons für eine „Micro-Community". Das vorgegebene Baumaterial beschränkte sich auf 30 Polypropylen-Hohlstegplatten, 180 × 180 × 0,5 cm. Die Studierenden hatten die Aufgabe innerhalb von vier Tagen die Konstruktion zu entwerfen und zu bauen.

„P-Cubed: ply-polypropylene", das Projekt des Grazer Teams beschäftigte sich mit den Themen Nachhaltigkeit und minimaler überdachter, wettergeschützter Raum. Der entworfene Pavillon nutzte konstruktiv die gesamte Kubatur aus und kam mit einem sehr geringen Materialverschnitt und Arbeitsaufwand aus. Ziel war es, bei diesem Projekt einen Raum zu schaffen, der Privatheit und Öffentlichkeit räumlich verbindet. Die Grundform eines Hauses mit Giebeldach wird aufgeschnitten und gegeneinander versetzt, um Öffnungen zu schaffen. Die Konstruktion bestand aus 3 Lagen der Polypropylen-Platten, die nach dem Prinzip von Sperrholz aus gegeneinander verdrehten Lagen des Materials hergestellt sind. Die Platten wurden um eine halbe Plattenabmessung versetzt, um damit die Konstruktion des

Hauses zu verstärken. Dadurch konnte die Stabilität des Materials erhöht werden. Der Pavillon ist wetterfest und über die Öffnungen querbelüftet. Das transluzente Material dient als Schutz vor direktem Sonnenlicht und erzeugt ein diffuses Licht im Innenraum. In der Dunkelheit wird der Pavillon zum Leuchtkörper.

Rund 60 Teams von über 20 internationalen und chinesischen Universitäten, in Summe ca. 500 Studierende, nahmen am Festival teil. Die intensive Arbeitswoche wurde mit der Preisverleihung feierlich abgeschlossen: Das Team der TU Graz konnte sich gegenüber dem letzten Jahr von Platz 3 auf den 2. Platz verbessern. ∎

Teilnehmende Studierende: **Robert Anagnostopulous**, **Tobias Figlmüller**, **Johannes Kummer**, **Angelika Lisa Mayr**, **Desiree Wurnitsch**
Betreuer: **Wolfgang List**, **Daniel Schürr**

Daniel Schürr

Tongji – International Construction Festival 2017

2nd place for the project **"P-Cubed: ply-polypropylene"** **by the Institute of Construction and Design Principles**

Already for the second time, the Faculty of Architecture at Graz University of Technology was invited to participate in the International Construction Festival 2017 at Tongji University in Shanghai. The five involved students were invited to an anonymous competition process in the Institute of Construction and Design Principles,

among all second-semester students. The topic of the Construction Festival was the design and construction of a pavilion for a "micro-community." The stipulated building material was limited to thirty polypropylene multi-skin sheets with dimensions of 180 × 180 × 0.5 cm. The students were given the task of designing and building the structure within four days.

The Graz team's project "P-Cubed: ply-polypropylene" dealt with the themes of sustainability and minimally roofed, weatherproof space. The designed pavilion structurally used the entire cubature and made do with very little material waste or workload. The objective of this project was to create a room that spatially connects the private and public spheres. The basic form of a house with a gabled roof was dissected and staggered in order to create openings. The structure was made of three layers of polypropylene panels, produced according to the principle of laminated wood with material layered in different directions. The panels were offset by the dimensions of half of a panel in order to strengthen the construction of the building. This enabled an increase in material stability. The pavilion is weatherproof and features crosswise ventilation through the openings. The translucent material serves as protection against direct sunlight and engenders a diffuse light inside. In the dark, the pavilion becomes a luminary.

Around sixty teams from over twenty international and Chinese universities, approx. 500 students in total, participated in the festival. The intensive workweek concluded with a festive awards ceremony: the team from Graz University of Technology took 2nd place, improving their standing from last year's 3rd place. ∎

Participating students: **Robert Anagnostopulous**, **Tobias Figlmüller**, **Johannes Kummer**, **Angelika Lisa Mayr**, **Desiree Wurnitsch**
Advisors: **Wolfgang List**, **Daniel Schürr**

Daniel Schürr

Die Jurymitglieder der GAD Awards '17 | The jury members of the GAD Awards '17, Marianne Skjulhaug & John Palmesino, im Gespräch mit | in conversation with Klaus K. Loenhart © Institut für Architektur und Landschaft | Institute of Architecture and Landscape

Graz Architecture Diploma Awards '17
Verleihung des **15. Grazer Architekturdiplompreises** der **Architekturfakultät** der **TU Graz**

Am 13. Oktober 2017 wurden im Rahmen einer feierlichen Verleihung die besten Abschlussarbeiten, die im vergangenen Studienjahr 2016/2017 an der Fakultät für Architektur verfasst wurden, mit dem Grazer Architecture Diplompreis (GAD) ausgezeichnet. Verliehen zum bereits 15. Mal, bedeuten die GAD Awards für Absolventinnen und Absolventen einen begehrten Preis zu Beginn ihrer Berufslaufbahn. In diesem Jahr wurden 47 Projekte nominiert, die in einem anonymen Wettbewerbsverfahren durch eine Jury bewertet wurden. Das Institut für Architektur und Landschaft, das mit der Organisation und Durchführung der GAD Awards betraut war, konnte mit John Palmesino (AA School of Architecture, London) und Marianne Skjulhaug (AHO, Oslo) zwei Juroren gewinnen, deren Expertise und Erfahrung die eingereichten Projekte im internationalen Vergleich positionierte. Die inhaltliche Breite und konzeptionelle Tiefe überzeugte bei den fünf ausgezeichneten Absolventinnen und Absolventen:

1. Preis: **Catherine Papst** (Projekt: „BA NAMAK: Teheran's new urban form", Betreuer: Urs Hirschberg)
2. Preis: **Alina Kratzer** (Projekt: „Ein Badehaus für Frauen", Betreuerin: Petra Petersson)
3. Preis: **Thomas Hörmann** (Projekt: „REPLIKATION – Modell zu einer neuen kommunalen Zentralität in der suburbanen Landschaft", Betreuer: Andreas Lechner)
Hollomey-Reisepreis: **George Nikolov** (Projekt: „Incongruous – Hinsicht. Reimaging the Park-Monument to the Bulgarian-Soviet friendship in Varna, Bulgaria", Betreuerin: Milica Tomić)
Tschom-Wohnbaupreis: **Claudia Pittino** (Projekt: „sport+ Wohnen und Sport. Eine Neuauslegung in bestehendem Umfeld", Betreuer: Andreas Lichtblau)

Mithilfe der großzügigen Unterstützung durch die Sponsoren der GAD Awards '17 wurden alle nominierten und ausgezeichneten Projekte im Anschluss an die feierliche Verleihung in einer Ausstellung im Hörsaal II, an der TU Graz präsentiert. Zusätzlich erhielten die Preisträgerinnen und Preisträger die Möglichkeit im Rahmen von Kurzvorträgen im Haus der Architektur sich und ihre Arbeit der Öffentlichkeit vorzustellen. ∎

Christoph Walter Pirker

Graz Architecture Diploma Awards '17
Awarding of the **15th Graz Architecture Diploma Award** of the **Faculty of Architecture** at **Graz University of Technology**

On October 13, 2017, the best theses written during the previous academic year 2016–17 in the Faculty of Architecture were distinguished with the Graz Architecture Diploma (GAD) Awards at the awards ceremony. Presented for the fifteenth time, the GAD Awards are a coveted prize among graduates, marking the beginning of their professional careers. This year, forty-seven projects were nominated, which were then evaluated by a jury in an anonymous competition process. The Institute of Architecture and Landscape, entrusted with the organization and implementation of

the GAD Awards, was able to acquire two jurors—John Palmesino (AA School of Architecture, London) and Marianne Skjulhaug (AHO, Oslo)—whose expertise and experience positioned the submitted projects in international comparison. The breadth of content and the conceptual depth of the five award-winning graduates proved convincing:

1st prize: **Catherine Papst** (project: "BA NAMAK: Teheran's new urban form," advisor: Urs Hirschberg)

2nd prize: **Alina Kratzer** (project: "Ein Badehaus für Frauen" [A Bathhouse for Women], advisor: Petra Petersson)

3rd prize: **Thomas Hörmann** (project: "REPLIKATION – Modell zu einer neuen kommunalen Zentralität in der suburbanen Landschaft" [Replication: Model for a New Municipal Centrality in the Suburban Landscape], advisor: Andreas Lechner)

Hollomey Travel Prize: **George Nikolov** (project: "Incongruous – Hinsicht: Reimaging the Park-Monument to the Bulgarian-Soviet Friendship in Varna, Bulgaria," advisor: Milica Tomić)

Tschom Housing Prize: **Claudia Pittino** (project: "sport+ Wohnen und Sport: Eine Neuauslegung in bestehendem Umfeld" [Housing and Sport: A New Interpretation in the Existing Setting], advisor: Andreas Lichtblau)

Thanks to the generous support of those sponsoring the GAD Awards '17, all nominated and prize-winning projects were presented in an exhibition in Lecture Hall II at Graz University of Technology after the awards ceremony. Additionally, the prizewinners were given the opportunity to introduce their works to the public in the scope of short presentations at the Haus der Architektur. ∎

Christoph Walter Pirker

Herbert Eichholzer Architekturförderungspreis 2017
Kolloquium und Verleihung durchgeführt vom
Institut für Wohnbau

Der von der Stadt Graz ausgelobte und 2017 vom Institut für Wohnbau an der TU Graz durchgeführte Herbert Eichholzer Architekturförderungspreis widmete sich der Fragestellung, ob, wann und wodurch Architektur in Theorie oder gebauter Realität politisch relevant wird oder werden kann. Im Kolloquium, das am

24. April 2017 vom Institut für Wohnbau als Impuls zum diesjährigen „Herbert Eichholzerpreis" veranstaltet und durch Stadtplanungsleiter Bernhard Inninger in Vertretung des Bürgermeisters der Stadt Graz eröffnet wurde, betonte zunächst Andreas Lichtblau, dass es für ArchitektInnen entscheidend ist, über grundlegende Aspekte der gesellschaftlichen „Raumproduktion" nachzudenken.

Antje Senarclens de Grancy analysierte das Zusammenwirken von Architekturschaffen und politischem Engagement Herbert Eichholzers, der 1943 von den Nationalsozialisten hingerichtet wurde. Eichholzer habe selbst betont, dass er „über die Architektur" bzw. über die Frage der Wohnungsnot zu seinem gesellschaftspolitischen Einsatz kam.

Eugen Gross (Werkgruppe Graz) schilderte, dass er als Student kurz nach dem 2. Weltkrieg nichts über Eichholzer erfahren habe – das Verleugnen, seiner architektonischen Leistungen hatte bereits begonnen.

Alex Hagners (gaupenraub +/-) Impulsvortrag stand im Zeichen des Otto Kapfinger-Zitates: „Man darf Mangel nicht mit Mangel begegnen." Auch Hagners offenes gesellschaftspolitisches Engagement rührt aus persönlicher Erfahrung: der Begegnung mit Obdachlosen. „Gesetzlos bauen" müsse die Devise lauten, wenn Vorschriften, Gesetze und Normen verhinderten, dass ein Teil der Gesellschaft eine „Wohnung" findet, weil die Leistbarkeit nicht mehr gegeben ist bzw. auch (Grund-)Bedürfnisse missachtet werden.

Von gesellschaftspolitischer Verantwortung sprach auch Peter Reitmayr (reitmayr architekten), ein Zusammenhang zwischen Architektur und Politik lässt sich für ihn vor allem in der Herstellung von und im Umgang mit dem öffentliche Raum – und dies nicht nur im räumlichen Sinn! – zeigen.

Bernhard Inningers bevorzugtes „Werkzeug" als Stadtplaner ist das dialogische Agieren und Vermitteln zwischen verschiedensten Parteien. Die Kernfrage neben vielen anderen interessanten Themen lautet auch bei ihm: FÜR WEN macht man den öffentlichen Raum, welche Nutzungen soll er innerhalb einer immer feinteiliger segmentierten Gesellschaft ermöglichen.

Im Wettbewerb gab es formal kaum Einschränkungen, die einzelnen Wettbewerbsbeiträge konnten theoretisch in Form eines Essays die Frage nach der politischen Aussage und Auswirkung von Architektur stellen, oder ein konkreter Entwurf auf Grundlage einer kurzen schriftlichen Positionierung sein. Andreas Lichtblau übernahm aufgrund der Komplexität der Aufgabe die Betreuung der Entwürfe und verzichtete deshalb auf seine Teilnahme an der Jury. Bis zum 31. August 2017 wurden 9 Projekte (von insgesamt 17 Studierenden) zeitgerecht und korrekt anonymisiert eingereicht. Die Jurysitzung mit Antje Senarclens de Grancy als Vorsitzende fand am 11. September 2017 im Media-Center des Grazer Rathauses statt.

Das Siegerprojekt „wohnbau und öffentlichkeit" von Jakob Öhlinger thematisiert die Vielschichtigkeit und Multiperspektivität der Beziehung zwischen Wohnbau und Öffentlichkeit, Architektur und Politik, indem es eine große Anzahl an Themen in feuilletonhaft gestalteten Texten und aussagekräftigen Bildern aufgreift. Die in sich abgeschlossenen, prägnanten Texte geben – ohne zu moralisieren oder Anspruch auf Vollständigkeit erheben zu wollen – einen breiten Überblick über Pro-

Die PreisträgerInnen im Beisein der JurorInnen | The laureates in presence of the jury members, Professor Andreas Lichtblau & Kulturstadtrat Dr. Günther Riegler © Institut für Wohnbau | Institute of Housing

blematiken des Themenfeldes Architektur/Stadt/öffentlicher Raum/sozialer Wohnbau/Verkehr/Kontrolle etc. Das Projekt zeigt Stoßrichtungen auf und spricht vielfältige innovative Lösungsansätze an. Unter anderem werden soziale Standards statt Baustandards, soziale Dichte durch soziale Interaktion oder Randzonen für Kommunikation anstatt ökonomisch genutzter Hauptplätze eingefordert.

Der zweite Preis ging an Helena Eichlinger und Therese Eberl für „Commedia dell´Arte". Der architektonische Entwurf für den Grazer Bezirk Gries, eine Art Rauminszenierung in Anlehnung an die griechische Polis, versucht auf experimentell-theatralische Weise, Formen von kommunikativem Wohnen und Arbeiten in einer architektonischen Szenerie umzusetzen. Dieses Wohnmodell steht als gesellschaftspolitischer Experimentierraum in markantem Gegensatz zu dem, was derzeit als Standard der Wohnbaugenossenschaften gilt. Diversität, hybrides Wohnen, die Auflösung der Trennung von Öffentlichkeit und Privatem werden implizit bzw. in der Sprache der Architektur thematisiert. Drei Anerkennungspreise gingen an Michael Pleschberger und Amila Smajlovic für „Ein Recht auf Wohnen", an Michael Heil für „ghetto vs. gated. gesellschaftspolitische aspekte einer stadt", sowie an Karina Brünner für „give me 5 years. Leerstände werden zu temporären Wohnungen". Die Preisverleihung fand am 30. November 2017 im Sitzungssaal des Gemeinderats im Grazer Rathaus statt. ∎

Sigrid Verhovsek

Herbert Eichholzer Architecture Award 2017

Colloquium and award presentation carried out by the **Institute of Housing**

The Herbert Eichholzer Architecture Award, which was conferred by the City of Graz and organized in 2017 by the Institute of Housing at Graz University of Technology, was devoted to the question of whether, when, and how architecture in theory or built reality will or can be politically relevant. At the colloquium, which was held on April 24, 2017, in the Institute of Housing—as an impulse for this year's Herbert Eichholzer Award—and was opened by the urban planning head Bernhard Inninger as a representative of the mayor of the City of Graz, it was initially Andreas Lichtblau who emphasized how important it is for architects to think about fundamental aspects of "spatial production" within society.

Antje Senarclens de Grancy analyzed the interaction between the architectural practice and the political commitment of Herbert Eichholzer, who was executed by the National Socialists in 1943. Eichholzer himself emphasized that he had arrived at his sociopolitical activity "through architecture" or through the issue of housing shortage.

Eugen Gross (Werkgruppe Graz) described how, as a student shortly after the Second World War, he heard nothing about Eichholzer—the denial of his architectural achievements had already begun. The keynote speech by Alex Hagner (gaupenraub +/-) was aligned to this Otto Kapfinger quote: "One must avoid encountering deficiency with deficiency." Hagner's open sociopolitical commitment is likewise based on personal experience: an encounter with the homeless. The motto should be "building lawlessly" if provisions, laws, and norms prevent part of society from finding an "apartment" because affordability is no longer a given or also because (basic) needs are ignored.

Peter Reitmayr (reitmayr architekten) also spoke of sociopolitical responsibility. To him, a connection between architecture and politics is mostly evident in the production and treatment of public space—and this not only in a spatial sense!

Bernhard Inninger's preferred "tool" as an urban planner is dialogical action and mediation among the most diverse parties. In his eyes, the core question, next to many other interesting topics, is: FOR WHOM is the public space being made, and which utilizations should it facilitate within a society that is becoming ever more finely segmented?

In the competition, there were hardly any limitations; the individual competition contributions could theoretically take the form of an essay posing the question of the political statement and effect of architecture, or a concrete design based on a short written position statement. Due to the complexity of the task, Andreas Lichtblau took over the advising of the designs and thus relinquished participation in the jury. By August 31, 2017, nine projects (by seventeen students total) were submitted on time and in the correct anonymous form. The jury session with Antje Senarclens de Grancy as chair took place on September 11, 2017, in the Media Center of the Graz city hall.

The winning project "wohnbau und öffentlichkeit" (housing and public) by Jakob Öhlinger thematically explores the complexity and multiperspectival nature of the relationship between housing and public, architecture and politics, by taking up a large number of themes in texts designed in feuilleton style and in expressive images. The self-contained, concise texts provide—with a moralizing tone or any intended claim to completeness—a broad overview of the problems faced in the thematic field of architecture/city/public space/social housing/traffic/supervision, et cetera. The project highlights strategic directions and addresses various innovative potential solutions. Demanded, among other things, are social standards instead of building standards, social density through social interaction or peripheral zones for communication instead of economically exploited town squares.

The second prize went to Helena Eichlinger and Therese Eberl für "Commedia dell'Arte". This architectural design for the Graz district of Gries, a kind of spatial staging inspired by the Greek polis, takes an experimental-theatrical approach to realizing forms of communicative housing and projects in an architectural setting. This housing model as sociopolitical space for experimentation is posited in stark contrast to what is currently considered the standard of housing associations. Diversity, hybrid housing, the dissolution of the division between public and private are implicitly thematized, in the language of architecture. Three recognition awards went to Michael Pleschberger and Amila Smajlovic for "Ein Recht auf Wohnen" (A Right to Housing), Michael Heil for "ghetto vs. gated: gesellschaftspolitische aspekte einer stadt" (sociopolitical aspects of a city), and Karina Brünner for "give me 5 years: Leerstände werden zu temporären Wohnungen" (Vacancies Become Temporary Housing).

The awards ceremony was held on November 30, 2017, in the conference room of the municipal council in Graz's city hall. ∎

Sigrid Verhovsek

Studentenwettbewerb „Inhabitable Skin"

Institut für Gebäude und Energie

Vor dem Hintergrund eines Entwicklungsprogramms im freifinanzierten Wohnbau in Österreich wurde ein interdisziplinäres Team von der ARE (Austrian Real Estate) Development, ein bedeutender Entwickler von Wohnbauprojekten in Österreich, beauftragt, innovative Ansätze für zukünftige Wohngebäudeprojekte zu entwickeln sowie deren Implementierung zu begleiten. Das Kernteam besteht aus Elsa Prochazka (Architektur-

Der Preisträger des „Grand Prix", Martin Wild (2. v. r.) mit den ARE-Geschäftsführer DI Hans-Peter Weiss (l.) und DI Wolfgang Gleissner (2. v. l.) und Prof. Brian Cody (r.) | "Grand Prix" winner Martin Wild (2. f. r.) with the managing directors of ARE, Hans-Peter Weiss (l.) & Wolfgang Gleissner (2. f. l.) und Prof. Brian Cody (r.) © IGE

büro Elsa Prochazka, Wien), Cino Zucchi (Politecnico Milano, Italien) und Brian Cody (Institut für Gebäude und Energie, TU Graz).

Mit freundlicher Unterstützung der „ARE Development" wurde ein Studentenwettbewerb ins Leben gerufen, bei dem die besten Studierendenprojekte mit Preisgeldern prämiert wurden. Teilnahmeberechtigt waren Studierende, die im Studienjahr 2016/17 ein Entwurfsprojekt im Rahmen des Jahresthemas „Inhabitable Skin" absolviert haben. Beteiligt waren Studierende des Bachelorstudiums und Masterstudiums Architektur an der TU Graz Graz und Studierende des Masterstudiums Architektur an der Universität für Angewandte Kunst Wien.

Am 9. Oktober 2017 wurden die besten Projekte von einer unabhängigen Jury, bestehend aus den ArchitektInnen Elsa Prohazka, Wolfgang Köck (Pentaplan) und Erich Ranegger (Atelier Thomas Pucher) ausgewählt und von den ARE-Geschäftsführern Hans-Peter Weiss und Wolfgang Gleissner in der Aula feierlich überreicht. Die Veranstaltung wurde mit einer Rede von Rektor Harald Kainz eröffnet und mit einer Diskussionsrunde mit den JurorInnen und Vertretern der AuftraggeberInnen abgerundet. Das Institut für Gebäude und Energie gratuliert allen PreisträgerInnen herzlich! ∎

Preise:

Kategorie 1, Bachelorstudium TU Graz:
1. Preis (EUR 1.800,–): **Felix Dokonal** und **Julian Lanca-Gil** mit dem Projekt „Cross Fortification"; 2. Preis (EUR 1.300,–): **Norma Grossmann**, **Bettina Jenner**, **Stephanie Lieskonig**, **Hannes Petautschnig** und **Charlotte Stella** mit dem Projekt „Mobo"; 3. Preis (EUR 700,–): **Benjamin Schnablegger** mit dem Projekt „Suncut"

Kategorie 2, Masterstudium TU Graz:
1. Preis (EUR 1.800,–): **Sarah Peers** mit dem Projekt „Vertical Village"; 2. Preis (EUR 1.300,–): **Petra Lienhart** mit dem Projekt „Green Oasis"; 3. Preis (EUR 700,–): **Elmas Karajic** mit dem Projekt „the skin u're in"

Kategorie 3, Masterstudium die Angewandte:
1. Preis (EUR 1.800,–): **Martin Wild** mit dem Projekt „Affordable Living"; 2. Preis (EUR 1.300,–): **Benjamin Goern** und **Mihai Potra** mit dem Projekt „Cross Diffusion"; 3. Preis (EUR 700,–): **Mary Denman**, **Mathias Juul Frost** und **Angel Yonchev** mit dem Projekt „Permeable Clusters"

Martin Wild wurde zusätzlich mit einem Preisgeld von EUR 600,– mit dem „Grand Prix" ausgezeichnet.

Brian Cody/Alexander Eberl

Student Competition Inhabitable Skin
Institute of Building and Energy

Against the backdrop of a development program in private housing in Austria, an interdisciplinary team was commissioned by ARE (Austrian Real Estate) Development, a major developer of residential buildings in Austria, to develop innovative approaches for future residential buildings and to accompany their implementation. The core team consists of Elsa Prochazka (Vienna), Cino Zucchi (Milan) and Brian Cody (Graz).

With the kind support of ARE Development, a student competition was launched and the best student projects were awarded prizes. The competition was held amongst students who completed a design project on the annual topic "Inhabitable Skin" during the academic year 2016/17. This included students of the Bachelor's degree and Master's degree in Architecture at the Graz University of Technology and students of the Master's degree in Architecture of the University of Applied Arts Vienna.

On October 9th, the best projects were selected by an independent jury consisting of architects Elsa Prohazka, Wolfgang Köck (Pentaplan) and Erich Ranegger (Atelier Thomas Pucher). The winners were announced in an award ceremony at the Aula of the TU Graz and were presented with an award by the managing directors of ARE Hans-Peter Weiss and Wolfgang Gleissner. The event was opened with a speech by Rector Harald Kainz and rounded off with a discussion with the jurors and representatives of ARE.

We would like to congratulate all prize winners on behalf of the Institute of Building and Energy! ∎

Awards:

Category 1, Bachelor's degree TU Graz:
1st Prize (EUR 1,800): **Felix Dokonal** and **Julian Lanca-Gil** with the project "Cross Fortification"; 2nd Prize (EUR 1,300): **Norma Grossmann**, **Bettina Jenner**, **Stephanie Lieskonig**, **Hannes Petautschnig** and **Charlotte Stella** with the project "Mobo"; 3rd Prize (EUR 700): **Benjamin Schnablegger** with the project "Suncut"

Category 2, Master's degree TU Graz:
1st Prize (EUR 1,800): **Sarah Peers** with the project "Vertical Village"; 2nd Prize (EUR 1,300): **Petra Lienhart** with the project "Green Oasis"; 3rd Prize (EUR 700): **Elmas Karajic** with the project "the skin u're in"

Category 3, Master's degree of the University of Applied Arts:
1st Prize (EUR 1,800): **Martin Wild** with the project "Affordable Living"; 2nd Prize (EUR 1,300): **Benjamin Goern** and **Mihai Potra** with the project "Cross Diffusion"; 3rd Prize (EUR 700): **Mary Denman**, **Mathias Juul Frost** and **Angel Yonchev** with the project "Permeable Clusters"

Martin Wild was special honored with the EUR 600 "Grand Prix" award.

Brian Cody/Alexander Eberl

Auszeichnungen und Preise für die ArchitektInnen der TU Graz

Die Mitglieder der Architekturfakultät der TU Graz freuen sich über zahlreiche Auszeichnungen und Preise im Jahr 2017: Riegler Riewe mit seinem Büro wurde für das, gemeinsam mit Brandlhuber + Emde, Burlon (Berlin) bearbeitete Projekt „St. Agnes Kunst- und Kulturzentrum/KÖNIG Galerie" in Berlin gleich mehrfach ausgezeichnet. Zunächst mit dem Architekturpreis-Berlin als wichtigsten Architekturpreis der Stadt Berlin, gefolgt von einer Nominierung für den international renommierten Mies van der Rohe Award 2017 und einer von insgesamt 4 Anerkennungen beim Architekturpreis Beton BDA Berlin.

Auch Hans Gangoly mit seinem Büro Gangoly & Kristiner Architekten ist heuer wieder prämiert worden, unter anderem mit einer Anerkennung beim Architekturpreis des Landes Steiermark sowie mit einer Nominierung zum Mies van der Rohe Award 2017. Beide Nominierungen erhielten Gangoly & Kristiner Architekten für die denkmalgerechte Sanierung des Chemiegebäudes der TU Graz. Uli Tischler vom Institut für Gebäudelehre wurde mit dem Projekt „Fortress Backyard – Festivalzentrum Steirischer Herbst" für den Landesarchitekturpreis des Landes Steiermark nominiert.

Aglaée Degros – die Leiterin des Instituts für Städtebau – hat mit ihrem Büro Artgineering gemeinsam mit Urban Platform den Preis der belgischen Städtebaukammer Règles d'or de l'urbanisme in der Kategorie Öffentlicher Raum für die Gestaltung des städtischen Platzes „Parvis Saint Antoine" im Brüsseler Quartier Forest erhalten. Radostina Radulova-Stahmer, Assistentin am Institut für Städtebau war mit ihrem Beitrag „Unfolding the Fan" beim Europan 14 – Die produktive Stadt erfolgreich und erzielte den ersten Preis für den Standort Graz. Mit der Talentförderprämie 2016 des Landes Oberösterreich für die Kategorie Architektur wurde Nicole Kirchberger, ebenfalls Assistentin am Institut für Städtebau ausgezeichnet. Der Preis unterstützt ihre weitere Arbeit sowie ihre Dissertation „Spatial Justice within Strategic Metropolitan Planning. An analysis of ideas, actor constellations and planning action".

Das Institut für Tragwerksentwurf unter der Leitung von Dekan Stefan Peters wurde für den Staatspreis Design nominiert und konnte sich unter die fünf Finalisten einreihen.

Auch zahlreiche Studierende der Architekturfakultät wurden für ihre herausragenden Leistungen prämiert: Mit seiner ausgezeichneten Masterarbeit „I-710/I-105 #more than infrastructure" gewann Alexander Gebetsroither den Hunter Douglas Award von der Archiprix Foundation.

Die Masterarbeit „Von der Norm zur Form" von Stefan Dygruber erhielt besondere Aufmerksamkeit von der Bundessektion Architekten und wurde mit dem Forschungspreis der Bundeskammer für ZiviltechnikerInnen 2016 ausgezeichnet.

Martina Spies erhielt den Johanna Dohnal Förderpreis 2017 für Ihre Dissertation „Plätze und Identitäten. Eine architektonisch-soziologische Aufnahme von fünf ausgewählten Plätzen innerhalb der informellen Siedlung Dharavi, Mumbai". Die Dissertation wurde von Peter Schreibmayer betreut und 2017 abgeschlossen.

Alina Kratzer konnte sich über den mit EUR 1.000,– dotierten Gender- und Diversitätspreis der TU Graz für Ihre Masterarbeit: „Ein Badehaus für Frauen" freuen. Also auch dieses Jahr wieder: Viele Beste und am besten gemeinsam! Wir gratulieren! ∎

Armin Stocker/Irmgard Humenberger

Distinctions and Prizes for the Architects of Graz University of Technology

Members of the Faculty of Architecture at Graz University of Technology are pleased about the various distinctions and prizes received in the year 2017: Riegler Riewe with his firm was distinguished multiple times, together with collaborators Brandlhuber + Emde, Burlon (Berlin), for the project "St. Agnes Kunst- und Kulturzentrum/KÖNIG Galerie" in Berlin. First they received the Architecture Prize Berlin, which is the city of Berlin's most important architectural award, followed by a nomination for the internationally renowned Mies van der Rohe Award 2017, and also one of four recognitions from the Concrete Architecture Awards (Federation of German Architects [BDA]).

This year, Hans Gangoly with his firm Gangoly & Kristiner Architekten was also distinguished, including recognition from the Styrian Architecture Award and a nomination for the Mies van der Rohe Award 2017. Both nominations were given to Gangoly & Kristiner Architekten for the restoration of the chemistry building at Graz University of Technology in line with accepted conservation practice. Uli Tischler from the Institute of Design and Building Typology was nominated for the State Architecture Award of Styria with the project "Fortress Backyard – Festivalzentrum Steirischer Herbst."

Aglaée Degros, head of the Institute of Urbanism, and her firm Artgineering together with Urban Platform received the prize of the Belgian urban-development chamber Règles d'or de l'urbanisme in the category public space for the design of the urban plaza "Parvis Saint

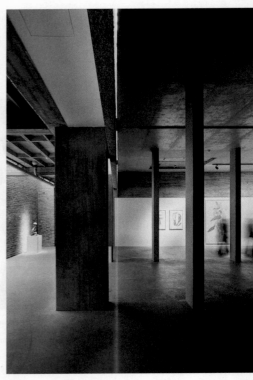

St. Agnes Kunst- und Kulturzentrum von | by Riegler Riewe
© Michael Reisch

Antoine" in the Quartier Forest in Brussels. Radostina Radulova-Stahmer, associate in the Institute of Urbanism, enjoyed success with her contribution "Unfolding the Fan" at Europan 14 – Die produktive Stadt, receiving first prize for the site of Graz. Nicole Kirchberger, also associate in the Institute of Urbanism, was honored with the Talent Incentive Bonus 2016 of the State of Upper Austria in the category of architecture. The prize supports her continued work and also her dissertation "Spatial Justice within Strategic Metropolitan Planning: An Analysis of Ideas, Actor Constellations and Planning Action."

The Institute of Structural Design lead by Dean Stefan Peters was nominated for the State Design Award and finished among the five finalists.

Numerous students from the Faculty of Architecture were distinguished for their outstanding achievements as well: with his outstanding master's thesis "I-710/I-105 #more than infrastructure," Alexander Gebetsroither won the Hunter Douglas Award from the Archiprix Foundation.

The master's thesis "Von der Norm zur Form" (From Norm to Form) by Stefan Dygruber received a special mention from the Bundessektion Architekten and was awarded the Research Prize of the Federal Chamber of Civil Engineers 2016.

Martina Spies received the Johanna Dohnal Award 2017 for her dissertation "Plätze und Identitäten: Eine architektonisch-soziologische Aufnahme von fünf ausgewählten Plätzen innerhalb der informellen Siedlung Dharavi, Mumbai" (Places and Identities: An Architectural and Sociological Survey of Five Selected Places within the Informal Settlement Dharavi, Mumbai). The dissertation was supervised by Peter Schreibmayer and completed in 2017.

Alina Kratzer was pleased to receive the Gender and Diversity Award from Graz University of Technology, endowed with 1,000 euros, for her master's thesis "Ein Badehaus für Frauen" (A Bathhouse for Women).

So this year once again: Many best, and the best together! Congratulations! ▪

Armin Stocker/Irmgard Humenberger

Exhibitions

Ausstellungen des Instituts für Zeitgenössische Kunst

Während des Studienjahrs 2017 realisierte das Institut für Zeitgenössische Kunst (IZK) eine Serie von Ausstellungen, die einerseits die Arbeit von InstitutsmitarbeiterInnen und andererseits Studierendenarbeiten zeigen und aus den Lehrveranstaltungen des Instituts entstanden sind.

„Sans Souci': Four Faces of Omarska" – Lernumgebung und Forschungslabor

Milica Tomić stellte im Rahmen des *Steirischen Herbst 2016* in der Ausstellung „Body Luggage" – kuratiert von Zasha Colah im Kunsthaus Graz (September 2016 bis Januar 2017) – verschiedene Unterlagen und Objekte aus unterschiedlichen zeitlichen und räumlichen Ebenen aus, die sich auf das Gebiet der Bergbauanlage Omarska im nördlichen Bosnien und Herzegowina beziehen. „Four Faces of Omarska" verfolgt die Bedeutung dieses Ortes als sozialistischer Bergbaustandort, als Konzentrationslager, als kapitalistisches Unternehmen und als Filmset für den im Zweiten Weltkrieg spielenden, serbischen Historienblockbusterfilm „Der Heilige Georg tötet den Drachen".

In diesem Kontext schuf Tomić innerhalb der Ausstellung ein Forschungslabor, in dem das Projektstudio des IZK zu einem Raum der Erforschung neuartiger Formen von Konzentrationslagern wurde, die in den Kriegen der 1990er entstanden. Durch die Verwendung des Elements eines runden Tisches (ein Ergebnis des Workshops „From the Roundabout to the Round Table" gehalten von Eyal Weizman am IZK im Sommersemester 2016, der mit dem Konzept öffentlicher Wahrheit verbunden war) werden konzeptuelle Gedanken und produzierte Gegenstände an einem Ort versammelt, um eine Teilnahme und Reflexion durch die Kommunikation mit Ausstellungsbesuchern zu ermöglichen. Auf diese Art arbeiteten die Studierenden mit Objekten und dem präsentierten Wissen, um neue Formen urbaner und sozialer Beziehungen zu untersuchen, die im (Post-) Bosnien und Herzegowina-Konflikt entstanden sind. Dies etablierte ein transitorisches Labor, das Ausstellen als Forschungsmethode erkundete, indem der Raum durch Vorträge und Interventionen kontinuierlich neu bespielt und aktiviert wurde, so dass sich den Besuchern des Kunsthauses komplexe thematische Verbindungen offenbarten. Das Labor reflektierte die derzeitigen sozialen, kulturellen und wirtschaftlichen Zusammenhänge, die durch einen globalen Ausnahmezustand in Zeiten ständiger Konflikte gekennzeichnet sind, welche die Menschen in eine Bedrohungslage permanenten

Krieges versetzen, wie sie tief im kapitalistischen System der Ausbeutung in der Moderne verwurzelt ist. ∎

Lehrende: **Daniel Gethmann**, **Milica Tomić** und **Simon Oberhofer**
Gäste und InterviewpartnerInnen: **Srđan Hercigonja**, **Andrew Herscher**, **Satko Mujagić**, **Sudbin Musić**, **Lidija Radojević** und **Dubravka Sekulić** und Gast-kritikerInnen **Marcello Fantuz** und **Sophia Meeres**
KursteilnehmerInnen: **IZK Masterstudierende**

Masterstudioausstellung

im **HDA** – Haus der Architektur,
24. bis **26. Januar 2017** und
„Sans Souci", Malta Festival Poznań,
Polen, 16. bis **25. Juni 2017**

Die Ausstellung und Performance im Haus der Architektur (HDA) war eine Transposition des Masterstudiolabors am IZK. Im Rahmen des Malta Festivals Poznań in Polen waren Studierende des IZK eingeladen, „Sans Souci" in Kooperation mit dem Projekt „The Container" der Künstlerin Milica Tomić auszustellen.

Die Masterstudioausstellung bildete ein Forschungswerkzeug, um die Nachforschungen der Studierenden in einen Dialog mit Geschehnissen und weiterhin bestehenden Strukturen in einem globalen kapitalistischen Maßstab in Bosnien und Herzegowina zu bringen. Die Studierenden entwickelten komplexe Modelle, die auf Archivarbeit, Exkursionen zu den Konzentrationslagern, Interviews, Vorträgen und Forschung basierten, welche es ermöglichten, die Gewalterfahrungen durch die Analyse der Macht- und Raumverhältnisse vor, während und nach den Gräueltaten in den Lagern nachzuvollziehen und dabei ein maßstabsunabhängiges Beziehungsnetz entstehen ließen.

Die Dokumentationsunterlagen und Forschungswerkzeuge aus dem wissenschaftlichen Bereich der Architekturforschung wurden im Rahmen der Balkanplattform des Malta Festival Poznań 2017 so verstanden, dass sie „auf die Dekonstruktion und Entzauberung der historischen Phantasmen und unserer Imagination des Balkans zielten". Das Malta Festival Poznań, ein internationales Theaterfestival, das sich mit der Zeit auch auf andere Kunstbereiche erstreckte, erzeugte eine Diskussions- und Interaktionsplattform im Kontext zeitgenössischer Politik. Deshalb bot das Festival in Kooperation mit Milica Tomićs Projekt „The Container" eine Möglichkeit, die geopolitische Landschaft eines permanenten modernen Krieges zu zeigen. ∎

Gäste und InterviewpartnerInnen: **Ivana Bago**, **Marcello Fantuz**, **Armina Galijaš**, **Daniel Gethmann**, **Srđan Hercigonja**, **Namka Konjević**, **Milorad Kremenović**,

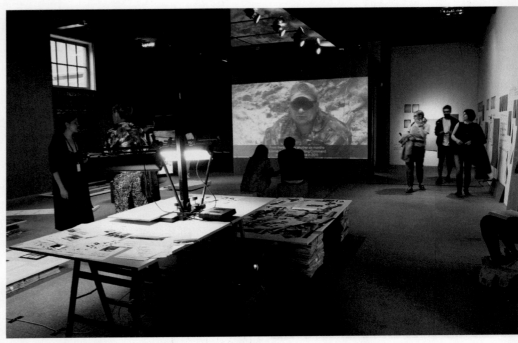

„Sans Souci" Ausstellung | exhibition Malta Festival Poznań, Art Stations Gallery, Poznań, Polen | Poland, Juni | June 2017 © IZK

Satko Mujagić, **Sudbin Musić**, **Lidija Radojević**, **Berina Ramić**, **Dubravka Sekulić** und **Branimir Stojanović**
Teilnehmende Studierende: **Amina Abazović**, **Džana Ajanović**, **Ajna Babahmetović**, **Therese Eberl**, **Helena Katharina Eichlinger**, **Angelika Hinterbrandner**, **Muris Kalić**, **Aldin Kanurić**, **Anousheh Kehar**, **Amir Ihab Tharwat Kozman**, **Ina Barbara Lichtenegger**, **Hilette Lindeque**, **Melissa Muhri**, **Alisa Pekić**, **Tina Petek**, **Andrea Peković**, **Clara Primschitz** und **Philipp Sattler**

Džana Ajanović/Anousheh Kehar/Philipp Sattler/Milica Tomić

„State of Nature"

im Salon des **Museums für Zeitgenössische Kunst** in **Belgrad** vom **21. April** bis **29. Mai 2017**

Die Ausstellung „State of Nature" realisierte Dejan Marković im Rahmen des künstlerischen Forschungsprojekts „The Incomputable". Seine Untersuchung zu den gegenwärtigen Transformationen des digitalen Kapitalismus haben zum Ziel, dessen neue epistemologischen Paradigmen zu identifizieren. Die Ausstellung zeigt die Simulation eines Trainingszentrums für autonome Maschinen – das wissenschaftliche Modell eines „Ausnahmezustands" – und eine Vier-Kanal-Videoinstallation. Mit dem Ausstellen von didaktischen Werkzeugen des Digital Engineering und einer neuen nicht-humanzentrierten Sichtweise stellt der Künstler heraus, wie neue Beziehungen zwischen Natur, Mensch und Maschine konstruiert werden. Gleichzeitig hinter-

fragt er die politischen Implikationen dieser Prozesse. Diese Ausstellung bildet das Resultat einer Zusammenarbeit mit Experten, die an der Entwicklung autonomer Roboter, des unabhängigen maschinellen Lernens, maschineller Bilderkennung, künstlicher Intelligenz und an neuronalen Netzwerken an der Technischen Universität Graz (Institut für Softwaretechnologie und Institut für Maschinelles Sehen und Darstellen) arbeiten, sowie mit den KuratorInnen und RestauratorInnen des Universalmuseums Joanneum. ∎

Ausstellungsarchitektur: **Marco Wenegger**; Kamera: **Rettungsroboter Wowbagger**, **Staša Tomić**; 3D-Kartierung: **Rettungsroboter Wowbagger**, **Matthias Rüther**; Maschinelles Sehen: **Rettungsroboter Wowbagger**, **Horst Possegger**; Maschinensteuerung: **Michael Stradner** und **Clemens Mühlbacher**; Editing: **Studio Stasa Tomić**; Sound Design: **Jan Nemeček**

Dejan Marković

Exhibitions of the Institute of Contemporary Art

During the academic year 2017 the Institute of Contemporary Art realized a series of exhibitions showcasing the work of the institute's faculty as well as student works which have resulted from the institute's curriculum.

"'Sans Souci': Four Faces of Omarska" – Learning Space and Research Lab

Milica Tomić exhibited at Steirischer Herbst Festival 2016 at "Body Luggage" curated by Zasha Colah at Kunsthaus Graz, (September 2016 – January 2017) various material and objects from different layers of time and space focalized on the site of Omarska mining complex in northern Bosnia and Herzegovina. "Four Faces of Omarska" traced the site as a socialist mine, a concentration camp, a capitalist enterprise and a filmset for the Serbian historical blockbuster Saint George Slays the Dragon set in WWI.

In this context, at the exhibition, Tomić created a research lab where the Integral Design Studio of the Institute for Contemporary Art became a space of investigation into the novel form of concentration camps established in the wars of the 1990s. By introducing the element of an actual round table (a product of the workshop from the Roundabout to the Round Table conducted by Eyal Weizman at the IZK in the summer semester 2016, connected to the concept of public truth), features in conceptual and crafted manner were incorporated to enable engagement and reflection in communication with visitors. In this way students worked with the objects and knowledge presented in order to investigate new forms of urbanism and societal relations emerging in a (post) conflict Bosnia and Herzegovina.

This established a transitory laboratory that explored exhibiting as a research method which continuously rearranged and activated the space through lectures and interventions, as it unfolded complex entanglements in the presence of the audience of Kunsthaus Graz. It reflected on the present social, cultural and economic contexts, simultaneously related to a global state emerging out of conflict, situating people in a notion of permanent war deeply rooted in capitalist systems and exploitations of modernity. ∎

Course leaders: **Daniel Gethmann**, **Milica Tomić** and **Simon Oberhofer**
Guests and lecturers: **Srđan Hercigonja**, **Andrew Herscher**, **Satko Mujagić**, **Sudbin Musić**, **Lidija Radojević** and **Dubravka Sekulić**, and guest critics **Marcello Fantuz**, and **Sophia Meeres**
Course participation: **IZK Masters students**

Master Studio Exhibition
HDA – Haus der Architektur, 24–26 January, 2017 and "Sans Souci", Malta Festival Poznań, Poland, 16–25 June, 2017

The exhibition and performance at Haus der Architektur Graz (HDA) was a transposition of the master studio laboratory at the Institute for Contemporary Art. At the Malta Festival Poznań in Poland, students from

IZK were invited to exhibit Sans Souci in cooperation with "The Container" project by artist Milica Tomić.

The master studio exhibition was a tool to illustrate student investigations into a dialogue of events and ongoing systems on a global capitalist scale, localized in Bosnia and Herzegovina. The students developed complex models based on archives, excursions to camp sites, interviews, lectures and research which enabled explorations of bodily forces that shaped relations of power and space before, during and after the atrocities on the sites, and consequently created multi-layers across scales.

The documentary materials and tools evolved from the academic realm of architectural research into the framework of Malta Festival Poznań 2017 Balkans Platform idiom, "aimed at deconstructing and disenchanting the historical phantasms and our imaginary Balkans." Malta Festival Poznań, an international theatre festival that branched into other domains of art over time, established a platform for discussion and interaction in the context of contemporary politics. As such, in cooperation with Milica Tomić' project "The Container," the space was a means to showcase the geopolitical landscape of constant modern warfare. ∎

Guests and Interviewees: **Ivana Bago**, **Marcello Fantuz**, **Armina Galijaš**, **Daniel Gethmann**, **Srđan Hercigonja**, **Namka Konjević**, **Milorad Kremenović**, **Satko Mujagić**, **Sudbin Musić**, **Lidija Radojević**, **Berina Ramić**, **Dubravka Sekulić** and **Branimir Stojanović**
Participating students: **Amina Abazović**, **Džana Ajanović**, **Ajna Babahmetović**, **Therese Eberl**, **Helena Katharina Eichlinger**, **Angelika Hinterbrandner**, **Muris Kalić**, **Aldin Kanurić**, **Anousheh Kehar**, **Amir Ihab Tharwat Kozman**, **Ina Barbara Lichtenegger**, **Hilette Lindeque**, **Melissa Muhri**, **Alisa Pekić**, **Tina Petek**, **Andrea Peković**, **Clara Primschitz** and **Philipp Sattler**

Džana Ajanović/Anousheh Kehar/Philipp Sattler/ Milica Tomić

"State of Nature"
at the Museum of Contemporary Art in Belgrade, April 21–May 29, 2017

The exhibition "State of Nature" was realized by Dejan Marković in the framework of the art based research project "The Incomputable." His investigation of current transformations of digital capitalism aims

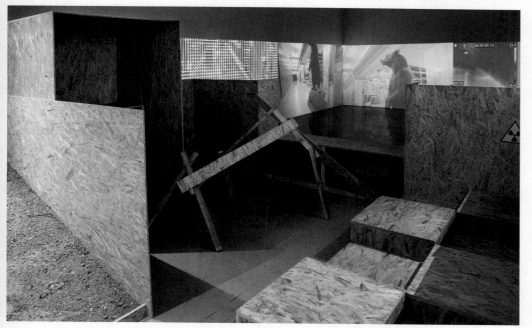

„State of Nature" exhibition view | Ausstellungsansicht, Dejan Marković © MSUB

to identify new epistemological paradigms. The exhibition showcased a simulation of a training centre for autonomous machines—the scientific model of "a state of exception"—and a four-channel video installation. By exhibiting didactic tools of digital engineering and a novel non-human centric view, the artist emphasized how new relations between nature, human and machine are being constructed. Simultaneously, he questioned the political implications of these transformations. This exhibition was the outcome of a collaboration with experts working on developing autonomous robots, independent machine learning, a machinic comprehension of images, artificial intelligence and neural networks, at the Graz University of Technology (Institute for Software Technology and Institute for Computer Graphics and Vision) and curators and restorers at the Universalmuseum Joanneum. ∎

Architecture design: **Marco Wenegger**; Camera: **Rescue robot Wowbagger, Staša Tomić**; 3D Mapping: **Rescue robot Wowbagger, Matthias Rüther**; Machine vision: **Rescue robot Wowbagger, Horst Possegger**; Robotic machine operators: **Michael Stradner, Clemens Mühlbacher**; Editing: **Studio Staša Tomić**; Sound design: **Jan Nemeček**

Dejan Marković

Der gefaltete Raum 2.0 und Ornament 3 × 3 = 6
Ausstellungen des
Instituts für Architektur und Medien im **MUWA** –
Museum der Wahrnehmung

Von September 2016 bis April 2017 zeigte der gefaltete Raum 2.0 in einer großen Ausstellung im MUWA erstmals Arbeiten von Studierenden im Hauptraum. Unter der Leitung von Milena Stavrić und der Mitarbeit von Albert Wiltsche und Julian Jauk haben die Studierenden in der Lehrveranstaltung „Entwerfen spezialisierter Themen" gefaltete Raumstrukturen am Computer entwickelt, parametrisiert, mittels Lasercutter ausgeschnitten und schlussendlich händisch gefaltet und zusammengebaut. Mit der Präsentation von ästhetisch und technisch hochentwickelten Ergebnissen unterschiedlicher Dimensionen wurde im Rahmen dieser großen Ausstellung einmal mehr auf die Bedeutung der Schnittstelle zwischen Technologie und manueller Fertigung hingewiesen.

Wie lässt sich eine Idee oder eine Vorstellung im Kopf mit Hilfe von Zahlen und Algorithmen in eine ästhetische Form verwandeln? Wie kann man den einfachen Formen wie Quader, Pyramide oder Kegel eine Dynamik zuweisen? Wie wird ein zweidimensionales Stück Papier durch Falten in eine gewünschte dreidimensionale Raumstruktur umgewandelt? Ist durch den Vorgang der Faltung die eigene Leidenschaft für Mathematik, Technik und Wissenschaft in einen künstlerischen Prozess übertragbar? Das sind nur einige der Fragen mit denen die Studierenden bei der Realisierung der ausgestellten Exponate konfrontiert wurden. Die ausgestellten Faltstrukturen umfassen ein Spektrum von kleinformatigen Objekten (33 × 33 cm), größeren modularen Strukturen (70 × 70 cm) bis hin zu raumgreifenden Faltarbeiten (70 × 100 cm).

Die zweite Ausstellung im Museum der Wahrnehmung (MUWA) in Graz fand von Februar bis März 2017 unter dem Titel „Ornament 3 × 3 = 6" statt. Es wurden Studierendenarbeiten der Lehrveranstaltung „Darstellungsmethoden" vom Wintersemester 2016/2017 präsentiert. Im Rahmen der von Milena Stavrić und Florian Schober geleiteten Lehrveranstaltung stand das Ornament in unterschiedlichen Variationen und verschiedenen Möglichkeiten der Darstellung im Fokus. Die Studierenden der Lehrveranstaltung entwickelten individuelle Schneide-, Biege-, Gravur- und Raster-Varianten aus einer ihnen zugeteilten Ornamentgruppe und ordneten sechs Arbeiten zu einem Ensemble. In der Ausstellung wurden im steten Wechsel von drei Wochen die Ergebnisse aller TeilnehmerInnen gezeigt. Aufgrund des großen Interesses wurden die Studierendenarbeiten im Rahmen der Vienna Design Week 2017 im Fedrigoni Showroom in Wien präsentiert. ∎

Milena Stavrić

The Folded Room 2.0 and Ornament 3 × 3 = 6
Exhibitions by the **Institute of Architecture and Media** at **MUWA** – Museum of Perception

From September 2016 to April 2017, in a large exhibition at MUWA, the folded Room 2.0 showed for the first time works by students in the main exhibition space. Under the direction of Milena Stavrić and the collaboration of Albert Wiltsche and Julian Jauk, students from the class "Entwerfen spezialisierter Themen" (Designing Specialized Themes) developed and parameterized folded spatial structures on the computer and then cut them out using a laser cutter before finally hand-folding and assembling them. With the presentation of

Vernissage, Urs Hirschberg (Redner | speaker) und
Eva Furstner (Leiterin | Manager MUWA Museum) © iam

aesthetically and technically advanced results of various dimensions, yet another reference was made in the scope of this large exhibition to the significance of the interface between technology and manual production processes.

How can an idea or a concept in the mind be transformed into an aesthetic form with the aid of numbers and algorithms? How can one imbue simple forms like a square, pyramid, or cone with a sense of dynamics? How can a two-dimensional piece of paper be transformed into the desired three-dimensional spatial structure through folding? Might one's own passion for mathematics, technology, and science be translated into an artistic process by means of the process of folding? These are just a few of the questions that confronted the students during the realization of the exhibited projects. The folded structures presented there encompass a spectrum ranging from small-format objects (33 × 33 cm) and larger modular structures (70 × 70 cm), to space-filling folded works (70 × 100 cm). The second exhibition at the Museum of Perception (MUWA) in Graz was held from February to March 2017 under the title *Ornament 3 × 3 = 6*. Student works from the course "Darstellungsmethoden" (Methods of Representation) from winter semester 2016–17 were shown. In the framework of this course taught by Milena Stavrić and Florian Schober, the ornament was taken as a point of focus in all its different variations and various representational opportunities. The students of the course developed individual ornament variants using cutting, bending, engraving, and grids from the ornament group assigned to them and assembled six works to create an ensemble. In the exhibition, the results of all participants were shown at regular intervals of three weeks each. Due to the strong interest, the student works were also presented in the Fedrigoni Showroom in Vienna as part of Vienna Design Week 2017. ∎

Milena Stavrić

Prater Türme Wien – Typologie des Urbanen zu Gast in Berlin
Institut für Gebäudelehre

Im Rahmen der Projektübung „Prater Türme Wien – Typologie des Urbanen" entstanden Arbeiten von Studierenden, die im März 2017 im O&O Baukunst Depot in Berlin einer interessierten Öffentlichkeit präsentiert wurden.

Der Fokus der Lehrveranstaltung war auf die Typologie des Wohnhochhauses gerichtet und die Bedeutung, die es derzeit europaweit in Städten und im Diskurs um städtische Verdichtung einnimmt. Auf dem südlichsten Grundstück des „Quartier Viertel Zwei", einem zentralen Wiener Stadtentwicklungsgebiet sollen in naher Zukunft zwei Wohnhochhäuser mit Sockel als der letzte und größte Baustein entwickelt werden. Das war der Ausgangspunkt für die Entwurfsaufgabe. Markus Penell lud fünf der Teams nach Berlin ein, um ihre Arbeiten in Form von Plakaten und dem Umgebungsmodell mit Einsatzmodellen der Projekte auszustellen. Die ausgewählten Arbeiten untersuchten den Zusammenhang unterschiedlicher Funktionen im Sockel auf Wohntypologie und Wohnform in den Türmen. Ebenso standen sie für Visionen urbaner Komplexität und poetischer und atmosphärischer Neuinterpretationen einer jetzt stärker wiederkehrenden Typologie. Sie zeigten vielseitige Möglichkeiten auf, wie durch Programmierung und Strukturierung des urbanen Sockels der Hybrid zwischen der U-Bahn Linie U2, der alten Trabrennbahn Krieau, dem Happel Stadion und dem Prater verankert und mit seiner Umgebung vernetzt werden kann. Verschiedene städtebauliche Antworten regten spannende Diskussionen unter den zahlreichen Besuchern an und bestätigten, dass Studierendenarbeiten einen wertvollen Beitrag zum aktuellen Diskurs leisten können. Nicht nur die Entwürfe überzeugten, auch der Ausarbeitungsgrad bis hin zu Fassadendetails und die außergewöhnlich überzeugenden Darstellungen fanden großen Anklang. ∎

Betreuer: **Hans Gangoly, Markus Penell, Evelyn Temmel**
Studierende: **Daniela Cobas, Katharina Hohenwarter, Lisa-Marie Illmer, Marcus Nussbaumer, Gernot Bergant, Markus Pöll, Melanie Marie Afschar, Christina Falle, Sebastian Reiter, Jonathan Schreder, Stefan Kropsch**

Evelyn Temmel

Prater Towers Vienna – Typology of the Urban as a Guest in Berlin
Institute of Design and Building Typology

In the scope of the project "Prater Türme Wien – Typologie des Urbanen" (Prater Towers Vienna – Typology of the Urban) students created works that were presented in March 2017 to an interested public at the O&O Baukunst Depot in Berlin.

The focus of the course was trained on the typology of high-rise housing and on the significance that it presently holds in cities throughout Europe and in the discourse on urban density. Set to be built in the near future on the southernmost plot of the "Quartier Viertel Zwei," a central urban-development area in Vienna, are two high-rise residential buildings on a base as the last and largest structural element in the area. This was the starting point for the design task. Markus Penell invited five of the teams to Berlin to exhibit their works in the form of posters and an environmental model with the projects' respective fielding models. The selected works investigated the connection between different functions in the base as to housing typology and housing form in the towers. They also represented visions of urban complexity and poetic and atmospheric reinterpretations of a typology that is now returning more strongly. They highlighted versatile possibilities for programming and structuring the urban base in order to anchor the hybrid between the subway line U2, the old Krieau horseracing track, the Happel Stadion, and Prater and to enable networking within its surroundings. Different urban-planning responses fostered exciting discussions among the many visitors and confirmed that student works can make a valuable contribution to current discourse. Not only the designs proved convincing and popular, but also everything from the level of workmanship to the façade details and convincing representations. ∎

Advisors: **Hans Gangoly, Markus Penell, Evelyn Temmel**
Students: **Daniela Cobas, Katharina Hohenwarter, Lisa-Marie Illmer, Marcus Nussbaumer, Gernot Bergant, Markus Pöll, Melanie Marie Afschar, Christina Falle, Sebastian Reiter, Jonathan Schreder, Stefan Kropsch**

Evelyn Temmel

„Modell 1:500" Studierendenprojekt von | student project by Daniela Cobbs & Katharina Hohenwarter
© Institut für Gebäudelehre | Institute of Design and Building Typology

amm war dabei!
Teilnahme der **Möbelwerkstatt** des **Instituts für Raumgestaltung** beim **Internationalen Kunst und Design Festival POTENTIALe**, im November 2017 in Feldkirch/Vorarlberg und der **Milano Design Week**, **VENTURA LAMBRATE** im April 2017 in Mailand

Eine feine Selektion der Prototypen der letzten beiden Semester präsentierte „amm – architektinnen machen möbel" vom Institut für Raumgestaltung unter neuem Logo beim internationalen Kunst und Design Festival POTENTIALe in Feldkirch. Das Institut für Raumgestaltung unter der Leitung von Irmgard Frank folgte damit einer der Einladungen, die auf der „Ventura Lambrate" in Mailand ausgesprochen wurden. Ebenda, in einer der alternativen Hallen zum Salone Internazionale del Mobile im Bezirk Lambrate hatten sich die GrazerInnen samt türkisem Rahmen durch das klar erkennbare Konzept der Objekte im internationalen Vergleich der Design-Universitäten abgehoben.

Irmgard Frank & Team: Franziska Hederer, Marianne Machner, Judith Augustinovič, Sebastian Reiter, Petr Müller, Corinna Wassermann, Philip Waldhuber und Rainer Eberl, Ventura Lambrate © amm

In Feldkirch eigentlich der Rubrik Talente zugehörig beteiligte sich amm an der Messe, prominent in der Eingangshalle im Pförtnerhaus platziert, und vergütete, im wahrsten Sinn des Wortes, den Stand mit der POTENTIALe Edition „lunar_lander". Der einzigartige Charakter dieses Entwurfs resultiert aus Gestalt und Sitzerlebnis. Drei Elemente, gleich Rotorblätter nur in einem Punkt verbunden fragil und dynamisch zugleich sind das Ergebnis des kompromisslosen minimierten Materialeinsatzes. Das Sitzobjekt, entworfen von Philip Waldhuber in der Lehrveranstaltung „Möbel Design Herstellung", wurde in Mailand als Prototyp präsentiert. In seiner überarbeiteten Form kommt es ohne metallische Verbindungsteile aus und ist nicht nur durch die Verwendung von Zwetschkenholz sehr ausgefallen. Drei Stück dieses Modells werden amm permanent in Feldkirch in der POTENTIALe FESTIVALZENTRALe im Pulverturm vertreten. ∎

amm Projektteam: **Irmgard Frank**, **Franziska Hederer**, **Judith Augustinovič**, **Rainer Eberl**, **Marianne Machner** Studierende: **Sebastian Reiter**, **Petra Müller**, **Corinna Wassermann**, **Philip Waldhuber**

Judith Augustinovič

amm Was There!

Participation in the **Furniture Workshop** of the **Institute of Spatial Design** at the **International Art and Design Festival POTENTIALe**, in November 2017 in Feldkirch/Vorarlberg, and the **Milan Design Week**, **VENTURA LAMBRATE**, in April 2017 in Milan

A fine selection of prototypes from the last two semesters were presented by "amm – architektinnen machen möbel" (Architects Making Furniture) from the Institute of Spatial Design under a new logo at the International Art and Design Festival POTENTIALe in Feldkirch. The Institute of Spatial Design, under the direction of Irmgard Frank, thus followed one of the invitations extended at the "Ventura Lambrate" in Milan. Also, in one of the alternative halls for the Salone Internazionale del Mobile in the Lambrate district, the Graz students with their turquoise frame stood out with the clearly recognizable concept of objects in international comparison among the design universities.

Despite actually being assigned to the talent category in Feldkirch, amm took part in the fair, situated prominently in the gatehouse of the entrance hall, and provided the stand with the POTENTIALe Edition "lunar_lander." The unique character of this design results from shape and seating experience. Three elements, similar to rotor blades but attached in one place, fragile and dynamic simultaneously, are the result of the uncompromising minimized use of material. The seating object, designed by Philip Waldhuber in the course "Möbel Design Herstellung" (Furniture Design Production), was presented as a prototype in Milan. In its revised form, the seat does without metal connecting parts and is very unique, not least because of the use of plum wood. Three units of this model will represent amm permanently in Feldkirch at the POTENTIALe FESTIVALZENTRALe in the Pulverturm. ∎

amm project team: **Irmgard Frank**, **Franziska Hederer**, **Judith Augustinovič**, **Rainer Eberl**, **Marianne Machner** Students: **Sebastian Reiter**, **Petra Müller**, **Corinna Wassermann**, **Philip Waldhuber**

Judith Augustinovič

Ein lebendiges Stück Architektur
Ausstellung der **Diplomarbeit** von **Julian Jauk** bei der **Ars Electronica Festival Highlight Tour** im September 2017 in Linz

Julian Jauks „A Living Piece of Architecture" (oder „Ein lebendiges Stück Architektur") ist ein konzeptueller und utopischer Entwurf für eine Architektur jenseits von „smart homes", der anstrebt, bestehende Dualismen wie digital und materiell, künstlich und natürlich zu überwinden. Das kinetische, fotosensitive und adaptive Modell zeigt eine Typologie von Architektur, welche ihre Gestalt ständig wechselt, um sich nicht nur an die physische Umgebung anzupassen, sondern auch an die Gefühlszustände der BewohnerInnen. Form, Größe und Geschwindigkeit dieser Anpassung werden von einem evolutionären Optimierungsalgorithmus kontrolliert, einer bionischen Technologie, inspiriert von Systemen in der Natur. Anders jedoch als ein Lebenszyklus dauert eine Iteration lediglich wenige Sekunden. Dieser Algorithmus folgt den biologischen Kriterien des Lebens, welche auf Architektur übertragen worden sind; wie zum Beispiel physische Reizbarkeit und Wachstum durch dehnbare Materialien in einem selbst erhaltenden System. BesucherInnen wurden eingeladen die Architektur durch Eingabe ihres (gewünschten) Gefühlszustands und durch Änderung der Stärke und Position der Energie- und Lichtquelle zu stimulieren. Dadurch erleben sie, wie sich die Gestalt des Hauses an das erzeugte physische und psychische Klima adaptiert – genauso wie es Pflanzen und Tiere tun. ∎

https://www.aec.at/ai/de/living-piece-architecture/
https://vimeo.com/243619600

Julian Jauk

A Living Piece of Architecture
Exhibition **Julian Jauk's Master Thesis Project** at the **Ars Electronica Festival Highlight Tour** in September 2017 in Linz

Julian Jauk's utopian design project "A Living Piece of Architecture" addresses housing beyond "smart homes" and is intended to overcome existing dualisms such as digital and material or artificial and natural. The kinetic, photosensitive, and adaptive model shows a type of architecture that constantly changes its morphology to adapt not only to the environment but also to human emotions and behaviour. The shape, size, and speed of adaptation are controlled by an evolutionary optimization algorithm—a bionic technology inspired by nature.

But unlike in a lifetime cycle, one iteration takes just a few seconds. This algorithm follows the biological criteria for life and applies them to architecture. For example, the physical irritability within a self-regulating system or growth through tensile materials. Visitors were invited to stimulate the architecture by setting their (desired) mood and by changing the energy and light sources. Hence, they were able to experience how the structure was adapting to the physical and psychological climate that had been provided—a process usually performed by plants or animals. ∎

https://www.aec.at/ai/de/living-piece-architecture/
https://vimeo.com/243619600

Julian Jauk

PreisträgerInnen des Architekturskizzenbuchpreises | Awardees of the Architecture Sketches Award © KOEN

Modell von | Model of „A living piece of archicture",
Ars Electronica Linz Festival © Julian Jauk, 2017

Graz Open Architecture '17
Jahresausstellung und Sommerfest
der Architekturfakultät am Campus Alte Technik

Unter dem Titel „Sommerfest und Ausstellung – Graz Open Architecture '17" feierte die Architekturfakultät der TU Graz den alljährlichen Abschluss des Sommersemesters. In einer großangelegten, zweitägigen Ausstellung wurden hervorragende Studierendenarbeiten und -projekte aus dem Winter- und Sommersemester 2016/17 präsentiert, die bei einem Rundgang durch die Institute am Campus Alte Technik in der Rechbauerstraße 12, in der Lessingstraße 25, im Park und im Innenhof der Alten Technik von allen Architektur-, Kultur- und Kunstbegeisterten besichtigt werden konnte. In Zusammenarbeit mit dem HDA – Haus der Architektur fanden zusätzlich zwei geführte Touren statt, bei denen Armin Stocker einen Einblick in die architektonischen Ideen der studentischen Arbeiten vermittelte. Ein besonderes Highlight der Veranstaltung war ein erster Besuch der neu ausgebauten Masterstu-

dios im Dachgeschoß, die im Oktober 2017 offiziell eröffnet wurden.

Live-Musik, kulinarische Kostproben und sommerliches Flair sorgten für eine festliche Atmosphäre und begeisterten die BesucherInnen noch bis in die späten Abendstunden.

Im Rahmen des Sommerfestes wurden auch zahlreiche Preise an engagierte, kreative Studierende der TU Graz überreicht: Der mit EUR 200,– dotierte Büchergutschein für den Plakatwettbewerb ging an Helena Eichlinger. Für die Gestaltung des urba Graz Logos erhielt Clara Hamann einen Buchpreis vom Institut für Städtebau. Der Architekturskizzenpreis des Instituts für Grundlagen der Konstruktion und des Entwerfens ging an: **Nicole Eggenreich** (1. Preis), **Stefanie Insupp** und **Angelika Lisa Mayr** (2. Preis). Herzliche Gratulation den PreisträgerInnen!

Für das Sponsoring der Preise ergeht ein besonderer Dank an das HDA Graz, an Architekturbedarf Kropf in Graz und an die Fakultät für Architektur der TU Graz. ∎

Irmgard Humenberger

Graz Open Architecure 17
Annual Exhibition and Summer Festival of the
Department of Architecture at the Campus Alte Technik

Under the title "Sommerfest und Ausstellung—GRAZ Open Architecture 17" (Summer Festival and Exhibition – GRAZ Open Architecture 17), the Department of Architecture at Graz University of Technology celebrated the yearly conclusion of the summer semester. In a large-scale, two-day exhibition, outstanding student works and projects from the winter and sum-

mer semesters 2016–17 were presented. These projects could be viewed by all architecture, culture, and art aficionados along a circuit through the institutes at the Campus Alte Technik at Rechbauerstraße 12, at Lessingstraße 25, at the park, and in the interior courtyard of the Alte Technik building. In collaboration with Haus der Architektur (HDA), two guided tours were additionally held, with Armin Stocker providing insight into the architectural ideas of the student works. A special highlight of the event was a first-time visit of the newly renovated master studios in the attic, which were officially opened in October 2017.

Live music, culinary samples, and a summery flair provided for a festive atmosphere and delighted the visitors well into the evening hours.

In the framework of the summer festival, numerous prizes were also presented to committed, creative students of Graz University of Technology. The book gift certificate valued at 200 euros for the poster competition went to Helena Eichlinger. For the design of the urba Graz logo, Clara Hamann received a book prize from the Institute of Urbanism. The architecture sketching prize of the Institute of Construction and Design Principles went to: **Nicole Eggenreich** (1st prize), **Stefanie Insupp** and **Angelika Lisa Mayr** (2nd prize). Warm congratulations to the prizewinners!

For sponsoring the prizes, special thanks is extended to the HDA Graz, Architekturbedarf Kropf in Graz, and the Department of Architecture at Graz University of Technology. ∎

Irmgard Humenberger

Events/ Projects

© Grafik Christian Pichlkastner, ITE, TU Graz

Junge Architekturforschung in Graz

Eine Veranstaltung der **Doctoral School** der **Fakultät für Architektur** und dem **HDA – Haus der Architektur** in Graz

Am 5. Juli 2017 präsentierten im HDA – Haus der Architektur junge Nachwuchsforscherinnen und Nachwuchsforscher der Fakultät für Architektur anhand laufender Dissertationsarbeiten aktuelle Themen, Fragestellungen und Methoden in der Architekturforschung. Das HDA fungierte dabei als Schnittstelle zwischen der akademischen Forschung und der Öffentlichkeit. Die Veranstaltung wurde von Brian Cody organisiert und geleitet. Die Moderation übernahm Anselm Wagner. ▪

Markus Bogensberger (Haus der Architektur Graz), **Stefan Peters** (Dekan der Fakultät für Architektur TU Graz) und **Brian Cody** (Leiter des Koordinationsteams der Doctoral School Architektur, TU Graz) NachwuchsforscherInnen:
Renate Weissenböck: „Dynamic robotic shaping"; Betreuer: Urs Hirschberg, Institut für Architektur und Medien
Alexander Eberl: „Herangehensweisen an die Revitalisierung von Wohnsiedlungen aus der Ära des Strukturalismus"; Betreuer: Brian Cody, Institut für Gebäude und Energie
Eva Pirker: „Computational methods for the design of material reduced concrete SLABS"; Betreuer: Stefan Peters, Institut für Tragwerksentwurf
Christian Pichlkastner: „Mapping research activities in architecture"; Betreuer: Stefan Peters, Institut für Tragwerksentwurf

Žiga Krešević: „Towards Architecture of Diversely-tempered Environment"; Betreuer: Roger Riewe, Institut für Architekturtechnologie
Gernot Parmann: „Schalentragwerke aus UHPC Fertigteilen. Prozess und Produktion"; Betreuer: Stefan Peters, Institut für Tragwerksentwurf
Sophia Walk: „Alltagssiedlungen. Einfluss der aktuellen Ästhetikdebatte zur Nachkriegsmoderne auf den real gelebten Raum der Siedlungen der 1950er und 60er Jahre"; Betreuer: Anselm Wagner, Institut für Architekturtheorie, Kunst- und Kulturwissenschaften
Tobias Weiss: „Flexible Nullenergiegebäude und Quartiere – Potentiale für Gebäudeenergiesysteme, Bauphysik und Baukonstruktionen"; Betreuer: Brian Cody, Institut für Gebäude und Energie
Radostina Radulova-Stahmer: „Urbane Medien – Medien des Urbanen"; Betreuerin: Aglaée Degros, Institut für Städtebau

Alexander Eberl

Young Architectural Research in Graz

An event by the **Doctoral School** of the **Faculty of Architecture** and the **Haus der Architektur (HDA)** in Graz

On July 5, 2017, at the Haus der Architektur (HDA), young upcoming researchers from the Faculty of Architecture discussed current issues, explorative questions, and methods in architectural research based on their ongoing dissertations. The HDA functions as an interface between academic research and the public. The event was organized and run by Brian Cody. Moderation was carried out by Anselm Wagner. ▪

Markus Bogensberger (Haus der Architektur Graz), **Stefan Peters** (dean of the Faculty of Architecture, Graz University of Technology), and **Brian Cody** (head of the coordination team of the Doctoral School Architecture, Graz University of Technology)
Young researchers:
Renate Weissenböck: "Dynamic Robotic Shaping." Advisor: Urs Hirschberg, Institute of Architecture and Media
Alexander Eberl: "Herangehensweisen an die Revitalisierung von Wohnsiedlungen aus der Ära des Strukturalismus" (Approaches to the Revitalization of Housing Estates from the Era of Structuralism). Advisor: Brian Cody, Institute of Buildings and Energy
Eva Pirker: "Computational Methods for the Design of Material Reduced Concrete SLABS." Advisor: Stefan Peters, Institute of Structural Design

Christian Pichlkastner: "Mapping Research Activities in Architecture." Advisor: Stefan Peters, Institute of Structural Design

Ziga Kresevic: "Towards Architecture of Diversely-Tempered Environment." Advisor: Roger Riewe, Institute of Architecture Technology

Gernot Parmann: "Schalentragwerke aus UHPC Fertigteilen: Prozess und Produktion" (Shell Structures Made of Prefabricated UHPC Elements). Advisor: Stefan Peters, Institute of Structural Design

Sophia Walk: "Alltagssiedlungen: Einfluss der aktuellen Ästhetikdebatte zur Nachkriegsmoderne auf den real gelebten Raum der Siedlungen der 1950er und 60er Jahre" (Everyday Settlements: How Current Aesthetics Discourse on Postwar Modernism Impacts the Real Lived Space of 1950s and 1960s Settlements). Advisor: Anselm Wagner, Institute of Architectural Theory, History of Art and Cultural Studies

Tobias Weiss: "Flexible Nullenergiegebäude und Quartiere: Potentiale für Gebäudeenergiesysteme, Bauphysik und Baukonstruktionen" (Flexible Zero Energy Buildings and Districts: Potentials for Building Energy Systems, Structural Physics, and Building Construction). Advisor: Brian Cody, Institute of Buildings and Energy

Radostina Radulova-Stahmer: "Urbane Medien – Medien des Urbanen" (Urban Media – Media of the Urban). Advisor: Aglaée Degros, Institute of Urbanism

Alexander Eberl

Graz Architecture Lectures 2017
Eine Veranstaltung der **Architekturfakultät**, organisiert vom **Institut für Architekturtheorie, Kunst- und Kulturwissenschaften**

Bereits zum vierten Mal konnten bei den Graz Architecture Lectures namhafte und internationale ArchitektInnen und TheoretikerInnen in Graz begrüßt werden, um deren Vorträge über neueste Projekte und Forschungen im Wohnbau, der Stadtplanung und -forschung, der Landschaftsarchitektur, der sozialen Praxis von Architektur und der Architekturtheorie zu hören. Die lebhaft diskutierten Lectures, die am 8. Juni 2017 in der Aula der Alten Technik stattfanden und auf Einladung der einzelnen Institute unserer Fakultät zustande kamen, spiegelten deren vielfältige Schwerpunkte wider und machten sichtbar, dass hier ein integraler Architekturbegriff vertreten wird, der das soziokulturelle Leben in allen Bereichen betrifft. ∎

Programm:

Hélène Frichot (Royal Institute of Technology, Stockholm): „Architectural Environment-Worlds" (Institut für Zeitgenössische Kunst)

André Tavares (ETH Zürich, Porto): „Echoes of Present Dilemmas" (Institut für Architekturtheorie, Kunst- und Kulturwissenschaften)

Luis Callejas (Medellín, Oslo School of Architecture and Design): „Images of Many Natures" (Institut für Architektur und Landschaft)

Anne Mie Depuydt (uapS, Paris): „Ile de Nantes: Designing Dialogues" (Institut für Städtebau)

Martin Haller (caramel architekten, Wien): „Home Made" (Institut für Wohnbau)

Ingrid Taillandier (ITAR architectures, Paris): „Housing in Paris" (Institut für Grundlagen der Konstruktion und des Entwerfens)

Silja Tillner (Architekten Tillner & Willinger, Wien): „Urban Revitalization – Existing and New" (Institut für Architekturtechnologie)

Anselm Wagner

© akk

Graz Architecture Lectures
An event by the **Faculty of Architecture**, organized by the **Institute of Architectural Theory, History of Art and Cultural Studies**

The Graz Architecture Lectures 2017, now held for the fourth time, brought to Graz seven international

architects, artists, and theorists in order to introduce their most recent projects and research in the fields of urban planning and research, cultural theory, the social practice of architecture, the architecture–art interface, and digital design. The animatedly discussed lectures, which took place on June 8th, 2017, in the auditorium of the Alte Technik building and were carried out by our Faculty upon invitation of the individual institutes, mirrored the diverse focus areas and evidenced how a comprehensive concept of architecture is represented here, one that pertains to sociocultural life in all its facets. ∎

Program:

Hélène Frichot (Royal Institute of Technology, Stockholm): "Architectural Environment-Worlds" (Institute for Contemporary Art)

André Tavares (ETH Zürich, Porto): "Echoes of Present Dilemmas" (Institute of Architectural Theory, Art History and Cultural Studies)

Luis Callejas (Medellín, Oslo School of Architecture and Design): "Images of Many Natures" (Institute of Architecture and Landscape)

Anne Mie Depuydt (uapS, Paris): "Ile de Nantes: Designing Dialogues" (Institute of Urbanism)

Martin Haller (caramel architekten, Wien): "Home Made" (Institute of Housing)

Ingrid Taillandier (ITAR architectures, Paris): "Housing in Paris" (Institute of Construction and Design Principles)

Silja Tillner (Architekten Tillner & Willinger, Wien): "Urban Revitalization – Existing and New" (Institute of Architecture Technology)

Anselm Wagner

Ringvorlesung Architekturforschung 2017
Veranstaltet vom **Institut für Architekturtheorie, Kunst- und Kulturwissenschaften**

Die Ringvorlesung Architekturforschung bildet bereits seit zehn Jahren einen integralen Bestandteil der Doctoral School Architektur an der Technischen Universität Graz. In Abendvorträgen stellen Lehrende der TU Graz und internationale Gäste aktuelle Projekte der Architekturforschung hinsichtlich ihrer Konzepte, Methoden und Ergebnisse vor. In darauffolgenden Workshops diskutieren die Vortragenden mit den angemeldeten TeilnehmerInnen der Ringvorlesung über ihre Zu-

gänge zur Architekturforschung und die sich daraus eröffnenden Forschungsfragestellungen und Perspektiven.

Im Wintersemester 2017/18 hielten folgende WissenschaftlerInnen Vorträge in der Ringvorlesung Architekturforschung: Antoine Picon von der Harvard University Graduate School of Design, Tim Ingold von der University of Aberdeen, Deland Chan von der Stanford University, Angelika Schnell von der Akademie der bildenden Künste in Wien und Alexander Hagner, Mitbegründer des Architekturbüros gaupenraub+/-, der als Gastprofessor am Institut für Wohnbau der TU Graz sowie als Stiftungsprofessor an der Fachhochschule Kärnten lehrt. ∎

Daniel Gethmann

© akk, TU Graz

Lecture Series
Architectural Research 2017

Organized by the **Institute of Architectural Theory, History of Art and Cultural Studies**

As an integral part of the Doctoral School of Architecture for ten years now, the lecture series introduces current projects in architectural research and details their concepts, methods, and results. In the subsequent workshops, the lecturers discuss the lecture series participants' individual approaches to conducting architecture research as well as their theses and perspectives that open up as a result. Visiting lecturers during the winter semester 2017 were Antoine Picon from the Harvard University Graduate School of Design, Tim Ingold from the University of Aberdeen, Deland Chan from Stanford University, Angelika Schnell from the Academy of Fine Arts in Vienna and Alexander Hagner, co-founder of the office gaupenraub+/-, TUG Guest Professor at the Institute of Housing as well as Stiftungsprofessor at the University of Applied Sciences in Carinthia. ∎

Daniel Gethmann

November Talks 2017 –
Think Tank Architecture

Vortragsreihe am **Institut für Architekturtechnologie** in Kooperation mit der **Sto-Stiftung**

Auch das vermeintlich verflixte siebte Jahr konnte dem Erfolg der in Graz seit 2011 veranstalteten Vortragsreihe „November Talks" unter der Leitung und Moderation von Roger Riewe und in Kooperation mit der Sto-Stiftung keinen Abbruch tun. Namhafte internationale Architektinnen und Architekten präsentieren im Rahmen eines 45-minütigen Vortrags ihre Positionen zur zeitgenössischen Architektur und erläutern diese zusätzlich in einer anschließenden Podiumsdiskussion.

Die im letzten Jahr vorgestellte Neuausrichtung der Reihe unter dem Titel „Think Tank Architecture" wurde fortgesetzt und der Schwerpunkt erneut auf Forschungsfelder und Projekte gelegt, die derzeitige sowie zukünftige Fragestellungen und Entwicklungen der Architektur zum Thema haben.

In diesem Zusammenhang bestand die Runde der Gäste erstmalig in der Grazer Reihe nicht ausschließlich aus praktizierenden Architekten. Neben Mette Lange (Mette Lange Architects) aus Kopenhagen, Francisco Mangado (Mangado & Asociados SL) aus Pamplona und Peter St John (Caruso St John Architects) aus London folgte auch Peter Cachola Schmal, Direktor des Deutschen Architektur Museums in Frankfurt, der Einladung.

Vorgestellt wurden maßgefertigte Sommerhäuser und Häuser als Meterware, schwimmende Schulen und Schulen in ehemaligen Fabrikanlagen, Gebäude für Ausstellungen und ausgestellte Gebäude. Man sprach über die Wichtigkeit des Daches und den unverzichtbaren Faktor Zeit, man fragte sich ob nicht eher eine Wohnungs- denn eine Flüchtlingskrise bestehe und was genau eigentlich unter dem Begriff „Brickism" zu verstehen ist.

Nachberichte der einzelnen Abende sind auf der Webseite der Sto-Stiftung zu finden, während die Homepage des Instituts für Architekturtechnologie (www.iat.tugraz.at) im Medienarchiv die Videoaufnahmen der Vorträge zum Nachschauen bereithält. Zusätzlich erscheint im kommenden Jahr wie gewohnt die November Talks Broschüre mit Transkriptionen der Podiumsgespräche sowie weiteren Hintergrundinformationen zu den Vortragenden und ausgewählten Projekten.

Besonderer Dank geht an die Sto-Stiftung für die finanzielle Unterstützung der Vortragsreihe. ∎

Aleksandra Pavićević

Roger Riewe & Žiga Kreševič im Gespräch mit | in conversation with Mette Lange © Marius Sabo, Sto-Stiftung

Graz University of Technology
Think Tank Architecture

NOVEMBER TALKS 2017

monday
30|10 **Mette Lange** - Copenhagen
Mette Lange Architects
www.mettelange.com

monday
06|11 **Peter Cachola Schmal** - Frankfurt
Deutsches Architekturmuseum
www.dam-online.de

monday
13|11 **Francisco Mangado** - Pamplona
Mangado & Asociados SL
www.fmangado.es

monday
20|11 **Peter St John** - London
Caruso St John Architects
www.carusostjohn.com

Every Monday evening at 7pm
Aula Alte Technik

Graz University of Technology
Rechbauerstr. 12/I
8010 Graz - Austria

www.iat-tugraz.at
www.sto-stiftung.de

IAT Institute of Architecture Technology

Sto Stiftung
A lecture series in
co-operation with Sto-Stiftung

November Talks 2017 –
Think Tank Architecture

Lecture series at the **Institute of Architecture Technology** in cooperation with the **Sto-Stiftung**

Even the supposed "seven-year itch" could not stand up to the success of the "November Talks," a lecture series held in Graz since 2011 under the direction and moderation of Roger Riewe and in cooperation with the Sto-Stiftung. Well-known international architects present their positions on contemporary architecture in the scope of a forty-five-minute lecture and additionally expound on these positions in the panel discussion that follows.

The new alignment of the series under the title "Think Tank Architecture," as announced last year, was continued here. The focus was once again placed on research fields and projects that thematize both current and future explorative questions and developments in architecture.

In this context, the group of guest lecturers was, for the first time in the Graz series, comprised not only of practicing architects. In addition to Mette Lange (Mette Lange Architects) from Copenhagen, Francisco Mangado (Mangado & Asociados SL) from Pamplona, and Peter St John (Caruso St John Architects) from London, the invitation was also accepted by Peter Cachola Schmal, director of the Deutsches Architektur Museum in Frankfurt.

Custom-built summer houses were introduced, as well as homes in bulk, swimming schools, schools in former factory buildings, architecture for exhibitions, and exhibited architecture. The importance of roofing was discussed and also the vital factor of time; likewise considered was whether we are immersed in a housing crisis rather than a refugee crisis and what precisely is meant by the term "brickism."

Follow-up reports on the individual evenings are found on the Sto-Stiftung website, while the homepage of the Institute of Architecture Technology (www.iat.tugraz.at) offers video recordings of the lectures for viewing in the media archive. Also, as in previous years, a booklet on the November Talks will be released with transcriptions of the panel discussions, along with further background information on the lecturers and the selected projects.

Special thanks is extended to the Sto-Stiftung for the financial support of this lecture series. ∎

Aleksandra Pavićević

Intensified Density —
Nachverdichtungsstrategien
für den periurbanen Raum

Symposium organisiert von **KOEN, Institut für Grundlagen der Konstruktion und des Entwerfens** in Kooperation mit dem **HDA** – Haus der Architektur Graz

Im Rahmen des einjährigen Sondierungsprojekts „Intensified Density – Kleinmaßstäbliche Nachverdichtung in modularer Bauweise", lud am 12. Oktober 2017 das Forschungsteam unter der Leitung von Petra Petersson zu einem eintägigen Forschungstag ins Haus der Architektur Graz. Ziel des Forschungsprojekts ist es, konkrete Umsetzungsmöglichkeiten in modularer Bauweise in Zusammenarbeit mit dem Institut für Tragwerksentwurf an der TU Graz und dem Fachbereich für Bauphysik und Bauklimatik an der TU Potsdam auszuloten und in den periurbanen Kontext einzubetten. Der Vormittag startete mit einem internen Workshop, gefolgt von einem international besetzten Symposium am Nachmittag.

TeilnehmerInnen aus den Bereichen Stadtplanung und Architektur präsentierten Projekte und Konzepte, die in ihrer Spannbreite von räumlicher, programmatischer bis sozialer Nachverdichtung reichten und die Vielschichtigkeit des Themas aufzeigten.

Sophie Wolfrum (TU München) eröffnete das Symposium und fragte in ihrem Vortrag nach der Notwendigkeit einer Agenda der porösen Stadt.

Marianne Skjulhaug (Oslo School of Architecture and Design) stellte bisherige Strategien zur Verdichtung im Stadtzentrum von Oslo und auch im regionalen Umland vor. Sie zeigte eine Reihe alternativer Antworten auf, wie zukünftige Denkmodelle in Reaktion auf unerwartetes Wachstum aussehen könnten.

Matthew Griffin (Architekt in Berlin), erklärte anhand eines gewerblichen Baugruppenprojekts in Berlin, wie Akteurperspektiven verändert und Handlungsfelder verdichtet werden können und bisher als disziplinfern identifizierte Verantwortlichkeiten auch von Seiten der PlanerInnen übernommen werden können.

Bernd Vlay (Architekt in Wien) stellte unter dem Titel ReSourcing drei Projekt-Paarkonstellationen vor, die Ressourcen innerhalb städtischer Kontexte neu denken, erweitern und verdichten.

Aglaée Degros (Städteplanerin in Brüssel und Leiterin des Instituts für Städtebau an der TU Graz), verwies in ihrer Präsentation auf die Rolle und Wichtigkeit der urban commons, gemeinschaftlich genutzter (Grün-)Flächen anhand historischer Beispiele und auch einer zeitgenössischen Umsetzung eines solchen Projekts im kanadischen Montmagny. ∎

TeilnehmerInnen des Symposiums | Participants of the Symposium © KOEN

Informationen zum Symposium und zum Forschungsprojekt: intensified-density.org

Forschungsteam und Organisation:

KOEN Institut für Grundlagen der Konstruktion und des Entwerfens, TU Graz (Petra Petersson, Christina Linortner, Bernadette Krejs, Petra Kickenweitz, Donika Luzhnica, Gresa Kastrati)

ITE Institut für Tragwerksentwurf, TU GRAZ (Stefan Peters, Andreas Trummer, Christian Pichlkastner, Christoph Holzinger, Bernd Hausegger)

FB Bauphysik und Bauklimatik, FH Potsdam (Rüdiger Lorenz)

Christina Linortner

Intensified Density: Strategies for Densification in the Periurban Zone

Symposium organized by **KOEN, Institute of Construction and Design Principles**, in cooperation with the **Haus der Architektur Graz (HDA)**

In the framework of the one-year exploratory project "Intensified Density: Strategies for Small-Scale Densification in Modular Construction," the research team under the direction of Petra Petersson offered a one-day research event at Haus der Architektur (HDA) in Graz on October 12, 2017. The goal of the research initiative was to explore concrete possibilities for implementation using modular construction in collaboration with the Institute of Structural Design at Graz University of Technology and the Special Field Construction Engineering at the University of Applied Sciences Potsdam and to embed them into the periurban context. The morning started with an internal workshop, followed by an internationally visited symposium in the afternoon.

Participants from the fields of urban planning and architecture presented projects and concepts whose breadth ranged from spatial, programmatic densification to social densification, illustrating the multidimensional nature of the topic.

Sophie Wolfrum (Technical University of Munich) opened the symposium and in her lecture questioned the necessity of a porous city agenda.

Marianne Skjulhaug (Oslo School of Architecture and Design) introduced densification strategies used in the Oslo city center and also in the regional vicinity. She pointed out a series of alternative responses, illustrating how future conceptual models might look in reaction to unexpected growth.

Matthew Griffin (architect in Berlin) explained, based on a professional building group project in Berlin, how the perspectives of involved persons can be changed and activity fields densified. He also spoke about how responsibilities previously identified as outside of the discipline can be taken on by the planners.

Bernd Vlay (architect in Vienna) introduced under the title "ReSourcing" three constellations of project pairs that newly conceptualize, expand, and densify resources within urban contexts.

Aglaée Degros (urban planner in Brussels and head of the Institute of Urbanism at Graz University of Technology) referenced in her presentation the role and importance of urban commons or collectively used (green) areas, citing historical examples and also a contemporary implementation of such a project in the Canadian town of Montmagny. ∎

Information on the symposium and the research project: intensified-density.org

Research team and organization:

Institute of Construction and Design Principles (KOEN), Graz University of Technology (Petra Petersson, Christina Linortner, Bernadette Krejs, Petra Kickenweitz, Donika Luzhnica, Gresa Kastrati)

Institute of Structural Design (ITE), Graz University of Technology (Stefan Peters, Andreas Trummer, Christian Pichlkastner, Christoph Holzinger, Bernd Hausegger)

Special Field Construction Engineering, University of Applied Sciences Potsdam (Rüdiger Lorenz)

Christina Linortner

Neue Masterstudios an der Alten Technik eröffnet

Eine Veranstaltung der **Fakultät für Architektur**

Die Dachböden der Alten Technik entlang der Techniker- und Lessingstraße wurden in den letzten beiden Jahren zu Masterstudios für die Architekturfakultät ausgebaut. Seit Beginn des Wintersemesters 2017/18 befinden sich hier nun 160 Arbeitsplätze für Studierende des Masterstudiums der Architektur. Diese 800 Quadratmeter stehen für die Projektübungen den Instituten und Studierenden semesterweise zur Verfügung und die neue Infrastruktur schafft nun die Grundlage für das, was seit Einführung der Projektübungen im Masterstudium immer als Studio- und Atelierarbeit gedacht war. Diese konzentrierte Art des Architektur-

Blick ins Studio | Studio view © Marianne Sar, IAT

schaffens kann nun gelebt werden, Erfahrungen, Gelerntes und selbst Entwickeltes mit den benachbarten Studios geteilt und verglichen werden. Es ist ein Arbeits- und Lebensraum entstanden, in dem Konfrontation im besten Sinn stattfinden kann.

Begleitet wurde die Errichtung und Gestaltung der Räume von Studiendekan Professor Hans Gangoly, Vorstand des Instituts für Gebäudelehre und Armin Stocker vom Institut für Architekturtechnologie. Am 3. Oktober 2017 sind die neuen Räume der Architekturfakultät von Rektor Harald Kainz eröffnet worden. Gefeiert wurde mit Unterstützung der Architekturzeichensäle und der gesamten Fakultät bis in die viel zitierten Morgenstunden um einen Tag darauf die Architekturlehre in den neuen Räumen zu starten. ∎

Armin Stocker

New Master Studios Opened at the Alte Technik Building

An event by the **Faculty of Architecture**

The attics in the Alte Technik building located at Techniker- and Lessingstraße were renovated over the last two years to create master studios for the Faculty of Architecture. Since the beginning of winter semester 2017–18, there are now 160 workspaces for students earning their master's degree in architecture. These 800 square meters are available to the institutes and the students for project exercises on a semester basis, and the new infrastructure creates a foundation for what was always imagined for studio work since the introduction of project exercises for the master's program. This concentrated approach to architectural practice can now be lived, with experiences, learned material, and self-developed aspects shared and compared with neighboring studios. Arising here is a space for work and living where confrontation in the best possible sense can take place.

The construction and design of the spaces was accompanied by the academic dean Professor Hans Gangoly, chair of the Institute of Design and Building Typology, and by Armin Stocker from the Institute of Architecture Technology. On October 3, 2017, the new rooms in the Faculty of Architecture were inaugurated by rector Harald Kainz. The celebration of this initiation of architectural teaching in the new rooms lasted well into the morning hours of the next day, with the support of the architecture design halls and the entire faculty. ∎

Armin Stocker

Jorge Pérez Jaramillo, „Medellin: An Urban Citizen Project" im Rahmen der Vortragsreihe des Instituts für Städtebau | as part of the lecture series of the Institute of Urbanism © Institut für Städtebau

Internationale Positionen zur Zukunft der Stadtentwicklung
Green Sofa Interviews und neue Vortragsreihe am **Institut für Städtebau**

Das Institut für Städtebau hat mit den Green Sofa Interviews und einer neuen Vortragsreihe zwei Formate geschaffen die sich zum Ziel gesetzt haben aktuelle und internationale Positionen zum Städtebau mit dem Schwerpunkt Öffentlicher Raum und Mobilität zu sammeln, zu kommunizieren und zu dokumentieren. Bereits nach einem Jahr entstand daraus ein breites Spektrum an unter-

schiedlichen Sichtweisen, die in Summe eine dichte Grundlage an Thesen, Begriffen, Vorstellungen und Visionen für die Diskussion von Stadt und städtischen Spannungsfeldern bieten. Das neue Format wurde mit der Berufung von Aglaée Degros 2016 initiiert.

2016 waren unter anderen **Ans Persoons**, Politikerin und Vize-Bürgermeisterin aus Brüssel, **Paul Gerretsen**, Architekt und Direktor der Deltametropolis Association in Rotterdam, **Eric Frijters**, Partner im Architekturbüro Fabric aus Amsterdam und **Chris Younès**, Philosophin und Anthropologin von der Ecole Spéciale d'Architecture in Paris Gäste bei den Green Sofa Interviews.

Ein Highlight der neuen Vortragsreihe fand am 3. Mai 2017 im HDA – Haus der Architektur in Kooperation mit dem Lateinamerikanischen Institut statt. **Jorge Pérez Jaramillo**, der ehemalige Planungsdirektor der Stadt Medellín (Kolumbien) sprach zum Thema „Medellín, an Urban Citizen Project". Er gab Einblicke in die urbanen Transformationen, die sich in Medellín in den letzten Jahrzehnten ereigneten und wie sich diese von einer Stadt in der Krise zum Vorzeigebeispiel der Stadtentwicklung gewandelt hat. Partizipative Stadtplanung und Gestaltung von öffentlichen Räumen sowie die Entwicklung von Infrastrukturen wurden dabei aktiv als „soziale Werkzeuge" benutzt. ∎

Nicole Kirchberger/Radostina Radulova-Stahmer

International Positions on the Future of Urban Development
Green Sofa Interviews and a new lecture series at the **Institute of Urbanism**

With the Green Sofa Interviews and a new lecture series, the Institute of Urbanism has created two formats that aim to compile, communicate, and document current and international positions on urbanism with a focus on public space and mobility. After only a year, this has resulted in a broad spectrum of different viewpoints, which as a whole offer a dense foundation of theses, concepts, ideas, and visions for discussing cities and urban areas of challenge. The new format was initiated after the appointment of Aglaée Degros in 2016.

In 2016, the guests at the Green Sofa Interviews were, among others, **Ans Persoons**, politician and vice-mayor from Brussels, **Paul Gerretsen**, architect and director of the Deltametropolis Association in Rotterdam, **Eric Frijters**, partner in the architecture firm Fabric from Amsterdam, and **Chris Younès**, philosopher and anthropologist from the Ecole Spéciale d'Architecture in Paris.

A highlight of the new lecture series took place on May 3, 2017, at the Haus der Architektur (HDA) in cooperation with the Latin American Institute. **Jorge Pérez Jaramillo**, the former planning director of the City of Medellín (Colombia) spoke about the topic "Medellin, an Urban Citizen Project." He gave insight into the urban transformations that have evolved over recent decades in Medellín and how it transformed from a crisis-laden city to a model example of urban development. Participative urban planning and the designing of public spaces, as well as the development of infrastructures, were actively used here as "social tools." ∎

Nicole Kirchberger/Radostina Radulova-Stahmer

IZK Theory Lecture Series 2016/2017
Eine Veranstaltung des
Instituts für Zeitgenössische Kunst

Das Institut für Zeitgenössische Kunst etablierte die IZK Theory Lecture Series als eine Schnittstelle zwischen Forschung und dem akademischen Programm, welches internationale Autoren, Studierende, Kunstinstitutionen und das interessierte Publikum verbindet. Dies bezieht auch eine fortlaufende Zusammenarbeit mit lokalen Kunstinstitutionen in Graz ein und verlässt damit das akademische Umfeld.

13. März 2017: „Beyond Socialist Modernism – ‚New Artistic Practice' in Yugoslavia in the Sixties and the Seventies", gehalten von **Branislav Dimitrijević**, Professor für Kunstgeschichte und Theorie an der School for Art and Design in Belgrad, der zuvor als zeitgenössischer Kunstkritiker aktiv war. Seine Hauptforschungsinteressen liegen in den Feldern visueller Kunst, der Populärkultur und des Jugoslawisch-Sozialistischen Films. Der Vortrag, gehalten im Grazer Kunstverein in Kooperation mit dem Zentrum für Südosteuropäische Studien, nahm die Standpunkte und die Praxis einer neuen Generation von Künstlern in den Blick, die aus den Studentenbewegungen und den Philosophien der neuen Linken in den späten 1960er und frühen 1970er Jahren als Konsequenzen der ökonomischen Reformen und der sozialen „Befreiung" der frühen 1950er bis in die späten 1960er Jahre, entstanden.

12. Oktober 2016: „Detroit Resists and Architecture in Resistance", gehalten von **Andrew Herscher**, Associate Professor am Tubman College of Architecture and Urban Planning der Universität Michigan und Creative Cities Fellow am Stanford Arts Institute der Universität Stanford. Bei seinem Vortrag im Kunsthaus

Graz präsentierte er mit „Detroit Resists" eine Vereinigung, die im Interesse einer inklusiven, gerechten und demokratischen Stadt arbeitet und besprach einige der theoretischen, historischen und praktischen Auswirkungen seiner These, dass Architektur nur dekolonisiert und demokratisiert werden kann, wenn sie sich mit Sozialen Bewegungen solidarisch zeigt, – der einzigen emanzipatorischen politischen Kraft in unseren gegenwärtigen historischen Umständen. ▪

Milica Tomić

IZK Theory
Lecture Series 2016/2017

An event by the **Institute of Contemporary Art**

The Institute of Contemporary Art has established the IZK Theory Lecture Series as an interface for research, investigation, and the academic program, interconnecting international authors, students, art institutions, and the committed audience. It also involves a continuous collaboration with local institutions in Graz, while stepping outside the academic parameters.

March 13, 2017: "Beyond Socialist Modernism – 'New Artistic Practice' in Yugoslavia in the Sixties and the Seventies" held by **Branislav Dimitrijević**, Professor of History and Theory of Art at the School for Art and Design in Belgrade, who was formerly active as a contemporary art curator. His main research interests are in the fields of visual art, popular culture, and Yugoslav Socialist Film. Held at the Grazer Kunstverein,

in collaboration with the Centre for Southeast European Studies, the lecture focused on the standpoints and practices of the new generation of artists emerging with the student movements and new-left philosophies in the late 1960s and early 1970s, as a consequences of the economic reforms and a social "liberalization" from the early 1950s to the late 1960s.

October 12, 2016: "Detroit Resists and Architecture in Resistance" held by **Andrew Herscher**, Associate Professor of the Taubman College of Architecture and Urban Planning at the University of Michigan and Creative Cities Fellow at the Stanford Arts Institute at Stanford University. In his talk at Kunsthaus Graz, he presented "Detroit Resists," a coalition working on behalf of an inclusive, equitable, and democratic city and discussed some of the theoretical, historical, and practical implications of his thesis, that architecture can only be decolonized and democratized in solidarity with movement-based activism—the only site of emancipatory political agency in our historical conjuncture. ▪

Milica Tomić

Holzfaltatelier Gmünd

Ein Projekt des **Institutes für Architektur und Medien** für die **Künstlerstadt** in **Gmünd**

Das Institut für Architektur und Medien hat in Kooperation mit der holz.bau forschungs gmbh an der

TU Graz und der Firma Hasslacher Norica Timber für die Künstlerstadt Gmünd in Kärnten ein einzigartiges Holzfaltatelier geschaffen. Jahrelange Forschung und Erfahrung im Bereich des geometrischen Papierfaltens und der Nonstandard Holz-Architektur wurden zu diesem Projekt zusammengeführt. Die große Herausforderung war die Umsetzung einer digitalen Produktionskette vom parametrischen Design bis hin zur CNC-gesteuerten Fertigung. Alle Einzelteile des Bauwerkes sind Unikate, die hohen geometrischen und mechanischen Beanspruchungen gerecht werden mussten. Das Atelier dient in den Sommermonaten als Bühne für Bildhauer, sowohl als Ausstellungsraum als auch als Werkraum. Die Künstler können somit während der Arbeit an ihren Modellen beobachtet und gleichzeitig deren fertig gestellte Modelle betrachtet werden. Die äußere Form des Ateliers wurde aus einer handgroßen, gefalteten Origamiform aus Papier abgeleitet und auf einen architektonischen Maßstab vergrößert und angepasst. Die zackige Form des Faltwerkes spiegelt vor allem die gebirgige Umgebung der Alpen wieder. Für den Bau wurde durchgehend Brettsperrholz als Material verwendet, welches auf einem mobilen Betonfundament aufgesetzt ist. Für den Witterungsschutz dienen dunkle Bitumen-Dachschindeln, die einen höchst interessanten Kontrast zum hellen Holz ergeben. Das außergewöhnliche Design des Ateliers wurde von Milena Stavrić und Albert Wiltsche vom Institut für Architektur und Medien entwickelt. Das Engineering und die statischen Berechnungen erfolgten an der holz.bau forschungs gmbh unter der Leitung von Thomas Bogensperger und Gregor Silly. Die Realisierung des gesamten Projektes wurde schließlich von Georg Jeitler von der Firma Hasslacher Norica Timber ständig begleitet, unterstützt, wie auch umgesetzt. ▪

Milena Stavrić/Albert Wiltsche

Wood Folding Studio Gmünd

A project by the **Institute of Architecture and Media** for the **Artists Town** in **Gmünd**

The Institute of Architecture and Media has created a unique wooden folding studio for the Artists Town Gmünd in cooperation with the holz.bau forschungs gmbh at Graz University of Technology and the company Hasslacher Norica Timber. Longstanding research and experience in the area of geometric paper folding and non-standard wooden architecture were combined for this project. The great challenge was to implement a digital production chain from parametric design to CNC-controlled manufacturing. All individual components of the structure are unique, designed to withstand the

high geometric and mechanical loads. In the summer months, the studio serves as a stage for sculptors, both as exhibition space and as a workroom. It is therefore possible to observe the artists while they are working on their models and to view their finished models at the same time. The exterior form of the studio was inspired by a hand-sized, folded origami form made of paper that was enlarged and adapted to an architectural scale. The jagged form of the folded work mirrors in particular the mountainous surroundings of the Alps. For the construction, plywood was used as a material throughout, placed on a mobile concrete foundation. Serving as weather protection are dark bitumen roof shingles that render a very interesting contrast to the light-colored wood. The unusual design of the studio was developed by Milena Stavrić and Albert Wiltsche from the Institute of Architecture and Media. The engineering and static calculations were done by the holz.bau forschungs gmbh under the direction of Thomas Bogensperger and Gregor Silly. The realization of the entire project was ultimately accompanied, supported, and also implemented by Georg Jeitler from the company Hasslacher Norica Timber. ∎

Milena Stavrić / Albert Wiltsche

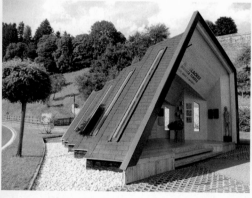

Holzfaltatelier | Wood Folding Studio, Entwurf | Design: Milena Stavrić & Albert Wiltsche, Gmünd/Kärnten, 2017 © IAM

Integrale Landschaften – Palmas, Tocantins, Brasilien
Ein Projekt des **Instituts für Architektur und Landschaft**

Die Trennung von Stadt und Landschaft – ein Erbe der Moderne – möchten wir fundamental infrage stellen. Denn nur so ist es möglich, Synergien zwischen der urbanen Form, Prozessen, der Performanz und den Akteuren zu ermöglichen. Angesichts der Herausforderungen des Klimawandels lenken wir unsere Aufmerksamkeit

auf Entwurfsstrategien, die Landschaft stärker in unsere kulturelle Praxis einbeziehen.

Ausgestattet mit diesem neuen Stellenwert kann sie von einem passiven Hintergrund zur gestaltenden Kraft („formative agent") werden und aktiv Einfluss auf die Entwicklung der Stadt nehmen. Diese strategische Neuausrichtung hat durch die Erarbeitung von nachhaltigen und ökologischen Richtlinien direkten Einfluss auf Entwicklungsziele und Bedürfnisse der Stadt. Aufbauend auf diesen Grundsätzen hat das Institut für Architektur und Landschaft ein integrales Landschaftskonzept für ein 600 Hektar großes Areal inmitten der Stadt Palmas, Brasilien entwickelt. Die Hauptstadt des 1989 gegründeten Bundesstaats Tocantins ist neue Heimat für momentan 280.000 Einwohner und liegt in der Übergangszone zwischen dem Amazonas Regenwald und dem Cerrado Buschwald mit subtropischem Klima variierend zwischen Regen- und Trockenzeit. Das integrale Landschaftsprojekt bietet die einzigartige Chance durch Einbindung landschaftlicher Qualitäten und Prozesse ein System zu entwickeln, das verschiedene Themen miteinander verbindet und Synergien schafft; stärkere Identifikation mit der Nachbarschaft, wirtschaftlicher Aufschwung, Ökologie und Anpassung an den Klimawandel sind Themen, die aktiv eingebunden werden.

In einem Workshop haben lokale Experten und Interessensvertreter, Leiter und Mitarbeiter des Stadtplanungsamts Palmas sowie Studierende der TU Graz und dem Institut für Architektur und Landschaft erste Konzeptideen und Strategien erarbeitet. In kontinuierlicher Entwurfsarbeit im darauffolgenden Masterstudio wurden die Inhalte mit den Studenten und Experten wei-

terentwickelt und den Partnern in Brasilien präsentiert. Sie sind mittlerweile Teil des städtischen Masterplans 2025.

Eine Zusammenfassung der Konzepte wird im Buch „Paisagens Integrativas Palmas" im Verlag der TU Graz publiziert. ∎

Projektpartner:
Institut für Architektur und Landschaft der TU Graz,
Instituto de Planejamento Urbano de Palmas
Universidade Federal do Tocantins
Lehrende:
Klaus K. Loenhart, Andreas Boden, Bernhard König

Andreas Boden

Integral Landscapes – Palmas, Tocantins, Brazil
A project by the **Institute of Architecture and Landscape**

When modern separations of city and the living environment are fundamentally questioned – unexpected combinations of urban form, processes, performance and actors emerge. In the advent of changing climates, our attention then shifts towards a design strategy, where landscape turns into a formative force within cultural operations.

Landscape as such, transfers from the passive backdrop to a "formative agent" within the future development of the city. This strategic positioning of landscape illuminates future urban goals and demands by developing sustainable and ecological guidelines – an integral thinking of the environment and our societal develop-

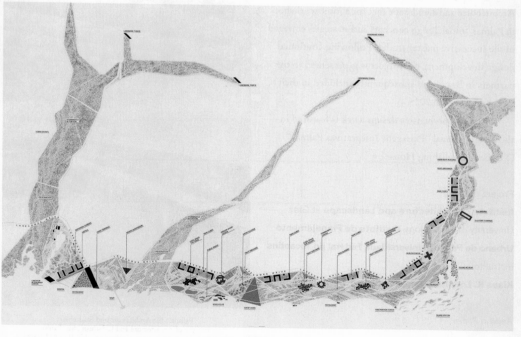

© IAL

Teilnehmer des Projektes | Participants of the Project in
Palmas Tocantins © IAL

ment. With this approach applied – the Institute of Architecture and Landscape developed the integral landscape concept for the 600 Hectares site within the city of Palmas, Brazil. The city is the capital of the new state of Tocantins founded in 1989 and is now home to about 280,000 inhabitants. Located in the transition zone between the Amazon rainforest and the Cerrado (bush land), the subtropical climate alternates between rain and dry season.

The Palmas Integral Landscape Project is the unique opportunity to unfold strategies of a landscape-based urbanism, which can act as a linking apparatus, connecting even diverse issues like building neighborhood identity, economic growth and ecologies of changing climates.

After local experts, stakeholders, representatives of the urban planning department, and the Institute for Architecture and Landscape met for a joint workshop in Palmas, initial design concepts and strategies emerged in the successive master studio. Following continued design development, the project was presented to the partners in Brazil and subsequently included in their urban master plan 2025.

The comprehensive design work is featured in the design manual "Paisagens Integrativas Palmas" (TU Graz Publishing House). ▪

Project partner:
Institute of Architecture and Landscape at Graz University of Technology, **Instituto de Planejamento Urbano de Palmas**, **Universidade Federal do Tocantins**
Instructors:
Klaus K. Loenhart, Andreas Boden, Bernhard König

Andreas Boden

Zwischen Renovierung und Bezug: Gemeinsamen Raum leben und reproduzieren mitten in der Metropole
Das **Institut für Wohnbau** bei der **Summerschool** 2017 in **São Paulo**

Im Juli 2017 wurde zum dritten Mal eine gemeinsame Summerschool von der BTU Cottbus – Senftenberg unter der Leitung von J. Miller Stevens, der Universidade de São Paulo unter der Leitung von Beatriz Rufino, und dem Institut für Wohnbau der TU Graz unter der Leitung von Andreas Lichtblau veranstaltet. Die diesjährige „Arbeitsstätte" der Summerschool-Studierenden war die Fakultät für Architektur und Städtebau/Faculty of Architecture and Urbanism (FAU-USP) in São Paulo.

Der Workshop stellte die 21 Studierenden aus Österreich, Deutschland und Brasilien vor die Herausforderung, im Zentrum von São Paulo zwischen den Polen kleinräumlicher Nachbarschaft und metropolitanem Umfeld Räume für verschiedene Formen der Gemeinschaft bzw. Öffentlichkeit zu entwickeln. Die Aufgabenstellung an die Studenten war im Grunde sehr offen, und gerade deshalb auch sehr schwierig. Innerhalb eines recht großen Areals um die Avenida Nove de Julho sollten sich die Studentengruppen einen Ort für ihre Intervention bzw. für ihren Entwurf zum Thema: „Between Renovation and Occupation: Living and Reproducing Common Spaces in the Center of Metropolis" suchen.

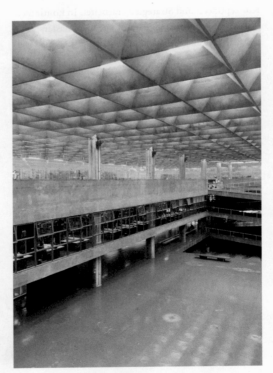

Fakultät für Architektur und Städtebau |
Faculty of Architecture and Urbanism, São Paulo,
João Batista Vilanova Artigas, Carlos Cascaldi, 1961 © Lichtblau

Die finale Präsentation fand im Stadtzentrum, im Instituto de Arquitetos do Brasil – Departamento de São Paulo statt und zeigte die für die kurze Arbeitszeit erstaunlichen Ergebnisse der sieben Gruppen.

Zum Ausklang spazierten Betreuer und Studierende entlang der Avenida Paulista, der Hauptverkehrsstraße von São Paulo, die am Sonntag jeweils für den Autoverkehr gesperrt wird und sich so in einen riesigen, sehr gut besuchten öffentlichen Raum verwandelt – durchaus passend zum Thema der Summerschool 2017! ▪

Betreuer: **Beatriz Rufino** (Universidade de São Paulo), **J. Miller Stevens** und **Stephan Schwarz** (Institut Stadtplanung und Raumgestaltung, BTU Cottbus – Senftenberg), **Andreas Lichtblau** und **Sigrid Verhovsek** (Institut für Wohnbau, TU Graz)
Studierende: **Anca Cristina Mosut**, **Mak Pavelic**, **Sasa Ritonja**, **Bruno Raskaj**, **Hana Vasatko**

Sigrid Verhovsek

Between Renovation and Occupation: Living and Reproducing Common Spaces in the Center of Metropolis
The **Institute of Housing** at **Summer School** 2017 in **São Paulo**

In July 2017, for the third time, a joint summer school was held, by the BTU Cottbus – Senftenberg under the direction of J. Miller Stevens, the Universidade de São Paulo under the direction of Beatriz Rufino, and the Institute of Housing at Graz University of Technology under the direction of Andreas Lichtblau. This year's "worksite" for the summer school students was the Faculty of Architecture and Urbanism (FAU-USP) in São Paulo.

The workshop presented the twenty-students from Austria, Germany, and Brazil with the challenge of developing spaces for various forms of community or publicness at the center of São Paulo between the poles of a small-scale neighborhood setting and the metropolitan environment. The task presented to the students was basically very open, and very difficult precisely for this reason. Within a rather large area surrounding the Avenida Nove de Julho, the student groups were asked to find a site for their intervention or for their design on the theme: "Between Renovation and Occupation: Living and Reproducing Common Spaces in the Center of Metropolis."

The final presentation took place in the city center at the Instituto de Arquitetos do Brasil – Departamento

de São Paulo, and remarkable results by the seven groups were shown from this short working period.

In closure, advisors and students walked along the Avenida Paulista, the main thoroughfare in São Paulo, which is closed to motor vehicles on Sundays and is transformed into a gigantic, highly frequented public space—very fitting to the theme of the summer school 2017! ∎

Advisors: **Beatriz Rufino** (Universidade de São Paulo), **J. Miller Stevens** and **Stephan Schwarz** (Department of Urban Planning and Spatial Design, BTU Cottbus – Senftenberg), **Andreas Lichtblau** and **Sigrid Verhovsek** (Institute of Housing, TU Graz)
Students: **Anca Cristina Mosut**, **Mak Pavelic**, **Sasa Ritonja**, **Bruno Raskaj**, **Hana Vasatko**

Sigrid Verhovsek

Präsentation der Ergebnisse | Presentation of the results in Shanghai; Bildmitte | center of the picture: Prof. Yongie Cai & Prof. Roger Riewe mit den Studierenden | with the students © Johanna Reisinger

Campus++

Joint Studio des **Instituts für Architekturtechnologie** der TU Graz und der **Tongji University Shanghai**

„Campus++" war das Thema des Joint Master-Studio der Projektübung des Instituts für Architekturtechnologie – geleitet von Prof. Roger Riewe und Claudia Volberg – mit der Tongji University Shanghai im Sommersemester 2017. Als Aufgabe sollte ein hybrides Campusgebäude entworfen werden, welches an zwei möglichen Bauplätzen innerhalb des Campusgeländes der Tongji University in Shanghai entwickelt werden konnte. Durch das zu erarbeitende Raumprogramm sowie der Auswahl der zu verbauenden Fläche wurden Studierende motiviert, freier und struktureller an die eigene Bearbeitung des Themas heranzugehen. Verbunden mit einem Aufenthalt an der Tongji University Shanghai und gemeinsamen Besprechungen mit Professor Cai und seinem Team, war es für fünfzehn Studierende der TU Graz eine besondere Möglichkeit, den Bauplatz zu analysieren, aber auch neue Felder der Architektur und Sichtweisen vor Ort zu entdecken.

Die Idee zur Erweiterung und Verdichtung des Universitätscampus fand großes Interesse bei den Lehrenden der Tongji University und wurde als wertvolle Anregung für mögliche Ansätze zur Weiterentwicklung der Universität angesehen.

Nach den gesammelten Erfahrungen wurde an den Entwürfen in Graz weitergearbeitet. Aus der Fülle an Informationen und Eindrücken musste nun ein Weg gefunden werden, wie man die eigene Auffassung der Architektur, geprägt vom europäischen Kontext, auf einen neuen Kulturkreis sinnvoll übertragen und welche man von dem anderen aufnehmen kann.

Zur Schlusspräsentation des Joint Studios wurden am Semesterende die Lehrenden der Tongji University an der TU Graz begrüßt und die Projekte gemeinsam kommentiert. ∎

Susanne Hebenstreit/Johanna Reisinger

Campus++

Joint Studio by the **Institute of Architecture Technology** at Graz University of Technology and **Tongji University Shanghai**

"Campus++" was the topic of the joint master studio of the project exercise by the Institute of Architecture Technology—headed by Prof. Roger Riewe and Claudia Volberg—with the Tongji University Shanghai during summer semester 2017. The task was to design a hybrid campus building that could be developed at two possible building plots within the campus premises of Tongji University in Shanghai. Through the spatial program to be developed and the selection of the building site, the students were motivated to approach their own treatment of the topic in a more open and structural way. Thanks to a stay at Tongji University in Shanghai and to joint discussions with Professor Cai and his team, fifteen students from Graz University of Technology were given a special opportunity to analyze the plot, but also to explore new facets of architecture and viewpoints on site.

The idea of expanding and densifying the university campus was met with great interest by the instructors at Tongji University and was considered to be a valuable idea for possible approaches to further developing the university.

After these experiences, work on the designs was continued in Graz. From the wealth of information and impressions, now a path was sought for meaningfully transferring one's own understanding of architecture, influenced by the European context, to a new cultural sphere, while considering which aspects one might adopt from the other.

For the final presentation of the joint studio, the instructors from Tongji University were welcomed to Graz University of Technology at the end of the semester and the projects jointly assessed. ∎

Susanne Hebenstreit/Johanna Reisinger

Tropical Space Pioneers

Ein Projekt des **Instituts für Raumgestaltung** in **Rio de Janeiro**, unter anderem in Zusammenarbeit mit **DAU PUC-Rio**[1] und **DPA der FAU UFRJ**[2]

Wenn man über das Thema Wohnen auf kleinstem Raum nachdenkt, kommt man unweigerlich auf das Modell RaumMöbel: multifunktionales, sinnliches und dynamisches Objekt, das Raum fasst, erforderlichen Nutzungen Raum bietet und dem eine gewisse Versatilität im Einsatz innewohnt.

Mit dem Workshop „Space Pioneers – Living in the smallest Space" an der PUC-Rio will man das Modell RaumMöbel umsetzen – unter dem Kriterium möglichst nur ein Material zu verwenden.

Im Vortrag „Primeira, Segunda e Terçeira Pele" erörterte Judith Augustinovič zunächst das Konzept der ersten, zweiten und dritten Haut und veranschaulichte dieses anhand räumlicher und künstlerischer Installationen. In dem Workshop „Space Pioneers" galt es für die Studierenden einen minimalen Raumbedarf zu konzeptualisieren. Die fünf Arbeitsgruppen des Workshops legten jeweils eine schlüssige Umsetzung mit spezifischem Raumprogramm und materialadäquatem Einsatz in der Konstruktion und den raumdefinierenden Hüllen vor und berücksichtigten Aspekte wie Wirtschaftlichkeit sowie Nachnutzung. Der Schwerpunkt auf Materialität, der Erkundung des Materials, den Schlussfolgerungen, deren konsequenter Umsetzung in ein Raumkonzept sowie die andauernde Verifizierung im Projektverlauf bestärkten das verwendete Material als vielschichtiges und facettenreiches Instrument im Entwurf und im Raumerleben durch gezielten Einsatz der sensorischen Qualitäten.

Raumkörperhüllen mit transkutanen Begrenzungen – im wörtlichen Sinn durch Haut – wurden in beiden Workshops Vestes Espacais (Raumkleider) von den Studierenden des MA.DE.IN.[3] am IED-Rio entwickelt. Die ausgeprägte Körperlichkeit, die Auseinandersetzung und der Umgang mit dem (eigenen) Körper sind zentrale Elemente der Kultur der Cariocas, und knüpfen spätestens seit Lygia Clark den Kontext zu zeitgenössischer Kunst, Raum und Architektur: „A casa é o corpo."[4] ∎

Konzept, Leitung:

Carlos Eduardo Spencer und **Judith Augustinovič**
Eingeladene KritikerInnen, JurorInnen und Vortragende:
Josep Ferrando, Alziro Carvalho Neto, Fernando Esposito Galarce, Nina Quintanilha Felinto, Tatiana Grinberg und **João Modé**
Master StudentInnen der **DAU PUC-Rio** und **DPA der FAU UFRJ**

Judith Augustinovič

1 Departamento de Arquitetura e Urbanismo, Pontifical Catholic University of Rio de Janeiro unterstützt von der CCE – Coordenação Central de Extensão.

2 Departamento de Projeto de Arquitetura, Faculdade de Arquitetura e Urbanismo, Universidade Federal do Rio de Janeiro.

3 Post-gradualer Kurs MA.DE.IN. Design de Espaço. Der von Josep Ferrando am IED-Barcelona initiierte Kurs wurde von mir am Istituto Europeo di Design Rio de Janeiro umgesetzt und auf die Besonderheiten der Cariocas (EinwohnerInnen Rio de Janeiros) und die Anforderungen des MEC (Ministério da Educação) adaptiert sowie koordiniert und als Lehrende für Entwurf, Materialität und Tektonik begleitet.

4 Das Haus ist der Körper ist eine Rauminstallation von Lygia Clark im MAM-RJ und an der Biennale di Venezia, 1968.

Tropical Space Pioneers

A project by the **Institute of Spatial Design** held in **Rio de Janeiro**, in collaboration with **DAU PUC-Rio**[1] and **DPA of the FAU UFRJ**[2] among others

When reflecting on the topic of housing within the smallest of spaces, the model "RaumMöbel" (SpaceFurniture) inevitably arises: a multifunctional, sensory, and dynamic object that encompasses space, offers space of necessary usage, and embodies a certain versatility of use.

With the workshop "Space Pioneers – Living in the Smallest Space" at the PUC-Rio, the aim was to implement the model "RaumMöbel"—under the criterion of using only a single material if possible.

In the lecture "Primeira, Segunda e Terçeira Pele" (First, Second, and Third Skin), Judith Augustinovič initially discussed the first, second, and third skin and visualized this based on spatial and artistic installations. In the workshop "Space Pioneers," the students were asked to conceptualize a minimal space requirement. The five working groups within the workshop each presented a coherent strategy for implementation with a specific spatial program and use of adequate material in terms of construction and the space-defining shells, while taking aspects like economic viability and continued use into consideration. The focus on materiality, exploration of the material, conclusions, their consistent implementation in spatial concepts, and persistent verification over the course of the project strengthened the material used as a complex and multifaceted instrument in the design and in the spatial experience through the targeted application of sensorial qualities.

Space-body shells with transcutaneous barriers—in a literal sense, through the skin—were developed in the two workshops "Vestes Espacais" (Space Clothing) by the MA.DE.IN.[3] students at IED-Rio. The pronounced corporeality, the exploration and handling of the body (one's own body) are central elements in cariocas culture. At the latest since Lygia Clark, links to contemporary art, space, and architecture have been evident: "A casa é o corpo."[4] ∎

Concept, lead:

Carlos Eduardo Spencer and **Judith Augustinovič**
Invited critics, jurors, and lecturers: **Josep Ferrando, Alziro Carvalho Neto, Fernando Esposito Galarce, Nina Quintanilha Felinto, Tatiana Grinberg**, and **João Modé**
Master's students from the **DAU PUC-Rio** and **DPA of the FAU UFRJ**

Judith Augustinovič

1 Departamento de Arquitetura e Urbanismo, Pontifical Catholic University of Rio de Janeiro supported by CCE – Coordenação Central de Extensão.

2 Departamento de Projeto de Arquitetura, Faculdade de Arquitetura e Urbanismo, Universidade Federal do Rio de Janeiro.

3 Postgraduate course MA.DE.IN. Design de Espaço. Initiated by Josep Ferrando at the IED-Barcelona, this course was implemented and coordinated by Judith Augustinovič at the Istituto Europeo di Design, Rio de Janeiro and adapted to the special conditions of the cariocas (residents of Rio de Janeiro) and the demands of the MEC (Ministério da Educação), as well as accompanied by instructors for design, materials, and tectonics.

4 The House Is the Body is a spatial installation by Lygia Clark at MAM-RJ and was shown at the Biennale di Venezia in 1968.

Jury der Schlusspräsentation | Jury members of the final presentation © Nina Quintanilha Felinto

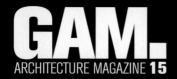

GAM. 15 – CALL FOR PAPERS
Territorial Justice

GAM.15 widmet sich der territorialen Gerechtigkeit. Der Begriff der territorialen Gerechtigkeit bezieht sich auf die räumliche Dimension sozialer Gerechtigkeit; er bezieht sich auf ein Verständnis von Planung, in dem jeder und jedem die gleiche Zugänglichkeit zu öffentlichen Gütern und Dienstleistungen (z.B. Verkehrsinfrastruktur, soziale Dienste, Gesundheitsversorgung, Bildung, Kultur, Beschäftigung) gewährt werden, wodurch der Zugang zu den Vorteilen eines gesellschaftlichen Netzes möglich wird. Die wachsende Kluft zwischen den reichsten und den ärmsten Mitgliedern der Gesellschaft manifestiert sich auch räumlich in einem Bruch zwischen wohlhabenden und marginalisierten Gebieten – sogar in Europa. In seinem jüngsten Manifest *La citta dei ricchi e la citta dei poveri* lud Bernardo Secchi Stadtforschende und -gestaltende ein, der gesellschaftlichen Verpflichtung nachzukommen, indem sie nach territorialer Gerechtigkeit streben: „Dem Urbanismus", schreibt Secchi, „muss hinsichtlich der Frage nach der Zuspitzung sozialer Ungerechtigkeiten eine große und kar definierte Verantwortung zukommen."[1]

Seit mehr als einem halben Jahrhundert arbeitet die Disziplin des Urbanismus auf der Grundlage eines wachstumsabhängigen Paradigmas. Seine Strategien basierten auf einer marktorientierten Stadtentwicklung und versuchten, durch Marktgewinne Vorteile für die Gesellschaft zu schaffen. Die Umverteilungsmechanismen sind jedoch gescheitert oder wurden im Laufe der Zeit ausgehöhlt, was uns in einen Zustand der territorialen Ungerechtigkeit versetzte. Yvonne Rydin fordert uns in ihrem 2013 erschienenen Buch über die Zukunft der Planung[2] dazu auf, Werte jenseits der Ökonomie zu betrachten, die Bemühungen und neue Methoden in Planung und Urbanismus erheblich vorantreiben könnten. Einem ähnlichen Gedanken folgend weist Pierre Veltz auf den „zentrifugalen Effekt" der Stadt hin,[3] also darauf, dass in Westeuropa Haushalte mit mittlerem und niedrigem Einkommen von der Immobilienspekulation aus den Städten in außerhalb gelegene Gebiete getrieben werden. Viele von ihnen finden sich in ländlichen Gemeinden mit wenigen Gemeinschaftseinrichtungen weit weg vom Arbeitsmarkt wieder.

Gegen die Schwierigkeiten des täglichen Lebens in diesen Gebieten, insbesondere Wohnungs- und Transportkosten, gibt es eine zunehmende Zahl von Protesten in Europa. Wie Rem Koolhaas treffend spekulierte, ist die Vernachlässigung des ländlichen Raums und damit seiner aktuellen problematischen Transformation möglicherweise ein Grund für den globalen Trend zum Populismus.[4] Regierungen, Medien und Wissenschaft konzentrieren sich auf die Stadt, ohne sich der Unzufriedenheit im ländlichen Raum bewusst zu sein. Viele Faktoren tragen zur drastischen Veränderung von außerstädtischen Gebieten bei: der sogenannte Brain-Drain, Bevölkerungsanteile, die überproportional älter, schlechter ausgebildet und/oder kürzlich migriert sind, ein Mangel an Arbeitsplätzen in der Nähe, die Automatisierung der Landwirtschaft oder der Klimawandel. Diese aktuellen Umstände haben dazu geführt, dass sich der ländliche Raum weltweit schneller wandelt als die Städte.[5] Und dennoch beginnen Disziplinen wie Stadtplanung und Urbanismus ihre Äußerungen häufig mit dem gleichen Mantra: „50% der Weltbevölkerung lebt in Städten" - als ob die sozialräumlichen Realitäten der restlichen 50% keine Untersuchungen wert wären.

GAM.15 – „Territorial Justice" lädt daher ein, die Gebiete außerhalb der Städte aus dem Blickwinkel der Gleichheit und Gerechtigkeit zu betrachten und solche Arten des Urbanismus zu erforschen, die die Entwicklung des Wohlbefindens und den Zugang zu Bildungs-, Kultur-, Sozial- und Gesundheitsinfrastrukturen sowie Energie, Wasser und natürlichen Ressourcen fördern. *GAM 15* lädt Forschende und Praktizierende aus Architektur, Urbanismus, Planung, Geografie, Landschaftsarchitektur und Kulturtheorie ein, jene Perspektiven einzubringen, die das vorherrschende Planungssystem herausfordern, indem sie über einen vom Wirtschaftswachstum abhängigen Urbanismus hinausschauen und so territoriale Gleichheit und Gerechtigkeit fördern. Abstracts (max. 500 Wörter) zum Thema „Territorial Justice" können bis zum **7. Mai 2018** mit einer Kurzbiografie an **gam@tugraz.at** eingereicht werden. **Einsendeschluss** für die finalisierten Beiträge ist der **3. September 2018.**

1 „L'urbanistica ha forti, precise responsabilità nell'aggravarsi delle disuguaglianze." Secchi, Bernardo: *La città dei ricchi e la città dei poveri*, Bari 2013, VII.

2 Rydin, Yvonne: *The Future of Planning. Beyond Growth Dependence*, Bristol 2013.

3 Veltz, Pierre: „Fractures sociales, Fractures territoriales?" in *Metis*, February 17, 2017, accessed online: January 20, 2018, http://www.metiseurope.eu/fractures-sociales-fractures-territoriales_fr_70_art_30504.html

4 See Koolhaas, Rem: „Countryside Architecture," in *Icon*, September 23, 2014, accessed online: January, 20, 2018, https://www.iconeye.com/architecture/features/item/11031-rem-koolhaas-in-the-country

5 Ibid.

GAM.15 will be dedicated to territorial justice. The notion of territorial justice relates to the spatial dimension of social justice; it refers to a system of spatial planning in which everyone is granted the same conditions of access to public goods and services (such as transport infrastructures, social services, health care, education, culture, employment) thus enabling access to the advantages of a societal network. As the gap between the richest and poorest members of society widens, a growing gulf between prosperous and relegated territories is physically manifesting itself; even in Europe. Bernardo Secchi, in his latest manifesto *La citta dei ricchi e la citta dei poveri*, invited urban researchers to embrace societal responsibilities by striving for territorial justice: "Urbanism," writes Secchi, "has to assume a major and clearly defined responsibility when it comes to questions concerning the aggravation of social inequalities."[1]

For more than half a century now, the discipline of urbanism has operated on the basis of a growth-dependant paradigm. Its strategies have been based on market-led urban development and have sought to provide community benefits through market profits. The redistribution mechanisms have, however, failed or been eroded over time, leaving us in a state of territorial injustice. Yvonne Rydin, in her 2013 book about the future of planning,[2] urges us to consider values beyond the economic which could considerably drive efforts and new methods in planning and urbanism. Along similar lines, Pierre Veltz draws attention to the "centrifugal effect" of the city[3] and that in Western Europe, middle and low-income households are expelled from cities, towards peri-urban areas, due to real estate speculation. Many of them find themselves in rural communes with few collective amenities, far from the job market.

The difficulties of everyday life, in particular housing and transport costs, are, amongst other factors, responsible for the rise of protests in Europe. As Rem Koolhaas rightly speculated, negligence of the countryside and its on-going problematic transformation is possibly a reason for the global trend in populism.[4] Governments, journalists, and scientists are focusing on the city, unaware of the dissatisfaction that lies outside of it. Many factors are contributing to the drastic transformation of extra-urban areas: brain drain, fragile populations (due to disproportionately elderly, poorly educated, new migrant community members), lack of, and distance to, employment, automation of agriculture, or climate change. These current circumstances have resulted in the fact that the countryside, worldwide, is transforming faster than the city.[5] And yet, our urban planning and urbanism disciplines often begin their utterances with the same mantra: "50% of the world's population lives in cities"—as if the socio-spatial realities of the remaining 50% were not worth studying.

Therefore, *GAM.15*—"Territorial Justice" invites you to look at the territories outside cities through the lens of equality and justice and to explore types of urbanism that encourage the development of well-being, the access to educational, cultural, social and health care infrastructures, as well as energy, water, and green resources. This call invites architects, urbanists, planners, geographers, landscape architects and cultural theorists to provide perspectives that challenge the current system of planning by looking beyond an urbanism that depends on economic growth, thus fostering territorial equality and justice. Abstracts (max. 500 words) on the topic "Territorial Justice" can be submitted, along with a short biography, to **gam@tugraz.at** by **May 7, 2018**. The **submission deadline** for finalized contributions is **September 3rd, 2018**.

1 "L'urbanistica ha forti, precise responsabilità nell'aggravarsi delle disuguaglianze." Bernardo Secchi, *La città dei ricchi e la città dei poveri* (Bari, 2013), p. VII.

2 Yvonne Rydin, *The Future of Planning. Beyond Growth Dependence* (Bristol, 2013).

3 Pierre Veltz, "Fractures sociales, Fractures territoriales?" in *Metis*, February 17, 2017, accessed online: January 20, 2018, http://www.metiseurope.eu/fractures-sociales-fractures-territoriales_fr_70_art_30504.html.

4 See Rem Koolhaas, "Countryside Architecture," in *Icon*, September 23, 2014, accessed online: January, 20, 2018, https://www.iconeye.com/architecture/features/item/11031-rem-koolhaas-in-the-country.

5 Ibid.

AUTORINNEN | AUTHORS

Bart De Baere ist Direktor des M HKA in Antwerpen, einem Museum für zeitgenössische Kunst, das sich mit der visuellen Kultur in ihrer Gesamtheit beschäftigt. Im Jahr 2015 hat er die 5. Moskauer Biennale gemeinsam mit Defne Ayas und Nicolaus Schafhausen kuratiert, die vor kurzem im Buch *How to Gather* (2017) vom M HKA Antwerpen, Witte de With Rotterdam, der Kunsthalle Wien und der V-A-C Stiftung, publiziert wurde.
Bart De Baere is the director of the M HKA in Antwerp, a contemporary art museum, dealing with visual culture at large. In 2015 he curated the 5th Moscow Biennale together with Defne Ayas and Nicolaus Schafhausen, which has recently resulted in the book *How to Gather* (2017), published by M HKA Antwerp, Witte de With Rotterdam, Kunsthalle Wien and the V-A-C Foundation. He is now working with Anders Kreuger and Jan De Vree on the notion of museum research.

Ivana Bago ist eine in Zagreb lebende Kunsthistorikerin, Schriftstellerin und Kuratorin. Sie ist Mitbegründerin des Delve | Institute for Duration, Location and Variables (www.delve.hr). Ihr Forschungsinteresse liegt in den Bereichen jugoslawische Kunst, Konzeptkunst, Ausstellungsgeschichte, Kunstgeschichte, Kunsttheorie, Kunst-Geschichtsschreibung nach 1989 und Dekoloniale Ästhetik. Derzeit arbeitet sie an ihrer Dissertation über (post-)jugoslawische Kunst und Ästhetik an der Duke University.
Ivana Bago is an art historian, writer, and curator based in Zagreb. She is the co-founder of Delve | Institute for Duration, Location and Variables (www.delve.hr). Her research interests include Yugoslav art, conceptual art, exhibition history, art theory, post-1989 art historiographies and decolonial aesthetics. She is currently finishing her dissertation on (post-)Yugoslav art and aesthetics at Duke University.

Ana Bezić ist eine archäologische Forscherin, die ebenfalls in anthropologischen und critical studies gearbeitet hat. Ihre aktuelle Forschung untersucht die Schnittstelle, Umsetzung und ethischen Auswirkungen von Kunst und Archäologie an Orten von Massenverbrechen. Derzeit ist sie Visiting Researcher am Cultural Studies Department der Universität von Rijeka. Seit 2009 ist sie Mitglied des Kunsttheorie-Kollektivs Spomenik/Monument Group.
Ana Bezić is an archaeological scholar with a background in anthropological and critical studies. Her current research explores the intersection, transposition, and ethical implications of art and archaeology in places of mass atrocities. She is currently a visiting researcher in the Cultural Studies Department at the University of Rijeka. Since 2009, she has been a member of the art-theory group Grupa Spomenik/Monument Group.

Nicolas Bourriaud ist ein französischer Kunstkritiker, -theoretiker und Kurator. Er ist Mitbegründer und Ko-Direktor des Palais de Tokyo in Paris (2000–2006), und Gulbenkian Kurator für Zeitgenössische Kunst am Tate Britain Museum. Gegenwärtig ist er Direktor des Montpellier Contemporain (MoCo), dem auch das La Panacée Kunstzentrum und die Ecole Supérieure des Beaux Arts und das zukünftige MoCo Museum angehören. Er ist Autor von *Relationale Ästhetik* (1998), *Postproduction* (2007), *Radikant* (2009), und *The Exform* (2015).
Nicolas Bourriaud is a French art critic, theoretician, and curator. He was the co-founder and the co-director of the Palais de Tokyo in Paris (2000–2006) and Gulbenkian Curator for Contemporary Art at Tate Britain. Currently he is director of Montpellier Contemporain (MoCo), including La Panacée art center, Ecole Supérieure des Beaux-Arts and the future MoCo Museum. He is the author of *Relational Aesthetics* (1998), *Postproduction* (2007), *The Radicant* (2009) and *The Exform* (2015).

Maria Bremer ist Kunsthistorikerin an der Bibliotheca Hertziana – Max-Planck-Institut für Kunstgeschichte in Rom. Ihre derzeitige Forschung untersucht das historiografische Potenzial des Mediums Ausstellung. 2017 promovierte sie an der Freien Universität Berlin mit einer Arbeit über die documenta Ausstellungen der 1970er Jahre. Ihre Forschungsschwerpunkte liegen in zeitgenössischer Kunst und Ausstellungsgeschichte mit einem Fokus auf Autorschaft, Kanonisierung und Geschichtsschreibung.
Maria Bremer is an art historian at the Bibliotheca Hertziana – Max Planck Institute for Art History in Rome. Her current research explores the historiographical potential of the exhibition medium. She obtained her PhD at Freie Universität Berlin in 2017, with a thesis on the documenta editions of the 1970s. Her research interests lie in contemporary art and exhibition history, with a focus on authorship, canonization, and historiography.

Das Museum of American Art in Berlin ist eine Bildungseinrichtung, die sich dem Zusammenfügen, Erhalten und Ausstellen von Erinnerungen an das MoMA International Programm und seiner Wechselausstellungen, widmet. Es sind diese meist von Dorothy Miller kuratierten MoMA Ausstellungen, die geholfen haben, im Westeuropa der Nachkriegszeit eine gemeinsame kulturelle Identität basierend auf Internationalisierung, Modernismus und Individualismus zu etablieren. Zusätzlich zu den Dauerausstellungen in der Stalinallee 91 in Berlin besitzt das Museum mehrere Sammlungen, die bei unterschiedlichen Ausstellungen gezeigt werden.
The Museum of American Art in Berlin is an educational institution dedicated to assembling, preserving, and exhibiting memories on the MoMA International Program and its circulating exhibitions. It is those MoMA exhibitions, most of them curated by Dorothy Miller, that helped to establish in western Europe the post-war common cultural identity based on internationalism, modernism, and individualism. In addition to its permanent exhibits located at Stalinallee 91 in Berlin, the museum holds several collections shown at various exhibitions.

Ekaterina Degot ist Kunsthistorikerin, Kunstkritikerin und Kuratorin. Sie befasst sich insbesondere mit ästhetischen und soziopolitischen Aspekten der Kunst in Russland und Osteuropa. Sie lehrte an russischen, europäischen und US-amerikanischen Universitäten, kuratierte u.a. den russischen Pavillon bei der Biennale von Venedig 2001, die erste Ural Industrial Biennale in Jekaterinenburg (2010) und entwickelte 2012 die Diskussionsplattform der ersten Kiew Biennale für Gegenwartskunst Arsenale „Kunst nach dem Ende der Welt". Seit Januar 2018 ist sie Intendantin und Hauptkuratorin des Steirischen Herbst in Graz.
Ekaterina Degot is an art historian, art critic, and curator. She has taught in Russian, European, and US-American Universities and curated, amongst others, the Russian pavilion at the Venice Biennial in 2001 as well as the first Ural Industrial Biennial in Jekaterinenburg (2010). In 2012 she developed "Art after the End of the World", a discussion platform of the Kiev Biennial of Contemporary Art. In January 2018 she has been appointed intendant and main curator of the Steirischer Herbst in Graz.

Ana Dević ist Kuratorin und lebt Zagreb. Sie ist aktives Mitglied des Kollektivs What, How and from Whom/WHW, das seit 2000 aktiv ist. WHW hat zahlreiche Ausstellungen kuratiert, wie zum Beispiel: „What keeps mankind alive?", 11th Istanbul Biennial (2009) und „Really Useful Knowledge" MNRS, Madrid, (2014). Sie interessiert sich für diverse Situationen, in denen, wie T.J. Clark es definiert, Kunst und Politik einander nicht entkommen können. Sie ist Doktorandin an der Universität von Zadar.
Ana Dević is a curator based in Zagreb. She is a member of the collective What, How and from Whom/WHW, active since 2000. WHW curated numerous exhibitions, such as: "What keeps mankind alive?" at the 11th Istanbul Biennial (2009) and "Really Useful Knowledge" at the MNRS, Madrid, (2014). She is interested in various situations, in which, as T. J. Clark defines it, art and politics could not escape each other. She is a doctoral candidate at the University of Zadar.

Anselm Franke lebt und arbeitet als Kurator und Autor in Berlin. Seit 2013 ist er Leiter des Bereichs Bildende Kunst und Film am Haus der Kulturen der Welt. Zuvor war er Kurator an den KW Berlin und Direktor der Extra City Kunsthal in Antwerpen. Mit Stefanie Schulte Strathaus gründete er 2005 das Forum Expanded der Internationalen Filmfestspiele Berlin und ist seither Ko-Kurator.
Anselm Franke lives and works in Berlin as a curator and author. He has been the head of the Department of Visual Arts and Film at Haus der Kulturen der Welt since 2013. He previously worked as a curator at KW Berlin and as director of the Extra City Kunsthal in Antwerp. In 2005 he and Stefanie Schulte Strathaus founded the Forum Expanded for the Berlin International Film Festival of which he has been co-curator since.

Andrew Herscher ist Gründungmitglied einer Reihe von militanten Forschungskooperationen, wie etwa des We the people of Detroit Community Research Collective, Detroit Resists, und der Commune Research Commune. In seiner wissenschaftlichen Arbeit untersucht er die Architekturen von politischer Gewalt, von Migration und Vertreibung und von Widerstand und Selbstbestimmung an einer Reihe von Orten weltweit. Derzeit ist er Associate Professor an der University of Michigan.
Andrew Herscher is a co-founding member of a series of militant research collaboratives including the We the People of Detroit Community Research Collective, Detroit Resists, and the Commune Research Commune. In his scholarly work, he explores the architecture of political violence, migration and displacement, and resistance and self-determination across a range of global sites. He is currently an Associate Professor at the University of Michigan.

Christian Inderbitzin studierte Architektur an der ETH Zürich. 2005 gründete er zusammen mit Elli Mosayebi und Ron Edelaar ein eigenes Architekturbüro in Zürich. Bis 2015 arbeitete er als wissenschaftlicher Assistent am ETH Studio Basel. Danach war er Gastdozent an der TU Graz, Gastprofessor an der École polytechnique fédérale in Lausanne. Derzeit unterrichtet er zusammen mit Elli Mosayebi und Ron Edelaar an der ETH Zürich.
Christian Inderbitzin studied architecture at the ETH Zurich. In 2005 he founded his own architectural office together with Elli Mosayebi and Ron Edelaar. Until 2015 he worked as a research assistant at ETH Studio Basel. After that he was a guest lecturer at TU Graz and taught as a guest professor at the École polytechnique fédérale in Lausanne. He is currently teaching together with Elli Mosayebi and Ron Edelaar at the ETH Zurich.

Branislav Jakovljević ist Associate Professor und Leiter des Lehrstuhls für Theater und Performance an der Stanford University. In seiner Forschung beschäftigt er sich mit Avantgarde und Experimentaltheater, Performance-Theorie, Performance und Politik

und aktuell mit radikaler Performance und Ästhetik. Seine jüngsten Bücher sind *Alienation Effects. Performance and Self-Management in Yugoslavia 1945–1991* (2016) und *Smrznuti magarac i drugi eseji/Frozen Donkey and Other Essays* (2017).

Branislav Jakovljević is an Associate Professor and Chair in the Department of Theater and Performance Studies at Stanford University. His research focuses on avant-garde and experimental theater, performance theory, performance and politics and currently on radical performance and ethics. His most recent books are *Alienation Effects: Performance and Self-Management in Yugoslavia 1945–1991* (2016) and *Smrznuti magarac i drugi eseji/Frozen Donkey and Other Essays* (2017).

Sami Khatib ist Kulturtheoretiker und Philosoph. Er unterrichtete an der Freien Universität Berlin, der Jan van Eyck Academie Maastricht, der American University of Beirut und an der Akademie der bildenden Künste Wien. Aktuell ist er promovierter Forscher an der Leuphana Universität Lüneburg. Er ist Autor des Buches *Teleologie ohne Endzweck. Walter Benjamins Entstellung des Messianischen* (2013).

Sami Khatib is a cultural theorist and philosopher. He taught at Freie Universität Berlin, Jan van Eyck Academie Maastricht, American University of Beirut and Akademie der bildenden Künste Vienna. Currently, he is a postdoctoral researcher at Leuphana Universität Lüneburg. He is the author of *Teleologie ohne Endzweck: Walter Benjamins Entstellung des Messianischen* (2013).

Wilfried Kuehn ist Architekt und Kurator. Mit Johannes Kuehn und Simona Malvezzi gründete er 2001 in Berlin Kuehn Malvezzi. 2006–12 war Wilfried Kuehn Professor für Ausstellungsdesign und Kuratorische Praxis an der Hochschule für Gestaltung Karlsruhe, wo er *Displayer*, eine Zeitschrift für kuratorisches Design, initiierte und herausgab. Seit 2017 leitet er das Forschungsprojekt „Curatorial Design" am Institut für Zeitgenössische Kunst der TU Graz.

Wilfried Kuehn is an architect and curator. Together with Johannes Kuehn and Somina Malvezzi he founded Kuehn Malvezzi 2001 in Berlin. From 2006 to 2012 Wilfried Kuehn was professor for exhibition design and curatorial design at Karlsruhe University of Arts and Design, where he initiated and edited the *Displayer*, a magazine for curatorial design. Since 2017 he leads the research project "Curatorial Design" at the Institute of Contemporary Art at TU Graz.

Nicole Lai Yi-Hsin ist selbstständige Kuratorin und lebt und arbeitet in Taiwan. 2011 gründete sie ihr Atelier Art Square Taiwan. Sie leitet ein Residency-Programm, welches sich auf die Thematik des postkolonialen städtischen Raumes in Beziehung zur Erinnerung der Menschen und zeitgenössischen Kunst konzentriert. Lai's aktuelle Forschung widmet sich dem Thema „Kunst als Widerstand und Schutz". Sie war Kuratorin der Ausstellungen „Shattered Sanctity" (2017), „The Bared Sound" (2017), und „Lost in the Mobius-Taiwan Macau" (2014–2016).

Nicole Lai Yi-Hsin is an independent curator who lives and works in Taiwan. She founded Art Square Taiwan in 2011 as a studio space and runs a residency program focused on the theme of postcolonial urban space in relation to people's memory and contemporary culture. Lai's current research focuses on the topic "Art as Resistance and Shelter." She has curated the exhibitions "Shattered Sanctity" (2017), "The Bared Sound" (2017), and "Lost in the Mobius-Taiwan Macau" (2014–2016).

Bruno Latour ist emeritierter Professor, verbunden mit dem Médialab und dem experimentellen Programm in politischer Kunst (SPEAPO) der Sciences Po Paris. Seit Januar 2018 ist er für zwei Jahre Fellow am Zentrum für Kunst und Medien (ZKM) und Professor an der Staatlichen Hochschule für Gestaltung (HfG) in Karlsruhe. Er ist Mitglied in zahlreichen Akademien und Empfänger von sechs Ehrendoktoraten. 2013 wurde ihm der Holberg Gedenkpreis verliehen. Er hat mehr als zwanzig Bücher verfasst und herausgegeben sowie weit über 150 Artikel publiziert.

Bruno Latour is an emeritus professor associated with the Médialab and the Experimental Program in Political Arts (SPEAP) of Sciences Po Paris. Since January 2018 he has been fellow at the Zentrum für Kunst und Medien (ZKM) and professor at the Staatliche Hochschule für Gestaltung (HfG), both in Karlsruhe. He is a member of several academies, the recipient of six doctorates, and has received the Holberg Prize in 2013. He has written and edited more than twenty books and published more than one hundred and fifty articles.

Ana María León ist Architekturhistorikerin an der Universität von Michigan. Ihre Forschung untersucht Raumpolitiken der Pädagogik und Partizipation, des öffentlichen Raums und des sozialen Wohnbaus, sowie Zusammenhänge zwischen Kapital, Gewalt und dem „exhibitionary complex". Sie partizipiert an mehreren Kollaborationen, wie z.B. der Feminist Art and Architecture Collaborative (FAAC), GAHTC und Detroit Resists, die die Reichweite von Architekturgeschichte erweitern.

Ana María León is an architectural historian at the University of Michigan. Her research examines the spatial politics of pedagogy and participation, public space and public housing, and the links between capital, violence, and the exhibitionary complex. She is part of several collaborations broadening the reach of architectural history including the Feminist Art and Architecture Collaborative (FAAC), GAHTC, and Detroit Resists.

Armin Linke analysiert als Fotograf und Filmemacher die Gestaltung unserer natürlichen, technologischen und städtischen Umgebung. Durch die Arbeit im eigenen Archiv und gemeinsam mit anderen Medienarchiven fordert er die Konventionen der fotografischen Praxis heraus. Linke war Research Affiliate am MIT Visual Arts Programm Cambridge, Professor für Fotografie an der Staatlichen Hochschule für Gestaltung Karlsruhe und unterrichtet an der IUAV Arts and Design University in Venedig.

Armin Linke is a photographer and filmmaker who investigates the configurations of our natural, technological and urban environment. Through working with his own archive as well as with other media archives, he challenges the conventions of photographic practice. Linke was a Research Affiliate at the MIT Visual Arts Program Cambridge, Professor for Photography at the University for Arts and Design Karlsruhe and currently teaches at the IUAV Arts and Design University in Venice.

Antonia Majača ist eine in Berlin lebende Kunsthistorikerin, Kuratorin und Schriftstellerin, zudem ist sie Forschungsleiterin am Institut für Zeitgenössische Kunst (IZK) an der Technischen Universität Graz. Neben ihrer Lehrtätigkeit publiziert sie in zahlreichen Veröffentlichungen zur zeitgenössischen Kunst und Kunstgeschichte. Vor kurzem ko-kuratierte sie die Ausstellung „Parapolitics-Cultural Freedom and the Cold War" im Haus der Kulturen der Welt (HKW) in Berlin.

Antonia Majača is an art historian, curator, and writer based in Berlin as well as a research associate at the Institute for Contemporary Art (IZK) at Graz University of Technology. Antonia lectures regularly and has contributed to numerous publications in the field of contemporary art and art history. She recently co-curated the exhibition "Parapolitics-Cultural Freedom and the Cold War" at the Haus der Kulturen der Welt (HKW) in Berlin.

Doreen Mende ist Kuratorin, Autorin und Wissenschaftlerin und hat im Fachgebiet Curatorial/Knowledge an der Goldsmith University in London promoviert. Aktuell ist sie Associate Professor am Visual Arts Department der Haute Ecole d'art et de design de Genève (HEAD), wo sie das Research Master und PhD-Forum leitet. Zu ihren aktuellsten Publikationen zählen *KP Brehmer. Real Capital Production* (2017) und *Thinking under Turbulence* (2017).

Doreen Mende is a curator, writer, researcher and theorist and holds a PhD in Curatorial/Knowledge from Goldsmiths, University of London. She is currently Associate Professor of the CCC Research Program heading the Research Master and PhD-Forum of the Visual Arts Department at HEAD Genève/Switzerland. Her latest publications include *KP Brehmer: Real Capital Production* (2017) and *Thinking under Turbulence* (2017).

Ana Miljački ist Kritikerin, Kuratorin und Associate Professor für Architektur am Massachusetts Institute of Technology (MIT), wo sie Geschichte, Theorie und Design unterrichtet. Miljački war Teil des aus drei Personen bestehenden Kuratoren-Teams des „Office-US" Projekts auf der 14. Architekturbiennale in Venedig. Sie ist Autorin von *The Optimum Imperative* (2017) und Mitherausgeberin von *Terms of Appropriation* (2017).

Ana Miljački is a critic, curator and Associate Professor of Architecture at the Massachusetts Institute of Technology (MIT), where she teaches history, theory and design. Miljački was part of the three-member curatorial team of the "Office-US" project at the 2014 Venice Architecture Biennale. She is the author of *The Optimum Imperative* (2017) and co-editor of *Terms of Appropriation* (2017).

Vincent Normand ist Kunsthistoriker, Schriftsteller und gelegentlich Kurator. Er unterrichte an der ECAL/University of Art and Design Lausanne, wo er das Forschungsprojekt „Theater, Garden, Bestiary: A Materialist History of Exhibitions" (theatergardenbestiary.com) leitet. Er ist Ko-Direktor der Forschungs-Plattform und der Zeitschrift *Glass Bead* (www.glassbead.org). Seine Texte veröffentlichte er in diversen Ausstellungskatalogen, Sammelbänden und Zeitschriften.

Vincent Normand is an art historian, writer, and occasional curator. He teaches at the ECAL/University of Art and Design Lausanne, where he is director of the research project "Theater, Garden, Bestiary: A Materialist History of Exhibitions" (theatergardenbestiary.com). He is co-director and co-editor of the research platform and journal *Glass Bead* (www.glassbead.org). His texts are published in various exhibition catalogues, edited volumes, and journals.

Christoph Walter Pirker ist Doktorand im Fach Architektur, Performance-Künstler, Autor und Musiker. Als Universitätsassistent am Institut für Architektur und Landschaft an der Technischen Universität Graz untersucht er zeitgenössische Landschaften, Lebenswelten und Ökologien. Seine von Milica Tomić betreute Dissertation mit dem Titel „Visuelle Ontologien des Unbestimmten" erforscht performativ die Rolle des Menschlichen und Nichtmenschlichen in der Architektur.

Christoph Walter Pirker is a PhD candidate in architecture, performance artist, writer, and musician. As Assistant Professor at the Institute for Architecture and Landscape at the Graz University of Technology he is investigating contemporary landscapes, environments, and ecologies. His dissertation (supervised by Milica Tomić), entitled "Visual Ontologies of the Indefinite," performatively examines the role of the human and the non-human in architecture.

Dubravka Sekulić schreibt über die Produktion von Raum. Sie ist Universitätsassistentin am Institut für Zeitgenössische Kunst der TU Graz und Doktoratsstipendiatin am Institut für Geschichte und Theorie der Architektur an der ETH Zürich. Sie ist Autorin von *Glotzt Nicht so Romantisch! On Extra-legal Space in Belgrade* (2012), *Constructing Non-alignment. The Case of Energoprojekt* (2016), und Ko-Herausgeberin gemeinsam mit Žiga Testen und Gal Kirn von *Surfing the Black* (2012). Zudem ist sie Laien-Bibliothekarin an der Public Library/ Memory of the World.

Dubravka Sekulić writes about the production of space. She is an assistant professor at the Institute for Contemporary Art, Graz University of Technolgoy and a PhD fellow at gta ETH Zürich. She wrote *Glotzt Nicht so Romantisch! On Extra-legal Space in Belgrade* (2012), *Constructing Non-alignment: The Case of Energoprojekt* (2016), and co-edited, together with Žiga Testen and Gal Kirn, *Surfing the Black* (2012). She is an amateur-librarian at the Public Library/ Memory of the World.

Antje Senarclens de Grancy ist Architekturhistorikerin am Institut für Architekturtheorie, Kunst- und Kulturwissenschaften der TU Graz, seit 2016 Assistenzprofessorin. Derzeit forscht sie zu einer Beziehungsgeschichte zwischen Lager und moderner Architektur am Beispiel der Flüchtlingslager der Habsburgermonarchie im Ersten Weltkrieg. 2019 wird sie gemeinsam mit Heidrun Zettelbauer das Themenheft „Camps as Cultural Spaces" der Zeitschrift *zeitgeschichte* herausgeben.

Antje Senarclens de Grancy is an architectural historian at the Institute of Architectural Theory, Art History and Cultural Studies at Graz University of Technology, since 2016 she holds the position of Associate Professor. Currently she is researching a relational history between camps and modern architecture at the example of refugee camps in the Habsburg monarchy during the First World War. In 2019 she will be co-editing the special issue "Camps as Cultural Spaces" of the magazine *zeitgeschichte* together with Heidrun Zettlebauer.

Katharina Sommer ist Architektin und freie Journalistin mit den Schwerpunkten Architektur, Stadtplanung und Design. Sie ist Mitherausgeberin der Architekturzeitschrift *manege für architektur* und war als Redakteurin für die Zürcher Zeitschrift *archithese*, für das Magazin *Detail* in München und den Birkhäuser Verlag in Basel tätig. Sie studierte Architektur an der Technischen Universität München und der Rhode Island School of Design sowie Kulturpublizistik an der Zürcher Hochschule der Künste.

Katharina Sommer is a journalist working in the field of architecture, interior design, and urbanism. She is the co-editor of the architecture magazine *manege für architektur*. Her professional experience includes editorial positions at *archithese* (Zurich), Birkhäuser (Basel) or *Detail* (Munich). She studied architecture at the Technical University Munich and the Rhode Island School of Design as well as cultural publishing at the Zurich University of the Arts.

Anna-Sophie Springer ist freie Ausstellungsmacherin, Autorin und betreibt das künstlerische Verlagsprojekt K. in Berlin. In ihrer Arbeit spielen Archive und das Buch als Ausstellung eine zentrale Rolle. Sie ist Ko-Herausgeberin und Verlegerin der Reihe *intercalations: paginated exhibition* und Ko-Herausgeberin von *Fantasies of the Library* (2016). Derzeit ist sie Gastdozentin am Institut Kunst, Basel.

Anna-Sophie Springer is an independent exhibition maker, writer and directs the publishing project K. Verlag in Berlin. Her work focuses on archives and the book-as-exhibition. She is co-editor and co-founder of the *intercalations: paginated exhibition* series and co-editor of *Fantasies of the Library* (2016). Currently she is a visiting lecturer at Institut Kunst, Basel.

Barbara Steiner ist Leiterin des Kunsthauses Graz. Bis September 2017 hatte sie eine Vertretungsprofessur für Kulturen des Kuratorischen an der HGB Leipzig inne. Sie publizierte eine Reihe von themenbezogenen Büchern über Raumkonzeptionen, das Verhältnis von öffentlich und privat sowie über Kunst und Ökonomie. In ihrer Arbeit widmet sie sich den Bedingungen kultureller Produktion, unter Berücksichtigung von widerstreitenden Interessen und damit verbundenen Prozessen des Aushandelns.

Barbara Steiner is the director of Kunsthaus Graz. Until September 2017, she was visiting professor for Cultures of the Curatorial at the Academy of Fine Arts Leipzig. Steiner published a series of theme-related books on conceptions of space, the relationship between private and public, and on art and the economy. In her work, she looks into conditions of cultural production, drawing attention to conflicting concerns and interconnected processes of negotiation.

Kate Strain lebt in Graz und Dublin. Sie forscht zum Thema des Überlappens zwischen Performance und Performativität in der Praxis der bildenden Künste. Sie ist die künstlerische Leiterin des Grazer Kunstvereins, Österreich und Mitbegründerin des ersten Departments für Ultimologie am Trinity College Dublin in Zusammenarbeit mit dem Connect Centre for Future Networks and Communications, das die Ultimologie erforscht, die sich demjenigen widmet, was in allen möglichen Disziplinen vor dem Aussterben und Verschwinden steht.

Kate Strain is based in Graz and Dublin. Her research focuses on the overlap between performance and performativity in visual arts practice. She is the artistic director of Grazer Kunstverein, Austria and co-founder of the first Department of Ultimology at Trinity College Dublin, working with the Connect Centre for Future Networks and Communications to explore Ultimology as the study of that which is in danger of disappearing in any given discipline.

Žiga Testen ist ein slowenischer Grafikdesigner. Der Fokus seiner Arbeit liegt im Bereich der zeitgenössischen Kunst- und Kulturproduktion, bei der er eine enge Zusammenarbeit mit Künstlern, Kuratoren und kulturellen Organisationen bevorzugt. Anstatt eines ästhetischen Stils werden Kontext und projektspezifische Lösungen für individuelle Ansätze gesucht. Derzeit lebt und arbeitet er in Melbourne, Australien.

Žiga Testen is a Slovenian graphic designer. Typically, the focus of his practice is contemporary art and culture and he prioritizes work in close collaboration with artists, curators, and cultural organizations. Rather than an aesthetic or style, a context and project-specific solution is sought out for each individual commission. He is currently living and working in Melbourne.

Milica Tomić ist Künstlerin und leitet das Institut für zeitgenössische Kunst (IZK) der TU Graz. Sie ist Gründungsmitglied der „Grupa Spomenik" (2002), und sie hat das interdisziplinäre Projekt „Four Faces of Omarska" (2010) konzipiert. Ihre Ausstellungen waren unter anderem zu sehen im Haus der Kulturen der Welt, Berlin, dem Whitney Museum of American Art, New York, der Kunsthalle Wien, dem MUMOK, dem KIASMA Helsinki, sowie auf den Biennalen von Venedig, Sydney und Istanbul.

Milica Tomić is an artist and head of the Institute for Contemporary Art (IZK) at Graz University of Technology. She is a founding member of the art/theory group "Grupa Spomenik" (2002) and she conceived and initiated the cross-disciplinary project "Four Faces of Omarska" [2010]. Her exhibitions include those at the House of World Cultures (Berlin), the Whitney Museum of American Art (New York), the Kunsthalle (Vienna), the MUMOK (Vienna), the KIASMA (Helsinki), the Venice Biennale, the Sydney Biennale, and the International Istanbul Biennial among others.

Etienne Turpin ist Philosoph und Research Scientist am Massachusetts Institute of Technology; er leitet zudem das von ihm gegründete Atelier für Designforschung anexact office (Berlin/Jakarta). Gemeinsam mit Anna-Sophie Springer befasst er sich im Rahmen der Forschungsinitiative *Reassembling the Natural* mit Biodiversitätsverlust und Landnutzung. Beide geben seit 2014 auch die Publikationsreihe *intercalations: paginated exhibition* heraus. Er ist zudem Ko-Herausgeber von *Fantasies of the Library* (2016) und *Art in the Anthropocene* (2015).

Etienne Turpin is a philosopher and research scientist at the Massachusetts Institute of Technology and the director of anexact office, a design research office based in Jakarta and Berlin. Together with Anna-Sophie Springer he is an investigator of the research initiative *Reassembling the Natural*, an inquiry into biodiversity loss and land use transformation. He is also the co-editor of *Fantasies of the Library* (2016) and *Art in the Anthropocene* (2015).

What, How & for Whom/WHW ist ein KuratorInnen-Kollektiv, das 1999 in Zagreb und Berlin gegründet wurde. Die Mitglieder sind Ivet Ćurlin, Ana Dević, Nataša Ilić, Sabina Sabolović und Designer und Publizist Dejan Kršić. WHW organisiert eine Reihe von Produktionen, Ausstellungen und Publikationsprojekten und leitet die Gallery Nova in Zagreb. WHW-Projekte werden konzipiert als Plattform für progressive Modi der Kulturproduktion und Reflexion der sozialen Wirklichkeit.

What, How & for Whom/WHW is a curatorial collective formed in 1999 and based in Zagreb and Berlin. Its members are Ivet Ćurlin, Ana Dević, Nataša Ilić and Sabina Sabolović, and designer and publicist Dejan Kršić. WHW organizes a range of production, exhibition and publishing projects and directs Gallery Nova in Zagreb. WHW projects have been conceived as platforms for progressive modes of cultural production and reflections of social reality.